Into the Light

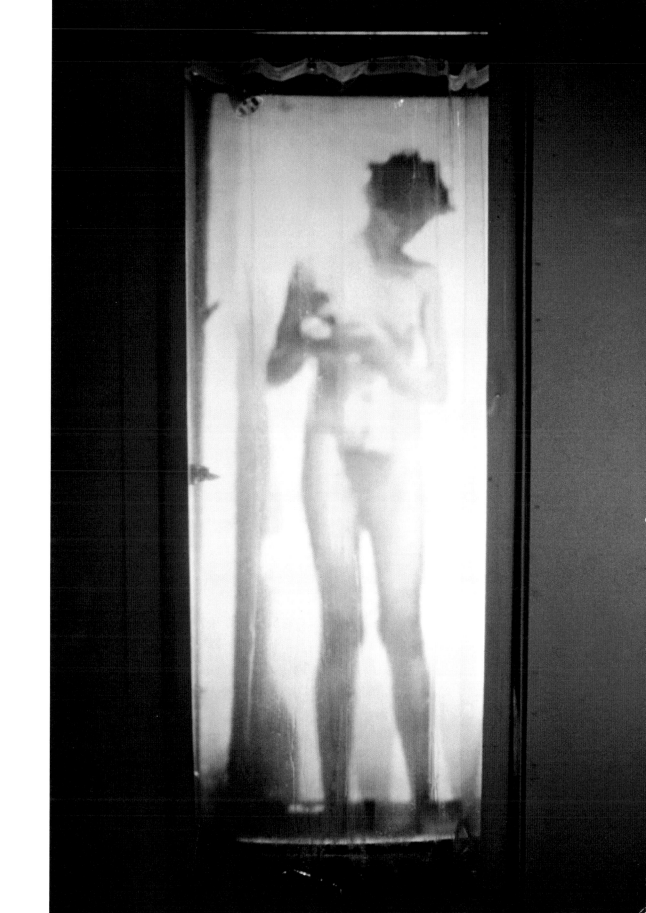

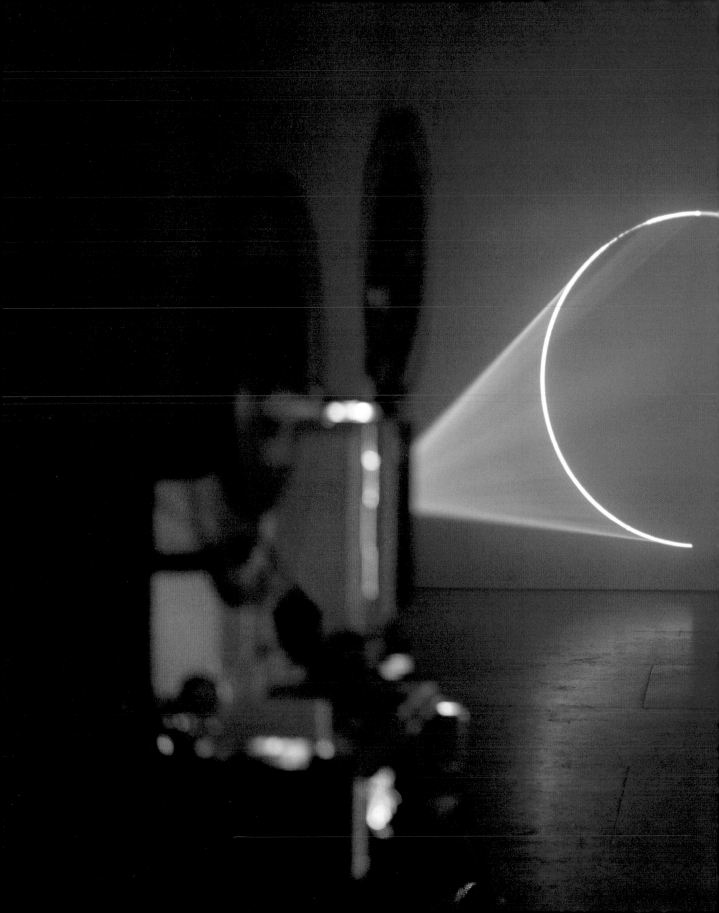

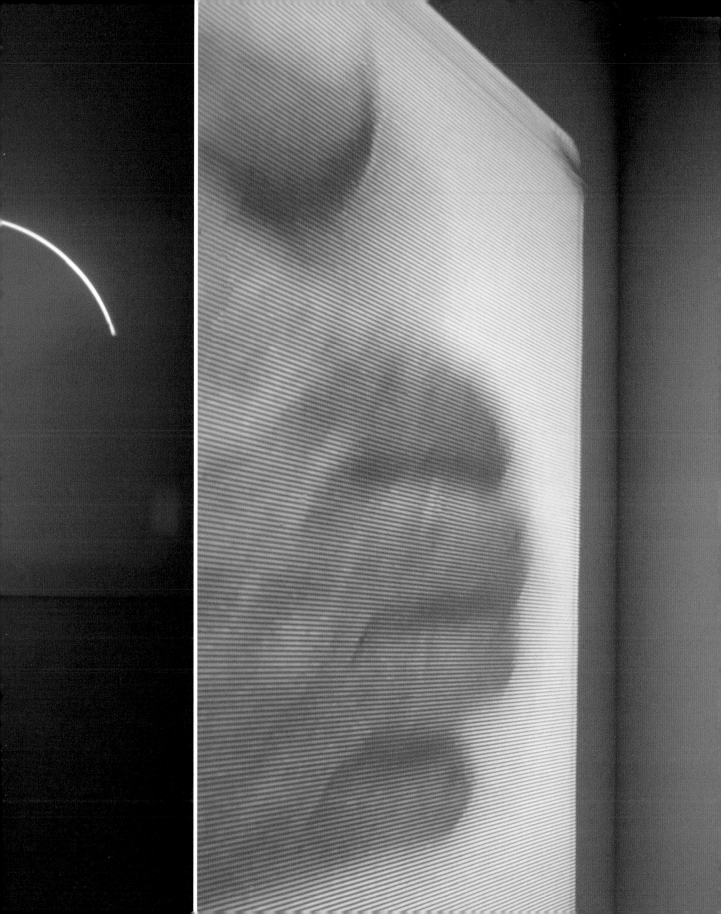

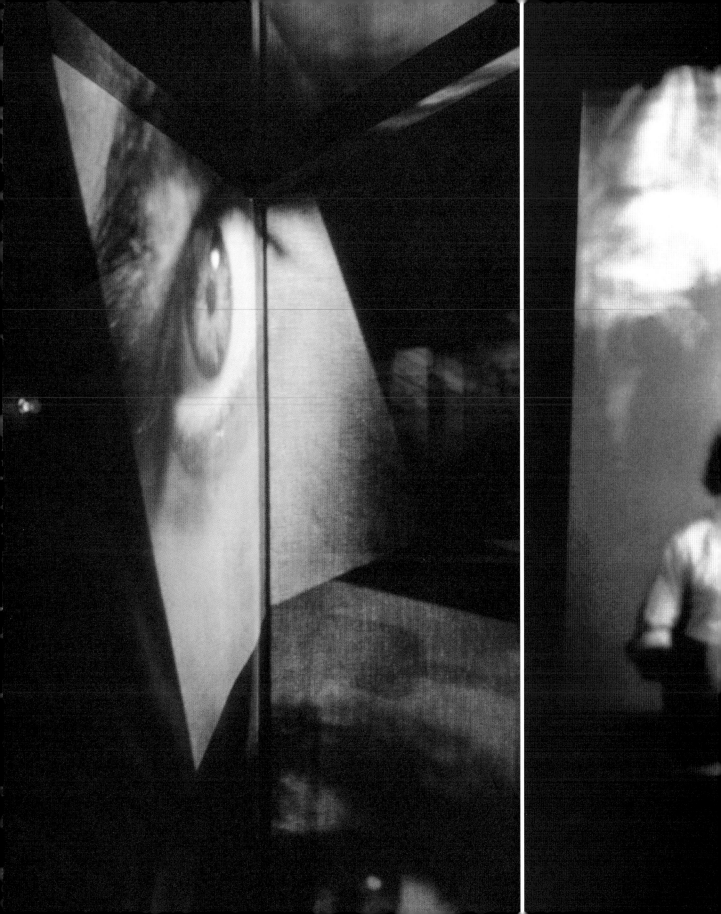

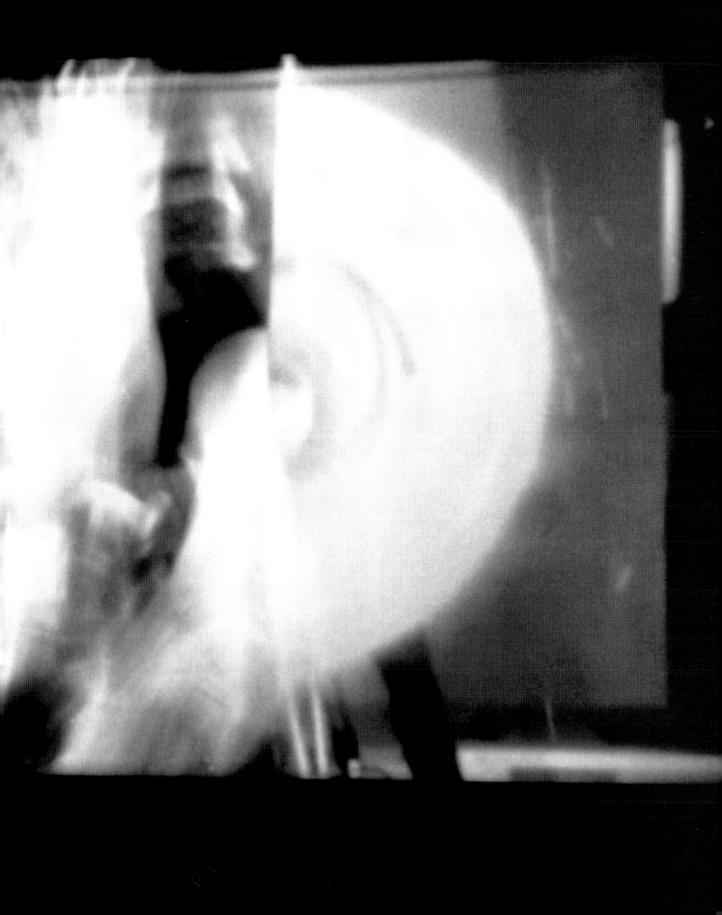

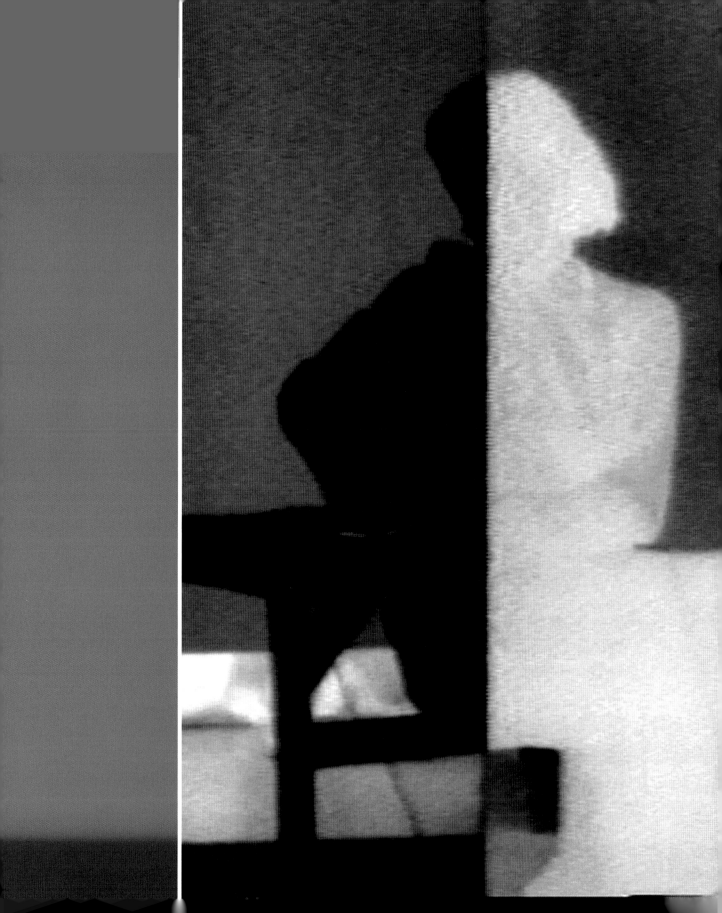

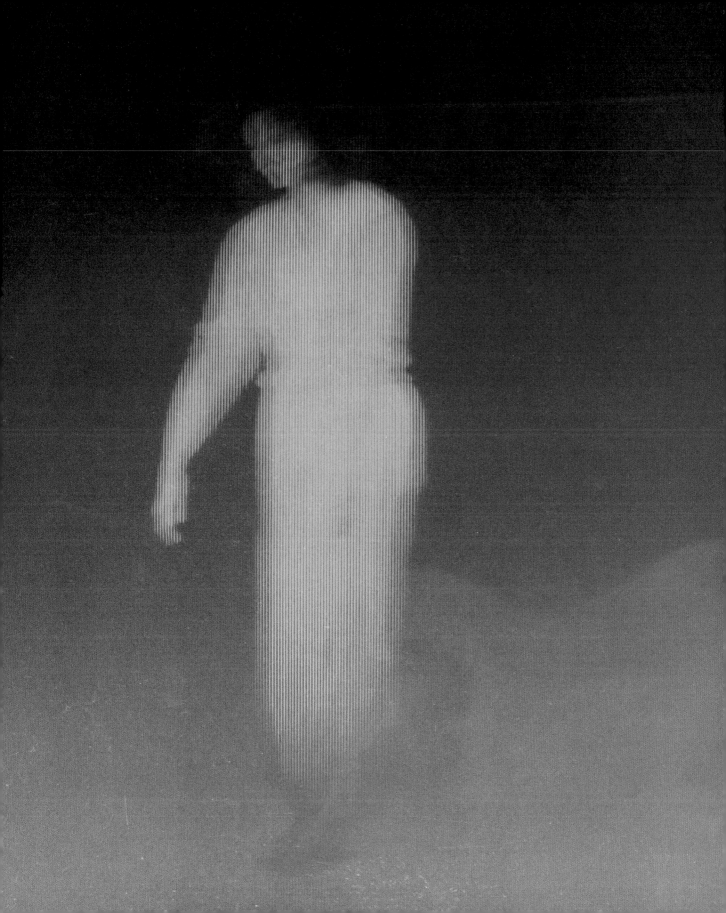

Into the Light

The Projected Image in American Art 1964–1977

Chrissie Iles

Whitney Museum of American Art, New York
Distributed by Harry N. Abrams, Inc., New York

This book was published on the occasion of the exhibition "Into the Light: The Projected Image in American Art 1964–1977" at the Whitney Museum of American Art, New York, October 18, 2001–January 6, 2002.

Preservation of works in the exhibition has been made possible by generous contributions from the New Art Trust and Cineric, Inc.

Research for Museum publications is supported by an endowment established by The Andrew W. Mellon Foundation and other generous donors.

A portion of the proceeds from the sale of this book benefits the Whitney Museum of American Art and its programs.

Full data for captions to works in the exhibition can be found on page 181.

Front cover: Paul Sharits, *Shutter Interface*, 1975 (detail). Back cover: Anthony McCall, *Line Describing a Cone*, 1973 (detail)

Images for pages 3–22 (all details):
Robert Whitman, *Shower*, 1964. Andy Warhol, *Lupe*, 1965. Yoko Ono, *Sky TV*, 1966. William Anastasi, *Free Will*, 1968. Robert Morris, *Mirror*, 1969. Bruce Nauman, *Spinning Spheres*, 1970. Mary Lucier, *Polaroid Image Series (Room)*, 1970. Keith Sonnier, *Channel Mix*, 1972. Dan Graham, *Helix/Spiral*, 1973. Anthony McCall, *Line Describing a Cone*, 1973. Dennis Oppenheim, *Echo*, 1973. Vito Acconci, *Other Voices for a Second Sight*, 1974. Michael Snow, *Two Sides to Every Story*, 1974. Beryl Korot, *Dachau 1974*, 1974. Gary Hill, *Hole in the Wall*, 1974. Paul Sharits, *Shutter Interface*, 1975. Joan Jonas, *Mirage*, 1976. Peter Campus, *aen*, 1977. Simone Forti, *Striding Crawling*, 1977

Library of Congress Cataloging-in-Publication Data

Iles, Chrissie.
 Into the light : the projected image in American art, 1964-1977 / Chrissie Iles.
 p. cm.
 Published on the occasion of an exhibition held at the Whitney Museum of American Art, New York, Oct. 18, 2001–Jan. 6, 2002.
 Includes bibliographical references.
 ISBN 0-87427-128-2 (Whitney)—
 ISBN 0-8109-6830-4 (Abrams)
 1. Video art—United States—Exhibitions.
 2. Installations (Art)—United States—Exhibitions. 3. Art, American—20th century—Exhibitions. I. Whitney Museum of American Art. II. Title.

 N6512.5.V53 I43 2001
 709'.73'0747471—dc21
 2001026965

©2001 Whitney Museum of American Art
945 Madison Avenue at 75th Street
New York, NY 10021
www.whitney.org

Contents

27 **Foreword**
Maxwell L. Anderson

29 **Acknowledgments**
Chrissie Iles

32 **Between the Still
and Moving Image**
Chrissie Iles

70 **Projection and
Dis/embodiment:
Genealogies
of the Virtual**
Thomas Zummer

Artists in the Exhibition
86 Robert Whitman
90 Andy Warhol
94 Yoko Ono
96 William Anastasi
98 Robert Morris
102 Bruce Nauman
106 Mary Lucier
112 Keith Sonnier
116 Dan Graham
120 Anthony McCall
126 Dennis Oppenheim
130 Vito Acconci
134 Michael Snow
138 Beryl Korot
142 Gary Hill
144 Paul Sharits
148 Joan Jonas
154 Peter Campus
156 Simone Forti

161 **Artists' Biographies
and Bibliographies**

181 **Works in the Exhibition**

Foreword

It is with great pride that we present "Into the Light" at the Whitney Museum of American Art. The exhibition underscores the Museum's commitment to the scholarly reassessment of critical moments in the history of American art. The period 1964–77 marked one such moment. In the short span of just over a decade, dramatic shifts were triggered by a range of developments from Pop, Minimalism, and Conceptual art to performance, Process art, avant-garde film, video, and projected installations. All the works in this exhibition belong to this rich period in America's history and helped redefine the parameters of art. Yet their ephemerality, which challenged modernism's strict division between the spatial and temporal arts, has rendered them somewhat invisible compared to their counterparts in other, more concrete media. Today, however, the appearance of new digital forms is paradoxically lending the older media of film, video, and slides a greater sense of materiality. "Into the Light" turns the spotlight back onto these classic works, revealing the important role the projective image has played in constructing a new language of artmaking.

The earliest work in the exhibition, Robert Whitman's film environment *Shower*, was made in 1964, at a moment when cinema was being eclipsed by television, and Marshall McLuhan's theories of the impact of electronic media first emerged. By juxtaposing a projected image (a woman showering) with a solid object (a shower stall and water), Whitman formed a bridge between the painterly Happenings he, Robert Rauschenberg, Allan Kaprow, Claes Oldenburg, Carolee Schneemann, and others had created from the late 1950s onward, incorporating film loops, slides, objects and performance, and the more conceptual installations made by artists such as Bruce Nauman, Robert Morris, Dan Graham, and Michael Snow in the later 1960s and early 1970s, in which projected images questioned and redefined both the darkened space of the cinema and the white cube of the gallery. In these installations, the phenomenology of space, as defined by Minimalist sculpture, was merged with the phenomenology of consciousness, as articulated by experimental film.

For this generation of artists, who had grown up in the 1950s, both these models rejected the traditional space of cinema, which had contained their early experiences of popular film. The emergence of the video camera as a tool for artistic experiment in the late 1960s, alongside the rise of television, coincided with artists' assertion of the film loop as a device by which the traditional space of cinema could be overturned.

"Into the Light" brings together installations by artists who articulate both these models. Some were also challenging the conventions of cinema in single-screen films (Michael Snow, Paul Sharits, Andy Warhol). Others used projective still and moving images in conjunction with photography, performance, sculpture, and sound to create what Robert Morris described in 1969 as a syncretic space, in which perception became a structural feature of the art work itself. Together, these installations allow us to assess the impact of this radical thinking on American art during the 1960s and 1970s, as well as to observe its significance for subsequent generations of artists working with the projected image, for whom these works have been highly influential and admired, yet impossible to see firsthand.

Many of the works in the exhibition are being reconstructed for the first time since their initial presentations in galleries, museums, and alternative spaces during the 1960s and 1970s. We are extremely grateful to the artists, their galleries, and all the lenders to the exhibition for making available to us such a wealth of historical work. Their generosity and support during each stage of the exhibition has been integral to its success. I would also like to thank Chrissie Iles, organizer of the exhibition, and the staff of the Whitney, for their hard work in realizing this complex project. Finally, I would like to acknowledge the generous contributions of the New Art Trust and Cineric, Inc. toward the preservation of works in the exhibition.

"Into the Light" provides an unprecedented opportunity to experience this body of classic works, which have played a major role in shaping perception and have radically transformed how we look at, and think about, contemporary art.

Maxwell L. Anderson
Director

Acknowledgments

This exhibition is the first to address the role of the projective image in a range of different media during one of the key moments in the history of American art. The reconstruction and re-presentation of so many classic historical moving image works is a complex matter and has taken a considerable amount of hard work and research. I would like to thank all the artists participating in the exhibition, who have worked tirelessly with us to realize each work and have borne all our requests for archival and technical information with patience and generosity. Their support for, and belief in, this project has been its driving force.

I am indebted to Christopher Eamon, assistant curator, film and video, who has worked so hard to coordinate the exhibition. He has collaborated closely with the artists in restoring and reconstructing the installations with technical and aesthetic accuracy. He has also ably organized the task of new photography, which has enabled us to have some of the works permanently recorded for the first time. His great skills as project coordinator have made the realization of this exhibition possible.

I would like to thank Tanya Leighton, curatorial assistant, film and video, for her meticulous work on the catalogue, and for her research and reconstruction of the artists' biographies and bibliographies. As research assistant for the exhibition, she has also made an invaluable contribution to the project overall. I would also like to thank Mercedes Vincente, former research assistant, who did important initial work on the catalogue.

I am deeply grateful to Thomas Zummer, who has provided an incisive catalogue text dealing with the issues addressed by the exhibition. His contribution has greatly enriched scholarship in the field. Kate Norment, interim director of publications and new media, has provided wonderful support and perceptively coordinated a complex catalogue. We are all delighted by the work of designers Kathleen Oginski and Greg Van Alstyne, whose imaginative understanding of the works has created a landmark publication. I am grateful to John Alan Farmer for his excellent editing of the catalogue texts. David Allison's skillful photography of installations we feared might be impossible to capture has renewed their visual power in permanent form, and I appreciate his patient dedication to a demanding task. I would like to thank Anita Duquette, the Whitney's manager of rights and reproductions, for her assistance in clearing the rights for the illustrations.

A number of people assisted in the research for my catalogue text. The artists

provided valuable insights in extended interviews, as well as precious new material, diagrams, and images, which have allowed us to shed new light on their work. I am particularly grateful to Simone Forti, Dan Graham, Beryl Korot, Mary Lucier, Anthony McCall, Robert Morris, and Dennis Oppenheim for their patient help with my research. Virginia Dwan provided important support and invaluable historical insights. Eric de Bruyn generously shared his research into the film work of Dan Graham and the artists' films produced in parallel to these projective installations, and Rhea Anastas provided additional research information on Dan Graham. Mel Bochner's feedback was invaluable in clarifying the unacknowledged role of the projected image in relation to Conceptual art. Callie Angell, the Whitney Museum's adjunct curator for the Warhol Film Project, made her expertise on Warhol's films available. Sean and Mary Kelly have lent invaluable support. Warren Nieslowski provided important ideas and feedback regarding the broader historical context. I am particularly grateful to Peter Ballantine for his expertise on Minimalism, and for his ongoing support.

Realizing an exhibition such as this demands rigorous planning and technical skills, and I am indebted to the professionalism and dedication of the Whitney Museum staff. Christy Putnam, associate director for collections and exhibitions management, provided essential expertise and support in all aspects of the exhibition's planning. The knowledge of our technical staff, Deborah Meehan and Richard Bloes, who both have extensive experience in the field of projective installation, has ensured an impeccable presentation. Holly Davey, of the Tate Modern in London, offered invaluable technical support and assistance in the planning stages of the exhibition. Robert and Jessica Miniaci of Robert Film Services, Inc., met the substantial technical demands of the film installations, building numerous film loopers and special lenses and providing film projectors for each piece. Keith Crippen's intelligent design and construction of the exhibition spaces have enabled each piece to be presented with integrity. I would also like to thank the Whitney Museum's registration department, in particular Suzanne Quigley, Tara Eckert, Joshua Rosenblatt, and Filippo Gentile, as well as our director of conservation, Carol Mancusi-Ungaro, all of whom have met the various registrarial, installation, and conservation demands of the exhibition with efficiency and goodwill.

I am especially grateful to all the artists, and to their assistants and studio staffs, for their invaluable information, advice, and support throughout the exhibition's planning, as well as to the institutions and companies who have assisted us: John Allen of Cinema Arts for his film preservation work; at The Museum of Modern Art, New York, Mary Lea Bandy, chief curator of film and video and deputy director for curatorial affairs, and Kitty Cleary from the Circulating Film Library; Ben Bloom for his work on Robert Whitman's photography; Barbara Castelli for her invaluable support in the restoration of Robert Morris' film works; Barbara Gladstone and her staff at the Barbara Gladstone Gallery, especially Ivy Shapiro; the Pat Hearn Gallery; Rayne Wilder at Gary Hill's studio; Marian Goodman, Diane Shamash, Elaine Budin, and the staff of the Marian Goodman Gallery for their hard work on the restoration of Dan Graham's films; Kathleen Graves for her support of Peter Campus; at the Solomon R. Guggenheim Museum, John Hanhardt, Jon Ippolito, Natasha Sigmund, Jody Myers, and particularly Paul Kuranko, for his technical advice and support regarding Bruce Nauman's installation. Thanks are also due to Jon Hendricks, as well as Karla Merriweather at Studio One, for Yoko Ono; Fred Henry at The Bohen Foundation, New York; the Bronwyn Keenan Gallery, New York; Arunas Kulikauskas

at Anthology Film Archives for his work on creating film frames; Jonas Mekas at Anthology Film Archives, whose tracking down of rare Paul Sharits film material allowed the installation to be realized; Bill Brand, for his meticulous restoration of that material; Juliet Myers at Bruce Nauman's studio; Greg Pierce at The Andy Warhol Museum, Pittsburgh; Amy Plumb for Dennis Oppenheim; Robert Rauschenberg and his staff; Lesley Raeside at Keith Sonnier's studio; Christopher Sharits, who generously made available important material and information on Paul Sharits' installations and lent invaluable support to our reconstruction of Sharits' work; Sonnabend Gallery, New York; Josh Weisberg at Scharf Weisberg; Sean Weiss at Vito Acconci's studio; Donald Young and all his staff at the Donald Young Gallery; and Lori Zippay, Galen Joseph-Hunter, Seth Price, and Jon Thomson at Electronic Arts Intermix for their work on Joan Jonas' installation and for general support. I am particularly grateful to Barbara Wise, president of Electronic Arts Intermix and a founding member of the Whitney Museum's Film and Video Collections Committee, for her ongoing support and advice.

Without the generous participation of all of these people, this ambitious exhibition would not have been possible.

Chrissie Iles
Curator of Film and Video

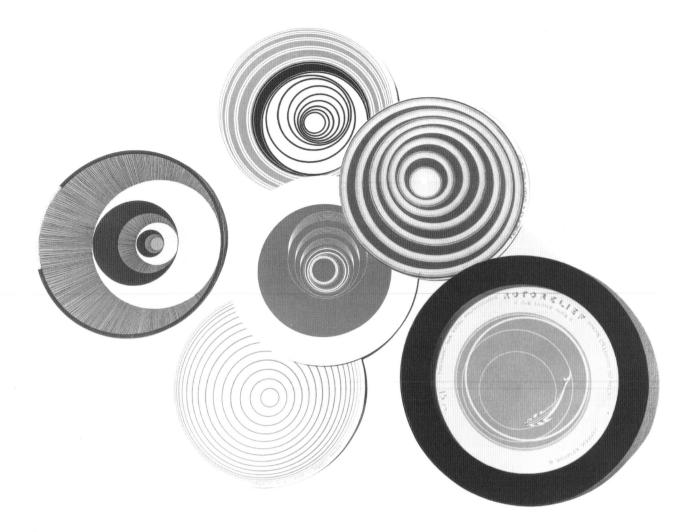

Marcel Duchamp. *Rotoreliefs*,
1935. Color lithograph on six
cardboard disks, with holder;
each disk approx. 8 in. (20.3 cm)
diameter. Philadelphia Museum
of Art; The Louise and Walter
Arensberg Collection

Between the Still and Moving Image

CHRISSIE ILES

During the 1960s and early 1970s, the projected image played a critical role in creating a new language of representation, as artists used film, slides, video, and holographic and photographic projection to measure, document, abstract, reflect, and transform the parameters of physical space. The pictorial space created by Renaissance linear perspective, where a fixed vanishing point dictated a singular position for the viewer, had endured for more than four hundred years. Beginning in the mid-nineteenth century the viability of this unmoving station was challenged, and by the 1960s, it was physically dismantled by Minimalism. Minimalist artists engaged the viewer in a phenomenological experience of objects in relation to the architectural dimensions of the gallery—not to pictorial space—transforming actual space into a perceptual field. Artists working with the projected image shifted the coordinates of this perceptual field from the brightly lit architecture of the gallery to the dark, reverie-laden space of the cinema. In this hybrid of white cube and black box, each model of space informed and modified the characteristics of the other.

As Roland Barthes observed, in the closed space of cinema there is no circulation, no movement, and no exchange. In the darkness, spectators sink into their seats as though slipping into bed. The cinema becomes a cocoon, inside which a crowd of relaxed, idle bodies is fixed, hypnotized by simulations of reality projected onto a single screen.[1] This model is broken apart by the folding of the dark space of cinema into the white cube of the gallery. Building on Minimalism's phenomenological approach, the darkened gallery's space invites participation, movement, the sharing of multiple viewpoints, the dismantling of the single frontal screen, and an analytical, distanced form of viewing. The spectator's attention turns from the illusion on the screen to the surrounding space, and to the physical mechanisms and properties of the moving image: the projector beam as a sculptural form, the transparency and illusionism of the cinema screen, the internal structure of the film frame, the camera as an extension of the body's own mental and ocular recording system, the seriality of the slide sequence, and the interlocking structure of multiple video images.

This prising of the viewer's gaze from the single screen into the surrounding space mimics the inherent mobility of the camera itself. The viewer is able to visually retrace the steps of the artist as the images were originally recorded. These images appear in the darkened gallery space in a radically different form from those

experienced in cinema. Projections and video screens are presented on and around the walls of the gallery—split, overlapping, multiplied, serialized, mirrored, rotated, made miniature or gigantic. These various forms belong to the conceptual, process-based practice of what came to be known as Postminimalist art. Most of the artists who created these forms were also making works in other media, including sculpture, language, photography, neon, earthworks, drawing, film, sound, and performance, each of which informed the texture and form of the others, and all united by an underlying temporality.[2]

This temporality is most clearly expressed in projective installations through artists' use of the gallery space, which in the late 1960s became a kind of field of exchange and activity. The field evolved as a result of a dramatic shift away from the frontal perspective of the camera obscura to an all-surrounding model of space which, as Jean Baudry observes, was discontinuous, heterogeneous, and multi-dimensional.[3] This final dismantling of traditional linear perspective completed the earlier experiments of stereoscopic photography, Paul Cézanne's breaking up of the picture plane, and the advent of cinema, then Cubism's introduction of temporality and Marcel Duchamp's experiments with multiple perspectives, opticality, perception, and the fourth dimension, all of which laid the groundwork for this Postminimalist decentering of the viewing subject.

The roots of this decentering also extend much further back, to philosophical discourses on vision from the sixteenth and seventeenth centuries. The seventeenth-

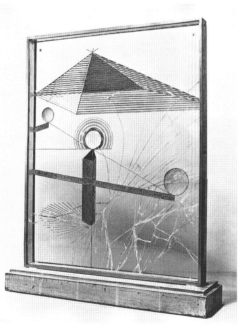

century German philosopher G.W. Leibniz showed great interest in multiple perspectives, which he compared to "varying architectural elevations or 'scenographies.'"[4] Another architectural metaphor anticipating the architectonic aspects of the multiperspective projective installations of the 1970s occurs in the French philosopher Nicole Malebranche's treatise *Dialogues on Metaphysics* (1688). As Catherine Wilson describes it, Malebranche's spokesman Theodore and his interlocutor Aristes retreat into a dark cabinet to exclude the distractions of the outside world, but decide not to pull the curtains completely. The optimum space for philosophical reflection, they decide, is "a place in which . . . [they are] neither subject to the solicitations of the illuminated world, in which objects appear in all their distract-

ing variety, nor plunged into the night world of unseen dangers. Inner illumination demands a dimming but not an extinguishing of the ambient light."[5] In this observation of the effect of space and the physiology of the eye on perception, one could draw a broad analogy with the installation space. In contrast to the hypnosis induced by the pitch-blackness of the cinema, within which the single bright screen seizes our minds in its distracting grip, the dimly lit gallery engages the viewer in a wakeful state of perception.

In this dimly lit space, we are invited to look not merely at the screen, but beyond it, to the walls onto which it is projected, and to the relationships set up between one

image and the next. This multidimensional viewing suggests a transparency of vision that has an important precedent in Marcel Duchamp's two three-dimensional works in glass, *The Bride Stripped Bare by Her Bachelors, Even*, commonly known as *The Large Glass* (1915–23), and *To Be Looked at (from the Other Side of the Glass) with One Eye, Close to, for Almost an Hour*, commonly known as *The Small Glass* (1918). In both these works, transparent surfaces suggest projection as well as the fourth dimension of time. For the significance of *The Small Glass* to the projected installation space, it is worth quoting at length Thierry de Duve's experience of the work:

> Its title is at once its instruction sheet: *To Be Looked at (from the Other Side of the Glass) with One Eye, Close to, for Almost an Hour*. I did this (not for an hour; patience has its limits), and the experience is very instructive. My eye riveted to the magnifying glass, I see—or rather I don't see—the work vanish from my visual field only for there to appear an inverted and reduced image of the gallery in the Museum of Modern Art where the object is exhibited. A waiting period, uncomfortable and boring, begins. The revelation takes place when by chance another visitor passes who appears to me like a homunculus [tiny man], upside down and in my former place, since I was initially on that side of the glass where the title/instruction sheet was to be read. A missed encounter has just taken place—the glass serving as obstacle—between two spectators, him and me. . . . Between the two of us the work was nothing but the instrument of this encounter. But since he occupies the place where I was, it is also with myself that I had this missed rendezvous to which I arrived late, and it is with himself that he will have, or that he already has a rendezvous, *with all kinds of delays.*[6]

De Duve's description of his experience of *The Small Glass* evokes viewers' encounters of the inverted image in Peter Campus' *aen* (1977). It also recalls the image of a room in miniature, seen faintly as a reflection on the surface of a ball bearing, in Bruce Nauman's *Spinning Spheres* (1970). Most directly, it recalls the dismantling of the two-dimensional picture plane in Michael Snow's double-sided film installation *Two Sides to Every Story* (1974), in which the viewer discovers that the image on one side of the screen appears, filmed from the opposite side, on the other. Maurice Merleau-Ponty had asserted that the infinite number of angles contained in a viewer's circumnavigation of an object renders that object transparent. This principle is demonstrated concretely in Duchamp's glass pieces and is addressed in filmic terms in Snow's installation.

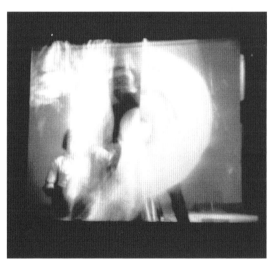

A woman is filmed by two fixed cameras, placed at opposite sides of a room 40 feet apart. She walks back and forth between the cameras, carrying a board colored blue on one side and cream on the other. As she approaches one camera, she brings the board up close to the lens before turning away to walk toward the other. Her movements are punctuated by the occasional placing of colored gels in front of the camera lenses by the cameramen, who are clearly visible behind each tripod. Snow can be seen sitting next to one of the cameras, issuing instructions from a written script. The visibility of the image's recording mechanism, and of the artist's participation in its construction, underlines the work's conceptual form. The woman's

symmetrical movements between both cameras confound the notion of a single pictorial space by creating another side to the image. Neither side can be read as the front or back of the image, however, since the two are interchangeable, and thereby rendered equal.

This breakdown of the single cinematic viewpoint into a tautological exchange is made spatial by the presentation of the films in the gallery space. The viewer is able to experience the two films only by moving around a screen suspended in the middle of the gallery, which shows one film on each side. The structure of the shoot is echoed in the installation: the projectors occupy the same position as that of the cameras during the shoot, and the viewer, moving back and forth to compare both sides of the screen, echoes the movements of the woman in the films. In this performative reconstruction of linear perspective, the central fixed viewpoint is first established then dismantled, calling the traditional physical and perceptual relationship between the film screen and the viewer into question.

Michael Snow's interest in transparency and framing is influenced by the work of Duchamp. This influence can be clearly felt in the woman, whose female presence in a dematerialized, three-dimensional plane could be compared to the bride in Duchamp's *Large Glass*, and in her encounter with a large sheet of transparent plastic in what had appeared to be open space as she walks toward the camera. This transparent plane becomes visible only when she produces a can of spray paint and sprays a green circle onto its surface, in a large spiral that recalls Duchamp's optical works, such as *Anemic Cinema* (1926) and *Rotary Glass Plates (Precision Optics)* (1920), and his series of circular cardboard rotoreliefs. Our unimpeded view of three-dimensional space is revealed to be an illusion, as our vision is bisected by an invisible flat surface, made visible through the painterly gesture of mark-making.

The assertion of a pictorial plane, implicitly that of the canvas, is immediately negated by one of the cameramen, who cuts into the transparent plastic with a knife, creating a long slit through which he steps into the space on the other side, closely followed by the woman. This action rejects a belief in both the two-dimensional pictorialism of painting and the illusion of truth suggested by the film image. The ongoing contradiction between opacity and transparency in Snow's work, given its most complex spatial expression in *Two Sides to Every Story*, recalls David Joselit's observation of the spatial paradox in Duchamp's *Small Glass*: it is "to be looked *at* like a screen, but it also explicitly instructs the viewer to look *through* it from behind, like an aperture."[7]

The multiple planes in Snow's installation—the transparent surface, the colored gels, the imaginary screen outlined by the woman with her hands in space, the two-sided colored boards, the painted green spiral, and the freestanding screen—all reinforce this contradiction. In contrast to the dominating presence of the cinema screen, framed by the darkness, Snow's screen in the gallery—prised away from the wall and held suspended in space as though floating—is so thin that the film image almost disappears. The impossibility of viewing the whole image on both screens simultaneously reinforces its elusiveness, evoking Duchamp's theory of "infra-thin," with which, as Joselit states, he associated "division, transparency and 'cuttage.'"[8]

Other installations from the period using film, video, holography, and slides assert what Rosalind Krauss has described as "sheer physical presence," as well as a simultaneous anxiety around its potential dissolution. The evidence of this dichotomy in the work of both Duchamp and artists of the late 1960s and early 1970s was, Krauss

TOP: **Bruce Nauman**. *Spinning Spheres*, 1970. Graphite on paper, 23 x 29 in. (58.4 x 73.7 cm). Courtesy Leo Castelli Gallery, New York

BOTTOM: **Bruce Nauman**. *Untitled*, 1971. Crayon and graphite on paper, 23 x 29 in. (58.4 x 73.7 cm). Courtesy Leo Castelli Gallery, New York.
In this drawing for an unrealized work, Nauman demonstrates his idea of creating an installation similar to *Spinning Spheres*, in which the film camera spins around a stationary object.

argued in 1977, a clear response to a crisis in representation brought about by Cubism in the first case and Minimalism in the second.[9] In the work of the 1960s and 1970s, it expressed itself through an inquiry into the perception of physical space.

Between 1970 and 1972, for example, Bruce Nauman made thirty-three architectonic installations in which space is physically and perceptually destabilized in constructed rooms (sometimes sealed), walls, and corridors, using film loops, video cameras, electric fans, audiotape, and neon light. The film installation *Spinning Spheres* is one of sixteen works Nauman made in 1970 alone. Four identical film loops projected on each wall of the gallery, floor to ceiling, show the surface of a ball bearing, spinning. After three minutes, the ball bearings slow down until they briefly come to a halt, before resuming their spinning.

The projected surface of the steel ball held within an enclosed model of a room achieves Nauman's desire for "no scale and no ground" and for "the experience [to become] less and less clear. The difficulty is intentional."[10]

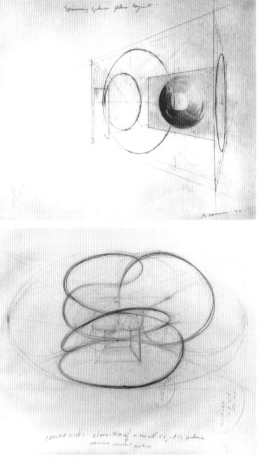

The "difficulty" in reading space in *Spinning Spheres* is achieved through a faintly seen pictorial representation of what Nauman himself referred to as an "idealized" room, whose interior is completely empty. The space in this reflected room is twice abstracted—once from the gallery, and once further, from the small construction in which it was filmed. With this work, Nauman confounds the body's ability to locate itself in space according to tangible coordinates. As in so many of his works, the resulting disorientation pushes the viewer not only out of the image but also, potentially, out of the room itself.

In this denial of entry into the space of the image, the alternation of the abstract surface with the faint outline of a space, seen briefly each time the steel ball slows to a standstill every three minutes, echoes Snow's use of opaqueness and transparency as a conceptual tool. Both are prefigured in Duchamp's articulation of his interest in the "difference between tactile exploration, three-dimensional wandering by the ordinary eye around a sphere and the vision of that sphere by the same eye fixing itself at a point of view (linear perspective)."[11] Nauman's own interest in the physiology of perception is made clear in the introductory paragraph to his article "Notes and Projects," written for *Artforum* in 1970, which includes the instructions for making *Spinning Spheres*: "It has been shown that at least part of the information received by the optical nerves is routed through and affected by memory before it reaches the part of the brain that deals with visual impulses (input). Now René Dubos discusses the distortion of stimuli: we tend to symbolize stimuli and then react to the symbol rather than directly to the stimuli. Assume this to be true of the other senses as well."[12]

Despite the Duchampian nature of much of Nauman's thinking, and the clear relationship between the vorticism of the spinning steel balls and Duchamp's optical experiments such as *Anemic Cinema*, it is Samuel Beckett who plays the more important role in the interpretation of *Spinning Spheres*. Nauman's extreme magnification of a small object recalls Beckett's descriptions of the meticulous

examination of surfaces of the body, including, for example, a telescopic view of an enlarged knee. Beckett's interest in measurement, the repetition of meaningless activities, and "seeking, finding and defining the centre"[13] all converge in Nauman's attempts to find and define a center, and then subsequently to obfuscate it.

Spinning Spheres inverts the centrifugal motion in Duchamp's optical rotary discs and the spinning spirals in *Anemic Cinema*, in which the center advances and recedes, becoming alternately convex and concave. The hypnotic mechanical rhythms in both Duchamp's and Nauman's visually ambiguous rotations suggest what Annette Michelson has described as a kind of autistic response.[14] In their spinning forms, autism becomes a conceptual language system.

The conceptual implications of autism were explored in three-dimensional terms by Robert Morris, in whose early work Duchamp also played a critical role. Inspired, as Maurice Berger points out, by Duchamp's *Rotary Demisphere* (1925),[15] Morris created *Pharmacy* (1962), a direct precursor of his film installation *Finch College Project* (1969). In *Pharmacy*, a freestanding glass plate is placed between two circular mirrors on stands. On each side of the glass is a silhouette of a small pharmaceutical bottle, red on one side, green on the other, reflected in each corresponding mirror. Morris makes direct reference to the mechanics of stereoscopic vision, in which the viewer's eyes merge two images, often through green and red filters, into a single three-dimensional one. Yet the spatial separation of the red and green silhouettes,

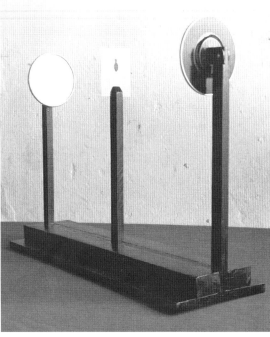

turned outward, and the angling of the mirrors (symbolic of the eyes) inward rather than to the front, prevents us from optically completing a unified picture of the external world. As in Snow's *Two Sides to Every Story*, the viewer must move between two opposite sides of a freestanding picture plane to read both images and can never reconcile them into a single spatial and temporal whole.

In *Finch College Project*, Morris extends this Duchampian optical conundrum to incorporate the three-dimensional space of the gallery and the fourth dimension of time. The loss of center—and therefore, by implication, of self—implied in the splitting of the image in *Pharmacy* is made even more corporeal by the disappearance of real space into the film image, which is then projected back into the same

LEFT: **Robert Morris**. *Pharmacy*, 1962. Painted wood, mirrors, and glass, 18 x 11½ x 36 in. (45.7 x 29.2 x 91.4 cm). Collection of the artist

OPPOSITE: **Jan van Eyck**. *Portrait of Giovanni Arnolfini and His Wife (The Arnolfini Marriage)* (detail), 1434. Oil on oak panel, 33¼ x 24⅝ in. (84.5 x 62.5 cm). National Gallery, London

space. In 1961, Morris had read the note scribbled by Duchamp in his *Green Box* (1919): "To place mirrored pieces of glass on the floor so that the room and the viewer are mirrored simultaneously."[16] From the early 1960s onward, Morris made a number of sculptures in which mirrored surfaces incorporated the viewer and the surrounding gallery space, dematerializing the object.

Finch College Project broadens this dematerialization to include both the physical object and the space of the gallery. Art handlers are filmed installing and de-installing, on opposite walls of the gallery, a photograph of a movie audience blown up large and an identically sized mirror. Both the photograph and the mirror have been

divided into a grid of separate squares, which are hung on the wall one by one until the complete image appears. Both are then de-installed one by one, until the gallery is once again an empty space, marked only by the traces of the hanging left by the dark glue, which forms a grid across the walls. This didactic exercise, filmed by Robert Fiore, recalls the tasklike actions in Morris' films made the same year, as well as in his early performances.[17] At certain moments, the camera can be seen reflected in the mirror it is filming, recalling a similar appearance of the film camera in a reflection of the landscape in Morris' film *Mirror* (1969), to which *Finch College Project* is strongly related.[18]

Fiore filmed the performed sequence in *Finch College Project* by slowly rotating the camera in a series of panoramic shots around the room at 1rpm for the duration of the action. The film was then looped and projected around the walls of the empty gallery on a turntable placed on a pedestal, rotating at exactly the same speed as the original filming. Flattening and abstracting the art object into a photographic and reflected simulacrum, Morris dematerializes it further by making the process of its assembly and dismantling visible and by projecting the film of it onto the same wall surface on which it had just been hung. Several doublings occur: real and filmed time; space and surface; and the reflection of the movie audience's faces back to themselves in the mirror, positioned where the film screen would be.

A further doubling occurs in the appearance of the simulation of an art work within a real art work. The enlarged found photograph of a movie audience is both part of the art work and an abstraction of the original photograph and of cinematic spectatorship. As in *Pharmacy*, the spectator is unable to complete the expected action of viewing. In the darkened gallery, we are able neither to observe a stable object on the wall, nor to absorb a central, fixed image on a conventional cinema screen. Morris has detached both the art object and the film image from their moorings. Instead, on an elusive film image rotating around the walls, we see traces of an exhibition in process, whose content records a fragment of another kind of filmic viewing space.

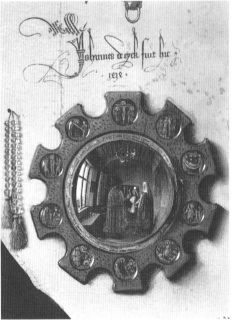

The revealing of a space otherwise invisible to the viewer in Duchamp, Snow, Nauman, and Morris has an important early precedent in the Flemish painter Jan van Eyck's iconic *Arnolfini Marriage* (1434). Van Eyck depicts, in one-point perspective, a betrothed couple standing together in a domestic interior. Behind them, a circular convex mirror, the focal point of the composition, reflects the other side of the room in miniature. The backs of the couple, the garden outside the window, and two visitors standing in the doorway (one of whom is van Eyck himself) can be clearly seen, as van Eyck juxtaposes opposite spatial viewpoints on a single plane. Hubert Damisch argues that this well-known example of a common practice in early Flemish painting is a deliberate attempt to acknowledge the different perspectives of viewers. The two tiny figures in the mirror create another vanishing point, making it impossible for the spectator to find a single, fixed position in the viewing space.[19]

Van Eyck's early acknowledgment of the impossibility of a single viewpoint, repeated in an ongoing dialogue between picture plane and mirror that has continued for more than five centuries, forms an important precedent for a number of

practices developed by artists in the 1960s and early 1970s: the use of mirrors, instant video feedback, and multiple film and video projections juxtaposed with each other and with performances; and a general concern to dismantle traditional definitions of the object in space. The relationship between the viewer and the 360-degree space implied by van Eyck's double perspective was explored in temporal and three-dimensional terms by Dan Graham, for example, in a series of topographical film projections made between 1969 and 1973. In *Helix/Spiral* (1973), two performers, including, in one version, Graham himself and the dancer Simone Forti, film each other in the open air.[20] The first stands in a "passive," fixed position, moving a camera pressed to the body downward from eyes to feet in a rotating helix, avoiding eye contact with the second performer. The second moves "actively" in a spiral toward the first, the viewfinder centered on the first performer's camera; the second performer tries to stay in the center of the first camera's gaze as it works its way down the body to the ground. While the first performer's framing of space is dictated by the movements of the camera across the contours of his/her own body fixed to one point in space, that of the second is affected by the rhythm of walking across the uneven Nova Scotia terrain on which the piece was performed.

Both performers' films comprise a series of panning movements, capturing the entire 360-degree space in which they are situated, in a dual fragmented perspective of opposites that recalls the two camera viewpoints in Snow's *Two Sides to Every Story*. Nevertheless, *Helix/Spiral* describes not a mirroring of identical movements, but a fusion of opposites. The first camera's mapping of the body in a helix from head to toe describes a vertical conical sphere that stands in the center of the flat, circular horizontal plane described by the second performer's spiraling movement across the ground. This structure conforms to the conventional pictorial model of figure and ground. Yet, as in van Eyck's convex mirror, the viewer, confronted by the

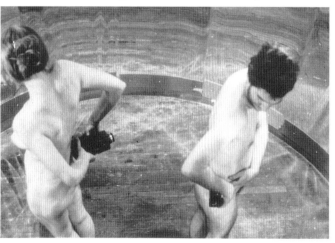

two film projections on either wall of the gallery, does not know where to stand. The center of the horizontal spiral, so clearly marked in the filming process by the upright body of the first performer, disappears in the projection of both films in the gallery. The space shifts from moving spiral to static square, and the performers are represented by a double filmic record of their mutually observed movements in another, outdoor space.

LEFT: Dan Graham. *Body Press*, 1970–72. Two 16mm film loops, color, silent, 8 minutes. Collection of Pamela and Richard Kramlich
Helix/Spiral (1973), Graham's last film work, strongly relates to both *Two Correlated Rotations* (1969) and *Body Press*.

OPPOSITE: Bruce Nauman. *Second Hologram Series: Full Figure Poses (B)*, 1969. Holographic image on glass, 8 x 10 in. (20.3 x 25.4 cm). Collection of Pamela and Richard Kramlich

In both the films of *Helix/Spiral*, it was important to Graham that the horizon be visible at all times. The viewer is grounded by the same horizon line used by the performers to measure space, as the camera moves between clear representations of their bodies and abstract close-ups or long shots of the surrounding open space. In effect, as Merleau-Ponty observed, the body becomes "the horizon latent in our experience and itself ever-present and anterior to every determining thought."[21] Partly inspired by Snow's vertiginous camerawork in films such as *La Région Centrale* (1971), Graham's analysis of the body's field of vision articulated

something that Duchamp had observed sixty years earlier in his examination of the body's role in defining perception: "Gravity and center of gravity make for horizontal and vertical in three-dimensional space. . . . Gravity is not controlled physically in us by one of the 5 ordinary senses. We always reduce a gravity experience to an autocognizance, real or imagined, registered inside us in the region of the stomach."[22]

The presence of the body as a major component of projective installations of the 1960s and 1970s emerged in part from the breaking down of boundaries between disciplines that had occurred in stages throughout the twentieth century and reached its apogee in the 1960s. Just as art incorporated dance, dance moved into other disciplines. Morris made constructions for Forti, dancers performed in Joan Jonas' group performances, Yvonne Rainer took up filmmaking, and Forti engaged the object in its most ephemeral form.

In the mid-1970s Forti, who had created and performed iconic dance works such as *Huddle* (1961), made a series of "integral" holograms—three-dimensional clear plexiglass cylinders on whose sides appeared ghostly images of her dance movements. Movement of the body has been mapped by every new technological recording apparatus since the invention of photography. The early 1970s saw the emergence of holography as the newest such medium, following the revolution created by the real-time, instant feedback potential offered by video. Holography's small scale and photographically based silent format ensured that it would never achieve the impact and popularity video enjoyed. But its intimacy and mysterious film-based virtual three-dimensionality offered another kind of visual experience grounded in nineteenth-century optical mechanisms rather than in the real-time popular culture of television.

In Forti's *Striding Crawling* (1977), an 18-inch-high plexiglass cylinder is balanced on top of three bricks. In the middle, underneath the cylinder, a small candle burns.

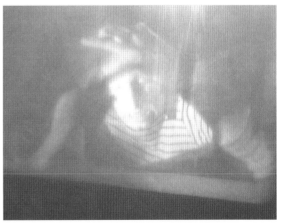

The only source of light in the room, it illuminates a delicate hologram of Forti making a single fluid movement from striding to crawling, which is activated by the viewer's own movement around the circular plane. Evoking Plato's cave, it also throws large shadows of the cylinder and the viewers around the walls.[23] Harnessing the most advanced visual technology of the day to ancient elements (flame, clay bricks, shadows), Forti creates a pre-cinematic moving image animated simply by the viewer's movement.

The ability to conjure Forti's dancing movement at will by moving around the cylinder evokes one of the earliest examples of the viewer bringing a coherent image into being: Hans Holbein the Younger's painting *The Ambassadors* (1533). The anamorphic image of a skull in the foreground can be read only when the viewer moves from a position directly in front of the painting to an oblique angle at the extreme right. The anamorphic skull—independent of the rest of the composition, floating weightlessly in space above a shadow created by a third, unseen light source, described by a separate vanishing point, almost solid in its three-dimensionality—anticipates the radicality of Forti's holographic form. The holographic image is unique in that it is not attached to a fixed surface. Created from laser light and partly silvered

mirrors, as Douglas Tyler explains, it exists both in front of and behind the holographic plates from which it emanates, a condition that lends it sculptural properties.[24] Like Anthony McCall's conceptual film *Line Describing a Cone* (1973), it possesses volume but not mass. Its existence both in front of and behind the conventional plane of two-dimensional space achieves a four-dimensionality Duchamp had only dreamed of. Just as Holbein's skull inserts itself between the picture and the viewer, reminding us that death can interrupt the continuum of life, Forti's body, detached from a fixed surface, oscillates between a still and moving image, brought to life by the movement of the viewer one minute and left suspended in frozen motion the next.

The series of frozen moments that becomes visible as the viewer moves to the pace of a film in extreme slow motion evokes the serial studies of motion undertaken by the nineteenth-century photographer Eadweard Muybridge. It also recalls the chronophotography of the scientist Etienne-Jules Marey, who sought to map, photographically, the role of time and space in the creation of movement. The similarity of the small cylindrical form of *Striding Crawling* to nineteenth-century protocinematic optical structures, such as the magic lantern, the zoetrope, the praxinoscope, and peep shows, connects Forti's hologram to a similar social and cultural moment, in which the rapid development of industrial production triggered an analytical approach to the body and its relationship to space through the use of mechanized recording apparatuses.

The miniaturization of Forti's body in relation to ours creates a sense of voyeurism, made stronger by our sense of the power we have to induce her movement through our own. Yet

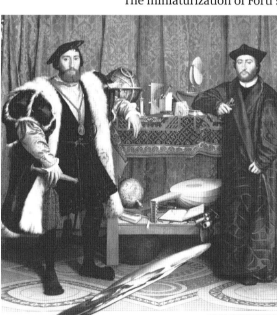

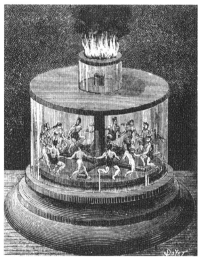

FAR LEFT: **Hans Holbein the Younger**. *Jean de Dinteville and Georges de Selve (The Ambassadors)*, 1533. Oil on wood, 81½ x 82½ in. (207 x 209.5 cm). National Gallery, London

LEFT: *Marvelous Altar (according to Heron)*. Engraving, 1800s. An early precursor of Simone Forti's moving figure captured within a transparent cylinder, this engraving depicts a Greek temple altar as described by the engineer Heron of Alexandria.

OPPOSITE, TOP: **Etienne-Jules Marey**. *Saut de pied ferme, longeur: sol glissant*, c. 1882. Chronophotograph, 1³⁄₁₆ x 5¹⁄₈ in. (3 x 13 cm). Collège de France, Paris

OPPOSITE, BOTTOM: **Eadweard Muybridge**. *Animal Locomotion: Dancing Girl* (detail), 1887. Collotype, 14³⁄₄ x 19¹⁄₄ in. (37.4 x 48.9 cm). Victoria and Albert Museum, London

her image will move only as fast as we do. The correlation between her movement and ours reflects the structure of the hologram's making. Forti's image comprises individual still film frames condensed into a sequence of vertical lines. As Tyler points out, our eyes see each line separately, but fuse them together stereoscopically.[25] Evoking Duchamp's stereoscopic constructions, this unprecedented structure positions Forti's hologram somewhere between film and sculpture.

The viewer's participation in the creation of the image sets *Striding Crawling* apart from its precursors. Yet its industrial context recalls the mechanism that drove the so-called Marvelous Altar of ancient Greece described by the Greek engineer

Heron of Alexandria: "Fire being lighted on an altar, figures will appear to execute a round dance. The altars should be transparent, and of glass or horn. . . . When the fire of the altar is lighted, the air, becoming heated, will pass into the tube; but being driven from the latter, it will pass through the small bent tubes and . . . cause the tube as well as the figures to revolve."[26] By contrast, the radical mechanism that drives *Striding Crawling* is hidden. Fire in Forti's structure operates not as pneumatic force, but as literal and symbolic illumination. The small candle occupies the middle of the cylinder, its presence a symbol, as the guru Pran Nath has suggested, of a centered state of mind. Forti's striding and crawling, derived from the natural movements of animals and t'ai chi, use physical movement to similarly center the body and communicate a mental and spiritual equilibrium.

Where we encounter Forti's image, miniaturized, in the shadows of a darkened space, in Peter Campus' video installation *aen* (1977), we encounter our own image made gigantic. *aen* is one of the last in a group of closed-circuit video installations Campus made during the 1970s, in which the viewer becomes the subject of the work. Campus uses reflection, shadows, mirroring, and projection to disorient us

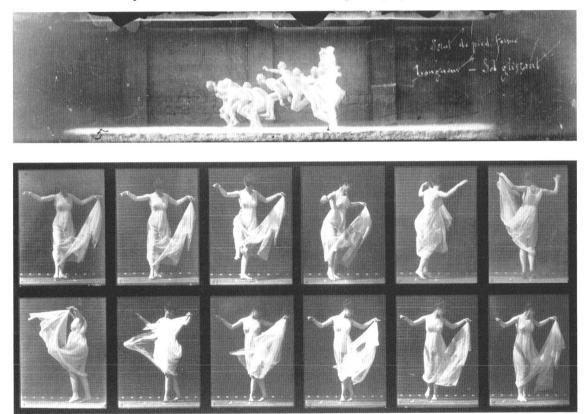

perceptually, and to obscure our familiar understanding of our own reflected image. In *aen*, the darkened space gradually reveals the viewer's head and shoulders, captured by a video camera, inverted and projected on the wall on a gigantic scale. The inversion of the image recalls not only a camera obscura, or a concave mirror, but the retinal structure of vision itself, in which the image appears upside down at the back of the eye and is corrected by the brain. This inversion causes a reverse movement, so that when the viewer's body shifts to one side, the head moves to the other.

Robert Pincus-Witten, writing about Campus' work in 1976, argued that

theatricality and temporality had become driving impulses for establishing a new groundwork for painting and sculpture following the collapse of formalism. Yet, he observed, Campus' silent installations in turn imposed a static vision of painting and sculpture onto technology, demonstrating technological art's debt to art history.[27] In a drawing of c.1500 attributed to the school of Leonardo da Vinci, a man standing in front of a candle creates a large shadow on the wall behind him; a colleague draws another shadow, thrown by a small statue onto a wall nearby. The drawing exercise appears to betray a deeper psychological exploration. Campus' own shadow reflections operate similarly on both a formal and psychological level, simultaneously as an aspect of three-dimensional form and as an externalization of the inner self.

As Victor Stoichita explains, the belief in the shadow as an aspect of the soul stretches back to ancient Egypt and Greece.[28] Acting as a person's double in life, the shadow disappears in death and is taken over by the spirit. In Campus' installations, the viewer is confronted not by the shadow as seen in daylight, but by a ghostly nocturnal reflection of the self, which appears in a disconcertingly dematerialized form. In a videotaped interview, Campus spoke of wanting viewers to encounter their spirit or, as he stated, *ka*, implying a premonition of death. In 1975, he described his own experience of his installations: "Very dark room . . . Rishi cave, perhaps a neolithic cave painting illuminated by flickering light, the camera obscura. . . . The presence of the wall next to me, the emptiness behind, the surrounding blackness and sound all co-ordinating the senses. . . . Photons of light penetrate the wall. . . . I let myself go into this extension of self. For a brief moment I am at the same time this image and this self."[29] This description seems almost to presage the experience of slipping into death: after *aen*, Campus went on to make a video installation titled *Head of a Man with Death on His Mind* (1978).

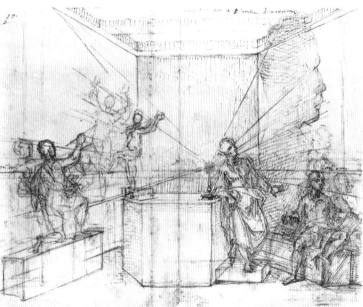

After Leonardo da Vinci. "Study of Shadow Projection." In *Codex Huygens*, c. 1500. Sheet 5¼ x 7⅛ in. (13.3 x 18.1 cm). The Pierpont Morgan Library, New York; MA 1139, f. 90

The notion of the double, which Freud described as an insurance against the destruction of the self, or death, became important for artists during the 1970s, especially those using the mirroring, real-time feedback properties of video. In art, the double usually performed two roles: an assertion of the self's existence and an expression of the fragmented, split self. In other words, an apparent fusion *with* the self through projection is, simultaneously, an encounter with the difference *from* the self. During the 1970s the shadow self, demonized as the unacceptable alter ego since the sixteenth century, became a subject of liberation, using ideas drawn from social theory, behavioral psychology, and psychoanalysis. Where Campus' early interactive projective installations presented the viewer in two images, as inherently split, in *aen* the image is a single face, writ large in the dark space of the gallery. The defamiliarized image of our inverted heads shifts this

resemblance between existential confrontation and a formal inquiry into space, surface, and scale, bringing the shadows of Plato's cave into the rationalized white cube of the gallery.

The enmeshing of formal concerns with subjective experience was a hallmark of the postmodern eclecticism of 1970s art. In 1973, Anthony McCall made the first film to occupy a three-dimensional presence in space. *Line Describing a Cone* combined the phenomenological reductivism of Minimalism with the participatory inclusiveness of Happenings to create an ephemeral projection event. In a complete reversal of conventional cinematic viewing, the audience stands in a darkened empty space, watching the film by looking directly at the light beam as it emanates from the projector. Over a period of thirty minutes, the slim pencil of light slowly evolves, first into a curved plane of light, then into a large hollow cone formed by the image, projected on the wall, of a circle being drawn in the darkness. As McCall observed, the process of the film's realization becomes its content.[30]

The structure of *Line Describing a Cone* was born out of McCall's desire to create a complete art work from a single idea. Restricting the form and content of the film to what was irreducibly cinematic, he drew on the prevailing conceptual climate of the early 1970s, including the experimental film environment of the filmmakers' cooperatives in London and New York, where filmmakers were creating a new process-based, anti-illusionist cinema. The structure of the film was also influenced by the conceptual purity of Snow's film *Wavelength* (1966–67), which apparently comprised a single forty-five-minute zoom shot of his New York loft from the far side to the opposite wall, ending in an extreme close-up of a photograph pinned to the far wall.[31] As Rosalind Krauss observed, Snow's film created "a spatial analogue for the experience of time."[32] In *Line Describing a Cone*, McCall makes this spatial analogue both abstract and concrete. Each stage of the cone's making is marked by the line of the circle gradually forming on the wall at the cone's widest end. McCall turns the forward motion of Snow's "time-shape" into an ephemeral three-dimensional volumetric form, which does not traverse two opposite points in space, but describes the area between them through the tangible presence of light.

At some of the earliest Japanese screenings of film at the beginning of the twentieth century, rows of seats were placed parallel to the projection beam, so that spectators could observe what Barthes has described as "the dancing cone which drills through the darkness of the theater like a laser beam. This beam transforms itself according to the rotating movement of its particles. . . . We turn our face toward the traces of a flickering vibration whose imperious thrust grazes our head from behind. . . . As in the old hypnosis experiments, we are entranced by this brilliant, immobile and dancing surface, without ever confronting it straight on. This beam of light seems to bore a keyhole for our stupefied gaze to pass through."[33]

In *Line Describing a Cone*, McCall shifts Barthes' imperious film beam, situated over our heads, into a democratic participatory field that almost touches the ground. We are invited to walk into its hollow cone, to lie under it, look into it, stand inside it, move our hands over the top of it, and drift through it, disappearing into its volume like mist, only to reappear on the other side, like Alice in *Alice Through the Looking Glass*: "Let's pretend there's a way of getting through into it somehow, Kitty. Let's pretend the glass has gone all soft like gauze, so that we can get through. Why, it's turning into a sort of mist now, I declare!"[34] Like Snow's *Two Sides to Every Story*, the surface of the film screen (looking glass) has been ruptured, freeing the viewer to experience an infinity of multiple viewpoints and

planes through a physical movement around the film.[35]

This intensely corporeal experience, resulting from McCall's reading of film as a tangible, sculptural form, is also strongly perceptual, evoking the relationship between idea and form in the work of Sol LeWitt. In structures such as LeWitt's *Incomplete Open Cubes* (1966), the mind automatically completes the missing side of each cube. In *Line Describing a Cone*, the mind similarly completes the missing part of the cone at each stage of its progress. The introduction of temporality allows us to witness the cone's formation over time, our minds anticipating the gradually appearing curved surface as the circle is drawn.

This conceptual engagement of the viewer in temporal terms is echoed in the reversed spatial relationship between viewer and image, which overturns the frontal perspective of the cinema (and, before that, of the camera obscura). Instead of the viewpoint emanating outward from the viewer's eye, for which the projector forms a surrogate, we turn backward toward that viewpoint, reorientating ourselves *within* the space of perspective, rather than as removed observers of it. The combination of architectonic perspective, volume, and temporality may have been what made McCall's film of interest to both Gordon Matta-Clark and Richard Serra.[36] In dismantling the space of conventional cinema and introducing multiple viewpoints, *Line Describing a Cone* produces a volumetric form which, in its ephemeral yet tangible solidity, fuses the properties of film, sculpture, performance, and Conceptual art.

McCall's concern with the actuality of time, place, and material was echoed by Paul Sharits, who commented that the projection of a film image directly onto the wall, rather than onto a screen, corresponded to Carl Andre's placement of his sculptures directly on the floor.[37] In the reductiveness of Andre's thin, flat floor works, which removed the allusion not only to the pedestal but to sculptural volume itself, Sharits saw a parallel with his own desire to erase pictorial representation and reveal the material substance of cinema in its purest form. Where McCall made the projection beam the subject, in the film installation *Shutter Interface* (1975) Sharits made visible the role of the camera and projector shutter in constructing the moving image. "Interface" is defined as both a "surface forming a common boundary between two regions" and a "point where interaction occurs between two systems."[38] In Sharits' installation, the shutter's physical and temporal interface with the film strip is revealed to be, as Krauss has observed, "the bridge between the still image and the moving one."[39]

Sharits' installation uses this bridge, or interface, to make visible to the viewer the individual frames of a film as it passes through the gate of the projector. On the wall of a darkened gallery, a large horizontal band of seven overlapping rectangles of pure color flickers and pulsates, as different colors ricochet from left to right in a series of mathematically determined combinations. The division of the band of

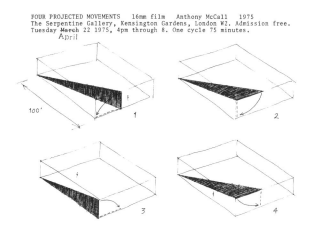

FOUR PROJECTED MOVEMENTS 16mm film Anthony McCall 1975
The Serpentine Gallery, Kensington Gardens, London W2. Admission free.
Tuesday March 22 1975, 4pm through 8. One cycle 75 minutes.
April

100'

1

2

3

4

LEFT: **Anthony McCall.** Diagram for *Four Projected Movements*, 1975. This 16mm black-and-white film was projected against the wall the right way up, upside down, back to front, and inside out.

OPPOSITE: **Gordon Matta-Clark.** *Conical Intersect*, 1975. Color photograph documenting Matta-Clark's sculptural action in Paris in 1975. Matta-Clark cited Anthony McCall's *Line Describing a Cone* as the inspiration for *Conical Intersect*. Matta-Clark's ideas regarding built space and his "an-architecture" projects paralleled many of the phenomenological experiments with perception, space, and the body that were undertaken by artists using the projected image.

colored rectangles into a series of nonhierarchical, nonrelational parts evokes the structure of Minimalist sculpture. The abstract colored forms of the multiple screens bear a stronger resemblance to Color Field painting. But the strongest influence on Sharits' temporal structure is drawn from Minimalist music. His use of vibrant colors, combined with an abstract soundtrack that punctuates each shift in hue, creates a percussive composition, in which each flicker is like a beat or musical note. The multiple screens allow a musical correspondence to develop between one and another across time. As Stuart Liebman explains, when hues in a series are far apart, their sequencing appears to have a more staccato form; when they are more closely related, "a gently rippling chromatic wave washes across the wall."[40]

Liebman's description illustrates the unique parallels between film and music. Sharits broke down the shared temporality of music and film into its constituent parts and married abstract film frames with individual beats, or notes, to create a synergy of optical and aural units. The flashing of static frames of color on each screen at high speed creates a tension between the still and moving image, as the alternation between screens creates a suggestion of forward movement that the static colored frames hold back.

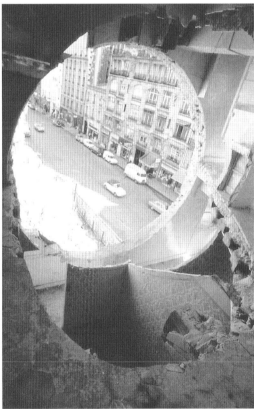

This perceptual autism arguably makes oblique reference to epilepsy, a subject important to Sharits, who studied the significance of the flicker in diagnosing and studying epileptic seizures. In his notes on the film installation *Epileptic Seizure Comparison*, made the year after *Shutter Interface*, he quotes the neurosurgeon Dr. W. Grey Walter's description of the brain rhythms of subjects during a quiet phase of an epileptic seizure: "their brain rhythms tended to be grouped in frequency bands. It was as if certain major chords constantly appeared against the trills and arpeggios of the normal activity. This harmonic grouping suggests that if a masterful conductor were introduced, the brain could be made to synchronise in a grand *tutti*, to develop under controlled conditions the majestic potentials of the convulsive seizure."[41]

Shutter Interface, which Sharits described as a "color space," is a three-dimensional metaphor of the space of the brain in an epileptic state, brought under control and harmonized. The interiority of the work draws the viewer into a mental state of perceptual reverie. As in McCall's *Line Describing a Cone*, *Shutter Interface* combines a rigorous conceptual structure with an aesthetic sensuality, which allows the viewer to take in the intensity of his work, and holds it in place. Sharits' understanding of the paradox between rigor and beauty is revealed in his poetic description of the surface of the film image seen in extreme close-up: "a forest of TRANSLUCENT PASTEL sLIVERS glowing negative diamond crystals (the molecular 'surface' of a mirror 'blown-up' to the extent that it appears to be a 'three-di-mension) ALAndscape:pe."[42]

Sharits' shift of the film image from illusionistic mirror to abstract surface reflects

the importance he attached to what he described as the prevailing impulses of 1970s culture and artmaking: investigation, measurement, documentation, methodology as subject matter, art as research. Within this analytical context, it was fitting that his inquiry into the phenomenology of cinema and the mechanics of film should adopt the structure of music, with which film shares a resonance with the physics (and metaphysics) of color.

The horizontality, seriality, and musical structure that underpin *Shutter Interface* were important elements for art being produced in a range of media during the early 1970s. The emphasis on seriality, in particular, was an indication of the extent to which models of industrial production had become integrated into the production of art. Like Sharits, whose *Shutter Interface* installation deals with the very process of mechanical reproduction, Beryl Korot used a serial structure to create a conceptual narrative. In her video installation *Dachau 1974* (1974), four video screens set into a white wall create a horizontal strip of moving images that suggests, at first glance, the serial photographic sequences of Muybridge. However, the moving images do not read linearly, but are structured as two sets of interlocking patterns. It is through the syntax of these units that forward movement occurs.

Dachau 1974's structure conforms to the Minimalist vocabulary of industrial forms: nonhierarchical, gridded seriality. Within this grid, each set of units presents a series of black-and-white shots of the concentration camp in Dachau, Germany, in a topographical study of a place of horror. Korot chose to videotape the camp in the present to discover what it might tell us about the past. In its present role as tourist destination, Dachau has become a repository of memories that people would prefer to forget but cannot, and perhaps should not, leave behind. Through Korot's carefully woven structure we are taken on a journey through the camp, from outside its walls to a stream on the other side of its perimeter. The intense emotional significance of the journey is contained by the conceptual format of the sequence, which guides us slowly forward in pairs of symmetrical shots.

The viewer's involvement in the narrative of *Dachau 1974* is intensified by the fact that, at any given moment, each pair of two apparently identical channels shows the same vista at slightly different moments. Often the difference between them is detectable only by the slightly varying distances of the tourists walking through the space, who become topographical markers of time and place. The viewer's attention is obliged to move backward and forward among all four screens to establish the location and time of each step of the journey. Sometimes the same view will be seen in close-up on one monitor and at a distance in the other. This conceptual device engages the viewer perceptually, creating a synergy between a rational analysis of the viewing experience and an emotional engagement with the subject matter.

As in Sharits' film installation, the images in *Dachau 1974* are punctuated by black frames. As Amy Taubin suggests, these moments of blackness, which create a contrapuntal rhythm, represent the place where one looks away, or the signs of what cannot be shown or even thought.[43] *Dachau 1974*'s structure, influenced by LeWitt's gridded structures, the notational sequences of new music, and Korot's experience as a weaver, is musical; and Taubin describes its viewing as "midway between hearing and reading a score." This score, presenting differences in time in identical material, influenced by the time delays in Frank Gillette and Ira Schneider's video installation *Wipe Cycle* (1969), creates a technological and conceptual equivalent of woven cloth. The horizontal threads of the four monitor

images, alternating in a clear rhythmic pattern, are woven into the vertical "threads" of time, measured both by the clock and by the vector of the topographical journey through the camp.

Korot's insertion of emotionally charged subject matter into a conceptual framework, combining a manual practice marginalized as women's craft with an intellectual idea applied to technology, reflected a contradiction inherent in the pluralism of 1970s artmaking. As Hal Foster has argued, the roots of this contradiction lie in the tension between individual creativity and industrial production that had existed since the Industrial Revolution.[44] Central to the early work of both Korot and Mary Lucier (who had studied photography in the late 1960s) were the procedures of seriality and repetition. Repetition became a method of, to paraphrase Foster, subverting representation and undercutting its referential logic.

In 1969, Mary Lucier began collaborating with her husband, the composer Alvin Lucier, with whom she had been touring and performing since the mid-1960s, to produce *Polaroid Image Series #1*. Alvin Lucier had composed the classic sound work *I Am Sitting in a Room* earlier the same year. For *Polaroid Image Series #1*, Mary Lucier created a series of Polaroid images, to be projected in the same room as the sound piece on 35mm slides. In *I Am Sitting in a Room*, Alvin Lucier plays a recording of himself reading a text describing the process of the work's making:

> I am sitting in a room different from the one you are in now. I am recording the sound of my speaking voice and I am going to play it back into the room again and again until the resonant frequencies of the room reinforce themselves so that any semblance of my speech, with perhaps the exception of rhythm, is destroyed.
>
> What you will hear, then, are the natural resonant frequencies of the room articulated by speech.
>
> I regard this activity not so much as a demonstration of a physical fact, but more as a way to smooth out any irregularities my speech might have.[45]

The sound is reproduced over and over and becomes increasingly abstract and unintelligible as a phonetic representational form. The text functions as a score whose directions, like those for LeWitt's wall drawings, can be carried out by anyone.

Mary Lucier's *Polaroid Image Series #1* began with a Polaroid photograph of a room—specifically, a corner of the room in which Alvin Lucier had made the sound work, and the chair in which he sat as he had described the process of making the piece.[46] *Room*, as this particular image is also titled, thus becomes not merely a photographic parallel of the sound work, but its visual equivalent. This equivalence recalls LeWitt's *Location* drawings, begun in 1974, in which geometric forms drawn on a page are partially filled in with precise penciled descriptions of their location on the page and in relation to each other.

The relationship between the visual and aural elements in *Room* is complex. While the sound work exists without its visual parallel, in many different renderings, *Room* can exist only in the combination of slides and sound, and its image is unique. The photographic representation of the room in which the recording took place becomes quickly abstracted. The room remains intact conceptually, however, since it is the aural chamber through which the increasingly abstract sound is projected, recycled, and processed. In other words, although the spoken text degenerates into unintelligibility, the space in which it was recorded remains a constant

presence as the architectural filter through which the abstraction occurs.

This interplay between presence and absence recalls Krauss' theorization of the contingency of presence in artmaking of the late 1960s and 1970s. The fragility of presence is implied here on several levels: in the increasingly abstract sound recording of the room's aural presence; in the image of the recently vacated chair from which Alvin Lucier recorded the text; and in the process of abstraction, as each black-and-white slide systematically obscures the representational image.

The degeneration of the image in *Room* and all the other versions of *Polaroid Image Series*, including *Shigeko* (a portrait of the video artist Shigeko Kubota), *Croquet* (a photograph of a group of people playing croquet), and *City of Boston* (the skyline photographed from Cambridge, at midday), shown in this exhibition with *Room*, weakens technology's role as producer of the endlessly perfect duplicate. This, in turn, challenges the overarching principle of sameness in replication, seen in industrial production, adopted by both Minimalism and Pop, and absorbed by all temporal art of the period. Both visual and aural aspects of *Polaroid Image Series #1* undermine the industrial model by interjecting manual manipulations into the automatic machine-based operation of duplication. The end result could, after all, have been achieved in half the time. But for Mary Lucier and Alvin Lucier, the slow process of repeated manual actions, and unpredictable details such as flecks of dirt, light changes, and slight shifts in alignment, were essential to the production of the work.

Alvin Lucier's understanding of sound and language as units of measurement, or physical facts, and their dependence on the room in which they were made, underlies a deeply hidden, personal aspect of the sound in *Room*. As the text explicitly states, "I regard this activity not so much as a demonstration of a physical fact, but more as a way to smooth out any irregularities my speech might have." The work moves beyond a self-reflexive exercise in sound into a public acknowledgment of a personal struggle with a speech impediment, in which the complex repetitions of sound reflect not merely the aesthetic possibilities of mechanical recording, but an attempt to come to grips with a physiological and psychological issue. As in *Dachau 1974*, emotive subject matter is contained within a strict formal structure. Representation, suppressed by seriality and repetition, uses both to reassert itself in a symbolic form.

In the image of *Room*, the personal is similarly made present in the abstraction, or disappearance, of a domestic space. Mary Lucier's relationship to the spaces of home has always been ambivalent. As Melinda Barlow points out, this ambivalence has been worked through in the rooms, corridors, and houses that have been major themes in Mary Lucier's work since *Polaroid Image Series*.[47] In *Room*, the gradual disappearance of the image of the room at the same time as coherent speech slips away suggests a loss of the entire structure of domestic existence and, in the increasingly muffled reverberations, a corresponding loss of self.

RIGHT: **Joan Jonas** performing *Mirage* at Anthology Film Archives, New York, 1976

FAR RIGHT: **Joan Jonas**. Still from *Mirage*, 1976. Film projected during performance at Anthology Film Archives

The loss of self, like the loss of a center, became a major theme in art of the 1970s. The process-based nature of art during this period allowed an exploration of subjectivity that interacted with, and in many cases undermined, the theoretical, philosophical, and aesthetic values of the previous generation. The early video and performance work of Joan Jonas epitomized this shift with a viscerality that embraced ancient ritual, the body, dance, esoteric knowledge, identity, female

desire, and transformation. *Mirage* (1976), the last in the group of what have come to be known as the "black-and-white" performances, took place at Anthology Film Archives at 80 Wooster Street in New York.

Since *Organic Honey's Visual Telepathy* (1972), Jonas had been combining film and video in her indoor performances. In *Mirage*, film and video are combined in both the making of the imagery and in the performance itself. Like Sharits and Snow, Jonas dismantles the conventional reading of film within the cinema space. But whereas in *Shutter Interface* and *Two Sides to Every Story* the cinema auditorium is replaced by the perambulatory space of the darkened gallery, in *Mirage* the dismantling takes place within the auditorium itself. The performance retains the traditional seated frontality of the viewer, and the perceptual shift occurs in the space immediately in front of the film screen, where live action, video, and objects are situated directly in front of the screen, and in relation to it.

In this conflation of the cinema and the theater space, the film screen becomes a frame for the overall performance, changing its shape according to the various scenes, from the normal aspect ratio to a horizontal then a vertical rectangle, in

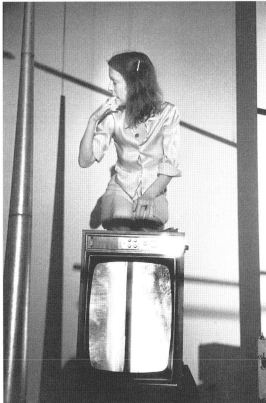

front of which action takes place. For most of the performance, the screen remains blank. It is as though the content has been erased from the screen and pulled out into the space of the auditorium, in a metaphor of the demise of two-dimensional painterly representation.

When a film does finally appear on the screen, its content becomes the subject of the rest of the performance, and all the live action and video imagery relate to it.[48] On the

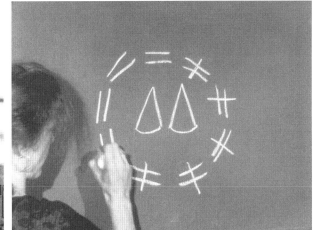

surface of a blackboard, Jonas draws a series of diagrammatic shapes in white chalk. Cones, lines, circles, stars, and animal forms create a sequence whose pattern, rhythm, and logic resemble a sentence. After each image is drawn, Jonas wipes the surface of the blackboard clean and draws the next. The ephemerality of each drawing was inspired by a rare screening at Anthology Film Archives of the raw, unedited footage of Maya Deren's last film, *Divine Horsemen—The Living Gods of Haiti* (1947–51), which included repeated shots of Voudon ritual sand drawings, or *vèvè*. Jonas also stated that "reading the essays in *Spiritual Disciplines*, I got [an] idea to use drawings . . . which I called 'Endless Drawings' after those described

in the Melukean Book of the Dead, the tribal ritual book of New Guinea. There it says that in order to go from one world to the next you must finish a drawing in sand which an old lady, the devouring witch, begins at the boundary between life and death."[49]

Jonas implicitly places herself in the role of the "devouring witch," who marks the interface between life and death through drawing and whom she must, herself, confront. The delicate interface is arguably expressed in the dialogue between live and recorded action, in which the viewer is left unsure of where to locate the final meaning, and of which event, the recorded or the live, is, in the end, more real. Jonas' performative actions reinforce the temporality of her on-screen drawings, whose tactile beauty and accomplished execution are, like so much of the process art of which they are a part, deeply material in their form, but ephemeral in their existence.

The strongly cinematic aspect of *Mirage* is underlined in the second part of the film, in which Babette Mangolte filmed a video sequence of Jonas stepping repeatedly through a hoop, as it appeared live on a television monitor. Both camera and monitor were turned onto their sides, so that the image appears, unusually for video, in a vertical orientation. The image in the frame is repeatedly interrupted by the vertical hold moving from left to right in a flickering, staccato movement, which gives the moving image a filmic quality and evokes a Muybridge-like sense of seriality.[50] Jonas is made distant by her multiple framing: within the film; within the monitor's box; within the parameters of the monitor screen inside it; within the frame created by the vertical hold's perpetual movement from left to right; and within the circle of the hoop, into and out of whose frame she continuously

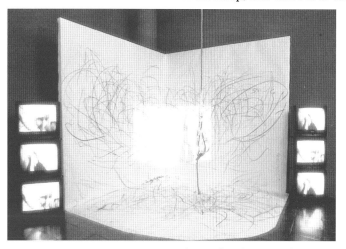

steps. The jerky backward movements created by the vertical hold appear to pull her image back toward us just as it is about to disappear, reversing film's illusion of forward movement and punctuating the image with an insistent percussive sound, like a metronome.

Seen in the context of an exhibition, *Mirage* raises important issues of how to re-present the space and

LEFT: **Carolee Schneemann**. *Up to and Including Her Limits*, 1971–77. Installation at the New Museum of Contemporary Art, New York, 1996.
In Schneemann's performance of the same title, she made evident the performative process of drawing. Swinging from a tree surgeon's harness, which she raised and lowered as she drew on paper attached to two walls, she created a web of crayon marks in the light of a film projector beam. These large drawings—traces of the body in motion—were subsequently presented as an installation, with the harness, film projector, and monitors documenting the performance.

OPPOSITE: **Dennis Oppenheim**. *Echo*, 1973. Two 16mm film loops, black-and-white, sound, projected simultaneously. Installation at the Museum of Conceptual Art, San Francisco, 1973. Collection of the artist

time of a site-specific performance decades later, in the static context of the museum space. Pamela M. Lee has articulated what she terms the "double time" of an art work: the temporality of its own internal structure and the changing perceptions of it across a historical trajectory.[51] The issue of presenting performance art as an installation at a later time and in a gallery space has been confronted by a number of artists, among them Joseph Beuys, Marina Abramović, and Carolee Schneemann, who resolved it by creating installation versions of their performances.[52] In so doing, they produced a double time frame for a single event.

In Jonas' *Mirage*, the installation re-presents the key moving image elements

from the performance: the uncut film and the videotapes *May Windows* and *Good Night, Good Morning* (both 1976). These re-edited fragments and outtakes are what Jonas terms "repressed material," which could easily have been included in the original performance, and appears in its installation version as a marker of the work's open-ended, process-based form.[53] The work is presented not as a static stage set without the actor, but as the trace of a live event, whose energy, sensibility, and meaning are communicated through fragments of recorded actions.

The stubborn retention of the concept of originality in the face of its ubiquitous dismantling during the 1960s and early 1970s ran parallel, paradoxically, with the myth that artists during this period rejected the white cube of the gallery. In fact, the gallery space became more critical then ever before, as a structure and symbol within or against which temporally based art works of all kinds could be shown, performed, documented, referred to, or measured. Each work in this exhibition engages directly with the space of the gallery, even as it rejects its traditional spatial and presentational parameters. During this period, the gallery became the oedipal body of the parent, against whose rigid modernist walls the art work flung itself.[54]

Dennis Oppenheim's film installation *Echo* (1973), in which four black-and-white films of a hand slapping the wall are projected onto the four walls of the gallery, represents, along with Barry Le Va's *Velocity Piece #1* (1969), one of the most concrete examples of an attempt to overcome the physical impasse of the gallery.[55] Where Oppenheim strikes the gallery wall with his hand and records the action on film, Le Va hurls his body against the wall and records it on audiotape. Like Le Va's act, Oppenheim's demonstrated the frustration produced by the limitations the walls represented in terms of psychological, philosophical, and physical containment.

Oppenheim's film installation followed his earthworks of the late 1960s, which had already brought the gallery, and the entire urban environment, into question as a viable context for art-making. As he made the shift from "the earth as site to the body as site" in the early 1970s, he began increasingly to work with his own body as both a material and a tool.[56] Like a group of little-known early films shot before it, *Echo* is characterized by its concern to define authenticity and economy through the body's force acting on itself. This concern reveals the extent to which, as Oppenheim has stated, his work retained traces of the influence of Minimalism.[57] The simple action of the hand slapping the wall in *Echo* symbolically removes not only the canvas from the wall of the gallery, but the paintbrush and even paint itself. Oppenheim pares the act of mark-making down to its most direct form: the surface of the artist's body meeting the surface of the wall. *Echo* is probably the artist's most reductive statement. Although it retains the body as the site of meaning, it is the body's most elemental force, its energy, that becomes the subject.

The resistance of the wall to the body in *Echo*, and of the body to the wall, made

concrete the boundary between the self and the outside world. This was becoming important in a period where such boundaries seemed increasingly contingent, weakened by the social and political upheavals of the late 1960s and by the growing sense of global interconnectedness brought about by the explosion of mass-media communication. *Echo* emerged out of three earlier films involving hands, shot by Robert Fiore in 1969 (the same year that Richard Serra made his four hand films, which Fiore also shot). *Echo* signaled the beginning of Oppenheim's attempts to mark the boundary between interior and exterior.

At the same time that Oppenheim's focus on determining the body's physical limits functioned as a means of self-definition, it also, paradoxically, involved an extension of those boundaries into external space. In *Echo*, his repeatedly moving hand is replicated on each wall of the gallery via the film projector, demonstrating

Iles: Between the Still and Moving Image

another touchstone of Minimalism, and of photography before it: repetition by industrial means. The appearance of hands as film imagery following the disappearance of the traditional manual facture of artmaking occurs in the films of Oppenheim, Serra, and Yvonne Rainer, all of which involve actions using a single forearm and hand seen close-up. Each hand performs a task-based action evoking its respective skills—in Serra's case, catching lead, bearing its weight, or handling metal filings; in Rainer's, moving each part of the hand as though stretching the body. Physical tasks, no longer necessary for the making of art, are abstracted into the construction of its meaning. In Oppenheim's *Echo*, the hand literally echoes his own use of the body to measure his physical limits and that of space around him.

The extension of the body through duplication is repeated in the four different echoes, whose syncopation lends the piece a strong musical aspect, evoking the percussive sound works of Steve Reich. It is not the slapping of the wall per se that interests Oppenheim, but what trace remains of the act once it has been completed. The trajectory of the aural reverberations of Oppenheim's slap into and around the room could be read as a kind of invisible casting, corresponding to the shape made by the pressing of his arm into asphalt in his film *Arm and Asphalt*, for example. In *Echo*, the echoes are moved around the room through carefully placed speakers, extending the visual marking of the boundary of the gallery by his hand into an aural delineation of space. Oppenheim's use of repetition to articulate space could be likened to Serra's *Casting* (1969), in which Serra repeatedly flung molten lead at the juncture between wall and floor and pulled the hardened form into the space of the gallery. Like Nauman, Vito Acconci, and others, Oppenheim pits the moving image against physical space to articulate a psychological anxiety about a loss of identity, boundaries, and self-control.[58]

The construction of identity, as so much theoretical and psychological research in the 1970s confirmed, revolves around language. In spite of the prominence of language in work made during this period, few artists used it in relation to the projected image in installation.[59] This was not a result of language's location strictly

LEFT: **Richard Serra**. Stills from *Hand Catching Lead*, 1968. 16mm film, black-and-white, silent, 4 minutes

OPPOSITE, RIGHT: **Yvonne Rainer**. Stills from *Hand Movie*, 1966. 16mm film, black-and-white, silent, 5 minutes. *Hand Movie* was first projected as part of a dance performance by Rainer in 1966; it was later screened alongside Serra's hand films at the Paula Cooper Gallery, New York, in 1969.

OPPOSITE, FAR RIGHT: **Dennis Oppenheim**. Still from *Arm and Asphalt*, 1969. 16mm film, black-and-white, silent, 6 minutes

within the reductive forms of Conceptual art. It appeared, for example, in Nauman's neon sculptures and sound works; in Oppenheim's sound, slide, and installation works and large-scale outdoor pieces; and in Morris' Duchampian sculptural puns. The emphasis in projective installations on physical space situates meaning not in the Duchampian optical extension of vision into the fourth dimension, but in a phenomenological inclusion of the whole body. In such installations of this period, language is internalized, as the body becomes a *metaphor* for language. It was only later, in the video work of Gary Hill, for example, that the spoken and written word emerged out of the body, in primal utterances, as well as in complex philosophical and poetic metaphors of thinking.[60]

Language found a rare home, however, in the installations of Vito Acconci, whose existential, language-based form prefigured Hill's more reductive linguistic spaces. Transforming the psychological power fields of his earlier performances into built spaces, Acconci's installations of the mid-1970s operate as a kind of house for a conceptual narrative. *Other Voices for a Second Sight* (1974) constructs an architectural space within the gallery, divided into three parts. Unlike Nauman's architectonic spaces, whose elements abstract the basic formal units of the gallery—walls, corridors, rooms—Acconci's three rooms operate as symbolic spaces. For Acconci, an encounter with his installations echoed the structure of his performance work, which focused on himself: "'you' came in 'me,' walked through 'me.' The space was from and for me: it

was as if the viewer was walking into my mind."[61] In *Other Voices for a Second Sight*, the contents of Acconci's mind are asserted through his voice, which speaks to the viewer in low, confidential tones, in three interlocking monologues. Barthes described the voice as being "the grain" of the body.[62] The gravelly, seductive texture of Acconci's voice asserts his presence in an almost tangible form, within an otherwise disembodied space.

The three rooms of *Other Voices for a Second Sight* all represent aspects of Acconci's identity, externalized as two opposites—a black room on the left and a white room on the right—held in place and synthesized by a central room, which

resembles the intimate space of a recording studio. In this central room, Acconci's voice can be heard emanating from a reel-to-reel tape recorder and speakers standing on a shelf in front of an empty chair. The monologue evokes that of a late-night radio program. A blinking red light on the wall above the tape recorder implies that, somewhere, live recording is in progress. This suggestion of voyeurism and hiddenness is reinforced by Acconci's naming of the black room on the left as a "secret room being looked in upon."[63] Vertical in shape, the space is dark and crowded, with sheets of plastic zigzagging across, onto which are projected images of Acconci's body and face, alongside images of political posters. The monologue emanating from the space reflects the artist's increasing concern with social and political issues. He speaks in the voice of a string of revolutionaries: Che Guevara, Leon Trotsky, George Jackson, Mao Ze-dong, Franz Fanon, and Abbie Hoffman, who broadcast their revolutionary messages through Acconci. If, as Acconci has stated, his use of language parodies an ordering system that he first establishes and then dismantles,[64] the ideological cries of the Marxist revolutionaries in the black room underscore the loss of political direction and integrity he and others felt during the Vietnam era. The personal content of the white room is repeated in the recording studio, interspersed with jazz music, radio host chatter, and autobiographical storytelling: "We'll keep the light away together . . . because that's why you turn me on each night: not to pass the night but to put off the day . . . this is your host Victor Ackon. . . . "[65]

At the end of each story, Victor Ackon the radio host also signs off as, variously,

Vettor Concher, Veda Conti, Vextor Coon, Vater Accons, Vita Conchy, Verter Cone, Voto Acco, Vic Accone, Virt Kincher, Vitter Ack, and Vic Acone. Acconci's identity is not only split among three rooms, but within each room it is splintered into even smaller fragments, multiplying into so many different identities that he appears to disappear. The viewer's search for the "real" Vito Acconci reveals "a language-world in which the self can reconnoiter its terrain only poorly: it meanders, lost, through space, searching for a stable domain, aiming to secure a place, to find a meaning. . . . No clear category or identity can maintain the self."[66]

The search for a stable domain runs through all the works brought together in this exhibition. There is no clear center within which the locus of meaning can rest. Walter Benjamin articulated this loss of center when it was wrought by the impact of the duplication of the image in photography and film. He observed that film "bursts open the restriction of being in one place and time, and thereby extends our perception of life, space and time."[67] Duchamp's experiments with the fourth dimension attempted to harness the sense of unease about this separation between the recorded image and its origin. The conceptual works of William

LEFT: **Vito Acconci.** *Learning Sessions (II): Activity for Photos,* 1970. Collage of vintage chromogenic color prints and text mounted on board, framed: 49 x 42⅝ x 2 in. (124.5 x 108.3 x 5.1 cm). The Wadsworth Atheneum, Hartford, Connecticut; The Douglas Tracy Smith and Dorothy Potter Smith Fund.
As Acconci practiced a t'ai chi movement, he recorded each attempt in photographs and notes, documenting the body's learning process through a grid of images and text.

OPPOSITE: **Mel Bochner.** *Theory of Boundaries,* 1969. Ink on paper, 5 x 8 in. (12.7 x 20.3 cm)

56 | 57

Iles: Between the Still and Moving Image

Anastasi, made in the late 1960s and influenced by Duchamp's interrogation of the nature of perception, make visible this separation by placing the original and its recording side by side.

In Anastasi's *Free Will* (1968), a video monitor placed on the floor in a corner of the gallery presents a live image of the corner, as it is framed by the lens of a black-and-white video camera placed on top of the monitor. This tautological statement simultaneously asserts the instant feedback properties of the newly emergent medium of video and denies video's other major characteristic: movement. The stasis of the potentially moving image creates a tension resulting from the unconscious anticipation of the viewer, who expects the image to move. The frustrated viewer shifts around the monitor in an attempt to animate it, as well as to confirm that the image is live, rather than a recording of the same space at a different time, which its stasis suggests. *Free Will* operates in direct opposition to Morris' *Finch College Project*, whose repetition occurs in the continual revolving of a film image around the space and whose continuous motion refuses the viewer a stable view of either the walls of the gallery or their images, filmed and projected back into the space.

The ambiguity between movement and stasis in *Free Will* is reinforced by the fact that the video image is in black-and-white, creating a clear distance from the full-color reality of the corner in real space and evoking the stillness and other time of photography. Despite this implied stasis, the viewer's presence does succeed in changing the image by revealing different aspects of the videotaped corner, which follow the angle of the moving body in relation to the screen. This also allows the monitor's physical shape to be experienced, as the viewer moves away from the frontal image of the corner and perceives the monitor's three-dimensional mass. The experience of a transformation of a space to a flat image in real time is replaced by a recognition of the image-generator as a solid object sitting inside that very space.

Anastasi's tautology is thus rendered undeniably material. It can also, paradoxically, be understood as an implicit critique of the institution of the museum and gallery, as well as of conventions of art presentation, in its rejection of the open space of the wall and conventional viewing height. The corner, and the floor, were important democratic locations in space for artists such as Dan Flavin, Carl Andre, and Bruce Nauman. Their use of neglected locations rejected traditional hierarchies of value (such as the pedestal and the frame) in favor of a more open-ended definition of meaning, for which, following Donald Judd's maxim, interest, rather than quality, became the benchmark. Anastasi's replication of a corner through a real-time image lends it the similar characteristics of both a void and an object.

By contrast, in Anastasi's *Microphone* (1963), an earlier conceptual work, the interface between real and replicate is more immaterially located. A reel-to-reel tape recorder plays back a recording of the machine's own recording mechanism, with the recorded and real sound set at the same volume. The almost intangible interval articulated by the space between the real and the recorded sound evokes the definition of temporality articulated by Duchamp's concept of "infra-thin" time, which he associated with transparency and interval, and whose immateriality he described as being like the warmth of a seat just after someone has left it.

The subtlety of this interface between one moment and another recalls both the wafer-thin screen of Snow's *Two Sides to Every Story* and Mel Bochner's slide work

Theory of Boundaries (1969), in which three slides project a thin layer of light onto the equally thin surface of a wall. Each rectangle of light shows parts of a statement that reads, in white capital letters photographed on a black wall, "Theory of Boundaries." In the intervals between the three slide projections, Bochner painted, on the white wall in black letters, the letters that appeared on the black wall represented by the slides. The resulting layering of real and projected surface, along with the theory implied, but not explicated, in the sentence, invites the viewer to consider the visual and textural boundary between the gallery wall and the wall documented on the slide. The projection of a slide image of one wall onto the surface of another forms a kind of interruption of the actual wall, heightening our awareness of it as surface. It also brings a representation of one space into the reality of another, making visible the fact that reality (actuality) lies in the relationship between what we observe and what we know.

This dichotomy was also demonstrated by Michael Heizer in a large negative sculpture titled *Munich Depression* (1969), made in Neue Perlich, Munich, and an accompanying projection work, *Actual Size: Munich Rotary* (1970), in which the large void of the sculpture's interior was photographed, and the black-and-white images of the interior projected into the gallery space, actual size. Both works deal with the viewer's optical experience of a large, enclosed negative space, and the horizon line, in phenomenological terms. When the viewer stood at the bottom of the depression, only the sides and skyline were visible, creating a stark horizon line. In their oval-shaped structures, both works evoke in us a strong sense of our physical center, as well as the spherical shape of our eye, whose dimensions directly correspond to the area of sky framed by the depression's perimeter. Both *Munich Depression* and *Actual Size: Munich Rotary* thus become not only art works, but devices for measuring opticality. The tension between void (real space) and surface (the immateriality of the projections on the wall) suggests that "actual size" is, after all, relative. Our perception locates the actual size as existing in both, and therefore somewhere between the two. As George Kubler noted:

> Actuality is when the lighthouse is dark between flashes; it is the instant between the ticks of the watch: it is a void interval tipping forever time: the rupture between past and future: the gap at the poles of the revolving magnetic field, infinitesimally small but ultimately real. It is the inter-chronic pause when nothing is happening. It is the void between events. Yet the instant of actuality is all we can ever know directly. The rest of time emerges only in signals.[68]

The rupturing of the gallery's boundary, either literally or conceptually, lay at the heart of the process-based practice of Postminimalist artmaking. Video was a part of this challenge to what were felt to be the confines of the gallery space, a confinement demonstrated through increasingly temporal interventions. The arrival of video as a medium capable of relaying events at the same moment that they took place changed the experience of time forever. Suddenly there was *parallel* time. Not the "double" time of past and future suggested by Pamela M. Lee; nor the conflated time in which episodes from a narrative were pictured together in a single image, as in painting from ancient Egypt onward; but a simultaneity of a present and an *electronically mediated* present. The profound impact of this electronic simultaneity was famously anticipated by Marshall McLuhan, in his predic-

Michael Heizer. *Actual Size: Munich Rotary*, 1970. Six black-and-white photographic projections. Installation at the Kröller-Müller Museum, Otterlo, The Netherlands, 1979. Whitney Museum of American Art, New York; Gift of Virginia Dwan 96.137a–jj

tion of a collapsing of boundaries and the emergence of a "global village."[69]

In artmaking, the perceptual properties of this new model of time were taken up at an early stage by Nam June Paik and Yoko Ono. In 1966, Yoko Ono exhibited *Sky TV* at the Indica Gallery in London. A video camera was placed outside the building, relaying a continuous live image of the sky onto a television set inside the gallery. The work also existed as a written instruction, or score. Ono's seemingly simple statement predicted the rupture of the gallery as a self-contained entity and expressed temporality, the everyday, and the nonartistic—all values that Duchamp had asserted nearly fifty years before and that modernism could be seen as having merely interrupted. *Sky TV* also echoed Duchamp's concern with transparency. Ono had rendered the interface between the gallery and the outside world transparent by transmitting the image of one space directly into the other in real time. This spatial simultaneity had already been expressed in static terms in her *Painting to See the Evening Light Through* (1961), in which a plexiglass rectangle was hung in front of a window, shifting the location of meaning from the opaque surface of a canvas to the relationship between a transparent plane and the outside world beyond it.[70]

Ono's substitution of the familiar imagery of television with an image of the everyday world conducive to contemplation undermined both the authority of

broadcast television and the integrity of the self-contained object. *Sky TV* takes further the rupture of the pictorial surface demonstrated in Nam June Paik's *Magnet TV* (1965), in which the autonomy of a quotidian object—a television set—is compromised by a household element—a large magnet placed on top of it. The visual disruptions caused by the magnet challenge the boundary of the object's frame and suggest movement into a space beyond it—evoking the phenomenological spatiality of both Minimalism and, later, projective installations.

Sky TV also evokes the anxiety felt by observers of early Minimalism, who worried that Minimalism's emphasis on temporality, the nonhierarchical, the use of

industrial materials, phenomenology, and nonauthorial fabrication was shifting art too much toward the everyday, the utilitarian, and the nonartistic. These were, of course, exactly the areas that Duchamp had already staked out and that the new medium of video was also seeking to occupy. Just as Paik's magnetically distorted abstraction rejects the conventional television image, the electronic light and blank surface of Dan Flavin's *ICON IV (Ireland Dying, to Louis Sullivan)* (1962–63) rejects the painterly (iconic) image and, in more general terms, painting itself. Flavin described his icons as "dumb . . . anonymous and inglorious . . . mute and indistinguished"—all Duchampian terms that could be applied equally to the television set and to Anastasi's gallery corner, Nauman's spinning ball bearings, Oppenheim's slapping hand, and Ono's sky.

Ono's conceptual rupturing of the membrane separating the gallery from the outside world took concrete form in Gary Hill's *Hole in the Wall* (1974). Using a video camera, Hill framed part of the surface of an outside wall to the same size as a monitor and recorded himself as he cut into its various layers, until he eventually broke through to the other side. The videotape of the process, cutting through layer upon layer of wallboard, fiberglass, and aluminum paper, was replayed as a loop on a monitor placed in the hole he had created, to exactly the same scale.

Hill's dramatic statement about the gallery space asserts what were to become two key strands of his work: the body and the image as performative tools and the construction and reading of the image as a mental concept. Whereas Oppenheim slaps the wall repeatedly in an atemporal cycle of both frustration and topographical marking, Hill cuts through it in a single performative action. Oppenheim is interested in space, but Hill is interested in what George Quasha and Charles Stein have called liminality: the threshold between one space or moment and another.[71] Hill's cut through the wall (which he likens to Gordon Matta-Clark's architectural cutting actions) identifies that threshold at the same time as it crosses it.

Nam June Paik. *Magnet TV*, 1965. 17-inch black-and-white television set with magnet, 28⅜ x 19¼ x 24½ in. (72.1 x 48.9 x 62.2 cm) overall. Whitney Museum of American Art, New York; Purchase, with funds from Dieter Rosenkranz 86.60a–b

Hill's projection of a recording of an action onto the site in which it took place creates what he has termed a "video memory."[72] This memory makes visible the process by which the hole was made, much as Snow exposes the process of the film's making in *Two Sides to Every Story*. In *Hole in the Wall*, the size of the cutting area, and therefore the final hole, was determined by the size of the monitor screen and the camera frame. The document of the making of the hole, occupying the exactly measured space of the hole itself, becomes part of the hole, and, therefore, an object, both physically and perceptually. This performative object evokes Morris' *Untitled (Standing Box)* and *Box with the Sound of Its Own Making* (both

1961) as well as the characteristics of 1960s sculpture they epitomized—including theatricality, temporality, and the insertion of the object directly into the gestalt of the viewing space. The principle of feedback, central to video, and to Hill's work in particular, has its roots in these profound shifts that took place in sculpture during this period, made strongly evident in the work of Morris and others.

In *Box with the Sound of Its Own Making*, Morris inserted into a 9-inch-square wooden box a three-hour audiotape of the sound of its construction. The entire three-hour tape constituted the "length" of the sculpture, endowing it with a measurable temporal duration as well as a physical form. Hill's *Hole in the Wall* parallels Morris' box in its fusion of material form with the temporal recording of its making. Like Ono, Hill brings one space into another—not through simultaneous transmission, but through the uniting of memory and real time.

The opening out of the parameters of the enclosed sculptural object that had led to the inclusion of a performer, or viewer, within the space of the work was articulated in literal terms by Keith Sonnier in his fluorescent and neon light and video environments. Video projection appeared in Sonnier's work in the early 1970s as a direct development of his use of large mirrors as a performative element in a series of sculptural environments and performances. In *Channel Mix* (1972), the mirrors were replaced by a live image of the viewer in the gallery space, mixed in real time with television broadcasts and projected in two large, split images on opposite walls of the gallery and colored with a diffused overall hue. As Robert Pincus-Witten observed, the two projected television images become a conceptual element within a luminous ambient space, in which "the opposed exhalations of constantly shifting lights and shadows" create a binary rhythm, moving back and forth and negating a sense of narrative, or forward movement.[73] Just as Ono obliterates television space, Sonnier brings it into the gallery, critiquing it not by refusing it, but by making visible its manufactured structure and incorporating it into a painterly ambient space.

In extending his use of light as matter to incorporate projected televisual imagery, Sonnier was not so much, as Bruce Kurtz suggests, extending painterly values to video, as he was defining the particular surface, space, and color of video as a medium.[74] In *Channel Mix*, viewers do not confront their individual images existentially, as the elusive shadow emerging from the darkness in Peter Campus' *aen*, but as everyday reflections that take their place within the flow of daytime television programming and become almost indistinguishable from it. Sonnier's fusion of the viewer with the viewed in real time demonstrates the essence of the video medium: the sense of a perpetual present created by the viewer's awareness of his or her body entering a "field" of continual feedback. This level of involvement in the electronic image is made possible, McLuhan argued, because of television's (and, by implication, video's) tactile power.[75] McLuhan famously suggested that television is an extension of touch rather than of sight alone, because of its low definition, which produces a diffused electronic mosaic of horizontal lines and dots that the viewer's eye completes. This intense involvement with the screen results in a kind of osmosis of viewing. In Sonnier's cinematic color field video projection, this involvement is given a performative context. The viewer's assumption of the role of performer situates the work somewhere between the live space of performance and a hybrid space in which the phenomenological ambient field of Color Field painting is fused with the vibrancy of the luminous, saturated electronic surface of video.

If Sonnier imbued painterly values with temporality, Robert Whitman used temporality as a material in another kind of performative context. Whitman introduced temporality into the gallery space most notably in iconic Happenings such as *American Moon* (1960), in which six film projection loops animated the performance space, and the 1965 performance *Prune Flat*. In the performances and Happenings of the early 1960s pioneered by Whitman, Allan Kaprow, Claes Oldenburg, Robert Rauschenberg, John Cage, and Carolee Schneemann among others, film and slides became important elements. The spatial and temporal juxtapositions of later Postminimalist moving image installations were already present in these early insertions of filmed narrative alongside live action.

Anthony McCall cites Rauschenberg's composite painting *Pilgrim* (1960), in which a chair is physically attached to the surface of a canvas, as an important influence on his own understanding of, and engagement with, temporality and space. Rauschenberg's intervention ruptured the illusionist surface of the picture plane, asserting real time and space over the viewer's desire to become absorbed in the painted image. Whitman, a close friend of Rauschenberg, made a similar juxtaposition of flat space and three-dimensional reality. His use of film as a material for temporal and spatial experimentation was explored in both performance and in a series of sculptural environments made in 1963–64. In perhaps his best-known cinema environment, *Shower* (1964), a film loop of a woman showering is projected onto the curtain of a real shower stall as water cascades from the faucet behind. The piece was first shown as part of a performance by Whitman in the landmark event "9 Evenings: Theatre and Engineering" at the Sixty-Ninth Regiment Armory in New York, organized by Rauschenberg and Billy Klüver for E.A.T. in 1966. The event, which featured nightly performances by Rauschenberg, Whitman, Yvonne Rainer, John Cage, Öyvind Fahlström, Steve Paxton, Deborah Hay, David Tudor, Lucinda Childs, and Alex Hay, involved the collaboration of Bell Lab engineers, scientists, and technicians in a radical experiment on an unprecedented scale.

Shower evokes both the cinematic drama of Alfred Hitchcock's thriller *Psycho* and the sculptural statement of Rauschenberg's chair in reverse. Illusionistic imagery is projected onto a physical object, creating a fusion of cinema and sculpture. Unlike Hill's *Hole in the Wall*, in which site and action are conceptually and temporally linked, *Shower* re-presents, on film, an act that took place in another time and place, uniting it within a separate physical representation of its filmed site in order to complete an image. Like Morris' *Untitled (Standing Box)* and *Box with the Sound of Its Own Making*, Whitman's juxtaposition of temporal activity with static three-dimensionality uses the performative to undermine the concept of a self-contained object.

Whitman's technological experimentation, and his fusion of a sculptural language with film, reflected a widespread interest in harnessing technology for creative ends during the 1960s.[76] During this period, there was a strong need to distinguish the mechanization and standardization that had penetrated artmaking from that of mass industrial production.[77] This contradiction between individual artistic statement and industrial labor is consistently demonstrated in the work of Andy Warhol, and his pastiche of industrial production, the Factory. Warhol's use of repetition and seriality in his films similarly critiques the Hollywood studio system by mimicking its factory production methods. Hal Foster argues that the blankness of Warhol's seriality is not merely part of the industrial model, but also represents the reaction of a "shocked subject," for whom repetition functions as a defense against

the traumatic subject matter he depicts (the tragic figure of Marilyn Monroe, car accidents, suicide, the electric chair). This argument is clearly demonstrated in Warhol's double-screen film *Lupe* (1965), a satire on the studio system, in which Edie Sedgwick acts out the final hours of the Hollywood star Lupe Velez, who committed suicide in 1944.[78]

Warhol's interest in tragedy and the melancholic, Foster suggests, not only reproduces the traumatic, but also *produces* it. This is illustrated in *Lupe*, which appears to be a premonition of Sedgwick's decline as well as a reprise of Velez's. Sedgwick is filmed waking up, putting on makeup, and walking languidly around in the apartment where the film was shot. The drama occurs in her gradual decline into a drink- and drug-induced stupor—unable to lift her head from the table, she finally collapses in the bathroom with her head in the toilet.

The duality of Warhol's dramatization of a true Hollywood story and its parody in Edie's own fragile state is underscored by the split screen. Warhol divides the narrative across the two screens at the moment that Sedgwick begins to spiral downward. The left screen shows Sedgwick in a pink baby-doll nightdress. Preparing for her glamorous suicidal moment, she has her hair cut by Billy Name and applies heavy eye makeup in front of the large mirror by her daybed. The left screen is further split by the large mirror, through which we see Sedgwick doubled for most of the film, except for certain moments when the camera zooms in to her face in the mirror or up to architectural details of the room.

On the right screen, Sedgwick drifts backward and forward between the table and the mantelpiece in a diaphanous blue gown. Her mood is one of languid distraction, as she pours herself glasses of wine and toys with a plate of food. The deterioration of Sedgwick's mental and physical state is registered by sudden wild movements of the camera, which sweeps up and down, out of focus, as her head droops, cigarette hanging from her hand. This pattern is repeated until she walks away, leaving an empty chair. The camera cuts to an identical shot of the bathroom scene, zooming in and out, and filming Sedgwick's slumped body through the mirror.

In Warhol's multiple portrait, splitting is expressed through the screen, the narrative, and the subject. The boundary between Sedgwick as herself, as Warhol superstar, and as Lupe Velez is unclear, since the reality of her own identity is simultaneously asserted and submerged. The mirroring, doubling, and breaking down of the single cinematic viewpoint in so many later moving image installations is already evident in Warhol's juxtaposition of two halves of the same narrative side by side, fractured further by the reflections of the large mirror. The mirrored reflections of Sedgwick also recall the quadruple portrait of *Outer and Inner Space*, made earlier the same year, in which Warhol filmed the superstar sitting next to her recorded image playing on a television set projected in double screen.

If Warhol's dismantling of linear cinematic time and the illusion of dramatic narrative anticipates Snow's *Two Sides to Every Story*, his prescient use of video in *Outer and Inner Space* predicts the temporal simultaneity of live feedback. In both films, Warhol's use of video feedback and mirror reflection to express psychological tension and the fracturing of the self engages repetition "to screen the real understood as traumatic."[79] Warhol's use of repetition is not, therefore, as in Minimalism, a repression of representation and subjectivity, but a means of exposing it. The existentialism of his fractured identities and psychological portraits would reemerge later, articulated spatially in installation works such as Acconci's *Other Voices for a Second Sight*, in which Warhol's traumatic subject is turned

inward, expressing the fragmentation of the artist himself.

The tension between objectivity and subjectivity evident in Warhol's films is the point around which much of the work of the 1960s and early 1970s pivots. As Sol LeWitt stated in his "Sentences on Conceptual Art" (1969): "Irrational thoughts should be followed logically and absolutely."[80] The work of Samuel Beckett, ruled by systems and repetition, yet deeply irrational, epitomizes the paradox surrounding the impurity of this work. This paradox expresses itself most clearly in temporality, the driving force of this period. The experience of temporality in art across all media occurred as a direct result of the restructuring of perception that took place during the mid-1960s. As Robert Morris argued in his text "Notes on Sculpture, Part IV," published in *Artforum* in 1969, a shift was occurring in perception, toward a more inclusive viewing experience, in which the viewer no longer focused on a gestalt reading of an object in perspective within an otherwise unimportant space. Instead, that space was included in a kind of environmental viewing: "a mode of vision [variously termed as] scanning, syncretistic or dedifferentiated. . . . This perceptual mode seeks significant clues out of which wholeness is sensed, rather than perceived as an image."[81]

As Morris observed, the new perceptual mode became incorporated as a structural feature of the art work itself. This was particularly true of projective installations, for which the orientation of the viewer in space was central to the reading

T.1 Pl.8

Vüe circulaire des Montagnes
qu'on découvre du sommet du Glacier
de Buet.

of the work. Many projective installations made during this period evoked a response similar to Rainer's description of her experience of viewing an abstract sculpture by Morris in 1967: "It looks the same from every aspect. You know you won't see anything different if you go to the other side, but you go to the other side. You know immediately what you are seeing, but you don't quite believe that another vantage point won't give you a more complete, more definitive, or even altered, view of it. It doesn't."[82]

Whether the multiple images of projective installations are identical or not, the viewer's attention is always directed upward and outward, to the walls of the space. This viewing mode is a direct reversal of our inward focus on an object, however phenomenological, *in* space. In most projective installations, the viewer does not share the space of the gallery

with the art work, but is enclosed *by* it. In this sense, projective installations differ from the other genres of art during this period. As Morris argues, a large object or projection makes more demands on viewers, who must stand at a greater distance to perceive it, and involve their bodies more fully in it. This architectonic aspect is underscored by the repetition of screens across the walls of the gallery space, which corresponds directly to the serial rectangular block, the paradigmatic unit of 1960s sculpture.

The use of the rectangular unit as extension is found in the projections of Anastasi, Graham, Korot, Lucier, Nauman, Oppenheim, Sharits, Sonnier, and Warhol.

LEFT: **Horace-Bénédict de Saussure**. *Vue circulaire des montagnes qu'on découvre du sommet du glacier de Buet*, 1780. Graphite on paper, sheet 10 1/4 x 7 7/8 in. (26 x 20 cm). Zentralbibliothek, Zurich. The all-surrounding perceptual viewing experience described by Robert Morris in his "Notes on Sculpture, Part IV" (1969) evokes the panoramic environments that appeared in Europe in the seventeenth century, during a similar period of technological and social revolution. This early drawing of a panorama of mountains in Switzerland indicates a parallel desire to portray the entire space of the circular environment, beyond the body's ocular limits, and the didactic process of measuring and recording the natural world.

OPPOSITE: **Bruce Nauman**. *Untitled*, 1974. Photographs, tape, paper, cardboard, and text, 37 x 24 13/16 in. (93.9 x 63 cm) overall. Staatsgalerie Stuttgart. This work is a template for *Cones Cojones* (1973–75), an installation shown at the Leo Castelli Gallery, New York, in 1975, in which concentric rings of masking tape on the floor of the gallery suggested a cross-section of large cones beginning at the center of the earth and stretching up to the sky. Viewers were to position themselves in the middle of the space, centered in the cones, or *cojones* (a vulgar term in Spanish meaning "testicles"). Nauman asks viewers to imagine the space underneath their feet and the ground below as a vast volumetric negative form, within whose center they should align their own.

Repetition occurs as a device through which both temporal and spatial presence is asserted. Yet in each case, temporality is used to render spatial presence elusive. In Lucier's *Room*, it disappears into abstraction; in Morris' *Finch College Project* it is glimpsed moving perpetually across the walls; in Nauman's *Spinning Spheres*, it is spun out of recognition; in Graham's *Helix/Spiral*, it swings in and out of the horizon line. This destabilizing of space disrupts the picture plane through temporality, not so much destroying illusionism as redefining its limits. As the works in this exhibition demonstrate, these limits are understood through the body, within which the mechanics of vision are lodged. The projective installation thus continues the mission of Duchamp's *Large Glass*: to make visible a model of consciousness in which, as George Quasha and Charles Stein have observed, we recognize that we exist within a continuous projection of our own "event."[83]

Notes

1. Roland Barthes, "Upon Leaving the Movie Theater," in Theresa Hak Kyung Cha, ed., *The Cinematographic Apparatus: Selected Writings* (New York: Tanam Press, 1980), p. 1.

2. Similar concerns were shared by the Brazilian artist Hélio Oiticica, particularly in his slide installations collectively titled *Quasi-Cinemas* (1970), made when he lived in New York.

3. Jean Baudry, "Ideological Effects of the Basic Cinematographic Apparatus," in Hak Kyung Cha, *The Cinematographic Apparatus*, pp. 27–28, describing the Greek model of space, circular and democratic in character, allowing many viewpoints for spectators.

4. Catherine Wilson, "Discourses of Vision in Seventeenth-Century Metaphysics," in David Michael Levin, ed., *Sites of Vision: The Discursive Construction of Sight in the History of Philosophy* (1997; 2nd ed., Cambridge, Massachusetts: The MIT Press, 1999), p. 133.

5. Ibid., p. 117.

6. Thierry de Duve, "Echoes of the Readymade: Critique of Pure Modernism," in Martha Buskirk and Mignon Nixon, eds., *The Duchamp Effect: Essays, Interviews, Round Table* (1996; 2nd ed., Cambridge, Massachusetts: The MIT Press; New York: October Books, 1999), pp. 109–10.

7. David Joselit, *Infinite Regress, Marcel Duchamp 1910–1941* (Cambridge, Massachusetts: The MIT Press, 1988), p. 173. See also Peter Campus' single-screen videotape *Three Transitions* (1973), in which he cuts into a paper wall superimposed onto an image of his back and climbs through it (and himself), only to emerge intact on the other side.

8. Ibid., p. 156. As Duchamp articulated in a note, "Reflection from a mirror—or glass—/flat/convex—infra-thin separation—better/than screen, because it indicates/interval (taken in one sense) and/screen (taken in another sense)—separation. . . ."

9. Rosalind E. Krauss, "Notes on the Index, Part 1," in *The Originality of the Avant-Garde and Other Modernist Myths* (Cambridge, Massachusetts: The MIT Press, 1985), pp. 196–209. Hal Foster critiques Krauss' argument in *The Return of the Real: The Avant-Garde at the End of the Century* (Cambridge, Massachusetts: The MIT Press, 1996), pp. 80–86.

10. Jane Livingston and Marcia Tucker, *Bruce Nauman: Work from 1965 to 1972*, exh. cat. (Los Angeles: Los Angeles County Museum of Art; New York: Whitney Museum of American Art, 1972), p. 24.

11. Marcel Duchamp, *Salt Seller: The Writings of Marcel Duchamp (Marchand du Sel)*, Michel Sanouillet and Almer Peterson, eds., quoted by Craig Adcock in "Duchamp's Way: Twisting Our Memory of the Past 'For the Fun of It,'" in Thierry de Duve, ed., *The Definitively Unfinished Marcel Duchamp* (1991; rev. ed., Cambridge, Massachusetts: The MIT Press, 1993), p. 326.

12. Bruce Nauman, "Notes and Projects," *Artforum*, 9 (December 1970), p. 44.

13. Gijs van Tuyl, "Human Condition/ Human Body," in *Bruce Nauman*, exh. cat. (London: Hayward Gallery, 1998), p. 69.

14. Annette Michelson, "Anemic Cinema: Reflections on an Emblematic Work," *Artforum*, 12 (October 1973), pp. 64–69.

15. See Maurice Berger, "Duchamp and I," *Labyrinths: Robert Morris, Minimalism, and the 1960s* (New York: Harper and Row, 1989), pp. 38–40. See also Warren Neidich, "Marcel Duchamp and His Optical Machines," unpublished lecture, School of Visual Arts, New York, 1994.

16. Buskirk and Nixon, *The Duchamp Effect*, p. 48.

17. The tasklike movements of *Finch College Project* also recall Morris' dance performances, in particular *Site* (1965), which, like *Finch College Project*, involved the systematic removal of panels. The removal of the last plywood panel in *Site* revealed Carolee Schneemann, reclining nude on a chaise longue in a pastiche of Édouard Manet's painting *Olympia*, suggesting a similar deconstruction of painterly illusionism.

18. In *Mirror* (1969), Morris holds up a large mirror as he walks in a large circle around a snowy landscape. The panoramic sweep of the mirror is recorded by the camera in a juxtaposition of reflected and real filmed space. In the second part of the film, Morris stops turning and walks backward, away from the camera, until the mirrored image becomes less of a frame within the film frame and more of a pictorial abstraction of the reflected landscape. Prints of the film are in the collections of the Whitney Museum of American Art and the Tate Gallery, London.

19. Hubert Damisch, *The Origin of Perspective* (1987; rev. ed., Cambridge, Massachusetts: The MIT Press, 1994), chap. 8, "The View," pp. 130–31.

20. The performers in different versions of *Helix/Spiral* have included Graham, Simone Forti, Ian Murray, and Duane Lundon.

21. Maurice Merleau-Ponty, *The Phenomenology of Perception*, quoted in Pamela M. Lee, *Object to Be Destroyed: The Work of Gordon Matta-Clark* (Cambridge, Massachusetts:

The MIT Press, 2000), chap. 3, "On Matta-Clark's 'Violence'; Or, What Is a 'Phenomenology of the Sublime?'" p. 133.

22. Herbert Molderings, "Objects of Modern Skepticism," in de Duve, *The Definitively Unfinished Marcel Duchamp*, p. 253.

23. For a comprehensive discussion of the shadow and projection in the history of art and culture, including Plato's classic simile of the cave in *The Republic*, see Victor Stoichita, *A Short History of the Shadow* (London: Reaktion Books, 1997).

24. Douglas E. Tyler, "Holography, Some Observations," in *International Exhibition of Creative Holography*, exh. cat. (Notre Dame, Indiana: St. Mary's College, 1983), p. 3.

25. Ibid., p. 9.

26. Albert A. Hopkins, ed., *Magic: Stage Illusions, Special Effects, and Trick Photography* (New York: Dover Publications, 1976), pp. 211–12.

27. Robert Pincus-Witten, "Peter Campus: Inference and Actuality," in *Projected Images*, exh. cat. (Minneapolis: Walker Art Center, 1974), p. 12.

28. Stoichita, *A Short History of the Shadow*, pp. 11–20.

29. Peter Campus, "sev," in *Peter Campus*, exh. cat. (Cologne: Kölnischer Kunstverein, 1979), p. 28.

30. Anthony McCall, interview with the author, New York, December 2000. A print of the film is in the collection of the Whitney Museum of American Art.

31. The much-touted purity of form in *Wavelength* emerged from erroneous written descriptions, perpetuated by those who have not seen it. The film is not a single zoom, but edited from several different shots.

32. Rosalind Krauss, "Paul Sharits," *Film Culture*, 65–66 (1978), p. 95.

33. Barthes, "Upon Leaving the Movie Theater," p. 2.

34. Lewis Carroll, *Alice Through the Looking Glass*, quoted by Paul Sharits, "-UR(i)N(u)L-S:TREAM:S:S:ECTION:S:SECTION:-S:S:ECTIONED-(A)(lysis)JO:'1968–70,'" *Film Culture*, 65–66 (1978), p. 7.

35. The viewer's involvement in *Line Describing a Cone* reflects McCall's interest in participating within an established structure or score. McCall's concern with participation was expressed in his earliest works, open-air group performances. He remembers being struck by the interactiveness of *HPSCHD* by John Cage and Hans Namuth, a sound performance he saw performed at the Roundhouse, London, in 1971. Walking round a circular space containing seven harpsichords, spectators mixed the sound according to their individual positions within the work. McCall conceived of *Line Describing a Cone* on a ship halfway from England to New York and made it within three months of arriving in the city. He cites lighthouse beams as an influence, and among a portfolio of his drawings there is a copy of an old map of lighthouses across the British Isles. Interview with the author, New York, December 2000.

36. Gordon Matta-Clark cites *Line Describing a Cone* as the inspiration for his architectural intervention *Conical Intersect* in Paris (1975), in which a cone was cut out of the side of a building destined for demolition in Les Halles, revealing the various layers of the building within. Richard Serra saw and admired another important conceptual film by McCall, *Four Projected Movements* (1975).

37. Paul Sharits, "Words per Page," *Film Culture*, 65–66 (1978), p. 11.

38. *The Concise Oxford English Dictionary* (1911; rev. ed., Oxford: Oxford University Press, 1995), p. 710.

39. Krauss, "Paul Sharits," p. 92. In Sharits' installation we do not, in fact, see each individual film frame separately, since that would require slowing down the film projector. Instead, Sharits created a film in which each color is composed of between two and ten frames, each unit separated by a single black frame, which can then be read as a single frame at 24 frames per second. Sharits wrote a three-page unpublished letter to Stuart Liebman outlining the central role played by the black frame in the construction and meaning of *Shutter Interface*.

40. Stuart Liebman, "Apparent Motion and Film Structure: Paul Sharits' Shutter Interface," *Millennium Film Journal*, 1 (Spring–Summer 1978), p. 107. Liebman's incisive article provides a detailed technical and theoretical discussion of *Shutter Interface*.

41. Paul Sharits, "Locational Film Pieces," *Film Culture*, 65–66 (1978), p. 124. *Shutter Interface* is directly related to *Epileptic Seizure Comparison* (1976), which presented a disturbing filmic and aural record of a patient in seizure, with the deliberate intention of inducing a similar state in the viewer.

42. Ibid., p. 24.

43. Amy Taubin, "See Me Feel Me," *The Village Voice*, August 30, 1988.

44. Foster, *The Return of the Real*, p. 63.

45. Alvin Lucier, "I Am Sitting in a Room (1969) (score)," in Melinda Barlow, ed., *Mary Lucier: Art and Performance* (Baltimore: The Johns Hopkins University Press, 2000), p. 67.

46. The Polaroid was copied fifty-one times

on a Polaroid copying machine.

47. Barlow, *Mary Lucier*, pp. 4–5.

48. The actions performed in relation to the film by Jonas and two other performers are only part of a series of actions too numerous to detail here. For a complete description and notation of the performance, see *Joan Jonas, Scripts and Descriptions 1968–1982*, exh. cat. (Berkeley: University Art Museum, University of California; Eindhoven: Stedelijk Van Abbemuseum, 1983), pp. 70–78.

49. The Maya Deren screening at Anthology Film Archives that Jonas cites as the inspiration for the ephemeral blackboard drawings in *Mirage* was a rare experience. The raw footage she saw was edited shortly afterward into a posthumous film, in which the repetitions of the raw footage of the sand drawings were lost. *Mirage* was also influenced by Jonas' first visit to India, and by the Melukean Book of the Dead, as she states in the Electronic Arts Intermix website text for *Mirage* (www.eai.org). For Jonas, *Mirage* marked a shift away from her concern with feminine identity to a larger theme of transformation, seen in her account of the New Guinea rite, in which she implictly casts herself as the "devouring witch."

50. In contrast to the videotape *Vertical Roll* (1972), in which Jonas performed live in relation to the movement of the vertical hold, in *Mirage* her actions bear no direct relationship to the hold.

51. Pamela M. Lee, "Some Kinds of Duration: The Temporality of Drawing as Process Art," in *Afterimage: Drawing Through Process*, exh. cat. (Los Angeles: The Museum of Contemporary Art, 1999), pp. 25–48, esp. p. 32.

52. Joseph Beuys presented elements from the performance *I Like America and America Likes Me* (1974) as an installation at the Ronald Feldman Gallery, New York, in 1979, adding further elements that he felt communicated the performance's symbolic meaning. For the exhibition "Out of Actions: Between Performance and the Object, 1949–1979," at The Museum of Contemporary Art, Los Angeles, in 1997, Marina Abramović reconstructed the table of objects she had originally provided for the audience in her performance *Rhythm O* (1974). Carolee Schneemann's performance *Up to and Including Her Limits* (1975) was re-presented as an installation consisting of the original drawings on paper and a film of her performing the work at its original location. See Miwon Kwon, "One Place After Another: Notes on Site-Specificity," *October*, no. 80 (Spring 1997), pp. 85–110.

53. *May Windows* and *Good Night, Good Morning* both document the passing of time in a conceptual structure that evokes the postcards of On Kawara. *May Windows* records the changing light on the window of Jonas' loft at different times of day, while *Good Night, Good Morning* records her greeting the camera at the beginning and end of each day over a period of time in New York and Nova Scotia.

54. See Kathy O'Dell, "Performance, Video, and Trouble in the Home," in Doug Hall and Sally Jo Fifer, eds., *Illuminating Video: An Essential Guide to Video Art* (New York: Aperture, 1985), pp. 135–51. Discussing the role played by the alternative space during this period, O'Dell argues that the contexts of these spaces, and of artists' lofts, differed from those of commercial galleries and museums and were more conducive to the work being made. "Gallery" is used here as a generic term.

55. For a fuller discussion of Barry Le Va's performance and the issue of process and the gallery space, see Carter Ratcliff, *Out of the Box: The Reinvention of Art 1965–1975* (New York: Allworth Press, 2000), pp. x–xi.

56. Thomas McEvilley, "The Rightness of Wrongness: Modernism and Its Alter-Ego in the Work of Dennis Oppenheim," in *Dennis Oppenheim*, exh. cat. (Long Island City, New York: The Institute for Contemporary Art, P.S. 1 Museum, 1992), p. 21.

57. Oppenheim, in conversation with the author, New York, December 1, 2000, commented that he felt he had not shed his feelings for the theoretical, which he had absorbed from Minimalism, and that Minimalism was an important influence on his early thinking. Many of the points made in this discussion of *Echo* are taken from a conversation in which Oppenheim discussed the ideas behind *Echo* at length. I am grateful to the artist for his generosity in sharing this information.

58. For a detailed discussion of the relationship between art and violence during the 1960s, see Maurice Berger, "Forms of Violence, Neo-Dada Performance," in *Neo-Dada, Redefining Art 1950–1962*, exh. cat. (New York: American Federation of Arts, 1994), pp. 67–83.

59. A notable exception includes Mary Lucier's *Polaroid Image Series #1*. In addition, Jonas' performance *Mirage* involved the reading out loud of fairy tales and short statements, and *Good Night, Good Morning* is a rare example of the use of language in her early videotapes; these tapes are almost all silent except for the ambient sounds of the

space in which they were recorded or abstract sounds such as the banging together of wooden blocks in *Vertical Roll*. Oppenheim made several monitor-based video installations that included spoken dialogue. Most of Nam June Paik's video installations involved a Fluxus-based use of experimental sound and sounds collaged from popular music and the media, but language was not a major element. Where language appears in video during this period, it is almost always in monitor-based works.

60. For a detailed discussion of Hill's work and the role of language in his videotapes and installations, see the important group of essays and writings by Hill in Robert C. Morgan, ed., *Gary Hill* (Baltimore: PAJ Books and The Johns Hopkins University Press, 2000).

61. Kate Linker, *Vito Acconci* (New York: Rizzoli, 1994), p. 64.

62. Ibid., p. 52

63. Vito Acconci, unpublished notes from the proposal submitted to The Museum of Modern Art, New York, for the making of the installation, 1974.

64. Linker, *Vito Acconci*, p. 72.

65. Acconci, unpublished notes.

66. Linker, *Vito Acconci*, p. 72.

67. Walter Benjamin, "The Work of Art in the Age of Mechanical Reproduction," in Robert S. Nelson and Richard Shiff, eds., *Critical Terms for Art History* (Chicago: University of Chicago Press, 1996), p. 331.

68. George Kubler, "The Shape of Time," in Pamela M. Lee, "Some Kinds of Duration," p. 35.

69. Marshall McLuhan's arguments are expounded in Eric McLuhan and Frank Szingrone, eds., *Essential McLuhan* (London: Routledge, 1997).

70. For a detailed discussion of Ono's works in various media, see *Yes: Yoko Ono* (New York: Japan Society, 2000), which includes a chapter by the present author on Ono's films and *Sky TV*. See also the author's catalogue text on Ono's work in *Have You Seen the Horizon Lately?* exh. cat. (Oxford: Museum of Modern Art, 1997), which discusses transparency and temporality in Ono's work.

71. George Quasha and Charles Stein, "Liminal Performance: Gary Hill in Dialogue," in Morgan, *Gary Hill*, p. 246.

72. Ibid.

73. Robert Pincus-Witten, "Keith Sonnier: Video and Film as Colorfield," *Artforum*, 10 (May 1972), pp. 35–37.

74. Bruce Kurtz, "Video Is Being Invented," *Arts Magazine*, 47 (December–January 1973), pp. 37–44.

75. Marshall McLuhan and Quentin Fiore, *The Medium Is the Massage: An Inventory of Effects* (London: Penguin Books, 1967), p. 125.

76. The interest in technology was epitomized in the "Art and Technology" project organized by Maurice Tuchman for the Los Angeles County Museum of Art. Tuchman commissioned projects using technology to be presented in the American Pavilion for Expo '70, Osaka, by a diverse group of artists, including Whitman, Rauschenberg, Morris, John Chamberlain, Robert Irwin, Oldenburg, Dan Flavin, and Andy Warhol. For Osaka, Warhol created an environmentally scaled work consisting of walls of large-scale printed flowers, which the spectator viewed through cascading sheets of water. Warhol's *Art and Technology* project evokes Whitman's shower piece, in which the image is projected through water.

77. See Foster, *The Return of the Real*, p. 66.

78. As Callie Angell explains, this is the second in a trilogy of Warhol films made in 1965–66 dealing with famous Hollywood scandals. The other two films are *More Milk Yvette* (1965), pastiching the life of Lana Turner, and *Hedy* (1966), inspired by the tragic life of Hedy Lamarr. Callie Angell, *The Films of Andy Warhol: Part II*, exh. cat. (New York: Whitney Museum of American Art, 1994), pp. 24–25.

79. Foster, *The Return of the Real*, p. 132. Foster's complex argument includes a Lacanian reading of repetition, trauma, and the real and develops this simple point much further.

80. Sol LeWitt, "Sentences on Conceptual Art," *Art-Language*, 1 (May 1969), pp. 11–13, reprinted in Gary Garrels, ed., *Sol LeWitt: A Retrospective*, exh. cat. (San Francisco: San Francisco Museum of Modern Art, 2000), p. 371.

81. Robert Morris, "Notes on Sculpture, Part IV," *Artforum*, 7 (April 1969), pp. 50–54, reprinted in Charles Harrison and Paul Wood, eds., *Art in Theory 1900–1990: An Anthology of Changing Ideas* (Oxford: Blackwell Publishers, 1992), pp. 868–73.

82. Yvonne Rainer, "Don't Give the Game Away," *Arts Magazine*, 41 (April 1967), p. 46.

83. Quasha and Stein, "Liminal Performance," p. 149.

Elements of the
interface: the screen
and the sound system

Projection and Dis/embodiment: Genealogies of the Virtual

THOMAS ZUMMER

"Now I address a matter of great import
For our inquiries, and I show that there
Exist what we call images of things,
Which as it were peeled off from the surfaces
Of objects, fly this way and that through the air;
These same, encountering us in wakeful hours,
Terrify our minds, and also in sleep, as when
We see strange shapes and phantoms of the dead
Which often as in slumber sunk we lay
Have roused us in horror; lest perchance we think
That spirits escape from Acheron, or ghosts
Flit among the living, or that after death
Something of us remains when once the body
And mind alike together have been destroyed,
And each to its primal atoms has dissolved. . . .

I say therefore that likenesses or thin shapes
Are sent out from the surfaces of things
Which we must call as it were their films or bark
Because the image bears the look and shape
Of the body from which it came, as it floats in the air."
—T. Lucretius Carus, *De rerum natura*[1]

It is as if Lucretius were describing a dream, one that coincides, upon waking, with the world; a speculative dream through which resonance one reimagines the world, so that we may act as if we are still dreaming, bringing the world into a dream. It is an apt description of the cinema, for a similar oneiric disposition is embedded in its history and its practices, so that one may well consider the cinema a waking dream, one that continues to haunt or possess us, even as we might possess and consume it. Jacques Derrida, in "La danse des fantômes," reminds us of the long history of spectrality inhabiting this medium: "When the very *first* perception of an image is linked to a structure of reproduction, then we are dealing with the realm of phantoms."[2]

Imagining *Things*

Inasmuch as it shares certain characteristics with the dream, cinema engages us in the image of the world,[3] and we react almost as if what is represented resides before us. Our hearts may race, our breath becomes rapid and shallow, hair standing on end, uncontrollable spasms of laughter, all in response to the play of shadows and light. Optical devices, says Gaston Bachelard, provide us images to dream with, and cinema's flickering sensibilia constitute perhaps the most replete and consuming instance of an interface for dreaming. Still, we are less unwitting spectators than willing collaborators in this "artificial dream," and we have retained and refined the capacity to pinch ourselves awake. It is this, our ability to invest in the phantasy of projections—somatically, sensorially, conceptually—in conjunction with our commensurate ability to apprehend and partake in them at the same time as spectacle, that forms the contours of a complex prosthetic relation between sense, memory, and technical mediations. Technologies and bodies commingle in this configuration, and there exist substrates, underlying material conditions of reproduction and perception common to all projective phenomena, even to our apprehension of shadows cast on the wall of a cave, even to dreams. Certain of these substrates, in the form of (cinematic) tropes having to do with pretense and recognition, the passage of time, and the presence and absence of phenomena, persist throughout the history of recording media, residing in unconscious memory. They are the active, potential, and mutable preconditions of mediated experience, the *habitus* through which we form a primary interface with technological reproductions of the real.

> "Our organs are no longer instruments; on the contrary, our instruments are detachable organs. Space is no longer what it was in the *Dioptric*, a network of relations between objects such as would be seen by a witness to my vision or by a geometer looking over it and reconstructing it from outside. It is, rather, a space reckoned starting from me as the zero point or degree zero of spatiality. I do not see it according to its exterior envelope; I live it from the inside; I am immersed in it. After all, the world is around me, not in front of me."
> —Maurice Merleau-Ponty, "Eye and Mind"[4]

There are certain preconceptions involved in the linking of the body to a register of instrumentation. These are, to use a phenomenological model, the inevitable "pre-understandings" of the world via the *forms* in which experience is given. The body's senses do not encounter the world except in a culturally prepared subject (ourselves). Sensory phenomena are interpreted by analogy or metaphor in relation to our own somatic memory: a microscopic view of the body is described as a "landscape," individual hairs are like "the trunks of giant trees," atoms are modeled as "miniature solar systems," and molecules are constructed in tinker-toy fashion. Such descriptions situate things in relation to the subjective and collective lived experience of the body's contact with the world. Strange microscopic things may appear charged with meaningful associations deriving from sensations of bodily proximity and familiarity, modified by conventional ways of reading, as we, inscribing ourselves into a relationship with things that are almost familiar, take possession of the image. In much the same way, notions of inference and continuity, succession and consequence derive from the body's physical/cognitive disposition in the everyday environment. We do not encounter the world *except* as already embodied and culturally

embedded. Moreover, the body's perception of itself also constitutes a *psychic substrate*, and the unconscious somatic memory that organizes lived experience is, itself, modified by specific technologies. These form still other, *technical*, *substrates* of unconscious memory. Optical devices, for instance, alter the experienced scale of an observer's body, while at the same time changing the apparent *place* of that transformation, affecting our ideas of spatiality and temporality, causing us to perceive things as closer, or larger, or more similar, in relation to our own perceived bodies. Perception, linked to technological instruments, stubbornly apprehends different phenomena according to the most familiar tropes, habitual conventions of pictorial representation, and fundamental intuitions of the body.

The history of scientific experimentation provides us with a number of examples of the relations between instruments and the imagination. Galileo, for instance, considered the human eye as an optical instrument, although he considered it to be far from ideal. He recognized that the eye is not an immediate source of information about nature, but that one's conception of the physical world is dependent on the means—instruments—used to study it. At the same time, he also had to persuade his contemporaries that the information provided by his telescope was not a distortion, and that the depictions of phenomena produced by his apparatus were not artificial aberrations, but natural extensions of the body's senses into the world via instruments. Such supplements to vision as telescopes, microscopes, and photographic apparatuses are organized according to tacit conceptions wherein somatic inscriptions—of the body's sensorium into instruments, and of prosthetic perceptions into the body—become naturalized.

"Machines for seeing modify perception."
—Paul Virilio[5]

It is clear that there is an unavoidable perceptual bias in our relation to the instruments we devise. For example, our senses register stimuli in logarithmic, not linear, increments, so that the systems and tools we employ—the acoustic decibel scale, the seismic scale for measuring earthquake severity, the magnitude scale for stellar brightness—are also logarithmic, in part because they reflect our propensity to perceive the world in that way. Other scales and types of detectors may increase the range of human senses—into the infrared register, for example—but they also translate data back into familiar forms and intuitions. The difference between the optics of the eye and of the camera is both marked *and* subsumed as it is naturalized. "The camera," Walter Benjamin writes, "introduces us to unconscious optics as does psychoanalysis to unconscious impulses."[6] The substrates of unconscious memory, technical or somatic, support an economy of translations between perceptions and instruments, such that "prosthetic" perceptions occupy the same cognitive space as bodily sensations.

There are memoirs and personal accounts in the development of the electron microscope in the mid-twentieth century that sound eerily close to phenomenological descriptions of embodiment. For these scientists the microscope became, within limits, an extension of the operator in his or her interactions with the minuscule. The microscope became a prosthetic sense-organ, and microscopists were among the earliest cyborgs. And, since almost all of the U.S. electron microscopists in the 1940s and 1950s used the same instruments,[7] there was a remarkable uniformity in their tacit and intimate understandings of their craft. This in turn must

have contributed greatly to the subsequent cohesiveness, even in popular magazine depictions, of their accounts of research into the realms of the unseen. It is an interesting problematic: with optical microscopes resolution is limited by the wavelength of light. Electron microscopes employ a beam of electrons, operating well below the wavelengths of visible light, to form an image of very small objects. In these devices high-energy electrons associated with considerably shorter wavelengths allow far greater resolution. The transmission electron microscope uses a sharply focused electron beam passing through a metallized specimen onto a fluorescent screen, where a visual image—which can be photographed—is formed. The scanning electron microscope forms a perspectival image, although both magnification and resolution are considerably lower. In this type of instrument, a beam of electrons scans a specimen, and those electrons that are reflected (along with any secondary electrons emitted) are collected. This current is then used to modulate a second electron beam in a television monitor, which scans the screen at the same frequency, thereby building up a picture of the specimen.

Electron microscopists, like the general populace, experienced themselves "transported by this instrument to an alien landscape,"[8] and the habitual conventions of reading "landscapes" came into play in the representation of these invisible topographies by invoking and communicating common bodily experiences and pictorial conventions. The interface of operator/machine/phenomena is modified—tuned—by both physical limitation and cultural presupposition. The intuitive perception of the resulting micrographs as everyday landscapes is further supported by the fact that in order to be reflective, specimens were coated with a thin layer of metal atoms by spraying them from a low angle. Microscopists use the length of the resulting "shadow" (formed where a feature has blocked metal deposition onto the surrounding support) to determine the "height" of that feature, thus casting the electron beam's "illumination" at "noon," rather than from the actual direction of metal deposition. In this way the micrograph is constructed in such a familiar manner that it does not intrude on one's intuitive perception of the image as a "landscape."[9] In the process of refining the scientific apparatus, the observer's lived experience takes up residence in—is *sutured* into—the machine, such that one "dwells" in the instrument, in a continuum of decreasing consciousness and increasing familiarity, consequently moving from alterity to embodiment.[10]

Cinema, one might say, is just such a lived technology. In the interface of architecture, technology, perception, and habit, we spectators are intimately inscribed into the mediated imaginary, taking up residence—for a moment—within a phantasmatic technology. Here we are an element of the dream, linked to a specular machinery where unconscious behavior, modifying and modified by the instrument, interactively constructs our experience. In the long history of projective environments—from Ibn al-Haytham to Leonardo da Vinci, Athanasius Kircher to E.G. Robertson, Thomas Edison and the Lumière brothers to today's cineplexes, home entertainment systems, and virtual realities—the body persists as a common and inextricable component of the apparatus, and familiar everyday perceptions are linked to a history of cinematic artifacts and behaviors in diverse, complex ways, so much so that even our recognition of their artifice is a culturally mediated form.

> ". . . if there is neither machine nor text without psychical origin, there is no domain of the psychic without text."
> —Jacques Derrida, "Freud and the Scene of Writing"[11]

Nor, one might add to complete the symmetry, without *machine*.[12] Derrida's implication of the relationship between unconscious memory and historically specific machine-metaphors reproblematizes issues of subjectivity and spectatorship relative to questions of ontology, technical reproduction, and virtuality. If unconscious memory is coextensive with, and inextricable from, the various "technical substrates" given to it with historically specific technologies, then a complex series of problems concerning specularity, interactivity, and mediation are rendered salient, and psychoanalysis and critical theories acquire another set of tasks. That certain of these technical substrates are more closely aligned with, and even derive from, projective environments such as cinema, television, computers, telecommunications systems, and the Internet is an issue to be seriously considered in any analysis of contemporary media. What might the role of such psychic/technical substrates be within a more singular, reflexive, and critical model of media, such as was articulated in certain projective/interactive installations of the early 1970s? While these works were enormously important and influential, they were also transient, localized, and somewhat marginal to the generalized interior technical unconscious of popular media. Yet at the same time they were permeated by it, and a good deal of their critical impetus was directed toward a tacit "auto-deconstruction" of the canonical discourses/categories of objects and subjects, references, representations, and institutions. These early seminal works dissolved traditional boundaries of territory and the body, transforming architectures into relays, passive reception into active engagement, data into interaction and connectivity, in a diffused topology that laid the initial traces of today's digital mediascape. It might be useful to examine some of the possible sites/origins of this transformation and to look at some of the cinematic substrates of unconscious memory that still continue to suffuse, constrain, and shape the contours of our perception and apprehension.[13]

"...only a movie"

> "Those optical metaphors through which the gaze manifests itself most emphatically at a given moment of time will always be those which are most technologically, psychically, discursively, economically, politically and culturally overdetermined and specified. However . . . each of those metaphors will also articulate the field of visual relations according to the representational logic of a specific apparatus."
> —Kaja Silverman, "What Is a Camera? or, History in the Field of Vision"[14]

What happens when we go to the movies? There is a tacit engagement with all of the elements of cinematic technology, its architectures, its history, its articulations of subjectivity, our own body's directed perception and history of apprehension. The physical space, ambient light, projection apparatus, and bodily disposition together already constitute an *interface*. We don't have to learn a new grammar every time we go to the movies. We interact with the one that is already there, pretty much the same one that pervades subsequent media. "The meaning of a camera," Silverman notes, is "both extrinsic and intrinsic," a consequence of its placement within a larger social and historical field and of a particular representational logic, a logic already inscribed—as an oedipal logic of narrativity, for example—in "spectatorship."[15] In the movies, the difference between oneself and a projected "character" with which one identifies or interacts does not hinder the fantasy of involvement. Rather, it is

naturalized. While we may never entirely forget this difference, it continues to circulate as an element of what one might call a technological unconscious, so that, under certain circumstances, our relation to these shadows as shadows is recuperable, not by opposing what is present to its representation (or to its referent), or by opposing effect to simulation, but in the recognition of the temporal *aporia* by which these categories are *already* spectral, as when we suddenly recover ourselves in that startling moment when the phantasmatic is no longer sustainable, or it simply ends.[16] And even though it might come back to haunt our memory, and we may not be entirely free of it, still we pinch ourselves into the recollection that, for all this, *it is only a movie*. The space of the dream, of technical reproducibility, and of lived experience coincide as both coextensive and permeable, and we inhabit them all.[17] What we are, when we walk into a movie or turn on a television, is already virtual.

Installation as Interface

In many installation works of the late 1960s and early 1970s, the architecture of projective environments enters into an ongoing critical discourse on the nature of the museum, the archive, the institution, and of the art work itself. Installations, which became a territorialization of the museum space, were simultaneously an inquiry into the ontological and cultural status of art production, interpretation, and works. This territorialization took many diverse forms: simulation, critique, appropriation, dematerialization/deconstruction, tactics of direct address, performative display, or interaction. Some works tacitly reproduced the museum's architecture as their own, or co-opted it, or some aspect of it; some effected an insular relation to the exhibition space; some contaminated it; some presumed it to reside solely within the purview of an audience; some blurred the distinctions between public and private. In each there are specific protocols and types of interactions that the works produce, critique, or require of a viewer, and many of these works depend on—or tamper with—established and unconscious traditions of (cinematic) spectatorship. Moreover, many of these works came about in close proximity to the interrogations of the art object that took place within the framework of Minimalism and Conceptualism, and in relation to discourses on technology and the avant-garde being addressed in the art world at that time. While there was often an uneasy or problematic relation between theoretical, political, aesthetic, and phenomenological approaches to the making of artifacts, there were also marked affinities. Reflection on the material conditions of the basic projective apparatus formed a fertile ground for the development of an important body of works where crucial questions—of a semiotics of media, theories of subjection and resistance, technical reproducibility, communications infrastructures, simulation, truth, mediation, and aesthetics—were shaped and exposed in novel ways. Media installations formed a permeable membrane, a demarcation between species of projective and interactive technologies, circumscribing technology and perception, and constituting a mediating instance between the architectures of the museum, gallery, movie theater, and public concourse, with their respective histories, desires, and dreams. They are, in short, an *interface*.[18]

What I would like to suggest is that many of the projective/interactive installations that developed during the period operated as a reflexive critique of certain institutions—the museum, galleries, cinema, television—and certain models of subjectivity in relation to contemporary philosophical and critical concerns (one might

even say "anxieties"). These works/spaces performed an important series of translations between the somewhat circumscribed and insular context of the art world and a global field of increasing mediation. Installations were reterritorialized spaces, simulating, co-opting, or contaminating the museum or theater, tampering with private spaces and public places, in order to confront or destabilize conventional positionings of art and its audience. They were reflexive interrogations of the status of all sorts of objects, subjects, materials, language, and cognition, and the discourses and institutions that authorized and guaranteed forms of perception and interpretation. One irreducible "hinge" on which these works turned was the *body*, and its disposition as both subject and object made of it, too, a form of *interface*.

> "A surface lying between two portions of matter or space, and forming their common boundary."
> —*Oxford English Dictionary*, p. 1462

The *OED* dispatches this definition of *interface* with uncharacteristic brevity. Perhaps it is because the term, which came into English usage in the early 1880s, is one of unparalleled ambiguity, apt to be employed as a verb, adjective, or noun, in a remarkable array of circumstances, with an equally diverse range of often conflicting connotations. The most common notion of an *interface* is as the visual representation, on a computer's screen, of its operating system and applications, with the secondary connotation that it is by way of the interface that human users interact with the computer. To this we might add that the term has come to bear certain abstract or conceptual connotations as well. And, since the interface is a surface—physical and/or conceptual—where two or more (biological and technological) entities meet, the term has also acquired a general sense in which it connotes a connection, hierarchy, or relationship of some sort, between or among diverse, heterogenous elements.[19] In this general sense all of the elements of a projective environment—ourselves included—constitute an interface, a common boundary within which sense and reflex, simulation and cognition, history and psyche interact. In the same way that all of the elements—architectural, biological, technological—of cinema, with its histories and practices, constitute an always accessible interface for viewers/users, the critical turn in projective/interactive exhibitions in the 1970s tacitly used many of those same preconditions to make new, reflective and self-referential interfaces through which to extend our critical awareness of the growing mediascape.

The organizing tropes in certain early installation works, especially those substrates grounded in our own historical relation to media, affect how we interact with new species of media, whether commercial, documentary, aesthetic, or experimental. Some of these preconceptions appear as tropes having to do with pretense and recognition, presence and absence, address and deferral of the body. They are tropes that persist throughout the history of recording media, modifying, interacting, and circulating in the culture at large. An interest in the basic preconditions and presuppositions of our engagement with media surfaced in a complex network of addresses and transmissions through which these early projective/interactive works grounded themselves in relation to art, discourse, performance, and public culture. The critical appearance of a kind of reflexive "auto-deconstruction" of media marked these works as different from commercial media forms, as well as from theatrical explorations, Happenings, collage, or kinetic works. Each installation/

projective environment offers a different interface where spectators engage as active/passive operators within a complex, permeable architecture. But these environments are not closed and insular, neither purely analytic, nor aesthetic, nor merely idiosyncratic. They present a variable and plural field for reflexive critical speculations on the nature of technical reproducibility, and on the nature and history of our own deep and subtle relation to images.

By the late 1960s, the notion of (mass) media, as it was theorized in relation to popular cinema and television, was giving way to the recognition of a much more intricate and pervasive field of mediations. Technologies for communicating and storing data had undergone a fundamental shift since the turn of the century. With advances in photography, the introduction of telegraphy, telephony, phonography, cinematography, and television, questions of referentiality and perception were being radically recast. With the development of computers, scientific simulations, and digital coding, information that had hitherto existed as separate modes of communication, in separate fields or channels, could be translated and fused into a common—digital—data-stream. With these emergent technologies, physical effects could be recorded, stored, reproduced, and mixed.[20] Projective installations were hybrid technologies, early multimedias, systems of objects and operators, which had begun to explore the extensions of media in an art world context. But at the same time there was an anxiety about things and images in the world, and about the accounts of things and images. Pictures of technological genocide, fear of the Bomb, global surveillance throughout the Cold War, the constant mediated deployments of capital influenced or generated philosophical and ethical discourses about alienation and authenticity, existence and phenomena, structure and deconstruction. There were interesting complicities between phenomenological analyses and Minimalism; Structuralism was oddly mirrored in Conceptual art; Critical Theory operated in the fissures between cultural institutions and aesthetic practices. Reflection on modes of artistic practice entered into critical and theoretical debate in a variety of ways, as praxis, but also as discourse, and as heterogenous admixtures of both. The hitherto discrete boundaries of thinking, acting, techné, and artifact dissolved, as artist and author, spectator and subject—bodies and all—were cast into a dissimulating abyss of mediations.[21]

The development of early projective and interactive spaces coincides with the self-referential inquiries into the nature and status of art objects and critical interrogations of the institutions that authorized and guaranteed forms of perception and interpretation. Questions of materiality, subjectivity, politics, and language formed the terrain, and much of the raw material, for these activities. Installations operated as reterritorialized spaces, simulating, co-opting, or contaminating the museum or the theater, reinventing private spaces or public places, in order to tamper with, question, or problematize conventional interactions between cultural producers, institutions, and consumers. Many projective environments had a critical, deconstructive dimension, reflecting on themselves as media, turning upon their own favored subjects, material conditions, or historical precedents. In this sense, projective environments formed a critical *interface*—a surface of contact and modification—between artists, institutions, spectators, and media technologies. There were also many commercial media environments at the time, such as light shows, or the pyrotechnic stagecraft of the rock music industry, foregrounding and promoting bands and music with all sorts of media closely integrated into multiple distribution systems. Andy Warhol's quasicommercial *Exploding Plastic Inevitable* is

an interesting sort of projective/interactive event in this respect, demarcating a transformation of unconscious presuppositions into intentional appropriation. Works that operated within or upon the space of the museum or gallery dissolved traditional boundaries of technology and discourse, bodies and architectures, puncturing the exhibition site, insinuating themselves into cultural institutions as another kind of interface, another semipermeable membrane between our engagements with naturalized (popular) media, and aesthetic/cultural discourses. These works *deconstructed*—de-structured—the relation of lived bodily experience to the habitual accommodations and presuppositions of media, rendering our comfortable, unconscious consumption of mediated pleasures, and the technologies that produce such specular pleasures, a site for critical, theoretical, ethical, and physical interrogation and confrontation.

> "Deconstruction interrupts, throws out of gear, the derivations between first philosophy and practical philosophy."
> —Reiner Schürmann, *Le principe d'anarchie* [22]

This is a very useful description of deconstruction. What is meant here by first philosophy is an ontology, that which provides a foundational or legitimating discipline in relation to the corpus or system of specialized disciplines. A foundation, or *principle*, is something held to be self-evident, inviolable, absolute, and true, so that a series of practices, institutions, legislations, or concrete acts may be grounded in it and derive their legitimacy from it. Here is an example: under the basic principle that human beings are *un*equal, and therefore do not have equal rights, a whole series of laws, oppressions, practices, and institutions were founded and organized under the name apartheid. Deconstruction, by tampering with the political derivations of this principle, reveals that the principle of racial inequality is not at all absolute, true, or beyond question, but rather that its practices came about within precise and discrete historical processes, served specific interests, and therefore cannot rest on absolute and inviolable true principles, but must *fall* under critical and ethical scrutiny. Our relationship to media technologies rests on a similar sort of grounding; and the legitimation, and its exercise, interpretation, or consumption, rests on tacit, unconscious preconceptions. Early projective/interactive works, presented within a museum context, began an important process of "auto-deconstruction" of the legitimations of technology, within ourselves and in our relation to subsequent media. The ongoing debates in contemporary discussions of media theory, Net-subjectivities, virtuality, connectivity, and globalization had a concrete origin in the media environments, performances, and discourses shaped in the 1960s and 1970s.

Our involvement with media has a complex and concrete history, and the specific technological and psychic substrates through which we integrate our bodies and cognitions into a prosthetic machinery of desire constitute a ready interface. In early projective/interactive installations, the breakdown of the tacit interface of cinema— of its specific architecture of machinery and light, of our posture and disposition as we sit, facing forward in the dark, attentive to a screen of projected images— forced a recognition of our complicities as passive spectators actively engaged in the construction of a sensory space where our investments of fantasy, belief, and desire take place in spectacle. These dispositions of the spectator are inscribed into projective environments, so that even at its most (inter)active an *audience* is always

generalized and potential, and an always replaceable conditional element of the cinematic apparatus. The audience is already *virtual*, even—especially—when the forms of address and persuasion that operate within media address us as if we are *there*, always, already the subject of interaction.

Fiction and illusion, presence and absence, staged or real, the flatness or spatiality of projective environments, pretense, repression, desire, notions of permanence and the ethereal, somatic reflex, desire, originary event/technical reproducibility: these are tropes common to all visual/aural recording devices. The recognition and interpretation of these tropes became increasingly important for the reflexive deconstruction of the cinematic apparatus/architecture that was to take place within the public sphere of the museum, gallery, theater, and cinema in the late 1960s and 1970s. Referencing cinema and media, or at least some of its unconscious armatures, these projective/interactive environments brought certain conditions of media into strong relief and introduced a critique of some of the principles by which we still figure ourselves within contemporary digital media.

Again and again, the promissory structure of a Deleuzian "pure repetition," occluded by its own constant iterations, punctuates the spaces of media, modeling the play between phenomenal and epiphenomenal that structures the work.[23] The idea of deictic extension—of the body into space, over time, into other spaces, over generations—and deferral of the body has been a constant variable in media. In the resulting *méconaissance*, the body is seen arrested for a moment, everything is uncovered, *mise-en-scène* shifts into *mise-en-abîme* and we aren't even ourselves anymore.[24] Somehow we have again become the performers, in real time, of a telecommunication oppositional to its myth of the past, to delay, and to the actuality of the present, an "optical switching of the *real* and the *figurative* that refers back to the observer physically present here and now, sole persistence of an illusion in which the body of the witness becomes the unique element of stability in a virtualized environment."[25]

Notes

1. This translation is from Lucretius, *On the Nature of the Universe: A New Verse Translation by Sir Ronald Melville* (Oxford: The Clarendon Press, 1997), pp. 102–03, lines 28–52.

2. Jacques Derrida with Mark Lewis and Andrew Payne, "La danse des fantômes: Entrevue avec Jacques Derrida"/"Ghost Dance: An Interview with Jacques Derrida," in *Public 2: The Lunatic of One Idea* (1989), p. 61.

3. See Martin Heidegger, "The Age of the World Picture," in *The Question Concerning Technology and Other Essays*, trans. William Lovitt (New York: Harper and Row, 1977).

4. Maurice Merleau-Ponty, "Eye and Mind," in Merleau-Ponty, *The Primacy of Perception, and Other Essays on Phenomenological Psychology, the Philosophy of Art, History, and Politics*, ed. James M. Edie (Chicago: Northwestern University Press, 1964), p. 178. The *Dioptric* is a treatise written by René Descartes in 1637, presenting his scientific findings and speculations on optics, the senses, and related matters. It is preceded by the *Discourse on Method*. See René Descartes, *Discours de la méthode, plus la dioptrique, les météores et la géometrie*, ed. Jean-Robert Armogathe and Vincent Carraud (Paris: Librairie Arthème Fayard/Corpus des oeuvres de philosophie en langue française, 1986).

5. Paul Virilio, conversation with the author. See idem, *War and Cinema: The Logistics of Perception*, trans. Patrick Camiller (London: Verso Books, 1989).

6. Walter Benjamin, "The Work of Art in the Age of Mechanical Reproduction," in Benjamin, *Illuminations: Essays and Reflections*, ed. and introd. Hannah Arendt, trans. Harry Zohn (New York: Harcourt, Brace and World, 1968), p. 239.

7. See Nicolas Rasmussen, *Picture Control: The Electron Microscope and the Transformation of Biology in America, 1940–1960* (Stanford, California: Stanford University Press, 1997). For a brilliant and sustained exploration of the place of the body as both a mode and an object of perception, see Susan Stewart, *On Longing: Narratives of the Miniature, the Gigantic, the Souvenir, the Collection* (Baltimore: The Johns Hopkins University Press, 1984).

8. Rasmussen, *Picture Control*, p. 232.

9. Ibid.

10. These early microscopists were apparently not unfamiliar with the European phenomenological tradition, and the notion of "dwelling" here may be given a distinctly Heideggerian inflection. The continuum of decreasing consciousness to greater familiarity maps a certain form of amnesia coextensive with technical artifacts. One treats an interface, network, or circuit as if it is the thing one is directly manipulating; and patterns of connectivity, habit, and artifice fade into the background. From turning out a light to playing the latest video game, there is a metaleptic conflation of interface and event in our perceptual horizon.

11. Jacques Derrida, "Freud and the Scene of Writing," in Derrida, *Writing and Difference*, trans. Alan Bass (Chicago: University of Chicago Press, 1978), p. 199.

12. See Sigmund Freud, "Note on the Mystic Writing-Pad" (1925), in *The Standard Edition of the Complete Psychological Works of Sigmund Freud*, vol. 19, trans. James Strachey (London: The Hogarth Press and Institute of Psycho-Analysis, 1959). One might paraphrase Derrida and ask: what must the psyche be, if it can be represented by a machine? Freud's initial appreciation and ultimate dissatisfaction with the *Wunderblock* as a concrete metaphor for the unconscious is a well-known matter of record. Derrida notes Freud's initial interest in an "optical machine" (camera) before employing the *Wunderblok* as a metaphor for the unconscious. Derrida's ruminations about other forms of archival machinery as a potentially more appropriate metaphor is taken up in *Archive Fever* (Chicago: University of Chicago Press, 1996). See also Patricia Ticineto Clough, *Autoaffection: Unconscious Thought in the Age of Teletechnology* (Minneapolis: University of Minnesota Press, 2000), for a superb and thorough discussion of "technical substrates." Clough similarly suggests that "it is hard not to think that television is a writing machine with a picture."

13. In the original long version of this essay, there is an extensive analysis and discussion of the tropes, tactics, and technics of the projective/interactive environments in this exhibition. A series of multiple trajectories, relative to the notion of the projective environment as a variable and interactive sur/face—inter/face—are traced through the works of Robert Whitman, Bruce Nauman, Dennis Oppenheim, Anthony McCall, Dan Graham, Peter Campus, Andy Warhol, Michael Snow, Yoko Ono, William Anastasi, Vito Acconci, Joan Jonas, Robert Morris, Simone Forti, Beryl Korot, Mary Lucier, Paul Sharits, and Keith Sonnier. And the relation of contemporary artists from both media and art world contexts, such as Harun

Farocki, Jürgen Reble, Martin Arnold, Gary Hill, Bill Viola, Judith Barry, Chantal Akerman, Leslie Thornton, and Trinh T. Minh-ha, to these earlier works is examined in detail.

14. See Kaja Silverman, "What Is a Camera? or, History in the Field of Vision," *Discourse*, 15 (1993), pp. 11–12.

15. Ibid.

16. In 1895, when Auguste and Louis Lumière presented their new Cinématographe in the basement of the Grand Café at 14, boulevard des Capucines, there was a film of a train speeding directly toward the audience, which caused a great panic and wholesale flight from the theater. This widely cited event is one of cinema's most enduring foundational myths, a sort of primal scene, through which the symptomatology of fantasy became inextricably linked to a modern machinery of desire. In all likelihood, it never happened. Parisians of a certain class and stature, who would have made up the audience for the Cinématographe at the turn of the century, were familiar with all sorts of technical imaging devices—magic lantern shows, the panorama, zoetropes, praxinoscopes, thaumatropes, phenakistascopes—and such spectacles as "animated photographs" would not have been shocking at all.

Another early Lumière film, *Démolition d'un mur (Demolition of a Wall)*, was repeatedly shown backward and forward, the constant fascination of a wall tumbling down, and then casting itself back in place, unimpeded by the acknowledgment that "it is only a movie." Here it was the display of the apparatus itself that constituted the spectacle, and the film's ostensible content, an ordinary, everyday event transformed by its passage through this clever machinery, was secondary. Tom Gunning (see note 17) points out that in this early "cinema of attraction," the apparatus itself was inscribed into the specular field, and was, in fact, inextricable from spectacle. This "exhibitionist" cinema set itself apart from the "voyeuristic" (or narrative) cinema that was concurrently developing. The demarcations are not precise: both narrative and expository tropes often inhabited the same early films.

17. See Tom Gunning, "The Cinema of Attractions: Early Film, Its Spectator and the Avant-Garde," in Thomas Elsaesser with Adam Barker, eds., *Early Cinema: Space, Frame, Narrative* (London: British Film Institute, 1990), pp. 56–62. According to Gunning, the "cinema of attractions" constructs relations with its spectators such that it is willing to rupture the self-enclosed fictional world required by narrative cinema, spoiling its illusion of reality. The "cinema of attractions" instead displays its visibility, securing a different order of attention in its audiences, employing a series of different strategies, from literally showing the "hidden" workings of the camera by revealing or foregrounding its presence, or locating its presence indirectly, via the responses of subjects or actors who take note of its presence, to using forms of direct address, or apostrophic asides to the audience, as one finds in early comedy. See also David Lindsay, *Madness in the Making: The Triumphant Rise and Untimely Fall of America's Show Inventors* (Tokyo: Kodansha, 1997). This is a fascinating account of the history of spectacular demonstrations of scientific enterprise, underscoring the complicities between science, technology, commercialism, and show business.

18. See John A. Barry, *Technobabble* (Cambridge, Massachusetts: The MIT Press, 1993).

19. Ibid. See also H. Wallace Sinaiko, ed., *Selected Papers on Human Factors in the Design and Use of Control Systems* (New York: Dover Publications, 1961).

20. See Friedrich A. Kittler, *Gramophone, Film, Typewriter*, trans. Geoffrey Winthrop-Young and Michael Wutz (Stanford, California: Stanford University Press, 1999). Kittler's position combines the poststructuralism of Michel Foucault, Jacques Derrida, and Paul Virilio with Lacanian psychoanalysis and the media theory of Marshall McLuhan and Roy Innis. See also Kittler's *Discourse Networks 1800–1900*, trans. Michael Metteer with Chris Cullens (Stanford, California: Stanford University Press, 1990); *Draculas Vermächtnis: Technischen Schriften* (Leipzig: Reclam Verlag, 1993); *Literature, Media, Information Systems*, ed. John Johnson (Amsterdam: Gordon & Breach, 1997). See also Bernhard Siegert, *Relays: Literature as an Epoch of the Postal System*, trans. Kevin Repp (Stanford, California: Stanford University Press, 1999).

21. One might translate (with some latitude) the term *mise-en-abîme* literally, as a "casting into the abyss," and counterpose that to the more familiar term *mise-en-scène*, translated as "casting into place," to designate the way in which it is used in cinema and stagecraft. A *mise-en-abîme* is an abyssal structure, a hole, blank space, or aporia in representation. A spectator, cast into the abyss of the image, constructs a reflection of the world via the (medium of) the image. This circumscribed domestication of the image within itself is an effect of the interface of

unconscious technological and somatic substrates interacting in a physical/projective environment, such as cinema, or even television. Reflection on this difficult, embedded, often invisible process was an important critical turn accomplished by early media installations. See Lucien Dällenbach, *Le récit spéculaire: Essai sur la mise en abîme* (Paris: Éditions de Seuil, 1977); see also Susan Stewart, *Crimes of Writing: Problems in the Containment of Representation* (Oxford: Oxford University Press, 1991).

22. Reiner Schürmann, *Le principe d'anarchie: Heidegger et la question de l'agir* (Paris: Éditions de Seuil, 1982), p. 11. See also idem, *Heidegger on Being and Acting: From Principles to Anarchy*, trans. Christine-Marie Gros in collaboration with the author (Bloomington: Indiana University Press, 1987), p. 1.

23. See Gilles Deleuze, *Difference and Repetition*, trans. Paul Patton (New York: Columbia University Press, 1994); see also idem, *The Logic of Sense*, trans. Mark Lester with Charles Stivale (New York: Columbia University Press, 1990).

24. A *deictic* term refers to the spatio-temporal context of production of an utterance (and by extension a text or artifact). In literary contexts, words such as "here," "now," "I," "you," "there," and "then," are deictics. I am using the term to designate the active, pluralized spatio-temporal articulations of the interactive, mediated body/consciousness. The term *méconaissance* comes from the psychoanalytic register, and means literally misrecognition. The play of recognition and misrecognition in media, and in the reflection on media, is pervasive and profound.

25. Paul Virilio, *A Landscape of Events*, trans. Julie Rose (Cambridge, Massachusetts: The MIT Press, 2000), p. 46.

Artists in the Exhibition

Robert Whitman
Shower

Robert Whitman created some of the first, and most significant, mixed-media performance works of the late 1950s and early 1960s. He began to use projected images as early as 1959 and incorporated Super-8 film projections in the classic performances *American Moon* (1960) and *Prune Flat* (1965). *Shower* is one of a group of four film "sculptures" Whitman made in 1963–64. The others are *Window* (1963), *Dressing Table*, and *Sink* (both 1964). In each work, an everyday action is depicted by fusing a filmed image of the action with the physical object with which it is associated—a woman takes a shower, applies cold cream to her face at a dressing table, brushes her teeth, or combs her hair and applies her makeup in a mirror above a sink.

In *Shower*, a film of a woman taking a shower is projected in a continuous loop onto a curtain, behind which water cascades inside a metal shower stall. Whitman described the piece as an environment, closely related to George Segal's sculptural tableaux. It was first presented during "9 Evenings: Theatre and Engineering" (1966), a landmark event at the Sixty-Ninth Regiment Armory in New York organized by Billy Klüver and Robert Rauschenberg for Experiments in Art and Technology (E.A.T.), of which Whitman was a founding member. *Shower* is one of the earliest examples of the projected image's shift away from the cinema screen into the medium of sculpture. In its presentation with his three other film sculptures at the Museum of Contemporary Art, Chicago, in 1968, Whitman issued a record on which he had recorded his own voice, altered by devices invented by the Bell Telephone Laboratories, singing four songs related to each work.

Robert Whitman
Shower, 1964
Installation at the Newark
Museum, New Jersey, 1999

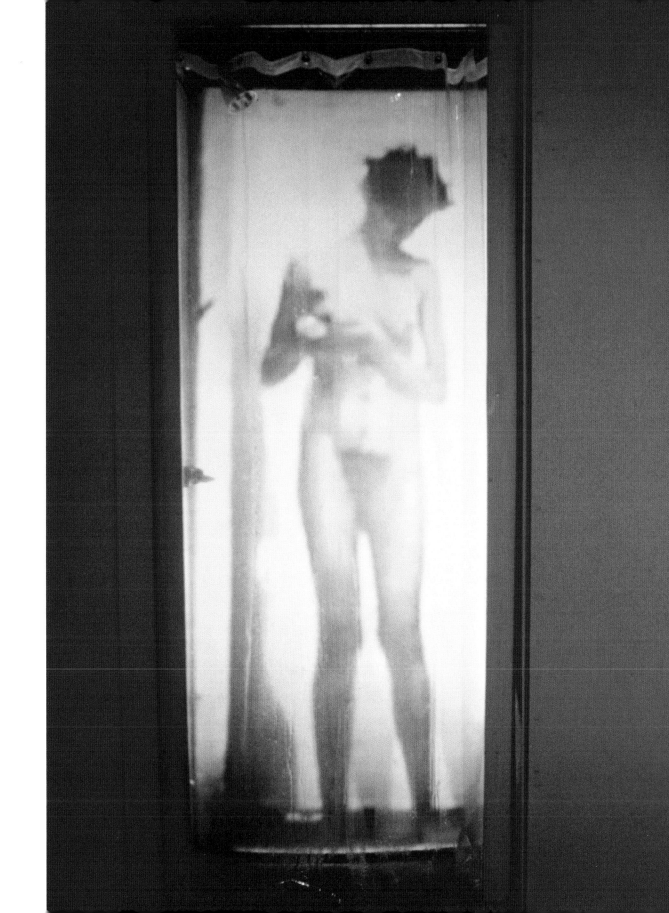

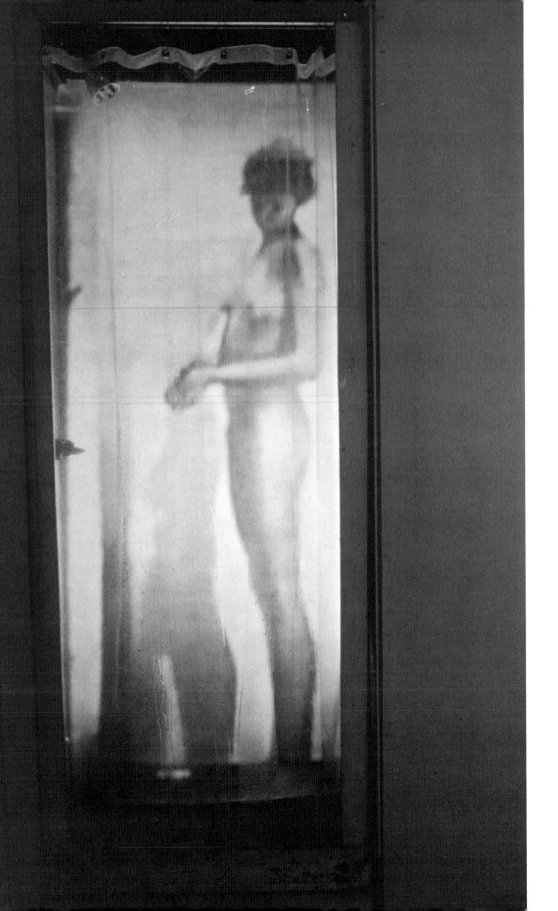

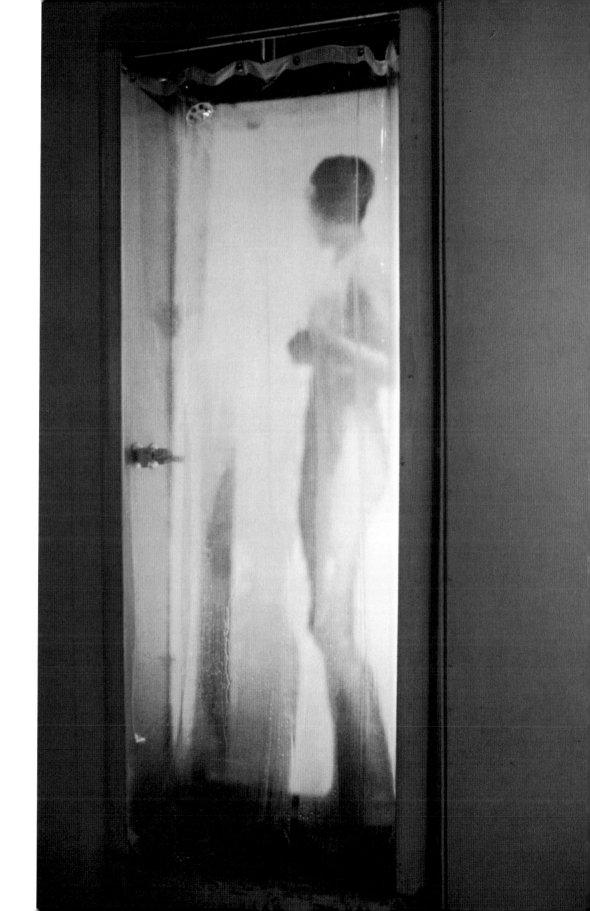

Andy Warhol
Lupe

Lupe is one of the first of Andy Warhol's double-screen films and, as Callie Angell notes, one of three films he made in the winter of 1965–66 dealing with scandals involving Hollywood actresses (*More Milk Yvette*, 1965, focused on Lana Turner and *Hedy*, 1966, on Hedy Lamarr). In *Lupe*, Edie Sedgwick enacts the hours leading to the suicide of the Hollywood siren Lupe Velez. Billy Name also appears, cutting Sedgwick's hair as she reclines on a daybed. The film marked both the end of Sedgwick's collaboration with Warhol and the beginning of Warhol's experiments with multiple projection. At the end of 1965, when he met the Velvet Underground, his film-making was shifting toward experiments with double and triple screens, and *Lupe* was shown on three screens at its premiere. Warhol instructed that, in distribution through the Film-Makers' Cooperative, the film could either be shown on a single screen, at 72 minutes, or on two screens, at 36 minutes.

Angell, who is preparing the catalogue raisonné of Warhol's films, to be published by the Whitney Museum, notes that "the extremely poor quality of the sound in this film was caused by Warhol's single-system Auricon camera, which recorded an optical soundtrack directly on the original film during shooting. Since optical tracks require black-and-white processing in order to retain sharpness of tone, the color processing of Warhol's Ektachrome original resulted in a considerable distortion of the film's sound."[1]

1. Callie Angell, *The Films of Andy Warhol: Part II*, exh. cat. (New York: Whitney Museum of American Art, 1994), p. 25.

Andy Warhol
Stills from *Lupe*, 1965

Yoko Ono
Sky TV

Sky TV is one of the earliest examples of video sculpture, and Yoko Ono's only video work. The piece also exists as an instruction, which may or may not be executed for the work to be realized. A camera is placed on the outside wall or roof of the gallery, trained on the sky. Live images of the sky are relayed to a television monitor in the gallery. *Sky TV* anticipates the self-reflexive video installation works of the later 1960s and reflects Ono's Fluxus-inflected, conceptual approach to video. Significantly, the camera is aimed not at the viewer but at the sky, implying the necessity of considering an infinite world beyond the ego and the hypnotic pull of commercial television. *Sky TV* was first shown at the Indica Gallery, London, in 1966, in Ono's first British solo exhibition. The same year, Ono made a series of black-and-white, slow-motion, fixed-frame films in New York and London, focusing on single actions (the lighting of a match; naked buttocks walking), to which *Sky TV* is conceptually related. *Sky TV* also anticipates the film *Apotheosis*, made with John Lennon in 1970, in which the camera is placed in a hot air balloon and films the landscape and then the clouds as it rises, until all that can be seen is the sky.

Yoko Ono
Sky TV, 1966
Installation at the Israel
Museum, Jerusalem, 2000

William Anastasi
Free Will

In 1968, William Anastasi made two video sculptures, *Transfer* and *Free Will*, both of which engaged the space of the gallery, focusing on two of its most mundane, ignored features: a wall socket and a corner. In both cases, a camera on top of a monitor is trained on the feature, whose black-and-white image is relayed live onto the monitor screen. The live image of the gallery corner in *Free Will* suggests the depth of the space through its focus on the wall's right-angled corner at floor level, and by the lack of movement in the live image, which emphasizes the volume of the feature, rather than any sense of action around it. *Free Will*'s ironic title refers to the shift Anastasi felt was occuring in ideas relating to selfhood, and in particular free will, which artists during this period were claiming to be a misguided illusion. Made at the height of the Vietnam War, *Free Will*, with its focus on an empty corner, also suggested the dead end that he and many others of his generation felt both art and politics had reached. *Free Will* relates to a number of other tautological works Anastasi made during this period, including *Untitled* (1966), in which he hung six photosilkscreens of the walls of the Dwan Gallery in New York directly onto the walls themselves, and *Nine Polaroid Photographs of a Mirror* (1967).

William Anastasi
Free Will, 1968
Installation at the Whitney
Museum of American Art,
New York, 1981

Robert Morris
Finch College Project

In 1969 Robert Morris made five films, as well as the film instal-
lation *Finch College Project*. The installation was originally made
for the Finch College Museum of Art in New York, and this is its first
re-presentation since its initial showing. The filmmaker Robert
Fiore was cameraman for the project, filming a crew installing
and de-installing a grid of mirrored squares and a gridded black-
and-white photograph of a movie audience on opposite walls of
the gallery. Fiore made the film slowly, rotating the camera around
the space on a turntable revolving at 1rpm. The resulting film was
then projected into the same space, rotated around the now
blank walls, on which the marks made by the attachment of the
mirrors and photographic grid were visible, the turntable revolving
at the same rate as Fiore's camera. The crew's movements evoke
the tasklike actions of Morris' earlier dance works, and at certain
moments the camera can be seen reflected in the mirror it is
filming, recalling the image of the camera in a reflection of the
landscape in Morris' film *Mirror* (1969), to which *Finch College
Project* is closely related.

Robert Morris
Finch College Project, 1969
Installation at Finch College
Museum of Art, New York, 1969

Robert Morris
Diagram for *Finch College Project*, 1969
Graphite on paper, 22 x 34 in.
(55.9 x 86.4 cm)
This drawing shows Morris'
sketches for possible formats
for *Finch College Project*. The
drawing of the figure holding
the mirror recalls the figure of
Morris in his film *Mirror*, made
the same year.

OPPOSITE:
Robert Morris
Stills from *Mirror*, 1969
16mm film, black-and-white,
silent, 9 minutes

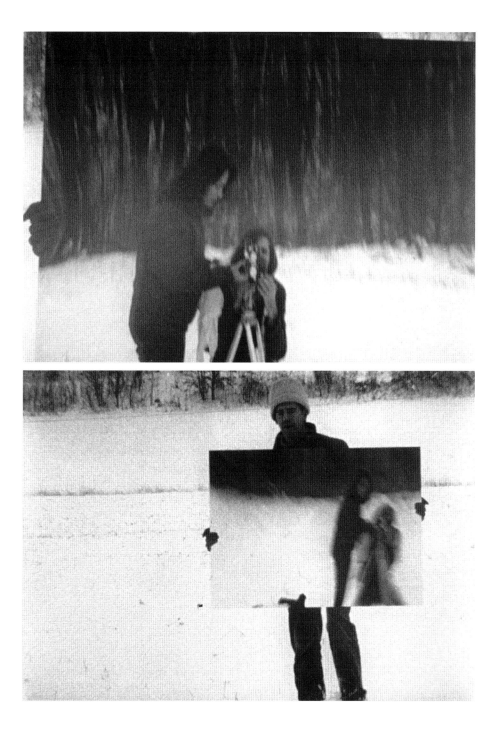

Bruce Nauman
Spinning Spheres

The film installation *Spinning Spheres* is one of sixteen installations
Bruce Nauman made in 1970, in which the viewer's perception of
space is destabilized. In his notes for the installation, Nauman
wrote: "A steel ball placed on a glass plate in a white cube of space.
The ball is set to spinning and filmed so that the image reflected
on the surface of the ball has one wall of the cube centered. . . .
The image reflected in the spinning sphere should not be that of
the real room but of a more idealized room, of course empty, and
not reflecting the image projected on the other room walls.
There will be no scale references."[1]

Spinning and rotating, movements that disrupt perspective,
appeared in Nauman's work for the first time in *Revolving Upside
Down* (1969), a videotape in which a camera, turned upside down,
records the artist executing a series of exercises in his studio.
In *Spinning Spheres*, the relation between object and space is
reversed. A tiny steel ball is made gigantic, and its expansive
abstract surface obscures all spatial coordinates.

Spinning Spheres was made as four 16mm film loops, trans-
ferred to Super-8 film to show in Super-8 film loop cartridges.
A color and a black-and-white version were made. The color version
was first shown at the Leo Castelli Gallery, New York, in 1971. This
is its first showing on 16mm film loops since its initial presentation.

1. Bruce Nauman, "Notes and Projects," *Artforum*, 9 (December 1970), p. 44.

Bruce Nauman
Spinning Spheres, 1970
Installation at Leo Castelli
Gallery, New York, 1971

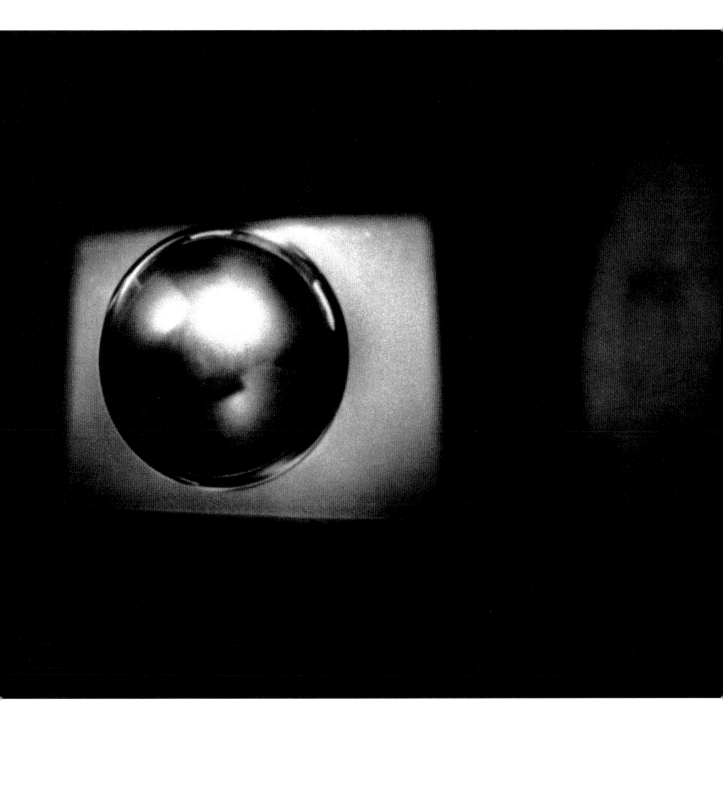

Bruce Nauman
Stills from *Spinning Spheres*,
1970

Mary Lucier
Polaroid Image Series
(*Room, Shigeko, Croquet, City of Boston*)

Between 1970 and 1974 Mary Lucier made a series of slide projection works titled *Polaroid Image Series*, begun as a collaboration with the composer Alvin Lucier and based on the structure of his composition for voice and tape *I Am Sitting in a Room*. In this sound work, Alvin Lucier recorded himself reading a text describing the making of the work. The recording was played back into the room repeatedly, rerecorded each time, until the original statement became unintelligible as a representational form. Following the same structure, Mary Lucier created a series of black-and-white photographic images that were copied repeatedly, up to 131 times, using a Polaroid copier. As in Alvin Lucier's sound work, details and small errors made during the process were incorporated into the work. The images are projected simultaneously with Alvin Lucier's thirteen-minute audio work. The first performance of *Polaroid Image Series* was *Room*, presented as a collaboration between the two artists at the Solomon R. Guggenheim Museum on March 25, 1970. Other titles in the series include *Shigeko, Croquet, City of Boston, David Behrman*, and *Three Points*. For its presentation in this exhibition, *Room, Shigeko, Croquet*, and *City of Boston* are projected onto four walls of the gallery, all synced to the audio soundtrack.

Mary Lucier
Slides from *Polaroid Image Series*
(*Croquet*), 1970–72
From top to bottom, these
images are the original, seventh,
eighteenth, and thirty-sixth
generation.

Pages 108–110:
Mary Lucier
Slides from *Polaroid Image Series*
(*Shigeko*), 1970–72

Mary Lucier
Slides from *Polaroid Image Series*
(*Room*), 1970
Top row: original image and fifth
generation; bottom row: thir-
teenth and fortieth generation

Keith Sonnier
Channel Mix

Channel Mix is one of the earliest examples of live-feed televi-
sion video installation. In the late 1960s and early 1970s, artists
including Nam June Paik, Frank Gillette and Ira Schneider, Antonio
Muntadas, Richard Serra, and Keith Sonnier inserted their work
into the seemingly impenetrable flow of commercial television. In
Channel Mix, live television images are juxtaposed with the viewer's
own image in two split-screen projections on opposite walls of
the gallery. *Channel Mix* was also shown as part of a performance,
Act I: In Illustrated Time Proscenium II, along with two other video
works, *T-Hybrid-V-III* and *T-Hybrid-V-IV*, at Documenta 5 in 1972.
Its format echoes the split rectangle format of Sonnier's mirror,
light, and plexiglass wall works, in which an opaque surface is jux-
taposed with a mirror surface.

Keith Sonnier
Channel Mix, 1972
Installation at Leo Castelli
Gallery, New York, 1973

Dan Graham
Helix/Spiral

Between 1969 and 1973, Dan Graham made six films, of which *Helix/Spiral* is the last. Graham made three versions of the film: a rehearsal version outside New York University's Loeb Student Center in Greenwich Village, and two versions in rural landscapes in Halifax, Nova Scotia, where the horizon may be seen clearly in the frame of both cameras. In each version, one person stands still, filming another person also holding a camera, walking slowly toward him or her in a spiral movement. The stationary performer presses the back of the camera to his/her body, covering the body's surface as he/she moves it in a descending helix from the eyes to the feet. The resulting panning shots include the second performer as he/she moves around the stationary performer in a spiral. The particular contour of the stationary performer's body determines the camera's angle at any given moment. The two films are projected onto opposite walls of the gallery. The film was first shown in the Artists' Film Series at Artists Space, New York, on January 2 and 3, 1976, with Graham's other film works. A variation of the film, titled *Helix/Circle* (1973), specifies a woman camera operator, but otherwise follows the same format as *Helix/Spiral*. This exhibition's presentation of *Helix/Spiral* includes the rehearsal version, made with Simone Forti.

Dan Graham
Stills from *Helix/Spiral*, 1973
These views of the two
performers' bodies were filmed
from opposite cameras.

Anthony McCall
Line Describing a Cone

In the early 1970s, Anthony McCall made a group of film works that engaged the space of the gallery, articulating the beam of light from the projector as a sculptural form. Some of the works, like *Line Describing a Cone*, comprise a single film, while others, such as *Long Film for Four Projectors* (1974), are durational and involve multiple projections. In *Line Describing a Cone*, a film showing the drawing of a large circle is projected onto the wall of a darkened room. A thin mist is introduced into the space, which makes the beam from the projector more visible, as it gradually develops from a line into a large cone, as the drawn circle evolves into completion. As viewers move around the space, looking toward the projector, they experience a large volume that the cone of light creates. *Line Describing a Cone* was first presented in 1973 at the Autumn Arts Festival, Fylkingen Society for Contemporary Music and Arts in Stockholm, and subsequently in 1974 at Artists Space in New York. It is related to *Four Projected Movements* (1975), another single-screen film, which is fed through the projector four times—the right way up, upside down, back to front, and inside out—creating four consecutive planes of light in different directions.

Anthony McCall
Line Describing a Cone, 1973
Projection at Artists Space,
New York, 1974

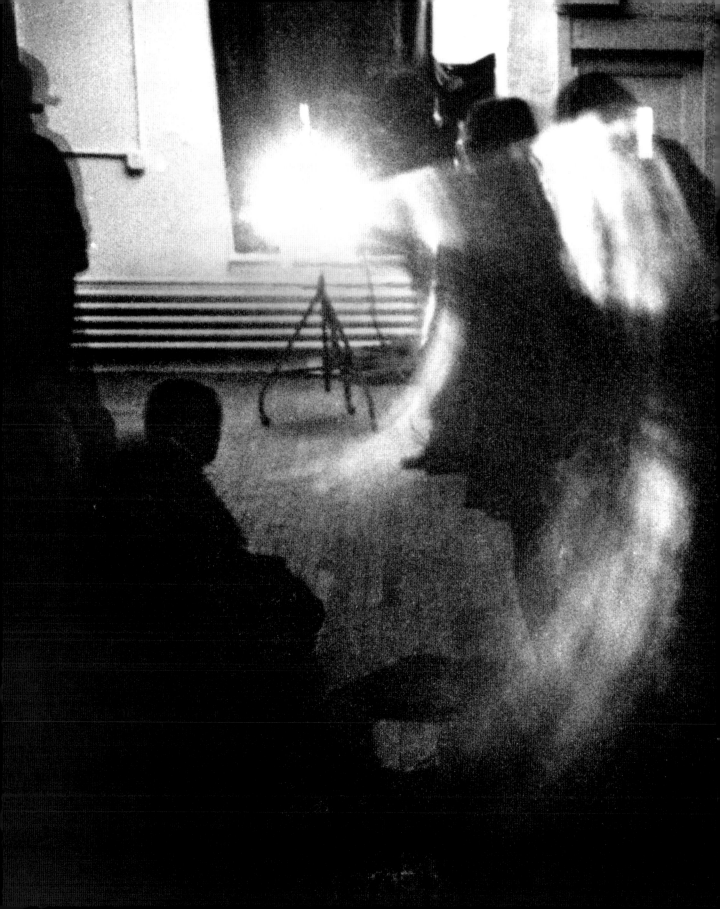

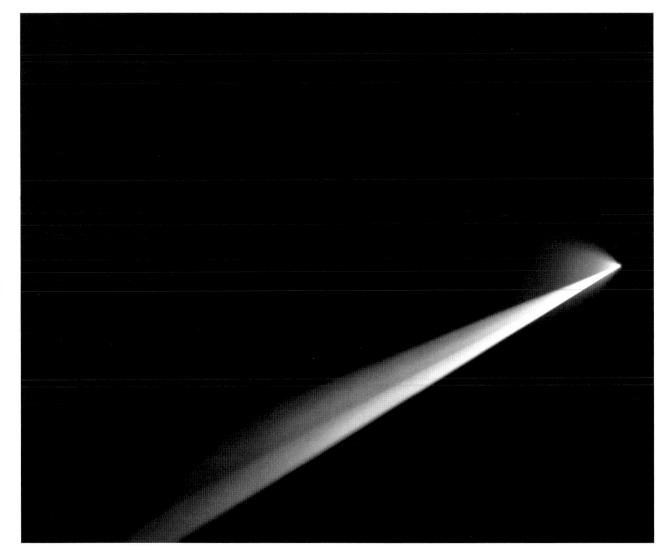

Anthony McCall
Line Describing a Cone, 1973
Projection at the Whitney
Museum of American Art,
New York, 2001

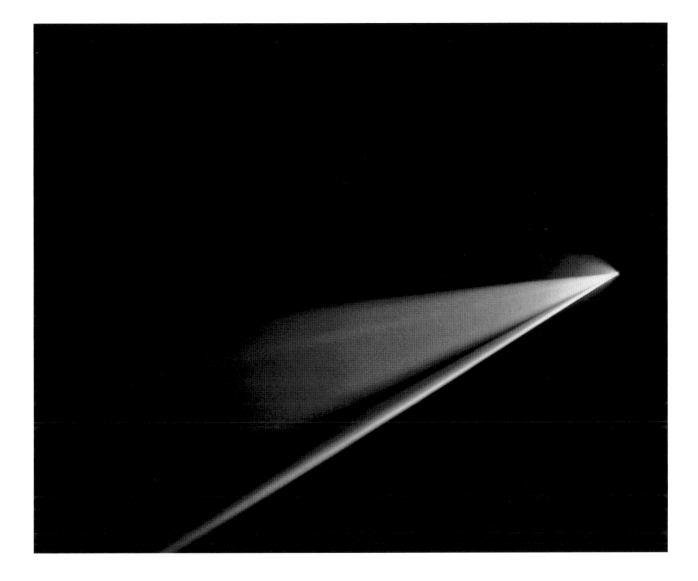

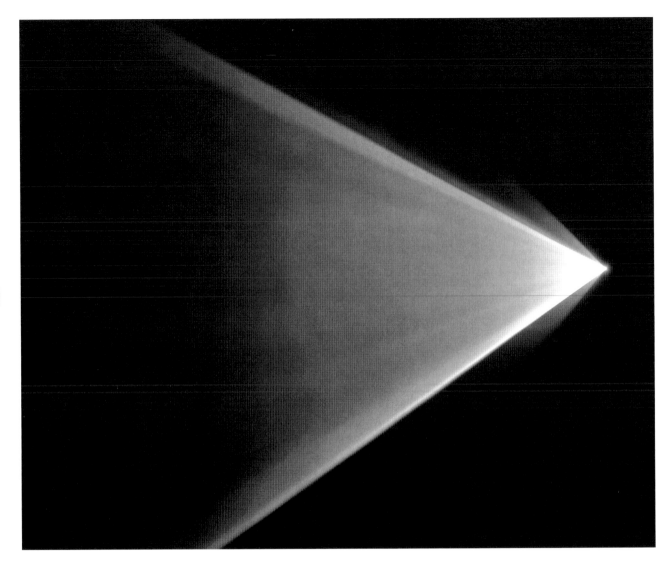

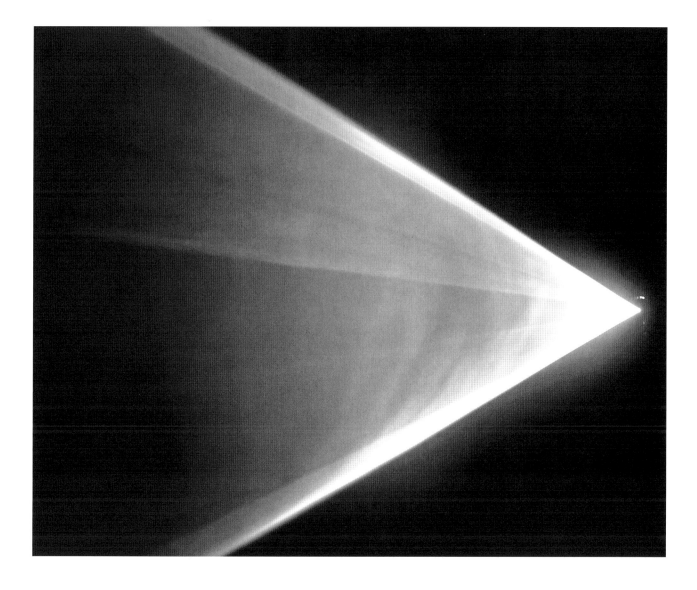

Dennis Oppenheim
Echo

Echo is one of Dennis Oppenheim's few film installations. Made in Oakland, California, and first shown at the Museum of Conceptual Art in San Francisco, it incorporates 16mm film loops and crystal sync sound. Four black-and-white projections show Oppenheim's hand slapping the gallery wall; the sound of each slap ricochets around the space, creating a series of slowly reverberating echoes. This performative installation reflects Oppenheim's shift from land art to body art in the early 1970s. Other related works include *Gunfire*, another film loop installation in which four projections rotate around the gallery walls, shown with *Echo* at the John Gibson Gallery, New York, in 1975, and *Aspen Projects*, twenty-five short film works shown on double screens in two corners of the gallery. *Echo* was last shown in 1979, at the Art Gallery of Ontario.

Dennis Oppenheim
Echo, 1973
Installation at the Whitney
Museum of American Art,
New York, 2001

Vito Acconci
Other Voices for a Second Sight

In the early 1970s, Vito Acconci made a group of architectural video installations that combined his psychological explorations of personal identity with a broader political theme. The installation is divided into three constructed rooms. In the first, which resembles a sound studio, a reel-to-reel tape recorder sits on a shelf with a red light above and an empty chair in front. Acconci's disembodied voice relates a long monologue. In the right room, or "secret space," which can be seen only through a horizontal window, the structure is vertical and dark. Video and slide projections of Acconci's body and political posters appear in the darkness, alongside a second monologue pastiching communiqués from twentieth-century left-wing revolutionaries. The opposite room, also visible only through a horizontal window, is painted white and has a horizontal format. Onto opaque sheets are projected images of Acconci, alongside a third taped monologue, in which an obscure, dreamlike narrative develops. The installation was made for the exhibition "Eight Contemporary Artists," at The Museum of Modern Art, New York, in 1974.

Vito Acconci
Other Voices for a Second Sight,
1974
Installation at Barbara Gladstone
Gallery, 1998

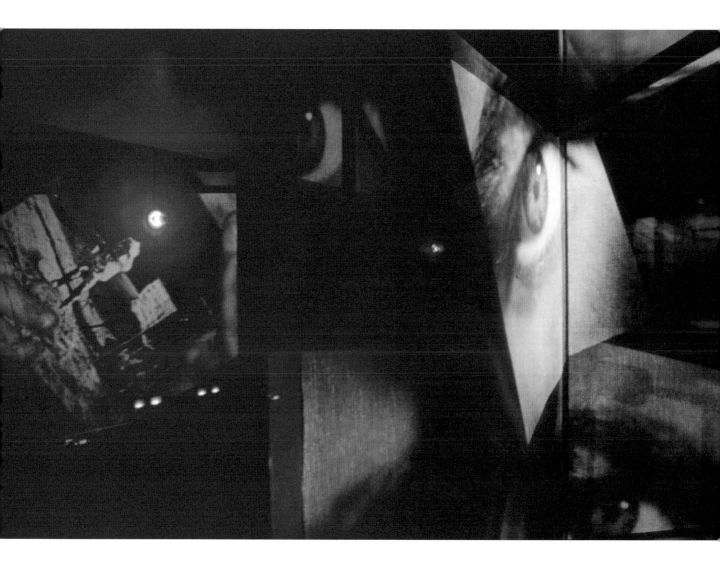

Michael Snow
Two Sides to Every Story

From the early 1960s onward, Michael Snow produced parallel bodies of work, in film and art, including photography, painting, holography, installation, and sculpture. *Two Sides to Every Story* articulates the interface between these two aspects of Snow's work. On two sides of a metal screen hung in the center of the gallery, two films are projected from opposite sides of the room in continuous loops. Both films show a woman making a series of movements as she walks between one cameraman and another. As her actions were filmed from both sides, so the films re-present the two perspectives, which the viewer can see only by walking between one side of the screen and the other, mimicking the positions of the cameramen in reverse. *Two Sides to Every Story* was commissioned for, and first shown at, the "Projected Images" exhibition at the Walker Art Center, Minneapolis, in 1974.

Michael Snow
Two Sides to Every Story, 1974
Installation at the Walker Art
Center, Minneapolis, 1974

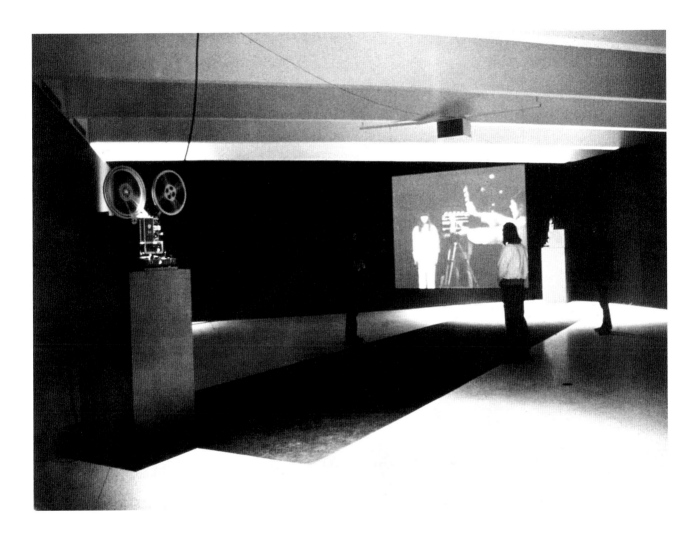

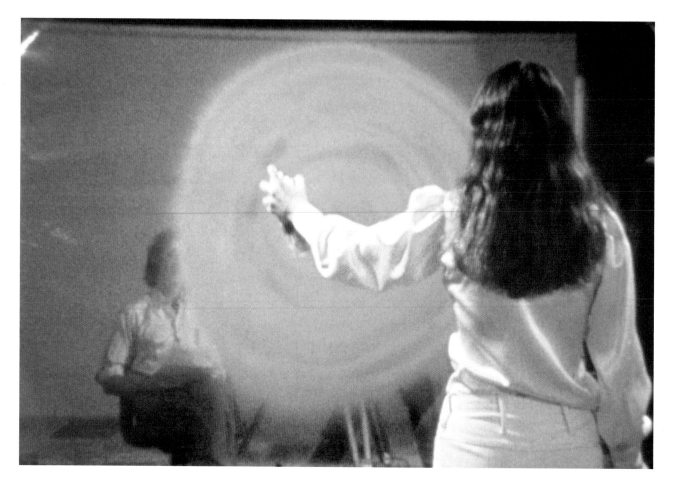

Michael Snow
Stills from opposite screens of
Two Sides to Every Story, 1974

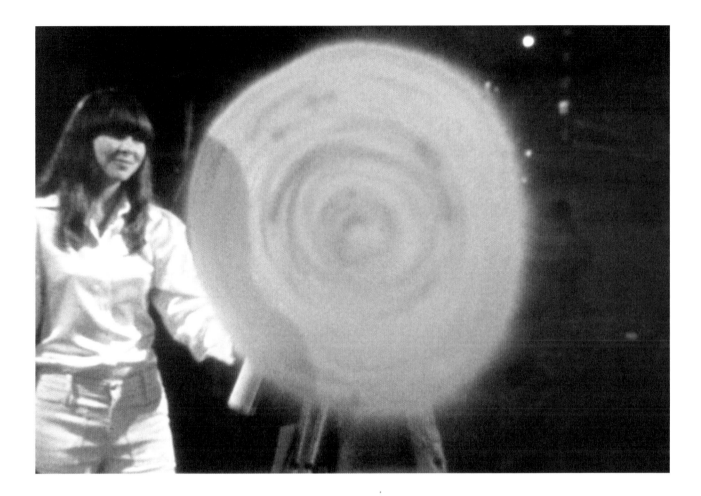

Beryl Korot
Dachau 1974

In *Dachau 1974*, four video monitors set into a white wall of the
gallery create a horizontal strip of black-and-white moving images
that proceed in two sets of interlocking patterns. Beryl Korot
takes us through the concentration camp in Dachau, Germany,
in a sequence progressing from the entrance, through the path-
ways and open parade ground, to the wooden sleeping quarters,
ovens, and a stream beyond. The sequence of the images, inspired
by the warp and weft principles of weaving, interlocks the two
strands of images together to create a harrowing topographical
journey.

Beryl Korot
Structural diagram for
Dachau 1974, 1974

OPPOSITE:
Beryl Korot
Dachau 1974, 1974
Installation at The Kitchen,
New York, 1974

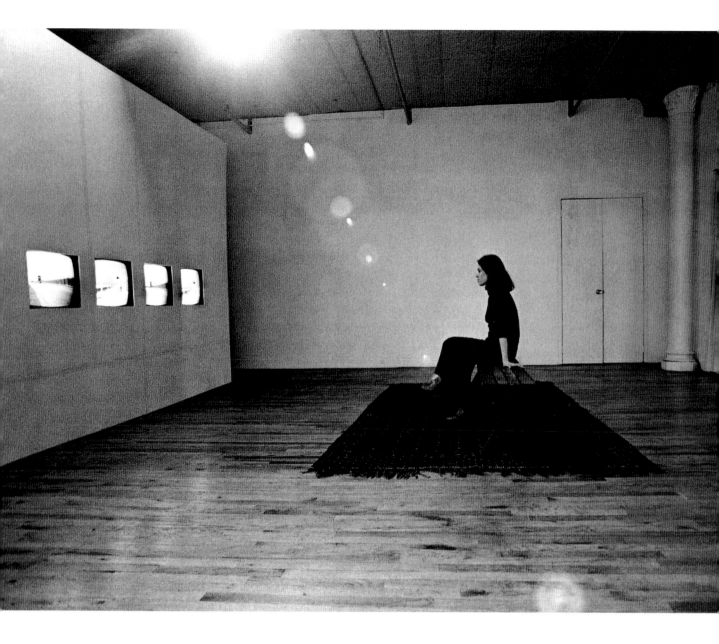

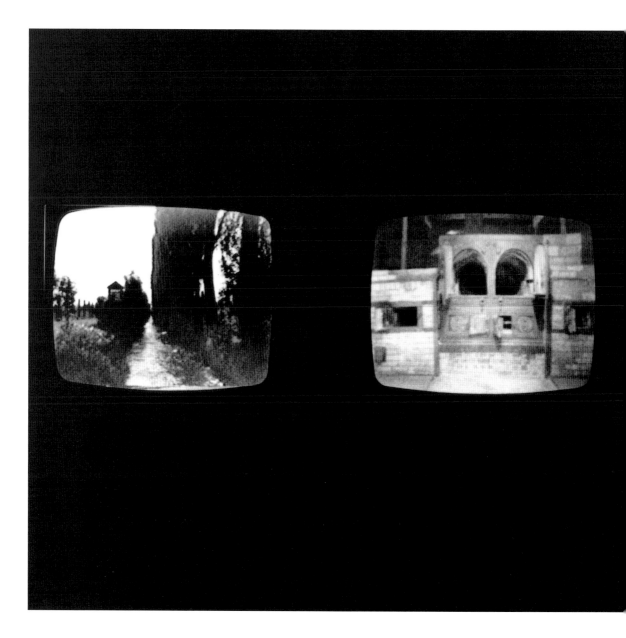

Beryl Korot
Dachau 1974, 1974
Installation detail

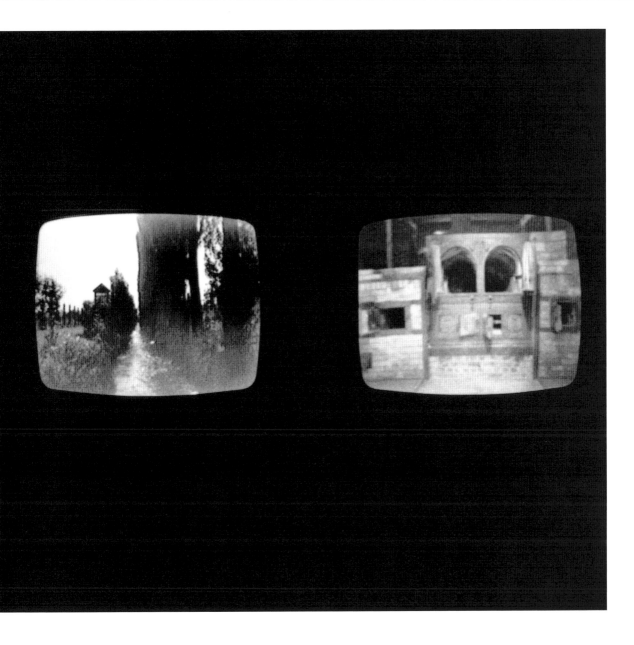

Gary Hill
Hole in the Wall

In 1974, Gary Hill made his first video installation, in a performance at the Woodstock Artists Association in upstate New York. Training a video camera on the inside wall of the gallery, Hill cut a large hole the size of a monitor in the wall, until he had reached the exterior of the building. He then placed a monitor in the hole, playing the tape of the action of the hole-cutting on a continuous loop. *Hole in the Wall* is a transitional work that marked Hill's shift from sculpture to video. This is the first presentation of the work since the 1970s.

Gary Hill
Hole in the Wall, 1974
Installation at the Woodstock
Artists Association,
Woodstock, New York, 1974

Paul Sharits
Shutter Interface

Shutter Interface is one of Paul Sharits' "Locational" pieces: multiple-screen gallery installations. In these works, Sharits explored his rigorous analysis of the material properties of film and the mechanics of cinema in spatial terms. *Shutter Interface* exists in two-and four-screen versions. The two-screen version has been reconstructed for this exhibition (the whereabouts of the additional two negatives and prints that would have comprised the four-screen version are unknown).

In *Shutter Interface*, Sharits wanted "to create a metaphor of the basic intermittency mechanism of the cinema: the shutter. If one slows down a projector, one observes a 'flicker,' [which] reveals the rotating shutter activity of the system. Instead of slowing down a projector, one can metaphorically suggest the frame-by-frame structure of the film ... by differentiating each frame of the film by radical shifts in value or hue."[1] On the wall of the gallery, a band of seven overlapping rectangles of pure color flickers and pulsates. Each sequence is interspersed with black frames representing the shutter action. An abstract soundtrack punctuates each shift in hue, creating a percussive composition. The loops are all of varying lengths, which allows different relationships between colors to evolve, and underscores the continuous format of the projected environment, or "color space." *Shutter Interface* was first shown at Artpark, Lewiston, New York, in 1975, and subsequently at the Albright-Knox Art Gallery, Buffalo, New York, in 1976.

1. Paul Sharits, "Locational Film Pieces," *Film Culture*, 65–66 (1978), p. 122.

Paul Sharits
Study 4: Shutter Interface (Optimal Arrangement), 1975
Colored pencil on graph paper,
16 x 20 in. (40.6 x 50.8 cm)
Collection of Christopher Sharits
This drawing shows the four-screen version of *Shutter Interface*, as it was first presented at the Droll/Kolbert Gallery, New York, in 1977.

Study & Shutter Interface (Optimal Arrangement) Paul Sharits 1975

Paul Sharits
Shutter Interface, 1975
(two-screen version)
Projection at the Whitney
Museum of American Art,
New York, 2001

Joan Jonas
Mirage

Mirage, the last of Joan Jonas' "black-and-white" performances, was performed at Anthology Film Archives at 80 Wooster Street in New York. Frontal in composition, it combined film, video, performance, and drawing. Its structure, which addressed the space of cinema, echoed Anthology's own challenge to the conventions of cinema through its commitment to avant-garde film. Jonas changed the sizes of the screen and connected the action on the screen to that of the space immediately in front of it. With another performer, she created a series of actions, including a sequence also projected on the film screen, in which she drew a series of symbolic drawings on a blackboard, erasing each one before the next was sketched, to create a "magical" sentence. She also used a number of props, including masks and a long metal cone.

The presentation of *Mirage* for this exhibition includes the moving image elements from the original performance. A black-and-white film shows Jonas drawing on the blackboard and appearing in a horizontal roll sequence, shot by Babette Mangolte. A second, smaller projection collages material shot before and at the time of the performance: Jonas dancing in Sardinia, shot by Richard Serra; Jonas and Pat Steir performing in the streets of Manhattan, shot by Andy Mann; and footage shot by Jonas herself. Two videotapes of Jonas performing, *May Windows* and *Good Night, Good Morning*, are shown in front of both projections, on a monitor turned on its side. These elements create a projective environment that evokes the spirit of the original performance. Unlike Jonas' other performances, *Mirage* can be represented as an installation in slightly different forms. This is the first gallery presentation of *Mirage* in this format.

Joan Jonas
Mirage, 1976
Performance at Anthology
Film Archives, New York
When Jonas performed in
Anthology Film Archives' cinema
space, she altered the blank
screen's aspect ratio through-
out the performance, using
black curtains. Jonas sang and
spoke into a long metal cone.

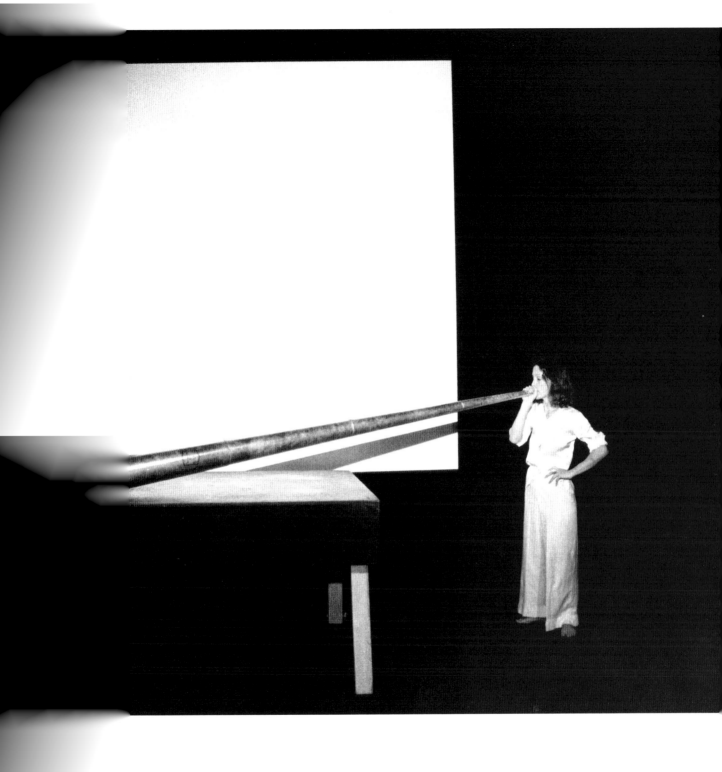

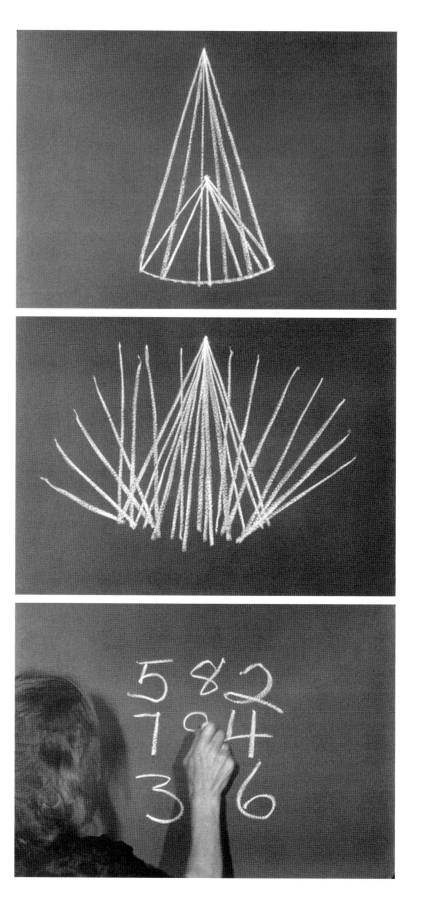

Joan Jonas
Stills from *Mirage*, 1976

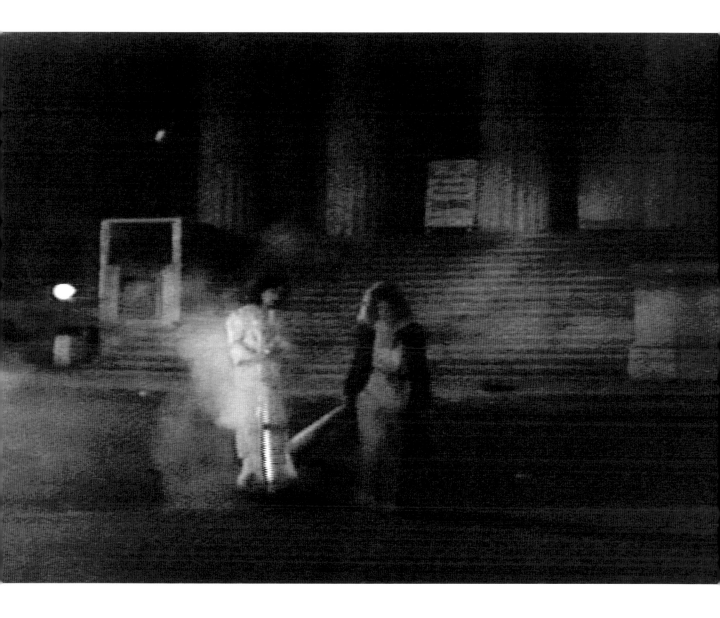

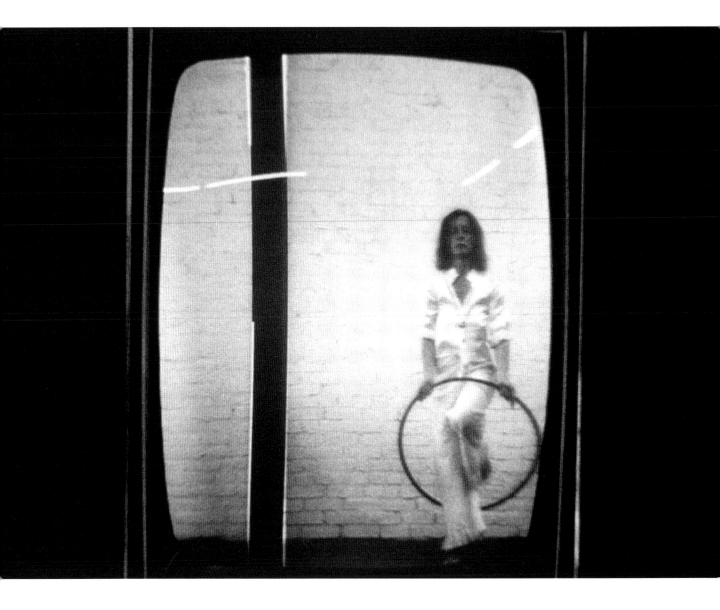

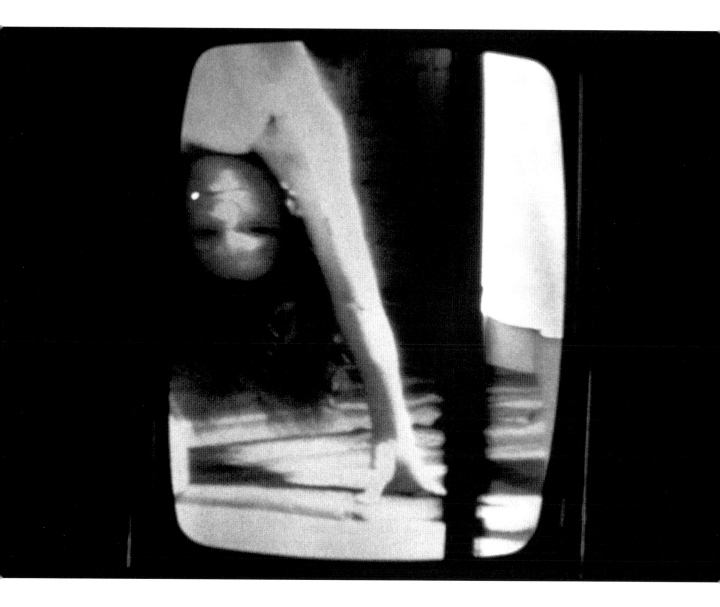

Peter Campus
aen

aen (a reference to "pain"), belongs to the last group of Peter Campus' fifteen early closed-circuit video installations. In this last group of three (*aen*, *num*, and *lus*), made in 1977, Campus focused on the viewer's head and turned the camera upside down. The camera is mounted on the wall at shoulder height. The viewer sees an image of his or her head and shoulders, large-scale and inverted. As Roberta Smith observed, this group of installations is "perhaps his most difficult, and certainly, as the titles suggest, his most disturbing. As if to bring the viewer to a purely subjective experience of the work, spatial interaction is severely tamped down. The light-field . . . [is] flat and unangled. . . . The viewer is brought to a virtual standstill against the wall; you can do little but turn your head slightly . . . not only upside down, your face is almost lost in the shadows, distorted to the point of being unfamiliar and a bit frightening."[1] *aen* was first shown at The Museum of Modern Art, New York.

1. Roberta Smith, "Dark Light," in *Peter Campus*, exh. cat. (Cologne: Kölnischer Kunstverein, 1979), p. 36.

Peter Campus
aen, 1977
Installation at the Whitney
Museum of American Art,
New York, 1989–90

Simone Forti
Striding Crawling

The dancer Simone Forti made a number of holographic works in 1976 and 1977, in which she appeared standing, striding, and crawling in a ghostly shimmering sequence activated by the viewer's movement around a plexiglass cylinder, balanced on three bricks and lit from beneath by a candle. The holographic process had recently become available to artists, and Forti and Bruce Nauman were two of the best-known artists who used the new medium. Forti used the cylindrical hologram *Angel* in a performance at Judson Memorial Church in New York in 1976. *Striding Crawling* was first shown in a solo exhibition at the Leo Castelli Gallery, New York, along with other holograms by Forti.

Simone Forti
Striding Crawling, 1977
Installation at the Whitney
Museum of American Art,
New York, 2001

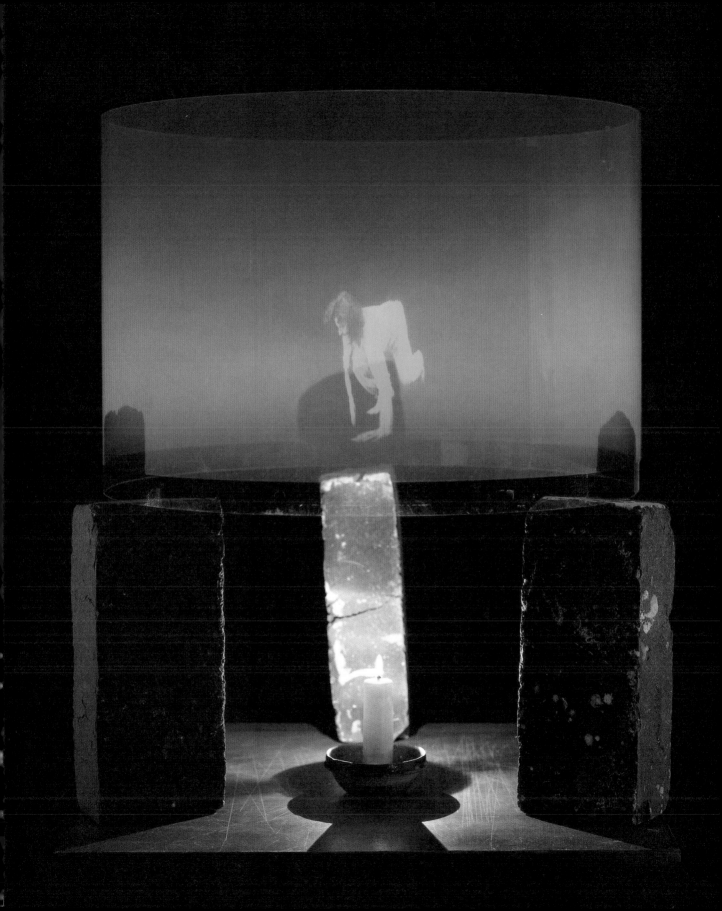

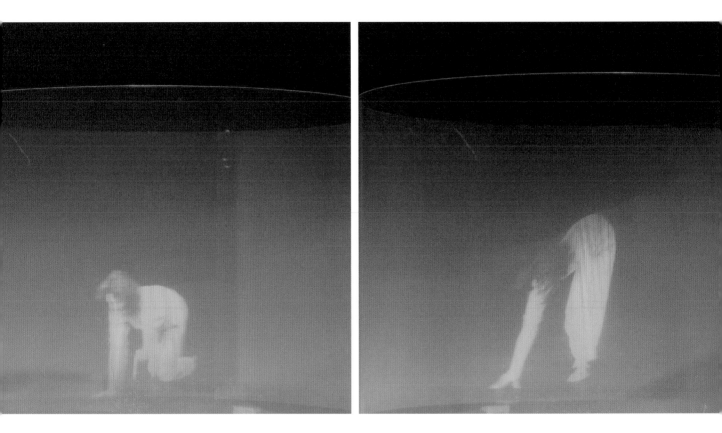

Simone Forti
The movement sequence of
Striding Crawling, 1977

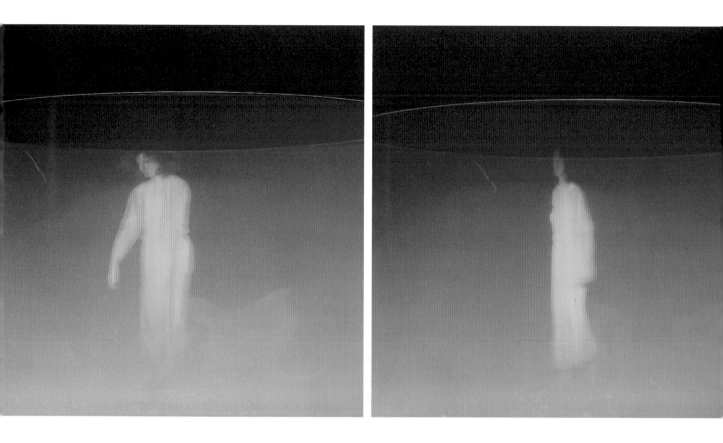

Artists' Biographies and Bibliographies

COMPILED BY
TANYA LEIGHTON

The artists' biographies include projected works, exhibitions, and events from 1964 to 1977 only. The bibliographies include key texts from the period, as well as recent publications that cover historical work.

Vito Acconci

Born 1940, Bronx, New York
Lives in Brooklyn, New York

Selected Installations

Remote Control, 1971. Two-channel video installation (each videotape, black-and-white, sound; 62 minutes). With Kathy Dillon.

Airtime, 1973. Audio installation with performance on closed-circuit video (videotape, black-and-white, sound; 37 minutes). Three 90-minute performances each day.

Command Performance, 1974. Video installation (videotape, black-and-white, sound; 50 minutes).

Memory Box III (Vanishing Point), 1974. Installation with slide projections and audiotape.

Other Voices for a Second Sight, 1974. Installation with Super-8 film, slide projections, and audiotape.

Plot, 1974–75. Installation with slide projections and audiotape.

Body Building in the Great Northwest, 1975. Installation with film, video, slide projections, and audiotape (film since transferred to video).

Leveling, 1975. Installation with slide projections and audiotape.

Pornography in the Classroom, 1975. Installation with film, video, and slide projections (film since transferred to video).

Selected Films

Filling Space, 1969. Super-8, color, silent; 3 minutes.

Two Attention Studies (Coming In, Catching Up), 1969. Super-8, color, silent; 9 minutes.

Applications, 1970. Super-8, color, silent; 20 minutes. With Kathy Dillon and Dennis Oppenheim.

Breakthrough, 1970. Super-8, color, silent; 3 minutes.

Breathe In (To)/Out (Of), 1970. Super-8, color, silent; 3 minutes.

Contemplation Piece, 1970. Super-8, color, silent; 3 minutes.

Dance Medley, 1970. Super-8, color, silent; 3 minutes.

Digging Piece, 1970. Super-8, color, silent; 15 minutes.

Flour/Breath, 1970. Super-8, color, silent; 3 minutes.

Gargle/Spit, 1970. Super-8, color, silent; 3 minutes.

Licks, 1970. Super-8, color, silent; 3 minutes.

Open/Close, 1970. Super-8, color, silent; 6 minutes.

Openings, 1970. Super-8, color, silent; 15 minutes.

Push, 1970. Super-8, color, silent; 3 minutes.

Rubbings, 1970. Super-8, color, silent; 8 minutes.

Run-Off, 1970. Super-8, color, silent; 12 minutes.

See Red, 1970. Super-8, color, silent; 3 minutes.

See Through, 1970. Super-8, color, silent; 5 minutes.

Three Adaptation Studies (Blindfolded Catching, Hand and Mouth, Soap and Eyes), 1970. Super-8, black-and-white, silent; 8 minutes.

Adaptation Study (Hand and Mouth), 1970. Super-8, black-and-white, silent; 3 minutes. 16mm, color, silent; 7 minutes.

Adaptation Study (Soap and Eyes), 1970. Super-8, black-and-white, silent; 3 minutes.

Three Frame Studies (Jump, Circle, Push), 1970. Super-8, color, silent; 9 minutes.

Three Relationship Studies (Manipulations, Imitations, Shadow-Play), 1970. Super-8, color, silent; 15 minutes.

Two Cover Studies (Scene Steal, Container), 1970. Super-8, color, silent; 9 minutes.

Two Takes (Grass and Mouth, Hair and Mouth), 1970. Super-8, color, silent; 8 minutes.

Watch, 1970. Super-8, black-and-white, silent; 9 minutes.

Conversions I, II, and III, 1971. Super-8, black-and-white, silent; 24 minutes each (72 minutes total running time).

Eye Control, 1971. Super-8, color, silent; 15 minutes.

Pick-ups, 1971. Super-8, color, silent; 15 minutes.

Watch, 1971. Super-8, black-and-white, silent; 9 minutes.

Waterways, 1971. Super-8, color, silent; 6 minutes.

Zone, 1970–71. Super-8, color, silent; 15 minutes.

Face to Face, 1972. Super-8, color, silent; 15 minutes.

Hand to Hand, 1972. Super-8, black-and-white, silent; 12 minutes.

My Word, 1973–74. Super-8, black-and-white and color, silent; 120 minutes.

Selected Videotapes

Corrections, 1970. Black-and-white, silent; 15 minutes.

Association Area, 1971. Black-and-white, sound; 62 minutes. With Doug Waterman.

Centers, 1971. Black-and-white, silent; 22 minutes.

Claim Excerpts, 1971. Black-and-white, sound; 62 minutes.

Connecting Medium, 1971. Black-and-white, sound; 30 minutes.

Contacts, 1971. Black-and-white, sound; 30 minutes.

Feelers, 1971. Black-and-white, silent; 30 minutes.

Filler, 1971. Black-and-white, sound; 30 minutes.

Flinch, 1971. Black-and-white, sound; 29 minutes.

Focal Point, 1971. Black-and-white, sound; 33 minutes.

Passes, 1971. Black-and-white, silent; 20 minutes.

Pryings, 1971. Black-and-white, sound; 17 minutes. With Kathy Dillon.

Pull, 1971. Black-and-white, sound; 32 minutes.

Remote Control, 1971. Black-and-white, sound; 32 minutes. With Kathy Dillon.

Two Track, 1971. Black-and-white, sound; 29 minutes.

Waiting Room, 1971. Black-and-white, sound; 20 minutes.

Waterways: 4 Saliva Studies, 1971. Black-and-white, sound; 22 minutes.

Projections, 1972. Black-and-white, sound; 30 minutes.
Face-Off, 1973. Black-and-white, sound; 33 minutes.
Full Circle, 1973. Black-and-white, sound; 30 minutes.
Home Movies, 1973. Black-and-white, sound; 32 minutes.
Recording Studio from Air Time, 1973. Black-and-white, sound; 37 minutes.
Stages, 1973. Black-and-white, sound; 33 minutes.
Theme Song, 1973. Black-and-white, sound; 30 minutes.
Undertone, 1973. Black-and-white, sound; 34 minutes.
Walk-Over, 1973. Black-and-white, sound; 30 minutes.
Command Performance, 1974. Black-and-white, sound; 57 minutes.
Face of the Earth, 1974. Color, sound; 22 minutes.
Open Book, 1974. Color, sound; 10 minutes.
Shoot, 1974. Color, sound; 10 minutes.
Turn-On, 1974. Color, sound; 22 minutes.
The Red Tapes, 1976. Black-and-white, sound; 141 minutes. Camera: Ed Bowes. Sound: Tom Bowes. Music: Charles Ives.

Selected One-Artist Exhibitions and Screenings
112 Greene Street, New York, 1974.
Hallwalls, Buffalo, New York, 1975.
Museum of Conceptual Art, San Francisco, 1975.
Anthology Film Archives, New York, 1976, 1977.
Artists Space, New York, 1976.
Franklin Furnace, New York, 1976.
University Art Galleries, Wright State University, Dayton, Ohio, 1976.
Centre d'Art Contemporain, Geneva, 1977.
The Clocktower, Institute for Art and Urban Resources, New York, 1977.
The Kitchen, New York, 1977.
University of Massachusetts, Amherst, 1977.

Selected Group Exhibitions and Screenings
Dwan Gallery, New York, "Language III," 1969.
Moore College of Art, Philadelphia, "Recorded Activities," 1970.
The Museum of Modern Art, New York, "Information," 1970.
Gramercy Arts Theater, New York, "Events," 1970.
Museum of Conceptual Art, San Francisco, "Body Works," 1970.
Park Sonsbeek, Arnhem, The Netherlands, "Sonsbeek 71: Buiten de Perken," 1971.
Kunsthalle Düsseldorf, "Prospect 71: Projection," 1971.
The Museum of Modern Art, New York, "Projects: Pier 18," 1971.
Finch College Museum of Art, New York, "Projected Art," 1971.
John Gibson Gallery, New York, "Body Art," 1971.
Finch College Museum of Art, New York, "Artists' Videotapes," 1971.
Kassel, Documenta 5, 1972.
Kölnischer Kunstverein, Cologne, "Video Tapes," 1974.
The Museum of Modern Art, New York, "Eight Contemporary Artists," 1974.

The Museum of Modern Art, New York, "Video Art," 1975.
Institute of Contemporary Art, University of Pennsylvania, Philadelphia, "Video Art," 1975.
San Francisco Museum of Modern Art, "Video Art: An Overview," 1976.
Venice Biennale, 1976.
Kassel, Documenta 6, 1977.
School of Visual Arts Gallery, New York, "Acconci/Jonas: Video Installations," 1977.

Selected Bibliography

Books and Catalogues
Linker, Kate. *Vito Acconci*. New York: Rizzoli, 1994.
Vito Acconci (exhibition catalogue). Prato, Italy: Museo d'Arte Contemporanea, 1991.
Vito Acconci/Acconci Studio Para-Cities (exhibition catalogue). Bristol: Arnolfini Gallery, 2001.
Vito Acconci: Cultural Space Pieces 1974–1978 (exhibition catalogue). Lucerne: Kunstmuseum Luzern, 1978.
Vito Acconci: Domestic Trappings (exhibition catalogue). La Jolla, California: Museum of Contemporary Art, 1988.
Vito Acconci: Making Public (exhibition catalogue). The Hague: STROOM, 1993.
Vito Acconci: Photographic Works: 1969–1970 (exhibition catalogue). New York: Brooke Alexander Gallery, 1988. Texts by Kate Linker and Vito Acconci.
Vito Acconci: Public Places (exhibition catalogue). New York: The Museum of Modern Art, 1988. Texts by Linda Shearer and Vito Acconci.
Vito Acconci: A Retrospective: 1969 to 1980 (exhibition catalogue). Chicago: Museum of Contemporary Art, 1980.

Articles
Burnham, Jack. "Alice's Head: Reflections on Conceptual Art." *Artforum*, 8 (February 1970), pp. 37–43.
Kozloff, Max. "Pygmalion Reversed." *Artforum*, 14 (November 1975), pp. 30–37.
_____. "Traversing the Field. . .: 'Eight Contemporary Artists' at MoMA." *Artforum*, 13 (December 1974), pp. 44–49.
Krauss, Rosalind. "Notes on the Index: Seventies Art in America." *October*, no. 3 (Spring 1977), pp. 68–81.
_____. "Video: The Aesthetics of Narcissism," *October*, no. 1 (Spring 1976), pp. 50–64.
Pincus-Witten, Robert. "Vito Acconci and the Conceptual Performance." *Artforum*, 10 (April 1972), pp. 47–49.
Sharp, Willoughby. "Body Works." *Avalanche*, no. 1 (Fall 1970), pp. 14–17.
_____, and Liza Bear, "A Discussion with Acconci, Fox, and Oppenheim." *Avalanche*, no. 2 (Winter 1971), pp. 96–99.
Sondheim, Alan. "Vito Acconci: Work, 1973–1984." *Arts Magazine*, 49 (March 1975), pp. 49–52.
"Vito Acconci." *Avalanche*, no. 6 (Fall 1972). Special issue on Vito Acconci with documentation of artist's projects.

William Anastasi

Born 1933, Philadelphia, Pennsylvania
Lives in New York, New York

Selected Film Installations
Viewing a Film in/of a Gallery of the Period and Audition, 1967. 16mm, color, silent; approximately 60 minutes, projected continuously.

Selected Video Installations and Video Sculptures
All closed-circuit except *What Was*.

Through, 1967. Black-and-white video camera, monitor, silent.
8 Hippocratical Programs, 1968. Eight black-and-white video cameras, eight monitors, silent.
Free Will, 1968. Black-and-white video camera, monitor, silent.
Transfer, 1968. Black-and-white video camera, monitor, silent.
Exploit, 1970. Black-and-white video camera, two monitors, silent.
What Was, 1970. Monitor, videotape player, videotape (black-and-white, silent; 60 minutes).

Selected One-Artist Exhibitions
Washington Square Gallery, New York, 1964.
Dwan Gallery, New York, "Sound Objects," 1966.
Dwan Gallery, New York, "Six Sites," 1967.
Dwan Gallery, New York, "Continuum," 1970.
O.K. Harris Gallery, New York, 1973.
Hetzler and Keler, Stuttgart, 1973.
P.S. 1 Museum, Institute for Art and Urban Resources, Long Island City, New York, 1977.

Selected Group Exhibitions
Betty Parsons Gallery, New York, 1964.
Leo Castelli Gallery, New York, "E.A.T. Benefit," 1969.
Musée Cantonal des Beaux-Arts, Lausanne, "3e Salon International des Galeries Pilotes: Artistes et Découvreurs de Notre Temps," 1970.
Paula Cooper Gallery, New York, 1972.
P.S. 1 Museum, Institute for Art and Urban Resources, Long Island City, New York, "Projects for the Seventies," 1977.

Selected Bibliography

Books and Catalogues
Battcock, Gregory. *Why Art: Casual Notes on the Aesthetics of the Immediate Past.* New York: Dutton, 1977.
_____, ed. *Idea Art: A Critical Anthology.* New York: Dutton, 1968.
_____, ed. *Minimal Art: A Critical Anthology* (1968). Rev. ed. Berkeley: University of California Press, 1995.
_____, and Robert Nickas, eds. *The Art of Performance: A Critical Anthology.* New York: Dutton, 1984.
Hanhardt, John, and Eileen Neff, eds. *William Anastasi: A Retrospective 1960–1995* (exhibition catalogue). Philadelphia: Moore College of Art and Design, 1995.

Lippard, Lucy, ed. *Six Years: The Demateriali-zation of the Art Object from 1966 to 1972*. New York: Praeger, 1973.

Merce Cunningham: Fifty Years. New York: Aperture Foundation, 1997.

Morgan, Robert C. *Between Modernism and Conceptual Art*. Jefferson, North Carolina, and London: McFarland, 1997, pp. 156–59.

O'Doherty, Brian. *Inside the White Cube: The Ideology of the Gallery Space*. Santa Monica, California: Lapis Press, 1986. Introduction by Thomas McEvilley.

William Anastasi: Selections of the Work from 1960–1989 (exhibition catalogue). New York: Scott Hanson Gallery, 1989.

William Anastasi: Sink, 1963; Trespass, 1966; Issue 1966; Incision, 1966 (exhibition catalogue). New York: Sandra Gering Gallery, 1991.

William Anastasi: Works from 1961 to 1995 (exhibition catalogue). Stromness, Scotland: The Pier Gallery, 1995.

Articles

Baker, Kenneth. "Dwan Gallery, New York." *Artforum*, 9 (February 1971), p. 80.

Battcock, Gregory. "Wall Paintings and the Wall." *Arts Magazine*, 45 (December 1970), pp. 24–26.

_____. "Four Artists Who Didn't Show in New York This Season." *Arts Magazine*, 42 (Summer 1968), pp. 15–16.

_____. "In the Galleries." *Arts Magazine*, 41 (Summer 1967), p. 57.

Brown, Gordon. "Light: Object and Image." *Arts Magazine*, 42 (Summer 1968), p. 54.

Peter Campus

Born 1937, New York, New York
Lives in East Patchogue, New York

Selected Video Installations
All closed-circuit.

Kiva, 1971. Surveillance camera, monitor, mirrors.

Interface, 1972. Surveillance camera, projector, large glass.

Mer, 1972. Surveillance camera, monitor, pyramid of mirrors.

Prototype for Interface, 1972. Surveillance camera, projector, large glass.

Optical Sockets, 1972–73. Four surveillance cameras, four monitors, mixer.

Stasis, 1973. Two surveillance cameras, projector, mixer, rotating prisms, motor.

Negative Crossing, 1974. Surveillance camera, projector, monitor, screen, black box.

Shadow Projection, 1974. Surveillance camera, projector, screen, spotlight.

dor, 1975. Surveillance camera, projector.

mem, 1975. Low-light surveillance camera, projector, red light.

mir, 1975. Low-light surveillance camera, projector, red light.

sev, 1975. Low-light surveillance camera, projector, red light.

bys, 1976. Low-light surveillance camera, projector, red light.

aen, 1977. Low-light surveillance camera, projector, blue light.

lus, 1977. Low-light surveillance camera, projector, blue light.

num, 1977. Low-light surveillance camera, projector, blue light.

Selected Films
Dark Light, 1966. 16mm, black-and-white, sound; 5 minutes.

Selected Videotapes
Double Vision, 1971. Black-and-white, silent; 15 minutes.

Dynamic Field Series, 1971. Black-and-white, sound; 25 minutes.

Three Transitions, 1973. Color, sound; 6 minutes.

R-G-B, 1974. Color, sound; 15 minutes.

Set of Co-incidence, 1974. Color, sound; 13 minutes.

East Ended Tape, 1976. Color, sound; 8 minutes.

Four Sided Tape, 1976. Color, sound; 4 minutes.

Six Fragments, 1976. Color, sound; 4 minutes.

Third Tape, 1976. Color, sound; 5 minutes.

Selected One-Artist Exhibitions and Screenings
Bykert Gallery, New York, 1972, 1973, 1975.
Everson Museum of Art, Syracuse, 1974.
Leo Castelli Gallery, New York, 1976.
Hayden Gallery, Massachusetts Institute of Technology, Cambridge, 1976.
The Museum of Modern Art, New York, 1976.
The Kitchen, New York, 1977.
Ohio State University, Columbus, 1977.
Atlantic Gallery, Boston, 1978.
Sarah Lawrence College, Bronxville, New York, 1978.
Whitney Museum of American Art, New York, "New American Filmmakers Series," 1978.

Selected Group Exhibitions and Screenings
Finch College Museum of Art, New York, "Projected Art II," 1971.
Finch College Museum of Art, New York, "Video Performances," 1971.
Bykert Gallery, New York, 1972.
Everson Museum of Art, Syracuse, "Circuit: A Video Invitational," 1973.
Whitney Museum of American Art, New York, Biennial Exhibition, 1973.
Kölnischer Kunstverein, "Kunst bleibt Kunst: Project '74: Aspekte internationaler Kunst am Anfang der 70er Jahre," 1974.
Walker Art Center, Minneapolis, "Projected Images," 1974.
Institute of Contemporary Art, University of Pennsylvania, Philadelphia, "Video Art," 1975.
Whitney Museum of American Art, New York, "Projected Video," 1975.
Whitney Museum of American Art, New York, "Autogeography," 1976.
Kassel, Documenta 6, 1977.

Selected Bibliography

Books and Catalogues

Biennale d'Art Contemporain de Lyon: Installation, Cinéma, Vidéo, Informatique (exhibition catalogue). Paris: Réunion des Musées Nationaux/Biennale d'Art Contemporain, 1995, pp. 136–39, 248.

The Elusive Image (exhibition catalogue). Minneapolis: Walker Art Center, 1979.

Peter Campus (exhibition catalogue). Syracuse: Everson Museum of Art, 1974.

Peter Campus (exhibition catalogue). Cologne: Kölnischer Kunstverein, 1979. Texts by Peter Campus, Wulf Herzograth, Roberta Smith.

Peter Campus: Projected Images (exhibition catalogue). New York: Whitney Museum of American Art, 1988. Texts by John G. Hanhardt and Peter Campus.

Peter Campus: Selected Works 1973–1987 (exhibition catalogue). Reading, Pennsylvania: Freedman Gallery, Albright College; Philadelphia: Institute of Contemporary Art, University of Pennsylvania, 1987. Texts by David Rubin and Judith Tannenbaum.

Points of Departure—Origins in Video. New York: Independent Curators Incorporated, 1990, pp. 16–20. Text by William D. Judson.

Projected Images (exhibition catalogue). Minneapolis: Walker Art Center, 1974. Text by Robert Pincus-Witten.

Video Art (exhibition catalogue). Philadelphia: Institute of Contemporary Art, University of Pennsylvania, 1975.

Video-Skulptur: Retrospektiv und Aktuell 1963–1989 (exhibition catalogue). Cologne: Kölnischer Kunstverein, 1989.

Articles

Campus, Peter. "Peter Campus on *sev* (1975)." *Studio International*, 191 (May–June 1976), p. 238.

Davis, Douglas. "Video Obscura." *Artforum*, 10 (April 1972), pp. 64–67.

Krauss, Rosalind. "Video: The Aesthetics of Narcissism." *October*, no. 1 (Spring 1976), pp. 51–64.

Kurtz, Bruce. "Fields: Peter Campus." *Arts Magazine*, 47 (May 1973), pp. 25–29.

_____. "Video Is Being Invented." *Arts Magazine*, 47 (December 1972), pp. 37–44.

Moore, Alan. "Video and the Art Museum at the Everson Museum." *Artforum*, 12 (June 1974), pp. 77–78.

Perreault, John. "Mirrors Worth Reflecting On." *Village Voice*, October 26, 1972, p. 29.

Perrone, Jeff. "The Ins and Outs of Video." *Artforum*, 14 (June 1976), pp. 53–58.

Ross, David A. "Provisional Overview of Artists' Television in the U.S." *Studio International*, 191 (May–June 1976), p. 271.

Smith, Roberta. "About Faces: The New Work of Campus." *Art in America*, 65 (March–April 1977), pp. 85–87.

Simone Forti

Born 1935, Florence, Italy
Lives in Los Angeles, California

Selected Holograms
Integral holography (Multiplex).
 Holographer: Lloyd Cross.

Angel, 1976.
Bug Jump, 1977.
Dancer, 1977.
Figure 8, 1977.
Harmonics, 1977.
Illuminations, 1977.
Planet in Retrograde, 1977.
Striding Crawling, 1977.

Selected Performances with Holograms
Angel, 1976. Judson Memorial Church,
 New York.
Some Images, 1976. Fine Arts Building,
 New York.
Illuminations, 1977. Montreal, "Rencontres
 Internationales d'Art Contemporain."

Selected Performances
Cloths, Song, Face Tunes, 1967. School of
 Visual Arts, New York.
Book, Bottom, Fallers, 1968. School of
 Architecture, Cornell University, Ithaca,
 New York.
Sleep Walkers, Throat Dance, 1968.
 L'Attico, Rome.
Buzzing, Illuminations (later known as *Sheila
 in Progress*), 1971. Pasadena Art Museum,
 California.
The Zero, Crawling, 1974. Sonnabend Gallery,
 New York.
Big Room, 1975. Artists Space, New York.
 With Peter Van Riper.
Fan Dance, 1975. Galleria Ala, Milan.
Red-Green, 1975. Dance Today Festival, Tokyo.
Planet, 1976. P.S. 1, Long Island City, New York.
 Group performance.

Selected Group Exhibitions
Vancouver Art Gallery, "WHOLE MESSAGE
 holos: whole gram: message HOLOGRAPHY,"
 1976.
Museum of Holography, New York, "Opening
 Exhibition," 1976.
Museum of Holography, New York, "Holodeon,"
 1977.

Selected Bibliography

Books and Catalogues
Barilleaux, Rene Paul, ed. *Holography (Re)
 Defined/Innovation Through Tradition*.
 New York: Museum of Holography, 1984.
Forti, Simone. *Handbook in Motion*. Halifax:
 Nova Scotia College of Art and Design,
 1974.
Tyler, Douglas E. *International Exhibition of
 Creative Holography*. Notre Dame, Indiana:
 St. Mary's College, 1983.
*WHOLE MESSAGE holos: whole gram: message
 HOLOGRAPHY* (exhibition catalogue).
 Vancouver: Vancouver Art Gallery, 1976.

Articles
Alliata, Vicky. "Simone Forti, performance
 a Milano (Galleria Ala)." *Domus*, no. 545
 (April 1975), p. 55.
Baker, Rob. "Through the Vanishing Point."
 Soho Weekly News, January 15, 1976.
Goldberg, RoseLee. "Space as Praxis."
 Studio International, 190 (September
 1975), pp. 130–36.
Jackson, Rosemary H. "Off the Wall."
 Holosphere, 8 (November 1979), p. 3.
Minarik, Fran. "Simone Forti's Holographic
 Angel." *Theater Design and Technology* (Fall
 1978), pp. 17–18.
Rubinfien, Leo. "Sonnabend Gallery, New York;
 Exhibit." *Artforum*, 17 (December 1978),
 p. 65.
"Show me your dances . . . Joan Jonas and
 Simone Forti Talk with Carla Liss." *Art and
 Artists*, 8 (October 1973), pp. 14–21.

Dan Graham

Born 1942, Urbana, Illinois
Lives in New York, New York

Selected Films
Sunset to Sunrise, 1969. 16mm, color, silent;
 8 minutes.
Two Correlated Rotations, 1969. Two Super-8
 films enlarged to 16mm, black-and-white,
 silent, 3 minutes; projected simultaneously
 on perpendicular walls.
Binocular Zoom, 1969–70. Two Super-8 films,
 color, silent, 1 minute; projected simulta-
 neously as one split-screen image.
Roll, 1970. Two Super-8 films enlarged to
 16mm, color, silent, 1 minute; projected
 simultaneously on parallel walls.
Body Press, 1970–72. Two 16mm films, color,
 silent, 20 minutes; projected simultaneously
 on parallel walls.
Helix/Spiral, 1973. Two Super-8 films enlarged
 to 16mm, color, silent, 3 minutes; projected
 simultaneously on opposite walls.

Selected Video Installations
All closed-circuit.

Mirror Window Corner Piece, 1974. Mirrored
 corner across from windowed/glass
 corner, two video cameras, two monitors,
 with time-delay.
Opposing Mirrors, 1974. Two mirrors, two video
 cameras, two monitors, with time-delay.
Present Continuous Past, 1974. Two-way
 mirror, camera zoom, monitor, micro-
 processor, with time-delay.
Time Delay Room 1, 1974. Two rooms with one
 entry/exit, video camera, two monitors,
 with time-delay.
Two Rooms/Reverse Video Delay, 1974. Two
 rooms, mirrored walls, two video cameras,
 two monitors, with time-delay.
Video Piece for Courtyard, 1974. Windows of
 two rooms across a courtyard, mirrored
 walls, two video cameras, two monitors,
 with time-delay.
Two Viewing Rooms, 1975. Two-way mirror,
 video camera, monitor, fluorescent lights.
Yesterday/Today, 1975. Video camera, monitor,
 microphones, with audio time-delay.
*Video Piece for Showcase Windows in Shopping
 Arcade*, 1976. Two mirrors, two video cameras,
 two monitors, with time-delay.
Video Piece for Two Glass Office Buildings,
 1976. Two mirrors, two video cameras, two
 monitors, with time-delay.

Selected Slide Projections
Project for Slide Projector, 1966. 80 35mm
 slides, color.
Homes for America, 1966–67. Approximately
 20 35mm slides, color.

Selected Videotapes
Lax/Relax, 1969/96. Published by Lisson
 Gallery, London.
Past Future Split Attention, 1972. Black-and-
 white, sound; 17 minutes.
Performer/Audience/Mirror, 1975. Black-
 and-white, sound; 23 minutes.

Selected Performances
Lax/Relax, 1969. Paula Cooper Gallery,
 New York, "Coulisse."
TV Camera/Monitor Performance, 1970. Nova
 Scotia College of Art and Design, Halifax.
Like, 1971. Nova Scotia College of Art and
 Design, Halifax.
Project for a Local Cable TV, 1971. Nova Scotia
 College of Art and Design, Halifax.
Intention Intentionality Sequence, 1972.
 Lisson Gallery, London.
Past Future Split Attention, 1972. Lisson
 Gallery, London.
Two Consciousness Projection(s), 1972.
 98 Greene Street Loft, New York.
*Time Delay Room 2, Time Delay Room 3, Time
 Delay Room 7*, 1974. Nova Scotia College of
 Art and Design, Halifax.
Two Rooms/Relative Slow-Motion, 1974. Nova
 Scotia College of Art and Design, Halifax.
Performer/Audience Sequence, 1975. San
 Francisco Art Institute.
Performer/Audience/Mirror, 1977. De Appel,
 Amsterdam.

Selected One-Artist Exhibitions
and Screenings
Lisson Gallery, London, 1972, 1974.
Galleria Marilena, Bonomo, Bari, Italy, 1974.
Griffiths Art Centre, St. Lawrence University,
 Canton, New York, "Video Project," 1975.
John Gibson Gallery, New York, 1975.
Palais des Beaux-Arts, Brussels, 1975.
Artists Space, New York, "Artists' Film Series:
 Dan Graham," 1976.
Galerie Vega, Liège, Belgium, 1976.
Kunsthalle, Basel, 1976 (with Lawrence Weiner).
Leeds Polytechnic Gallery, Leeds, England, "Video
 Piece for Two Glass Office Buildings," 1976.
New Gallery, Institute of Contemporary Arts,
 London, 1976.
Museum van Hedendaagse Kunst, Ghent,
 Belgium, "Two Rooms Reverse Video Delay,"
 1977.
Stedelijk Van Abbemuseum, Eindhoven,
 The Netherlands, 1977.

Selected Group Exhibitions and Screenings
Finch College Museum of Art, New York, "Projected Art," 1966.
Multiples Gallery, New York, "Artists and Photographs," 1969.
Städtisches Museum, Leverkusen, "Konzeption-Conception," 1969.
Moore College of Art, Philadelphia, "Recorded Activities," 1970.
The Museum of Modern Art, New York, "Information," 1970.
The Museum of Modern Art, New York, "Projects: Pier 18," 1971.
Park Sonsbeek, Arnhem, The Netherlands, "Sonsbeek 71: Buiten de Perken," 1971.
Kunsthalle Düsseldorf, "Prospect 71: Projection," 1971.
Kassel, Documenta 5, 1972.
Musée d'Art Moderne de la Ville de Paris, "Art Video/Confrontation," 1974.
Wallraf-Richardtz-Museum, Kölnischer Kunstverein, and Kunsthalle, Cologne, "Kunst bleibt Kunst: Project '74: Aspekte internationaler Kunst am Anfang der 70er Jahre," 1974.
Institute of Contemporary Art, University of Pennsylvania, Philadelphia, "Video Art," 1975.
Venice Biennale, "Ambiente Arte," 1976.
Kassel, Documenta 6, 1977.
Philadelphia College of Art, Philadelphia, "Time," 1977.

Selected Bibliography

Books and Catalogues
Alberro, Alexander, and Dan Graham, eds. *Two Way Mirror Power: Selected Writings by Dan Graham on His Art*. Cambridge, Massachusetts: The MIT Press, 1999.
Brouwer, Marianne, ed. *Dan Graham Works 1965–2000* (exhibition catalogue). Porto: Museu de Arte Contemporânea de Serralves, 2001. Interviews by Benjamin H.D. Buchloh and Markus Müller; texts by Marianne Brouwer, Eric de Bruyn, Thierry de Duve, Brian Hatton, John Miller.
Buchloh, Benjamin H.D., ed. *Dan Graham: Video–Architecture–Television: Writings on Video and Video Works 1970–1978*. Halifax: The Press of the Nova Scotia College of Art and Design; New York: New York University Press, 1979. Contributions by Michael Asher and Dara Birnbaum.
Dan Graham: Kunst und Architektur/ Architektur und Kunst (exhibition catalogue). Villeurbane: Le Nouveau Musée; Eindhoven: Stedelijk Van Abbemuseum; Munich: Museum Villa Stuck, 1994. Texts by Jo-Anne Birnie Danzker, Dan Graham, Birgit Pelzer, Adachiara Zevi.
Films (exhibition catalogue). Geneva: Éditions Centre d'Art Contemporain, Salle Patino, and Écart Publications, 1977. Texts by Dan Graham.
Graham, Dan. *Dan Graham: Articles*. R.H. Fuchs, ed. Eindhoven: Stedelijk Van Abbemuseum, 1978. Texts by Fuchs and Benjamin H.D. Buchloh.
Huber, Hans-Dieter, ed. *Dan Graham: Interviews*. Ostfildern-Ruit: Cantz, 1997. Interviews and text by Huber.
Moure, Gloria, ed. *Dan Graham: 12 May–12 July 1998* (exhibition catalogue). Barcelona: Fundació Antoni Tàpies, 1998.
Six Films (exhibition catalogue). New York: Artists Space, 1976.
Wallis, Brian, ed. *Dan Graham: Rock My Religion. Writings and Art Projects 1965–1990*. Cambridge, Massachusetts: The MIT Press, 1993. Text by Dan Graham.

Articles
Dercon, Chris. "Dan Graham" (interview). *Forum International*, 9 (September–October 1991), pp. 73–80.
Graham, Dan. "Dan Graham: Various Pieces." *Interfunktionen*, no. 9 (1973), pp. 57–64.
_____. "Eight Pieces by Dan Graham, 1966–72." *Studio International*, 183 (May 1972), pp. 210–13.
_____. "Film Pieces: Visual Field"; documentation of works. *Interfunktionen*, no. 8 (January 1972), pp. 27–33.
_____. "Several Works" and "Performance as Perceptual Process," *Interfunktionen*, no. 7 (1971), pp. 83–89.
_____. "Two Consciousness Projections(s)." *Arts Magazine*, 49 (December 1974), pp. 63–66.
Kuspit, Donald. "Dan Graham: Prometheus Mediabound." *Artforum*, 23 (May 1985), pp. 75–81.
Meyer, R. "Dan Graham: Past and Present." *Art in America*, 63 (November 1975), p. 83.

Gary Hill

Born 1951, Santa Monica, California
Lives in Seattle, Washington

Selected Video Installations
Hole in the Wall, 1974. Site-specific, single-channel, black-and-white, sound; repeated continuously.

Selected Videotapes
The Fall, 1973. Black-and-white, sound; 11 minutes.
Air Raid, 1974. Black-and-white, sound; 6 minutes.
Rock City Road, 1974–75. Color; silent; 12 minutes.
Earth Pulse, 1975. Color, sound; 6 minutes.
Improvisations with Bluestone, 1976. Color, sound; 6 minutes.
Mirror Road, 1976. Color, silent; 6 minutes.
Bathing, 1977. Color, silent; 4 minutes.
Bits, 1977. Color, silent; 2 minutes.

Selected One–Artist Exhibitions and Screenings
El Jay Gallery, Los Angeles, 1968.
Polari Gallery, Woodstock, New York, "Gary Hill: Painted Constructions," 1971.
Polari Gallery, Woodstock, New York, 1972. With Donna Albright.
Allusion Gallery, New York, 1973.
Woodstock Artists Association, Woodstock, New York, "Gary Hill: Constructions," 1973.
South Houston Gallery, New York, 1974.
Anthology Film Archives, New York, 1975, 1976, 1977.
Woodstock Artists Association, Woodstock, New York, "Videotapes: Gary Hill," 1976.

Selected Group Exhibitions and Screenings
Woodstock Artists Association, Woodstock, New York, 1970, 1971, 1972, 1973, 1974.
The Museum of Modern Art, New York, "Projects: Video VI," 1975.
Annual New York Avant-Garde Festival, 1975.
Walnut Street Theatre, Philadelphia, "An Evening of Video," 1975.
Artists' Cooperative Gallery, Woodstock, New York, "Woodstock Video Exposition," 1975.
Everson Museum of Art, Syracuse, "New Work in Abstract Video Imagery," 1976.
Ohio University, Athens, Athens International Film Festival, 1976.
Woodstock Community Video, Woodstock, New York, "Woodstock Video Expovision '76," 1976.
Arnolfini Arts Center, Rhinebeck, New York, "Dance Video Music," 1977.
Ithaca, New York, 3rd Annual Ithaca Video Festival, 1977.
Woodstock Artists Association, Woodstock, New York, "Videotapes, Performances, Installations," 1977.

Selected Bibliography

Books and Catalogues
Bruce, Chris, ed. *Gary Hill* (exhibition catalogue). Seattle: Henry Art Gallery, 1994. Texts by Lynne Cooke, Bruce W. Ferguson, John G. Hanhardt, Robert Mittenthal.
Gary Hill (exhibition catalogue). Valencia: I.V.A.M. Centre del Carme, 1993. Texts by Christine Van Assche, Gary Hill, Jacinto Lageira, Lynne Cooke, Hippolyte Massardier.
Gary Hill: Around and About: A Performative View. Boxed edition containing a DVD compilation by Gary Hill entitled "Performative Images" (with excerpts from videotapes, installations, and performances) and three books: Gary Hill, *Withershins 1995*; Jacinto Lageira, *Des Premiers Mots aux derniers silences*; George Quasha and Charles Stein, *La Performance elle-même*. Paris: Éditions du Regard, 2001.
Gary Hill: In Light of the Other (exhibition catalogue). Oxford: Museum of Modern Art Oxford; Liverpool: Tate Gallery Liverpool, 1993. Texts by Corinne Diserens, Bruce Ferguson, Stuart Morgan, Lars Nittve, Robert Mittenthal.
Gary Hill: Midnight Crossing (exhibition catalogue). Münster: Westfälischer Kunstverein, 1997. Texts by Heinz Liesbrock and Robert Mittenthal.
Gary Hill: Sites Recited (exhibition catalogue). Long Beach, California: Long Beach Museum of Art, 1993. Texts by Harold B. Nelson, Carole Ann Klonarides, Steven Kolpan, George Quasha, Raymond Bellour.
Morgan, Robert C., ed. *Gary Hill*. Baltimore: PAJ Books and The Johns Hopkins University Press, 2000. Texts by Robert C. Morgan, Barbara London, Jacques Derrida, et al.

Quasha, George, and Charles Stein. *Gary Hill: Hand Heard–Liminal Objects* (exhibition catalogue). Paris: Galerie des Archives; Barrytown, New York: Station Hill Arts, 1996.

———. *Tall Ships: Gary Hill's Projective Installations—Number 2* (exhibition catalogue). Barrytown, New York: Station Hill Arts, 1997.

———. *Viewer: Gary Hill's Projective Installations—Number 3* (exhibition catalogue). Barrytown, New York: Station Hill Arts, 1997.

Van Assche, Christine. *Gary Hill* (exhibition catalogue). Trans. by Alexia Walker. Paris: Éditions du Centre Georges Pompidou, 1992. Texts by Lynne Cooke, Jacinto Lageira, Hippolyte Massardier.

Vischer, Theodora, ed. *Gary Hill: Imagining the Brain Closer Than the Eyes* (exhibition catalogue). Basel: Museum für Gegenwartskunst; Ostfildern: Cantz, 1995. Texts by Hans Belting, Gottfried Boehm, Gary Hill, et al.

Articles

Cooke, Lynne. "Gary Hill: 'Who am I but a figure of speech?'" *Parkett*, no. 34 (1992), pp. 16–27.

Cornwell, Regina. "Interview with Gary Hill." *Art Monthly*, 170 (October 1993), pp. 3–11.

Duncan, Michael. "In Plato's Electronic Cave." *Art in America*, 83 (June 1995), pp. 68–73.

Furlong, Lucinda. "A Manner of Speaking: An Interview with Gary Hill." *Afterimage*, 10 (March 1983), pp. 9–16.

Lageira, Jacinto. "Une Verbalisation du regard." *Parachute*, no. 62 (April–May–June 1991), pp. 4–11.

Joan Jonas

Born 1936, New York, New York
Lives in New York, New York

Selected Performances

Oad Lau, 1968. St. Peter's Church, New York.
Mirror Piece I, 1969. Loeb Student Center, New York University, New York.
Mirror Piece II, 1970. Emanu-El YMHA, New York.
Mirror Check, 1970. Performed as part of *Mirror Piece II*, 1970; later performed as part of *Organic Honey's Vertical Roll*, 1972–74.
Choreomania, 1971. Jonas' loft, Grand Street, New York.
Nova Scotia Beach Dance, 1971. Outdoor performance in Inverness, Cape Breton, Nova Scotia.
Delay, Delay, 1972. Outdoor performance on lower west side of Manhattan and at Documenta 5, Kassel.
Organic Honey's Vertical Roll, 1972. Video performance, Ace Gallery, Los Angeles.
Organic Honey's Visual Telepathy, 1972. Video performance, LoGiudice Gallery, New York.
Funnel, 1974. Video performance, The Kitchen, New York; Kunsthalle, Cologne, "Kunst bleibt Kunst: Project '74: Aspekte internationaler Kunst am Anfang der 70er Jahre."
Twilight, 1975. Video performance, Anthology Film Archives, New York; Los Angeles Institute of Contemporary Art.
Twilight (& Native Dance), 1976. Video performance, San Francisco Museum of Art.
Mirage, 1976. Video performance, Anthology Film Archives, New York, 1976; Documenta 6, Kassel, 1977.

Selected Films

Wind, 1968. 16mm, black-and-white, silent; 6 minutes. Camera and co-editing: Peter Campus.
Veil, 1971. 16mm, black-and-white, silent; 6 minutes, kinescope, projected continuously.
Paul Revere, 1971. 16mm, black-and-white, sound; 9 minutes. In collaboration with Richard Serra; camera: John Knopp.
Songdelay, 1973. 16mm, black-and-white, sound; 18 minutes. Camera and co-editing: Robert Fiore; sound: Kurt Munkacsi.

Selected Videotapes

Duet, 1972. Black-and-white, sound; 4 minutes.
Left Side Right Side, 1972. Black-and-white, sound; 9 minutes.
Organic Honey's Visual Telepathy, 1972. Black-and-white, sound; 17 minutes.
Vertical Roll, 1972. Black-and-white, sound; 20 minutes.
Barking, 1973. Black-and-white, sound; 2 minutes. With Simone Forti.
Disturbances, 1974. Black-and-white, sound; 11 minutes.
Glass Puzzle, 1974. Black-and-white, sound; 17 minutes.
Merlo, 1974. Black-and-white, sound; 11 minutes.
Three Returns, 1974. Black-and-white, sound; 13 minutes.
Two Women, 1974. Black-and-white, silent; 20 minutes.
Good Night, Good Morning, 1976. Black-and-white, sound; 12 minutes.
May Windows, 1976. Black-and-white, sound; 14 minutes.
I Want to Live in the Country (and Other Romances), 1976–77. Color, sound; 24 minutes.

Selected One-Artist Exhibitions and Screenings

Institute of Contemporary Art, University of Pennsylvania, Philadelphia, "Stage Sets," 1976.
School of Visual Arts, New York, "Drawing Room," 1977.

Selected Group Exhibitions and Screenings

Musée Galliéra, Paris, "Aspects de l'art actuel présentés par la Galérie Sonnabend," 1973.
Saõ Paulo Bienal, 1973.
Kunsthalle, Cologne, "Kunst bleibt Kunst: Project '74: Aspekte internationaler Kunst am Anfang der 70er Jahre," 1974.
Kennedy Center for the Performing Arts, Washington, D.C., "Art Now," 1974.
Berlin International Filmforum, 1975.
Serpentine Gallery, London, "The Video Show," 1975.
San Francisco Museum of Art, "Video Art: An Overview," 1975.
Whitney Museum of American Art, New York, "New American Filmmakers Series," 1975.
Galerie Krinzinger, Innsbruck, "Frauenkunst–Neue Tendenzen," 1977.
Kassel, Documenta 6, "Three Tales," 1977.

Selected Bibliography

Books and Catalogues

Almhofer, Edith. *Performance Art: Joan Jonas, Laurie Anderson, Carolee Schneemann, Colette* (exhibition catalogue). Vienna: Böhlau Verlag, 1986.

Arman, Bour, Jonas, Kirkeby (exhibition catalogue). Munich: Berliner Künstlerprogramm DAAD at Künstlerwerkstatt München, 1983.

Crimp, Douglas, ed. *Joan Jonas: Scripts and Descriptions, 1968–1982* (exhibition catalogue). Berkeley: University Art Museum, University of California; Eindhoven: Stedelijk Van Abbemuseum, 1983. Introduction by Douglas Crimp, text by David Ross.

Joan Jonas: Works 1968–1994 (exhibition catalogue). Amsterdam: Stedelijk Museum, 1994. Introduction by R.H. Fuchs; texts by Bruce Ferguson and Dorine Mignot.

Schmidt, Johann-Karl, ed. *Joan Jonas: Performances Film Installations 1968–2000* (exhibition catalogue). Stuttgart: Hatje Cantz, 2001. Introduction and interview by Joan Simon; texts by Ralf Christofori, Chrissie Iles, Andre Jahn, Johann-Karl Schmidt, et al.

Video Art: Expanded Forms (exhibition catalogue). New York: Whitney Museum of American Art, 1988.

Articles

Carroll, Noël. "Joan Jonas: Making the Image Visible." *Artforum*, 12 (April 1974), pp. 52–53.

Crimp, Douglas. "Joan Jonas's Performance Works." *Studio International*, 192 (July–August 1976), pp. 10–12.

de Jong, Constance. "Joan Jonas: Organic Honey's Vertical Roll." *Arts Magazine*, 47 (March 1973), pp. 27–29.

———. "Organic Honey's Visual Telepathy." *The Drama Review*, 16 (June 1972), pp. 63–65.

Hanhardt, John G., and Joan Jonas. "The New American Filmmakers Series." *Whitney Museum of American Art Bulletin*, 7 (1982), pp. 1–43.

Jonas, Joan, and Rosalind Krauss. "Seven Years." *The Drama Review*, 19 (March 1975), pp. 13–16.

Junker, Howard. "Joan Jonas: The Mirror Staged." *Art in America*, 69 (February 1981), pp. 87–95.

Kaye, Nick. "Mask, Role, Narrative: An Interview with Joan Jonas." *Performance*, no. 65–66 (Spring 1992), pp. 48–59.

Reiring, Janelle. "Joan Jonas: Delay Delay." *The Drama Review*, 16 (September 1972), pp. 142–51.

Silverthorne, Jeanne. "Performance as Metamorphosis: The Art of Joan Jonas." *Philadelphia Arts Exchange*, 1 (March–April 1977), pp. 11–14.

Simon, Joan. "Scenes and Variations: An Interview with Joan Jonas." *Art in America*, 7 (July 1995), pp. 72–79, 100–101.

Beryl Korot

Born 1945, New York, New York
Lives in New York, New York

Selected Video Installations
Dachau 1974, 1974. Four-channel, black-and-white, sound; 24 minutes, repeated continuously.
Text and Commentary, 1976. Five-channel, black-and-white, sound; 35 minutes, repeated continuously; five weavings, five drawings, five pictographic notations.

Selected Videotapes
Organic/Inorganic, Information Collage of Metaphysician/Architect Anne Tyng, 1972. Black-and-white, sound; 24 minutes.
Trilogy: Invision; Lost Lascaux Bull; Transit, 1973. Black-and-white, sound; 24 minutes.
Berlin Bees, 1974. Black-and-white, sound; 5 minutes, repeated continuously.

Selected One-Artist Exhibitions and Screenings
The Kitchen, New York, 1974.
Everson Museum of Art, Syracuse, 1975.
Hartwick College, Center for the Arts, Oneonta, New York, 1976.
Leo Castelli Gallery, New York, 1977.

Selected Group Exhibitions and Screenings
Finch College Museum of Art, New York, "Women in the Arts," 1972.
Los Angeles County Museum of Art, "Circuit Invitational," 1973.
Creative Artist Public Service Grants, New York State Council, Video Festival, 1974.
Kennedy Center for the Performing Arts, Washington, D.C., "Art Now," 1974.
Kölnischer Kunstverein, "Kunst bleibt Kunst: Project '74: Aspekte internationaler Kunst am Anfang der 70er Jahre," 1974.
Media Study Center, Buffalo, "Women in Film and Video," 1974.
Whitney Museum of American Art, New York, Biennial Exhibition, 1975.
Kölnischer Kunstverein, "Radical Software," 1975.
São Paulo Bienal, 1975.
Kassel, Documenta 6, 1977.

Selected Bibliography

Books and Catalogues
Cott, Jonathan. *The Cave* Libretto. Beryl Korot and Steve Reich (interview). New York: Boosey and Hawkes, 1993.
Hanhardt, John. "The Television Environment." In Ira Schneider and Beryl Korot, eds. *Video Art*. New York and London: Harcourt Brace Jovanovich, 1976.
Judson, Bill. *Points of Departure: Origins in Video* (exhibition brochure). Pittsburgh: Carnegie Museum of Art, 1990.
Kain, Jacqueline. *Planes of Memory* (exhibition catalogue). Long Beach, California: Long Beach Museum of Art, 1988.
Nemiroff, Diane. "Text and Commentary." In *Yesterday and Today* (exhibition catalogue). Montreal: Musée des Beaux-Arts, 1980.
Schneider, Ira, and Beryl Korot, eds. *Video Art*. New York and London: Harcourt Brace Jovanovich, 1976.

Articles
Cott, Jonathan. "Modern Folk Tales and Ancient Stories: A Conversation with Beryl Korot and Steve Reich." *Afterimage*, 27 (Fall 1999), p. 7.
Davidson, Gigliotti. "Text and Commentary." *Soho Weekly News*, March 31, 1977.
Freed, Hermine. "In Time, of Time." *Arts Magazine*, 49 (June 1975), pp. 82–84.
Heineman, Susan. "Dachau 1974." *Artforum*, 13 (June 1975), p. 76.
Knight, Christopher. "Moving Pictures and 'Planes of Memory.'" *Los Angeles Herald Examiner*, February 14, 1988.
Korot, Beryl. "Dachau 1974." *Studio International*, 191 (May–June 1976), p. 276.
Perrone, Jeff. "Text and Commentary." *Artforum*, 15 (May 1977), p. 63.
Ross, David A. "Provisional Overview of Artists' Television in the U.S." *Studio International*, 191 (May–June 1976), pp. 265–72.
Taubin, Amy. "See Me, Feel Me." *Village Voice*, August 30, 1988.
Vita, Tricia. "Text and Commentary." *Feminist Art Journal*, 5 (Summer 1977), p. 45.
Wiegand, Ingrid. "Multi-Monitors." *Soho Weekly News*, March 20, 1975.
Zimmer, William. "Text and Commentary." *Arts Magazine*, 51 (May 1977), p. 33.

Mary Lucier

Born 1944, Bucyrus, Ohio
Lives in New York, New York

Selected Performances and Projected Works
Polaroid Image Series #1: Room, 1970. Black-and-white Polaroid photographs and slides. Solomon R. Guggenheim Museum, New York.
Polaroid Image Series #2–6: Shigeko; Croquet; City of Boston; David Behrman; Three Points, 1970–72. Black-and-white Polaroid photographs and slides.
The Caverned Man, 1971. Performance with miniature projected images. Wesleyan University, Middletown, Connecticut.
Color Phantoms, 1971. Series of projected 35mm sandwiched slides. First exhibited with a sensory environment by composer Richard Martin. Wesleyan University, Middletown, Connecticut.
Journal of Private Lives, 1972. Performance with slide projections, film projection, and live projected writing. Spencer Memorial Church, Brooklyn.
Second Journal (Miniature), 1972. Four rear-screen miniature slide projections with magnifying glasses. South Street Seaport, New York, Ninth Annual New York Avant-Garde Festival.
Red Herring Journal (The Boston Strangler Was a Woman), 1972. Performance with slide projections, live projected writing, and spoken text. The Kitchen, New York, "Red, White, Yellow, and Black."
The Occasion of Her First Dance and How She Looked, 1973. Performance with video, slide projections, and audio text in a mixed-media set (videotape, black-and-white; 30 minutes). Collaboration with Cecilia Sandoval. The Kitchen, New York, "Red, White, Yellow, and Black."
Antique with Video Ants and Generations of Dinosaurs, 1973. Mixed-media installation with video (videotape, black-and-white, silent; 30 minutes, repeated continuously). Grand Central Terminal, New York, Tenth Annual New York Avant-Garde Festival.
The Trial of Anne Opie Wehrer by Robert Ashley, 1974. Videotape, black-and-white, sound; 52 minutes. Shot as part of a performance of the Merce Cunningham Dance Company at Cunningham Studio, New York.
Chalk Writing with Air Writing/Video, 1974. Mixed-media performance with black-and-white videotape, photographs, and text. Shea Stadium, Flushing, New York, Eleventh Annual New York Avant-Garde Festival.
Air Writing, 1975. Three-channel video installation, black-and-white, sound; 40 minutes, repeated continuously. The Kitchen, New York.
Fire Writing, 1975. Performance with lasers, video camera, prerecorded audio text with accumulating live vidicon burn calligraphy displayed on multiple monitors; black-and-white, sound; 40 minutes. The Kitchen, New York.
Dawn Burn, 1975–76. Seven-channel video installation with seven monitors and color slide projections; black-and-white, silent; 30 minutes, repeated continuously. Anthology Film Archives, New York.
Untitled Display System, 1977. Installation with burned vidicon tubes and videotape (black-and-white, silent; repeated continuously). And/Or Gallery, Seattle.
A Burn for the Bigfoot/Sasquatch, 1977. Three-channel video performance with slide projections (videotape, black-and-white, sound; 30 minutes). And/Or Gallery, Seattle.
Paris Dawn Burn, 1977. Seven-channel video installation with seven monitors and color slide projection; black-and-white, sound; 30 minutes, repeated continuously. Musée d'Art Moderne de la Ville de Paris, "10e Biennale de Paris."
Laser Burning Video/Lasering, 1977. Installation with live laser, camera, and videotape (black-and-white, silent; repeated continuously). Hudson River Museum, Yonkers, New York.
XY, 1978. Performance with slide projections, suspended helium neon laser, and musical hose. P.S. 1, Long Island City, New York, "A Tower in the Auditorium of P.S. 1."

Selected Videotapes
Fire Writing I and II, 1975–76. Videotapes from live performances of *Fire Writing* at

The Kitchen, New York, and the Everson Museum of Art, Syracuse. Black-and-white, sound; 40 minutes.

Bird's Eye, 1978. Black-and-white, sound; 10 minutes. Music by Alvin Lucier.

Selected One-Artist Exhibitions
St. Clements Estate, Portland, Connecticut, 1971.
The Kitchen, New York, 1975.
Anthology Film Archives, New York, 1976.
Everson Museum of Art, Syracuse, 1976.
And/Or Gallery, Seattle, 1977.

Selected Group Exhibitions
Walker Art Center, Minneapolis; Solomon R. Guggenheim Museum, New York, "Sonic Arts Union," 1970.
Spencer Memorial Church, Brooklyn, "Three New Works," 1972.
The Kitchen, New York, "Red, White, Yellow, and Black," 1973.
Grand Central Terminal, New York, Tenth Annual New York Avant-Garde Festival, 1973.
Rose Art Museum, Brandeis University, Waltham, Massachusetts, "A Generation of Brandeis Artists," 1974.
Everson Museum of Art, Syracuse, "New Work in Abstract Video Imagery," 1976.
Musée d'Art Moderne de la Ville de Paris, "10e Biennale de Paris," 1977.

Selected Bibliography

Books and Catalogues
Barlow, Melinda, ed. *Mary Lucier: Art and Performance.* Baltimore: The Johns Hopkins University Press, 2000.
The First Generation: Women and Video, 1970–1975 (exhibition catalogue). New York: Independent Curators Incorporated, 1993.
Hall, Doug, and Sally Jo Fifer, eds. *Illuminating Video: An Essential Guide to Video Art.* New York: Aperture Books/Bay Area Video Coalition, 1991.
Hanhardt, John G., ed. *Video Art: Expanded Forms* (exhibition catalogue). New York: Whitney Museum of American Art at Equitable Center, 1988.
Judson, William D., ed. *American Landscape Video* (exhibition catalogue). Pittsburgh: Carnegie Museum of Art, 1988.
Knowles, Alison, and Anna Lockwood, eds. *Women's Work.* Brooklyn: Print Center, 1975.
Making Their Mark: Women Artists Move into the Mainstream, 1970–85. New York: Abbeville Press, 1989.
Musée d'Art Moderne de la Ville de Paris. *10e Biennale de Paris* (exhibition catalogue). Paris: Musée d'Art Moderne de la Ville de Paris, 1977.
Schneider, Ira, and Beryl Korot, eds. *Video Art.* New York: Harcourt Brace Jovanovich, 1976.
Tsai, Eugenie, and Kerri Sakamoto. *Gazing Back: Shigeko Kubota and Mary Lucier* (exhibition brochure). New York: Whitney Museum of American Art, 1995.

Articles
Cornwell, Regina. "Mary Lucier." *Artscribe*, no. 87 (Summer 1991), pp. 67–68.
Duguet, Anne-Marie. "The Luminous Image: Video Installation." *Camera Obscura*, 13–14 (1985), pp. 29–40.
Grundberg, Andy. "Mary Lucier." *Artforum*, 22 (Summer 1984), p. 90.
Lorber, Richard. "Mary Lucier: The Kitchen." *Artforum*, 17 (September 1978), p. 81.
Lucier, Mary. "Organic." *Art and Cinema*, 3 (December 1978), pp. 23–27, 66–67.
Morgan, Robert. "Mary Lucier." *Arts Magazine*, 63 (April 1989), p. 98.

Anthony McCall

Born 1946, St. Paul's Cray, England
Lives in New York, New York

Selected Films
Stages, 1971. 16mm, color, silent; 1 minute.
Landscape for Fire, 1972. 16mm, color, optical sound; 7 minutes.
Untitled I, II, III, IV, V, 1972. 16mm, color, silent; each 2 minutes.
Line Describing a Cone, 1973. 16mm, black-and-white, silent; 31 minutes.
Cone of Variable Volume, 1974. 16mm, black-and-white, silent; 10 minutes.
Conical Solid, 1974. 16mm, black-and-white, silent; 10 minutes.
Long Film for Four Projectors, 1974. 16mm, black-and-white, silent; 75 minutes.
Partial Cone, 1974. 16mm, black-and-white, silent; 15 minutes.
Four Projected Movements, 1975. 16mm, black-and-white, silent; 75 minutes.
Long Film for Ambient Light, 1975. 16mm, black-and-white, silent; projected continuously.
Argument, 1978. 16mm, color, optical sound; 75 minutes. Collaboration with Andrew Tyndall.
Sigmund Freud's Dora, 1979. 16mm, color, optical sound; 40 minutes. Collaboration with Claire Pajaczkowska, Andrew Tyndall, Jane Weinstock.

Selected Performances
Landscape for Fire I, 1972. Open-air performance, Pearman's Grove Farm, Reading, England.
Landscape for Fire II, 1972. Open-air performance, North Weald, England.
Landscape for Fire III, 1972. Open-air performance, Oxford University, Oxford.
Fire Cycles I, 1973. William Patterson University, Wayne, New Jersey.
Fire Cycles II, 1973. Fylkingen Society for Contemporary Music and Arts, Stockholm.

Selected One-Artist Exhibitions and Screenings
Artists Space, New York, 1974, 1976.
Collective for Living Cinema and Film Forum, New York, "Anthony McCall: Solid Light Films," 1974.
London Filmmakers Cooperative, London, 1974, 1975.
Millennium Film Workshop, New York, 1974, 1976.
Museum of Modern Art, Oxford, 1974.
Collective for Living Cinema, New York, 1975.
Carnegie Museum of Art, Pittsburgh, 1975.
Serpentine Gallery, London, 1975.
Musée National d'Art Moderne, Centre Georges Pompidou, Paris, 1976.
The Museum of Modern Art, New York, "Cineprobe," 1976.
Neue Galerie, Aachen, 1976.

Selected Group Exhibitions and Screenings
Gallery House, London, "A Survey of the Avant-Garde in Britain," 1972.
Fylkingen Society for Contemporary Music and Arts, Stockholm, Autumn Arts Festival, 1973.
The Clocktower, New York, "Works: Words," 1974.
Arnolfini Gallery, Bristol, Festival of Independent British Cinema, 1975.
Biennale de Paris, 1975.
The Idea Warehouse, New York, "Ideas," 1975.
Wright State University Art Gallery, Dayton, Ohio, "Luminous Realities," 1975.
30th International Film Festival, Edinburgh, International Forum of Avant-Garde Film, 1976.
Institute of Contemporary Arts, London, Festival of Expanded Cinema, 1976.
Venice Biennale, "Where Are You Standing?" 1976. With Joseph Kosuth and Sarah Charlesworth.
Kassel, Documenta 6, 1977.
Kölnischer Kunstverein, "Film als Film: 1910 bis heute," 1977.
San Francisco Art Institute, "Four and Seven," 1977.

Selected Bibliography

Books and Catalogues
Hanhardt, John. "The Medium Viewed." In *A History of the American Avant-Garde Cinema* (exhibition catalogue). New York: American Federation of Arts, 1976.
MacDonald, Scott. *A Critical Cinema II* (interview). Berkeley: University of California Press, 1992, pp. 157–74.
McCall, Anthony, and Andrew Tyndall, eds. *Argument.* New York: Jay Street Film Project, 1979.
Sitney, P. Adams, ed. *The Avant-Garde Film: A Reader of Theory and Criticism.* New York: New York University Press, 1978.

Articles
"Anthony McCall." *Performing Arts Journal* (interview), 1 (1977), pp. 51–61.
Carroll, Noël. "The Soho Syndrome (Interview with Anthony McCall and Andrew Tyndall)." *Soho Weekly News*, August 30, 1979, pp. 38, 48.
Curtis, David. "Festival of Expanded Cinema." *Studio International*, 191 (March 1976), p. 211.
Dusinberre, Deke. "On Expanding Cinema." *Studio International*, 190 (November–December 1975), pp. 220–24.
Ehrenberg, Felipe. "On Conditions (Felipe Ehrenberg Discusses the Work of Anthony McCall)." *Art and Artists*, 7 (June 1973), pp. 39–43.

LeGrice, Malcolm. "Line Describing a Cone." *Studio International*, 187 (February 1974), pp. 82–83.

MacDonald, Scott. "The Cinema Audience: Some New Perspectives." *Film Criticism*, 3 (Spring 1979), pp. 32–40.

McCall, Anthony, and Andrew Tyndall. "Sixteen Working Statements." *Millennium Film Journal*, 1 (Spring–Summer 1978), pp. 29–37.

Michelson, Annette, and P. Adams Sitney. "A Conversation on Knokke and the Independent Filmmaker." *Artforum*, 13 (May 1976), pp. 63–66.

Rayns, Tony. "Exprmntl 5: Line Describing an Impasse." *Sight and Sound International Film Quarterly*, 44 (Spring 1975), pp. 78–80.

Rich, B. Ruby. "Light for Light's Sake." *Chicago Reader*, 7 (January 1978).

Weinstock, Jane. "Sigmund Freud's Dora?" *Screen*, 22 (1981), pp. 73–79.

_____. "The Subject of Argument." *Downtown Review*, 1 (1979), pp. 6–8.

Robert Morris

Born 1931, Kansas City, Missouri
Lives in Gardiner, New York

Selected Film Installations
Finch College Project, 1969. 16mm, black-and-white, silent, projected continuously; motorized platform.

Selected Films
Gas Station, 1969. Two-screen projection, 16mm, color, silent; 34 minutes.
Mirror, 1969. 16mm, black-and-white, silent; 9 minutes.
Slow Motion, 1969. 16mm, black-and-white, silent; 18 minutes.
Wisconsin, 1970. 16mm, black-and-white, silent; 15 minutes.
Neo-Classic, 1971. 16mm, black-and-white, silent; 15 minutes.

Selected Videotapes
Exchange, 1973. Black-and-white, sound; 32 minutes.

Selected One-Artist Exhibitions
Dwan Gallery, Los Angeles, 1966.
Leo Castelli Gallery, New York, 1967, 1968, 1969, 1972, 1974, 1976, 1979.
Stedelijk Van Abbemuseum, Eindhoven, The Netherlands, 1968.
Galerie Ileana Sonnabend, Paris, 1968, 1971, 1973, 1974, 1976, 1979.
Corcoran Gallery of Art, Washington, D.C., 1969.
The Detroit Institute of Arts, 1970.
Whitney Museum of American Art, New York, 1970.
Tate Gallery, London, 1971.
Ace Gallery, Venice, California, 1973.
Galerie Konrad Fischer, Düsseldorf, 1973.
Galerie Art in Progress, Munich, 1974, 1977.

Institute of Contemporary Art, University of Pennsylvania, Philadelphia, 1974.
Louisiana Museum of Modern Art, Humlebaek, Denmark, 1977.
Stedelijk Museum, Amsterdam, 1977.

Selected Group Exhibitions
Finch College Museum of Art, New York, "Art in Process," 1966.
The Museum of Modern Art, New York, "New Media: New Methods," 1969.
Stedelijk Museum, Amsterdam, "Op Losse Schroeven: Situaties en Cryptostructuren (Square Pegs in Round Holes)," 1969.
Finch College Museum of Art, New York, "Art in Process IV," 1969.
Hayward Gallery, London, "Pop Art," 1969.
Kunsthalle Bern, "When Attitudes Become Form: Works—Concepts—Processes—Situations—Information: Live in Your Head," 1969.
The Museum of Modern Art, New York, "Information," 1970.
Kunsthalle Nürnberg, "Artist/Theory/Work," 1971.
Leo Castelli Gallery, New York, "Works on Film," 1971.
Los Angeles County Museum of Art, "Art & Technology Program of the Los Angeles County Museum of Art (1967–1971)," 1971.
Kunsthalle Düsseldorf, "Prospect 71: Projection," 1971.
Louisiana Museum of Modern Art, Humlebaek, Denmark, "Projektion," 1972.
Musée National d'Art Moderne, Centre Georges Pompidou, Paris, "Art/Voir," 1974.

Selected Bibliography

Books and Catalogues
Berger, Maurice. *Labyrinths: Robert Morris, Minimalism, and the 1960s*. New York: Harper and Row, 1989.
Compton, Michael, and David Sylvester. *Robert Morris*. London: Barron, 1977.
Krauss, Rosalind, Maurice Berger, and David Antin. *Robert Morris: The Mind/Body Problem* (exhibition catalogue). New York: Guggenheim Museum Publications, 1994.
Morris, Robert. *Continuous Project Altered Daily: The Writings of Robert Morris*. Cambridge, Massachusetts: The MIT Press, 1993.
Robert Morris (exhibition catalogue). Eindhoven: Stedelijk Van Abbemuseum, 1968. Texts by Jean Leering and Annette Michelson.
Robert Morris. Washington, D.C.: Corcoran Gallery of Art, 1969. Text by Annette Michelson.
Robert Morris (exhibition catalogue). London: Tate Gallery, 1971.
Robert Morris: Mirror Works 1961–78 (exhibition catalogue). New York: Leo Castelli, 1979.
Robert Morris: Selected Works 1970–1980 (exhibition catalogue). Houston: Contemporary Arts Museum, 1982. Text by Marti Mayo.
Tucker, Marcia. *Robert Morris*. New York: Whitney Museum of American Art, 1970.

Articles
Battcock, Gregory. "Robert Morris." *Arts Magazine*, 42 (May 1968), pp. 30–31.
Celant, Germano. "Robert Morris: Information, Documentation, Archives." *Arte Contemporanea*, 7 (1971), pp. 36–43.
Krauss, Rosalind. "Sense and Sensibility." *Artforum*, 12 (November 1973), pp. 43–53.
Michelson, Annette. "3 Notes on an Exhibition as a Work." *Artforum*, 8 (June 1970), pp. 62–64.
Morris, Robert. "Anti-Form." *Artforum*, 6 (April 1968), pp. 33–35.
_____. "Notes on Sculpture." *Artforum*, 4 (February 1966), pp. 42–44.
_____. "Notes on Sculpture, Part II." *Artforum*, 5 (October 1966), pp. 20–23.
_____. "Notes on Sculpture, Part III," *Artforum*, 5 (June 1967), pp. 24–29.
_____. "Notes on Sculpture, Part IV." *Artforum*, 7 (April 1969), pp. 50–54.
_____. "The Present Tense of Space." *Art in America*, 66 (January–February 1978), pp. 70–81.
_____. "Some Notes on the Phenomenology of Making: The Search for the Motivated." *Artforum*, 8 (April 1970), pp. 62–66.
Rainer, Yvonne. "Don't Give the Game Away." *Arts Magazine*, 41 (April 1967), pp. 44–47.
Rose, Barbara. "Problems of Criticism, VI: The Politics of Art, Part 3." *Artforum*, 7 (May 1969), pp. 46–51.

Bruce Nauman

Born 1941, Fort Wayne, Indiana
Lives in Galisteo, New Mexico

Selected Film Installations
Rotating Glass Walls, 1970. Four 16mm film loops (transferred to Super-8), black-and-white, silent; projected continuously.
Spinning Spheres, 1970. Four 16mm film loops (transferred to Super-8), color, silent; projected simultaneously on four walls.
Set design for *Rollback*, 1970. Two-screen projection, 16mm (transferred from video), color, sound.

Selected Video Installations
All closed-circuit except *Untitled*.

Video Corridor for San Francisco (Come Piece), 1969. Two video cameras, two monitors.
Audio Video Piece for London, Ontario, 1969–70. Video camera, monitor, audiotape player, audiotape.
Video Surveillance Piece (Public Room, Private Room), 1969–70. Two video cameras, two monitors.
Corridor Installation (Nick Wilder Installation), 1970. Wallboard, three video cameras, scanner and mount, five monitors, videotape player, videotape (black-and-white, silent).
Four Corner Piece, 1970. Wallboard, four video cameras, four monitors.
Going Around the Corner Piece, 1970. Wallboard, four video cameras, four monitors.

Going Around the Corner Piece with Live and Taped Monitors, 1970. Wallboard, video camera, two monitors, videotape player, videotape.
Live-Taped Video Corridor, 1970. Wallboard, video camera, two monitors, videotape player, videotape.
Untitled, 1970. Performance, videotape, two monitors.
Indoor/Outdoor, 1972. Video camera, monitor, microphone, amplifier.
Audio-Video Underground Chamber, 1972–74. Concrete chamber, video camera, microphone, rubber gasket, steel plate, bolts, cord, monitor.

Selected Films
Manipulating the T-Bar, 1965–66. 16mm, black-and-white, silent; 10 minutes.
Abstracting the Shoe, 1966. 16mm, color, silent; 3 minutes. Made with William Allan.
Building a New Slant Step, 1966. 16mm, black-and-white, silent; 8 minutes. Made with William Allan (unfinished).
Fishing for Asian Carp, 1966. 16mm, color, sound; 3 minutes. Made with William Allan and Robert Nelson.
Legal Size, 1966. 16mm, color, silent; 4 minutes. Made with William Allan.
Span, 1966. 16mm, color, silent; 11 minutes. Made with William Allan.
Bouncing Two Balls Between the Floor and Ceiling with Changing Rhythms, 1967. 16mm, black-and-white, sound; 10 minutes.
Thighing, 1967. 16mm, color, sound; 10 minutes.
Art Make-Up, No. 1: White, Art Make-Up, No. 2: Pink, Art Make-Up, No. 3: Green, Art Make-Up, No. 4: Black, 1967–68. 16mm, color, silent; 10 minutes each.
Dance or Exercise on the Perimeter of a Square, 1967–68. 16mm, black-and-white, sound; 10 minutes.
Playing a Note on the Violin While I Walk Around the Studio, 1967–68. 16mm, black-and-white, sound; 10 minutes.
Walking in an Exaggerated Manner Around the Perimeter of a Square, 1967–68. 16mm, black-and-white, silent; 10 minutes.
Pinch Neck, 1968. 16mm, color, silent; 2 minutes.
Black Balls, 1969. 16mm, black-and-white, silent; 8 minutes.
Bouncing Balls, 1969. 16mm, black-and-white, silent; 9 minutes.
Gauze, 1969. 16mm, black-and-white, silent; 8 minutes.
Pulling Mouth, 1969. 16mm, black-and-white, silent; 8 minutes.
Pursuit, 1975. 16mm, color, sound; 28 minutes. Made with Frank Owen.

Selected Videotapes
All repeated continuously.

Bouncing in the Corner, No. 1, 1968. Black-and-white, sound; 60 minutes.
Flesh to White to Black to Flesh, 1968. Black-and-white, sound; 60 minutes.
Slow Angle Walk (Beckett Walk), 1968. Black-and-white, sound; 60 minutes.
Stamping in the Studio, 1968. Black-and-white, sound; 60 minutes.

Walk with Contrapposto, 1968. Black-and-white, sound; 60 minutes.
Wall-Floor Positions, 1968. Black-and-white, sound; 60 minutes.
Bouncing in the Corner, No. 2: Upside Down, 1969. Black-and-white, sound; 60 minutes.
Lip Sync, 1969. Black-and-white, sound; 60 minutes.
Manipulating a Fluorescent Tube, 1969. Black-and-white, sound; 60 minutes.
Pacing Upside Down, 1969. Black-and-white, sound; 60 minutes.
Revolving Upside Down, 1969. Black-and-white, sound; 60 minutes.
Violin Tuned D E A D, 1969. Black-and-white, sound; 60 minutes.
Elke Allowing the Floor to Rise Up over Her, Face Up, 1973. Color, sound; 40 minutes.
Tony Sinking into the Floor, Face Up and Face Down, 1973. Color, sound; 60 minutes.

Selected One-Artist Exhibitions and Screenings
Nicholas Wilder Gallery, Los Angeles, 1966, 1970.
Leo Castelli Gallery, New York, 1968, 1969, 1971, 1973, 1975, 1978.
Galerie Konrad Fischer, Düsseldorf, 1968.
Galerie Ileana Sonnabend, Paris, 1969, 1971, 1974.
Palley Cellar, San Francisco, 1969.
San Jose State College, San Jose, California, 1970.
Ursula Wevers, Cologne, "Bruce Nauman: 16mm Filme 1967–1970," 1972.
Los Angeles County Museum of Art, Los Angeles; Whitney Museum of American Art, New York, "Bruce Nauman: Work from 1965 to 1972," 1972.
Ace Gallery, Vancouver, 1973.
Galerie Art in Progress, Munich, 1974.
Albright-Knox Art Gallery, Buffalo, 1975.

Selected Group Exhibitions and Screenings
Kassel, Documenta 4, 5, 6, 1968, 1972, 1977.
Kunsthalle Düsseldorf, "Prospect 68," 1968.
John Gibson Gallery, New York, "Anti-Form," 1968.
Museum Folkwang, Essen, "Op Losse Schroeven: Situaties en Cryptostructuren (Square Pegs in Round Holes)," 1969.
Kunsthalle Bern, "When Attitudes Become Form: Works—Concepts—Processes—Situations—Information: Live in Your Head," 1969.
Whitney Museum of American Art, New York, "Anti-Illusion: Procedures/Materials," 1969.
Finch College Museum of Art, New York, "Art in Process IV," 1969.
Finch College Museum of Art, New York, "N Dimensional Space," 1970.
Park Sonsbeek, Arnhem, The Netherlands, "Sonsbeek 71: Buiten de Perken," 1971.
Loeb Student Center, New York University, New York, "Body," 1971.
Kunsthalle Düsseldorf, "Prospect 71: Projection," 1971.
Hansen-Fuller Gallery, San Francisco, "The Artist as Filmmaker," 1971.
Whitney Museum of American Art, New York, "Films by American Artists," 1972.

Selected Bibliography

Books and Catalogues
Art in Process (exhibition catalogue). New York: Finch College Museum of Art, 1969. Text by Elayne H. Varian.
Bruce Nauman (exhibition catalogue). New York: Leo Castelli, 1968. Text by David Whitney.
Bruce Nauman (exhibition catalogue). London: Whitechapel Art Gallery, 1986. Texts by Jean-Christophe Ammann, Nick Serota, Joan Simon.
Bruce Nauman: Image/Text, 1966–1996 (exhibition catalogue). Paris: Musée National d'Art Moderne/Centre de Création Industrielle, Centre Georges Pompidou, 1997. Texts by François Albera, Michele De Angelus, Chris Dercon, et al.
Bruce Nauman, 1972–1981 (exhibition catalogue). Otterlo: Kröller-Müller Museum; Baden-Baden: Staatliche Kunsthalle, 1981. Texts by Katharina Schmidt, Ellen Joosten, Siegmar Holsten.
Bruce Nauman Drawings, 1965–1986 (exhibition catalogue and catalogue raisonné of drawings). Basel: Museum für Gegenwartskunst, 1986. Texts by Coosje van Bruggen, Dieter Koepplin, Franz Meyer.
Bruce Nauman: Work from 1965 to 1972 (exhibition catalogue). Los Angeles: Los Angeles County Museum of Art; New York: Whitney Museum of American Art, 1972. Texts by Jane Livingston and Marcia Tucker.
Bruggen, Coosje van. *Bruce Nauman*. New York: Rizzoli, 1988.
Hoffmann, Christine, ed. *Bruce Nauman: Interviews, 1967–1988*. Amsterdam: Verlag der Kunst, 1996.
Simon, Joan, ed. *Bruce Nauman* (exhibition catalogue and catalogue raisonné). Minneapolis: Walker Art Center, 1994. Texts by Neal Benezra, Kathy Halbreich, Paul Schimmel, Robert Storr.

Articles
"Body Works." *Interfunktionen*, no. 6 (September 1971), pp. 2–8.
Cooke, Lynne. "Minimalism Reviewed." *Burlington Magazine*, 131 (September 1989), pp. 641–45.
Danieli, Fidel A. "The Art of Bruce Nauman," *Artforum*, 6 (December 1967), pp. 15–19.
Nauman, Bruce. "Notes and Projects." *Artforum*, 9 (December 1970), p. 44.
Plagens, Peter. "Roughly Ordered Thoughts on the Occasion of the Bruce Nauman Retrospective in Los Angeles." *Artforum*, 11 (March 1973), pp. 57–59.
Price, Jonathan. "Video Art: A Medium Discovering Itself." *Art News*, 76 (January 1977), pp. 41–47.

Yoko Ono

Born 1933, Tokyo
Lives in New York, New York

Selected Films
No. 1 (Match) (also known as *Fluxfilm 14*), 1966.
16mm, black-and-white, silent; 5 minutes.
Eyeblink (also known as *Fluxfilm 9*, *Fluxfilm 15*,
One, and *One Blink*), 1966. 16mm, black-and-
white, silent; 5 minutes.
No. 4 (also known as *Fluxfilm 16*), 1966. 16mm,
black-and-white, silent; 6 minutes.
Film No. 4 (Bottoms), 1966–67. 16mm, black-
and-white, sound; 80 minutes.
Film No. 12 (Up Your Legs Forever), 1967–70.
16mm, color, sound; 70 minutes.
Wrapping Event, 1967. 16mm, color, sound;
14 minutes.
Film No. 5 (Smile), 1968. 16mm, color, sound;
51 minutes.
Fly (also known as *Film No. 13*), 1968–70. 16mm,
color, sound; 25 minutes.
Rape (also known as *Film No. 5* and *Rape
[or Chase]*), 1968–69. 16mm, color, sound;
77 minutes. Directed in collaboration with
John Lennon.
Two Virgins, 1968. 16mm, color, sound;
19 minutes. Directed and produced in
collaboration with John Lennon.
Bed-In, 1969. 16mm, color, sound; 61 minutes.
Directed and produced in collaboration
with John Lennon.
Apotheosis, 1970. 16mm, color, sound; 19
minutes. Directed and produced in collabo-
ration with John Lennon.
Freedom, 1970. 16mm, color, sound; 1 minute.
Erection, 1971. 16mm, color, sound; 20 minutes.
Directed and produced in collaboration
with John Lennon.
Imagine, 1971. 16mm, color, sound; 70 minutes.
Directed and produced in collaboration
with John Lennon.
The Museum of Modern Art Show, 1971. 16mm,
color, sound; 7 minutes.

Video Work
Sky TV, 1966. Color television set and video
camera (closed-circuit).

Selected Film Scripts and Scores
The Walk to the Taj Mahal, 1964.
Mona Lisa & Her Smile, 1964.
Film Script 3, 1964.
Film Script 4, 1964.
Film Script 5, 1964.
Omnibus Film, 1964.
Film No. 12 (Up Your Legs Forever), 1967.
Film No. 1 (A Walk to Tajmahal), 1968.
Film No. 2 (Watch), 1968.
Film No. 3 (Toilet Thoughts), 1968.
Film No. 4 (Bottoms), 1968.
Film No. 5 (Rape or Chase), 1968.
*Film No. 6 (A Contemporary Sexual Manual
[366 Sexual Positions])*, 1968.
Film No. 7 (Tea Party), 1968.
Film No. 8 (Woman), 1968.
Film No. 9 (Don't Worry Love), 1968.
Film No. 10 (Sky), 1968.
Film No. 11 (Passing), 1968.
Film No. 13 (Fly), 1968.
*Imaginary Film Series, Shi—From the Cradle
to the Grave of Mr. So*, 1968.

Selected One–Artist Exhibitions and Screenings
Yamaichi Hall, Kyoto, "Contemporary American
Avant-Garde Music Concert: Insound and
Instructure," 1964. With Anthony Cox and
Al Wonderlick.
Carnegie Recital Hall, New York, "New Works
by Yoko Ono," 1965.
Indica Gallery, London, "Yoko at Indica," 1966.
Jacey Tatler Cinema, London, "Film No. 4," 1967.
Lisson Gallery, London, "Yoko Ono at Lisson:
Half-A-Wind Show," 1967.
Arts Lab Center, London, "Yoko Ono: Water
Show," 1968.
ORF TV, Vienna, "Rape" (film screening with
John Lennon), 1969.
New Cinema Club at Institute of Contemporary
Arts, London, "Evening with John and Yoko,"
1969.
Elgin Theatre, New York, "7 3/4 New York Film
Festival," 1970.
Everson Museum of Art, Syracuse, "This Is
Not Here," 1971.
"Museum of Modern [F]Art," 1971.
Whitney Museum of American Art, New York,
"Films of John Lennon and Yoko Ono," 1972.

Selected Group Exhibitions and Screenings
Film-Maker's Cinematheque at 41st Street
Theatre, New York, Fluxfilm Festival, 1966.
Judson Memorial Church, New York, 1966.
The Museum of Modern Art, "Animation: Films
from Many Nations," 1966.
Palais des Beaux-Arts, Brussels, Fourth
International Experimental Film Festival/
Knokke–Le Zoute, 1967.
Galerie Ben Doute de Tout, Venice, "Projecteur
de Films Fluxus," 1967.
Galerie Tobies & Siles, Cologne, "Fluxfilme und
Multiprojektionen," 1967.
Chicago International Film Festival, 1968.
Institute of Contemporary Arts, London, 1969.
"9ème Rose d'Or de Montreux," Switzerland,
1969.
Kölnischer Kunstverein, "Happening and
Fluxus," 1970.
Alexandra Palace, London, "Art Spectrum,"
1971.
Cannes Film Festival, 1971, 1972.
Grauman's Chinese Theatre, Los Angeles,
First Los Angeles International Film
Exposition, 1971.
San Francisco International Film Festival, 1971.
Kassel, Documenta 5, 1972.
Whitney Museum of American Art, New York,
"Imagine," 1973.

Selected Bibliography

Books and Catalogues
Benglian, Ani. *The Films of Yoko Ono*
(exhibition brochure). Boston: Institute
of Contemporary Art, 1990.
Hanhardt, John G. *The Films of Yoko Ono*
(exhibition brochure). New York: Whitney
Museum of American Art, 1991. Text by
Barbara Haskell.
Haskell, Barbara, and John G. Hanhardt.
Yoko Ono: Arias and Objects (exhibition
catalogue). New York: Whitney Museum
of American Art, 1991.
Hendricks, Jon. *Fluxus Codex*. New York:
Harry N. Abrams, in association with The
Gilbert and Lila Silverman Fluxus Collection,
Detroit, 1988.
____. *Yoko Ono: Color, Fly, Sky*. Roskilde,
Denmark: Museet for Samtidkunst, 1992.
Texts by Yoko Ono.
____, ed. *Yoko Ono: The Bronze Age*.
Bloomfield Hills, Michigan: Cranbrook
Academy of Art Museum, 1989. Texts by
Yoko Ono, Jon Hendricks, George Maciunas,
Roy Slade.
Iles, Chrissie, ed. *Yoko Ono: Have You Seen
the Horizon Lately?* (exhibition catalogue).
Oxford: Museum of Modern Art, 1997.
"John" by Yoko Ono, "Yoko" by John Lennon.
Coventry, England, 1968. Texts by Yoko Ono,
John Lennon, Anthony Fawcett.
Les Films de Yoko Ono 1966–82. Geneva:
Saint Gervais Genève et le Centre d'Art
Contemporain de Genève, 1992.
MacDonald, Scott. "Yoko Ono." In *A Critical
Cinema 2: Interviews with Independent
Filmmakers*. Berkeley: University of
California Press, 1992, pp. 139–56.
____. "Yoko Ono: 4 (Bottoms)." In *Avant-Garde
Film: Motion Studies*. New York: Cambridge
University Press, 1993.
Munroe, Alexandra, ed., with Jon Hendricks.
Yes Yoko Ono. New York: Harry N. Abrams,
2000. Texts by David A. Ross, Murray Sayle,
Jann S. Wenner; contributions by Bruce
Altshuler et al.
Ono, Yoko. "Addendum '88." On Film No. 4
(in taking the bottoms of 365 saints of our
time)." "On Film No. 5 & Two Virgins." "On Film
No. 6 (Rape)." "Shi—From the Cradle to the
Grave of Mr. So—A Film of Super-Realism."
Reprinted in *Yoko Ono Conceptual
Photography*. Copenhagen: Fotografisk
Center, 1997.
____. *Grapefruit*. Tokyo: Wunternaum Press,
1964.
____. *Grapefruit*. New York: Simon and
Schuster, 1970.
____. "Six Film Scripts by Yoko Ono Tokyo,
June 1964." Self-published. Reprinted
in *Yoko Ono Conceptual Photography*.
Copenhagen: Fotografisk Center, 1997.
____. "Thirteen Film Scores by Yoko Ono
London '68." Self-published. Reprinted in
Yoko Ono Conceptual Photography.
Copenhagen: Fotografisk Center, 1997.
____. "To the Wesleyan People (who attended
the meeting.)—a footnote to my lecture
of January 13th, 1966." Self-published as
insert in *The Stone*. New York: Judson
Gallery, 1966.
O'Pray, Michael. "Yoko Ono: Bodily Matters."
In *Yoko Ono In Facing*. London: Riverside
Studios, 1990.
This Is Not Here. Syracuse: Everson Museum
of Art, 1971.
Yoko Ono at Indica. London: Indica Gallery,
1966.
Yoko Ono at Lisson: Half-A-Wind Show. London:
Lisson Gallery, 1967. Text by Yoko Ono.

Articles

Benedikt, Michael. "Yoko Notes." *Art and Artists*, 6 (January 1972), pp. 26–29.

Chin, Daryl. "Walking on Thin Ice: The Films of Yoko Ono." *The Independent* (New York), 12 (April 1989), pp. 19–23.

Durgnat, Raymond. "Film No. 4." *Films and Filming*, 14 (October 1967), pp. 24–25.

Lambert, Jean-Clarence. "Yoko Ono." *Opus International*, 28 (November 1971), p. 48.

Maciunas, George. "A Footnote." *Film Culture*, 48–49 (Winter–Spring 1970), pp. 32–33.

Wasserman, Emily. "Yoko Ono at Syracuse: 'This Is Not Here.'" *Artforum*, 10 (January 1972), pp. 69–73.

Williams, Sheldon. "The Arts: Patterns in Today's Art: 1. Miniature Philosopher—The Trials of Yoko Ono." *Contemporary Review*, 212 (May 1968), pp. 263–69.

Wolfram, Eddie. "London: Does Yoko Ono Know?" *Art and Artists*, 1 (March 1967), pp. 42–45.

Dennis Oppenheim

Born 1938, Electric City, Washington
Lives in New York, New York

Selected Film Installations

Material Interchange, 1970. Two Super-8 loops, color, silent.
Gingerbread Man, 1970–71. Super-8 loop (transferred to video), black-and-white, silent.
Protection, 1972. Super-8 loop, color, silent.
Echo, 1973. Three Super-8 loops (transferred to video), black-and-white, sound.
Whirlpool—Eye of the Storm, 1973. Super-8 loop (transferred to video), color, silent.
Gunfire, 1974. Three Super-8 loops, black-and-white, sound.

Selected Video Installations

All repeated continuously.

Color Application for Chandra, 1971. Single-channel, color, sound.
Untitled Installation for Video Projector (Proposal for Yvon Lambert), 1971. Single-channel, live transmission, color, sound.
Violations, 1971–72. Single-channel, black-and-white, silent.
Face to Face Interrogation (Proposal for Rotterdamse Kunststichting), 1973. Two-channel, color, sound.
Pull Video Project (Proposal with Mirrored Wall/Graphic Dust Floor), 1973. Single-channel, black-and-white, sound.
Rehearsal for Five Hour Slump, 1973. Single-channel, black-and-white, sound.
Untitled Video Installation (Proposal for Gallery D, Brussels), 1973. Two-channel, color, silent.
Recall, 1974. Single-channel, black-and-white, sound.
Video Project for Indoor/Outdoor Situation (Proposal for Kennedy Center, Washington, D.C.), 1974. Two-channel, color, silent.

Black Skin—Black Walls, 1975. Two-channel, black-and-white, sound.
Golden Slide Rule, 1975. Two-channel, closed-circuit, black-and-white, silent, two performers.
Mind Twist—Wandering, 1975. Two-channel, black-and-white, sound.
Search for Clues, 1976. Single-channel, color, sound.
Whipping into Shape, 1977. Single-channel, color, sound.

Selected Slide Installations

Ground Gel, 1972. Two-screen projection, color; dissolve system.
Polarities, 1972. Two-screen projection, color; dissolve system.
2000' Shadow Projection, 1972. Two-screen projection, color; dissolve system.

Selected Films

Arm and Asphalt, 1969. 16mm, black-and-white, silent; 6 minutes.
Arm and Wire, 1969. 16mm, black-and-white, silent; 8 minutes.
Backtrack, 1969. 16mm, black-and-white, sound; 7 minutes.
Wrist and Land, 1969. 16mm, black-and-white, silent; 12 minutes.
Compression—Fern (Face), 1970*. 16mm, color, silent; 6 minutes.
Compression—Fern (Hand), 1970*. 16mm, color, silent; 6 minutes.
Compression—Poison Oak, 1970*. 16mm, color, silent; 3 minutes.
Extended Armour, 1970*. 16mm, black-and-white, silent; 2 minutes.
Fusion: Tooth and Nail, 1970*. 16mm, color, silent; 12 minutes.
Gingerbread Man, 1970*. 16mm, black-and-white, silent; 2 minutes.
Gingerbread Man, 1970*. Super-8, black-and-white, silent; 9 minutes.
Glassed Hand, 1970. 16mm, color, silent; 3 minutes.
Lead Sink for Sebastian, 1970. Super-8, color, silent; 5 minutes.
Leafed Hand, 1970*. 16mm, color, silent; 4 minutes.
Material Interchange, 1970*. Super-8, black-and-white, silent; 3 minutes.
Nail Sharpening, 1970*. 16mm, black-and-white, silent; 3 minutes.
Nail Sharpening, 1970*. Super-8, color, silent; 6 minutes.
Parallel Arcs, 1970. Super-8, color, silent; 6 minutes.
Pressure Piece (Fingers), 1970*. 16mm, color, silent; 6 minutes.
Pressure Piece (Glass), 1970*. 16mm, color, silent; 6 minutes.
Rocked-Circle-Fear, 1970. Super-8, color, silent; 30 minutes.
Rocked Hand, 1970*. 16mm, color, silent; 3 minutes.
Rocked Stomach, 1970*. 16mm, color, silent; 3 minutes.
Toward Becoming a Devil, 1970*. 16mm, black-and-white, silent; 2 minutes.
Arm Wrestle, 1970–71. Super-8, black-and-white, silent; 6 minutes.

Broad Jump, 1970–71. Super-8, color, silent; 6 minutes.
Extended Skin Strata, 1970–71. Super-8, black-and-white, silent; 6 minutes.
Foot Pressure, 1970–71. Super-8, black-and-white, silent; 6 minutes.
Landslide #1, 1970–71. Super-8, black-and-white, silent; 6 minutes.
Landslide #2, 1970–71. Super-8, black-and-white, silent; 6 minutes.
Slow Punch, 1970–71. Super-8, black-and-white, silent; 6 minutes.
Stomach X Ray, 1970–71. Super-8, black-and-white, silent; 6 minutes.
Objectified Counter Forces, 1971. Super-8, color, silent; 2 minutes.
Toward Becoming a Scarecrow, 1971. Super-8, color, silent; 16 minutes.
Disappear, 1972. 16mm, black-and-white, sound; 9 minutes.
I'm Failing, 1972. 16mm, color, sound; 5 minutes.
My Father's Socks, 1972. 16mm, black-and-white, sound; 6 minutes.
Playing Dead, 1972. 16mm, black-and-white, sound; 12 minutes.
Stewing Around, 1972. 16mm, black-and-white, sound; 16 minutes.
Brush, 1973. 16mm, color, sound; 5 minutes.
Mittens, 1974. 16mm, black-and-white, sound; 8 minutes.

* Compiled as a separate film program, "Aspen Projects, 1970–1971." More recently recompiled on video as "Aspen Projects, 1970: Program One and Two."

Selected Videotapes

Air Pressure (Face), 1970. Black-and-white, silent; 15 minutes.
Rocked-Circle-Fear, 1970. Black-and-white, silent; 30 minutes.
Air Pressure (Hand), 1971. Black-and-white, silent; 15 minutes.
Do-It, 1971. Black-and-white, silent; 11 minutes.
Extended Expressions, 1971. Black-and-white, silent; 15 minutes.
Feed-Back: Kristin, 1971. Color, silent; 10 minutes.
A Feedback Situation, 1971. Black-and-white, silent; 15 minutes.
Forming Sounds, 1971. Black-and-white, silent; 5 minutes.
Shadow Projection, 1971. Black-and-white, silent; 5 minutes.
Spinal Tap, 1971. Color, silent; 10 minutes.
Star Exchange, 1971. Color, silent; 10 minutes.
Tooth and Nail, 1971. Black-and-white, silent, 15 minutes.
Tooth and Nail, 1971. Color, silent, 10 minutes.
Two Stage Transfer Drawing (Advancing to a Future State), 1971. Black-and-white, silent; 13 minutes.
Two Stage Transfer Drawing (Returning to a Past State), 1971. Black-and-white, silent; 8 minutes.
Vibration #1, 1971. Black-and-white, silent; 20 minutes.
Vibration #2, 1972. Black-and-white, silent; 15 minutes.
Bar Time, 1975. Color, sound; 30 minutes.

Drumming up Old Work, 1975. Color, sound;
45 minutes.
Flash in the Pan, 1975. Color, sound; 20 minutes.
Like Swatting Flies, 1975. Color, sound;
20 minutes.
Pulling, 1975. Color, silent; 20 minutes.
Spinning Knife, 1975. Color, sound; 45 minutes.
Spinning a Yarn, 1975. Color, sound; 45 minutes.
Study, 1975. Color, sound; 20 minutes.

Selected One-Artist Exhibitions and Screenings
Galerie Yvon Lambert, Paris, 1969, 1971, 1972.
School of Visual Arts, New York, "Films by
Dennis Oppenheim," 1970.
L'Attico, Rome, "Films and Projects," 1972.
Sonnabend Gallery, New York, "Continuous
Outdoor Projections," 1972.
Tate Gallery, London, 1972.
Museum of Conceptual Art, San Francisco, 1973.
Stedelijk Museum, Amsterdam, 1974.
Anthology Film Archives, New York, "Selected
Films and Video Tapes," 1975.
The Kitchen, New York, 1975.
Palais des Beaux-Arts, Brussels, 1975.
M.L. d'Arc Gallery, New York, "Search for Clues,"
1976.
Museum Boijmans Van Beuningen, Rotterdam,
1976.
CARP, Venice, "A New Projection Project," 1977.

Selected Group Exhibitions and Screenings
Kunsthalle Bern, "When Attitudes Become
Form: Works—Concepts—Situations—
Information: Live in Your Head," 1969.
Kunsthalle Düsseldorf, "Prospect 69," 1969.
Stedelijk Museum, Amsterdam, "Op Losse
Schroeven: Situaties en Cryptostructuren
(Square Pegs in Round Holes)," 1969.
The Art Institute of Chicago, "Films—Wabash
Transit," 1970.
San Francisco Museum of Art, "Body," 1970.
The Museum of Modern Art, New York,
"Information," 1970.
The Museum of Modern Art, New York,
"Recorded Activities," 1970.
Finch College Museum of Art, New York,
"Artist/Video/Performance," 1971.
Kunsthalle Düsseldorf, "Prospect 71:
Projection," 1971.
Park Sonsbeek, Arnhem, The Netherlands,
"Sonsbeek 71: Buiten de Perken," 1971.
Kassel, Documenta 5, 1972.
Kunsthalle, Cologne, "Kunst bleibt Kunst:
Project '74: Aspekte internationaler
Kunst am Anfang der 70er Jahre," 1974.
Institute of Contemporary Art, University of
Pennsylvania, Philadelphia, "Video Art," 1975.
Lunds Konsthall, Lund, Sweden, "Camera Art,"
1975.
Museum of Contemporary Art, Chicago,
"Body Works," 1975.
São Paulo Bienal, "Video Art USA," 1975.
Venice Biennale, "72–76," 1976.
Kassel, Documenta 6, 1977.

Selected Bibliography

Books and Catalogues
Celant, Germano. *Oppenheim Explorations*.
Milan: Edizioni Charta, 1997.

Dennis Oppenheim (exhibition catalogue).
Amsterdam: Stedelijk Museum, 1974.
Text by Gijs van Tuyl.
*Dennis Oppenheim: Retrospective Works
1967–1977* (exhibition catalogue). Montreal:
Musée d'Art Contemporain, 1978. Text by
Peter Frank; interview by Alain Parent.
Dennis Oppenheim: Selected Works: 1967–90
(exhibition catalogue). Long Island City,
New York: P.S.1 Museum, The Institute for
Art and Urban Resources, 1992. Text by
Thomas McEvilley; interview by Alanna Heiss.
Oppenheim, Dennis. *Proposals 1967–1974*.
Brussels: Lebeer-Hossman, 1975.
Pluchart, François. *Dennis Oppenheim
1967–1971* (exhibition catalogue). Paris:
Galerie Mathias Felds, 1972.
Van Tieghem, Jean-Pierre, and Vincent
Baudoux. *Dennis Oppenheim* (exhibition
catalogue). Brussels: Palais des Beaux-
Arts, 1975.

Articles
Duchow, Achim. "Projects 1967–72."
Interfunktionen, no. 9 (Summer 1972),
pp. 3–43.
Hershman, Lynn. "Interview with Dennis
Oppenheim." *Studio International*,
186 (November 1973), pp. 196–97.
Kozloff, Max. "Pygmalion Reversed." *Artforum*,
14 (November 1975), p. 30.
"Performance." *Avalanche*, no. 9 (May 1974), p. 4.
Pincus-Witten, Robert. "Theatre of the
Conceptual: Autobiography and Myth."
Artforum, 12 (October 1973), pp. 40–44.
Sharp, Willoughby. "A Discussion with Terry
Fox, Vito Acconci, and Dennis Oppenheim,"
Avalanche, no. 2 (Winter 1971), pp. 18–19.
———. "Discussions with Oppenheim, Heizer,
Smithson." *Avalanche*, no. 1 (Fall 1970), p. 3.
———. "Interview with Dennis Oppenheim."
Studio International, 182 (November 1971),
pp. 186–93.
Smithson, Robert. "A Sedimentation of
the Mind." *Artforum*, 7 (September 1968),
pp. 44–50.

Paul Sharits

Born 1943, Denver, Colorado
Died 1993, Buffalo, New York

"Locational Pieces"
Sharits used the term "Locations" to
describe his gallery installation works, which
were looped to run continuously. For more
information, see *Film Culture*, 65–66 (1978),
and *Millennium Film Journal*, 1 (Spring–
Summer 1978).

Sound Strip/Film Strip, 1972. Four-screen
projection, 16mm, color, sound;
8 minutes each.
Synchronousoundtracks, 1973–74. Three-
screen projection, 16mm, color, sound;
10 minutes each.
Damaged Film Loop, 1973–74. Two-screen
projection, 16mm, color, silent.

Vertical Contiguity, 1974. Two-screen projec-
tion, color, sound.
The Forgetting of Intention and Impressions,
1974. Two-screen projection, 16mm, color,
sound.
Shutter Interface (Arrangement III), 1975.
Four-screen projection, 16mm, color,
sound; 5–6 minutes each.
Dream Displacement, 1975–76. Four-screen
projection, 16mm, color, sound.
Epileptic Seizure Comparison, 1976. Two-
screen projection, 16mm, color, sound.

Selected Single-Screen Films
Ray Gun Virus, 1966. 16mm, color, sound;
14 minutes.
Piece Mandala/End War, 1966. 16mm, black-
and-white and color, silent; 5 minutes.
Word Movie/Fluxfilm 29, 1966. 16mm, color,
sound; 4 minutes.
N:O:T:H:I:N:G, 1968. 16mm, color, sound;
36 minutes.
T:O:U:C:H:I:N:G, 1968. 16mm, color, sound;
12 minutes.
S:TREAM:S:S:ECTION:S:ECTION:S:SECTIONED,
1968–71. 16mm, color, sound; 42 minutes.
Inferential Current, 1971. 16mm, color, sound;
8 minutes.
Analytical Studies I: The Film Frame, 1971–76.
16mm, color, silent; 25 minutes.
Analytical Studies II: Un-Frame-Lines,
1971–76. 16mm, color, silent; 30 minutes at
24 fps or 41 minutes at 18 fps.
Axiomatic Granularity, 1972–73. 16mm, color,
sound; 20 minutes.
Analytical Studies III: Color Frame Passages,
1973–74. 16mm, color, silent; 20 minutes
at 18 fps.
Color Sound Frames, 1974. 16mm, color, sound;
27 minutes.
Apparent Motion, 1974. 16mm, color, silent;
36 minutes.
Epileptic Seizure Comparison, 1974.
16mm, color, sound; 30 minutes. Also
conceived as a two-screen, stereo-sound
installation.
Tails, 1974. 16mm, color, silent; 4 minutes at
18 fps or 3 minutes at 24 fps.
Analytical Studies IV: Blank Color Frame,
1974–76. 16mm, color, silent; 20 minutes
at 18 fps.
Episodic Generation, 1976–78. 16mm, color,
sound; 30 minutes.

Selected Double-Screen Films
Some of Sharits' "Locations" were also shown
as double-screen films, in either horizontal or
vertical format. See the catalogue of the New
York Film-Makers' Cooperative collection for
detailed notes by Sharits.

Sears Catalogue, 1964–80. 16mm, black-and-
white, silent; 15 minutes.
Razor Blades, 1965–68. 16mm, color and
black-and-white, stereo; 25 minutes.
Sound Strip/Film Strip, 1971–72. 16mm, color,
¼" stereo tape; 25 minutes.
Element Studies: Earth/Water/Sky/Fire,
1971–75. 16mm, color, silent; 15 minutes.
Synchronousoundtracks, 1973–74. 16mm,
color, stereo; 35 minutes.

Shutter Interface, 1975. 16mm, color, stereo; 33 minutes.

3D Movie, 1975. 16mm, color, silent; 12 minutes (red-green glasses required for viewing).

Tirgu Jiu, 1975. 16mm, color, silent; 13 minutes.

Dream Displacement, 1975. 16mm, color, ¼" stereo tape; 25 minutes.

Declarative Mode, 1976–77. 16mm, color, silent; 39 minutes. Now single-screen only.

Brancusi's Sculpture Ensemble at Tirgu Jiu, 1977–84. 16mm, color, silent; 21 minutes.

Selected One-Artist Exhibitions and Screenings
The Museum of Modern Art, New York, 1968.
Anthology Film Archives, New York, 1972.
Bykert Gallery, New York, 1972, 1974.
Carnegie Museum of Art, Pittsburgh, 1973, 1977.
Galerie Rolf Ricke, Cologne, 1974, 1977.
Walker Art Center, Minneapolis, 1974.
Artpark, Lewiston, New York, 1975.
Whitney Museum of American Art, New York, 1975.
Albright-Knox Art Gallery, Buffalo, 1976.
Stedelijk Van Abbemuseum, Eindhoven, The Netherlands, 1976.
Centre National d'Art et de Culture, Centre Georges Pompidou, Paris, 1977.
Droll/Kolbert Gallery, New York, 1977.
Galerie 'A,' Amsterdam, 1977.
Galerie Waalkens, Finsterwolde, The Netherlands, 1977.
Kröller-Müller Museum, Otterlo, The Netherlands, 1977.
Stedelijk Museum, Amsterdam, 1977.

Selected Group Exhibitions and Screenings
Kölnischer Kunstverein, "Happenings and Fluxus," 1970.
The Museum of Modern Art, New York, "Information," 1970.
Park Sonsbeek, Arnhem, The Netherlands, "Sonsbeek 71: Buiten de Perken," 1971.
Whitney Museum of American Art, New York, "Independent Filmmakers Series," 1971, 1975, 1977.
Kassel, Documenta 5, 1972.
Solomon R. Guggenheim Museum, New York, "New Forms in Film," 1972.
Vancouver Art Gallery, "Form and Structure in Recent Cinema," 1972.
American Film Institute, Kennedy Center for the Performing Arts, Washington, D.C., "Film As/On Art," 1974.
Walker Art Center, Minneapolis, "Projected Images," 1974.
Wright State University Art Gallery, Dayton, Ohio, "Luminous Realities," 1975.
The Museum of Modern Art, New York, "A History of the American Avant-Garde Cinema," 1976.
Kassel, Documenta 6, 1977.
Kölnischer Kunstverein, "Film als Film: 1910 bis heute," 1977.

Selected Bibliography

Books and Catalogues
Cornwell, Regina. "Paul Sharits: Illusion and Object." In Bill Nichols, ed. *Anthology: Movies and Methods*. Berkeley: University of California Press, 1976.
Curtis, David. *Experimental Cinema*. New York: University Books; London: Vista Ltd., 1971.
Gidal, Peter, ed. *Structural Film Anthology*. London: British Film Institute, 1976.
Kubelka, Peter, ed. *Une Histoire du cinéma* (exhibition catalogue). Paris: Musée National d'Art Moderne, Centre Georges Pompidou, 1976.
Michelson, Annette. "Paul Sharits and the Critique of Illusionism." *Projected Images* (exhibition catalogue). Minneapolis: Walker Art Center, 1974.
_____, ed. *New Forms in Film* (exhibition catalogue). Montreaux: Imprimerie Corbaz, 1974.
Sharits, Paul. "Epileptic Seizure Comparison." In *Illusions of Reality* (exhibition catalogue). North Sydney: Australian Gallery Directors' Council, 1977.
Singer, Marilyn, ed. *A History of the American Avant-Garde Cinema*. New York: American Federation of Arts, 1976.
Sitney, P. Adams. *Visionary Film: The American Avant-Garde*. New York: Oxford University Press, 1974.
Tyler, Parker. *Underground Film: A Critical History*. New York: Grove Press, 1969.

Articles
Cornwell, Regina. "Paul Sharits: Illusion and Object." *Artforum*, 10 (September 1971), pp. 56–62.
_____. "Some Formalist Tendencies in the American Avant-Garde Film." *Studio International*, 184 (October 1972), pp. 110–14.
Crimp, Douglas. "New York Letter: Review of Sound Strip/Film Strip." *Art International*, 17 (March 1973), pp. 40–42.
Krauss, Rosalind. "Paul Sharits: Stop Time." *Artforum*, 11 (April 1973), pp. 60–61.
Liebman, Stuart. "Apparent Motion and Film Structure: Paul Sharits' Shutter Interface." *Millennium Film Journal*, 1 (Spring–Summer 1978), pp. 101–09.
Liebman, Stuart. "Paul Sharits' "S:TREAM:S:-S:ECTION:S:ECTION:S:SECTIONED: Paradigm Lost, or, Adventures of the Dialectic." *Millennium Film Journal*, 16/17/18 (Fall–Winter 1986–87), pp. 190–94.
"Paul Sharits." *Film Culture*, 65–66 (1978), pp. 1–133.
Sharits, Paul. "Notes on Films." *Interfunktionen*, no. 4 (March 1970).
_____. "Words per Page." *Afterimage*, 4 (Autumn 1972), pp. 27–43.
Sitney, P. Adams. "Structural Film." *Film Culture*, 47 (Summer 1969), pp. 1–10.
Wollen, Peter. "'Ontology' and 'Materialism' in Film." *Screen*, 17 (Spring 1976), pp. 7–23.

Michael Snow

Born 1929, Toronto, Ontario
Lives in Toronto, Ontario

Selected Film Installations
Two Sides to Every Story, 1974. Two synchronized 16mm films, color, sound; 8 minutes, projected continuously on two sides of an aluminum screen.
Breakfast (Table Top Dolly), 1972–76. 16mm, color, sound; 15 minutes.

Selected Film-Related Work
Little Walk, 1965. 8mm, color, silent; 3 minutes; projected on a cutout "Walking Woman" surface.
Right Reader, 1965. Performance with audiotape, plexiglass sheet, projected light, screen, props.
A Casing Shelved, 1969. 35mm slide and 40-minute audiotape. Designed to be presented as a single-frame film in a motion-picture theater.
De La, 1969–71. Aluminum and steel mechanical sculpture with electronic controls, television camera, four video monitors.
Untitled Slidelength, 1969–71. 80 35mm slides; projected continuously.
Sink, 1970. Color photograph, 80 35mm slides; slides projected continuously next to photograph.
Breakfast (Table Top Dolly), 1972. Videotape of three versions of the film of the same name.

Selected Films
New York Eye and Ear Control, 1964. 16mm, black-and-white, sound; 34 minutes.
Short Shave, 1965. 16mm, black-and-white, sound; 4 minutes.
Wavelength, 1966–67. 16mm, color, sound; 45 minutes.
Standard Time, 1967. 16mm, color, sound; 8 minutes.
←→ (Back and Forth), 1968–69. 16mm, color, sound; 50 minutes.
One Second in Montreal, 1969. 16mm, black-and-white, silent; 26 minutes.
Dripping Water (with Joyce Wieland), 1969. 16mm, black-and-white, silent; 12 minutes.
Side Seat Paintings Slides Sound Film, 1970. 16mm, color; 20 minutes.
La Région Centrale, 1971. 16mm, color, sound; 190 minutes.
Rameau's Nephew by Diderot (Thanx to Dennis Young) by Wilma Schoen, 1974. 16mm, color, sound; 260 minutes.

Selected One-Artist Exhibitions and Screenings
Poindexter Gallery, New York, 1965, 1968.
Vancouver Art Gallery, "Michael Snow Walking Woman Retrospective 1963–1966," 1967.
Pacific Film Archive, San Francisco, 1969.
Art Gallery of Ontario, Toronto, "Michael Snow: A Survey," 1970.
Bykert Gallery, New York, 1970, 1972.
Walker Art Center, Minneapolis, 1970.
National Gallery of Canada, Ottawa, 1971.
Cinémathèque Québécoise, Montreal, 1975.

Musée des Beaux-Arts, Ottawa, Ontario, "Michael Snow, *De La*," 1975.

Musée des Beaux-Arts, Ontario, "Michael Snow's *Two Sides to Every Story*," 1976.

The Museum of Modern Art, New York, 1976.

Musée National d'Art Moderne, Centre Georges Pompidou, Paris, "Michael Snow: Sept films et 'Plus Tard,'" 1977.

Selected Group Exhibitions and Screenings

Knokke–Le Zoute, Belgium, Fourth International Experimental Film Festival, 1967.

The Jewish Museum, New York, "The Artist as Film-Maker," 1967.

Musée National des Beaux-Arts, Paris, "Canada: Art aujourd'hui," 1968.

National Film Theatre, Ottawa, "Underground: Independent Canadian Film-Makers," 1968.

Whitney Museum of American Art, New York, "Anti-Illusion: Procedures/Materials," 1969.

Whitney Museum of American Art, New York, "Four Evenings of Extended Time Pieces and a Lecture," 1969.

Cannes Film Festival, 1970.

The Museum of Modern Art, New York, "Information," 1970.

Venice Biennale, 1970.

Kunsthalle Düsseldorf, "Prospect 71: Projection," 1971.

Vancouver Art Gallery, "Form and Structure in Recent Film," 1972.

Walker Art Center, Minneapolis, "Projected Images," 1974.

Wallraf-Richardtz-Museum, Kölnischer Kunstverein, and Kunsthalle, Cologne, "Kunst bleibt Kunst: Project '74: Aspekte internationaler Kunst am Anfang der 70er Jahre," 1974.

Rutgers University, New Brunswick, New Jersey; Walker Art Center, Minneapolis, "A Response to the Environment," 1975.

Musée National d'Art Moderne, Centre Georges Pompidou, Paris, "Une Histoire du cinéma," 1976.

Kassel, Documenta 6, 1977.

Kölnischer Kunstverein, "Film als Film: 1910 bis heute," 1977.

National Gallery of Canada, Ottawa, "Another Dimension," 1977.

Selected Bibliography

Books and Catalogues

Barbara, Alberto, and Stefano Della Casa, eds. *Michael Snow*. Turin: Festival Internazionale Cinema Giovani, 1986. Texts by Annette Michelson, P. Adams Sitney, Dominique Noguez, et al.

The Collected Writings of Michael Snow: The Michael Snow Project. Waterloo, Ontario: Wilfrid Laurier University Press, 1994.

Cornwell, Regina. "Michael Snow." In *Projected Images* (exhibition catalogue). Minneapolis: Walker Art Center, 1974, pp. 26–33.

____. *Snow Seen: The Films and Photographs of Michael Snow*. Toronto: Peter Martin Associates, 1978.

The Films of Michael Snow: 1956–1991. Presence and Absence: The Michael Snow Project. Toronto: Art Gallery of Ontario,

1995. Texts by Jonas Mekas, R. Bruce Elder, Steve Reich, et al.

Michael Snow (exhibition catalogue). Rotterdam: Museum Boijmans Van Beuningen, 1979.

Michael Snow (exhibition catalogue). Tokyo: Hara Museum of Contemporary Art, 1988. Text by Pierre Théberge.

Michael Snow: Selected Photographic Works (exhibition catalogue). Los Angeles: Frederick S. Wright Art Gallery, University of California, 1986. Texts by Christopher Dewdney and Pierre Théberge.

Michael Snow Retrospective (exhibition catalogue). Montreal: La Cinémathèque Québécoise, 1975

Mudie, Peter. *Michael Snow: Filmworks 1966–1991*. Perth: Bernt Porridge Group Publications, 1995. Texts by David Bromfield, Albie Thoms, Stan Brakhage.

Music/Sound 1948–1993: The Michael Snow Project. Toronto: Art Gallery of Ontario and The Power Plant, 1994. Texts by David Lancashire, Paul Dutton, Raymond Gervais, Bruce Elder, John Kamevaar, et al.

Projected Images (exhibition catalogue). Minneapolis: Walker Art Center, 1974.

Vanishing Presence (exhibition catalogue). Minneapolis: Walker Art Center, 1989.

Visionary Apparatus: Michael Snow and Juan Geuer. Cambridge: List Visual Arts Center, Massachusetts Institute of Technology, 1986.

Visual Art 1951–1993: The Michael Snow Project. Toronto: Art Gallery of Ontario and The Power Plant, 1994. Texts by Dennis Reid, Philip Monk, Louise Dompierre.

Articles

Chin, Daryl. "Michael Snow: *Rameau's Nephew by Diderot (Thanx to Dennis Young) by Wilma Schoen*." *Art & Cinema*, 3 (December 1978), pp. 59–60.

Cornwell, Regina. "Michael Snow: Cover to Cover and Back (Museum of Modern Art, New York, Exhibit)." *Studio International*, 191 (March–April 1976), pp. 193–97.

Duve, Thierry de. "Michael Snow: Les Déictiques de l'Expérience et Au-Delà. Self-referential and Romantic Motifs in Snow's Work, 1960–1992." *Cahiers du Musée National d'Art Moderne*, no. 50 (Winter 1994), pp. 30–55.

Foreman, Richard. "Critique: Glass and Snow." *Arts Magazine*, 44 (February 1970), pp. 20–22.

Freedman, Adele. "Close Encounters of the Fourth Kind: The Films of Michael Snow." *Art Magazine*, 11 (September–October 1979), pp. 38–40.

Michelson, Annette. "Toward Snow: Part 1." *Artforum*, 9 (June 1971), pp. 30–37.

Rayns, Tony. "Reflected Light." *Sight and Sound*, 43 (Winter 1973), pp. 16–19.

Rosenbaum, Jonathan. "Regrouping: Reflections on the Edinburgh Festival 1976." *Sight and Sound*, 46 (Winter 1976–77), pp. 2–8.

Snow, Michael. "Letter from Michael Snow." *Film Culture*, 4 (Autumn 1967), p. 4.

____. "Passage." *Artforum*, 10 (September 1971), p. 64.

Keith Sonnier

Born 1941, Mamou, Louisiana
Lives in New York, New York

Selected Video Installations and Performances

Live Video Installation, 1970. Four-channel, closed-circuit, with negative/positive projections on two screens, projected continuously; ruby laser lights.

Performance, The Museum of Modern Art, Project Space, 1971. Closed-circuit, with two split-screen negative/positive projections and infrared lights.

Channel Mix, 1972. Two split-screen negative/positive projections with sound, mixing daytime television broadcasts and closed-circuit video images.

Act II, 1972. Performance with color slide projection.

Selected Videotapes

Dis-play, 1969. Black-and-white, sound; 11 minutes.

Blow, 1969. Color, sound; 10 minutes.

Light Bulb and Fire, 1970. Black-and-white, sound; 20 minutes.

Painted Foot: Black Light, 1970. Black-and-white, sound; 16 minutes.

Positive-Negative, 1970. Black-and-white, silent; 12 minutes.

Rubdown, 1970. Black-and-white, sound; 11 minutes.

Negative, 1971. Black-and-white, sound; 11 minutes.

T-Hybrid-V-I, 1971. Color and black-and-white, sound; 13 minutes (transferred from 16mm film).

T-Hybrid-V-II, 1971. Color, sound; 11 minutes (transferred from 16mm film).

T-Hybrid-V-III, 1971. Color, sound; 11 minutes (transferred from 16mm film).

T-Hybrid-V-IV, 1971. Color, sound; 12 minutes (transferred from 16mm film).

Mat Key and Radio Track, 1972. Color, sound; 12 minutes.

TV In and TV Out, 1972. Color, sound; 10 minutes.

Animation I, 1973. Color, sound; 14 minutes.

Color Wipe, 1973. Color, sound; 30 minutes.

Animation II, 1974. Color, sound; 25 minutes.

Send/Receive Satellite Network: Phase I, 1977. Color, sound; 25 minutes. Co-produced with Liza Bear.

Send/Receive Satellite Network: Phase II, 1977. Color, sound; 30 minutes. Co-produced with Liza Bear.

Selected One-Artist Exhibitions and Screenings

Ace Gallery, Los Angeles, "Live Video Installation," 1970.

Castelli Warehouse, New York, 1970.

Stedelijk Van Abbemuseum, Eindhoven, The Netherlands, 1970.

Galerie Rolf Ricke, Cologne, 1971.

The Museum of Modern Art, New York, "Projects: Keith Sonnier," 1971.

Leo Castelli Gallery, New York, "Keith Sonnier Live and Channel Video, Stereo Projection," 1972.

The Kitchen, New York, "Keith Sonnier: Send/Receive/Send," 1973. Collaboration with Mabou Mines.
Leo Castelli Gallery, New York, "Radio Mix," 1974.
Leo Castelli Gallery, New York, and Ace Gallery, Los Angeles, "Air to Air," 1975. Realized in 1977 with a NASA satellite connecting New York to Ames Research Center, San Francisco, in "Send/Receive."
Center for New Art Activity, New York, "Send/Receive Satellite Network, New York City–San Francisco Bay," 1977.

Selected Group Exhibitions and Screenings
Castelli Warehouse, New York, "Nine at Castelli," 1968.
John Gibson Gallery, New York, "Anti-Form," 1968.
Kunsthalle Bern, "When Attitudes Become Form: Works—Concepts—Processes—Situations—Information: Live in Your Head," 1969.
Whitney Museum of American Art, New York, "Anti-Illusion: Procedures/Materials," 1969.
The Museum of Modern Art, New York, "Information," 1970.
Leo Castelli Gallery, New York, "Works on Film," 1971.
Kassel, Documenta 5, 1972.
Venice Biennale, 1972.
Leo Castelli Gallery, New York, "In Three Dimensions," 1974.
Musée National d'Art Moderne, Centre Georges Pompidou, Paris, "Art/Voir," 1974.
The Museum of Modern Art, New York, "Projects: Video I," 1974.
Musée d'Art Moderne de la Ville de Paris, "9e Biennale de Paris: Manifestation Internationale des Jeunes Artistes," 1975.
Whitney Museum of American Art, New York, "Projected Video," 1975.
Leo Castelli Gallery, New York, "Robert Barry, Don Judd, Robert Morris, Keith Sonnier," 1977.

Selected Bibliography

Books and Catalogues
Buck, Robert T. Interview with Keith Sonnier. In *Keith Sonnier: Sculpture 1966–98* (exhibition catalogue). New York: Malborough Gallery, 1999.
Delehanty, Suzanne, et al. *Video Art* (exhibition catalogue). Philadelphia: Institute of Contemporary Art, University of Pennsylvania, 1975.
Fagone, Vittorio. "Art and Cinema." In *La Biennale de Venezia: From Nature to Art, from Art to Nature* (exhibition catalogue). Milan: Electa, 1978, pp. 240–43.
Heiss, Alanna. *Keith Sonnier* (exhibition catalogue). New York: P.S. 1, Institute for Art and Urban Resources, 1983.
Keith Sonnier: BA-O-BA, SEL Series, Argon-und-Neon-Arbeiten (exhibition catalogue). Krefeld, Germany: Museum Haus Lange, 1979.
Keith Sonnier: Object Situation Object 1969–1970 (exhibition catalogue). Cologne: Galerie Rolf Ricke, 1970.
Keith Sonnier: Runic Serie 1980 (exhibition catalogue). Cologne: Galerie Rolf Ricke, 1981.

Köb, Edelbert. In *Keith Sonnier Environmental Works 1968–99* (exhibition catalogue). Bregenz, Austria: Kunsthaus Bregenz, 1999.
Pincus-Witten, Robert. "Keith Sonnier: Materials and Pictorialism." In *Post-minimalism*. New York: Out of London Press, 1977, pp. 32–41.
Reedijk, Hein, and J. Leering, *Keith Sonnier: 1 Soundpiece, 2 Dark/Light piece, 3 Lightpiece* (exhibition catalogue). Eindhoven: Stedelijk Van Abbemuseum, 1970.

Articles
Baker, Kenneth. "Keith Sonnier." *Artforum*, 10 (October 1971), pp. 72–81.
Gholson, Craig. "Keith Sonnier: Communication Art." *Interview*, 7 (November 1977), pp. 36–37.
Kurtz, Bruce. "Video Is Being Invented." *Arts Magazine*, 47 (December–January 1973), pp. 37–44.
Pincus-Witten, Robert. "Keith Sonnier: Video and Film as Colorfield." *Artforum*, 10 (May 1972), pp. 35–37.
_____. "Theatre of the Conceptual: Autobiography and Myth." *Artforum*, 12 (October 1973), pp. 40–46.
Sharp, Willoughby. "Keith Sonnier at Eindhoven: An Interview." *Arts Magazine*, 45 (February 1971), pp. 24–27.
Sonnier, Keith, and Tina Girouard. "Illustrated Time—Proscenium II." *Avalanche*, no. 5 (Summer 1972), pp. 37–43.
Thornburn, Ray. "Ray Thornburn Talks with Keith Sonnier." *Art International*, 20 (January–February 1976), pp. 69–74.

Andy Warhol

Born 1928, Pittsburgh, Pennsylvania
Died 1987, New York, New York

Selected Films
Eat, 1964. 16mm, black-and-white, silent; 35 minutes, 18 fps.
Blow Job, 1964. 16mm, black-and-white, silent; 36 minutes, 18 fps.
Empire, 1964. 16mm, black-and-white, silent; 8 hours, 5 minutes, 16 fps.
Henry Geldzahler, 1964. 16mm, black-and-white, silent; 88 minutes, 18 fps.
Taylor Mead's Ass, 1964. 16mm, black-and-white, silent; 76 minutes, 18 fps.
Soap Opera, 1964. Co-directed by Andy Warhol and Jerry Benjamin. 16mm, black-and-white, sound; 47 minutes (one-reel excerpt), 24 fps.
Couch, 1964. 16mm, black-and-white, silent; 52 minutes, 18 fps.
Four of Andy Warhol's Most Beautiful Women, 1964–70. 16mm film, black-and-white, silent; 15 minutes, 18 fps.
Shoulder, 1964. 16mm, black-and-white, silent; 3 minutes, 18 fps.
Mario Banana (No. 1), 1964. 16mm, color, silent; 4 minutes, 18 fps.
Mario Banana (No. 2), 1964. 16mm, black-and-white, silent; 3 minutes, 18 fps. With Mario Montez.
Harlot, 1964. 16mm, black-and-white, sound; 66 minutes, 24 fps.
Screen Tests, 1964–66. Between 1964 and 1966 Warhol made more than 470 screen tests, which were black-and-white, silent, and shown at 18 fps, approximately 4 minutes.
John and Ivy, 1965. 16mm, black-and-white, sound; 33 minutes, 24 fps.
Screen Test No. 1, 1965. 16mm, black-and-white, sound; 66 minutes, 24 fps.
Screen Test No. 2, 1965. 16mm, black-and-white, sound; 66 minutes, 24 fps.
Poor Little Rich Girl, 1965. 16mm, black-and-white, sound; 66 minutes, 24 fps.
The Life of Juanita Castro, 1965. 16mm, black-and-white, sound; 66 minutes, 24 fps.
Horse, 1965. 16mm, black-and-white, sound; 100 minutes, 24 fps.
Vinyl, 1965. 16mm, black-and-white, sound; 66 minutes, 24 fps.
Kitchen, 1965. 16mm, black-and-white, sound; 66 minutes, 24 fps.
Restaurant, 1965. 16mm, black-and-white, sound; 33 minutes, 24 fps.
Beauty #2, 1965. 16mm, black-and-white, sound; 66 minutes, 24 fps.
Afternoon, 1965. 16mm, black-and-white, sound; 100 minutes, 24 fps.
Space, 1965. 16mm, black-and-white, sound; 66 minutes, 24 fps.
Outer and Inner Space, 1965. 16mm, black-and-white, sound; 66 minutes, 24 fps. The film may be shown in single- or double-screen format.
My Hustler, 1965. 16mm, black-and-white, sound; 66 minutes, 24 fps.
Camp, 1965. 16mm, black-and-white, sound; 66 minutes, 24 fps.
Paul Swan, 1965. 16mm, color, sound; 66 minutes, 24 fps.
More Milk Yvette, 1965. 16mm, black-and-white, sound; 66 minutes, 24 fps.
Lupe, 1965. 16mm, color, sound; 72 minutes, 24 fps. The film may be shown in single- or double-screen format.
The Velvet Underground and Nico, 1966. 16mm, black-and-white, sound; 66 minutes, 24 fps.
The Velvet Underground, 1966. 16mm, black-and-white, sound; 66 minutes, 24 fps. The film may be shown in single- or double-screen format.
Salvador Dali, 1966. 16mm, black-and-white, silent; 22 minutes, 18 fps.
Hedy, 1966. 16mm, black-and-white, sound; 66 minutes, 24 fps.
The Closet, 1966. 16mm, black-and-white, sound; 66 minutes, 24 fps.
The Chelsea Girls, 1966. 16mm, black-and-white and color, sound; 3 hours, 30 minutes in double-screen format, 24 fps.
Eating Too Fast, 1966. 16mm, black-and-white, sound; 66 minutes, 24 fps.
Bufferin, 1966. 16mm, color, sound; 33 minutes, 24 fps.
The Nude Restaurant, 1967. 16mm, color, sound; 100 minutes, 24 fps.
Sunset, 1967. 16mm, color, sound; 33 minutes, 24 fps.

I a Man, 1967–68. 16mm, color, sound; 95 minutes, 24 fps.
Bike Boy, 1967–68. 16mm, color, sound; 109 minutes, 24 fps.
The Loves of Ondine, 1967–68. 16mm, color, sound; 85 minutes, 24 fps.
Lonesome Cowboys, 1967–68. 16mm, color, sound; 109 minutes, 24 fps.
Imitation of Christ, 1967–69. 16mm, color, sound; 85 minutes, 24 fps.
San Diego Surf, 1968. 16mm, color, sound; 90 minutes, 24 fps.

Selected Videotapes

Factory Diaries, 1965. 11 videotapes, 1" reel-to-reel, black-and-white; 30 minutes each. Camera: Paul Morrissey.
Factory Diaries, 1971–78. Videotapes, varying lengths, ½" reel-to-reel, black-and-white and color. Camera: Andy Warhol, Vincent Fremont, Michael Netter, Ronnie Cutrone, and others.
Vivian's Girls, 1973. 10 videotapes, ½" reel-to-reel, black-and-white; approximately 30 minutes each. Produced and directed by Andy Warhol and Vincent Fremont.
Phoney, 1973. 23 videotapes, ½" reel-to-reel, black-and-white; approximately 30 minutes each. Produced and directed by Andy Warhol and Vincent Fremont.
Fight, 1975. 7 videotapes, ¾", black-and-white; approximately 30 minutes each. Produced and directed by Andy Warhol and Vincent Fremont.

Selected One-Artist Exhibitions and Screenings

Note: The pre-1988 exhibition histories of Warhol's films will be forthcoming in a two-volume catalogue raisonné of his films by Callie Angell, to be published by the Whitney Museum.

Whitney Museum of American Art, New York, "The Films of Andy Warhol: An Introduction," 1988.
The Museum of Modern Art, New York, "Andy Warhol: A Retrospective," 1989.
Musée National d'Art Moderne, Centre Georges Pompidou, Paris, 1990.
San Francisco Cinematheque, "The Films of Andy Warhol: A Seven Week Introduction," 1990.
Whitney Museum of American Art, New York, "Andy Warhol's Video and Television," 1991.
Museum of Contemporary Art, Sydney, "Something Secret: Portraiture in Warhol's Films," 1994.
Whitney Museum of American Art, New York, "The Films of Andy Warhol: Part II," 1994.
Museum of Contemporary Art, Tokyo, "Andy Warhol 1956–1986: Mirror of His Time," 1996.
Kunstmuseum Wolfsburg, "Andy Warhol: A Factory," 1998.

Selected Bibliography

Books and Catalogues
Angell, Callie. "Andy Warhol, Filmmaker." In *The Andy Warhol Museum*. New York: D.A.P.; Stuttgart: Cantz, 1994, pp. 120–45.
_____. *The Films of Andy Warhol: Part II* (exhibition catalogue). New York: Whitney Museum of American Art, 1994.
_____. "Some Early Warhol Films: Notes on Technique." In Thomas Kellein, ed. *Andy Warhol Abstracts* (exhibition catalogue). Munich: Prestel Verlag, 1993, pp. 72–82.
_____. "Something Secret": Portraiture in Warhol's Films (exhibition catalogue). Sydney: Museum of Contemporary Art, 1994.
Bockris, Victor. *The Life and Death of Andy Warhol*. New York: Bantam Books, 1989.
Bourdon, David. *Warhol*. New York: Harry N. Abrams, 1989.
Hanhardt, John G., *Andy Warhol's Video and Television* (exhibition catalogue). New York: Whitney Museum of American Art, 1991.
Hanhardt, John G., and Jon Gartenberg. *The Films of Andy Warhol: An Introduction* (exhibition catalogue). New York: Whitney Museum of American Art, 1988.
Koch, Stephen. *Stargazer: Andy Warhol's World and His Films* (1973). Rev. ed. New York: Marion Boyars Publishers, 1991.
McShine, Kynaston, ed. *Andy Warhol: A Retrospective* (exhibition catalogue). New York: The Museum of Modern Art, 1989.
Miller, Debra. *Billy Name's Stills from the Warhol Films*. Munich: Prestel Verlag, 1994.
O'Pray, Michael, ed. *Andy Warhol: The Film Factory*. London: British Film Institute, 1989.
Smith, Patrick S. *Andy Warhol's Art and Films*. Ann Arbor: UMI Research Press, 1986.
Stein, Jean, with George Plimpton, eds. *Edie: An American Biography*. New York: Alfred A. Knopf, 1982.
Warhol, Andy. *The Philosophy of Andy Warhol (From A to B and Back Again)*. New York: Harcourt Brace Jovanovich, 1975.
_____, and Pat Hackett. *POPism: The Warhol 60s*. New York: Harcourt Brace Jovanovich, 1980.

Articles
"Andy Warhol as a Film-Maker: a Discussion Between Paul Morrissey and Derek Hill." *Studio International*, 181 (February 1971), pp. 57–61.
Battcock, Gregory. "Notes on the Chelsea Girls: A Film by Andy Warhol." *Art Journal*, 26 (Summer 1967), pp. 363–65.
Berg, Gretchen. "Nothing to Lose: Interview with Andy Warhol." *Cahiers du Cinéma in English*, 10 (May 1967), pp. 38–43.
Junker, Howard. "Andy Warhol, Movie Maker." *The Nation*, February 22, 1965, pp. 206–208.
McIlhenny, Sterling, and Peter Ray. "Inside Andy Warhol: An Interview with Andy Warhol." *Cavalier* (September 1966), pp. 44–45, 86–89.
O'Brien, Glenn. "Andy Warhol." *High Times*, 24 (August 1977), pp. 20–22, 34–42.
Stoller, James. "Beyond Cinema: Notes on Some Films by Andy Warhol." *Film Quarterly*, 20 (Fall 1966), pp. 35–38.

Robert Whitman

Born 1935, New York, New York
Lives in Warwick, New York

Selected Film Works
All projected continuously.

Dressing Table, 1964. 16mm, color, silent.
Shower, 1964. 16mm, color, silent; shower stall, water, water pump.
Sink, 1964. 16mm, color, silent.
Room, 1974. 16mm, color, silent; rotating platform, circular room.

Selected Theater Works and Happenings
Night Time Sky, 1965. First New York Theater Rally, New York.
Prune Flat, 1965. Cinematheque, New York.
Two Holes of Water No. 3, 1966. Sixty-Ninth Regiment Armory, New York, "9 Evenings: Theatre and Engineering."
Two Holes of Water No. 2, 1966. Lincoln Center Film Festival, New York.
Two Holes of Water No. 1, 1966. Presented by Midsummer, Easthampton, New York.
An Untitled Work, 1966. Martinique Theater and Circle in the Square, New York; University of Massachusetts, Amherst.
Prune Flat, 1966. Martinique Theater and Circle in the Square, New York; University of Massachusetts, Amherst; The Now Festival, Washington, D.C.
Prune Flat, 1967. Midsummer, Easthampton, New York.
An Untitled Work, 1969. University of California, Los Angeles.
An Untitled Work, 1970. Fondation Maeght Festival, St. Paul, France.
Flag, 1972. Walker Art Center, Minneapolis.
Architecture, 1972. Hoboken Ferry Terminal and adjacent piers, New York.
Salad P.N., 1974. Southern Methodist University, Dallas.
Music, 1974. The Kitchen, New York; L'Attico, Rome; Walker Art Center, Minneapolis.
Robert Whitman: Theater Works, 1960–1976: American Moon (1960), Flower (1963), Prune Flat (1965), Night Time Sky (1965), Salad P.N. (1974), Light Touch (premiere), and Film Images (1960–1976), 1976. 589 Washington Street, New York.
Light Touch, 1977. Contemporary Arts Museum, Houston.
Sound, 1977. 3452 Inwood Drive, Houston.

Selected One-Artist Exhibitions
Pace Gallery, New York, "Dark," 1967.
The Jewish Museum, New York, "Pond," 1968.
Museum of Contemporary Art, Chicago, "Robert Whitman: 4 Cinema Pieces," 1968.
The Museum of Modern Art, New York, "Projects," 1973.
L'Attico, Rome, 1974.
Bykert Gallery, New York, 1974.
Hudson River Museum, Yonkers, New York, "Palisade," 1979.

Selected Group Exhibitions

Sidney Janis Gallery, New York, "6 Artists," 1964.
Sidney Janis Gallery, New York, "Erotic Art," 1966.
Finch College Museum of Art, New York, "Projected Art," 1967.
Albright-Knox Art Gallery, Buffalo; Walker Art Center, Minneapolis, "Six Artists, 6 Exhibitions," 1968.
Brooklyn Museum of Art, New York, "Some More Beginnings," 1968.
Newark College of Engineering, Newark, New Jersey, "Light as Art," 1968.
Walker Art Center, Minneapolis, "Dining Room Table, Figures/Environments," 1969.
Los Angeles County Museum of Art, Los Angeles, "Art and Technology," 1971.
Moderna Museet, Stockholm, "New York Collection for Stockholm," 1973.
Walker Art Center, Minneapolis, "Projected Images," 1974.

Selected Bibliography

Books and Catalogues

Drip, Blow, Burn: Forces of Nature in Contemporary Art. Yonkers, New York: Hudson River Museum, 1999.
Kaprow, Allan. *Assemblage, Environments, and Happenings.* New York: Harry N. Abrams, 1970.
Kirby, Michael. *Art of Time.* New York: Dutton, 1969.
_____. *Happenings.* New York: Dutton, 1964, pp. 134–83.
Kluver, J.W., and Barbara Rose, eds. *Pavilion.* New York: Dutton, 1972.
Marter, Joan, ed. *Off Limits: Rutgers University and the Avant-Garde, 1957–1963.* Newark, New Jersey: The Newark Museum; New Brunswick, New Jersey: Rutgers University Press, 1999. Texts by Simon Anderson, Joseph Jacobs, Jackson Lears, Joan Marter, Kristine Stiles.
Mussman, Toby. "The Images of Robert Whitman." In Gregory Battcock, ed. *The New American Cinema.* New York: Dutton, 1967.
Renan, Sheldon. *An Introduction to the American Underground Film.* New York: Dial Press, 1968.
Robert Whitman: 4 Cinema Pieces (exhibition catalogue). Chicago: Museum of Contemporary Art. 1968. Text by Jan van der Marck.
Rose, Barbara. "Considering Robert Whitman." In *Projected Images* (exhibition catalogue). Minneapolis: Walker Art Center, 1974, pp. 38–45.
Six Artists, Six Exhibitions (exhibition catalogue). Buffalo: Albright-Knox Art Gallery; Minneapolis: Walker Art Center, 1968.
Tuchman, Maurice. *Art and Technology* (exhibition catalogue). New York: Viking Press, 1971.

Articles

Ashton, Dore. "A Planned Coincidence." *Art in America,* 57 (September–October 1969), pp. 36–47.
Goldin, Amy. "Art and Technology in a Social Vacuum." *Art in America,* 60 (March–April 1972), pp. 46–51.
Livingston, Jane. "Some Thoughts on 'Art and Technology.'" *Studio International,* 181 (June 1971), pp. 258–63.
Segal, George. "On Whitman and Things." *Art and Artists,* 7 (November 1972), pp. 16–19, and *Arts Magazine,* 47 (November 1972), pp. 53–55.
Steele, Mike. "Beyond Flashing Lights." *Art News,* 73 (December 1974), p. 65.
Thomsen, Barbara. "Robert Whitman at Bykert Downtown." *Art in America,* 62 (July–August 1974), pp. 82–83.
Tuchman, Maurice. "Art and Technology." *Art in America,* 58 (March–April 1970), pp. 78–79.
Tully, Judd. "Robert Whitman." *Arts Magazine,* 53 (June 1979), p. 17.
Whitman, Robert. "Light Touch." *October,* no. 4 (Fall 1977), pp. 81–93.

Works in the Exhibition

(in chronological order)

Robert Whitman
Shower, 1964
16mm film loop (transferred to video), shower stall, water, and water pump
Collection of Robert Rauschenberg

Andy Warhol
Lupe, 1965
16mm film, color, sound, 36 minutes at 24 fps; shown in double-screen format
The Andy Warhol Museum, Pittsburgh; courtesy The Museum of Modern Art, New York

Yoko Ono
Sky TV, 1966
Color television set and video camera (closed-circuit)
Collection of the artist

William Anastasi
Free Will, 1968
Black-and-white video monitor and video camera (closed-circuit)
Collection of the artist

Robert Morris
Finch College Project, 1969/2001
16mm film, black-and-white, silent, projected continuously; motorized platform
Courtesy Sonnabend Gallery, New York

Bruce Nauman
Spinning Spheres, 1970
Four 16mm film loops, color, silent, projected simultaneously on four walls
Solomon R. Guggenheim Museum, New York; Panza Collection, 1991 91.3830

Mary Lucier
Polaroid Image Series (*Room, Shigeko, Croquet, City of Boston*), 1970–72
Four slide projections, black-and-white, sound, 23 minutes (*Room*, 51 black-and-white 35mm slides; *Shigeko*, 66 black-and-white 35mm slides; *Croquet*, 71 black-and-white 35mm slides; *City of Boston*, 34 black-and-white 35mm slides)
Collection of the artist

Keith Sonnier
Channel Mix, 1972
Two split-screen negative/positive projections with sound, mixing daytime television broadcasts and closed-circuit video images
Neues Museum—Staatliches Museum für Kunst und Design in Nürnberg

Dan Graham
Helix/Spiral, 1973
Two Super-8 films enlarged to 16mm, color, silent, projected simultaneously on opposite walls
Courtesy Marian Goodman Gallery, New York and Paris

Anthony McCall
Line Describing a Cone, 1973
16mm film, black-and-white, silent, 31 minutes
Whitney Museum of American Art, New York; Purchase, with funds from the Film and Video Committee T.99.7

Dennis Oppenheim
Echo, 1973
Four 16mm film loops (transferred to video), black-and-white, sound, projected simultaneously on four walls
Collection of the artist

Vito Acconci
Other Voices for a Second Sight, 1974
Three-room installation with Super-8 film (transferred to video), slide projections, and audiotape; wood, plastic, acoustical board, audio equipment, red light, and swivel chair
Courtesy Barbara Gladstone Gallery, New York

Michael Snow
Two Sides to Every Story, 1974
Two synchronized 16mm films, color, sound, 8 minutes, projected continuously on two sides of an aluminum screen
National Gallery of Canada, Ottawa; Purchased 1977

Beryl Korot
Dachau 1974, 1974
Four-channel video installation, black-and-white, sound, 24 minutes, repeated continuously
Collection of the artist

Gary Hill
Hole in the Wall, 1974/2001
Site-specific single-channel video installation, black-and-white, sound, repeated continuously
Courtesy Donald Young Gallery, Chicago

Paul Sharits
Shutter Interface, 1975
Two synchronized 16mm films, color, sound, 33 minutes, projected simultaneously
Whitney Museum of American Art, New York; Purchase, with funds from the Film and Video Committee 2000.263

Joan Jonas
Mirage, 1976/2001
16mm film, black-and-white, silent, 31 minutes; video projection, black-and-white, sound, 30 minutes; two videotapes (transferred to laserdisc) shown on a monitor: *May Windows*, black-and-white, sound, 14 minutes; *Good Night, Good Morning*, black-and-white, sound, 12 minutes; both repeated continuously (one of several installation versions)
Courtesy Pat Hearn Gallery, New York

Peter Campus
aen, 1977
Closed-circuit video installation, black-and-white; low-light surveillance camera; blue light
Whitney Museum of American Art, New York; Promised gift of The Bohen Foundation P.91.5

Simone Forti
Striding Crawling, 1977
Integral hologram (Multiplex), plexiglass support, polymer protective covering, candle, clay dish, and bricks
Holography by Lloyd Cross
Collection of the artist

Photograph and Reproduction Credits

New photographs of reconstructed works in the exhibition by Simone Forti (pp. 21, 157–59), Anthony McCall (back cover, pp. 12, 122–25), Dennis Oppenheim (pp. 13, 126–29), and Paul Sharits (front cover, pp. 18, 146–47) were taken by David Allison. Credits for all other photographs are listed below by page number.

3, 87–89 Courtesy Robert Rauschenberg and Robert Whitman

4, 91–93 © 2001 The Andy Warhol Museum, Pittsburgh, a museum of the Carnegie Institute

5, 95 Courtesy Japan Society, New York. Photograph by Oded Lobl. © 2001 Yoko Ono

6, 97 Courtesy William Anastasi

7, 100, 101 Courtesy Sonnabend Gallery, New York, and Robert Morris. © 2001 Robert Morris/Artists Rights Society (ARS), New York

8, 102–5 Courtesy Solomon R. Guggenheim Museum, New York. © 2001 Bruce Nauman/Artists Rights Society (ARS), New York

9, 107, 108–11 Courtesy Mary Lucier

10, 112–15 Courtesy Keith Sonnier. Photograph by Richard Landry. © 2001 Keith Sonnier/Artists Rights Society (ARS), New York

11, 117–19 Courtesy Marian Goodman Gallery, New York, and Dan Graham

14, 131–33 Courtesy Barbara Gladstone Gallery, New York, and Vito Acconci

15, 35 Courtesy Michael Snow

16, 138, 140–41 Courtesy Beryl Korot

17, 143 Courtesy Donald Young Gallery, Chicago

19, 150–53 Courtesy Electronic Arts Intermix, New York, and Joan Jonas

20, 155 Photographs by David Allison

32, 34 © 2001 Artists Rights Society (ARS), New York/ADAGP, Paris/Estate of Marcel Duchamp

37 Courtesy Leo Castelli Gallery, New York. © 2001 Bruce Nauman/Artists Rights Society (ARS), New York

38 © 2001 Robert Morris/Artists Rights Society (ARS), New York

40 Courtesy Thea Westreich Art Advisory Services

41 Courtesy Thea Westreich Art Advisory Services. © 2001 Bruce Nauman/Artists Rights Society (ARS), New York

42 right From Albert A. Hopkins, ed., *Magic: Stage Illusions, Special Effects, and Trick Photography* (New York: Dover Publications, 1976), p. 211, fig. 8

43 top © Collège de France, Paris

46 Courtesy Anthony McCall

47 Courtesy David Zwirner Gallery, New York, and Jane Crawford. © 2001 Estate of Gordon Matta-Clark/Artists Rights Society (ARS), New York

51 left Courtesy Pat Hearn Gallery, New York, and Joan Jonas. Photograph by Roberta Neiman

51 right Courtesy Pat Hearn Gallery, New York, and Joan Jonas

52 Courtesy Carolee Schneemann. Photograph by Fred Scruton. © 2001 Carolee Schneemann/Artists Rights Society (ARS), New York

53, 55 right Courtesy Dennis Oppenheim

54 Courtesy Richard Serra. © 2001 Richard Serra/Artists Rights Society (ARS), New York

55 left Courtesy Yvonne Rainer

56 Courtesy Vito Acconci and Galerie Lelong, New York

57 Courtesy Sonnabend Gallery, New York, and Mel Bochner

59 Courtesy Michael Heizer

65 © 2001 Bruce Nauman/Artists Rights Society (ARS), New York

70 From J.M.F. Van De Ven, *Film* (Rotterdam: Uitgevers Wyt, 1946)

121 Courtesy Anthony McCall. Photograph by Peter Moore. © Estate of Peter Moore/Licensed by VAGA, New York, NY

139 Courtesy Beryl Korot. Photograph by Mary Lucier

145 Courtesy Christopher Sharits. Photograph by Sheldan C. Collins

148–49 Courtesy Joan Jonas. Photograph by Babette Mangolte

Whitney Museum of American Art Officers and Trustees

This exhibition and publication were organized by Chrissie Iles, curator of film and video, with the assistance of Christopher Eamon, assistant curator, and Tanya Leighton, curatorial assistant.

This publication was produced by the Publications and New Media Department at the Whitney Museum: Garrett White, Director; *Editorial*: Sheila Schwartz, Senior Editor; Susan Richmond, Managing Editor; *Design*: Makiko Ushiba, Senior Graphic Designer; Christine Knorr, Graphic Designer; *Production*: Vickie Leung, Production Coordinator; Tracey Fugami, Publications and New Media Assistant; *Rights and Reproductions*: Anita Duquette, Manager; Jennifer Belt, Photographs and Permissions Coordinator; *New Media*: Michael Gee, Web Manager/New Media Designer; David Youn, Web Programmer; *Intern*: Samantha Shapses

Catalogue Design: Kathleen Oginski & Greg Van Alstyne
Project Manager: Kate Norment
Text Editor: John Alan Farmer

Printing: Cantz, Ostfildern, Germany
Separations: C+S Repro, Filderstadt, Germany
Binding: Bramscher Buchbinder Betriebe, Bramsche, Germany
Printed and bound in Germany

Published to accompany the exhibition *Elizabeth*,
devised by Tarnya Cooper
and the staff of the National Maritime Museum
with David Starkey

ELIZABETH

The Exhibition at the National Maritime Museum

GUEST CURATOR

David Starkey

EDITED

BY

Susan Doran

PUBLISHED BY

CHATTO & WINDUS

in association with

THE NATIONAL MARITIME MUSEUM

Published by Chatto & Windus 2003

2 4 6 8 10 9 7 5 3 1

This catalogue has been published to accompany the exhibition held at the
National Maritime Museum, Greenwich, London, 1 May – 14 September 2003

The National Maritime Museum
Greenwich
London SE10 9NF
www.nmm.ac.uk

First published in Great Britain in 2003 by
Chatto & Windus
Random House, 20 Vauxhall Bridge Road,
London SW1V 2SA

Random House Australia (Pty) Limited
20 Alfred Street, Milsons Point, Sydney, New South Wales 2061, Australia

Random House New Zealand Limited
18 Poland Road, Glenfield, Auckland 10, New Zealand

Random House (Pty) Limited
Endulini, 5A Jubilee Road, Parktown, 2193, South Africa

The Random House Group Limited Reg. No. 954009
www.randomhouse.co.uk

A CIP catalogue record for this book is available from the British Library

ISBN 0 7011 7476 5

Papers used by Random House are natural, recyclable products made from wood grown in sustainable forests.
The manufacturing processes conform to the environmental regulations of the country of origin

Catalogue design by Peter Ward
Printed and bound in Great Britain by Butler & Tanner Ltd, Frome, Somerset

The exhibition is sponsored by

LIST OF CONTENTS

Sponsor's foreword vii
Director's preface ix
Acknowledgements x
List of lenders xi
Catalogue contributors xii
Notes on conventions xiii

INTRODUCTION

DAVID STARKEY
Elizabeth: Woman, Monarch, Mission
3

EXHIBITION CATALOGUE ENTRIES: 1–26
9

ELIZABETH'S ENGLAND

PATRICK COLLINSON
The Mongrel Religion of Elizabethan England
27

IAN W. ARCHER
The City of London: Court and Trade
33

EXHIBITION CATALOGUE ENTRIES: 27–58
41

THE QUEEN'S COURT

SUSAN DORAN
The Queen's Suitors and the Problem of the Succession
65

SUSAN FRYE
Entertainments at Court
73

EXHIBITION CATALOGUE ENTRIES: 59–130
81

ELIZABETH'S ADVENTURERS

SIAN FLYNN AND DAVID SPENCE
Imperial Ambition and Elizabeth's Adventurers
121

EXHIBITION CATALOGUE ENTRIES: 131–91
133

REPRESENTING THE QUEEN

TARNYA COOPER
The Queen's Visual Presence
175

DIANA SCARISBRICK
Elizabeth's Jewellery
183

EXHIBITION CATALOGUE ENTRIES: 192–212
189

THREAT TO THE CROWN

THOMAS McCOOG SJ
The Catholic Threat to Elizabeth
207

EXHIBITION CATALOGUE ENTRIES: 213–51
215

ELIZABETH'S LAST YEARS AND DEATH

EXHIBITION CATALOGUE ENTRIES: 252–70
241

MICHAEL DOBSON AND NICOLA WATSON
ELIZABETH'S LEGACY
255

Footnotes and Further Reading 263 Genealogy 275
Select Bibliography 267 Picture Credits 277
Chronology 273 Index 279

SPONSOR'S FOREWORD

T HIS EXHIBITION, which marks the 400th anniversary of the death of Elizabeth I, is perhaps the most complete and wide-ranging examination of her life and influence ever assembled. As part of our long tradition of supporting significant cultural events, Morgan Stanley is very pleased to be associated with this unique and important show.

Elizabeth I was a remarkable leader, a remarkable woman and a remarkable Briton. All of these attributes make her a most relevant subject for many of the constituencies that are important to Morgan Stanley: our people, our clients, our British friends and the women who constitute such an important part of all these groups.

The exhibition highlights each of the aspects – political, commercial, religious and cultural – that defined Elizabeth's reign and contributed to the pervasive and lasting influence she exerted on the nation. She ruled in turbulent times, survived innumerable threats to her throne and, indeed, to her life. Through it all, she managed to lead England into an age of unprecedented political, commercial and cultural prominence – an age which bears her name. Versatile, resourceful and resilient, she is recognised as one of the great leaders of her time, as one of the greatest heads of state that Great Britain has ever had, and as a woman who demonstrated that gender was irrelevant for one who had 'the heart and stomach of a king, and of a king of England too'.

For us at Morgan Stanley, leadership is a subject of great interest. It is what separates exceptional organisations from ordinary ones. We therefore take particular pleasure in sponsoring an exhibition focused on Elizabeth I, from whose life and reign there is so much to be learned about the subject.

In conjunction with this sponsorship of *Elizabeth*, Morgan Stanley is working closely with the National Maritime Museum to develop an education programme that will draw upon the rich content of the exhibition and reach school children around Morgan Stanley's European headquarters at Canary Wharf and in Greenwich.

We congratulate the National Maritime Museum on putting together this excellent exhibition.

Stephan F. Newhouse
Chairman
Morgan Stanley International

DIRECTOR'S PREFACE

ON THE 400TH ANNIVERSARY of Elizabeth I's death, it is timely to reconsider her life and significance to England. Elizabeth was born at Greenwich. It was at Greenwich that her mother was arrested for multiple adultery, and from the window of Greenwich Palace that Elizabeth waved to Martin Frobisher as he sailed on his voyage to the North-West Passage in 1576 to claim new lands for England. It was at Greenwich that she received the traditional New Year's gifts on 1 January 1588, a year that would see the attempted invasion of England and was to prove her sternest test as a monarch and great leader. It was also possibly on his visit to Greenwich that Elizabeth accepted the marriage proposal of Francis, Duke of Anjou. Had she not reconsidered, this match would have changed the history of our country, and our perception of its queen.

It is also appropriate for the National Maritime Museum to stage this exhibition because some of this nation's most resounding seafaring achievements emanate from Elizabeth's reign. The conspicuous increase in maritime confidence during the Elizabethan era became the basis for British maritime supremacy, and ultimately the foundation of Empire. The courage, seamanship and fortitude of the many legendary figures of the period are the paradigm for Britain's enduring relationship with the sea. Defined by trade, exploration, wealth-creation, migration and the ebb and flow of power, this maritime influence is nowhere stronger than in the City of London today, where — with origins in Elizabeth's reign — many institutions and companies continue to energise the national economy.

The Museum could not have created this exhibition without the support of a great number of people, starting with my distinguished predecessor, Richard Ormond, and Sir Roy Strong who laid the groundwork. Our sponsor, Morgan Stanley, has been most generous and their wholehearted commitment to the project has been inspirational. Our Guest Curator, David Starkey, has been key to our progress, ever encouraging, constructive and imaginative. Another member of the team, Tarnya Cooper, has been extraordinarily generous with her time and energy.

The catalogue has been carefully and thoughtfully constructed by Susan Doran and aims to provide both a general introduction to the subject as well as a detailed examination of some of the themes in the exhibition.

The National Maritime Museum would also like to acknowledge the large number of lenders, both public institutions and private individuals, without whom this exhibition would not have happened. Full acknowledgements are made elsewhere, but I would like to thank particularly Her Majesty the Queen and the staff of the Royal Collection, the British Museum and British Library, the National Portrait Gallery, the Victoria and Albert Museum and the Museum of London.

Finally, I extend my congratulations to Jane Holmes, who has organised the exhibition production, and Sian Flynn and David Spence who have envisaged and created the show that we now anticipate will engage and enthuse our many visitors at home and abroad.

Roy Clare
Director, National Maritime Museum
Greenwich
2003

ACKNOWLEDGEMENTS

M ANY PEOPLE HAVE CONTRIBUTED to the success of the exhibition, but the National Maritime Museum would like to thank especially David Starkey, Tarnya Cooper and Susan Doran. We are also grateful to: Sian Flynn, the principal in-house curator, assisted by Claire Warrior; Jane Holmes who has managed the exhibition production; Louise Ellison for her help with sponsor relations. We extend our particular thanks to those who have lent items to the exhibition; their generous support has enabled the Museum to bring together a spectacular show. The richness of the product is reflected in the catalogue and we are very grateful to all those who have contributed to it. The complex process of organising and editing the material has been carried out skilfully by Susan Doran with the assistance of Tarnya Cooper, who between them have also written a considerable number of the catalogue entries in addition to their individual essays. Stephen Deuchar (formerly Head of Exhibitions and Display at the National Maritime Museum) provided an important early input and we are grateful to him and to Sir Roy Strong for their initial research, which laid secure foundations.

The staging of an exhibition of this magnitude necessarily involves the whole organisation. Firstly, we would like to thank CP Ships, sponsor of the Special Exhibition Gallery. In addition, many external specialists and advisors have assisted with the process. I would like to record my personal thanks to: Derek Adlam; Sir Nicholas Bacon; Jamie Beveridge; Simon Bobak; Christopher Brown; Barrie Cook; Katie Coombs; Alison Cresswell; Elena Gagarina; Jo Graham; Sir John Guinness; the Lord Hastings; Professor John Hattendorf; Jørgen Hein; Rica Jones; Nicola Kalinsky; Alastair Laing; Sophie Lee; Chris Lloyd; Christiane Lukatis; Catharine MacLeod; Jo Moore; Pamela Porter; Sir Hugh Roberts; the Hon. Jane Roberts; the Lord Tollemache; Rebecca Wallace; Robin Harcourt Williams; the staff of the Witt Library; Robert Yorke.

Many Museum staff were directly involved, too: Rachel Giles, Fiona Renkin and Alicia Worrall with the catalogue; photographic work was by Tina Chambers, Ken Hickey, Josh Akin and Lisa Macleod. Catalogue design by Peter Ward. In various ways: Michael Barrett; Helen Beioley; Laurence Birnie; Kirsten Canning; Elizabeth Hamilton-Eddy; Jessica Elliot; Dennis Hayler; Julie Keith; Elena Kuryleva; Sarah Lockwood; Pieter van der Merwe; Hélène Mitchell; Richard Norris; David Packer; Emily Price; Liz Smith.

Finally, I would like to thank the designer David Bentheim, with Diego Trolliet and Graham Wileman; lighting designer Max von Barnholt; Quantity Surveyor Chris Coleing; building contractors Silver Knight Exhibitions Limited and the designer of the Discovery gallery, Steve Ridgeway, with interactive design by Darius Wilson.

David Spence
Director of Exhibitions

LIST OF LENDERS

Her Majesty The Queen
Ashmolean Museum, Oxford
Gordon S. Barrass
Trustees of Lady Beauchamp's Will Trust
Trustees of the Berkeley Will Trust
Bodleian Library, University of Oxford
The British Library, London
The British Museum, London
The Burghley House Collection
The Archbishop of Canterbury and the Church
 Commissioners for England
The Chequers Trust
The College of Arms, London
De Danske Kongers Kronologiske Samling paa Rosenborg
Dr Philip Dixon, University of Nottingham
Dover Museum
Syndics of the Fitzwilliam Museum, Cambridge
Glasgow Museums: Art Gallery and Museum, Kelvingrove
Hardwick Hall, The Devonshire Collection (The National
 Trust)
Staatliche Museen Kassel, Graphische Sammlung
Moscow Kremlin Museums
The Lord Mayor of the City of London, Mansion House
Loseley Park
The Honourable Society of the Middle Temple
Montacute, The Sir Malcolm Stewart Bequest (The National
 Trust)
Museum of London

Board of Trustees of the National Museums and Galleries
 on Merseyside (Walker Art Gallery, Liverpool)
Trustees of the National Museums of Scotland, Edinburgh
National Portrait Gallery, London
The Duke of Norfolk, Arundel Castle
Northampton Museums and Art Gallery
Parham House and Gardens, West Sussex, England
Parochial Church Council of the Parish Church of St Mary's,
 Preston St Mary, Suffolk
The Public Record Office, Kew
Board of Trustees of the Royal Armouries
Royal Mint
The Marquess of Salisbury
The Earl of Scarbrough, on loan to the Leeds Castle
 Foundation
Scottish National Portrait Gallery, Edinburgh
Society of Antiquaries of London
Trustees of the Titsey Foundation
The Lord Tollemache
William Tyrwhitt-Drake
Ulster Museum, Belfast (Antiquities Collection)
Victoria and Albert Museum, London
The Vintners' Company
Waddesdon Manor, The Rothschild Collection (Rothschild
 Family Trusts)
The Parish of Wool and East Stoke
All generous private lenders

CATALOGUE CONTRIBUTORS

Note: Each catalogue entry is followed by the initials of its author.

Silke Ackermann, Curator, Department of Medieval and Modern Europe, British Museum (SA)

Robert Blyth, Curator, Imperial and Maritime History, National Maritime Museum (RB)

Clare Browne, Curator, Department of Furniture, Textiles and Fashion, Victoria and Albert Museum (CB)

Gloria Clifton, Curator of Navigational Instruments, National Maritime Museum, and Head of the Royal Observatory Greenwich (GC)

Barrie Cook, Curator of Medieval and Early Modern Coinage, Department of Coins and Medals, British Museum (BC)

Tarnya Cooper, Curator, Elizabeth Exhibition, National Maritime Museum; Curator of sixteenth century collections, National Portrait Gallery (TC)

Diana Dethloff, Lecturer, Art History, University College London (DD)

Susan Doran, Lecturer, Early-Modern History, Christ Church, Oxford (SD)

Edwina Ehrman, Curator of Dress and Decorative Art, Museum of London (EE)

Sian Flynn, Exhibitions Manager, National Maritime Museum (SF)

Hazel Forsyth, Curator (Post Medieval), Department of Early London History and Collections, Museum of London (HF)

David Gaimster, Department for Culture, Media and Sport, Cultural Property Unit (DG)

Philippa Glanville, Academic Director, Waddesdon Manor, International Trust Property, Somerset House, London; Consultant Curator, Gilbert Collection (PG)

Karen Hearn, Curator of Sixteenth- and Seventeenth-Century British Art, Tate Britain (KH)

Robin Hildyard, Senior Curator, Ceramics and Glass Collection, Victoria and Albert Museum (RH)

Maurice Howard, Professor of Art History, University of Sussex (MH)

Nick Humphrey, Curator, Department of Furniture, Textiles and Fashion, Victoria and Albert Museum (NH)

Gillian Hutchinson, Curator of the History of Cartography, National Maritime Museum (GH)

Kristen Lippincott, Deputy Director, National Maritime Museum (KL)

Stephen Lloyd, Senior Curator, Scottish National Portrait Gallery (SL)

Arthur MacGregor, Senior Assistant Keeper, Department of Antiquities, Ashmolean Museum, Oxford (AM)

Thomas M. McCoog, sj, Archivist of the British Province of the Society of Jesus (TM)

Nick Mayhew, Keeper of the Heberden Coin Room, Ashmolean Museum, Oxford (NMa)

Natalie Mears, Lecturer in Early Modern History, University of Manchester (NM)

Pieter van der Merwe, General Editor, National Maritime Museum (PvdM)

Amy Miller, Curator of Decorative Arts, National Maritime Museum (APM)

Roger Quarm, Curator of Pictures, National Maritime Museum (RQ)

Thom Richardson, Keeper of Armour, Royal Armouries (TR)

Diana Scarisbrick, Freelance Art Historian (DS)

David Spence, Director of Exhibitions and Display, National Maritime Museum (DSp)

Simon Stephens, Curator of Ship Model and Boat Collections, National Maritime Museum (SS)

Barbara Tomlinson, Curator of Antiquities, National Maritime Museum (BT)

Liza Verity, Information Specialist, National Maritime Museum (LV)

Graham Walker, Cellist (GW)

Emily Winterburn, Curator of Astronomy, Royal Observatory (EW)

Robert Woosnam-Savage, Curator of European Edged Weapons, Royal Armouries (RWS)

James York, Curator, Furniture, Textiles and Fashion Department, Victoria and Albert Museum (JY)

NOTES ON CONVENTIONS

THE INFORMATION in the catalogue has been given as fully and accurately as possible, but areas of uncertainty do exist. Catalogue entries have been compiled in the following order:

— Title and date of object. Square brackets indicate date is uncertain.

— Artist/maker/author and his/her dates or school or place of origin where appropriate or certain.

— Media, and publisher of printed books.

— Dimensions in cms: height x width. Measurements have only been introduced for paintings, and single-leaf prints and drawings.

— Inscriptions on paintings or where they add to the meaning of the object.

— Provenance where known.

— Collection, location, and reference number where documented. Page and folio numbers have been noted when illustrated.

— Text. Spelling has been modernised, except for long quotations in verse or poetry. All dates are old style, following the Julian Calendar followed by England in this period. Year begins on 1 January.

— Literature. Up to three works have been selected. Full details are provided for works that only appear once. Otherwise, the full reference appears in the bibliography.

— Authorship. Abbreviations are explained on the previous page.

INTRODUCTION

ELIZABETH: WOMAN, MONARCH, MISSION

David Starkey

ELIZABETH IS EXTRAORDINARY. SHE LOOKS EXTRAORDINARY. SHE BEHAVES in an extraordinary way. And, as a woman moving effortlessly in a man's world, she is doubly extraordinary. Part of the trouble, though, is that we think of her as being extraordinary for the wrong reasons. We think of Elizabeth, above all, as that bizarre confection of the last part of the reign: bejewelled, bewigged, beruffed, and utterly artificial. I invite you to consider another, very different Elizabeth, the Elizabeth portrayed as she was when she was young. This Elizabeth appears in a painting executed by a great though unknown artist almost certainly in the last month of her father's life, January 1547 (Cat. no. 13). Here she is completely natural, and she looks what she is: a rather shy, rather awkward teenager.

What we have in this portrait is the teenager who formed the woman. And one of the most important things about the Exhibition is that it deals with this teenager and with her formative experience. So we do not just look at Gloriana, at the painted mask of her final artificiality. We do not just look at the glory days of the latter part of the reign. We also look, long and hard, at the brutal experience of her youth.

This means that, when we open the Catalogue or go into the Exhibition galleries, the first thing we see is not an exquisite painting by Hilliard, not a confectionery-dress, nor some frou-frou, but an armour for man and horse (see page 1). It is beautifully decorated with the characteristic gold inlaid borders of the best Greenwich armour. But it is not a parade armour, but the real, working armour of one of the power-brokers of the middle of the sixteenth century, William Herbert, 1st Earl of Pembroke. It is astonishing, brutal, like the mounted statue of an Italian *condottiere*.

And the man inside it fully lived up to the image. Herbert committed at least two murders in his youth. But he was twice pardoned by Elizabeth's father, Henry VIII. Indeed, impressed it is said by his performance in a sword-fight outside Whitehall, Henry took him into his household. There he rose rapidly. He married Anne Parr which made him, in the fullness of time, brother-in-law of Henry VIII's last queen, Catherine Parr. And he became Chief Gentleman of the privy chamber, or joint-principal body servant of the King. As such, he witnessed Henry's almost-certainly doctored Will, which gave him a substantial legacy and made him a member of the young King Edward VI's privy council. Here he proved as grimly dextrous in politics as he was with the sword. He backed Northumberland against Somerset and was rewarded with an earldom. Then, after Edward's death, he threw over Northumberland and Northumberland's creature, Lady Jane Grey, and informed his demoralised fellow-councillors: 'either this sword shall make Mary Queen or I'll lose my life'.

He was as good as his word and was, effectively, Mary's queen-maker. And he showed a similar bold determination in the other crises of the 1550s, such as Wyatt's revolt, when he was Mary's most effective commander, and the battle of St Quintin, when he led the English contingent that covered itself in glory.

So Elizabeth grew up a vulnerable teenager in a thug

Greenwich Palace where Elizabeth was born in 1533.

culture. And the reason she is so great, the reason she is so different from her father and her brother and sister, is that she had been on the receiving end.

The result is the most remarkable formation of any monarch in British history. It is as though Prince William had been sent not to Eton but to Wormwood Scrubs. For Elizabeth's entire early life was a switchback. She was born to ease, as Princess and inheritrix of England. But her gender was a mistake: she was intended to be a boy, and the letters survive that announced the birth of the 'Prince', with the word hastily changed into 'Princess' by the addition of a scribbled letter 's' when this unwelcome object was popped into the cradle designed by Holbein and made by the royal goldsmith.

Her mother, Anne Boleyn, more than compensated by the fine clothes and demonstrative affection she lavished on her daughter. But within three years Anne was divorced and executed. And not only executed but morally rent apart. The false charges on which she was destroyed were not simply adultery but multiple adultery with five men; and not simply multiple adultery but incest, as one of the men was her brother; and not simply incest but perversion. I didn't know the Latin for French kissing but there it is in the indictment: which lip-smackingly described how first the queen inserted her tongue into the mouth of her 'natural brother', George

Boleyn, Lord Rochford, and how he in turn put his in hers as they kissed lewdly with open mouths.

How could the child of a mother so demonised survive, psychologically, if not physically? But Anne's death didn't destroy Elizabeth. Even more remarkably, it did not produce a devotion to her mother such as Mary felt after her mother, Catherine of Aragon's, only slightly lesser martyrdom at Henry's hands.

Instead, Elizabeth was devoted to her father. She was 'her father's daughter'. This phrase was first used about her at the age of six. And it appeared constantly thereafter. For contemporaries had only to use their eyes to see that it was true. She looked like Henry, with her father's hair, skin-colour, nose and lips (though her eyes were dark and lustrous, like her mother's, and she had her mother's exceptionally long, slender fingers). She had much of Henry's character as well: his intelligence, his force of personality, his eloquence, and his ineffable star-quality that made her, like him, the automatic centre of attention.

But in other, equally important respects, she was different, and self-consciously so.

When her father made himself Supreme Head of the Church, he began by reconsidering his coronation, much of whose ritual and language were wholly incompatible with his present claims. In particular, he revised the second part of the

coronation service, the Oath, which was the equivalent of a contract between monarch and people. And he altered the Oath fundamentally. Obviously, the monarch's promise, central since Magna Charta, to respect 'the liberties of the Church' was wholly rewritten. But that was only the beginning. The result was to transform the Oath from what it had been since the Anglo-Saxon period, a compact between the king and the people, into a solipsistic promise to defend the rights of the Crown. In other words, Henry changed it from the English participatory Oath into a French-style absolutist Oath. But most interesting and personally revealing are his alterations to the undertaking that deals with the monarch and justice. At his coronation he had sworn – like his predecessors and like all his successors, from Elizabeth I to Elizabeth II – to do justice not only in truth but in mercy. But now, in his redrafting, he crossed out the word 'mercy'.

Henry did not believe in mercy. Elizabeth did. She also believed in its concomitant, a 'middle way'. That she was able to put this aspiration in practice, however imperfectly, is remarkable. For she succeeded to the throne after two reigns of deliberate extremism: the reign of her brother, which had swung England acutely in the direction of Protestantism (if Edward had survived and produced an heir, we would be like the old Prussia or Sweden); immediately followed by Mary (and if Mary and Philip had produced a child, we would be like Sicily).

Elizabeth, curiously, had been a victim of both regimes. Edward's Protector, Somerset, had subjected Elizabeth to a humiliating investigation on charges of lewd conduct with his brother, Thomas, Lord Seymour of Sudeley; while Edward himself tried to disinherit her, since, as a woman, she was unfit to rule. Mary, though equally the target of her brother's attempted changes to the succession, pursued an even more dangerous vendetta against Elizabeth. By the very fact of her birth, Mary saw her as a symbol of the Reformation and of resistance to the Catholicism that Mary was determined to reimpose on the country. So Elizabeth was sent to the Tower under suspicion of treasonable involvement in Wyatt's revolt. She escaped execution by a whisker and was released only into a lengthy house arrest at distant, isolated Woodstock.

It would be too simple to see these experiences at her brother's and sister's hands as leading Elizabeth to say 'a plague on both your houses'. But there is no doubt that they reinforced her intellectual preference for the 'middle way'. And her choice, whatever her motives, seems to me to be the real foundation of England.

For the essence of England is carefully thought-out, exquisitely-achieved muddle – that and the avoidance of extremes: in punishment, in religion, in politics. Elizabeth literally reinvented what politics is about. And she did it in a few days, at Hatfield and the London Charterhouse, at the very start of her reign in 1558.

Mary died on 17 November and, between then and 23 November, Elizabeth remained in semi-isolation at Hatfield, the house where she had lived for much of Mary's reign. She used her time well. For, in the course, effectively, of two days she revolutionised the nature of her government. When Mary had come to the throne, she had recruited councillors rather as a rolling stone gathers dross. Each group of notables who joined her standard and acknowledged her as queen – however diverse, however contradictory its politics – was taken on board. The result was that, by the time she finally entered London, she had a council of between thirty-five and forty. It was riven from top to bottom; it was everything from Protestant to Catholic, from pro-French to pro-Spanish. It was, in short, a complete mess. Elizabeth ruled that out. She decided – and she said it with extraordinary clarity – that she would have a small council.

She made her announcement in a speech in which she addressed her assembled nobility – then virtually synonymous with the council – and explained why she was sacking most of them. She concluded with the phrase: 'I do consider that a multitude doth make rather discord and confusion, than good counsel'. So she decided that she wanted a small, hand-picked team. We can watch the process of interviewing – done, not by the queen herself, but largely by her right-hand man William Cecil. We can even watch an interview in which somebody turned a job down, and then was invited to advise on the range of alternative candidates. How many cabinets of modern governments or boards of modern companies, I wonder, are the result of quite such careful sifting?

Having chosen this very small team, carefully balanced and reflecting her personal wishes, she did something else that those in business or modern politics need to remember: she

Hatfield Old Palace in Hertfordshire.
It was here that Elizabeth selected her first council,
with the help of William Cecil (*right*).

gave them her absolute trust. Here, she was defying much of the advice she had been given, which was to keep people on the hook, never fully to trust anybody, to follow Machiavelli (whom she could well have read, given her excellent Italian). In return for her trust, she demanded an absolute loyalty and also an absolute plain-speaking.

This was set out most clearly in her injunction to her chief minister, the Secretary William Cecil. 'This judgement I have of you', she said, 'that you will not be corrupted with any manner of gift (I fear he was, but never mind), and that you will be faithful to the state, and that without respect of my private will, you will give me that counsel that you think best.'

She asked him, in short, to speak to her honestly; even to say things that she did not want to hear.

The reign thus began with the choosing of the board, with the Queen acting, not as her own prime minister or chief executive, but as chairman, and always being conscious of the limitations, as well as the importance of the chairman's role. It was a secret process or at least one that took place behind closed doors. And only when it was accomplished did she leave

Hatfield, on 23 November, and come to the Charterhouse. The Charterhouse is one of only four substantial buildings in London that Elizabeth would still recognise (the Abbey, the Tower and Southwark Cathedral are the other three). And it was chosen, not only because it was large, up-to-date and luxurious, but also – quite deliberately – on grounds of its location. For it was almost in London but not quite, lying by Aldersgate just outside the City walls, and separated from them by the precinct of St Bartholomew's Hospital.

For there were things to be decided before she actually entered the City, or went to her own palace of Whitehall. The principal issue was religion. Elizabeth was worried about moving to Whitehall because the public nature of religious services in the palace would mean that, once she entered it, she would have to declare her hand on the matter of religion. And this, for reasons foreign and domestic, she wished to put off as long as possible. Not for the last time, she proved a mistress of delay. It was only on 23 December that she finally took up residence in Whitehall. And it was only on Christmas Day, when she withdrew from the Chapel Royal at the moment

of the elevation of the Mass, that she made her religious preferences plain.

The final pieces of the jigsaw in Elizabeth's style of leadership were put in place in January 1559. On the 14th, she made her entry into the City of London; on the 15th she was crowned and on the 23rd she met parliament. Elizabeth was an absolute, God-given monarch and proud of the fact. But she was also a monarch who would always pay attention to her Lords, her Commons, her Church and, above all, to her People. The great sequence of ceremonies of January 1559 made it clear how she would discharge the task.

Most important was the speech which Lord Keeper Bacon read to parliament for her, in which Elizabeth announced her mission statement. Her mission statement (like almost all such) divided into three parts. The first was to repeat the assurance she had already given to Cecil – that she would rule with 'counsel'. This didn't mean she would be ruled *by* her councillors, but it did mean she would rule *with* them and would take their advice, even when it was unpalatable. All of which, if we look at the reigns of her father, her sister and her brother, was novel enough in itself.

Her second promise was even more extraordinary, and was the thing that produced the new politics. Traditionally the Tudors demanded absolute obedience from their subjects, and rebellion was presented as the ultimate crime against the monarchy. But towards the end of Elizabeth's speech, Bacon diverged sharply from this text. He noted that the last few years had seen several rebellions: Wyatt's revolt against Mary, the revolts of East Anglia and the West Country against Edward, and the resistance against Mary following her marriage to Philip. As we have seen, in theory such rebellions were simply a sin on the part of the subject and were both inexcusable and without excuse. But Bacon said something very different. He acknowledged that a monarch's misguided policies can trigger revolt and had indeed done so. But the new queen, for her part, would avoid this mistake. Elizabeth, he declared, 'is not, nor ever meaneth to be, so wedded to her own will and fantasy that for the satisfaction thereof she will do anything . . . to bring any bondage or servitude to her people, or give any just occasion to them of any inward grudge whereby any tumults or stirs might arise as hath done of late days'.

This stood the central commonplace of Tudor political theory on its head: rebellion was not so much the result of the subject's disobedience but of royal folly. In recognising this, Elizabeth acknowledged that she ruled by consent. Which in turn meant that she depended on popularity.

And she indeed displayed an extraordinary talent for gaining, maintaining and keeping popularity. She hoarded it like a miser and she was as jealous of it as any lover. She was also a mistress of all its techniques. She image-made. She sloganised. She speechified. And she made sure that all the speeches were reported, edited and made available in the improved version. She also excelled at things we think of as entirely modern, such as walkabouts and photo-opportunities. And we can see all this in operation, right at the beginning of the reign in her pre-coronation entrée into London on 14 January.

Normally, the coronation procession saw the people address the monarch, through the tableaux and pageants along the route. But Elizabeth answered back, and we can sense the surprise of the people when this happened. She saw an old man weeping in the crowd. Clearly he was a Catholic, mourning for his religion. But what did the queen say? 'Look, he's crying tears of joy!' A humble woman gave her a little gift of rosemary. Elizabeth received it gratefully and it was noticed that, when the procession finally reached Westminster, this humble sprig of rosemary was still lying in her litter alongside the great gifts of the City.

This was genius.

But the climax came when she almost destroyed the centre-piece of the performance. This was the pageant in which she was to be presented with the English Bible – the crux of the English Reformation. In her eagerness to receive it, she asked for it to be given to her immediately, before the players had done their little performance. But she was persuaded to wait and hear them through. Finally the Bible was lowered from the pageant and presented to her. The people had never seen anything like her reaction. She kissed it. She placed it upon her bosom. She held it up. She wept tears of joy. She showed it to the crowd. Nothing could be cruder or more vulgar. And it's perfect. It is Princess Diana at her best. Popularity *is* vulgarity – that's what's demonstrated by this scene, and Elizabeth was a master-mistress of it.

But we haven't finished with the mission statement. The first two promises were to take 'counsel', and to remain popular.

Then came the tough edge, as she promised not to lose territory but to fight for market share.

For her sister's entire reign had been destroyed by the loss of Calais. 'Could there have happened to this imperial Crown a greater loss in honour, strength and treasure than to lose that [place], Calais, I mean?' Bacon demanded on Elizabeth's behalf. Thereupon the queen, in front of her parliament and people, solemnly pledged that she would not disgrace herself or her country by a similar loss of territory. And if you look at the darkest episodes of her reign, as well as the greatest, this promise is the key. It inspired her at the time of the Armada, but it is also the thing that leads to the horror of Ireland. The threat of the loss of territory is one that she would do anything to avoid – and she was right. You cannot hold respect and sacrifice territory.

Finally, the human side. She never forgot what it was like to be on the receiving end of power. Take two instances. The 4th Duke of Norfolk was her cousin and her greatest nobleman. But he was lying in the Tower awaiting execution for his part in the Northern Revolt in 1569 and the Ridolfi plot of 1572. All that was needed was for Elizabeth to sign his death warrant. But she had sleepless nights. In the middle of one of them she wrote Cecil a note which arrived at two in the morning. She had countermanded the execution. And nothing was to be done without her further orders, 'lest an irrevocable deed be in meanwhile committed'. Finally she did give the necessary orders for the execution. But that note, that doubt, that sleeplessness, seems to me another mark of true greatness. This is not a psychopath, like so many leaders; it is somebody who knows what it is like to suffer herself. So she never lost sight of the human cost of power. But equally, she was never hamstrung by that knowledge: she was sensitive but never sentimental.

The same holds true in her treatment of Mary, Queen of Scots. Mary is another central figure in our story, and she is a perfect foil for Elizabeth's greatness. For Mary, Queen of Scots was one of the least worthy persons ever to have exercised sovereignty. She was foolish, self-indulgent, frivolous, unreliable and treacherous. Her behaviour in Scotland had demeaned the notion of monarchy, which Elizabeth held sacred. Her flight to England, to escape her vengeful Scottish subjects, broke Elizabeth's carefully crafted middle way in religion. For ten years, no one had been executed for religion and no one had rebelled for it either. Mary's arrival reopened the old wounds and Elizabeth found herself a persecutor against her better judgement. Finally, Mary repeatedly dabbled in plots against Elizabeth and in the end openly conspired her death. Yet Elizabeth kept her alive for twenty years, and even after she had been condemned to death, her death warrant had to be got out of the English Queen by trickery.

This is an astonishing record. For Elizabeth was that rarest of rulers. Not only was she great; she was also admirable. She can appeal – and that is the magic of her – both to an age who loved heroes, as did the Victorians, and to us, an age of sentimentalists, who like our public figures to be a bit cuddly and victims too (but Elizabeth had the good sense to keep quiet about the cuddliness and the victimhood, and I like her all the more for it).

1. 1st Earl of Pembroke Armour, about 1550

See page 1.
Royal workshops at Greenwich under the master Erasmus
 Kyrkenar.
Steel, etched and gilt, leather.
Provenance: Pembroke family, Wilton House. Purchased by
 R. L. Scott, and bequeathed 1939.
Glasgow Museums: Art Gallery and Museum, Kelvingrove
 (Scott Collection), 1939.65.a–d.

This dramatic armour illustrates the military power of the nobility
during the period of Elizabeth's childhood. It belonged to William
Herbert, created 1st earl of Pembroke in 1551 by Edward VI, and is the
only surviving example of armour made for man and horse at the Royal
Armoury at Greenwich.

At the time of Elizabeth's accession Pembroke was an influential
power broker who had held high office under Henry VIII, Edward VI
and Mary I, proving himself an inveterate survivor of the changing
English political and religious scene. Pembroke was one of Elizabeth's
first privy councillors, appointed just days after her accession.

The armour takes the form of a complete field armour. It is of
russet steel decorated with narrow recessed bands etched with strap-
work arabesques and gilt. This armour would have been completed
when worn by pieces of coloured fabric or leather which contrasted
with the steel. The armour was in existence by 1558 when it was recorded
in the inventory of Pembroke's armour at Wilton. TR & DSp

LITERATURE: Gamber, 'Royal Workshops at Greenwich', pp. 3, 7,
pl. 5; Mann, *Greenwich Exhibition*, pp. 13–14, no. 6, pl. vii.

2. Portrait of Henry VIII, late sixteenth century

After Hans Holbein (1497/8–1543).
Oil on panel.
66.1 x 46.4cm.
Inscribed: 'HENRICUS. VIII ANG. REX'.
National Maritime Museum, Greenwich, BHC2763.

Henry was born at Greenwich on 28 June 1491, the second son and third
child of Henry VII and Elizabeth of York. On the death of his elder
brother Arthur in 1502, Henry became heir apparent, and on 22 April
1509 he inherited the throne. One of his first acts as king was to
marry Arthur's widow, Katherine of Aragon (1485-1536), who bore their
daughter Princess Mary in 1516. By the end of 1526, however, Henry
wanted the marriage annulled in order to marry Anne Boleyn. After
Pope Clement VII refused to cooperate, Henry eventually broke
away from Rome and initiated the Henrician Reformation. His strong
attraction to Anne, who refused to become his mistress, together with

his concerns about the succession and a growing conviction that
marriage to his brother's widow contravened the law of God were the
motives that drove him into this drastic course of action. The couple
were secretly married in January 1533, and the following May Archbishop
Cranmer dissolved Henry's first marriage.

Henry's marriage to Anne lasted only three years. She had angered
him in producing only a daughter, the future Queen Elizabeth, and in
May 1536 she was executed on a charge of adultery with her brother and
several men of the privy chamber. The same month Henry married Jane
Seymour, who gave birth to Prince Edward on 12 October 1537. At last
Henry had the male heir he required. Following her mother's death, the
infant Elizabeth lived harmoniously with her half-sister Mary (1516-58)
at Hunsdon in Hertfordshire. Although Henry saw little of Elizabeth,
he was well informed of her development and oversaw her education.

This portrait of Henry is closely related to a portrait which was
part of Holbein's wall painting in the privy chamber of Whitehall
Palace, destroyed in the 1698 fire. The wall painting was completed in
1537 and depicted Henry VII, Elizabeth of York, Henry VIII and Jane

Seymour. Only Holbein's cartoon for this with full-length figures of Henry VII and Henry VIII survives and is in the National Portrait Gallery (NPG 4027). The painting was intended to commemorate recent triumphs of the Tudor dynasty and the birth of Prince Edward that year, and does not include Henry's daughters, unlike the painting of c. 1544 at Hampton Court. That many early copies of Henry's portrait survive is evidence that it was regarded as the official image of post-Reformation monarchy, and has become the best-known image of the king today. SD & RQ

LITERATURE: Scarisbrick, *Henry VIII*; Ives, *Anne Boleyn*.

3. Portrait of a Woman, probably Anne Boleyn, c. 1532–6

Hans Holbein (1497/8–1543).
Black and coloured chalks on pink prepared paper.
28.1 x 19.2cm.
Inscribed: in gold over red 'Anna Bollein Queen'.
 Verso: heraldic sketches in black chalk.
Her Majesty The Queen.

It has not been conclusively proved that this carefully observed drawing depicts Anne Boleyn (1507-36), but it has long been connected with her name, and may have been identified as early as the 1540s by Prince Edward's tutor, Sir John Cheke. Several historians, however, have doubted the identification, questioning the colour of her hair which was thought to be darker brown, and whether the queen would have sat for Holbein wearing only her under cap rather than her full headdress. Contemporary descriptions of the queen record that she was of 'middle stature, swarthy complexion, long neck, wide mouth, bosom not much raised, . . . eyes, which are black and beautiful'. Another commentator recorded Anne's appearance at her coronation where he said: 'She wore a violet mantle, with a high ruff of gold thread and pearls, which conceals a swelling she has resembling goitre' (Strong, p. 6). This drawing was undoubtedly drawn from life and Holbein has recorded the sitter's high necked collar, slight swelling under her chin and dark eyes which do suggest the original inscription may be accurate. Although many later portraits of Anne Boleyn exist, few images of the queen have been positively identified (Cat. no. 7). This study is one of a large number of drawings of the English court that Holbein made on his second visit to England between 1532 and 1543. Prior to the birth of Elizabeth on 7 September 1533, Holbein had helped design an ornate jewelled cradle, which was presumably for Anne's expected child. The heraldic devices on the verso are not connected with Anne Boleyn. TC

LITERATURE: Rowlands and Starkey, 'An Old Tradition', pp. 88-92; Roberts, *Drawings by Holbein*, p. 90; Strong, *Portraits*, pp. 5-6. Ives, *Anne Boleyn*.

4. Gold and Enamel Pendant, c. 1520

Gold and enamel.
Victoria and Albert Museum, London, anonymous loan.

According to family tradition, on the morning of her execution in the Tower of London Anne Boleyn gave this pendant to Captain Gwyn, officer of the guard, saying that it was the first token the king had given her and then asking him to observe 'that a serpent formed part of the device and a serpent the giver had proved to her'.

The pistol shaped case, which can be used as a whistle, is engraved with leaves and flowers, with a snake entwined round the barrel. It contains a set of tooth- and ear-picks, with spear, scythe and spatula-shaped blades. Whistles, used to summon servants and hounds, were designed like pieces of jewellery: Sir Nicholas Bacon (Cat. no. 35) is

wearing one shaped like a dragon in a portrait dated 1579. DS

LITERATURE: Starkey (ed.) *European Court*, p. 11; H.A. Grueber and others, *Exhibition of the Royal House of Tudor* (London, 1890), no. 898, p. 186; Yung, *National Portrait Gallery*, p. 24.

5. Medal of Anne Boleyn, 1534
Unidentified artist (Netherlandish or German?).
Lead.
British Museum, London, CM M9010.

This curious medal would seem to have been produced in celebration of the coronation of Anne, which took place on 1 June 1534. It is the earliest known English medal to mark such an event. The inscription, 'The Moost Happi Anno 1534', partly in English and partly in Latin, suggests that it was not an official commission. It may have been made by a Netherlandish or German craftsman, for it appears to have been cast from a model carved in stone or wood, which in the early sixteenth century was the preferred method of making medals in those countries; the three-quarter facing bust was commonly used on German medals of the time as an alternative to the Italianate profile. The letters A R are abbreviations of ANNA REGINA (Queen Anne). PA

LITERATURE: Hawkins, Franks and Grueber, *Medallic Illustrations*, i, p. 34, no. 22.

6. Coins of Henry VIII and his Queens
London Mint.
Gold.
Inscribed on all: Obv.: 'HENRIC VIII RVTILANS ROSA SINE SPINA' (Henry VIII, a dazzling rose without a thorn).

(a) (b) (c)

(a) Initial mark rose, 1526–9
Additionally inscribed: 'H K', for Henry and Katherine, on both sides.
British Museum, London, CM 1935-4-1-933 (T.B. Clarke-Thornhill Bequest).

(b) Initial mark arrow, 1532–42
Additionally inscribed: 'H A', for Henry and Anne, on both sides.
British Museum, London, CM 1935-4-1-967 (T.B. Clarke-Thornhill Bequest).

(c) Initial mark arrow
Additionally inscribed: 'H I', for Henry and Jane, on both sides.
British Museum, London, CM 1935-4-1-974 (T.B. Clarke-Thornhill Bequest).

When the crown of the double rose was introduced as part of the coinage reforms of 1526, in an exceptionally rare gesture the coin's design made explicit reference to the queen consort, with the presence of her initial alongside the king's visible on both sides of the coin. This development was originally in honour of Katherine of Aragon, whose initial remained in place into the period of initial mark arrow (1532-42), during which the shifts in the king's marital status were faithfully reflected, with first Anne Boleyn and then Jane Seymour making their appearance on the denomination. At some point, and probably soon after Queen Jane's death in 1537, during the king's months of unaccustomed bachelorhood, the coin design was changed to H R, for *Henricus Rex*, which was then retained for the rest of the reign. BC

LITERATURE: Whitton, 'Coinage of Henry VIII', pp. 172-3.

7. Queen Elizabeth's Locket Ring, c. 1575
Mother-of-pearl hoop, table-cut rubies, pearl, table-cut diamonds, enamel.
Provenance: a gift from James I to the 1st Lord Home (1566–1619). Thence by descent until sold, Christie's, 18 June 1919, lot 131, bought by S.J. Phillips for Viscount Lee of Fareham.
The Chequers Trust.

This ring opens to show two portraits: one profile portrait of Queen Elizabeth and the other probably an authentic likeness of Anne Boleyn (Cat. no. 3). Anne is wearing a French hood, necklace, a jewelled square neckline and at her breast a diamond brooch. A phoenix and coronet are enamelled on the back of the oval bezel. Elizabeth's

ownership of this ring provides evidence that she publicly acknow-
ledged her mother, despite Anne's disgrace and execution in 1536.

The queen may have received this ring as a gift from Edward
Seymour, earl of Hertford (1537-1621) since the phoenix was his device
as well as hers. The ring probably dates from about 1575, as the profile
head of the queen is close to that of the Phoenix Badge of 1570-80.

DS

LITERATURE: Somers Cocks (ed.), *Princely Magnificence*, no. 37;
Scarisbrick, *Ancestral Jewels*, p. 30; Norma Major, *Chequers* (London,
1996), p. 223.

8. Dagger

Dagger (*khanjar*) and scabbard, sixteenth–seventeenth century.
The blade Iranian, probably late sixteenth century, the mounts
Turkish, seventeenth century.
Steel blade damascened in gold, hilt and scabbard nephrite
set with hessonite garnets (jacinths) and emeralds in gold,
silver gilt guard decorated with niello.
Private Collection.

The tradition associated with this dagger is that it belonged to Henry
VIII. It is now thought that this attribution is impossible, although
he had at least one very similar piece, which was recorded in the 1547
inventory. The inventory records a dagger of a green stone with a sheath
garnished with diamonds, rubies and emeralds and a blade wrought
with 'morisco work', garnished with small rubies. Henry's possession of
such a dagger provides insight into his taste for exotic goods.

This particular dagger was purchased by Edward Harley
(1689–1741) in 1720 from the sale of the Arundel collection at Tart Hall,
by which time it had acquired its traditional ascription to the collection
of Henry VIII.

TR

LITERATURE: A. Ivanov, 'A group of Iranian daggers of the period
from the fifteenth century to the beginning of the seventeenth, with
Persian inscriptions', in R. Elgood, *Islamic Arms and Armour*, (London,
1979), pp. 64–77; Starkey (ed.), *Inventory of King Henry VIII*, p. 80.

9. Letter from Anne Boleyn to Lord Cobham, 1533

Manuscript.
British Library, London, Harleian MS 283 fo. 75.

Henry VIII and Anne fully expected their first child would be a boy, and planned to call it Henry or Edward. But at 3 pm on Sunday 7 September 1533 at Greenwich Palace, Anne delivered a daughter. Letters announcing the birth were immediately sent out, some of which (including this one) had been written in advance. Here God is thanked for sending the queen 'good speed in the deliverance and bringing forth of a prince'. Hastily an 's' had to be added to announce the birth of a 'prince[s]'.

The sex of the baby was a grave disappointment to her parents. The jousts arranged to celebrate the birth of a royal son were cancelled and the celebrations were low key. A herald, however, announced the arrival of the first of Henry's 'legitimate children' and the Chapel Royal sang the *Te Deum* to thank God. SD

LITERATURE: Ives, *Anne Boleyn*; Starkey, *Elizabeth*.

Elizabeth's Childhood

10. A Treatise or Chronicle of Anne Boleyn by William Latymer

Manuscript.
Bodleian Library, Oxford, MS Don.C42 fos 21-33.

We cannot be certain that this treatise on the life of Anne Boleyn was actually presented to her daughter. The manuscript seems to be a draft rather than a presentation copy, although it is prefaced by a dedicatory epistle to Queen Elizabeth. Nonetheless, there is a strong possibility that Elizabeth did receive the chronicle as Latymer certainly received many rewards at her hands.

Latymer had been Anne Boleyn's chaplain in the 1530s, and his main purpose in writing the chronicle was to rehabilitate his late mistress who had a reputation as a harlot after her conviction in 1536 as a multiple adulteress. Anne is therefore shown in a sombre light – never dancing, feasting or enjoying courtly pastimes – but instead well read in the scriptures, charitable to the poor, a patron of Protestants, and a moral force in her household. Latymer's second purpose in writing the chronicle was to present Anne as a model for Elizabeth to follow: to encourage the queen to complete her mother's work in reforming the

Church. He also hoped no doubt to endear himself to Elizabeth and thereby secure advancement in his career. SD

LITERATURE: Maria Dowling (ed.), 'William Latymer's Chronickille of Anne Bulleyne', in *Camden Miscellany XXX*, Camden Society, fourth series, 39 (London, 1990).

11. a-d. Elizabethan Toys: a miniature lidded ewer, late sixteenth to early seventeenth century; male and female figures, late sixteenth century; ship, late sixteenth century

Tin and tin-lead alloy.
Museum of London, 98.2/154; 98.2/367; 98.2/433 and 98.2/431.

Like those of other royal and some noble children, much of Elizabeth's childhood was spent being tutored in the scriptures, the Classics, and

European languages, and developing skills such as music and needle-work but many young children from wealthy backgrounds would have also have played with toys. They probably played with base-metal toy vessels and utensils and other shapes such as ships, as shown here. Such miniatures were also collected by adults to display in purpose-built cabinets for the privileged few to admire.

The first specific reference to the ownership of pewter toys in English sources is a rather enigmatic entry in the 1562 Wardrobe Accounts of Elizabeth I to 'One Baby [doll] of pewter' for Ippolyta the Tartarian, a serving woman (possibly a midget) in the service of the queen. It is possible that this 'toy' was similar to these male and female figurines which were probably intended to be used as a pair with string threaded through their looped hands so that they could be 'walked' towards each other across the table. The dress of the female suggests European manufacture, although comparable examples have yet to be found from excavations on the Continent. HF

LITERATURE: Forsyth, *Toys, Trifles and Trinkets*.

12. Embroidered Prayer Book Translation of Queen Katherine's *Prayers or Meditations*, 1546

Handwritten book with embroidered cover.
British Library, London, Royal MS. 7.D. X.

This trilingual translation of Queen Katherine's *Prayers or Meditations* was a New Year's gift from Princess Elizabeth to her father for 1 January 1546. Its elaborately embroidered crimson cover may be Elizabeth's own handiwork, for she was by then an accomplished needlewoman, although it does appear to be a professional job. Henry VIII and Katherine's initials are entwined in the centre of the front cover, and in each corner is stitched a white rose, the emblem of the princess's namesake and paternal royal grandmother, Elizabeth of York. Inside are 117 pages written in Elizabeth's neatest hand, which provide a translation into Latin, French and Italian of a collection of prayers and meditations which Katherine had originally composed in English. The epistolary preface to the book, written in Latin, is the only extant letter from Elizabeth to her father. It is dated 31 December 1545 and addressed from Hertford, the royal residence where the princess and probably her brother Edward were then living. As is to be expected, the letter is highly complimentary to the king; it also emphasises Elizabeth's duty of obedience to him as a daughter and subject, referring to him, for example, as 'a god on earth'. Six times in the letter Elizabeth draws attention to her royal descent and familial relationship with Henry. Perhaps she still did not feel confident of her place in her father's affections despite the 1544 Act of Succession, which had given her a right to inherit the throne if her brother and sister died without heirs.

The form of Elizabeth's present to her father was not unique. The same year she gave Katherine an English translation of chapter one of Jean Calvin's *Institution de La Religion Chrestienne*; the previous year she had given Katherine an English translation of a French devotional work by Marguerite d'Angoulême, entitled *The Mirror or Glass of the Sinful Soul*. These gifts illustrate both Elizabeth's developing skills in foreign languages, under the instruction of her tutor William Grindal, and her interest in devotional works which reflected evangelical or reformed thinking. SD

LITERATURE: Klein, 'Elizabethan Gifts of Needlework'.

13. Portrait of Elizabeth I when Princess, c. 1546

? Flemish School.
Oil on panel.
108.5 x 81.8cm.
Inscribed: top left: in a slightly later hand
'[E]lizabetha / [Fi]lia Rex / [A]nglia'.
Provenance: see Millar, *Collection*, p. 65.
Her Majesty The Queen.

This is the earliest extant individual portrait of Elizabeth. She is identified by the inscription in Latin which can be translated as 'Elizabeth, daughter of the king of England'. It was presumably painted for her father Henry VIII, because it is listed in the inventory of his property inherited by her half-brother Edward in 1547. It is by the same unidentified artist as a three-quarter-length image of Prince Edward in the Royal Collection of almost identical dimensions and probably of similar date.

Both are extremely sophisticated works, and they could be by an artist called Guillim Scrots (active 1537–c. 1553) who had previously been employed as court painter to the Habsburg ruler, Mary of Hungary, at Brussels. By Michaelmas 1545 Scrots was working for Henry VIII on a high salary – which he continued to receive in the reign of Edward VI. It is not easy to establish Scrots's *oeuvre*, and it is possible that these two works may be by another – at present unidentified – highly trained émigré artist. The young Elizabeth is here depicted as a king's daughter, richly dressed and wearing jewellery appropriate to this status.

This portrait seems to have undergone a number of changes before it was completed. We know this because, over the years, the paint has become more transparent, revealing that the artist made alterations to the fingers of Elizabeth's right hand and to the position of the small book that she holds. The curtain was painted over an earlier wall with elegant architectural features. There is (now, at least) no sign of any lettering on the pages of the large open volume to the side of Elizabeth. Portraits of Protestant rulers often included books, which not only represented the Bible – which was central to the text-focused reformed religion – but were also symbolic of royal authority. KH

LITERATURE: Millar, *Collection*, p. 65; Hearn (ed.), *Dynasties*, pp. 78-9; Howard, *Tudor Image*, p. 54.

14. Portrait called Katherine Ashley (d. 1565), c. late 1550s–1560

French School.
Oil on paper laid down on to canvas.
22 x 16cm.
Inscribed: 'mon Coeur regayne de lier . . . rein et vous re pecher pas' on the table 'AN° DNI 15 . . .'; on verso in a later hand: 'Catherine Ashley, Lady of the Bedchamber to Queen Elizabeth. By C. Janet'.
Provenance: By tradition from the sitter's husband John Astley to Jacob Baron Astley of Reading (1600–53); Elizabeth and Edward Astley. From 1743 in the collection of their great-grandson Sir Jacob Astley, Bart., thereafter by descent.
Private Collection.

Katherine Ashley (or Astley) née Champernowne had been appointed to be Elizabeth's governess by the end of 1539, if not before. She soon formed an extremely close bond with her charge which was to last through to her death in 1565. Katherine (or Kat) may have had some hand in tutoring Elizabeth before her formal education begun under the Cambridge scholars, William Grindal (d.1548) and Roger Ascham (1515–68), as some years before his appointment Ascham had written to Katherine advising her not to press her charge in learning too intensively. Katherine's close ties to Elizabeth were strengthened by her marriage in 1545 or 1546 to John Astley (or Asteley), a cousin of Anne Boleyn. Following the death of Katherine Parr in 1548, Katherine encouraged Elizabeth to consider Thomas Seymour as a husband (Cat. no. 16). Consequently, when Seymour was arrested for treason, she was sent to the Tower while Elizabeth was interrogated at Hatfield (cat. no. 19), but she had returned to the princess's household by August 1549. Katherine was arrested again in May 1556, this time for possessing anti-Catholic books under Mary, but after her release she was not permitted to return to Elizabeth's household.

The portrait has a strong claim to represent Katherine Ashley and may date from around the time of Elizabeth's accession when Katherine was rewarded for her loyalty by being appointed Chief Gentlewoman of the Privy Chamber. Katherine's husband, who had gone into exile under Mary I, was also given an important household post as Master of the Jewel House and is represented in numerous other portraits. However, as there are no other known portraits of Katherine Ashley, exact identification is problematic. The use of oil on paper for finished portraiture is highly unusual for English work of this period, although not unknown by Northern French or Flemish artists. The French inscription is partly illegible but refers to the strength of the sitter's heart to resist temptation to sin. The inclusion of the skull in the background strikes a similar note as this motif was frequently used to encourage reflection on passing time and the need for meditation upon salvation. This symbol was a relatively common one in English portraiture of this period and would have been a suitable motif for an individual intent on stating his or her piety and sound moral purpose. TC

LITERATURE: Duleep Singh, *Portraits in Norfolk Houses*; Starkey, *Elizabeth*; Wright, 'Female Household'; Merton, 'Women who Served'.

Photo, pre-conservation

15. Portrait of Edward VI as a prince,
 early seventeenth century

Unknown artist after Hans Holbein (1497/8–1543).
Oil on panel.
43 x 33cm.
National Maritime Museum, Greenwich,
 Caird Collection, BHC2678.

Following the execution of Elizabeth's mother, Henry VIII married
Jane Seymour who died shortly after delivering a male heir, Prince
Edward (1537-53). Elizabeth played an important role in the baby's
christening, although she herself had to be carried, and for the rest of
Henry's reign she enjoyed good relations with her young half-brother
with whom she frequently lived in Hertfordshire. From an early
age, Edward was given an excellent humanist education by his tutors,
including John Cheke and Roger Ascham (who later became tutor to
Elizabeth), which continued after his accession to the throne in January
1547. It was during Edward's reign that Protestant worship was
introduced into England.

This portrait shows Edward aged about five. He is clothed and
posed in a way that recalls Holbein's portraits of his father. The source
for this frontal pose portrait derives from a drawing by Hans Holbein
now at Windsor Castle, and became one of the standard representations
of the young king. The portrait was probably once part of a much
larger set of images of English monarchs produced for display in the
long gallery of a country house, which became fashionable in the 1590s.
Like many panel paintings of this period the image therefore served
as an historic record rather than a work of art, but it was still designed
to appear impressive and the artist has used a large amount of gold
paint, particularly in the sleeves. It has recently undergone conservation
treatment to remove a considerable amount of later over painting.

TC & SD

Elizabeth's bedchamber in the morning before she had dressed. Over the next year, Seymour made sexual advances towards Elizabeth, slapping her on the buttocks, slashing at her dress with his sword, and on at least one occasion holding her in an embrace. Eventually, her step-mother intervened both to protect her stepdaughter and safeguard her own marriage. At Whitsuntide 1548, Elizabeth was sent away to live with Sir Anthony Denny who was married to the sister of Kat Ashley (Cat. no. 14).

After the death of Katherine, Seymour began to pursue his political ambitions with greater energy. He revived his project to marry Elizabeth and also made plans to build up a party among the nobility and seize control of the king. He was arrested on 17 January 1549 and executed on 19 March.

Although this miniature approaches Holbein in quality, it seems to have been painted neither by Holbein himself nor by his follower, Lucas Horenbout, and is more likely to have been made by a hitherto unidentified artist, perhaps working in a workshop run by Holbein, which it is now thought may have existed, despite Holbein's status as a foreign national.

SD & RQ

LITERATURE: G. W. Bernard, 'The Downfall of Sir Thomas Seymour', in G.W. Bernard (ed.), *The Tudor Nobility* (Manchester, 1992), pp. 212–40.

16. Miniature of Thomas Seymour

Workshop of Hans Holbein (1497/8–1543).
Miniature on vellum.
4.3cm diameter.
Inscribed: *verso, The Picture of Sr.Thos Seymer Knight.*
 L. Admyrall of England.
Provenance: duke of Buccleuch.
National Maritime Museum, Greenwich, MNT0137.

Brother to Henry VIII's third wife Queen Jane, Thomas Seymour (c. 1508–49) was uncle to Edward VI. When the nine-year-old Edward succeeded to the throne, Seymour was elevated to the peerage as Lord Seymour of Sudeley. Jealous of his elder brother Edward Seymour, who had been appointed duke of Somerset and the lord protector of England, Seymour sought to advance his own status and power through marriage. Initially he thought of marrying Elizabeth, but he soon realised that the privy council would never consent to the match and he therefore took the dowager queen, Katherine (Cat. no. 20), as his wife in mid-April 1547.

His marriage brought him into close contact with Elizabeth who was then living with her stepmother in Chelsea. The household was run on informal lines, and Seymour began the practice of entering

17. Letter from Elizabeth to Dowager Queen Katherine [about June 1548]

Manuscript.
Public Record Office, Kew, SP10/2 fo. 84c.

Elizabeth was staying at Cheshunt in Hertfordshire, the home of Sir Anthony Denny, when she wrote this letter to her stepmother. In May 1548, she had left Katherine's household in Chelsea probably because of the dowager queen's concern about the inappropriate attention her new husband Lord Thomas Seymour (Cat. no. 16) had been showing her young charge. From this letter it appears that their parting had been somewhat tense and cold, and that Elizabeth now regretted it. According to her admission here, Elizabeth had failed to give her stepmother fulsome thanks for her many kindnesses, and also 'answered little' when Katherine warned her of the dangers that could arise from gossip. The reference to Katherine being 'undoubtful of health' no doubt relates to her pregnancy. The two women exchanged further letters but they never saw each other again. Katherine died on 5

September 1548, seven days after the birth of her daughter. Shortly afterwards Elizabeth moved from Cheshunt to set up her own household in Hatfield. SD

LITERATURE: Marcus, Mueller and Rose (eds), *Elizabeth I*, pp. 17–19 Starkey, *Elizabeth*; James, *Kateryn Parr*.

18. Letter from Elizabeth to Edward Seymour, Lord Protector Somerset, 6 February 1549

Manuscript with remnant of seal attached.
Bodleian Library, Oxford, Ashmole MS 1729 art. 6 recatalogued as Arch F.c.39.

Soon after Thomas Seymour's arrest on 16 January 1549, the lord protector sent Sir Robert Tyrwhit to Hatfield to interrogate Elizabeth about Seymour's plan to marry her. Elizabeth was then without her principal servants, Thomas Parry and Kat Ashley (Cat. no. 14), who had just been arrested. Under interrogation in the Tower, Parry revealed that he had talked with Seymour about a possible marriage. He also confessed what he had heard of the baron's overfamiliarity with the princess. Ashley then made her own statement, describing Seymour's 'boldness' towards Elizabeth at Chelsea and admitting her talks with the princess about his suitability as a husband. But, despite this incriminating evidence, both of them denied that they were planning a secret marriage without first securing the privy council's consent.

Elizabeth wrote this letter to the lord protector promising to cooperate in Tyrwhit's investigation as long as he treated her honourably. She also claimed that any omissions she might make in her testimony arose from her forgetfulness and were not attempts to conceal what she knew to avoid self-incrimination. Tyrwhit, however, justifiably suspected Elizabeth of concealment and complained that she and her servants 'all sing one song, and so I think they would not do unless they had set the note before'. SD

LITERATURE: Marcus, Mueller and Rose (eds), *Elizabeth I*, p. 31; Starkey, *Elizabeth*.

19. Elizabeth's Written Answers to Interrogations [February 1549]

Manuscript.
The Marquess of Salisbury, CP150/89-90/2r (fo. 90r illustrated).

When interrogated by Tyrwhit, Elizabeth admitted very little, and tailored her account to match those of her servants. Her testimony

began in her own neat italic hand, but continued in that of Tyrwhit. She then read through his transcription, added a short paragraph and signed her name at the end. Although Tyrwhit strongly suspected her of lying, he could not prove her mendacity and she was exonerated of treason. Her servants were released shortly afterwards and eventually returned to her household, without losing her trust or favour. Elizabeth's reputation, however, was severely dented by the affair. It was rumoured that she had been intimate with her stepfather and was pregnant with his child. Over the next few years she tried to repair the damage by presenting herself as the studious, pious princess she had appeared to be in an earlier self-portrait (Cat. no. 13). The whole Seymour episode shows Elizabeth's remarkable self-possession under intense pressure, yet the events also made her aware of the care she needed to exercise over her own sexual reputation. SD

LITERATURE: Starkey, *Elizabeth*.

20. Portrait of Katherine Parr, c. 1545–50

English School.
Oil on panel.
76.2 x 63.5cm.
Inscribed: left, in a slightly later hand, 'KATHERINE PARRE'.
Provenance: 1st duke of Hamilton before 1643; by descent until
 sold Hamilton Palace sale 1882 (1016); Bingham Mildmay
 sale Christie's 21 June 1893 (25); by descent to Major H.C.
 Parr by whom sold Christie's 21 June 1968, lot 96; bought
 Gooden & Fox Ltd, then purchased by NPG.
National Portrait Gallery, London, NPG 4618.

Katherine Parr (c. 1512–48) may have been named after Katherine of
Aragon whom her mother had served as a lady in waiting. The quality
and extent of her education have been hotly disputed by historians,
but her latest biographer considers that she had an 'unusually advanced
education', learning Latin, French and Italian as a child (James, p. 137).
By 1543, while serving in the household of Henry VIII's elder daughter
Mary, she had caught the interest of the aging king, and at the death
of her second husband, Lord Latimer, she found that it was her
duty to become the sixth (and last) bride of Henry VIII, although
she had hoped to marry Sir Thomas Seymour (Cat. no. 16). The small
wedding took place on 12 July 1543 and was attended by Henry's
daughters, the twenty-six-year-old Mary and nine-year-old Elizabeth.
Katherine treated the king's children with genuine kindness, and helped
reconcile Henry to his two daughters, whom he restored to the line of
succession in 1544. Katherine was a committed supporter of the
reformed religion, and her devotional writings were published in 1545
and 1547.

Katherine is known to have employed such painters as John Bettes
and Lucas Horenbout, but the artist of the present portrait is unknown.
She is shown in a costly gown of scarlet damask – from surviving
records, evidently her favourite colour – embroidered in gold thread in
a pattern that includes Tudor roses. KH

LITERATURE: James, *Kateryn Parr*; Strong, *Portraits*, i, pp. 364–5, ii, p. 690.

Edward VI and Mary

21. Medal of Edward VI, 1547

Attributed to Henry Basse.
Gold.
Inscribed: obv.: SCVTVM FIDEI PROTEGET EVM (The shield of
 faith will protect him); rev.: 1547 ANNO DECIMO ETATIS
 EIVS (In the tenth year of his age).
British Museum, London, CM 1872-3-7-2.

This piece was probably struck to celebrate Edward's tenth birthday in
October 1547. It has previously been associated with his coronation,
which took place the previous February, but, if that were the case, the
medal would probably have been dated 1546 as the new year only began
on 25 March. This is the date that appears on a larger medal produced
for that event – the first medal to celebrate the coronation of an English
king – which has been attributed to Henry Basse, chief engraver at
the London Mint. The portrait here may have been engraved originally
as a pattern for a coin that never went into production, and would
presumably also have been the work of Basse. PA

LITERATURE: Hawkins, Franks and Grueber, *Medallic Illustrations*, i,
p. 56, no. 4.

22. Letter from Elizabeth to Edward VI [around spring 1553]

Manuscript.
British Library, London, Harleian MS 6986 art. 16 fo. 2.

Elizabeth wrote quite frequently to her brother Edward, sometimes in English but more often in Latin. This undated letter was probably written in the spring of 1553 when the king was ill, and is typical of Elizabeth's florid style. From its contents it is evident that Elizabeth had tried to visit him but was commanded to return to her house at Hatfield. There is a hint in the letter that Elizabeth suspected Edward was being influenced against her, possibly by the 'lord marquess' (who was most likely Henry Grey, the marquess of Dorset, the father of Lady Jane Grey). Her suspicions were correct. Edward signed a 'Device for the Succession' in June 1553 disinheriting his half-sisters and leaving his throne to his cousin Lady Jane Grey. SD

LITERATURE: Marcus, Mueller and Rose (eds), *Elizabeth I*, pp. 38–9.

23. Portrait of Queen Mary I and King Philip, early seventeenth century

English School.
Oil on canvas.
106 x 77.6cm.
Inscribed: 'Aº 1558 / ETANNIS REGNEY PHELIPPI / ET MARIE DEI GRACIA REGIS. / & REGINE. A.H.F. UTRIUSO & C.I. / ET.H. FIDEI DEFENSOR ARCHIDUCU / AU.DU.B.M. & BRA COUNTU. H.F.F. & T / QUARTI / & QUINTO' (1558 in the reign of Philip and Mary, by the grace of god, King and Queen of England, Spain and France, Sicily, Jerusalem and Ireland,, Austria, Burgundy . . . and Brabant . . .).
National Maritime Museum, Greenwich, BHC 2952.

Soon after her coronation in September 1553, Queen Mary (1516–53) decided to marry her cousin Prince Philip of Spain (1527–98). Eleven years younger than Mary, Philip was already a widower with an heir.

Despite strong opposition to the marriage at court, which culminated in the rebellion of Sir Thomas Wyatt in January 1554, the wedding took place on 25 July 1554. By the end of the year, Mary believed she was pregnant but by June it was evident that she had either miscarried or never conceived at all. Soon afterwards, Philip left England, returning only briefly in 1557. Again Mary convinced herself that she was pregnant, only to suffer another bitter disappointment. The queen's failure to produce a child left Elizabeth as the heir presumptive to the throne according to the parliamentary statute of 1544.

The couple are shown here in a room overlooking the Thames and Old St Paul's Cathedral. Their chairs of estate, with the arms of England above Mary's, symbolise their positions. The Latin inscription giving the extent of their dominions highlights the political importance of their marriage.

This is a seventeenth-century copy, with some slight differences, of a painting of 1558 at Woburn Abbey traditionally ascribed to Lucas de Heere (1534–84), which itself is perhaps a copy of a painting of 1554, the year of the sitters' marriage.

SD & RQ

24. Medal of Philip and Mary, 1555

Jacopo da Trezzo (c. 1514-89).
Gilt bronze.
British Museum, London, CM M6830.

This medal, by the Italian gem engraver and metal worker Jacopo da Trezzo, exemplifies Philip's taste for Italian art. Jacopo served him in the Netherlands in the 1550s and subsequently in Spain, and is known to have been in London in December 1554, for it was from there that he sent a silver example of this portrait of Mary to Antoine Perrenot de Granvelle, adviser to the emperor Charles V. The artist had probably accompanied Philip to England for his marriage to Mary at Winchester the preceding July. The portrait of Philip followed in 1555. Both portraits were provided with allegorical reverses praising the royal pair, but here they have been joined together in one medal as a memorial to their union.

PA

LITERATURE: Hawkins, Franks and Grueber, *Medallic Illustrations*, i, p. 71, no. 17; Attwood, *Italian Medals*, p. 121, no. 88.

25. Shilling of Philip and Mary (1554-8)

London Mint.
Silver.
Inscribed: obv.: 'PHILIP ET MARIA D G R ANG FR NEAP PR HISP' (Philip and Mary, by the grace of God, king and queen of England, France and Naples and princes of Spain; rev.: 'POSVIMVS DEVM ADIVTOREM NOSTRVM' (We have made God our helper).
British Museum, London, CM 1935-4-1-1984
(T.B. Clarke-Thornhill Bequest).

Mary's early coins were the first unchallenged issues of an English queen regnant, and some featured her portrait. On her marriage to Philip of Spain in 1554, she issued her first shillings and sixpences, adopting for them a design derived from that used on the extensive and well-known coinage of her grandmother, Isabella of Castile. This involved adding her husband's portrait to the design, facing her own and on the left, in the place of primacy. The portraits on the shillings in particular show a high degree of realism and skill, and resemble the medal portraits of Jacopo da Trezzo. Other sixteenth-century ruling queens, in Navarre and Scotland, would also follow this style on their marriage.

BC

LITERATURE: Farquhar, 'Portraiture of our Tudor monarchs', pp. 118–27.

26. Letter from Elizabeth to Mary I, 16 March 1554

Manuscript.
Public Record Office, Kew, SP11/4/2 fos 3r-v.

Elizabeth wrote this letter to her half-sister on the day that two members of Mary's council arrived at Whitehall Palace to escort her by barge to the Tower on suspicion of treason. Mary had believed that Elizabeth was involved in the short-lived rebellion of Sir Thomas Wyatt, and as soon as the rebellion collapsed Elizabeth was brought under armed guard from her house at Ashridge in Hertfordshire to Whitehall. Wyatt, who was convicted of treason on 15 March, never implicated Elizabeth in his conspiracy, but there was circumstantial evidence against her and Mary hoped that she would confess under interrogation in the Tower.

Elizabeth wrote to request an audience with the queen so that she would not be condemned unheard. At the very least, she hoped to delay her journey to the Tower, for by the time she would have finished writing, the tide of the River Thames would have turned and there would be no possibility of setting out that day. Elizabeth's letter began with a reminder that when she had left court the previous autumn Mary had promised not to believe any slanders against her without first hearing her defence. On this count, she appealed to Mary's conscience

by quoting the adage 'that a king's word was more than another man's oath'. In the second paragraph, she claimed that Thomas Seymour (Cat. no. 16) would never have been executed for treason, had he been permitted to speak with his brother, the lord protector. Finally she rebutted the evidence against her: Wyatt may have written her a letter, she declared, 'but on my faith I never received any from him'. Similarly, she denied that she had ever communicated with the French king. Historians are still unsure whether or not she was telling the truth.

Despite her fear that she would be executed at the Tower,

Elizabeth kept a clear head. The last page of the letter is scored with diagonal strokes to prevent the insertion of forged material. At the bottom she added the postscript – 'I humbly crave but one word of answer from yourself' – but her appeal failed to move Mary, who refused to see her sister. The following morning, Palm Sunday, Elizabeth entered the Tower where she remained until mid-May. SD

LITERATURE: Marcus, Mueller and Rose, *Elizabeth I*, pp. 41–2; Freeman, ' John Foxe's Notes'; Loades, *Mary Tudor.*

THE MONGREL RELIGION OF ELIZABETHAN ENGLAND

Patrick Collinson

GENERATIONS OF HISTORIANS HAVE SCRATCHED THEIR HEADS OVER the religion of Elizabethan England. When there were plans for Elizabeth to marry some foreign Catholic prince, differences of religion were played down. But it was on the religious issue that all these marriage plans foundered. If Elizabeth was negotiating with the Lutheran princes of Germany, she assured them that she was Lutheran, but if she was dealing with Calvinists she agreed with them too. In 1564 the archbishop of Canterbury, Matthew Parker (Cat. no 53), was flattered to be told by the French ambassador that 'we were in religion very nigh to them'.

No wonder the earl of Sussex, setting out on a piece of diplomatic wooing in 1567, asked: What is the religion of England? When in 1570 Pope Pius V excommunicated Elizabeth it simplified matters a little. But forty years on, the poet George Herbert praised 'the British Church' for what the French ambassador had called its 'mediocrity', standing midway between Rome and Geneva. Yet the answer to Sussex's question was not 'Anglican'. 'Anglicanism' was not a distinct and separate colour on the ecclesiastical map before the nineteenth century.

It was Elizabeth's father, Henry VIII, who had thrown the stone into the pond which set up not so much ripples as tidal waves. Henry, for reasons partly pragmatic – the need to obtain a divorce in order to remarry and produce a male heir – partly out of an exalted notion of his more than royal status, shook off the Roman obedience and took the title of Supreme Head of the English Church, with almost unlimited powers to regulate its life and doctrine (Cat. no. 52). Henry VIII's religion used to be called 'Catholicism without the pope'. But it was a very peculiar Catholicism. All monasteries and religious orders were, in that polite administrative word, 'dissolved'. There was

an onslaught on much of the traditional, popular piety of Catholic England: shrines, images, and pilgrimage. The English Bible was set up in churches for all to read, and the saints and their legends were demoted. Only on such core issues as the doctrine of the mass did Henry remain some kind of Catholic.

But once Henry was dead, the Reformation carried out in the name of the boy king Edward VI made England more unequivocally Protestant than it would ever be again. Archbishop Thomas Cranmer's 1552 Prayer Book aligned England with the Reformed Churches of Switzerland and South Germany. It was to those Churches and cities that the leading cadres of English Protestantism went when Henry's elder daughter Mary I put back the religious clock, restoring the mass and papal authority. What 'the people' thought of all this is a different and difficult question. There is no reason to suppose that more than a minority were hearts-and-minds Protestants, or that the restoration of Catholicism under Mary was doomed to failure. The stability of the country depended on those who did not know quite what to think, or believe, but were prepared to conform to whatever the monarch for the

time being required. In Elizabethan England, such people were called 'cold statute Protestants'.

AS PEOPLE OFTEN remarked, Elizabeth was her father's daughter, but she was also the daughter of Anne Boleyn and in a literal and biological sense the product of the Reformation. So she could never have been the kind of Catholic that her sister was, and she was bound to reign as some sort of Protestant. But what sort? The answer to that question has been bedevilled by the Elizabethan spin doctors, who presented her as the last word in 'godliness', with godliness understood as a deep and sincere commitment to evangelical Protestantism.

THIS WAS IN MANY ways a misrepresentation. Elizabeth was a very old-fashioned Protestant. She was criticised for fortifying her speech with old-fashioned oaths, like 'by the Mass', or 'by God's body'. She shared many of the religious values of her stepmother, Queen Katherine Parr (Cat. no. 20), which stopped short of Protestantism. Like Katherine, she revered the imagery of the cross, which many of her Protestant subjects regarded as a popish idol, and she was less iconoclastic than her father. Although her views on the sacrament of the altar are far from clear, she seems to have believed in the real presence.

WE OWE TO ELIZABETH the preservation of our cathedrals, and of the musical culture which they enshrine. No Elizabeth, no choral evensong! Elizabeth was old-fashioned in her dislike of clerical marriage. She was suspicious of the almost uncontrollable religious force of preaching, preferring the reading of set-piece homilies, which she herself had vetted. When she told her second archbishop of Canterbury, Edmund Grindal, that two or three preachers were sufficient for a shire, he could hardly believe his ears. 'I cannot marvel enough, how this strange opinion should enter into your mind, that it should be good for the Church to have few preachers.' In the perception of a Protestant like Grindal, sermons were not some optional extra but the very lifeblood of the Church. His difference with the queen on this issue cost him his job and plunged the Elizabethan Church into its most damaging crisis.

PROTESTANT PREACHERS sought out and worked like spiritual surgeons on the secrets of the heart. Elizabeth believed it best that they should remain secrets. It was said that she had no desire to make windows in men's souls. She herself had gone to mass in her sister's reign. Consistently, Elizabeth did what she could to moderate the penal legislation against Catholics. Her intention was that a distinction should be made between being, or even becoming, a Catholic, and any treasonable intent that that might involve. For twenty years, she refused to do what her more ardently Protestant subjects wanted, cut off the head of Mary, Queen of Scots. Many Protestants were far from confident that Elizabeth was to be trusted to defend true religion.

THERE WAS NOTHING sacrosanct or permanent about the settlement of religion which was made in Elizabeth's first parliament of 1559. No one could have foreseen that in 2003 the Church of England would still be the Church of that settlement. What of the settlements which Henry VIII had made, and Edward VI, and Mary? If Elizabeth had died within thirty years of her accession, the acts of parliament which made the settlement would have been so much waste parchment, good only for lampshades.

THE SETTLEMENT WAS a balancing act, but not between Rome and Calvinist Geneva. When it initially proved impossible to obtain passage of the necessary legislation through the House of Lords because of Catholic opposition, a religious debate was staged which was a charade, intended to provide a pretext for imprisoning some of the recalcitrant bishops and so massaging a parliamentary majority in favour of the settlement. Clearly Elizabeth and her ministers – including, especially, William Cecil (Cat. no. 33) and his brother-in-law, Nicholas Bacon (Cat. no. 35), who had most to do with it – intended some sort of Protestant settlement. The programme of the government consisted from the word go of both an Act of Supremacy and an Act of Uniformity.

SO WHAT KIND OF balancing act was it? There were a number of concessions to conservative religious values, and in general the settlement fell so far short of what many Protestants wanted that it was barely acceptable, except as an

interim measure. The Act of Supremacy made the queen Supreme Governor rather than Supreme Head of her Church. The Act of Uniformity restored the second, 1552, version of Cranmer's Prayer Book as the only legal form of worship, but with some conservative adjustments (Cat. no. 54). Many of the so-called 'ornaments' of worship, mainly the traditional vestments worn by the clergy, were to remain. And the words of administration of the bread and the wine in the communion service made it possible to believe in the real presence in the sacrament, especially when the 'Injunctions' which Elizabeth published once the 1559 parliament was over indicated the use of unleavened wafers, looking very much like the 'singing cakes' of Catholic worship, rather than common baker's bread. Evidently the intention was to persuade all those unreconstructed Catholics out there, and foreign governments (remember that French ambassador), that in appearance little had changed.

THE RELIGIOUS SETTLEMENT was shaped as much by what was not done as by what was. The 1559 parliament did not tell England what to believe, except indirectly, in the language of the Prayer Book. In 1563 the governing body of the Church, convocation, adopted the doctrinal Thirty-Nine Articles, but not until 1571 was this underwritten by parliament, and then only to a limited extent (Cat. no. 58). So Elizabethan England was not a confessional state. No windows in English souls!

As FOR THE STRUCTURE and organisation of the Church,

Title page from *The Bishop's Bible*, quarto edition 1569 (Cat. no. 56). The British Library, London.

absolutely nothing was done. Under the overarching royal supremacy the principle of hierarchy, government by bishops and their underlings, remained untouched; so too the parishes, the mechanisms for appointing the parish clergy, their payment with tithes rather than salaries. There was to be no general reform of canon law, which meant that the Church had to manage with such of the old canons (with various *ad hoc* additions) as were not in conflict with the laws of England. The law of marriage, for example, was not brought up to date as it was everywhere else in Protestant Europe, and it remained a medieval fossil until the eighteenth century. In all these respects, Elizabeth proved to be, as one historian has said, a 'do nothing' queen.

LEGISLATION WAS ONE THING, implementation and enforcement another. That was the business not of the queen but of her ministers and her leading clergy. The royal visitation of the Church which followed the 1559 parliament saw an iconoclastic holocaust of Catholic images and other objects, the fiery end to Catholic England. There was a hopeful perception that the process of reformation had only just begun, and much store was set on a vast expansion of what was called a godly, learned, preaching ministry, a force to convert all those hearts and minds. Many of the bishops underwrote the preaching conventions called 'prophesyings', a kind of open university intended to convert the pigs' ears of the old clergy into the silken purses of a preaching ministry. Elizabeth refused to countenance the prophesyings and in effect sacked Archbishop

Grindal when he refused to transmit her order to suppress them. Grindal's triumph came long after his death. The Jacobean Church would be a preaching Church.

MEANWHILE ATTEMPTS BY the bishops to improve on the settlement, first in convocation and then in parliament, came to nothing. Eventually restless and unsatisfied Protestants got the message. The queen had travelled as far along the road of reformation as she intended to go. Thirty years after 1559, another parliament would be told that she had 'placed her Reformation as upon a square stone to remain constant'. Out of the consequent frustration 'puritanism' was born.

AT FIRST THE EMPHASIS was on what Bishop Jewel called the 'scenic apparatus' of worship, which everyone agreed was a subsidiary, 'indifferent' issue. But when, in the mid-1560s, Elizabeth insisted that her bishops should enforce the wearing of the white linen surplice as an acid test of conformity, there was organised resistance. The bishops began to suspend, deprive, and even imprison the recalcitrants. Such extremes bred extremity. Soon a younger generation of nonconformist ministers was complaining that what was wrong with the Church was fundamental, not superficial. In a radical manifesto, an *Admonition to the Parliament* (1572), two young London preachers, John Field and Thomas Wilcox, denounced the 1559 Prayer Book in something like its entirety, and with it episcopacy, demanding a ministry like that of the 'best reformed churches', ministerial parity. Out of the *Admonition* grew a public debate, the 'Admonition Controversy', the leading puritan ideologue Thomas Cartwright versus John Whitgift, who would succeed Grindal as a very different archbishop of Canterbury. This served to draw a line between the conformist and nonconformist wings of the Church, the latter increasingly attracting the defining label, and stigma, of 'puritans'. Towards the end of Elizabeth's reign, Richard Hooker would write a magisterial defence of the establishment in his *Laws of Ecclesiastical Polity*.

THE *Admonition* HAD ROUNDLY declared that 'we in England are so far off from having a church rightly reformed . . . that as yet we are not come to the outward face of the same'. But the

'not' was later altered to 'scarce'. If the Church had not arrived at even the basic structures of a reformed Church, then it would be necessary to desert it, fleeing from Babylon to build a real Church somewhere else. This is what some radical puritans proceeded to do. These separatists became known, after the name of one of their leaders, Robert Brown, as 'Brownists'. But the vast majority of puritans clung to the 'scarce'. That meant that they remained in the Church but were not entirely of it. In the 1580s the more radical puritan ministers constructed an underground network of conferences from which they agitated, in parliament and elsewhere, for 'further reformation', and which provided an embryonic framework for a different English Church, a presbyterian Church. What made this a potent force out of all proportion to the numbers involved was that the cause of further reformation became fused with the growing militancy of a beleaguered Protestant nation. The puritans had potent political supporters, including Elizabeth's favourite of favourites, Robert Dudley, earl of Leicester (Cat. no. 60).

IT IS NOT POSSIBLE to understand the phenomenon of puritanism without reference to 'popery', for the 'papists' were in an inverse relationship, each serving to construct the identity of the other. The very name 'puritan' was coined by a Catholic controversialist, while those called puritans were aware that the church ceremonies to which they took exception were there for the sake of the Catholics.

FOR THE FIRST TEN YEARS of the reign, Catholicism was a religion of survivors, and, as with the Church of England today, it was not clear how long it would survive the passing of the older generation. Yet in the history of post-Reformation Catholicism and its continuity with the past that generation played an indispensable part. The years around 1570 were nevertheless an important watershed. Pius V's excommunication of Elizabeth (Cat. no. 214) was a political mistake, but it sent a signal that English Catholics were not to be left to the fate of slow absorption into a Protestant Church. Soon after this, Catholic seminaries on the Continent began to send their newly trained priests back into England. This is often referred to as a 'mission', but the role of the seminarists was as much to provide those survivalists with pastoral care as to achieve

conversions. But whether or not it should be understood as mission, Elizabethan Catholicism mounted an aggressive religious operation impressive in its scale. Given the scarcity of priests, there was a heavy dependence on all sorts of Catholic books, so that, contrary to common assumptions, the printing press was if anything a more important part of Catholic than of Protestant evangelism.

ANOTHER LANDMARK WAS the arrival in 1580 of the first two Jesuits to set foot in England, Edmund Campion and Robert Parsons. Campion was taken and, after a sensational trial, executed with all the obscenity which the law reserved for traitors, a fate suffered by hundreds of priests and some of their supporters in coming years, under penal legislation progressively ratcheted up under a regime paranoiac about international terrorism (Cat. no. 224). But Parsons escaped and returned to base, from which he spent the next thirty years plotting the downfall of the government, for the Catholic mission made little sense apart from what we have recently learned to call 'regime change'.

Page from *The Monument of Matrones . . . ,* 1582.
The British Library, London.
[G12047/845.c.21]

Protestant services placed their souls in jeopardy. But this was a message as much for the benefit of the Protestant regime as for those Catholics to whom it was ostensibly addressed, and more privately, in the casuistry of the confessional, different advice was often given.

THE FLUIDITY OF RELIGIOUS affiliations was a source of strength for both the established, Protestant Church, and, paradoxically, for Catholics. Towards the end of Elizabeth's reign the government found that it could exploit to its advantage the deep fissures in the Catholic community, which had a great deal to do with anti-Jesuit sentiment. The question was whether English Catholics should be subject to an archpriest, a Jesuit plan, and the appellants against it were ripe to be picked off early in the reign of James I by an Oath of Allegiance. By this time Catholics in the full recusant sense numbered perhaps 2 per cent of the population, although the proportion among the nobility and gentry was much higher. We cannot say how many 'church papists' there may have been, since, like 'puritan', this was a stigma thrown around with gay abandon.

IN 1580 PARSONS had published, from a secret press, a book 'containing certain reasons why Catholics refuse to go to church'. To refuse to go to church was to be a 'recusant', an offence which attracted crippling fines. But, *pace* Parsons, most 'Catholics' did not refuse to go to church. The Elizabethan population included a large number of so-called 'church papists'. According to the polemical pens of Parsons and other propagandists, these were 'schismatics', whose attendance at

GIVEN THE DEEPLY DIVIDED religious state of the Elizabethan nation, it is remarkable that there was so little religiously motivated communal violence. People were not cut down in the street as they came back from church, which happened in France. There were atrocities, but only on the public scaffold. Elizabeth deserves some of the credit for this, but not all. England was a profoundly law-abiding nation, and

with respect for the law went an equal commitment to the values of communal harmony. The only good Catholic might be a dead Catholic, but not if he was your neighbour.

ELIZABETH, IN ONE WORD, was the reason why the puritan campaign to complete the English Reformation failed. Every move to relegislate the Elizabethan Settlement was effectively blocked, and from the top. Eventually, out of sheer frustration, the puritans, or some of them, overplayed their hand. They published the Marprelate Tracts (1588–9), satirical attacks on the bishops which to us are as entertaining as they were meant to be, but which at the time were regarded as seditious libels. The anti-Martinist backlash launched the stage puritan, best

known from Malvolio in *Twelfth Night* and Zeal-of-the-Land Busy in *Bartholomew Fair*, which ensured that the godly would be figures of spiteful fun for centuries to come.

AS FOR THE MORE tangible dangers represented by the new Catholicism of the Council of Trent, Jesuits, daggers and gunpowder, Elizabeth outlived them, dying two years before that 11 September moment, 5 November 1605. Her great achievement was to live for far longer than any other member of her family, and to hand on her government to a young Scottish cousin (Cat. no. 67) who was content to say, steady as she goes.

Drawings of the Coronation Procession, 14 January 1559, c. 1560–70 (Cat. no. 30).
College of Arms, London.

THE CITY OF LONDON,
COURT AND TRADE

Ian W. Archer

O N 14 January 1559 Elizabeth, carried in a litter covered with yellow cloth of gold, left the Tower of London to begin her procession through her capital city to her coronation in Westminster Abbey (Cat. no. 30). Her route took her along Cornhill and Cheapside, through the churchyard of the cathedral church of St Paul's, down Ludgate Hill to Fleet Street, and along the Strand towards Westminster. The route was punctuated by a series of pageants which celebrated her legitimacy and offered advice on the qualities of rulership. At the Cornhill conduit an effigy of the queen sat enthroned in the 'seat of worthy governance' above four virtues, Pure Religion, Love of Subjects, Wisdom and Justice, treading on their opposites, Superstition, Ignorance, Rebellion and Insolency. At the Little Conduit in Cheapside the message offered a more explicit critique of the preceding regime, for on either side of a figure representing Time were two tableaux depicting the ruined commonwealth (for which read Mary I's regime) and the flourishing commonwealth (Elizabeth's). From Time's grotto emerged the figure of Truth bearing a Bible, and explaining that it was the possession of the Bible, 'the Word of Truth', which accounted for the difference between the two commonwealths.

T HROUGHOUT THE DAY Elizabeth played her role with aplomb, and the contrasts with Mary's performance at the pageants for her marriage to Philip of Spain in 1554 would not have been lost on the spectators. Confronted with the Word of Truth Elizabeth held it up in the air and then clasped it to her breast. In 1554, by contrast, there had been a row over the depiction of Henry VIII with a Bible in his hand: Bishop Gardiner, hammer of the godly, had insisted that it be painted out and replaced with a pair of gloves. Elizabeth, we are told, stopped her litter to hearken to the petitions of her poorer subjects, and at St Dunstan's church, where the children of Christ's Hospital stood in their blue coats before her, she took the point, declaring 'here I see this merciful work towards the poor, whom I must in the midst of my royalty needs remember'.[1] When Mary had seen the children of the hospital on the occasion of her entry to the capital in 1553 she had averted her gaze from these objects of Protestant charity.

IT WAS A HUGE public relations success, celebrating the close bond felt by the City with the new queen, and signalling a

fresh start. But it was perhaps not quite as straightforward as that. The pageants had been masterminded by Richard Grafton, the publisher of Henry VIII's Great Bible, and a key figure among the City's godly. He had doubtless worked with William Cecil in devising the programme, but the scheme may have owed more to their reformist agenda than to Elizabeth's own. The role of Deborah in which she was cast at the Fleet Street pageant was not one with which she was entirely happy. Moreover, the pageants smoothed over divisions of opinion in the City, spinning an idealised version of civic unity. Mary's regime had not been without its supporters in the capital. Many parishioners had responded with enthusiasm to the restoration of Catholic worship, and many were willing to cooperate with the persecution of heretics. The Reformation had divided Londoners as it had divided opinion in the country at large. Nor were Mary's policies necessarily as harmful to the commercial classes as the London MP, who claimed (on what evidence is not known) that her regime had cost the City £300,000, would have us believe. Although Mary's government had angered City opinion by its initial favour to the foreign merchants of the Hanseatic League, the marriage to Philip of Spain guaranteed amicable relations with England's main trading partner, the Netherlands, which was then ruled by his father. News of the defeat of Wyatt's rebellion (directed against the marriage) in 1554 was greeted among the English merchants in Antwerp with carousing, bonfires, and give-aways to the poor. For Protestant businessmen commercial and confessional priorities were sometimes at odds.

BUT THE PAGEANT CYCLE of January 1559 did encapsulate the essential truth of the close interdependence of City and court. The prosperity of the City depended on the crown maintaining favourable conditions for trade, and Elizabeth's regime depended on City wealth. London enjoyed a favourable location with respect to the Antwerp entrepôt, where the key imports like luxury fabrics, wine and raw materials for the cloth industry could be easily obtained. The capital therefore benefited disproportionately from the growth in cloth exports in the early sixteenth century, up from around 40,000 cloths per annum in the 1490s to around 100,000 cloths per annum by the beginning of Elizabeth's reign. London now accounted for 88 per cent of cloth exports and possibly 75 per cent of all overseas trade. The cloth trade was a major employer in the City: about 40 per cent of London freemen were members of guilds involved in the production, processing, retailing and wholesaling of cloth. The expansion of the cloth trade was a major factor in the take-off of the City's population from about 60,000 inhabitants in 1520, to 75,000 in 1550, and 200,000 by the end of Elizabeth's reign, putting London behind only Naples and Paris in the league tables.

THIS WEALTH DEPENDED on the crown. Although the notion of an 'economic policy' is inappropriate to a regime where patronage relationships informed virtually everything that the government did, the consequences of government decisions for the pattern of trade were momentous. With so much trade funnelled through Antwerp, the state of English relations with the Netherlands was a critical determinant of the health of trade. The degree to which trade was in the hands of Englishmen depended critically on the nature of the customs regime: Elizabeth's reluctance to restore the privileges of the Hanseatic merchants was a major factor in eroding their share of trade, and in the longer term in allowing the penetration of the Baltic by English merchants. The dominant position of London in the nation's trade owed a great deal to the monopoly position of the Merchant Adventurers in handling the cloth trade to the Netherlands, and it was the crown which guaranteed the privileges of the company. The continuing support of the crown for the Adventurers' monopoly was due to the key role that the commercial wealth of the City played in the crown's finances. Ironically this was due in large measure to Mary, who in the closing months of her reign had grasped the nettle of customs reform, effectively doubling the crown's income from this source. The customs duties amounted to about one-quarter of Elizabeth's total revenues, and because London dominated overseas trade, by the 1580s about 80 per cent of that revenue was raised through the port of London. London merchants were also a source of short-term loans to the crown, and the City corporation or the major trading companies provided security for the repayment of loans raised on the overseas credit markets.

ELIZABETH'S GOVERNMENT also eventually secured the trust of the commercial classes through its restoration of

Portrait of a Merchant, called Thomas Gresham, c. 1550.
Trustees of the Titsey Foundation.

THE CLOSE RELATIONSHIP between the City and the court was embodied by Sir Thomas Gresham (Cat. no. 45). Gresham had been with the new queen at Hatfield within three days of her accession, and she promised that she would 'keep one ear shut to hear'² him. Gresham had begun his career as a Merchant Adventurer, but in the winter of 1551–2 he took over as the crown's financial agent in the Netherlands responsible for negotiating its loans on the international money market. Perhaps as much because of his well-developed self-promotional skills as because of his financial acumen he was able to retain this role through the successive changes of government, overcoming a period of initial disfavour from Mary's regime. Gresham cultivated contacts across the political spectrum, his dinner guests in the 1560s including Robert Dudley, William Cecil and the duke of Norfolk. As a merchant with far-flung contacts, he lay at the hub of an overseas intelligence network. In an age where diplomatic representation was piecemeal and *ad hoc*, this information could be critical to the government. Little wonder that his factor, Richard Candelar, was at Cecil's house first thing every morning 'to know your pleasure to know whether you will have anything said to me'.³ Gresham also enjoyed an unusual level of intimacy with the queen, exchanging New Year gifts with her, entertaining her at Gresham House in the City in 1571, and at his country retreats at Mayfield in Sussex in 1572, and at Osterley in 1576. It was the queen's visit in January 1571 that led to the rechristening of the bourse and shopping complex which Gresham had provided in cooperation with the City Corporation in 1568 as the Royal Exchange (Cat. no. 46).

the coinage (Cat. no. 43). The period from 1542 to 1551 had seen the government making enormous profits by debasing the coinage to finance military adventures. As people exchanged the coins at the market rate of their silver content rather than the official rates, prices had risen markedly in monetary terms, causing serious economic dislocation. Elizabeth tackled the problem head-on, calling in all the debased coin and replacing it with new coin in 1560–61. Elizabeth's first historian, William Camden, regarded the recoinage as Elizabeth's greatest glory; the epitaph on her tomb records it as her third greatest achievement after the religious settlement and the maintenance of peace.

NO OTHER MERCHANT could hobnob with the court elite to quite this extent. But Gresham's relationship with the regime represents in exaggerated form phenomena which are more typical. We are often too ready to think of court and City as two separate and hermetically sealed entities. They were not, for there were a variety of ways in which they interpenetrated. There was very little physical separation of the court from its surroundings. Aristocratic town houses in Westminster were located hard by the quarters of the trades-men who served them. Several of the queen's ministers, Sir Francis Walsingham (Cat. no. 213), Sir Walter Mildmay and the marquess of Winchester among them, actually lived in the

Interior view of the Royal Exchange (Cat. no. 46).
British Museum, London (Crace Collection).

heart of the commercial City. Some government ministers enjoyed strong ties of kinship with the merchant class. Winchester, Walsingham and Sir Richard Sackville had married the daughters of former lord mayors. Gresham's brother-in-law was Sir Nicholas Bacon, the lord keeper (Cat. no. 35), and his illegitimate daughter married Bacon's son Nathaniel. Other relationships were fostered through the ties of patronage, men like Cecil over the years building up a powerful clientele in the City bureaucracy. Favour shown towards courtiers in the distribution of plum City jobs gave

the City's rulers some leverage with the men of power at court, for patronage relationships were reciprocal.

PERSONAL TIES ALSO shaped the relationship between courtiers and London tradesmen. In their quest for services, courtiers maintained a high degree of customer loyalty, returning to the same tradesmen time and again. This reflected the need for the customer's insurance against potentially fraudulent tradesmen, but also the fact that much of the business was conducted on credit, and was therefore dependent on a

high degree of trust between the parties. In their perpetual quest for credit overstretched aristocrats might spread their net widely, as when Lord Robert Dudley raised money from fifteen City merchants in one sixteen-month period, but there were key individuals who remained central to their credit operations, in Dudley's case the customs official, William Byrde. The ties between the court elite and London interests were still further strengthened as the crown shifted its patronage rewards away from land, preferring to reward courtiers with commercial concessions which required the mediation of City interests. So, Dudley was rewarded early in the reign with licences to export wool and undressed cloths, and later he received the farm of the sweet wines, becoming closely associated with the customs official Thomas Smythe, who acted as his deputy.

ELIZABETH'S ENTRY to her capital in 1559 expresses another aspect of her relationship to the City, its public and participatory nature. Elizabeth, we saw, knew how to play the crowd, but groups among the citizens were also using the spectacle to promote their own reformist agendas. Elizabeth continued that sometimes uneasy dialogue throughout her reign. Court rituals were often highly public events. Tournaments, where courtiers vied to pay compliments to their queen but also sometimes to express particular policy options, were ticketed events at which special scaffolds were erected for citizens. Many court sermons, in which preachers offered thinly encoded advice to their sovereign, took place in the open-air preaching place at Whitehall with a capacity of five thousand.

IT WAS OVER RELIGIOUS matters that the tensions between the queen and her City were often most apparent. Most of the citizens, it is true, swung to a conformist Protestant position. Their loyalty was expressed in extraordinary scenes of Protestant communion such as greeted the arrest of the Babington conspirators in July 1586: there were sixty bonfires between Ludgate and Charing Cross; neighbours gathered in street parties, their grudges allegedly 'washed away with a cup of merry go down for her sake'; while elsewhere people 'sang psalms and made such melody as skill could devise with tabor and pipe'.[4] But it was a loyalism with a critical edge, for it was part of the campaign to put pressure on the queen to rid the realm of Mary Queen of Scots (Cat. no. 229). Likewise, the City responded with an enthusiasm which was too much for Elizabeth when the news broke of Mary's execution: the City churches peeled their bells in joy while the queen fumed in her palace.

LONDON'S POSITION as a citadel of Protestantism endangered its traditional trading relationships. As we have seen the City's continued prosperity seemed in the 1560s to depend on continued entente with Spain. But some among the City elite, a minority at first, came to take a different view, convinced that Philip of Spain, allied with the Catholic Guise faction in France and backed by the pope, was embarked on a campaign to destroy the Protestant religion. Among them were Sir Thomas Gresham and his factor, Richard Clough. As France descended into religious civil war in 1562, Gresham remarked that 'if Mr de Guyse have the upper hand of the Protestants, then the French king, the king of Spain, the Pope, the duke of Savoy and those of that religion will set upon the Queen's Majesty only for religion's sake'. Clough likewise saw the European conflict in starkly confessional terms, describing the iconoclastic riots in the Low Countries in 1566 as 'this great fall of Babylon', while of the arrival of Spanish troops under the duke of Alva (Cat. no. 220) to suppress the Protestant rebellion in 1567, he remarked that 'the devil is busy to provoke all mischiefs so that his kingdom may continue'.[5] Given the apparent readiness of these otherwise hard-headed businessmen to put conscience before easy profits, we might need to reassess some of our assumptions about the self-interest and non-ideological orientation of the London elite.

THE LOGIC OF THEIR position was that the dependence on Antwerp must be broken. As Cecil noted in 1564, 'it were better for this realm . . . that the commodities of the same were issued out rather to sundry places than to one and specially to such one as the lord thereof is of so great power'.[6] Gresham came to share this view during the iconoclastic troubles of 1566. It had already been proved feasible, for England had got round the temporary trade embargo imposed by Margaret of Parma's regency government in the Netherlands in 1564 by opening up a new mart in Emden, in north-west Germany, just over the frontier from Philip's territories.

THE SITUATION IN THE later 1560s was extremely tense as the mutual suspicions and competing conspiracy theories of the English and Spanish encouraged both sides to misinterpret the other's actions and thereby escalate conflict. This is what happened when in 1568 the English government unloaded (apparently for safekeeping) treasure from Spanish ships which had been driven on to the English coast by storms and Huguenot privateers. The Spanish ambassador in London assumed that the treasure was to be seized and advised Alva to arrest all English merchants in the Netherlands and to take possession of their goods. Elizabeth retaliated by seizing the treasure and imprisoning Spanish merchants, and negotiating a new outlet for English cloth in Hamburg. But it should be stressed that these actions did not meet with universal approval from the Merchant Adventurers. Protestant hard-liners may have welcomed the move, but others cried out for the old alliance with Burgundy, and in September 1569 the Adventurers refused the queen a loan.

BUT A VARIETY OF circumstances served to shift City opinion in the years ahead. Confirmation of Philip's designs on England was received with the exposure of the Ridolfi plot; events like the massacre of St Bartholomew in 1572 showed the outlook for Protestantism in Europe to be increasingly bleak, while in London the gradual emergence of a more thoroughly protestantised merchant elite ensured that opinion began to swing in favour of the confessional analysis. The scale of the continuing political unrest in the Netherlands revealed the futility of locating the mart there: though the Adventurers returned to Antwerp in 1573, the city's sack by mutinous Spanish troops in 1576 ended their association. They traded through Hamburg until 1578, and thereafter settled at Emden

Standing Salt 1569/70 (Cat. no. 51).
Vintner's Company.

(1578–87), Stade (1587–98 and 1601–11) and Middleburg (1587–1621).

THE LONDONERS HAD already begun to diversify their trade to some extent. While searching for a North-East passage to the spices of the East they had opened up trade with Russia almost by accident in 1553. One of those involved, Anthony Jenkinson (Cat. no. 179) undertook a series of arduous journeys in Central Asia, and visited Persia in 1562–3. More prosaically and of greater immediate significance, the weakening of the Hanseatic League between 1563 and 1570 also encouraged Londoners to penetrate the Baltic markets, securing direct access to strategically important naval stores. But the most important stimulus to their expanding horizons was the limited entrepôt functions provided by the new mart towns: at Hamburg the Londoners found that the rich Italian textiles and oriental spices they were used to at Antwerp were now in short supply. It was thus the rise in the prices of their imported goods which provided the incentive for the quest for new trade routes. There were, it is true, some visionaries like Michael Lok, scion of a leading godly family and owner of an extraordinarily rich cartographic library, who sunk most of his money in Martin Frobisher's (Cat. no. 174) ill-fated quest for the North-West Passage, but by and large the City elite invested cautiously. Trade with Iberia prospered during the 1570s and early 1580s, but on the outbreak of open war with Spain many of those involved turned to privateering. Taking advantage of the weakening of Venetian commerce, Londoners established a presence in the western and central Mediterranean, whence they imported spices, pepper, dried fruit, wine and silks using Italian intermediaries. The next step

was the penetration of the Turkish empire to secure direct access to these commodities. In 1578–9 the London merchants, Edward Osborne and Richard Staper, sent William Harborne on a secret mission to Sultan Murad III, and obtained commercial concessions for the English throughout the empire. In 1581 the small group of English merchants who traded there were incorporated as the Turkey Company, and in 1592 they merged with the fledgling Venice Company to form the Levant Company. But the arrival of the Dutch in the East Indies threatened the Mediterranean trade of the Levant merchants, many of whom joined in the first voyage of the East India Company in 1600. These ventures all received active encouragement from privy councillors. Leicester, Burghley and Walsingham were all members of the Russia Company; Leicester and his brother, the earl of Warwick, took a keen interest in speculative ventures, Leicester taking the Barbary Company under his wing in 1585; and Walsingham was a leading promoter of the Turkey trade. The ties between City and court remained strong.

Wool weight, cast in the form of a shield with the royal Tudor arms, late sixteenth century (Cat. no. 50(d)). Victoria and Albert Museum, London.

THE SIGNIFICANCE OF THE changes in the structure of commerce should not be exaggerated, but the foundations had been laid for future commercial expansion. By the end of Elizabeth's reign about 70 per cent of cloth exports still went to north-west Europe; the Baltic took 12 per cent, France 6 per cent, North Africa 2 per cent and the Levant 9 per cent. But the City tycoons at the end of Elizabeth's reign were a much more diverse group than they had been at the outset. Whereas probably two-thirds of the aldermen had been Merchant Adventurers in the 1560s, by 1600 only one-third were, reflecting the fact that dizzying fortunes were to be made in some of the newer trades, particularly the Levant. The City's leaders now included privateering princes like John Watts and Paul Bayning, Turkey merchants of legendary wealth like Sir John Spencer, and pioneers of the East Indies and North American

colonial trade like Sir Thomas Smyth. It is true that the commodity structure of the export trade was still dominated by cloth, and the overall level of broadcloth exports was little higher than in the mid-century, but an increasing volume of new draperies, lighter, cheaper and more colourful fabrics, were being exported to the southern markets in place of the traditional broadcloths. There was perhaps more change in imports, and indications of the beginning of the shift from export-led to import-led growth in trade. The successful pursuit of policies of import substitution meant that the volume of manufactured goods imported was declining, while increasing imports of luxury foodstuffs like sugar, wine, currants and spices suggest the rising levels of conspicuous consumption by the prosperous landed elites.

ANOTHER SIGNIFICANT SHIFT was in the means by which trade was organised. Conventionally merchants had traded in partnerships under the aegis of regulated companies like the Merchant Adventurers or the Staplers which had in effect been licensing organisations. The more speculative long-distance voyages required the spreading of risks, which was achieved through the joint stock company in which a large number of small investors pooled their capital. The first joint stock company was the Muscovy Company with 201 shareholders at its inception in 1555, but they only really took off from the 1570s, as the traders to the Levant, the Far East (via the Cape of Good Hope) and North America adopted joint stock principles. One important consequence of the new joint stock companies was that, because the investors did not have to take part in day-to-day management of the company's affairs, participation was not limited to merchants. Between 1575 and 1630 one-third of the membership and one-fifth of the capital of the joint stock companies was non-mercantile in origin. The new forms of organisation thus offered another means by which court and commercial interests could be meshed.

THERE WERE ALSO SIGNS of important cultural shifts in attitudes towards mercantile wealth. By the end of Elizabeth's reign there was perhaps less embarrassment about the nature of the City's wealth. Commercial wealth was more frequently celebrated and the contribution of merchants to national welfare acknowledged. In place of the conventional denunciations of covetousness, the preachers now offered a more nuanced approach, acknowledging the utility, lawfulness and even honour of the merchant's calling; some of them found their imagery infected by commercial metaphors comparing, in sermons with titles like *The Godly Merchant* and *The Merchant Royall*, the Christian quest for salvation with the merchant's quest for increase of profit. In his *Principall Navigations* the clergyman Richard Hakluyt (he had enjoyed the patronage of the pioneer of the Turkey trade, Richard Staper) provided the classic Elizabethan statement of the case for oceanic imperialism, and by equating wealth and honour with overseas trade in Richard Helgerson's words 'bringing merchants into the nation and bringing gentry into trade'.[7] The close connections between Elizabeth's court and the principal citizens of her capital City were long standing, but their significance was now more clearly recognised.

EXHIBITION
CATALOGUE
ENTRIES
27-58

27. 'Queen Elizabeth's speech to her secretary and other her lords before her coronation', dated 20 November 1558

Manuscript, contemporary copy.
Public Record Office, Kew, SP/12/1 fo. 7.

Elizabeth heard the news of her accession on 17 November 1558, the day of her sister's death. This is a copy of her first speech as queen. It was addressed to Sir William Cecil (Cat. no. 33) and the lords of Mary's council who had gathered at Hatfield. Turning to Cecil she charged him to be her privy councillor, as he was a man she could trust to give her honest and independent advice. His judgement, she said, would not be corrupted 'by any manner of gift' and he would always be faithful to the state. At the same time, Cecil was appointed principal secretary, but no mention was made of this promotion in the speech. He remained secretary until 1572 when he became lord treasurer, and continued as a councillor until his death in August 1598.

In addressing the lords who had sat on Mary's council, Elizabeth expressed her belief that God had placed her on the throne. She then went on to speak of her determination to rule 'by good advice and counsel', but hinted that she would not ask all of them to join her privy council. Those who were excluded, she explained, should not think it was 'for any disability in them' but because 'a multitude doth make rather disorder and confusion than good council'. Here Elizabeth's tact is evident.

Elizabeth's first council was indeed much smaller than Mary's had been. Some twenty-nine of Mary's councillors lost their positions, and only eight new ones were appointed; the total number was nineteen in 1559. Her additions were friends or kinsmen of Cecil, her own Boleyn relations, and men who had shown loyalty to her during Mary's reign. All the new-comers were Protestant, though only two had gone into exile under Mary.

SD

LITERATURE: Marcus, Mueller and Rose, *Elizabeth I*, pp. 51–2; Read, *Cecil*; MacCaffrey, *Elizabethan Regime.*

28. Miniature of Elizabeth I in her Coronation Robes, c. 1559–1570s?

English School.
Gouache on vellum laid on card with a diamond in the cross of the orb.
9.1 x 5.6cm.
Provenance: listed by George Vertue as within current collection 1743, thereafter by descent.
Private Collection.

Elizabeth is shown in the robes she wore on her coronation day on Sunday 15 January 1559. These same lavish robes had been used at the coronation of her sister Mary I in 1553, with the exception of the

sleeves and bodice which were newly made to fit Elizabeth. They have been painted with exacting precision, but as Arnold has noted, they might have easily been copied some time afterwards from the existing robes held in the royal wardrobe, which survived until her death.

This miniature has been the object of considerable speculation and scholars do not agree exactly when it was painted or who painted it. It has been attributed to both Nicholas Hilliard (1547–1619) and Levina Teerlinc (d.1576). Recent scholarship has attributed it to Teerlinc who served at Elizabeth's court as a miniaturist until her death (Cat. no. 113) because of its similarity to illuminations made by Teerlinc under Mary I (James and Franco). This assertion should be taken seriously and needs further investigation based on a close examination of the object. Perhaps some of the strongest pieces of evidence in Teerlinc's favour are the records of the portrait miniatures she presented as New Year's Day gifts early in the reign, and the restrained style of the piece

which reflects manuscript illumination, a tradition that flourished in the Ghent–Bruges School where Teerlinc trained.

Whoever the artist was, the miniature was certainly designed as a precious object to record the coronation, possibly as a gift to the queen. A diamond has been inserted into the cross of the orb and expensive ultramarine pigment has been used for the background. Hilliard had trained as a goldsmith, learning to design and set jewels, and was certainly very well able to put his considerable skills to these ends. Yet Teerlinc also knew Hilliard's master, the goldsmith Robert Brandon, and could perhaps have found a goldsmith to set the jewel to finish this impressive piece. TC

LITERATURE: Arnold, '"Coronation" Portrait'; Goulding, 'Miniatures', p. 59, no.10; James and Franco, 'Horenbout, Teerlinc'.

29. Portrait of Elizabeth I in her Coronation Robes, c. 1600

British School.
Oil on panel.
127.3 x 99.7cm.
Provenance: Warwick Castle.
National Portrait Gallery, London, NPG 5175.

This well known and striking panel painting was designed as a later commemoration of Elizabeth's coronation. As in the coronation miniature (Cat. no. 28) Elizabeth wears a nearly identical robe and a gold crown set with rubies, diamonds, sapphires and pearls lined with crimson velvet. This was apparently her personal crown which also appears in 'Elizabeth and the Three Goddesses' (Cat. no. 192). The costume has been accurately portrayed and the large numbers of 'merchants and artisans of every trade' in London who lined the streets to view the coronation procession in 1559 would have seen the queen in this attire.

As Elizabeth's reign progressed, her accession to the throne was increasingly seen as the beginning of a new age of peace and prosperity, celebrated annually in the Accession Day tilts at court and by ringing of bells in some parishes. Therefore the existence of later paintings marking Elizabeth's coronation is not surprising and reflects the interest in the retrospective celebration of her reign. Tree ring analysis has dated this panel to c. 1600, and, as Fletcher has noted, the painting might have been commissioned as part of events connected with Elizabeth's funeral in 1603. The painting was probably copied from a miniature, although because of significant differences between this painting and the existing miniature, the source was probably another earlier image now lost. TC

LITERATURE: Fletcher, 'Date of the Portrait'; Arnold, '"Coronation" Portrait'; Strong, Portraits of Elizabeth, p. 89.

30. Drawings of the Coronation Procession, 14 January 1559, c. 1560–70

British School.
Pen and ink drawings with green wash under the litter, bound in volume entitled 'Book of Ceremonies'.
College of Arms, London, MS M.6 fo. 41v.

This is one of a series of drawings made on fourteen sheets that were probably undertaken soon after the coronation by one of the heralds, many of whom were competent draftsmen and painters. Elizabeth had already consulted the astrologer and mathematician Dr John Dee (Cat. no. 165) for an auspicious date to conduct this important ceremony which was held only two months after her accession. This page shows the final stage of the procession through London that took place the day before the coronation ceremony amid a light snowfall and with deep mud on the ground. Elizabeth is depicted in a canopied litter in the centre which was 'trimmed down to the ground with gold brocade'

and led by elegant white horses. Robert Dudley (Cat. no. 60) as master of the horse followed immediately behind the queen while his brother Ambrose Dudley led the horse at the front of the litter. An Italian commentator describes the queen as 'surrounded by a multitude of footmen in crimson velvet jerkins' and either side of the queen the artist has shown rows of figures who included the duke of Norfolk as earl marshal of England (Cat. no. 216), gentlemen of the privy chamber and her gentleman pensioners. As was traditional, Elizabeth had spent the morning at services in the Tower, and the procession towards Westminster began soon afterwards.

Elizabeth was crowned the next day by the bishop of Carlisle, who in the service that followed pointedly made no elevation of the host during the mass, and the service itself was read in English rather than Latin, reflecting Protestant concerns that the word of God should be comprehensible to all. The coronation celebrations included around 1,000 horses and appear to have cost more than £16,000, with around £4,000 being spent on sumptuous fabrics alone. TC & SD

LITERATURE: Frye, *Elizabeth I*; Strong, *Portraits of Elizabeth*, p. 100, pl. P&I 4.

31. a-c. Three Men's Knitted Caps, sixteenth century
Wool.
Museum of London,
A26566; NN8512; A26567.

Merchants, artisans and other citizens of London lined the route of the queen's coronation procession in January 1559, and some of them must have worn caps similar to these examples. Knitted caps were worn by London's business and working communities, and the felted caps were designed to be warm and waterproof. Some protect the back of the neck and others have ear flaps but many were trimmed and finished to create modish head coverings whose styling imitated more expensive versions made in silk. Following the fashions of the time, brims were slashed to create decorative three-dimensional effects or threaded with silk ribbon. Many were dyed bright colours such as red or blue. The caps were made in London and as many as fifteen trades could be involved in their

manufacture. A large number were found on building sites during the redevelopment of the City of London in the early part of the twentieth century. The finds were not documented, making it impossible to assess how many are of a similar date, but contemporary pictorial sources suggest that the consumer could choose from a range of current styles.

The popularity of the cap had waned by 1570 and the following year a statute was passed for the 'Continuance of the Making of Caps'. This ordered everyone over the age of six, except those of high rank, to wear a knitted woollen cap, made in England, on Sundays and holidays. The Act, which was impossible to enforce and was largely ignored, was repealed in 1597. It was intended to boost sales of wool, which was England's principal commodity, and to safeguard employment and social distinctions. EE

LITERATURE: Gaimster and Stamper (eds), *Age of Transition*, pp. 245–6.

32. a-c. Children's Clothes: knitted vest, mitten and cap, sixteenth century
Wool.
Museum of London, 39.108/1; A1989; 5008.

Children would probably have worn garments similar to these items when watching the coronation procession which was held in mid-January amid a light snowfall. These unique excavated garments offer a rare insight into how children were protected from the cold in the Tudor period. All these items were knitted in the round in stocking

Opposite: Portrait of William Cecil, Lord Burghley.

stitch and were shaped by increasing or decreasing stitches. The vest formed a stretchy, warm covering for the body. Both the vest and the mitten were made from soft, white wool, but tannins, humic acids and iron salts in the soil in which they were preserved have permanently stained them brown. Both are practical garments but the mitten has been finished with a decorative band of contrasting colour, probably knitted with natural black sheep's wool. The cap has been fulled which helped to make it more waterproof. Contemporary records such as household accounts reveal that children's garments like these were commercially available but many simple knitted garments were undoubtedly made at home. EE

33. Portrait of William Cecil, Lord Burghley, c. 1571

See previous page.
Anglo-Netherlandish School.
Oil on panel.
61 x 51cm.
Provenance: Mrs Watman of Vintners, Maidstone, Kent;
 Purchased from Gooden & Fox Ltd, 1951.
Parham House and Gardens, West Sussex.

This portrait was designed to capture the qualities of sober statesmanship and political insight for which William Cecil (1520–98), Elizabeth's principal and longest serving minister, was renowned during his lifetime.

During the reign of Edward VI, Cecil had served first as private secretary to Lord Protector Seymour, and then in 1550 as principal secretary to the king. A committed Protestant, he lost political power under Mary, only to regain it in November 1558 when he was named as Elizabeth's principal secretary (Cat. no. 27). His appointment was predictable; not only was he an extremely experienced minister but he had also acted as the surveyor of Elizabeth's estates since 1550. Elizabeth nicknamed Cecil her 'spirit' and they frequently, though not always, shared a prudent approach to government; their successful partnership undoubtedly shaped the course of Elizabethan policy. His command of statesmanship was widely recognised, and there were few matters of political, social or religious importance that did not pass under his scrutiny. In 1571 he was created Baron Burghley and in 1572 lord treasurer. He hosted frequent entertainments for the queen at his estates at Wimbledon and Theobalds.

The large number of contemporary portraits of Cecil that would have hung in houses of the nobility and gentry by the 1590s testifies to the widespread recognition of his great political importance. This portrait is similar to a number of others at Hatfield House and in the National Portrait Gallery, although he appears in this image without his rod of office. Like the majority of portraits of well-known sitters

produced in this period the painting was probably not undertaken directly from life but derives from a standard pattern established some time in the 1560s. The painting has previously been attributed to Antonis Mor (1516/21–c. 1576), and is extremely competently painted, probably by an artist trained in the Netherlands. The definition of Burghley's strong facial features has been carefully rendered and a considerable amount of under drawing is now more evident to the naked eye than would previously have been seen when first painted. TC

LITERATURE: Graves, *Cecil*; Alford, *Succession*; Strong, *Portraits*, pp. 27–33.

34. *Theatrum Orbis Terrarum*, 1570

Abraham Ortelius (1527–98).
Printed book published by Aegidius
 Coppens Diesth, Antwerp.
Provenance: by descent.
The Burghley House Collection.

Cecil's copy of this first commercial atlas is filled with his annotations, which reveal the breadth of his interests and extensive intelligence gathering. As one of Cecil's responsibilities was foreign policy, he needed to be knowledgeable about affairs beyond the realm. His notes include the correct titles required when addressing European rulers and details on recent voyages of exploration, such as Frobisher's third voyage to present day Arctic Canada in 1578. SF

AMERICAE SIVE
NOVI ORBIS, NO-
VA DESCRIPTIO.

a privy councillor and knight. In the important post of lord keeper, he headed the court of Chancery and acted as the government spokesman in parliament, presiding over the House of Lords. Bacon was an ardent Protestant and the close friend and brother-in-law of William Cecil (Cat. no. 33). He protected puritans, encouraged preaching and vigorously opposed Mary Stewart's claims to the succession of the crown of England. This portrait shows him in his official role, holding a staff of office (Cat. no. 36) and the 'burse' embroidered with the royal arms which contained the great seal. As a senior political adviser, his dress is sober and restrained, although his black cloak is trimmed with expensive fur and he wears an elaborate dragon whistle jewel around his neck.

Elizabeth was a regular visitor at Bacon's country house at Gorhambury, Hertfordshire, and in 1577 the court stayed for at least five days, costing their host in excess of £550 for the preparation of banquets. This sensitively painted portrait is very similar to another version now in the National Portrait Gallery London (NPG 164) of a similar size and also dated 1579. In the portrait considered here, there are some differences between the handling of the costume, jewels etc. and the treatment of the face which is more delicately painted, and it is possible the portrait was painted by two artists, as was relatively common in the studios of English sixteenth-century artists.

TC

LITERATURE: Tittler, *Nicholas Bacon*; Strong, *Portraits*, pp. 15–17; Collinson, 'Sir Nicholas Bacon'.

35. Portrait of Sir Nicholas Bacon, Lord Keeper of the Privy Seal, c. 1579

British School.
Oil on panel.
61.5 x 49cm.
Inscribed top right: '1579 / ÆTATIS ○ SVAE, 68 / MEDIOCRIA FIRMA', (the year of 1579 at the age of 68 / The middle course is most secure).
Provenance: by descent.
Private collection.

In December 1558, Nicholas Bacon (1509–79) was appointed to the office of lord keeper of the privy seal and soon afterwards was made

36. Staff of Office of Sir Nicholas Bacon, 1558–79

Palm stem (West African or South American) with engraved silver mounts.

British Museum, London, MME 1997,11-3,1. Acquired with support of the National Heritage Memorial Fund.

This is the staff of office of the lord keeper of the privy seal, used for ceremonial purposes, similar to that shown in the portrait of Sir Nicholas Bacon (Cat. no. 35). The mid-eighteenth-century engraved inscription records the provenance of the staff in the Bacon family.

DG

37. Design for the Great Seal of Ireland, c. 1586

Nicholas Hilliard (1547–1619).
Pen and black ink over graphite on parchment.
126cm diameter.
British Museum, London, PD 1912-7-17-1.

From the mid-1580s Hilliard was engaged in making new patterns for the seals of the realm which were then engraved and used to authorise the decisions of government. The use of seals was an essential part of government authority that had a long tradition, upheld by the Tudor monarchs. This delicate drawing is a draft design for the great seal of Ireland as is shown by the harp upon the shield to the left, and three crowns to the right symbolising Munster. Although Ireland was nominally governed under the rule of Elizabeth as part of her realm, in reality the English crown only ever held a part of the country which was affected by near continual disorder and uprisings, particularly following attempts at colonisation (Cat. no. 183). The seal design includes a remarkable array of emblems to illustrate Elizabeth's right to rule, such as the divine hands at either side which appear as though holding the queen aloft from the heavens.

As with all the great seals Elizabeth is shown richly attired in her parliament robes as head of state. The design is carefully recorded by Hilliard upon parchment rather than paper to ensure its longevity, first in an early use of the graphite drawing medium and then more fully worked up in pen and ink. In contrast to much of Hilliard's work, he did receive some credit for his labour on the great seals and by 1587

Elizabeth had rewarded him with a lease of land 'in respect of his pains lately employed in the engraving of the great seal of England' (Strong, 1963, p. 148). TC

LITERATURE: Birch, *Seals*, pp. 272–3; Murray and Hulton, *Catalogue*, i, pp. 16–17; Woodward, *Drawings*.

38. Impression from Elizabeth I's Second Great Seal, 1586–1603

Nicholas Hilliard and Derek Anthony.
Wax.
British Library, London, Seals xxxvi, 10.

In 1584–6 Hilliard worked with the veteran mint engraver Derek Anthony on a new great seal, since, according to a letter to them of 15 July 1584 'our Great Seal by much use waxes unserviceable'. Hilliard made a series of drawings on parchment from which the queen made her choice. He and Anthony then had to 'emboss in lead wax or other fit stuff patterns . . . according to the last pattern made upon parchment by you Hildyard, and allowed by us, and by the same pattern to engrave and bring to perfection a new Great Seal in silver'. It was presumably Anthony's role to copy the wax version in the negative, perhaps with Hilliard's collaboration, to create a seal matrix in silver. This seal served for the rest of the reign, although a replacement was planned in the 1590s. BC

LITERATURE: Birch, *Catalogue of Seals* I, pp. 54–6; Farquhar, 'Nicholas Hilliard', pp. 341–3; Barclay and Syson, 'A medal die rediscovered: a new work by Nicholas Hilliard', pp. 7–9.

39. Edward VI's Debased Coinage

(a) Shilling of Edward VI, 1549–50, to be worth fourpence halfpenny in 1560–61

London Mint.
Base silver.
Inscribed: rev.: 'TIMOR:DOMINI:FONS:VITE:M:D:XLIX' (The fear of the Lord is a fountain of life (Proverbs 14: 27), 1549).
British Museum, London, CM E 0225.

(b) Shilling of Edward VI, 1550–51, to be worth twopence farthing in 1560–61

London Mint.
Base silver.
Inscribed: rev.: as (a), except date (1550).
British Museum, London, CM 1935-4-1-1811
(T.B. Clarke-Thornhill Bequest).

In the later years of Edward VI and under Mary most new coin was good quality, but issued in relatively small quantities, and the currency inherited by Elizabeth I was still dominated by the debased issues of c. 1547–51: 'the hideous monster of the base moneys', as the queen's proclamation termed them. These circulated at a face value reduced by 50 per cent in 1551, so that base shillings were current for sixpence. The queen's government estimated that there was somewhat more than £1,000,000 in base money in currency, of different finenesses. As part of the recoinage strategy implemented under Elizabeth, these coins were devalued at two rates, depending on their silver content. Withdrawal for recoinage was largely completed by October 1561. BC

LITERATURE: Pridmore, 'Documentary evidence', pp. 1–3; Challis, *Tudor Coinage*, pp. 122–4.

40. Trial Plates

(a) For the coinage of 'Crown Gold', 22 carats, 1560

London Mint.
Gold.
Royal Mint.

(b) For the silver coinage, 11 ounces, two penny weight, 1560

London Mint.
Silver.
Royal Mint.

As part of the procedures of coin production, trial plates were produced to ensure a regular standard of coinage. These were metal sheets which could be tested against newly minted coins, and, as the ragged edges of the plates indicate here, pieces have been cut away to be checked against a sample of the coinage, routinely set aside from the mint's output. This exercise – known as the Trial of the Pyx – took the form of 'cupellation' carried out by members of the Goldsmiths' Company. If the members were satisfied, the presiding mint officials were considered to be upholding their duty, if not they would be fined. These plates date to the recoinage year of 1560. There were three plates, all of which survive at the Royal Mint, for fine gold, used for 30-shilling sovereigns and angels; crown gold (of 22 carats), used for half-pounds, crowns and half-crowns; and silver of the ancient sterling standard, now restored to use, for all the silver denominations. BC

LITERATURE: Challis, *Coinage*.

41. Elizabethan Presentation Coins

(a) 'Pattern half-crown' (2 shillings 6 pence) of Elizabeth I, 1558-60

London Mint.
Silver.
British Museum, London, CM E 3394.

(b) Gold 30-shilling sovereign of Elizabeth I, 1560–61

London Mint.

Gold.

Inscribed: rev.: A DNO FACTV EST ISTVD ET EST MIRA IN
OCVL NRIS (This is the Lord's doing and it is marvellous
in our eyes, Psalms 118: 23).

British Museum, London, CM E 0297; 1935-4-1-2017
(T.B. Clarke-Thornhill Bequest).

This rare pattern half-crown was struck at the very start of Elizabeth's
reign. It is probably a presentation coin, produced for the queen or her
agents to give out in ceremonial contexts, a common practice of the
period, and, being so early, may have been put to this use at or around
her coronation. The coin also has a portrait in unusually high relief,
especially compared to the very low relief customary at the late Tudor
mint.

The 30-shilling sovereign was a version of Henry VII's sovereign,
the first pound coin, revalued in line with changing gold prices. It was
issued in small numbers as a prestige coin, symbolising the splendour
of the Tudor dynasty, and used for royal gift giving. Elizabeth's mint
began to produce it immediately, using the punches for the royal image
created for Mary. BC

LITERATURE: Cook, 'Showpieces'.

42. Early Coins of Elizabeth I, 1558–60

(a) Gold angel (10 shillings)

London Mint.

Inscribed: rev.: A:DNO'.FACTVM.EST.ISTVD.Z.EST.MIRABILE
(This is the Lord's doing and it is marvellous in our eyes
(Psalm 118: 23)).

British Museum, London, CM 1915-5-7-549.

(b) Crown (5 shillings)

London Mint.

Inscribed: rev.: SCVTVM.FIDEI.PROTEGET.EAM (The shield of
faith shall protect him).

British Museum, London, CM E 0323.

(c) Silver shilling

London Mint.

Inscribed: rev.: POSVI DEV'.ADIVTOREM:MEV'. (I have made
God my helper).

British Museum, London, CM 1896-12-2-22.

(d) Groat (4 pence)

London Mint.

Inscribed: rev.: POSVI DEV'.ADIVTOREM'.MEV' (I have made
God my helper).

British Museum, London, CM E 0531.

Soon after her accession, on 31 December 1558, Elizabeth's first mint
indenture was issued. In it she authorised the continuance of the coinage
standards and some of the denominations of the late Edwardian and
Marian mints, five in gold and five in silver. She retained the medieval
gold angel with the novel reverse legend introduced by Mary: 'This is
the Lord's doing…', but she also revived some of Edward VI's coins in
'crown gold' (22 carats), together with one of his reverse legends: 'The
shield of faith shall protect him', presumably a deliberate attempt to
retain continuity while transmitting a Protestant message. Meanwhile,
her government began to work on the problem of restoring the currency
to a respectable state, and in February 1559 a commission was set up to
inquire into the state of the mint and to plan for reform, building on
work begun under Mary. BC

43. Elizabeth's New Coins, 1560–61

(a) Two gold half-pounds (10 shillings)

London Mint.

British Museum, London, CM Bank of England Collection M268
and CM 1946-10-4-510.

(b) Two gold crowns (5 shillings)

London Mint.

British Museum, London, CM 1935-4-1-2053 and 2054
(T.B. Clarke-Thornhill Bequest).

(c) Two gold half-crowns (2 shillings 6 pence)

London Mint.

British Museum, London, CM 1935-4-1-2062 and 2063
(T.B. Clarke-Thornhill Bequest).

(d) Two gold angels (10 shillings)

London Mint.

British Museum, London, CM 1877-4-2-2 and 1935-4-1-2071
(T.B. Clarke-Thornhill Bequest).

(e) Two silver shillings

London Mint.

British Museum, London, CM 1896-12-2-18 and 1935-4-1-2121
(T.B. Clarke-Thornhill Bequest).

(f) Two silver groats (4 pence)

London Mint.

British Museum, London, CM 1896-12-2-19 and E0533.

(g) Two silver half-groat (2 pence)

London Mint.

British Museum, London, CM 1935-4-1-2321
(T.B. Clarke-Thornhill Bequest) and 1896-12-2-20.

(h) Two silver pennies

London Mint.

British Museum, London, CM 1935-4-1-2365
(T.B. Clarke-Thornhill Bequest).

(i) Two silver sixpences, 1561

London Mint.

British Museum, London, CM 1915-5-7-137 and E0400.

(j) Two silver threepences

London Mint.

British Museum, London, CM Bank of England Collection M117
and Grueber 519.

(k) Two silver three-halfpences

London Mint.

Grueber 524 and 1935-4-1-2347 (T.B. Clarke-Thornhill Bequest).

(l) Two silver three-farthings

London Mint.

British Museum, London, CM 1935-4-1-2392
(T.B. Clarke-Thornhill Bequest) and E0646.

The recoinage of debased currency was begun in December 1560. From then until October 1561, £670,000 of base silver money (about 86 per cent of the estimated total) was withdrawn and converted into sterling silver at the Tower, and by specialist refining teams not just at the Tower but also at the queen's storehouse in East Smithfield. In the silver, the recoinage concentrated on a limited number of denominations, especially shillings and groats. Once the main recoinage was complete, production of most of these denominations ceased, and there would

be no new shillings for twenty years or groats for the rest of the reign. Instead, in 1561 production shifted to other coins to fill out the denomination system. These included two new coins, three-halfpence and three-farthings, intended to solve the problem of the lack of small change, as halfpennies and especially farthings in good silver were too small to be easily made, although as denominations they still had an important role in daily business. Built into the arrangements for the recoinage was a healthy profit for the crown (estimated at £50,000), while the owners of base coin inevitably lost out on the exchange, bitter medicine, as the queen herself said. However, the advantages of stable, sound money were widely recognised and the queen's reputation undoubtedly benefited: the restoration of the currency was one of the three principal achievements noted on her tomb. BC

LITERATURE: Challis, *Tudor Coinage*, pp. 119–28.

44. Medal of Thomas Stanley, 1562

Steven van Herwijk (1530–65).
Silver.
British Museum, London, MI 105.32.

Thomas Stanley (1512–71) was a member of the Tower mint staff from at least 1545, when he appears as an 'assay-master'. From 1555 until his death he was largely in control of the mint, as comptroller, or under-treasurer. One of his principal achievements was to supervise the recoinage of 1560–61, and on 10 July 1561 he was able to receive the queen at the Tower mint, when she made a formal visit to congratulate her staff on the success of their endeavours. This medal was made when Stanley was aged fifty by Steven van Herwijk, who was apparently a refugee from Catholic Antwerp. Herwijk seems to have found a ready market for portrait medals amongst Elizabeth's courtiers and officials in 1562, including another senior mint official, the warden Richard Martin and his wife. BC

LITERATURE: Hawkins, *Medallic Illustrations i*, pp. 105–6, no. 32; Challis, 'Mint officials', p. 68.

45. Portrait of a Merchant, called Thomas Gresham, c. 1550

Flemish School.
Oil on panel.
45.5 x 33.5cm.
Inscribed: on a letter 'POR MADONA / CRESTINA LEONA'
(For Lady Christina Leona).
Provenance: Leveson Gower Collection.
Trustees of the Titsey Foundation.

As a client of the duke of Northumberland, Gresham lost his post on the accession of Mary I but later regained it owing to his skills as a financier. On Elizabeth I's accession he was one of the men who attended upon the new queen at Hatfield, and in 1559 he was knighted. Thereafter he divided his time between London and Flanders, serving the queen in a diplomatic and financial capacity. He advised on the necessity of recoinage, negotiated the movement of crown loans from foreign to English merchants, and between 1560 and 1563 acted as ambassador to the regent in the Netherlands. He ceased to be the royal agent in 1574.

On her annual progresses the queen visited Gresham regularly throughout the 1560s and 1570s at his country house at Osterley. In 1564 following the death of his only son, Gresham acted upon a plan to establish a Bourse, or Exchange, at his own expense for London merchants. TC

LITERATURE: Strong, *Portraits*, pp. 129–31; Bindoff, *Fame of Gresham*; Burgon, *Gresham*.

46. Interior View of the Royal Exchange

> Frans Hogenberg (c. 1540–90).
> Engraving.
> 38.8 x 52.9cm.
> British Museum, London, PD, 1880-11-13-367 (Crace Collection).

Plans to build an Exchange for London finally came to fruition after Gresham offered to meet the costs in January 1564. A site on Cornhill was identified, tenements cleared and work began in May 1566. John Stow records how Gresham laid the first brick and that the building was finished by November 1569. For expertise in the design, Gresham turned to Hendryck van Paesschen, who had probably participated in the building of Antwerp Town Hall. London bricklayers secured the bulk of the building work but Gresham imported ornamental stone from Antwerp and timber came from his estates at Ringshall in Suffolk. The Exchange proved a great success in the trading world of northern Europe as trade at Antwerp went into decline during the revolt of the Netherlands. According to Stow, the Exchange was accorded the name of 'Royal', by order of Elizabeth on her visit in January 1571. The building was destroyed in the fire of 1666.

Frans Hogenberg, who included the Exchange in the second edition of his map of London in 1574, engraved two prints of the exterior and interior. The interior is a remarkable, modern space of open loggias around a court, with Doric columns on the ground floor and Ionic pilasters above. The latter frame niches with statues of the sovereigns of England; those of the Tudor dynasty appear at the left. The celebratory nature of the inscriptions in the cartouches above extends what was undoubtedly a fantasy of the giant pillar with

Thomas Gresham (1518/19–79) was an extremely successful merchant who served Elizabeth as royal agent in Antwerp, negotiating loans on behalf of the crown and supplying foreign goods to the court. He had obtained his office in 1551 under Edward VI, and proved a highly skilled financier, significantly reducing the interest on crown loans. This portrait dates from the 1550s, before the accession of Elizabeth. It was painted in the Netherlands and shows a young man dressed as a merchant whose facial characteristics bear a reasonable similarity to other known portraits of Gresham. The portrait is well under life size and might have been produced as a portable memento for a family member or loved one, as indicated by the inscription.

Gresham's crest, the grasshopper, on the top (Cat. no. 48). The Exchange proved greatly influential on European buildings of this kind. It is also clear from the civic authorities' anxiety about disorder within the building that an entirely new kind of public space had been created. MH

LITERATURE: Saunders (ed.), *Royal Exchange*; Bindoff, *Fame of Gresham*; Stow, *Survey*, i, p. 193.

47. **Treasury Account Book 1572**

Manuscript.
National Maritime Museum, Greenwich, CAD/A/1.
 Open at fo. 19v-20r.

The Treasury was the queen's accounting office. This entry details the money Elizabeth paid to Sir Thomas Gresham. As a result of his work in Antwerp, he developed financial contacts throughout Europe, which enabled Elizabeth to borrow money at an extremely advantageous rate. In this entry, Gresham is being repaid for various loans he has taken on Elizabeth's behalf. DK

LITERATURE: Bindoff, *Fame of Gresham*.

48. Gresham Grasshopper Signet Ring, 1575

Gold, enamel, crystal intaglio.
Private Collection.

At the back of this ring there is a fine green grasshopper (a punning device for the merchant Sir Thomas Gresham (Cat. no. 45), derived from the Anglo Saxon words GRAES for grass and HAM for farm, who also displayed it in all his places of residence and business. The ring is set with an oval crystal engraved with the arms of Robert Taylor, who worked in the Exchequer and looked with a friendly eye on the Gresham accounts. The ring belongs to a group of seven, which were probably given as presents to men of influence connected with Gresham either by marriage or business. During his period of office as crown agent in the Netherlands, Gresham was notorious for his bribery of the Flemish customs and it would therefore be quite in character to reward officials at home winding up his affairs after his retirement, 1573–5. A foiled crystal intaglio signet made a handsome present, while the grasshopper hidden at the back would have reminded the recipient of his link with the celebrated donor. DS

LITERATURE: Scarisbrick, 'Sir Thomas Gresham and the Grasshopper Rings', in Saunders (ed.), *Royal Exchange*, pp. 57–8.

49. Mayor of London's Chain of Office, first half of the sixteenth century

Attributed to Robert Adamas.
Gold and enamel.
The Lord Mayor of the City of London.

This cast gold collar is comprised of red and white Tudor roses between pairs of 'Esses' alternating with Garter knots meeting in front at a portcullis, the badge of the Beauforts, the family of Lady Margaret

Beaufort, mother of Henry VII. The Esses, whose significance has never been resolved, were worn in collars by supporters of the Lancastrians during the reigns of Henry IV, Henry V and Henry VI; and Henry VII incorporated it with the Tudor badges to mark the union of the two houses of Lancaster and York to be worn in livery collars, as here, to mark allegiance or loyalty to the king.

Sir John Alleyn, mercer, twice mayor of London, bequeathed this collar in 1545 for his successors to 'use and occupy yearly at and upon principal and festival days'. He had probably received it from Henry VIII, on being appointed to the king's council. The only surviving gold livery collar, it is still used by the current lord mayor of London, although the enamel has been renewed and there have been various alterations including lengthening in 1567. DS

LITERATURE: Somers Cocks (ed.) *Princely Magnificence*, no. 18.

50. Elizabethan Measurement Standards

(a) Bronze pint measure cast with the royal cipher 'ER' for Elizabeth I, 1601

English.
Cast bronze.
British Museum, London, MME 1883, 04-09,1.

(b) Standard pint cup with 'ER' cipher, 1601

Pewter.
Victoria and Albert Museum, London, M137-1939.

(c) Wool weight, cast in the form of a shield with the royal Tudor arms, late sixteenth century

English, London Founders' Company.
Cast bronze.
The Croft Lyons Bequest, Victoria and Albert Museum, London, M962-1926.

Standards for measure had been established and enforced from London since 1496 to replace the customary measures of provincial towns. Discrepancies in the system led to reforms in 1601, when the Exchequer standards of capacity were reissued. The measuring utensils were usually made of bronze or brass.

A bushel was a measure of capacity used for dry goods such as grain, seeds etc, and had been in use at least from 1266 when it was mentioned in the *Assize of Bread and Ale*. Elizabeth's bushel conformed to the equivalent of 2,148.28 cubic centimetres.

For selling alcohol, a staple dietary necessity, a large pint measure for beer or ale and a smaller one for wine had been required in London since 1423. The pewterers had to have all new tavern measures tested for their accurate capacity and stamped, although the HR mark introduced by Henry VII was not brought up to date until the seventeenth century. All drink offered for sale had to be poured into a standard, marked vessel, whether gallon pot, flagon, pottle, quart or pint cup, although many shapes of drinking vessel in pewter were available.

Wools weights of 7 pounds were carried by the *tronager*, or collector of taxes, throughout his district across his saddle, hence the suspension holes.

SA, PG & DG

LITERATURE: R.D. Connor, *The Weights and Measures of England* (London, 1987), pp. 151–69.

51. Standing Salt, 1569/70

London, mark a bird, probably the royal goldsmith Affabel Partridge.
Silver gilt.
Vintners' Company.

The London Goldsmiths' was one of the wealthiest City Livery Companies in Elizabethan England. Amongst the many luxury products they manufactured were elaborate standing salts. Salts served as table ornaments at court and in the houses of the nobility, gentry and city elite. They were frequently made of valuable material such as rock crystal, and their design reflected the status of their owner. Covered with an embroidered cloth or coverpane, the standing salt was 'unveiled' as part of the ceremonies opening a dinner. The salt was actually served in small round or triangular containers, which were set out along the table, indicating that the standing salts were curiosities rather than practical pieces for the table.

In 1574 the queen owned 120 salts, one weighing more than 50 ounces. Many were inherited from Henry VIII, but she often received presents of elaborate gold salts. Her New Year's gifts from courtiers included lapis lazuli and agate salts, hung with pearls and precious stones and framed in gold.

The Vintners' Salt came to the Company as a bequest only in 1702 so its first owner is unknown, but the goldsmith worked for the queen and used German casting patterns to make this splendid object. Many of the most skilled artisans were Protestant émigrés who arrived during and after the 1560s. Their work set a standard for the producton of English metalwork. What marks out this piece is its architectural form and height at 31 centimetres, as well as the crisp panels of the Virtues, copied from lead plaquettes.

PG & TC

52. Painted Triptych of the Royal Arms

English School, c. 1550s with later additions.
Triptych, oil on three joined panels.
193 x 117cm (open).
Inscribed upon the central panel at top: 'E.R'; upon central
panel at base: 'Elizabetha Magna Regina Angliæ'; upon the
outer leaves: 'Before the Eternall thou shalt have no other /
God in any likeness whatsoever to bowe down / and to
worship it. Exod. 20. ver. 2: 3. The/ Lord Jehovah is only
the true God of who it is not lawfull to make any image
because no / creature cane comprehend the image of the /
creator neither muste any worship be performed / to him in
any image because such a creature is a / dead thing the
worke of mens hands and not of God, an idol is an image
erected in the way of / relligeon to represent eyether a false
or a true / God to be worshiped in the room eyether of /
God or as God. Idolatry is to worship false / Gods or the
true God in an idole. Corin. x chapt. : vers. 7:|10.. To
worship God in images as in that idole baal / which
represented God is horrible idolatraye all / exceptions is
proper only to God and not to any / Saint roode Crucifixe
or image which is on the / roome of God to receive honour

for God and /God by it, the heathen Gentills esteminge there / idols whom thay did worship to be Gods did / therefore bowe down t them and worship / them. Thou shalt bowe down to no other / God because the Lord whose name is Jealous / is a Jealous God. Exodus; chapt. 34; vers: 14. / If there be any found among you that hathe / sarved other Gods and worshiped them thou / shalt stone them with stones till he die. / Deut. 17: 23: 4.5. / All carved or molten images which ar an abomyna- / tion to the Lord, Be not deceived, no Idolators / shalt inhearit the kingdom of God. I Corin. / 6 chapt. vers. 9.11.'
　　Provenance: recorded at Preston by 1619.
　　Parochial Church Council of the Parish Church of St Mary's, Preston St Mary, Suffolk.

This impressive object is a rare survival of a sixteenth-century royal coat of arms designed to hang within a parish church. It is clear from the inscription that the triptych was in use under Elizabeth. The Reform-ation in religion introduced sweeping changes in both the practice of worship and the physical interior of the parish church. Under Henry VIII, royal arms began to appear in churches to symbolise the position of the monarch as supreme head of the Church of England. Under Edward VI, painted rood screens dividing the congregation from the choir or chancel were removed, and walls were whitewashed.

　　It appears probable that the interior of the triptych was first painted during the reign of Edward VI and then brought up to date when reinstalled under Elizabeth. At the top right we find Edward's badge of a gilt-painted sun in splendour. However, the coat of arms is not simply a straightforward version of the Tudor shield, but includes complex heraldic symbols designed to trace the lineage of the monarchy of England. Therefore we find the arms of Brutus the Trojan, Caesar Romanorum, St George, and others such as Rodericke the Great, an early ancestor of the Welsh Tudors. The outer wings of the triptych (visible when closed) contain various scriptural texts denouncing the use of religious images, reflecting the strong puritan influences present in the Elizabethan Church. The triptych was recorded as hanging in the church in 1618 by a local antiquarian, Robert Reyce. The panel has been repainted on many occasions, and the painted texts on the outer wings apparently trace an earlier rendering of the same inscriptions.　　TC

LITERATURE: Cautley, *Royal Arms*, pp. 36–42; Lord Francis Hervey, *Suffolk in the XVIIth Century; The Breviary of Suffolk by Robert Reyce, 1618* (London, 1902).

53.　Portrait of Matthew Parker, Archbishop of Canterbury, c. 1575

British School.
Half-length portrait of Archbishop Parker with an hourglass and Bible.
Oil on panel.
68 x 54cm.
Inscribed: upon the bell 'PETRVS'.
Provenance: Lambeth Palace, removed 1648, Archbishop Sheldon: Mrs Sheldon, sale July 1740, bought Lord Oxford, sold 3 March 1742, bought John Ives, who presented it to Lambeth 1773.
The Archbishop of Canterbury and the Church Commisssioners for England.

Matthew Parker (1504–75) was consecrated as Elizabeth's first archbishop of Canterbury in December 1559. He was an obvious choice for the post since he had acted as personal chaplain to Elizabeth's mother, Anne Boleyn, and later to her brother Edward VI, and he was also thought to be moderate in his views. Under Mary, he had been forced into hiding, but had not left England to work alongside other champions of Protestantism in Calvinist Europe. He proved a highly effective

administrator and supervised the publication of the Bishops' Bible (Cat. no. 56). Historians now think that he was the force behind a moderate reform package that was introduced into convocation in 1563 but rejected by Elizabeth. However, he is better remembered for attempting to impose conformity to the directives in the Prayer Book (Cat. no. 54) and royal injunctions on the puritans, who nicknamed him the 'Pope of Lambeth'.

This portrait probably dates from the last few years of Parker's life when the queen frequently visited him at his palaces in Lambeth, Croydon and Canterbury; in March 1574, for example, she had stayed with the archbishop at Lambeth Palace on her way down to Greenwich. This painting is apparently based upon other portraits of Parker recorded either in a contemporary manuscript (Corpus Christi College, Cambridge) dated 1573/4 or from an engraving dated 1575 by the Flemish artist employed by Parker, Remigius Hogenberg (c. 1536– c. 1588). Parker appears as though in his study engaged in contemplation, and the hourglass on the window to the left is designed to evoke reflection upon the passing of time and certainty of human transience. The portrait has been considerably repainted across the head and body of the sitter. TC & SD

LITERATURE: Corpus Christi College, Cambridge, *Matthew Parker's Legacy Books and Plate* (Cambridge: Corpus Christi College, Cambridge, 1970), p. 54; Ingamells, *English Episcopal Portrait*, pp. 316–18; Crankshaw, 'Preparations', pp. 60–93.

54. The Elizabethan Book of Common Prayer, 1571 edition

Printed book, published by Richard Jugge and J. Cawood, London.
British Library, London, c.108 aaa.3 (1).

Determined to restore Protestantism to England, Elizabeth and her ministers introduced legislation in the queen's first parliament of 1559 to effect a second break with Rome and enforce the use of a new Protestant prayer book. The prayer book was in English, not Latin, as Protestants believed that worship should be conducted in a language which ordinary people could understand.

Elizabeth's *Book of Common Prayer* was closely modelled on Archbishop Cranmer's second Edwardian prayer book of 1552, which was itself a revision of his first prayer book published in 1549. The second book was more uncompromisingly Protestant in its rejection of traditional Catholic patterns of worship and rituals. Elizabeth's prayer book, however, introduced a few significant modifications, the most important of which came in the communion service.

The communion service was a battleground for Reformation Europe. The theology that lay behind the sacrament of the Lord's Supper (celebrated in the service) was one of the most hotly disputed issues amongst different Christian Churches. The 1559 prayer book attempted to gloss over some of these differences and make the service broadly acceptable to most people. It therefore combined phrases from both the 1549 and 1552 prayer books. Thus, the Elizabethan minister was enjoined to use a form of words, taken from the 1549 book, which implied that Christ was physically present in the bread and wine, a theological position that Catholics and Lutherans followed but Calvinists fervently denied. Immediately afterwards, however, the Elizabethan minister had to say: 'Take and eat this in remembrance that Christ died for thee, and feed on him in thy heart by faith with thanksgiving', a phrase used in the 1552 book which emphasised the memorial aspect of the service and was generally acceptable to Calvinists.

The 1559 wording reflected Elizabeth's conservative preferences. She also tried to retain other traditional practices: communion was to be received kneeling, rather than standing or sitting, and wafers were to be used instead of ordinary bread. Many English Calvinists objected strongly to these practices and some refused point-blank to follow the royal directives. Those who would not conform were labelled 'puritans'. Yet, despite their criticisms, this prayer book was unambiguously Protestant, and in 1564 the pope ruled that English Catholics should not attend services using it.

Large copies of the *Book of Common Prayer* were printed for use by ministers in parish churches; in addition smaller, more modest versions of the book were purchased for domestic use and were sometimes bound together with the Bible. SD

LITERATURE: Doran, 'Letters'; MacCulloch, *Later Reformation*; Jones, *Faith by Statute*.

55. Church Plate from Mass to Communion

(a) Chalice for the mass, c. 1500

London.
Silver, partly gilt.
Parish of Wool and East Stoke, on loan to the Victoria and Albert Museum, London.

(b) Cup for communion, c. 1560

London, mark a stag's head, probably for Robert Taylboyes.
Silver.
Given by Henry Whittaker in memory of his brother Thomas (1883–1950) of Mellor, Blackburn.
Victoria and Albert Museum, London, M161-1951.

Although both these cups were made for the central act of Christian worship, the sacrament of the Lord's Supper, they stand either side of a religious divide. Until 1549, the Catholic priest celebrated every day at

ounces almost double the typical late medieval chalice in weight, was presumably ordered for an advanced parish.

The Elizabethan bishops drove a campaign of converting chalices to cups throughout the parishes of England and Wales More than 2,000 Elizabethan communion cups are recorded today, compared to fewer than seventy chalices, an indication of the success of this project to transform the trappings of worship within a generation. PG & SD

56. The Bishops' Bible, quarto edition 1569

See page 29.
Printed book, published by Richard Jugge, London.
British Library, London, 1105.f.1. Title page.

Protestants believed strongly that the scriptures were the sole authority for Christian truth. They consequently promoted the translation of the Bible into the vernacular and encouraged Bible-reading amongst the laity. After Henry VIII had broken with Rome and denied papal authority, he also came to promote the translation of the Bible into English, and in 1540 he authorised the Great Bible. This work, however, contained many errors in translation, and during Mary I's reign a new corrected English Bible was written by English Protestant exiles and published by Rowland Hall at Geneva in 1560. The Geneva Bible, however, was initially unacceptable to Elizabeth because of the Calvinist glosses which appeared in the substantial marginal notes. Archbishop Parker (Cat. no. 53), therefore supervised a revision of the Henrician Great Bible, assigning portions of the text to different scholars, most of whom were bishops. The completed work was published in 1568 in a folio edition to be used in churches. This quarto edition was issued in 1569 for domestic use. Called the Bishops' Bible, it was the one normally read out in churches, but it never became as popular as the Geneva Bible and was widely criticised.

The title page of this quarto edition was illustrated by Frans Hogenberg, a Protestant exile from the Netherlands. On each side of the enthroned queen are the female personifications of the four cardinal virtues: Justice, Mercy (Temperance), Prudence and Fortitude. Traditionally these virtues were associated with imperial power and their attendance on Elizabeth highlights her status as supreme governor of the Church. At the same time, however, their inclusion alludes to her role as the authority for divine truth, for the queen is being crowned by Justice and Mercy who carry the symbols of divine revelation: the sword of the Spirit and the Bible. In later editions of the Bishops' Bible the queen's portrait is voided, probably because of the growing hostility amongst Protestants to pictures appearing in religious books. SD

LITERATURE: Aston, '*Bishops' Bible* Illustrations'; King, *Tudor Royal Iconography*, pp. 233–4.

the altar beyond the rood screen the mass, the re-enactment of Christ's sacrifice. When he held up first the bread (a wafer called the 'host') and then the wine, they each became the body and blood of Christ at the moment of the priestly words of consecration. Every church and chapel owned chalices to hold the wine and patens for the wafer, whose design had evolved over a thousand years. The chalices could be small as only the priest could drink from it; the laity took only the wafer and then usually no more than once a year.

Protestants, however, demanded that the laity should receive the wine as well as the bread at the Lord's Supper, and in 1547 Edward VI's government introduced a statute enforcing 'communion in both kinds'. For the new communion service, a broad bucket shape adapted from a current form of goblet for wine replaced chalices in some royal chapels and advanced London parishes. Robert Taylboyes, a leading London goldsmith in the 1560s, supplied four new Protestant cups to St Margaret's Westminster in 1551 (of which two remain today). After the Marian Counter-Reformation, Elizabeth's government immediately re-introduced communion in both kinds, but many parishes were slow to buy new cups. This heavy and capacious communion cup, at 13

Elizabeth at the beginning of Mary's reign to signal the princess's love of her brother and sympathy with his religion. One cover is centred on a roundel of translucent green and red enamel, the other with a shell cameo bust of a young warrior wearing a nautilus shell helmet and facing towards the right in profile. DS

LITERATURE: Scarisbrick, *Ancestral Jewels*, pp. 14–15; Scarisbrick, *Jewellery in Britain*.

57. Girdle Prayer Book, first half of the sixteenth century

Gold, enamel shell cameo and paper.
Provenance: traditionally a gift from Elizabeth to her cousin
 Henry, 1st Lord Hunsdon, and thence by descent.
Trustees of the Berkeley Will Trust, on loan to the Victoria
 and Albert Museum, London.

Small-scale prayer books were worn by Elizabethan women on a chain hanging from the waist to allow moments of private religious contemplation. The fashion for richly decorated miniature books and the English woman's preference for religious works rather than literature was observed by John Lyly, *Euphues* (1580) 'it was thanks to the girdle book that English women were as cunning in ye scriptures as Italian ladies were in the works of Ariosto and Petrarch'.

Inside this particular book are the prayers of Edward VI, which the Protestant king was said to have recited on 6 July 1553 'two hours before his death . . . thinking that no one could hear him'. This memento of her brother's piety on his deathbed was reputedly worn by

58. The Thirty-Nine Articles of Religion Produced by Convocation, 31 January 1563

Manuscript.
Public Record Office, Kew, SP12/27/no. 42 fos 171-180r.

Convocation was the provincial assembly of the clergy held whenever a parliament was summoned: one met at York for the northern province and one at Canterbury for the southern. It was composed of the archbishops, bishops, archdeacons, deans and elected representatives of the lower clergy.

The main task of the 1563 Convocation was to produce a clear statement of the doctrines of the English Church. The bishops took on this responsibility, and after ten days of deliberation they all agreed on the number and content. More than a third of the Thirty-Nine Articles expressed ecumenical Christian doctrines, while another six refuted doctrines which were held by radical sects. On the doctrinal issues that divided Lutherans from Calvinists the bishops tried to steer a middle course, but they usually veered towards Calvinist theology. Two of the articles on the Lord's Supper, for example, were anathema to Lutherans; for this reason Article 28 was suppressed in printed versions until 1571. Article 17 on predestination (which begins at the bottom of fo. 174 shown in the exhibition) omitted many core beliefs on predestination held by Calvinists, but it nonetheless placed the Elizabethan Church securely within the Calvinist fold, by stating that 'Predestination to life is the everlasting purpose of God, whereby, before the foundations of the world were laid'.

In 1571 all the articles were approved in parliament. Subscription to them was enforced upon all the clergy, but some puritans refused to subscribe and consequently lost their posts. SD

LITERATURE: Haugaard, *Elizabeth and Reformation*; Horie, 'Lutheran Influence'; Crankshaw, 'Preparations'.

THE
QUEEN'S
COURT

Lady Katherine Grey with her son Lord Edward Beauchamp.

THE QUEEN'S SUITORS AND THE PROBLEM OF THE SUCCESSION

SUSAN DORAN

ALTHOUGH ALREADY TWENTY-FIVE YEARS OLD, ELIZABETH INHERITED the throne as an unmarried woman unencumbered with any prior betrothal contracts. During her childhood and adolescence, her father and siblings had considered several candidates for her hand, but these suits had come to nothing largely because of the young princess's legal status as a bastard. But no sooner had Elizabeth been crowned queen than foreign ambassadors began to shower her with proposals of marriage from their masters. One of the earliest suitors was her widowed brother-in-law, Philip II of Spain, (Cat. no. 23), who in an effort to keep England Catholic and pro-Spanish reluctantly offered the new queen his hand in January 1559. Over the following year, Elizabeth received matrimonial offers from a dozen or so somewhat less exalted princes, including Eric, king of Sweden, Archdukes Ferdinand and Charles of Austria, the Scottish earl of Arran and the dukes of Holstein and Saxony.

ELIZABETH REBUFFED all these men, explaining to them that she preferred to remain single for at least the foreseeable future and advising them to seek a bride elsewhere. To parliament in 1559, moreover, Elizabeth announced that she preferred to live and die a virgin, although she did not entirely exclude the possibility of marriage. This lack of urgency and enthusiasm about taking a husband was quite extraordinary for a ruler who had no clear-cut successor. As the last of Henry VIII's children, Elizabeth ideally needed to produce an heir — preferably male — from her own body, since otherwise a war of succession might well follow her death. Consequently, to her intense irritation, she was pestered by parliament to marry, and also petitioned to name an heir presumptive (Cat. no. 64).

THE RISK OF A WAR of succession seemed particularly great in the early and mid-1560s because of the competing claims of the two leading candidates, Mary Queen of Scots and Katherine Grey (see page 64). As the granddaughter of Henry VIII's elder sister, Mary unquestionably had the stronger hereditary claim to the succession. On the other hand, certain legal impediments stood in the way of her succession. First, Henry's will had implicitly excluded the Scottish line from the succession; and second, precedents in common law argued against an alien inheriting property in England. Probably of more significance, many people, particularly committed Protestants like Sir William Cecil (Cat. no. 33), opposed Mary's claim because of her Roman Catholicism and close kinship ties with France. Her mother, the Frenchwoman Mary of Guise, was the sister of a leading French Catholic nobleman while her new husband Francis had inherited the throne of France in July 1559 (Cat. no. 66). Mary, moreover, was an object of suspicion because in 1559 she had challenged Elizabeth's

right to the accession in order to promote papal and French interests.

BY CONTRAST, Mary's English rival, Katherine Grey, seemed to have a better title to the succession in law as Henry VIII had privileged her family line in his will. She was also generally more acceptable to most of the political elite, since she had been brought up as a Protestant. But Katherine was the granddaughter of Henry's younger – not older – sister, and thus her claim by blood was weaker. Furthermore, Elizabeth favoured Mary's claim and did all she could to put barriers in the way of a Grey succession. Her preference for Mary probably stemmed from both her belief in hereditary monarchy and her dislike of the Grey family for illegitimately attempting to divert the succession in 1553. It also seems that Elizabeth found Katherine personally unsympathetic.

ELIZABETH'S LACK of warmth towards Katherine turned into loathing after she discovered in August 1561 that the young woman had clandestinely married Edward Seymour, the earl of Hertford. The marriage only came to light when a heavily pregnant Katherine tearfully confessed her plight to Lord Robert Dudley (Cat. no. 60) who immediately informed the queen. Elizabeth was furious at her maid of honour's deceit. In addition, she feared that Katherine's marriage into the ambitious Seymour family was a stratagem to strengthen her claim to the succession. Elizabeth immediately confined the couple in the Tower of London, and soon after their son was born in September 1561 she appointed an ecclesiastical commission to inquire into the validity of his parents' marriage. The fact that Katherine and Hertford could produce no witnesses or documents to prove that they had exchanged

Marriage medal of Mary Queen of Scots, 1558.
British Museum, London.

marriage vows made it easy for the commission to decide that no marriage had taken place and the child was a bastard. Elizabeth's strong feelings on the issue, however, undoubtedly influenced the judgement. When secret conjugal visits in the Tower resulted in Katherine giving birth to a second son in 1563, Elizabeth made sure that he too was declared illegitimate. The two lovers were parted and Katherine was kept under house arrest until her death in January 1568, despite her piteous requests for forgiveness. In this way, Elizabeth hoped she had neutralised the political threat from Katherine and dealt a deathblow to the claims of the Grey line to the succession. It could be claimed that the queen's treatment of Katherine was spiteful and unnecessarily severe; after all, Katherine had evidently married out of romantic love, not political ambition, and she appeared a pathetic figure during her separation from Hertford. Elizabeth, however, believed that the Seymour marriage was a bid for the succession, or even possibly the throne, and her fears were reinforced when Katherine's supporters wrote pamphlets in the mid-1560s defending the right of her sons to inherit her claim.

ALTHOUGH ELIZABETH favoured the Scottish claim to the succession, she refused point-blank to designate Mary her heir presumptive. As she explained to Mary's ambassador in 1561, several political considerations weighed heavily against any such action. First, Englishmen were divided over the question, and disputes would come to the surface if she named an heir. Although she did not say so, it was also fairly unlikely that a bill placing Mary next in line for the throne could ever pass through a Protestant House of Commons, given that Cecil and some other councillors would oppose it. Second, Elizabeth

warned the ambassador that naming Mary her heir would inevitably end any possibility of friendship between the two monarchs: 'Think you that I could love my own winding-sheet' (meaning her shroud), she said.[1] By this comment Elizabeth was not so much expressing a personal jealousy but pointing out that monarchs always distrusted their successor. Third, Elizabeth noted that, even if loyal herself, Mary would become the focus of intrigue amongst disaffected Englishmen: 'I have good experience of myself in my sister's time, how desirous men were that I should be in place and earnest to set me up.'[2] Her experience also told Elizabeth that the attempts of rulers to determine the succession could be worthless: after all Edward VI had failed to put Lady Jane Grey on the throne.

GIVEN THESE PROBLEMS of the succession, why did Elizabeth not marry during the first decade of her reign when she was most likely to survive childbirth and produce a healthy heir? Some biographers have suggested that she rejected the idea of marriage altogether, because it would limit her power to rule. In the words of Susan Bassnett: 'Had she married, she would have remained Queen but still have found herself in a subservient position to her husband, and she must have had strong feelings about the undesirability of that state of affairs.'[3] For other biographers, though, psychological factors were paramount.[4] The trauma of losing her mother on the scaffold on a charge of adultery, they suggest, created a psychological barrier to marriage; while if, as some believe, Elizabeth had suffered a form of sexual abuse during her adolescence at the hands of Lord Thomas Seymour (Cat. no. 16), it would have been an

Portrait of Robert Dudley, Earl of Leicester, c. 1564.
Waddesdon Manor, The Rothschild Collection
(Rothschild Family Trusts)

experience that deepened the emotional scars of her childhood and reinforced her early antipathy to marriage.

APART FROM THE FACT that there is no evidence to support these propositions, Elizabeth gave every sign of wanting to marry early in her reign but found herself unable to wed the man of her choice. Her choice of husband was Lord Robert Dudley (Cat. no. 60), son of John Dudley, duke of Northumberland, who had been executed in 1553 for attempting to place his daughter-in-law, Lady Jane Grey, on the English throne. Elizabeth had probably first met Robert Dudley in 1540 or 1541 when he was present in Prince Edward's household, but almost nothing is known of their early friendship. During the last year of Mary I's reign, Dudley was living in Throcking, Hertfordshire, and possibly made frequent visits to Elizabeth, who was then residing at Hatfield in the same county. In any event, a Spanish envoy identified Dudley as one of Elizabeth's good friends in November 1558. Later that month, one of her earliest actions as queen was to appoint him as master of the horse with responsibility for supervising the royal stables, providing warhorses and attending on the monarch whenever she rode. In this capacity, he rode immediately behind the queen in the coronation procession (Cat. no. 30).

DURING 1559, ELIZABETH'S demonstrative affection for Dudley was causing gossip. As Dudley was a married man, their relationship was thought to be at the very least unseemly. Soon people were whispering at court that the two were lovers,

while wild rumours were heard in Essex and elsewhere that the queen was pregnant. More reliably, some courtiers expressed the opinion that Elizabeth would marry her favourite as soon as his wife, who was thought to be sick, were dead. But when Amy, Lady Dudley, did die in September 1560, the cause was not illness but a broken neck, incurred from a fall down a short flight of stairs. Dudley immediately came under suspicion of murder, as Amy, who was then living in a house owned by one of his connections, had been alone at the time of her death. Although Dudley was cleared by a coroner's court, rumours of his involvement in his wife's death persisted. Historians today are divided in their opinions about his level of responsibility: most believe he was entirely innocent and that the accident occurred because Amy's bones were crumbling as a result of breast cancer; at least one historian considers that there is some evidence that Amy was murdered, while I think the most plausible explanation is that she committed suicide.[5]

WITH DUDLEY FREE to marry, Elizabeth was in a quandary. She continued to give every appearance of being in love with her favourite, but at the same time she was well aware of the danger to her reputation, were she to wed the man suspected of being her lover and of killing his wife. Furthermore, powerful men at court strongly opposed the match, including Cecil and Thomas, duke of Norfolk, the premier nobleman in the realm (Cat. no. 216). At first, Elizabeth found it difficult to decide whether or not she could safely take Dudley as her husband. In November 1560, for example, she drew up a patent to ennoble him, a necessary preliminary to their marriage, but she then slashed through the document in a state of some emotional distress. By 1563, however, she had reached the conclusion that marriage to Dudley would so ruin her personal reputation and endanger her political position that she simply could not take the risk.

ONCE THIS RESOLUTION was reached, Elizabeth offered Dudley as a husband to the widowed Mary Queen of Scots and opened up negotiations for her own marriage to Archduke Charles of Austria, the youngest brother of the Holy Roman Emperor Maximilian II and a suitor much favoured by Cecil (Cat. no. 65). Dudley was elevated to the peerage as earl of Leicester in preparation for the courtship of Mary, but the Scottish queen was unwilling to marry Elizabeth's cast-off suitor without first securing the substantial political reward of being named heir presumptive in parliament. When Elizabeth refused, Mary made a love match with her second cousin, Henry Lord Darnley, much to Elizabeth and her council's dismay (Cat. no. 218). They feared that the marriage would strengthen the Stuart claim to the succession, or possibly even challenge Elizabeth's right to rule, for Darnley was also a descendant of Margaret Tudor and an Englishman to boot. To counteract the danger, Elizabeth and councillors like Cecil and Norfolk tried to revitalise the Archduke Charles match, but the negotiations with the Austrians ran into difficulties over the question of religion. Despite seeing the advantages of a dynastic alliance with the powerful Habsburg family, many of Elizabeth's councillors objected to the demands of the Austrian emperor that the archduke should be allowed to hear the Catholic mass within the privacy of his own apartments. Not surprisingly it was Leicester who headed the opposition to the match, an opposition that became so vocal in late 1566 that Elizabeth suspended the matrimonial negotiations. Soon afterwards the French royal family put forward its own candidate – the third son of Catherine de Medici (Cat. no. 225(e)) and brother to Charles IX – but these matrimonial negotiations also collapsed over the issue of religion.

BY THE MID-1570S, therefore, Elizabeth was still unwed with little prospect of securing a match with a foreign prince. Leicester too was single, though hardly faithful to the queen as he had fathered a son on Lady Douglas Sheffield in 1574. After their affair was over, the earl seems to have decided to make a last-ditch attempt to woo Elizabeth. Thus, when she visited his castle at Kenilworth in 1575, he mounted an elaborate proposal of marriage through a series of pageants, entertainments, even portraits (Cat. no. 68). By this time, however, Elizabeth had no wish to disturb the political *status quo* by taking Leicester as king-consort, though she still felt great affection for her 'eyes' or 'sweet Robyn' (Cat. no. 69). His hopes finally dashed and desperate for a legitimate heir, Leicester married secretly in 1578 the widowed Lettice, countess of Essex. Elizabeth was both distressed and angry when she learned of their union in the autumn of 1579, and Leicester did not fully return to favour until the death of their son in 1584 aroused her compassion. Lettice, however, was never permitted to attend court.

Elizabeth had her own opportunity to marry in 1578. In that year negotiations were opened for a marriage alliance with Francis, duke of Anjou, the fourth and youngest son of Catherine de Medici and brother to Henry III of France (Cat. no. 74). Francis was twenty-one years younger than the forty-five-year-old queen, but the marriage scheme was nonetheless taken seriously by both sides. Its purpose was not to produce a child, although Cecil claimed that Elizabeth was still capable of conceiving for five or six years yet (Cat. no. 73), but rather to resolve a set of intractable international problems and to forge a defensive treaty with the French monarchy.

In January 1579 the duke's household servant, Jean de Simier, arrived in London to negotiate a matrimonial treaty. His gallant behaviour soon charmed the queen, who dubbed him her ape, a nickname arising from a Latin pun on his name. Six months afterwards, on 17 August 1579, the duke came *incognito* to Greenwich to woo the queen in person and thereby to dispel her oft-made objection to marrying a man she had never seen. During their thirteen days together, they attended balls, parties and banquets at the palaces of Greenwich and Richmond. Elizabeth dubbed Anjou her 'frog', either because of his gravelly voice, pock-marked face or bandy legs; and she appeared enraptured by him, carrying around his miniature in a prayer book and taking every opportunity to mention his name. For the second time in her reign, it seems, 'Elizabeth could contemplate marriage not with distaste but pleasurable anticipation. As a bonus, she could retrieve her pride after the "desertion" by Leicester.'[6] For this reason she was ready to concede to Anjou the right to practise his religion in a private place, probably in

Portrait of Francis, Duke of Anjou.
National Maritime Museum.

the expectation that he would eventually conform to the English Church.

Most of Elizabeth's Protestant subjects, however, strongly objected to the Anjou match as they hated the duke's religion and nationality. They could not forget that the French royal family had ordered the St Bartholomew's Day massacre of Protestants seven years previously or that Anjou himself had taken up arms against French Protestants during the civil wars that had followed. To Elizabeth's fury, men spoke out against the marriage in ballads, sermons, pamphlets and Latin verses. Philip Sidney wrote a courteous and personal letter to Elizabeth, pleading with her to reject Anjou's suit, but the most famous diatribe was *The Discovery of a Gaping Gulf whereunto England is like to be swallowed by another French marriage . . .* written by John Stubbs. For this offence, he, his printer and publisher were put on trial under a contentious law. The printer was pardoned but Stubbs and the publisher had their right hands amputated in public to the horror of the crowd. It was a public relations disaster for the queen.

Elizabeth's councillors were divided over the marriage issue. Although Cecil (now Lord Burghley) and a few others approved the match, the majority led by Leicester, Sir Francis Walsingham (Cat. no. 213) and Sir Christopher Hatton (Cat. no. 72) strongly opposed it. Without obtaining her council's unanimous and unambiguous consent, Elizabeth could not go ahead with a marriage that was deeply unpopular in the court and country. The decision pained her, and she showed her grief by bursting into tears before four of her astonished

councillors. Although she did not immediately break off the negotiations and indeed provisionally signed a draft matrimonial treaty with the French, she warned Anjou that the match would founder unless he gave up his demand to hear the mass privately in England. At the same time, she hinted to the French king that she would be prepared to sign a political alliance without marriage. Neither Anjou nor Henry III responded positively to these advances.

MATTERS CAME TO A HEAD in the spring of 1581 when a French embassy arrived in London to ratify the matrimonial treaty. Elizabeth entertained it lavishly, treating the ambassadors to feasts, tournaments, the ceremony of the knights of the Garter, and a two-day entertainment entitled 'The Four Foster Children of Desire'. But she had already decided against the match and asked the French ambassadors (without success) to negotiate a treaty of alliance instead. In July 1581, Elizabeth wrote Anjou a loving letter explaining that she could not marry him. He visited her again later in the year when the talk of a marriage briefly revived, but three months later Anjou went off to fight in the Netherlands as the queen's protégé. Thereafter the two exchanged romantic letters (Cat. no. 75) until the duke's death in June 1584. On hearing the news, Elizabeth appeared inconsolable and acted the part of a grieving widow.

WITH ELIZABETH UNMARRIED, the succession question was still unresolved, but after 1568 an acceptable Protestant candidate began to emerge from the shadows. In Scotland, away from the influence of his mother who had fled to England, the young James VI (Cat. no. 67) was reared and educated by Calvinists. Born of an English father, he could argue that he was no alien; the great-grandchild of Henry VIII's sister on both his paternal and maternal side, his hereditary claim was impeccable (Cat. no. 266); and since the original of Henry VIII's will had disappeared, it could be argued that it had no legal status and was no longer relevant. But English Protestants still did not feel relaxed about the future. During the period of Mary's custody in England, plots were uncovered which were designed to anticipate the succession, assassinate Elizabeth, and place Mary on the throne (Cat. no. 219). Unless Mary were removed from the scene, Elizabeth's life seemed under threat and a Protestant succession remained uncertain.

MARY'S EXECUTION IN 1587 eased, but did not end, anxieties about the succession. James was now the frontrunner but other candidates were being promoted, including Infanta Isabella of Castile (the daughter of Philip II of Spain), Arbella Stuart (another great-grandchild of Margaret Tudor) and the two sons of Katherine Grey. It was in these circumstances that the MP Peter Wentworth wrote his pamphlet, *A Pithie Exhortation*, urging the queen to do her duty and allow parliament to name a successor (Cat. no. 262). His attempts to have the succession debated in parliament, however, ended with his confinement in 1593 in the Tower, where he died four years afterwards. Elizabeth remained defiant that no one should discuss the succession, let alone give a legal title to her heir. On the other hand, she helped to clear James VI's path to the succession and weaken the position of his rivals: Hertford's attempts in the 1590s to legitimise his sons, for example, were brusquely stopped and severely punished; Arbella Stuart was kept out of harm's way in Derbyshire, unmarried and cut off from any potential power base.

IN THE EVENT, JAMES VI (Cat. no. 267) succeeded to the throne unchallenged and unopposed. By the time of Elizabeth's death on 24 March 1603, he had secured the backing of most of the leading men in England, including Sir Robert Cecil, Elizabeth's secretary (Cat. no. 261). James had opened up a secret correspondence with Cecil immediately after the Essex rebellion of 1601, and thereafter the secretary did his utmost to ensure a smooth succession. During the last days of Elizabeth's final illness, he and the other councillors drafted the proclamation announcing James's accession which they sent to Scotland for his approval in advance of her death. To legitimise further James's claim to the throne, they spread the story that on her deathbed Elizabeth had nominated the Scottish king as her heir and had dismissed the pretensions of Katherine Grey's elder son, Edward, Lord Beauchamp.[7] In case anyone was tempted to take action on Beauchamp's behalf, a careful watch was placed on the areas where his father held land and influence. But Beauchamp lacked ambition, while virtually everyone – Protestants and Catholics alike – had

become reconciled to a Stuart succession. Although the diarist John Manningham (Cat. no. 263) reported nervousness in the City of London as news of the death of Elizabeth was expected, no other claimant appeared, and when James marched down to London to take his throne, he was greeted with enthusiasm by his new subjects.

JAMES DID NOT ENTER London until after Elizabeth's funeral, which took place on 28 April 1603 (Cat. no. 264). The procession to Westminster Abbey from Whitehall was magnificent: four horses draped in black drew the chariot holding the coffin, beneath a canopy held up by four knights. The coffin was covered in purple velvet, and on it lay a life-size painted effigy of the queen, dressed in her ceremonial robes of state, wearing a crown on her head, and holding a sceptre. Following the queen were first the peeresses of the realm, led by the chief mourner, the marchioness of Northampton, then all the important men, and finally two hundred or so poor

people. A huge crowd turned out to mourn their dead queen, and many spectators openly wept as the coffin passed by. At the same time, there was also great excitement at the prospect of rule by an adult, male king who had already proved himself a capable ruler in Scotland and had fathered two sons. Though unfairly criticised during her lifetime for failing to provide for the succession, Elizabeth was immediately praised on her death – equally unjustly – for providing for this excellent state of affairs. In the words of one accession ballad

> Queen Elizabeth she is gone
> Gloriously, Gloriously
> Up to the Angel's Throne
> Ever to dwell
> So prudent was her mind
> So careful and so kind
> All her state she hath assigned
> To our noble King James.[8]

ENTERTAINMENTS AT COURT

Susan Frye

THE COURT CONSISTED OF THE PRIVILEGED CIRCLE OF MEN AND WOMEN who, because of social networks and patronage, found a place in Queen Elizabeth's everyday life. Officers of the royal household were not only courtiers, but were also frequently members of the privy council, the group who advised the queen on domestic and foreign policy. Thus Lord William Howard of Effingham, who headed the court as lord chamberlain in 1558, was also a councillor; and Robert Dudley (Cat. no. 60), who held the position of master of the horse, was added to the council in 1564. The queen chose the ladies who attended her largely from among her mother's cousins from the Knollys, Howard and Carey families (Cat. no. 114), as well as from the wives of government office holders and courtiers, including the Cecil and Throckmorton families. Her gentlewomen and maids of honour looked to the queen's needs and pastimes while controlling access to her, a vital role since, in this personal monarchy, Elizabeth could if she chose make the final decisions about her aspiring subjects' positions and possessions. As a result, the court was the centre of royal power, where the government's leading administrators also performed as courtiers. As such, the court was a hotbed of political activity as every aspect of courtiers' lives – their business transactions, their suits for preferment, their religious convictions, their marriages – created bonds and divisions.

THE DAILY LIFE OF COURT involved elaborate rituals that expressed and reinforced the queen's position as head of the political and social hierarchy. Processions of courtiers, whether to the Chapel Royal or through the streets of London, followed rules in which precedence depended on title, gender, and, among the male children, birth order: Elizabeth walked or rode towards the end of the procession, the figure who authorised all who came before her. Rituals of precedence attended all aspects of court life, from processions and every form of entertainment, to feasts and public banquets, gift giving, christenings, funerals, and the two religious ceremonies surrounding the monarchy that Elizabeth chose to perpetuate, the touching for the King's Evil, in which the monarch, through her touch, was said to cure her subjects of a skin disease known as scrofula, and the observance of Maundy Thursday.

ON MAUNDY THURSDAY, Elizabeth, like Mary Tudor and the male monarchs before her, washed the feet of the poor in imitation of Jesus, although both Mary and Elizabeth chose to wash the feet of women, and Elizabeth did so only

after they had been washed by the yeomen of the laundry, her sub-almoner, and almoner. As Carole Levin points out, the ceremony grew longer as Elizabeth grew older, because the number of women honoured with the footwashing, Maundy robes and a purse was each year the same number as Elizabeth's age.[1] Levina Teerlinc's miniature of Elizabeth, seen front left wearing a purple-blue long-trained gown, records a Maundy ceremony from the early years of the reign (Cat. no. 113).

ALL COURTLY ACTIVITIES required that both male and female courtiers wear complexly produced clothing, consisting of silks, satins and velvets, often padded, tufted, slashed or heavily embroidered. Textiles, the principal marker of class in the sixteenth century, functioned as a kind of wearable currency. Elizabeth necessarily wore the most elaborate costumes of all, some of them New Year's gifts from members of the court or those at the periphery of the court, including peers, ambassadors and suitors. Both professionally and domestically produced textiles resplendent with pearls, gold, silver and jewels, were considered desirable gifts for the queen, and the gift roll of 1588 (Cat. no. 98) records several such gifts. Servants of all kinds, furthermore, were regularly paid in cloth or clothing in lieu of wages.

SUCCESS IN ATTRACTING the eye of Elizabeth could mean titles, estates, export licences and monopolies, and other forms of preferment, as men like Christopher Hatton and Walter Ralegh (Cat. no. 181) could attest. The men and women who sought to participate in the many forms of court entertainment consequently knew that their careers depended on pleasing their queen, even as they attempted to negotiate their own ambitions. From the neo-medieval splendour of jousts, to sumptuous masques featuring allegorical figures, dance, poetry,

An Elizabethan Maundy Ceremony, c. 1560.
Trustees of Lady Beauchamp's Will Trust.

music and special effects, to more private pastimes like dancing and hunting, entertainments served a variety of important social functions. Because they occurred at Elizabeth's court and often featured the queen herself as a participant, these were not merely pastimes, but performances. Court entertainments allowed Elizabeth's people to praise and glorify their sovereign and also to hold up standards and expectations for her behaviour. The entertainments also allowed the people who strove to entertain her to present themselves as extravagantly as they could afford or creditors could support, to represent their personal charms and accomplishments, while the queen used entertainments to demonstrate her attentiveness, her wit and her own point of view.

IN THE FIRST YEAR of her reign, Elizabeth enjoyed an elaborate entertainment at Greenwich, her birthplace. Elizabeth's entertainment at Greenwich in July 1559 featured a military skirmish at about five o'clock in the evening, when Robert Dudley, together with the lord admiral and other lords and knights headed two armies, which then tussled. The queen and her court watched this loud and fierce imitation of a close fight, after which Elizabeth thanked the city folk who had participated. They responded with a great shout and hurled their caps in the air, while the queen responded merrily. This show of battle was followed by a running at tilt. At Greenwich again, a few days later, a banqueting house was set up, elaborately furnished with flowers, herbs and rushes. Three challengers appeared against the queen's pensioners with lances and swords, after which there was a masque, a banquet, fireworks and gun shooting until midnight.[2] The gathering together of citizens and courtiers and the elaborate preparations necessary to organise the Greenwich entertainment of 1559 demonstrate how important this entertainment was early in Elizabeth's reign. At this point she was a vulnerable young

woman about whom everyone wondered: what kind of a leader would she prove to be? What would she do about her marriage and securing the succession? The military skirmish and the tilt, together with the pleasures of the banquet and Elizabeth's merriment displayed a monarch who, although young and female, could preside over commoners and nobles alike as a popular, stately, munificent and confident prince.

STAGED SKIRMISHES like that at Greenwich, together with Elizabethan jousting and tournament battles, formed both a serious athletic pastime for the combatants and the means to show off their prowess before the queen, the court and the public. Jousting sometimes occurred at Westminster, like the tournament in 1571 at which Edward de Vere, earl of Oxford, held sway over Charles Howard (Cat. no. 242), Sir Henry Lee (Cat. no. 76) and Christopher Hatton (Cat. no. 71). Often, the tournaments included entertainments with a political message. A tournament of 1581, for example, included the entertainment, 'The Four Foster Children of Desire', written by two members of the court known today for their poetry and prose, Philip Sidney and Sir Fulke Greville, joined by the earl of Arundel and the Lord Windsor. Their point was to demonstrate to the French that Elizabeth would not marry the duke of Anjou (Cat. no. 74). According to the description, at the tiltyard adjoining Whitehall Palace, a gallery stood at its end called 'The Castle or Fortresse of Perfect Beautie', where Queen Elizabeth took up her position. The Fortress of Beauty was under siege by desperate Desire and his army. Desire (an allegory for the queen's French suitor) had besieged Beauty because it believed that it could conquer all, in spite of the fact that the Fortress of Beauty's goddess, Elizabeth, kept constant watch against Desire.[3]

THE FOUR MEMBERS of Elizabeth's court opposing this French marriage had prepared to stage their siege of Beauty by creating an elaborate rolling machine topped by cannons made of wood, with gunners beside them. As the entertainment began, the knights entered with great pomp: the earl of Arundel, for example, came in first, as befitted his position,

New Year's Gift Roll, 1588 (Cat. no. 98).
British Library, London.

Portrait of Sir Henry Lee, 1568.
National Portrait Gallery, London.

in engraved armour with caparisons (armour and decorated covering for his horses) and tack intricately embroidered, attended by two gentlemen ushers, four pages on horseback and twenty of the earl's gentlemen. The earl's entourage wore short cloaks and Venetian hose of crimson velvet with gold lace, doublets of yellow satin, and were topped by hats with crimson velvet and gold hatbands and yellow feathers. Six trumpeters announced the earl's entrance, while thirty-one yeomen awaited him in matching liveries. After similarly elaborate entrances by the other three Children of Desire, the siege got underway in earnest: the cannons fired, one sweet water and the other sweet powder. Then several decorated scaling ladders were mounted against the fortress in which Elizabeth stood, and the besieging forces threw flowers against the walls until challenged by the defending forces, who then entered the tiltyard. At this juncture, twenty-one knights of

the court appeared together with the Queen's Champion, Sir Henry Lee, to defeat Desire's sweet-smelling siege. It was a victory for the court against outsiders, staged for the court, the French ambassadors and Elizabeth's public audience alike.

NOT EVERY TOURNAMENT and entertainment made such a decided political statement about foreign and domestic policy. Nevertheless, court entertainments were about the queen's pleasure and the queen's power. The Accession Day tournaments that took place from at least 1581, and possibly ten years earlier, celebrated Elizabeth's accession to the throne on 17 November 1558. Accession Day took on the aura of a 'holy day' as bells were rung across the countryside. In 1584 a visitor from Germany, Lupold von Wedel, witnessed the Accession Day tournament and recorded its pleasures, telling us that around noon the queen and her ladies placed themselves at the windows in a long room at Whitehall Palace, while the spectators — men and women, old and young — found places in the stands. The participants entered, elaborately dressed, their servants in some cases disguised as savages, and some of their horses equipped to look like elephants. When each combatant arrived, he sent his servant to address the queen, often making her and her ladies laugh.[4]

THE ENTERTAINMENTS and ceremonies preceding the Accession Day tournament of 1590 were as lengthy and important as 'The Four Foster Children of Desire'. As a group of armed knights approached the queen, suddenly she heard sweet music coming from an unknown place. Then the earth appeared to open, revealing a pavilion made of white taffeta, meant to be the Temple of the Vestal Virgins. Inside was an altar attended by three virgins, with gifts for the queen. The whole entertainment was, like the 'Sieve' portraits of Elizabeth, an extended reference to Elizabeth's iconography as the Vestal Virgin Tuccia,[5] who proved her virginity by carrying water in a sieve from the Tiber to the Temple of the Vestals — a reference that both glorified Elizabeth's virginity and associated England with Roman imperialism (Cat. no. 59).

THE NEXT EVENT in this Accession Day entertainment of 1590 occurred when the outgoing Queen's Champion, Sir Henry Lee, passed his position to George Clifford, earl of

PALATIVM REGIVM IN ANGLIÆ REGNO APPELLATVM NONCIVTZ,
Hoc est nusquam simile.

Effigiauit Georgius Houfnaglius Anno 1582.

Nonsuch Palace, with the Queen in her coach, 1582 or later (Cat. no. 96). British Museum, London.

Cumberland, by disarming himself and kneeling, in order to beseech Clifford to continue the Accession Day tournaments. After Elizabeth signalled her acceptance of this change, Lee armed the new champion, then mounted his horse and put on a black velvet coat, replacing his helmet with a cap of country fashion. If the outgoing champion wore a black coat and distinctly unmilitary country cap, the gorgeous miniature of Cumberland in full tournament attire (illustrated page 96) attests to what the new Queen's Champion may have worn when he assumed his position, at a time when male courtiers spent hundreds of pounds to set themselves out in a visual demonstration of their pedigrees and ambitions.

DURING THE SPRING and summer, Elizabeth I and her court proceeded on progress, which consisted in royal visits throughout southern England to the country houses of important courtiers as well as to the towns and villages along her way. By Mary Hill Cole's recent count, during all the progresses of her reign Elizabeth participated in at least 400 different entertainments,[6] which provided the means for the queen to socialise with and recognise a broad spectrum of her subjects, to hear their views on domestic and foreign policy whether she liked them or not, and to place herself on display. In the towns, Elizabeth met with influential citizens who frequently provided entertainments for her, perhaps an entry

Drawings of Elizabeth I and Robert Dudley, dated 1575 (Cat. no. 68). British Museum, London.

along the lines of Elizabeth's entries into London, and at least a ceremonial welcome.

ALSO ON PROGRESS, Elizabeth often visited the towns and universities of Oxford and Cambridge. At Cambridge, together with her court, Elizabeth enjoyed a stay of five days in early August 1564. Upon her arrival on horseback, the queen, dressed in a gown of black pinked velvet, her hat decorated with spangled gold and a bush of feathers, arrived to the blast of trumpeters in the midst of a procession of the lords in order of precedence. After being generally introduced to the scholars and after her accompanying courtiers dismounted, Elizabeth alone remained on horseback to ride into town. There she heard scholarly disputations and other scholastic exercises in physics and divinity, and was entertained by university productions of plays adapted from Greek and Latin sources. On the final day, she responded with an oration in Latin in which she modestly but decidedly demonstrated her linguistic and rhetorical abilities.

PERHAPS THE BEST-KNOWN of the progress entertainments occurred at Kenilworth in 1575, when Robert Dudley, earl of Leicester, provided the most elaborate festivities of her reign over three weeks. In the way that 'The Four Foster Children of Desire' would seek to represent Elizabeth's unwillingness to marry the duke of Anjou in 1581, or the Accession Day entertainment of 1590 would make a statement about the Roman antecedents of Elizabeth's imperial virginity, the enter-

tainments at Kenilworth in 1575 represented the queen in ways that staged current political points of view while highlighting Leicester's importance as suitor to the queen. Shortly before arriving at Kenilworth, Elizabeth and members of her privy council had sent envoys to the Netherlands in order to investigate this region, locked in a fierce civil war between the Protestants, headed by William of Orange (Cat. no. 225(c)), and the Catholic Spanish authorities. After hesitating to participate in this conflict for several years, Elizabeth seemed finally ready to consider an armed intervention, an intervention strongly supported by Leicester and other Protestant militants – a step she would not take for another ten years. But Leicester could not have known that, and the entertainments at Kenilworth may consequently be read as the earl's staging of his importance as the man closest to the queen, a relationship that the visiting Italian artist, Federico Zuccaro, preserved earlier that year in his companion drawings of Elizabeth and Leicester from May 1575 (Cat. no. 68).

OF THE MANY ENTERTAINMENTS in which Elizabeth participated, whether as an active performer or as an audience member, some might have been considered 'higher' forms of art than others, especially if they derived from classical works. The vast majority were probably considered what today would be called 'popular culture'. Nevertheless, because the most innovative minds in England helped to create the entertainments at Elizabeth's court, they deeply influenced the developing drama, prose and poetry of the literary period known in retrospect as the Golden Age of English literature. At the beginning of Elizabeth's reign, English was not widely considered a language expressive enough to be the vehicle of great poetry, prose and drama, in spite of the achievements of Chaucer, Gower and Wycliffe, Skelton, More, Wyatt and the earl of Surrey. But by the conclusion of Elizabeth's reign, the English language, although still relatively new and flexible, had become the literary language of Edmund Spenser, Philip Sidney and Elizabeth herself, as well as of the great playwrights of the age, Ben Jonson, Thomas Kyd, Christopher Marlowe and William Shakespeare. These city dwellers mingled the tastes and concerns of court, university and city to create a drama whose treatment of comedy, tragedy and history was unprecedented. As Elizabeth's reign progressed,

the printing press made possible an ever-wider dissemination of their writings.

THE ACHIEVEMENTS of the great writers of this age cannot be separated from the court and court entertainments: Edmund Spenser wrote his epic poem, *The Fairie Queene*, dedicating it to Elizabeth, who was figured as the Fairy Queen in entertainments both before and after the publication of the poem's first three books in 1590. The pretext for Spenser's entire poem appears to be a combined court entertainment and tournament closely resembling those held on Accession Day. The reference to a 'vestal virgin' in *A Midsummer Night's Dream* not only suggests court entertainments that linked Elizabeth's virginity to that of the Roman vestals, but has also suggested to scholars that a young William Shakespeare may have witnessed the Kenilworth entertainments, which took place a few miles from Stratford. *A Midsummer Night's Dream*, like Spenser's poem, features a Fairy Queen, Titania, but as a less solemn figure than that of Spenser. Philip Sidney's prose romance, *Arcadia*, features jousts and battles clearly drawn from court tournaments, while Ben Jonson created *Cynthia's Revels*, a dramatic masque, for the court.

MUCH OF THIS GREAT outpouring of drama and literature was stimulated by court patronage. Acting companies existed in large part because of the courtly interest in entertainment. These companies included the Boys of St Paul's, who performed publicly and at court under the patronage of the earl of Oxford, among others. The Children of the Chapel, who probably participated in the Kenilworth entertainments, were supported by the queen, who also contributed to the Children of Windsor and the Children of the Queen's Revels, also known as the Children of Blackfriars. Adult companies of actors received patents from Elizabeth that granted them the right to perform in the city and just outside it, while insisting on her right to summon them to court. In addition to the Queen's Men, the companies during the course of her reign appeared under the sponsorship of courtiers from whom they took their name, including the earls of Leicester, Sussex, Warwick, Arundel, Hertford, Derby and Pembroke, as well as the Lords Rich, Abergavenny and Berkeley. The members of these acting companies were technically members of the households of their patrons.

ALTHOUGH MOST OF THE child and adult companies performed in the provinces as well as at court, three notable adult companies performed largely in London. The most popular troupe in the 1580s was the Queen's Men. The 1590s and the turn of the seventeenth century saw two rival companies in London. The first of these, the Admiral's Men, patronised by Lord Charles Howard of Effingham, featured the plays of Christopher Marlowe, Thomas Dekker and Ben Jonson. The second company, the Lord Chamberlain's Men, patronised by Lord Hunsdon, featured the plays of William Shakespeare. In the winter of 1600, the Lord Chamberlain's Men performed four times at court, and the Admiral's Men probably about four times as well. William Shakespeare, then, both acted in and wrote plays performed for the queen. *Twelfth Night*, *A Midsummer Night's Dream*, *Love's Labour's Lost* and *The Merry Wives of Windsor* are among the plays performed for the court, and there were doubtless many more. Several of Shakespeare's outspoken, educated and witty heroines draw to some extent on Elizabeth: Isabella in *Measure for Measure*, for example, Olivia in *Twelfth Night* and Rosalind in *As You Like It*. During the reign of Elizabeth's successor, James I, Elizabeth figured as one of Shakespeare's characters, when he ended *Henry VIII* with the christening of Elizabeth as a baby, during which Thomas Cranmer predicts her glory and virtue.

IN ADDITION TO the entertainments and plays at court, many courtiers and Elizabeth herself actively participated in the development of English poetry. At court the queen heard the poetry of Philip Sidney and his sister, Mary Sidney Herbert, countess of Pembroke, who were engaged in translating the psalms into English while experimenting with the ways in which English might imitate classical forms of rhyme and metre. Sidney's lyrical and witty sonnet cycle, *Astrophel and Stella*, was written for a court audience, and started a craze for sonnets that built on Petrarch, Wyatt and Howard, while leading to the sonnets of John Donne and Mary Sidney

Sieve Portrait cameo pendant, last quarter of the sixteenth century (Cat. no. 198(c)). Victoria and Albert Museum, London.

Wroth, among many others. The court read or heard the writings of Roger Ascham, Lady Mary Cheke, the earl of Oxford, Edward Dyer, Thomas Heneage, Thomas Sackville, Edward Hoby, Lady Elizabeth Russell, Fulke Greville, John Harington, Francis Bacon, John Lyly and Walter Ralegh.

Moreover, Elizabeth herself was an accomplished poet, and several of her poems suggest not only their political and courtly contexts, but the possibility that she, like her courtiers, read her poems to gatherings at court. In one poem for example, she made clear to her audience that, although a queen, she spent her life trying to please others: 'To others' will, my life is all addressed / And no way so, as might content me best.'[7]

ELIZABETH'S PRESENCE as a public speaker, author and translator of religious texts and as a poet had an impact beyond her court and lifetime. Elizabeth was not a supporter of women as a group because she viewed her own intellectual and political abilities as unique among women. However, for Bathsua Makin, an author and intellectual of the seventeenth century, Elizabeth's example provided a rationale to educate girls. And for Anne Bradstreet, born in England and America's first poet of note, Elizabeth was the shining example of what women could accomplish in the world: 'She hath wip'd off th'aspersion of her Sex, / That women wisdome lack to play the Rex.'[8] Bradstreet's lines not only summarise what Queen Elizabeth came to mean for posterity, but also express the underlying argument of the entertainments that her courtiers helped to prepare, to perform and to witness: that Elizabeth was a monarch whose successes were attributable not just to political genius, but to her appreciation for the power and beauty of the English language. Regardless of the difficulties that she encountered during her long reign, Elizabeth played the roles of both king and queen with a rare wisdom in ways that changed forever the content, form, and force of English literature.

60

ER

Sur Cristofor Hattono

EXHIBITION
CATALOGUE
ENTRIES
59-130

59. Portrait of Elizabeth I with a Sieve, 1579

George Gower (c. 1540-1596).

Oil on panel.

86.4 x 61cm.

Inscribed top left: 'TVTTO VEDO & / MOLTO MANCHA' (I see everything and much is lacking), top right: 'STANCHO RIPO /SO & RIPOSATO / AFFANO 1579' (weary I rest and having rested am still weary), upon the Sieve: 'A TERRA IL BEN MAL DIMORA IN SELLA' (the good falls to the ground while the bad remains in the saddle).

Provenance: by tradition from Enfield Palace, F.C. Boydell, Christies, 7th March 1930, lot 125; Leggatt; H. Groves, Enfield sold 1980.

Private Collection, courtesy of Morpheus Fine Art Ltd.

The queen is presented in this portrait as the chaste empress of the world and is shown for the first time displaying imperial aspirations through the globe, which was also an attribute of Roman emperors. This portrait is one of the earliest existing versions of a portrait type showing Elizabeth holding a sieve. The sieve served as a symbol of chastity, as the Roman vestal virgin 'Tuccia', (described in Petrarch's poem *Triumph of Chastity*) proved her purity by carrying a sieve full of water without spilling a single drop. Elizabeth is therefore cast in a role which champions her chastity and her wisdom, as the sieve can also be used to distinguish the wheat from the chaff and thus the emblem reflects upon on queen's sound judgement.

The original meanings of the motifs were easily identifiable to a courtly audience schooled in classical literature, and the numerous inscriptions expand on the Petrarchian references (see: Strong, pp. 96–7). It is not exactly clear who might have commissioned this particular portrait but the sieve motif and reference to imperial aspirations appeared in several other portraits of Elizabeth dating between 1579 and 1583. This group includes a version by Quentin Metsys the Younger, which has been linked with the courtier Sir Christopher Hatton. As Roy Strong has noted, it is curious that portraits which celebrate chastity appear at the period Elizabeth was engaged in marriage negotiations with the duke of Anjou (Cat. no. 74). The sieve and globe motifs coupled with Elizabeth's image therefore appear to have been produced to serve the interests of those who opposed the marriage and sought to establish Elizabeth, the miraculous virgin queen, as empress of England with the power to light up the world and spearhead the expansion of the empire. Such ambition had already been given a voice by John Dee in 1577 in his *General and Rare Memorials* (Cat. no. 141) and was to be taken up by enthusiasts of maritime expansion in the coming decades. TC

LITERATURE: Strong, *Gloriana*, pp. 94–99; Hearn (ed.), *Dynasties*, pp. 85–6.

Marriage and Succession

60. Portrait of Robert Dudley, Earl of Leicester, c. 1564

Anglo-Netherlandish School.

Oil on panel.

110 x 80cm.

Provenance: the earls of Westmorland, Apethorpe, Northants, private collection by 1890.

Waddesdon Manor. The Rothschild Collection (Rothschild Family Trusts).

This impressive portrait of Leicester (1532/3–88) shows him as a knight of the Order of the Garter, an honour he received in 1559 (see page oo). Leicester had been appointed as master of the horse in 1558, a role which meant he was frequently at Elizabeth's side, and he soon became her principal favourite. He entered the council in October 1562 and was raised to the peerage in 1564. After the death of his wife Amy Robsart (1530–60), he sought to win the queen's hand in marriage, but because of the mysterious circumstances in which Amy had died, Elizabeth recognised the match would seriously damage her reputation. Certainly, few at court supported the idea, as the queen's marriage to a subject was seen as demeaning, while others feared Leicester's influence at court. Elizabeth's emotional attachment to Dudley was undoubtedly sincere and lasted throughout his life; indeed she kept his last letter as a personal treasure until her own death (Cat. no. 70). He is shown here glamorously dressed in a white silk doublet edged with gold thread and matching hose, with his dog gazing adoringly at his side.

The painting has been dated to 1564 because the coat of arms to the left (surrounded by the order of St Michael awarded by Charles IX in 1566) and the coronet above the arms upon the two pillars have been added slightly later, indicating that it was probably painted before Elizabeth awarded him the earldom on 29 September 1564. Whatever the exact date, the painting seems to reflect or foreshadow an argument with his opponent the duke of Norfolk (Cat. no. 216) which occurred

61. Handkerchief, c. 1600

Linen with cutwork, needle lace and embroidery in detached buttonhole and satin stitches.
Victoria and Albert Museum, London, 288-1906.

This handkerchief is similar to the one shown in Leicester's portrait. The fine quality of its decoration reflects the importance of embroidery and lace in this period of ostentatious display in dress. Decorated in this way the handkerchief had a function beyond its everyday use, and could be carried as a fashionable accessory. The technique of cutwork used here was the creation of a delicate structure of needle lace stitches across the spaces cut in a fine linen ground. It reached the height of its popularity in the late sixteenth and early seventeenth century, when it was used to decorate every type of linen and in particular to draw attention to the face and throat in the form of collars and ruffs. CB

in March 1565. Following a tennis match where Leicester openly displayed his overfamiliarity with the queen by grasping her handkerchief to wipe his brow, he was challenged by the duke and the pair set to blows. Curiously, he is shown here fingering a tasselled handkerchief which he takes from his purse and the portrait of Norfolk made the same year also includes similar accessories. Numerous contemporary portraits of Leicester exist in different poses and attire and this portrait is a highly accomplished example of work, probably by a Netherlandish artist working in England, and reflects Leicester's interest in commissioning artists of considerable talent to record his likeness. TC

LITERATURE: Hearn (ed.), *Dynasties*, pp. 96–7; Voorthuis, 'Portraits of Leicester'.

62. Garter Badge: the Lesser George, second half of the sixteenth century

Gold, diamond and enamel.
Provenance: possibly belonging to Robert Dudley, bequeathed to Robert, earl of Essex and bestowed upon Christian IV in 1603.
De Danske Kongers Krondogiske Samling paa Rosenborg.

The chivalric Order of the Garter was founded during the reign of Edward III, probably in 1348. Its insignia includes the Lesser George, which consists of a figure of St George (its patron saint) slaying the dragon, surrounded by an oval band bearing the order's motto, *Honi soit qui mal y pense* (Shame on him who thinks evil of it). Knights of the Garter wore this badge hanging from a broad, blue sash, which passed

over the left shoulder so that the St George would rest on the right hip. A similar badge is worn by Robert Dudley, hanging from a jewelled chain in a portrait of c. 1564 (Illustrated page 84). The Greater George was also worn by the knights, but suspended from the collar. The ceremonies associated with the order took place on 23 April, the feast day of St George, when the knights and the monarch processed to St George's Chapel at Windsor for a service and then returned to the royal presence chamber for a feast, at which the knights affirmed their loyalty to the sovereign. Membership of this exclusive and prestigious order was restricted to twenty-four knights in addition to the monarch and his elder son, the Prince of Wales. Foreign princes were also honoured by election to the Garter, including Frederick II of Denmark (1534–88), who received this badge in 1582.

The Protestant king, Edward VI, had tried to reform the order by disassociating it from its patron saint and assembling the knights in November or December. Elizabeth, however, felt no scruples in holding the festivities in April but she parted from tradition by celebrating Garter feasts at Greenwich or Whitehall as well. SD & DS

LITERATURE: Waddington, 'Elizabeth and the Garter'; Strong, *The Cult of Elizabeth*, pp. 164–85.

63. Medal Commemorating Elizabeth's Recovery from Smallpox, 1562

Unidentified artist, English School.
Silver.
British Museum, London, CM M6877.

This medal was produced as a thanksgiving for the recovery of the queen from the disease that threatened her life and as an affirmation of the rightness of her religious convictions. The inscriptions on both sides give the credit for her deliverance to divine protection. It is unsurprising that, on the obverse, the face of the queen appears free of any physical effects of the disease; on the reverse, a hand is shown shaking a snake into a fire. This is an allusion to the biblical account of

St Paul being bitten by a snake, an incident that left him similarly unharmed (Acts 28: 1–6). The traditional equation of the snake with Satan adds an additional resonance to the image. PA

LITERATURE: Hawkins, Franks and Grueber, *Medallic Illustrations*, i, p. 116, no. 48.

64. Elizabeth's Answer to the Commons' Petition that She Marry [28 January 1563]

Manuscript: a clerk's copy with a marginal note by
Sir William Cecil.
Public Record Office, Kew, SP 12/27 fos 143r –144v.

Elizabeth's parliament of 1559 had petitioned her to marry and she had replied graciously leaving all options open. In this her second parliament, the Commons again urged the queen to take a husband as a way of resolving the succession question. Elizabeth's near fatal attack of smallpox in October 1562 had alarmed its members who feared a disputed succession on her death.

Elizabeth's answer provides a good example of her art of procrastination. She explained that she could not make a decision in haste on 'so great and weighty a matter' and called on the authority of a philosopher who would always delay before giving any opinion to 'have his wit the riper'. The answer is also illustrative of Elizabeth's way of referring to her gender in speeches. On the one hand she distanced herself from her sex by claiming that she would not respond as a woman 'wanting wit and memory' who was too bashful to speak of marriage but as a prince placed on the throne by God. On the other hand, she exploited her gender by presenting herself as the mother of her people, lovingly concerned for its safety.

Shortly after this parliament ended, Elizabeth allowed Cecil to open up negotiations with the Holy Roman Emperor Ferdinand II for a marriage with his son, Archduke Charles of Austria (1540–90). SD

LITERATURE: Hartley, *Proceedings*, i, pp. 94–5; Neale, *Parliaments*, i; Doran, *Matrimony*.

65. Cecil's Memorandum on Elizabeth's Marriage, 4 February 1567

Manuscript.
The Marquess of Salisbury, CP 148/25.

In this memorandum, William Cecil (Cat. no. 33) compares the advantages of a match between Elizabeth and Archduke Charles of Austria

with the disadvantages of her marrying her favourite, Robert Dudley, earl of Leicester. Cecil's strong bias against a Leicester marriage is evident from the document. He refers to the earl's relatively lowly status, lack of wealth and poor reputation, making particular reference to the scandal of his wife's death. Amy Robsart had been found dead at the bottom of a short flight of stairs in September 1560 and it was widely rumoured that Dudley had arranged her murder so that he could marry the queen. When Cecil lists the advantages of the archduke match he makes points that would best show up the disadvantages of a marriage to Leicester. He also ignores the crucial issue of the archduke's Roman Catholicism, which was the main obstacle to the match. Cecil backed Archduke Charles's suit from 1564 until it faded away in early 1567. SD

LITERATURE: Adams, *Leicester*; Doran, *Matrimony*.

66. **Marriage Medal of Mary Queen of Scots, 1558**

Anonymous.
Electrotype.
British Museum, London, CM 1878-4-7-3.

Mary (1542–87) was the main Catholic claimant to the succession, but between 1558 and 1560 many in England feared that she would challenge Elizabeth's very right to the crown, as Catholics did not recognise Elizabeth's legitimacy. When Mary married Francis, son of Henry II of France, in April 1558, therefore, this close Franco-Scottish alliance could have posed a serious danger to Elizabeth if French forces had ever been in a position to invade England through Scotland. Luckily for Elizabeth, Francis died in December 1560, only one year after succeeding to the French throne.

Under the marriage agreement, the French prince became King of Scotland, and it is this title that he is given on this piece, which shows the couple facing each other below a single royal crown. Under a secret agreement Scotland was promised to France in the case of Mary dying without an heir. This is an electroformed copy of the medal, made in the nineteenth century from a rare surviving example. PA

LITERATURE: Hawkins, Franks and Grueber, *Medallic Illustrations*, i, p. 91, no. 4.

67. **Portrait of King James VI with a Hawk, c. 1574**

Arnold Bronckorst (fl.1565/6–1583).
Oil on panel.
43.2 x 27.9cm.
Provenance: probably in the collection of Sir Peter Young, tutor to James VI; presented to Charles I by Robert Young; sold 1651; recovered at the Restoration; probably left Royal Collection in eighteenth century; John Bell of North Park Glasgow, sold Christie's 24 and 25 June 1881; Hon. R. Baillie-Hamilton, 1889; Christie's 27 March 1925, lot 12.
Scottish National Portrait Gallery, Edinburgh, SNPG PG 992.

James Stuart (1566–1625) was born to Mary Queen of Scots and her second husband Henry Stuart, Lord Darnley (1546–67) (Cat. no. 218).

Six months after his birth Elizabeth became James's godmother, sending a proxy to Scotland with a christening present of a gold font. His claim to the English throne rested upon his descent from Margaret Tudor the elder sister of Henry VIII (Cat. no. 266) and, while the claim was never openly acknowledged by Elizabeth, the two monarchs were in regular correspondence. James was crowned King of Scotland as an infant in 1567 following the forced abdication of his mother by some of the Scottish nobles. He spent his youth under the influence of various Protestant lords and was carefully tutored in the Calvinist faith.

This portrait shows James as a child but it is not clear exactly when it was painted. A description of a portrait of James aged five, wearing a 'black Cap and white feather, having upon his left fist a glove and a Martin thereon' in the collection of Charles I, seems to reflect accurately what is seen here (Miller (ed.) p. 232). However, there is also a record of a later payment to Arnold Bronckorst, a painter in the service of the Scottish court, in a manuscript of 1580, when James was aged around fourteen which has been linked with this painting. However, it seems unlikely that the child shown here is an adolescent. The sparrow hawk in his left hand (identified by van der Doort as a 'Martin') is evidence of the young king's great love of hawking. The extremely elaborate gilt frame reflects the esteem in which James was placed by the later Stuart dynasty. TC

LITERATURE: Miller (ed.), 'Abraham van der Doort's Catalogue', pp. 65, 232; Thomson, *Painting*, p. 23; Strong, *English Icon*, p. 137. We are grateful for access to unpublished papers at the SNPG.

68. Drawings of Elizabeth I and Robert Dudley, dated 1575

See page 78.

(a) Portrait of Elizabeth

Federico Zuccaro (1540/41–1609).
Black and red chalk on paper.
36.5 x 27.5cm.
Inscribed: on verso: 'La Rigina Elisbeta ingiltera / in londra magio 1575' (Queen Elizabeth of England in London May 1575).
Provenance: see Gere and Pouncey.
British Museum, London, PD Gg. 1-1417.

(b) Portrait of Dudley

Federico Zuccaro (1540/41–1609).
37.8 x 27.5cm.

Inscribed: (no longer visable) 'Il conte Roberto de Leicestre / Milord lestre favorito de la / reina d'Ingiltera nel 1575 / londra fedco Zucharo' (The Count Robert of Leicester / Favourite of the Queen of England 1575, London, Federico Zuccaro).
Provenance: see Gere and Pouncey.
British Museum, London, PD Gg. 1-1418.

These two portrait drawings were probably made as preparatory studies for full-length panel paintings commissioned by Dudley in the same year he staged an elaborate series of entertainments for the queen at Kenilworth. The drawings were never considered as finished works of art, but served only as Zuccaro's working designs. The resulting paintings are now apparently lost, although a full-length portrait of Dudley dressed in armour holding a similar pose was in existence up until the Second World War, when it was destroyed. The entertainments at Kenilworth have been considered as Dudley's last attempt to woo the queen into marriage. If this was so, the portraits would have formed part of the strategy to convince Elizabeth of his suitability and devotion. The drawings were probably taken from the life, and both sitters, who were in their forties, are depicted at a slight distance from the artist to accommodate the full-length format, and appear slightly world weary.

The portrait of the queen is only faintly sketched out and, as was common practice, the artist might have expected to have had access to the queen's clothes to work up a finished painting. The drawing includes a number of emblematic devices designed to reflect upon her personal virtues: on the right side is a column encircled by snakes, symbolising fortitude, constancy and prudence, the small dog at the top and its companion, which may be an ermine, are traditionally symbols of faith and purity respectively. To the left the motifs are very sketchy and less easy to interpret but may include a shell-shaped sculpture or piece of architecture. Although Zuccaro has not provided much detail, Elizabeth is dressed in clothes similar to those found in the 'Pelican Portrait' (Cat. no. 193) of around the same time and she also wears a rose in her bodice. The portrait of Dudley shows him in full armour designed for field and tilting made at the royal workshop at Greenwich (Cat. no. 81). The two drawings (and presumably resulting paintings) were not designed as a matching pair as both sitters are facing in the same direction; rather they are independent yet complementary pieces. Zuccaro was a leading Italian artist who came to England probably at the request of Dudley for the purpose of making portraits of his patron and the queen in 1575 and appears to have left the same year. TC

LITERATURE: Gere and Pouncey, *Italian Drawings*, 1, nos 300 and 301; Hearn (ed.), *Dynasties*, pp. 152–3; Doran, *Matrimony*, pp. 67–72.

leg from which she had recently suffered or from the toothache which periodically plagued her. Given that earlier Leicester says that Elizabeth needed exercise for her health it was probably the former.　　　SD

LITERATURE: Adams, *Leicester*; Perry, *Word of a Prince*.

70. Leicester's Last Letter to Elizabeth, 29 August 1588

Manuscript.
Public Record Office, Kew, SP12/215 no. 65.

This letter to Elizabeth from Leicester, endorsed 'his last letter', was written from the house of Lord Norris at Rycote in Oxfordshire. Leicester was staying there overnight with his wife while on his way to Buxton to take the spa waters. In the letter, he thanked Elizabeth for the medicine which she had given him and he continued to take. He also inquired after and prayed for her good health and long life. Six days

69. Leicester's Letter to Elizabeth 17 February [1571?]

Manuscript.
Public Record Office, Kew, SP15/20 no. 9.

Some twenty private letters from Leicester to Elizabeth have survived but only one private one is extant from the queen to her favourite. In this letter, as in many others, Leicester signed himself $\overline{o}\,\overline{o}$ to signify her pet name for him 'her eyes'. Several propositions have been made to explain why Elizabeth gave him this soubriquet: it has been suggested that he had beautiful eyes or that he kept watch over the queen. It has also been claimed that the nickname expressed Elizabeth's love for the earl, as it was said that spiritual love enters through the eyes and feeds the soul.

Leicester wrote this letter while he was away from court, carrying out his responsibility as master of the horse for organising the complicated travel arrangements required to transport the court on progress. In the letter, Leicester expresses his devotion to the queen by calling himself her 'bondman'. He also voices his concern about her health. The 'pangs' that he mentions may be from a varicose ulcer in her

afterwards, he died at his lodge at Cornbury, possibly from malaria. As he had requested in his will, he was buried in the Beauchamp Chapel of St Mary's Warwick, alongside his son and ancestors.

Leicester left Elizabeth a jewel of emeralds and diamonds and a rope of some 600 pearls. Deeply grieved at his death, Elizabeth kept this last letter as a treasured possession until her own death, when it was found in a small casket by her bed. SD

LITERATURE: Adams, *Leicester*, p. 149; Wilson, *Sweet Robin*.

71. Letter from Sir Christopher Hatton to Elizabeth, Wednesday [7] September 1580

Manuscript.
Public Record Office, Kew, SP12/142 no 8.

Christopher Hatton (1540–91), one of the queen's principal favourites, typically addressed the queen using elaborate romantic language. He

understood well that his position depended on his retaining the special bond of affection and intimacy that he had developed with the queen, and so he often wrote to her as an enamoured lover. Indeed, compared to the following manuscript, this letter is somewhat restrained. Here the rhetoric is one of a slave or vassal to his sovereign, rather than that of a lover to his lady, and its tone suggests that Elizabeth may have recently expressed some annoyance with him (Cat. no. 72). The cipher at the beginning of the letter refers to one of Elizabeth's pet names for Hatton, 'lids'. Perhaps he earned this nickname because he had unusual eyelids. He signed off with the word EveR to bring out the initial Elizabeth Regina. Gossip occasionally had it that Hatton was one of the queen's lovers, but there is no foundation for such tittle-tattle and according to one account Hatton denied it.

When this letter was written, Hatton had been a royal favourite for nearly twenty years. He had first caught the queen's attention by his fine dancing and fighting in tournaments, and she rewarded him by making him a gentleman pensioner in 1564 and captain of the guard in 1572. He was appointed to the household office of vice-chamberlain in 1577, the year he entered the council, and in 1587 he became lord chancellor, despite a lack of legal training. Hatton therefore made the successful transition from royal favourite to household servant to major officer of state, as did Robert Dudley. Even with the queen's favour, Hatton died with a huge debt of some £42,000, possibly because he had spent a fortune on his palatial house at Holdenby. He was buried at St Paul's Cathedral, where a massive memorial was erected for him, quite dwarfing those of Sir Francis Walsingham and Sir Philip Sidney. SD

LITERATURE: Brooks, *Hatton*; Vines, *Hatton*; Nicolas, *Memoirs*.

72. Letter from Hatton to Elizabeth, 19 September 1580

Manuscript.
Public Record Office, Kew, SP12/142 no. 73.

This letter written by Hatton is full of the hyperbolic expressions of love and devotion that he typically lays before the queen. Yet, from its content it is clear that the queen remained offended with him, and that her irritation was because of his dislike of the Anjou matrimonial project. Hatton warns Elizabeth that 'Frogs [a reference to Anjou and the French], near the friends where I then was, are more plentiful and of less value than their fish is'. At the end of the letter, Hatton uses both the queen's pet names for him, her lids and sheep. SD

LITERATURE: Nicolas, *Memoirs*, pp. 156–8.

73. 'Answers to the Objections against a Marriage with M. Alençon', Written by Lord Burghley, 27 March 1579

Manuscript.
The Marquess of Salisbury, CP 148/25.

William Cecil, Lord Burghley, supported the proposed match between Elizabeth and Francis, duke of Anjou, also known as Alençon. Here he answers some of the critics' objections. He particularly addresses the issue of the queen's age and fertility. While admitting that it would have been better if the forty-five-year-old Elizabeth had married 'when she was younger in years', he claims that she was still capable of producing a child for five or six years yet. Following the medical theory of the day, he also asserts that by forbearing from marriage (meaning, of course, sex) Elizabeth had suffered 'daily' from 'such dolours and infirmities as all physicians do usually impute to womankind for lack of marriage'. Marriage therefore, he thinks, would improve the queen's health. As for the projected bridegroom, Burghley tried to deal with the objection that Anjou was Catholic by pointing out that he was no persecutor, that he had Protestants in his entourage, and that La Noue (a well-known Huguenot leader) spoke well of him.

Most Protestants in England did not share Burghley's opinion of Anjou, however, and remembered instead that he had taken up arms against the Huguenots during the recent civil wars in France. They also held his mother, Catherine de Medici, responsible for initiating the massacre of some 3,000 Protestants in Paris on St Bartholomew's Eve 1572. Despite Burghley's endeavours, the privy council would not give Elizabeth unambiguous support for the marriage, forcing her to rethink her options.

SD

LITERATURE: Read, *Burghley*, pp. 210–11; Doran, *Matrimony*.

74. Portrait of Francis, Duke of Anjou

Engraving from *Les Guerres de Nassau . . .* by Willem Baudart (Amsterdam, 1616).
14.2 x 12.4cm.
Inscribed: 'FRANCISCUS VALESIUS, DUX ANDEGAVENSIS ALENCONIUS BRABANTIAE ETC: COMES FLANDRIAE'.
National Maritime Museum, Greenwich, PAD2367.

When Elizabeth was in her forties, she seemed close to succumbing to the marriage proposal from Francis, duke of Anjou (1554–84), the youngest son of Catherine de Medici (Cat. no. 225(e)) and Henry II of France. Anjou wooed her first through the attentions of his trusted household servant, Jean de Simier, whom Elizabeth nicknamed her 'singe', or monkey. Then in August 1579, unlike most other of her foreign suitors, Anjou arrived in England to court the queen in person.

During his ten days in England, he appeared to charm Elizabeth and she agreed verbally to marry him if she could secure the support of her subjects. The privy council, however, was divided while many at court, including Philip Sidney, were outspoken in their opposition to the match. Elizabeth, furious, backed off.

In November 1581 Anjou returned to the English court, and interest in the marriage was briefly reignited. But Anjou's aim this time was to obtain Elizabeth's financial aid for his campaign in the Netherlands against Philip II of Spain. Once he had secured loans from the queen, he left for Antwerp quite satisfied.

SD & RQ

LITERATURE: Doran, *Monarchy*; Mears, 'Anjou'.

75. Letter to Elizabeth Written in Code [1581?]

Manuscript.
The Marquess of Salisbury, CP 149/16.

After Anjou's visit to England in the summer of 1579, he kept in close touch with Elizabeth either directly or through his intermediary Jean de Simier. This letter written by Simier is typical of the correspondence exchanged between Elizabeth and the two Frenchmen in its extravagant expressions of romantic love and devotion. Until late 1581 they maintained the fiction that they would soon be wed. To signify the love Anjou bore the queen is the design at the top of the letter, where Elizabeth's initial is surrounded by emblems and placed inside a heart transfixed by an arrow. The whole of the letter is in cipher to keep it from prying eyes. Behind the amorous tone of their correspondence, however, lay the political reality of Anjou's ambitions in the Netherlands; he took every opportunity in his letters to keep Elizabeth informed of his campaign there against Philip II of Spain and his constant need for money to finance it.

SD

LITERATURE: HMC 9 *Salisbury*, ii, pp. 471–3.

76. Portrait of Sir Henry Lee, 1568

Antonis Mor van Dashorst (c. 1516/21–c. 1576).
Oil on panel.
64.2 x 53.3cm.
Inscribed: lower right: 'Antonius mor / pingebat ao 1568'.
Provenance: presumably by descent from the sitter; first
 recorded at the Lee family seat at Ditchley Park,
 Oxfordshire, in the eighteenth century, whence it was
 presented to the National Portrait Gallery by the 17th
 Viscount Dillon in 1925.
National Portrait Gallery, London, 2095.

Sir Henry Lee (1533–1611) had been raised partly in the household of his uncle, the poet Sir Thomas Wyatt. During the 1560s Lee travelled on various diplomatic missions to the Continent, visiting Germany, Italy and the Low Countries and sending dispatches back to Sir William Cecil and the earl of Leicester. While in Antwerp in June 1568, he sat for the distinguished Netherlandish painter, Antonis Mor, court portraitist to the Habsburg rulers Charles V and Philip II. The portrait that resulted is one of the finest surviving painted images of an English sitter from the sixteenth century.

Lee first performed in the tiltyard in 1571, three years after he sat for this portrait, and it is he who is credited with devising the extravagant annual court festival of the Accession Day tilt at Whitehall every 17 November, which marked the anniversary of Elizabeth's succession to the English throne. As the Queen's Champion he supervised these until his retirement in 1590. At these tournaments, gentlemen would appear in symbolic costume with attendants in fantasy dress and pageant cars and, before participating in the tilt, would deliver an elaborate speech before the queen.

Here Lee wears black and white, Elizabeth's personal colours, and the embroidery on his sleeves includes both lover's knots and armillary spheres. These spheres represent the harmonious circulation of the planets and the sun around the earth – a symbol of the queen's relationship with her courtiers, and one which Lee later employed elsewhere, for instance in the large 'Ditchley Portrait' of Elizabeth which he is thought to have commissioned from Marcus Gheeraerts the Younger almost twenty-five years later, in around 1592 (see page 180). Lee here wears a number of strands of gold chain – such chains were regularly given by royal and noble patrons to those who had carried out services for them. With his right thumb, Lee draws attention to the ring suspended round his neck by a tightly drawn scarlet cord. Two other rings are tied round the same arm with similar cords, while yet others are worn on his third finger. These items are evidently meant to be viewed as being of great significance and the painting seems to be constructed as a declaration of personal service and constancy. This could be meant for a specific mistress, but is more probably directed towards the distant queen herself.

KH

LITERATURE: Chambers, *Sir Henry Lee*, pp. 33–4; Joanna Woodall, 'The Portraiture of Antonis Mor', unpublished Ph.D. thesis, Courtauld Institute, 1989, vol. 2, pp. 488–92; Hearn (ed.), *Dynasties*, pp. 60–61.

Sir Christopher Hatton's Armour

Earl of Leicester's Armour

Earl of Pembroke's Armour

Sir Henry Lee's Armour

77. a-d. Four Double Sheets of Drawings from the *Almain Armourer's Album*, Showing Armour for Sir Henry Lee, the Earl of Pembroke, Sir Christopher Hatton and the Earl of Leicester, c. 1560–80

Jacob Halder, possibly from Landshut, Germany, master of the armoury at Greenwich.
Watercolour on paper.
Each of the eight sheets 42.9 x 29cm.
Victoria and Albert Museum, London, D604-1894 and D604A-1894, D601-1894 and D601A-1894, D600-1894 and D600A-1894, D588-1894 and D588A-1894.

The Greenwich armour workshops, founded by Henry VIII in 1515–16 to rival the armour produced by Germany and Italy, devoted much time in Elizabeth's reign to providing both fighting and tilt armour for leading courtiers. A royal licence was required to have armour made there. The Greenwich workshops were commonly known as a company of 'Almains' (Germans) but many leading English armourers were working there as the century progressed.

These double sheets are from an album of designs for armour, drawn and coloured by Jacob Halder, who came from Germany into the royal workshops about 1557 and rose to be master workman at Greenwich from 1576 until his death in 1608. The whole album consists of fifty-eight leaves depicting twenty-nine suits. It was originally in separate sheets and later bound together. The designs represent work carried out over much of Halder's long career.

The sheets record the elaborate ornament on armour popular among English courtiers. This would include, as with some of the examples here, the personal badges of the owners, worked into the design of the pauldrons (shoulder pieces) or as running motifs along the joins and strengthening ribs of the suit. English armour was never to reach the technical standards of the best products from Augsburg but here we can see alongside the ornament, the bolts and pins that skilfully held the armour together. Suits would have been gilded, engraved, damascened and coloured in a way difficult to appreciate among surviving, often overcleaned, examples today. The sheet for Sir Henry Lee, master of the armoury and the Queen's Champion at the tilt (Cat. no. 76), is one of three suits for him in the album. In all the suits Halder shows the figure in heavy cavalry armour and then alongside alternative components of the suit for other purposes, especially for light cavalry use or the tilt. While for some courtiers the suit of armour was purely for ceremonial use, for Lee it was highly functional. He fought celebrated mock combats before Elizabeth at Woodstock in 1575 and against Philip Sidney in 1581. This suit of armour for Lee does not survive, though other armour for him does at the Tower and the Armourers' Company. The designs for Hatton and the 2nd earl of

Pembroke can also be linked to surviving suits of armour at Windsor Castle and Wilton House. MH

LITERATURE: Viscount Dillon, *An Almain Armourer's Album. Selections from an Original MS in the Victoria and Albert Museum, London* (London, 1905); P. Glanville, in Ford (ed.), *Visual Arts*, pp. 277–83; I. Eaves, 'The Greenwich Armour and Locking-Gauntlet of Sir Henry Lee in the Collection of the Worshipful Company of Armourers and Brasiers', *The Journal of the Arms and Armour Society*, 16, no. 3 (1999), pp. 133–64.

78. Greenwich Armour-Making Tools, sixteenth and seventeenth centuries

Possibly from the armour workshop at the Tower or from the royal workshops at Greenwich.
Steel iron, wood.
Board of Trustees of the Royal Armouries, xviii.97-8, 830.

In 1511 all the tools in the Greenwich Armoury were recorded with their prices. These included a vice, large and small anvils (called the 'great Bear' and 'little Bear'), six different stakes, four pairs of shears, twenty hammers of different types, four chisels, two punches, eleven files, pincers, tongs, a water trough and a tempering barrel. The stakes, an example of which is shown in the exhibition, were iron formers like small anvils for the different shaping operations involved in the manufacture of plate armour. It is stamped twice with a mark, WP in a heart, which may connect it with William Pickering, master armourer at Greenwich from 1608 to 1618.

By the early seventeenth century, the number of tools in the workshop at Greenwich had quadrupled, reflecting the size of the workshop and the number of armourers employed. During the Civil Wars the tools were sold off. The two hammers in the exhibition were presented by the historian F. H. Cripps-Day in 1942 as being probably from the Greenwich workshops. TR

LITERATURE: Blair, 'Inventory of Henry Keene'; ffoulkes, *Armourer and his Craft*; Williams and de Reuck, *Royal Armoury*.

79. Armet from an Armour possibly of Sir Christopher Hatton, about 1587

Royal workshops at Greenwich under the master Jacob Halder.
Steel, etched and gilt, leather.
Board of Trustees of the Royal Armouries, ii. 77.

This helmet is part of a set of armour, also comprising collar, pair of pauldrons, vambraces (armplate) and greaves (shinplate). The pieces come as field armour fitted with extra pieces for lighter field use. TR

LITERATURE: Mann, *Greenwich Exhibition*, pp. 26–7, no. 20, pl. xxii.

80. Vamplate from an Armour of Sir Christopher Hatton, 1578–87

Royal workshops at Greenwich under the master Jacob Halder.
Steel, etched and gilt.
Board of Trustees of the Royal Armouries, iii.890.

This vamplate is the only surviving fragment of the second set of armour designed for Sir Christopher Hatton which appears in the *Almain Armourer's Album* (Cat. no. 77). Throughout the sixteenth century tournament lances were fitted with defences for the right hand called vamplates. At the royal workshops at Greenwich these were decorated en suite with armours. This one is etched and gilt with broad bands of strapwork alternating with plain bands decorated with roses and knots. TR

81. Tilt Armour of Robert Dudley, Earl of Leicester, about 1575

Royal workshops at Greenwich under the master John Kelte.

Steel, etched, gilt and embossed (on shaffron only), leather.

Board of Trustees of the Royal Armouries, ii.81, vi.49.

This armour was worn by Leicester in tournaments and may have been made for the entertainment that he staged for the queen at Kenilworth in 1575. It is likely that additional pieces would have been included for service in the field. The armour is decorated with broad recessed bands etched and formerly gilt with strapwork, joined diagonally by the ragged staves, which was the emblem associated with Dudley's family. On the breastplate, backplate and left pauldron is the muzzled bear (also part of the family badge) surrounded by the collar of the French Order of St Michael, which Dudley received in 1566. The badge of the Lesser George of the Order of the Garter (Cat. no. 62) occurs frequently in the decoration.

The *Almain Armourers' Album* (Cat. no. 77) illustrates two other armours designed for Dudley, both now lost; this piece represents a third and it is thought that it corresponds with a gap in the *Album*. One of the two other armours was depicted with its original blued or russet finish in a sketch by Federico Zuccaro (Cat. no. 68) though the present armour appeared in the final portrait (now also lost; see Blakeley, fig. 6). The other is illustrated in the Hastings portrait (Royal Armouries i.46, Blakeley, fig. 5).

<div align="right">TR</div>

LITERATURE: Blakeley, 'Tournament Garniture'; Mann, *Greenwich Exhibition*, pp. 18–19, no. 11, pl. xiv.

82. Score-cheque for the Accession Day Jousts at Westminster, 1584

See overleaf.

Ink on paper.

The College of Arms, London, TC 13c.

This is probably the score-cheque for the Accession Day tilt obliquely described in Sir Philip Sidney's *New Arcadia* (bk 2), in which he and the Queen's Champion, Sir Henry Lee (Cat. no. 76), opened the jousts. Lee entered as 'Laelius', chained and led by a nymph. Sidney, as 'Philisides', bore the *impresa* (badge) of a sheep marked with pitch, 'spotted to be known', entering to bagpipes and attended by squires dressed as shepherds. These then sang an 'eclogue' to the ladies, including Penelope,

Lady Rich, the sister of the earl of Essex, who was 'the *Star*' of Sidney's homage in his sonnets. Lee, Sidney and the earl of Cumberland, at the head of the list, broke all their lances in their six courses. PvdM

LITERATURE: Strong, *The Cult of Elizabeth*, pp. 147–9.

83. George Clifford, 3rd Earl of Cumberland,
c. 1590

Nicholas Hilliard (1547–1619).
Vellum on panel.
25.7 x 17.8cm.
Inscribed: upper right, on shield: 'Hasta quan[do]'.
Provenance: Buccleuch Collection.
National Maritime Museum, Greenwich, MNTO 193.

Towards the end of the 1580s, the English-born painter Nicholas Hilliard began to produce large rectangular miniatures, as well as small circular and oval ones. He based the composition of this finely wrought image

on a Netherlandish engraving of a pike bearer by Hendrick Goltzius published in 1582. We know that such prints were imported in England.

George Clifford, 3rd earl of Cumberland (1558–1605) inherited great estates in Westmorland and Yorkshire, and was the leading northern earl at Elizabeth's court. He equipped and sometimes commanded his own ships which attacked and plundered Spanish vessels and settlements. However, such privateering and other extravagancies resulted in huge debts. He is probably seen here as the Queen's Champion and organiser of the annual Accession Day tilt at Whitehall, a role he assumed in 1590 in succession to Sir Henry Lee (Cat. no. 76). This event was a major public pageant, and the aristocratic and gentleman participants wore elaborate and expensive allegorical attire. Cumberland is here shown holding his tilting lance and wearing a star-patterned armour made at the royal workshops in Greenwich. Over this armour, the lining of his gold-braided, jewelled surcoat and his ostrich-feather-topped hat are embroidered with armillary spheres (Cat. no. 208), olive branches (symbolising peace) and staffs encircled with snakes (emblems of the Roman god Mercury). A jewelled glove is attached to

Cumberland's hat – perhaps presented to him by the queen, after combat. The remaining elements of his armour – his plumed helmet and his two gauntlets (armoured gloves) – lie on the grass and rock around him. From the tree under which he stands hangs a shield, presumably of the pasteboard type displayed by knights at the Accession Day tilts and subsequently hung in the 'Shield Gallery' at Whitehall. The motto on it seems to proclaim that Cumberland would use his lance – 'Hasta' – on behalf of the queen until the sun, moon and earth (also depicted on the shield) have been eclipsed. Behind, to the left, is a view across the River Thames to distant Whitehall Palace, with its tiltyard.

KH

LITERATURE: Hearn (ed.), *Dynasties*, pp. 126–7; Spence, *Privateering Earl*, pp. 94–6.

Court Life and Entertainment

84. Artefacts Excavated from Greenwich Palace

Various media.
Provenance: artefacts from archaeological investigations (1970–71) by the Ministry of Public Building and Works.
Dr Philip Dixon, University of Nottingham.

Under Elizabeth, Greenwich was the most favoured royal out-of-town residence. Excavations have revealed much of the ground plan of the Tudor brick riverside palace, which ran along the waterfront and contained, from east to west, a chapel, the state rooms, the monarch's privy rooms and the privy kitchen. Roughly in the centre stood a five-storey residential tower, or *donjon*, that dominated the complex. The excavations also revealed the remains of the manor house built by Humphrey, duke of Gloucester, after acquiring the land in 1426.

Ceramic finds associated with Gloucester's house reflect a high level of comfort in the furnishing of this elite late medieval residence. Imported green-glazed ceramic stove-tiles with geometric and armorial mouldings were found in association with a small chamber that the excavators identified as a bathroom. The tiles belonged to a smokeless ceramic stove (Cat. no. 90).

The impact of the continental Renaissance can be seen directly in the polychrome glazed floors and moulded stucco ceilings of the Tudor palace complex. The excavations produced examples of late sixteenth-century tin-glazed floor-tiles painted with Italianate geometric designs that were imported from Antwerp. Moulded stucco forms another Italian Renaissance technology that is well represented on Tudor palace sites around London. Bosses in the form of Tudor flowers, along with fragments of battening, may represent the remains of the ornamental

fretwork ceiling and cornice recorded in the building accounts of the mid-1530s for the privy chamber. The cast gilded lead oak leaves also found on the site may have decorated the intersections of this spectacular moulded ceiling scheme or possibly have embellished the wainscoting. There is no archaeological evidence to suggest that this early Tudor interior scheme was drastically altered by Elizabeth or the early Stuart monarchs.

A fragment of gilded pipeclay plaque with moulded foliate arcade, possibly framing a devotional scene, may have formed the centrepiece of a portable altarpiece intended for the privy residence. Such plaques belong to a specialised luxury trade in devotional ceramics from western Germany that collapsed at the time of the English Reformation. Judging by its fragmentary state, this example was probably deliberately destroyed in a moment of iconoclastic zeal.

The heavy thumbed rim of a large lead-glazed red earthenware storage jar, in this case made locally in the Greenwich area, doubtless derives from the kitchen range on the eastern edge of the Tudor palace complex. In contrast to some of the artefacts relating to the interior decoration of the palace, domestic utensils were clearly sourced closer to home.

DG

LITERATURE: Dixon, 'Greenwich Palace Excavations 1970'; Dixon, *Excavations at Greenwich Palace*; Gaimster, 'London's Tudor Palaces Revisited'.

85. Goblet, Dated 1586

Giacomo Verzelini (d.1616),
London, engraved by
Anthony de Lysle.
Clear 'crystal' soda-glass, the bowl
with fine spiral threading and
mould-blown ribbing, the
mould-blown stem
with traces of gilding.
Inscribed: in diamond point:
'RP MP 1586' for Roger and
Maud Puleston of Flintshire,
and 'GOD.SAVE.QYNE.ELISABETH'.
Anonymous Bequest, Victoria and Albert Museum, London,
C.226-1983.

Drinking glasses were an expensive luxury during this period and were occasionally given to Elizabeth as gifts on New Year's Day. This presentation goblet was one of a very small group of surviving engraved English *cristallo* glasses, and was almost certainly made by Giacomo Verzelini, an experienced Italian glassmaker who settled in London in 1571. Soon he had taken over the Crutched Friars glasshouse where on 15 December 1575 Queen Elizabeth granted him a patent 'for the making of drinking glasses such as be accustomably made in the town of Morano'. Making this Venetian-style luxury glass eventually enabled him to retire to his estates in Kent where he died.

The reasons for attributing these glasses to Verzelini are circumstantial but compelling. All are diamond-point engraved with English inscriptions and the dates 1577–90, which puts them firmly into the period when imports from Venice were banned by Verzelini's monopoly. Furthermore, certain aspects of these glasses suggest that the engraver was also a pewterer, and in 1582–3 a Frenchman, Anthony de Lysle, was recorded in London as 'graver in pewter and glass'. Once proposed, this neat solution has never been challenged. RH

LITERATURE: Thorpe, 'An Historic Verzelini Glass', pl. A, B,C; Charleston, *English Glass*, pl. 13d; Liefkes (ed.), *Glass*, pl. 101.

86. Elizabethan Drinking Vessels

(a) Beer pot, 1556/7

German stoneware, English silver gilt mounts, London
(CA monogram).
Victoria and Albert Museum, London, 2120-1855.

(b) Stoke Prior wine cup, 1578/9

London (TS monogram).
Silver.
Victoria and Albert Museum, London, 289-1893.

(c) Wine cup, c. 1590

London.
Pewter.
Trustees of the National Museums of Scotland, Edinburgh,
A1874.1.32.

(d) Small wine cup, 1598/9

London (TF monogram).
Silver gilt.
Victoria and Albert Museum,
London, 417-1905.

(a)

Drinking vessels made of precious metal, or other materials mounted in gold or silver gilt, head every list of Tudor plate. In 1574 Elizabeth owned 525 drinking vessels, including forty-three cups and goblets of gold, mostly inherited from her father. Although not the heaviest, these were the most valued possessions in every plate collection. Richly decorated, in daily use, displayed on the cupboard, cups were exchanged as gifts and imbued with meaning. Plainer practical silver for the table or the buffet had no sentimental value or personal meaning and was melted down and recycled when it became 'Battered, Bruised and unfit for service'. The plain 1578/9 cup is a rare exception, found (with other silver) in a rabbit hole at Stoke Prior in 1894. Pewter was about one-twelfth the cost of silver but still a luxury. Cups, bowls and goblets came in sets of three, six or twelve, often with one cover to a set, so that the drink could be formally uncovered before being passed round.

Descriptions of decoration, combined with goldsmiths' bills, enable us to compare court orders with more modest vessels such as the briefly fashionable stoneware pot. In 1558 a French visitor, Etienne Perlin, noted how the English liked to drink beer and wine from 'earthen pots with

silver handles and covers, and this even in houses of persons of middling fortune'. This taste for squat pots of glass, tin glazed ware or stoneware for beer, enhanced with mounts of precious metal, started at court in the 1530s. Mounted stonewares occur in many Elizabethan inventories, particularly in Exeter. The merchant's mark on the lid indicates that this pot belonged to someone without a coat of arms, a typical customer. They combined prestige with the pleasure of cool clean metal against the lips. The hinged lid kept the contents free of flies and dust. PG

ready-made verse must have formed welcome compensation for any shortcomings in social skills around the dinner table. At the conclusion of the dessert course, eaten from the plain side of the trencher, guests would turn over their trenchers to discover the verses allocated to them, which they would declaim or sing as appropriate. Many were homilies on virtue and sobriety, sometimes incorporating biblical passages, though the stanzas on this set are in a lighter (if yet lugubrious) vein. Despite the presence of the royal monogram, the boxed set might easily have been produced to be given away as a gift at Christmas or on some other occasion. AM

87. Twelve Trenchers in a Box bearing the 'ER' Cipher for Elizabeth I, 1599

English.
Painted sycamore wood in box of beech wood.
Ashmolean Museum, Oxford: Bodleian loan, MS Eng. poet. f.5.

While more massive wooden trenchers had been standard features of the medieval table, the more delicate pieces represented here, intended specifically for the service of sweetmeats, were a phenomenon of the Elizabethan period and peculiarly English. The strapwork decoration commonly associated with English trenchers depends strongly for its inspiration on engraved pattern books which circulated widely at the period. Indeed cheaper forms of trenchers were sold with decorative schemes and corresponding texts printed on to paper discs and pasted down.

The emergence of these trenchers reflects the increased prominence accorded to the dessert course during the Elizabethan era, both in terms of the range of sweetmeats consumed and the opportunities provided for informal entertainment in an age when elegant diversion came to be valued in courtly circles as never before. It may also reflect the movement of the main meal to the evening, allowing for more leisurely consumption. In an age when dinner guests were increasingly expected to entertain the company, a printed crib in the form of a

88. Elizabethan Dish: engraved with a double rose and the 'ER' cipher, late sixteenth–early seventeenth century

English, maker's mark – 'Crowned N'.
Pewter.
Museum of London, A702.

London-made pewter, wrote William Harrison in 1577, '. . . is esteemed almost so precious as . . . vessels that are made of fine silver and in manner no less desired among the great estates'. The demand for pewter was such that garnishes of twelve platters, twelve dishes and twelve saucers with broad and narrow rims were sold, and many London pewterers maintained large stocks which were hired out for lavish feasts and social events. This deep dish is stamped on the rim with a double rose flanked by the initials 'ER', or Elizabeth Regina. HRF

89. Elizabethan 'Cutlery'

(a) Spoon with seal top, mid-sixteenth century

(b) Knife with grotesque design, 1590

(c) Knife amber/mother-of-pearl, late sixteenth century

All English: London.
Victoria and Albert Museum London, M214-1940; M77-1955; M539-1901.

Achieving splendour was a constant preoccupation for Elizabethans, and a taste for lavish expenditure on tableware ran through society. 'He must be a poor peasant indeed who does not possess . . . spoons', commented a visitor in the 1580s, and his observation is supported by evidence from probate inventories; in Essex, for example, one in ten of those leaving goods had spoons. Every market town, moreover, had its silversmiths. The cutlers of London had access to costly materials for knife handles such as amber, agate or shell, made up by skilled foreign workmen, attracted to this open market. Knives were treasured personal possessions, carried in pairs in a case and manipulated to spear morsels of food. Forks arrived only a generation later. PG

a bathroom, suggesting the stove was employed to generate steamy conditions in the manner of a Turkish bath. The link between smoke-less stove and royal Tudor bathroom is reinforced by contemporary witnesses, notably William Harrison in his *Description of England* (1587) who notes that 'As for stoves . . . they now begin to be made in diverse houses of the gentry and wealthy citizens, who build them not to work and feed in as in Germany, but now and then to sweat in, as occasion and need shall require it.' DG

LITERATURE: D. Gaimster, 'Post-Medieval Ceramic Stove-tiles Bearing the Royal Arms: Evidence for their Manufacture and Use in Southern Britain', *Archaeological Journal*, 145 (1988), pp. 314–43; Gaimster, in Thurley, *Whitehall Palace*, pp. 149–161.

90. Stove-tile Bearing Royal Arms and 'ER' Cipher for Elizabeth I, second half of the sixteenth century

Made on Surrey–Hampshire border.
Lead-glazed earthenware body.
Museum of London, inv. 6922.

The diary of the Moravian nobleman, Baron Waldstein, visiting England in 1600 observed that the queen had a tile-stove fired by sea coal in her bathroom at Hampton Court. Archaeology has shown that smokeless stoves made from ceramic tiles were imported from western Germany into southern England from the middle of the fifteenth century. Besides being a radical innovation in terms of domestic heating technology, their architectural form, intricate moulded relief and colour-glazed surfaces injected a new visual dimension into the pre-Reformation English interior. By the reign of Henry VIII the native pottery industry began producing stove-tiles moulded with the royal arms of England, the emblems of the Tudor dynasty and the cipher of the ruling monarch. Royal palaces form the principal loci for these elaborate stoves. Tiles moulded with the HR cipher of Henry VIII were found during excavations at Whitehall Palace in 1539 in association with

91. Candle-sconce bearing the Royal Arms and 'ER' Cipher for Elizabeth I, second half of sixteenth century

Made on Surrey–Hampshire border.
Lead-glazed earthenware body.
British Museum London, Bernal Collection, MME BL 1675.

Candle-sconces and cisterns moulded with the royal arms and heraldic insignia of the Tudor dynasty were made by potters as a sideline to stove-tiles in their output of decorative heating and lighting equipment. Utilising the same moulds employed to make the tiles for the armorial relief, the potters then added a tray below to hold the candle sockets and a pierced canopy above to reflect the candlelight. Suspended on the wall, the transparent lead glaze over the white earthenware fabric would have reflected the light as effectively as any brass-metal equivalent. The sconce was possibly designed to complement an armorial stove in a royal palace or aristocratic residence. DG

LITERATURE: B. Rackham, 'Early Tudor Pottery', *Trans. English Ceramic Circle*, 2 (1939), pp. 15–25; D. Gaimster, 'Post-Medieval Ceramic Stove-tiles Bearing the Royal Arms: Evidence for their Manufacture and Use in Southern Britain, *Archaeological Journal*, 145 (1988), pp. 314–43.

92. Two Chairs with Embroidered Cushions

Spanish.

Carved and gilded mahogany late sixteenth-century chairs with leather seat covers over eighteenth-century upholstered seats; the cushions English, linen canvas embroidered in wool in tent stitch, backed with seventeenth-century red silk damask.

Loseley Park, Surrey.

By family tradition these chairs were used by Elizabeth I's maids of honour, and the queen herself embroidered the cushions. Elizabeth visited Sir William More (1520–1600) at Loseley, near Guildford in Surrey, on four occasions, and his daughter Elizabeth became one of the queen's ladies-in-waiting, but no early reference to royal gifts has been found. More was an efficient county administrator for Surrey for over forty years.

Ornate low chairs would have been exceptional in England, where chairs indicated the high status of the sitter, and where on informal occasions women at court would have sat on cushions. Mahogany would also have been a great rarity as it was just becoming available in Europe through Spanish trade links with the Americas. It is possible that the chairs arrived in England through the Low Countries during the reign of Elizabeth, since they may be the two low gilded chairs recorded in the inventory of 1666 as 'old Gilt chairs & cushions'.

These covers are dated to the second quarter of the eighteenth century on the basis of the floral design. Few Elizabethan cushions in tent stitch have survived, as the wools are susceptible to pest damage. It seems plausible that the unusual form of the chairs and the historical visits of Elizabeth I to Loseley encouraged the tradition associating them and these cushions with the queen. In any case, their arrival at Loseley before 1666 is a notable early instance of Spanish mahogany furniture in England. NH

93. Miniature of Elizabeth I Playing a Lute, c. 1580

Nicholas Hilliard (1547–1619).
Gouache on vellum laid down on to card.
4.8 x 3.9cm (oval).
Provenance: probably belonged to Henry Carey, 1st Lord Hunsdon. At private collection since 1796.
Trustees of the Berkeley Will Trust.

Music was a central part of Tudor court life, being played not only at sumptuous entertainments for visiting dignitaries, but also at midday while the queen dined, and to accompany dances. Musical skill was an important accomplishment for women of high rank, and Elizabeth was considered a talented musician. She is shown here seated upon a throne playing a stringed instrument which is probably a lute. In its original state the miniature would have sparkled before the eyes of the viewer as Elizabeth's dress is painted with a silver pigment which has since oxidised, turning grey black. The image may have been given to her cousin Henry Carey, 1st Lord Hunsdon.

Elizabeth reported to the Scottish ambassador, Sir James Melville, that she played music alone to 'shun melancholy', but on occasion she clearly played to an audience, such as in 1572 when she performed a recital upon the virginals for French ambassadors. The lists of New Year's Day gifts across Elizabeth's reign include numerous lute strings and suggest that she continued to play throughout her life; for example, as in 1588 when the court was at Greenwich where the gift roll records that two minor court servants each gave her 'one box of lute strings' (Cat. no. 98).

The court employed about thirty musicians, many of whom were highly skilled foreign émigrés from Italy, France and the Netherlands. In contrast to the opinion of puritans and many of her own divines, Elizabeth viewed music played in churches as uplifting and highly appropriate to instil religious sentiment. The music played in her own chapel was devised by her organists Thomas Tallis (1505–85) and William Byrd (c. 1540–1623), two of the most famous composers of this period who were both apparently Catholic, but nonetheless protected by the queen. TC

LITERATURE: Donaldson (ed.), *Memoirs of Melville*, p. 36; Strong, *Portraits of Elizabeth*, p. 89; Woodfill, *Musicians*.

94. Queen Elizabeth's Orpharion, c. 1580

John Rose (d.1611).
Walnut.
Private Collection.

This orpharion by royal instrument maker John Rose is one of only two extant examples. Said to have been a gift from Elizabeth I to an ancestor of its current owner, its lavish decoration features exquisite purfling (the decorative inlaying particularly noticeable on the fingerboard) and a carved pear-wood scallop shell. The words inlaid on its side, *Cymbalum decachordum*, allude to Psalm 33:2: 'Sing praises unto him with the lute, and instrument of ten strings.' A member of the bandora family of instruments, the orpharion was for much of the seventeenth century almost as popular as the lute. Its name derives from two classical poets: Orpheus and Arion.

As William Barley (d.1614) explains in his *New Booke of Tabliture for the Orpharion* (1596), the technique for playing the Orpharion's wire strings necessarily differed from that required for the gut-strung lute:

"the Orpharion doth necessarily require a more gentle and drawing stroke than the lute, I mean the fingers of the right hand must be easily drawn over the strings, and not suddenly gripped, or sharply stroken as the lute is: for if ye should do so, then the wire strings would clash or jar together the one against the other; which would cause that the sound would be harsh and unpleasant."

Music written specifically for the Orpharion is somewhat limited: other than Barley's *Tabliture*, only two short pieces exist. It was, however, popularly used as an alternative to the lute in consort music and for accompanying songs by composers such as Dowland (d.1626) and Attley (d.1640).

GW

LITERATURE: D. Gill, 'An Orpharion by John Rose', *Lute Society Journal*, 2 (1960), p. 33; or D. Gill, 'The Orpharion and Bandora', *Galpin Society Journal*, 13 (1960), p. 14; R. Headlam Wells: 'The Orpharion: Symbol of a Humanist Ideal', *Early Music* (Oct., 1982), p. 427.

95. Elizabeth's Saddle, late sixteenth century

Covered with velvet and metal thread.
Private Collection.

Throughout her life Elizabeth maintained her passion for hunting. This saddle, from the latter part of the sixteenth century, is representative of the type of luxury goods used by both the queen and court for riding and hunting. Velvet at that period was made of silk and imported from Italy, and the saddle was heavily embellished with couched gold threads and applied gold braid. Embroidery like this, with its lavish use of gold thread, was extremely expensive and would certainly have been the work of a professional embroiderer. The queen employed several embroiderers, most notably David Smith, who embroidered most of her gowns, and William Middleton, who carried out the embroidery on her furnishings. APM

96. Nonsuch Palace, with the Queen in her Coach, 1582 or later

See page 77.
Frans Hogenberg (1540–90) after Joris Hoefnagel (1542–1601).
Engraving, later coloured wash.
316 x 444cm.
Inscribed: 'Effigiauit Georgius Houfnaglius Anno 1582.
PALATIUM REGIUM IN ANGLIAE REGNO APPELLATUM NONCIVTZ, Hoc est nusquam Simile'.
British Museum, London, PD Y5-153.

Nonsuch Palace, near Cheam, Surrey, was built by Henry VIII between 1538 and 1547 as a grand hunting palace. The rear façade of the inner court is shown here. A brick base carried timber upper floors which were decorated with narrative stucco reliefs bordered by gilded slate. The palace was sold to the earl of Arundel in 1557 and subsequently passed to Lord Lumley, though his debts to the crown were such that Elizabeth used the palace annually from 1580 and bought it back in 1592. By this time, the fame of her father's buildings was widespread and prompted the inclusion of this image in Braun and Hogenberg's *Civitates Orbis Terrarum* of 1598.

The print is based on one of two drawings by Joris Hoefnagel, dated 1568, now in the British Museum. It has been convincingly argued (Biddle, p. 94) that the date 1582 on the print seeks to replicate the original date but has misread the flourish after the '8' as a '2'. The print was certainly produced after Nonsuch was recognised as a royal palace once again, between 1580 and the 1598 publication. When Elizabeth made formal entries into towns and cities, or travelled on progresses, she frequently rode horseback but a 'chariot' (as it is described in a

procession to Westminster of 1596) was kept in readiness. Two coaches are known to have been built for her by the Dutch carriage maker, William Boonen.

The figures beneath celebrate the mercantile values of the English; the wives of merchants are depicted as soberly dressed compared with the luxuriant and red-coloured dress of the idle noblewomen. The images echo those in contemporary continental costume books recording national dress and customs. MH

LITERATURE: Colvin, *King's Works*, p. 4; Biddle entries in *The Renaissance at Sutton Place*, exhibition catalogue, Sutton Place Trust (1983), nos 91, p. 92; Thurley, *Palaces*.

97. Elizabeth I Receiving Dutch Emissaries, c. 1585?

German School.
Gouache on paper.
24.4 x 37.5cm.
Inscribed with names: *Liseter, Amiral, Konigin von Schotland, Vestlan, Walsbrun, Konigin, Ambassadur.*
Staatliche Museen Kassel, Graphische Sammlung, 10430.

As there are virtually no contemporary English representations of interiors, the work has taken on an extraordinary significance as a potential illustration of Elizabeth's court and the decoration of interiors generally. The imagined scene of Elizabeth and Mary in the same room and the composite nature of its sources may help to explain the anomalies. The German artist may not have painted this at the English court, or even in England. He may have worked in the 1580s from older images of the queen. The walls are usually said to be hung with closely fitted tapestry but they could equally be painted with dense foliage and flowers (even down to the illusionistic fringes) in the central European manner. Nevertheless, the image reflects something of

the richness but spare quality of a presence chamber, with its chair, cushioned rather than upholstered, a cloth of estate and a special carpet for the queen over the rush matting. The bird cages in the windows would have been familiar at European courts at this period. William Harrison, in his *Description of England*, speaks of the 'costly and curious aviaries' of the time and silver drinking pots for birds, with the king's arms on them, were recorded at Greenwich in the royal inventory of 1547.

Traditionally, this picture is said to represent the reception of the Dutch emissaries Vestlan and Walbruns by Elizabeth about 1585, at the time when England was negotiating to support the Dutch against the Spanish, confirmed by the Treaty of Nonsuch in August of that year. Leicester, who had long been a supporter of the Dutch cause, is annotated as one of the figures, as is the queen of Scotland. As Elizabeth never met Mary face to face, Mary's presence in the corner can only be explained in terms of her significance as one element in the conduct of English foreign policy. The date of this small work and its original function, belonging as it does more to the world of manuscripts and documents than framed panel paintings, must remain conjectural. Elements of the dress of the figures suggest both a date more of the 1560s and, especially in the details of the group of women at the left, German sources of inspiration. MH

LITERATURE: *Armada*, no. 3.5. Thurley, *Palaces*, p. 222.

Gift-Giving at Court

98. New Year's Gift Roll, 1588

See page 75.
Manuscript.
British Library London, Additional MS 8159.

This roll records gifts given to Elizabeth at New Year in 1588 when the court was at Greenwich.

The practice of giving gifts to the monarch at New Year (rather than Christmas) was because 1 January was the traditional time when the nobility paid obeisance to the king. Gifts were usually of gold plate, the weight of which was dictated by one's status. By Elizabeth's reign, plate had been largely replaced by gifts of elaborate jewellery including bracelets, pendants and hat badges, valuable accessories such as gloves, purses and slippers, clothes including petticoats, bodices and ruffs and more practical items such as books, embroidered cushions, drinking glasses, writing tables, lute strings and a large number of handkerchiefs. The type of present depended on the donor's rank and wealth: earls, bishops and lords gave gold, marquesses and countesses usually gave jewels, while baronesses, knights and ladies favoured gifts of clothing. Gentlewomen presented more modest accessories such as sweet bags, ruffs, scarves, handkerchiefs, shifts and hats. Gentlemen and servants preferred to give things of a less intimate nature: lute strings or luxury fare like ginger, preserved pears and marzipan.

This roll records that Elizabeth received an elaborate necklace of gold, diamonds and rubies, with matching earrings, from Sir Christopher Hatton (Cat. no. 133) and from the earl of Leicester (Cat. no. 60), a gold carcenet (heavy jewelled necklace) of letters and ragged staves (his emblem) and a sun design, set with Elizabeth's picture. Mrs Thomysen, a lesser courtier, gave a handkerchief; Mr Morgan, the queen's apothecary, presented his traditional gift of candied sugar and dried plums; while John Dudley, sergeant of the pastry, baked an oringed pie.

In return, Elizabeth also distributed gifts, all of plate, and they are recorded on the reverse of the roll. The plate did not reflect the value of the gift she received, but the social status of the recipient and Elizabeth's own personal preferences. The amount varied from the massive 400 ounces to Christopher Hatton to 5 ounces given to each of her musicians. Interestingly, though Leicester was her favourite, he received only 132 ounces of plate, less than both Hatton and another, less important favourite, the earl of Ormond. NM & SN

(a)

99. Scent Bottles, first half of the seventeenth century

(a) **Screw-top scent bottle**
Enamelled gold, rubies.
Private Collection.

(b) **Screw-top scent bottle**
Enamelled gold, emeralds.
Private Collection.

(c) **Screw-top scent bottle**
Gold, enamel, agate (opaline chalcedony) spinels, pink sapphires, diamonds.
Provenance: the Cheapside Hoard, a collection of seventeenth century jewellery discovered London in 1912.
Museum of London.

(b)

These richly decorated bottles were designed to contain the scents made from flower distillations and spices which were widely used to disguise unpleasant odours. Decorated like valuable jewellery, these bottles would have made expensive gifts, welcomed by Elizabeth on New Year's Day.

The third example, from the Museum of London, was worn at the belt, hanging from a chain comprising sapphire and spinel links alternating with enamelled flower heads. A sonnet by William Shakespeare refers to scent bottles, perhaps like these, filled with perfume described as 'summer's distillation left, / A liquid prisoner pent in walls of glass / Beauty's effect with beauty were bereft'. According to John Nichols, Queen Elizabeth had an aversion to heavy or cloying perfumes and preferred lighter scents. DS

LITERATURE: Forsyth, 'The Cheapside Hoard', pp. 14–17; Nichols, *Progresses and Possessions*.

100. Genealogical Tree Showing the Descent of Elizabeth from King Rollo

Manuscript.
British Library, London, Kings MS. 396. Open at fo. 3v & 4r.

The book was a gift to the queen, probably given on New Year's Day by one of the royal heralds, as similar works are recorded in gift rolls (Cat. no. 98). Its author is anonymous, but Robert Cooke, the Clarencieux King-of-Arms (d.1593), is thought a likely candidate, as the style resembles other pedigrees executed by him.

The genealogical tree presented here traces the descent of the queen from Rollo, the king of Normandy, and includes elaborate

drawings of many important rulers such as William the Conqueror (seen here). Showing the various foreign and English dignities that became merged into the English crown may well have had some political significance, given that one of the main arguments against James VI of Scotland's succession to the throne of England was his foreign birth. At the beginning of the book the author provides a historical sketch of the monarchy from the mythological King Brutus who was supposed to have ruled the whole of Britain. This was designed to show that the English sovereign was the overlord of Scotland, a claim frequently asserted by Tudor monarchs. SD

fifteen pairs in 1600 and twenty-one pairs in 1603, from various gentlemen. Perfumed gloves were a favourite gift item for those perhaps unsure of the queen's personal tastes. AM & SN

LITERATURE: Susan Corbett, '"When Gloves are Giving": A Royal History', *Country Life* (30 July 1981), pp. 391–2.

102. Handkerchief, c. 1600

Linen embroidered with silk in double running and detached buttonhole stitches, trimmed with silver-gilt bobbin lace.
Victoria and Albert Museum, London, T.133-1956.

Handkerchiefs made of plain linen served the same function in the sixteenth century as they do today. However, if they were decorated they could also be carried purely as fashionable accessories and given as gifts. Elizabeth frequently received sets of embroidered handkerchiefs on New Year's Day. The embroidery here, creating a pattern of stylised honeysuckle and grapevines, is partly worked in double running stitch. This is a double-sided stitch, creating identical patterns on the front and back of the fabric. The metal lace adds to the showy effect, and its weight would have made the handkerchief drape gracefully. The initials 'em' may indicate its maker, or its recipient (male or female), as a gift. CB

101. Pair of Gloves

Leather, silk and gold thread.
Ashmolean Museum, Oxford, AN 1887.1.

Tradition has it that these gloves were given to the queen when she visited the University of Oxford in 1566. Almost certainly they would have been scented for presentation. Elizabeth was proud of her shapely hands and indeed the suggestion has been made that it was the unflatteringly large size of the gloves commissioned by the dons that led the monarch to overlook them on her departure.

By the 1590s, gloves appear frequently in the New Year's gift rolls (Cat. no. 98). In 1598, the queen received ten pairs of perfumed gloves,

103. Pair of Mittens, c. 1600

Velvet and silk embroidered with silk, silver and silver-gilt thread.
Provenance: Sir Edward Denny.
Victoria and Albert Museum, London, 1507&A-1882.

According to *Burke's Peerage* and family history, the mittens were given by Elizabeth to Margaret Edgecumbe, a maid of honour. The New Year's gift rolls, however, bear no mention of Margaret Edgecumbe as a maid of honour, although not all the records for each year have survived. Nor is there any mention of gifts such as gloves; those documents that still

exist list only the gilt plate that the
queen bestowed on members of her court
each year. Nonetheless, other records indicate that
the queen gave away items of clothing on a regular basis. Edward
Denny, Margaret's husband, was a groom of the chamber and is listed
as a recipient of gilt plate at the New Year in 1589, 1598, 1600 and 1603.
As gloves and mittens were not distinguished in gender by their design,
this pair may have been a gift from the queen to Edward Denny.

The mitten was rarer than the glove as a form of hand covering.
This very fine pair is embroidered in a pattern of scrolling leaves with
borage, roses, pinks and honeysuckle. The inclusion of insects amongst
the foliage was a favourite device of the period and these mittens bear
a millipede creeping along the cuff. SN

LITERATURE: Arnold, *Wardrobe Unlock'd*, pp. 99–104, 174–5; Hart and
North, *Historical Fashion*, p. 206; Nichols, *Progresses and Processions*.

104. Bangle, second half of the sixteenth century

Gold, rock crystal,
 cabochon sapphire
 and ruby bangle.
Provenance: traditionally,
 from Queen Elizabeth to
 her cousin Henry, 1st Lord
 Hunsdon, and thence by descent.
Trustees of the Berkeley Will Trust, on loan to the Victoria
 and Albert Museum, London.

This bangle corresponds with an entry in the inventory of Elizabeth's
jewels drawn up in 1587 by Mrs Blanche Parry on her retirement for a

pair of rock crystal, ruby and sapphire bracelets, called 'Persia work'.
The bangle is gripped in four places by gold elements each with scroll-
work surmounted by a cluster of rubies and a sapphire. The type of
setting of the gold compares with South Indian jewellery and could
have made its way to Lisbon in Europe via the Portuguese trade route
from Goa. DS

LITERATURE: J.H. Hefner Alteneck, *Deutsche Goldschmiedewerke des
XVI Jahrhunderts* (Frankfurt, 1890), pl. 23, C and F; Scarisbrick,
Ancestral Jewels, p. 14.

105. Ship Pendant, second half of the sixteenth century

Gold, enamel,
 ebony, diamonds,
 pearls.
Provenance: by tradition
 said to have been given by Sir Francis Drake to Queen
 Elizabeth, and by her to her cousin Henry, 1st Lord
 Hunsdon, and thence by descent.
Trustees of the Berkeley Will Trust, on loan to the Victoria
 and Albert Museum, London.

A favourite theme of the Renaissance jeweller, particularly in a maritime
nation, was the ship, or 'nef', jewel symbolising prosperity and happiness.

Representing the ship on which he made his reputation and sending good wishes for happiness and prosperity, this jewel would have been a most appropriate token of loyalty from the greatest sailor of the age, Sir Francis Drake, to the queen.

The ebony hull of the ship is set with a table-cut diamond; the gold masts and rigging are enamelled blue, white, green and black and pinned with seed pearls. On deck, guarded by cannons, Cupid crowns Victory who is blowing her trumpet. From below hangs a small boat with pearl pendant. The liberal use of pearls compares with the ship pendants made by the jewellers of the Adriatic coast. DS

106. Portrait of George Carey, dated 1601

Nicholas Hilliard (1547–1619).
Gouache on vellum, stuck down on to card.
Inscribed: 'Ano. Dni, 1601. / Aetatis Suae 54'.
47 x 38cm.
Trustees of the Berkeley Will Trust.

Elizabeth appointed several of her own kinsmen from her mother's family to official crown positions. George Carey (1547–1603) was directly related to Elizabeth through his grandmother, Mary Boleyn. His father, Henry Carey (1524–96), as Elizabeth's first cousin was made 1st Lord Hunsdon and exchanged numerous elaborate gifts with the queen throughout his life, some of which are shown here (Cat. no. 104). As captain of the Isle of Wight, George Carey was involved in the Armada preparations and towards the end of his career became a knight of the Order of the Garter and lord chamberlain. TC

107. Cameo Jewel, second half of the seventeenth century

Gold, enamel, ruby and
onyx cameo.
Provenance: Dame Joan
Evans.
Victoria and Albert
Museum, London,
M69-1975.

This cameo depicts the profile of a Roman youth and such 'antique heads' were probably imported from Italy, where cameo cutting flourished. They were set in rings, pendants and brooches to demonstrate the wearer's interest in the classical culture of the Renaissance. DS

LITERATURE: Somers Cocks, 'Intaglios and Cameos', p. 369, pl. 20, c.

108. New Year's Gift of a Bible to Elizabeth, 1583–4

Printed book with embroidered cover.
Bodleian Library, Oxford, Douce bib. Eng. 1583 b.1.

As listed in the gift roll of 1583–4, this presentation copy of the Geneva Bible was a New Year's Day gift for Elizabeth from Christopher Barker, the royal printer. Its red velvet cover was richly embroidered with metal gold threads and seed pearls to form a design of Tudor roses linked by stylised stems, leaves and buds. Elizabeth was known to be fond of books bound in this way. It was a suitable gift from Barker for he had been given a licence in 1576 to print the first edition of the Geneva Bible to be published in England.

Barker, whose patron was Sir Francis Walsingham (Cat. no. 213), held the office of royal printer of all statutes, books, bills, acts of parliament, proclamations, injunctions, Bibles, and New Testaments, in the English tongue of any translation, all service books to be used in churches, and all other volumes ordered to be printed by the queen or parliament.

SD

within the Garter and are supported by a crowned lion and a griffin. The embroiderer has worked a Tudor rose in one corner and a flower head, possibly a marigold, in another. Similar flower heads embroidered on clothing appear in portraits of Elizabeth, and in 1595 a pair of sleeves 'powdered' with marigolds was made for the queen by her embroiderer, John Parr. The marigold, like the sunflower, symbolised devotion. Many of the metallic threads have decayed, leaving areas of threadbare patterning.

EE

LITERATURE: Arnold, *Wardrobe Unlock'd*, pp. 101–3, 192.

110. Salamander Hat Jewel, first half of the seventeenth century

Gold, enamel, cabochon emeralds, table cut diamonds.
Provenance: the Cheapside Hoard.
Museum of London. A14125.

Tudor and Jacobean hat jewels were more than decorative. They also had a deeper meaning, expressing either sentiment, or the sporting, spiritual and cultural interests of the wearer. The salamander had an emblematic significance for, like the phoenix it was believed to survive burning in the fire, as explained in numerous continental emblem books (Cat. no. 203). It was particularly associated with Francis I of France (1494–1547), who, resembling the salamander in his prowess in love and war, adopted it as his badge. Fashions in Renaissance jewellery were international and the salamander appears elsewhere, particularly in Spain (see the Girona salamander) and as here, in England. The tongue is missing from the salamander's open jaws and there is a gold fitting at the back to attach the jewel to the hat.

DS

109. English Embroidered Pillow Cover, c. 1558–1603

Linen, embroidered with metal thread.
Inscribed: 'ER', and below 'God save ye qeene'.
Provenance: bequeathed by Mary Campbell Needham through the National Art Collections Fund.
Museum of London, 30.173.

This cover was originally owned by the Radcliffe family who believed it had once been used by Elizabeth I. The association with the queen is supported by the role of Mary Radcliffe within the royal household. She was appointed a maid of honour in 1561 and remained in royal service, latterly as a gentlewoman of the privy chamber, until the queen's death. One of her responsibilities was to look after some of the queen's personal jewels.

Silver or silver-gilt metal thread has been used to embroider this pillow cover with the arms of Elizabeth I. They have been placed

111. Shepherd's Crook Bodkin, first half of the seventeenth century

Gold, enamel, rubies, diamonds.
Provenance: the Cheapside Hoard.
Museum of London, A14124.

In 1580, John Baret's *Dictionary* defined the bodkin as 'a big needle to crest the hairs', and Elizabeth I's inventory of 1587, compiled by Mrs

Blanche Parry, lists no fewer than sixty-six jewelled bodkins. The head of this tapering, long, flat, gold pin is shaped as a shepherd's crook set with table-cut rubies and diamonds. The pastoral theme here echoes much contemporary poetry, including that of Edmund Spenser (c. 1552–99) and Sir Philip Sidney (1554–86). DS

LITERATURE: Baart et al., *Opgranvingen*, p. 217, figs 401, 402.

112. Sweet Bag

Embroidered textile with silk and metal thread.
1588–1600.
Private Collection.

Sweet bags containing sweetmeats, of which Elizabeth was extremely fond, were among the gifts presented on New Year's Day. The bags could also be filled with aromatic herbs and used to 'sweeten clothes' or held up to the nose to ward off unpleasant odours. This bag may have been produced by a professional workshop. However, owing to the production of steel needles and an influx of coloured silks, the skill of many amateur embroiderers, such as Elizabeth, countess of Shrewsbury, and Mary Queen of Scots, often rivalled that of professionals. Patterns for embroidery designs, like those seen on the sweet bag, were available in printed sheets and books. Floral motifs of carnations and roses were fashionable, as were pansies, said to have been the queen's favourite flower. APM

113. An Elizabethan Maundy Ceremony, c. 1560

See page 74.
Attributed to Levina Teerlinc (c. 1510/20–1576).
Vellum on playing card.
Oval, 7 x 5.7cm.
Provenance: thought to have been acquired from an unknown source before 1863; thence by descent.
Trustees of the late Countess Beauchamp.
Trustees of Lady Beauchamp's Will Trust.

This miniature shows Elizabeth, seen front left wearing a purple-blue long-trained gown, participating in the Maundy Thursday ceremony, which was part of the Easter liturgy. In this ceremony the sovereign symbolically washed the feet of a group of poor people – their number being the same as her age in years – before presenting them with money, food and clothing, in imitation of Christ's washing of the feet of His disciples before the Last Supper. The ceremony dated back at least to the reign of Edward II and although the Church in England had broken away from Rome, the event remained part of the royal calendar and for Elizabeth it was a spectacle through which the monarchy could demonstrate its power.

The poor are depicted seated in two rows that run from the front to the back. A gentlewoman stands behind each, while in the centre at the back we see the almonry children, the gentleman of the Chapel Royal in copes, and in the rear the gentlemen pensioners holding the poleaxes that signify their role. The elderly man holding a white staff of office, whose face is at the centre of the oval, may be the lord chamberlain of the household or the treasurer of the chamber. The queen herself wears a long white apron, as do some of her ladies. The costumes depicted were the height of fashion in about 1560.

This miniature may have been painted by Levina Teerlinc although this attribution has regularly been challenged. Between 1559 and 1576 Levina is recorded as presenting to Elizabeth I nine pictures as New Year's gifts, some of which were images of the queen on her own while others showed her with 'many other personages'. This small work may be one of these. The miniature was originally rectangular or square but subsequently cut down to the present oval shape. KH

LITERATURE: Hearn (ed.), *Dynasties*, p. 121; James and Franco, 'Horenbout, Teerlinc' in *A chacun sa grace: femmes artistes en Belgique et aux Pays-Bas 1500–1950*, Royal Fine Arts Museum, Antwerp and Museum of Modern Art (Arnhem, 1999–2000), p .130.

virtue and beauty and attend the queen at chapel and at court events. In addition the queen employed seven or eight salaried gentle-women of the privy chamber, four chamberers, and four ladies of the bedchamber who attended to all her personal requirements, including preparing her attire and serving her meals, which were taken in private. Some of Elizabeth's closest companions served her in these roles, and all of these posts were highly sought after by the families of well-born young women, as, if the queen was willing, they could lead to advantageous marriages. Elizabeth Knollys was undoubtedly chosen because of her family associations: her father, Sir Francis Knollys (c. 1514–96), had been appointed as vice-chamberlain of the household and a privy councillor on Elizabeth's accession, and was then in 1570 promoted to be treasurer of the household; and her mother Catherine (née Carey) was the queen's first cousin on the Boleyn side, a lady of the bedchamber since 1558, and an intimate companion who was deeply mourned at her death in 1569. In 1578 Elizabeth married Sir Thomas Leighton (c. 1585–c. 1611), governor of Guernsey. Most of the queen's women had specific duties and it appears that Elizabeth may have been given the care of the queen's accessories, as on New Year's Day 1578 several gifts of perfumed gloves were passed into her care. Like many of the queen's ladies, Elizabeth occasionally received items from the royal wardrobe, which were frequently extremely valuable, and in 1565 she was given a 'Venetian gown of crimson velvet'.

This portrait by the queen's serjeant painter, George Gower, shows the sitter wearing extremely elaborate jewellery of rubies, pearls and probably jets, the three colours frequently favoured by the queen. Although some of her costume is repainted, she wears extremely fashionable attire including a tall black hat with pink feathers and an emblematic jewel showing a dove and a serpent hanging at her chest. TC

114. Portrait of Elizabeth Knollys, Dated 1577

George Gower (c. 1540–96).
Oil on panel.
60.4 x 45.1cm
Inscribed: top left 'AN° DNI 1577'; either side of the elephant: 'E K'.
Provenance: Charles Fairfax Murray in 1912.
Montacute, The Sir Malcolm Stewart Bequest, The National Trust.

LITERATURE: Arnold, *Wardrobe Unlock'd*, p. 217; Wright, 'Female Household'; Merton, 'Women who Served'. We are also grateful for unpublished notes from the National Trust.

115. William Wodwall's 'The Actes of Queene Elizabeth Allegorized'

Manuscript.
Bodleian Library, Oxford, MS. Eng.hist. e 198 fo. 85r.

This drawing, illustrating one of Wodwall's poems, has been interpreted as 'a daring caricature' of the elderly queen and her love of finery, but it was probably a more general satire on the fashions of the day.

This portrait of Elizabeth Knollys shows her at the time she served the queen as one of her closest attendants. The queen was served at any one time by six unpaid maids of honour, who were always young unmarried women of high birth, and Elizabeth Knollys had acted in this role at least from 1560. Their function was to serve as a spectacle of exemplary

116. Portrait of Henry Wriothesley, 3rd Earl of Southampton, 1594

Nicholas Hilliard (1547–1619).
Vellum stuck to a playing card with three hearts showing at the reverse, oval.
4.1 x 3.25cm.
Syndics of the Fitzwilliam Museum, Cambridge.

Extravagant white ruffs grew progressively larger throughout Elizabeth's reign and were worn by both men and women at court, fashionable gentry and wealthy city merchants. Through the use of starch and setting sticks, the ruffs could be wide and stacked up in two or three layers.

Wodwall's allegorical poem relates in six cantos six major crises in Elizabeth's reign: the Northern Rising, the Ridolfi plot, the Jesuit mission, the Babington plot, a crisis of pride (seen in sumptuary excess) and the Armada. Each one of Wodwall's crises was prefigured by signs and wonders, including monstrous births. This picture of a monstrous fowl accompanies the crisis of pride. The creature is a bird of prey: its single eye is deeply hooded; its beak resembles a dagger; and its feet are sharp claws. Its plumage is fantastically wide and layered, resembling the ruffs that appear in Elizabethan portraits from about 1585 onwards. SD

LITERATURE: Orwell and Reynolds, *British Pamphleteers*; Rob Content, 'Fair is Fowle', in Walker (ed.), *Dissing Elizabeth*, pp. 229–47.

Southampton (1573–1624) was famous for his flamboyant appearance and exemplifies the feminisation of male courtiers in the later Elizabethan period. He was also one of the leading court patrons of poets and dramatists, most notably Shakespeare. Southampton was presented at court around 1590 where he became a close friend of Robert Devereux, 2nd earl of Essex (Cat. no. 253) and a prominent participant in chivalric tournaments. After his secret marriage in 1598 to Elizabeth Vernon, a maid of honour, he fell out of royal favour and was briefly committed to the Fleet Prison. In 1601 he was directly implicated in Essex's abortive rising but thanks to Robert Cecil's intervention he was spared execution and confined in the Tower until Elizabeth's death.

In addition to this miniature, Southampton was painted many times in large-scale portraits by a number of émigré artists. Hilliard represents him as a handsome young man, his long auburn hair – for which he was famous – arranged artfully over his left shoulder. The calligraphic script recording the date and Southampton's age are characteristic of Hilliard's work, but the pleated velvet curtain, rather than the conventional plain blue background, is used here for the first time. DD

117. Inventory of Jewels, Plate etc, 14 March 1574

Manuscript.
British Library, London, Stowe MS 555.

This manuscript is an inventory of royal jewels and plate drawn up by a commission on 14 March 1574. Each leaf is signed by three of the commissioners: Lord Burghley, Sir Ralph Sadler and Sir Walter Mildmay. Some gifts given to Elizabeth while on progress and at New Year are also recorded. Later breakages and disappearances have been noted in the margin, some by Burghley. NM

LITERATURE: Arnold, *Wardrobe Unlock'd.*

118. Inventory of Clothes, Jewels etc, July 1600

Manuscript.
British Library, London, Stowe MS 557.

This inventory records over 1,200 separate items of clothes and jewels in the Great Wardrobe in July 1600. Both this and the previous inventory illustrate the huge quantity and rich variety of Elizabeth's clothes, jewels and plate, though her personal jewels are excluded. They both record crowns, sceptres, looking glasses, clocks, unicorn horns, cups, bowls, candlesticks, cutlery, gowns, mantles, kirtles and fans. They also include Elizabeth's coronation robes, two of the three crowns with which she was crowned (Cat. nos. 28 and 29), and the robes she wore at the opening of parliament.

Some items in this manuscript are noted as having been given away, including a golden cup, decorated with marguerites, given to James VI on the christening of his eldest son, Henry, in 1594. Other items were damaged or broken. A 'covering' of black network, lined with silver and black satin, had been eaten by rats, while three books were 'put to the Mint' where their decorative binding could be melted down and reused.

These inventories also demonstrate the demands made on the monarch. Much of the plate would have been used to serve courtiers and servants who were allowed to eat at court at Elizabeth's expense. Some items were loaned to the English ambassador in France. Plate also acted as the equivalent of a savings account: a financial resource that could be sold off or melted down to provide ready cash. NM

LITERATURE: Collins, *Jewels and Plate of Queen Elizabeth*; Arnold, *Wardrobe Unlock'd.*

119. Woman's Girdle, 1520–70

Metal wire.
Museum of London, 78.205.

Jewelled and ribbon girdles terminating in a tassel or pendant are often depicted in portraits of women associated with the Tudor court. This girdle, which was found on the foreshore of the River Thames at Queenhithe, is made of knitted and wound gold alloy wire wrapped in an organic fibre. It is composed of a series of linked double chains decorated with knots and loops of wire and finished with a triangular pendant which hung down the front of the skirt. The girdle is most unusual but its delicacy recalls necklaces of the period. EE

120. Petticoat Panel, c. 1600

Satin embroidered with silk, silver-gilt thread and silver spangles.
Victoria and Albert Museum, London, T.138-1981.

Fashionable gowns of the 1590s and early seventeenth century were often worn open in front to reveal a decorative petticoat or forepart underneath. A portrait of Elizabeth I by an unknown artist (c. 1599) at Hardwick Hall illustrates a splendidly embroidered example. This panel is thought to have once belonged to a similarly decorated petticoat. The design includes a spider web, jagged arrows, obelisk and armillary sphere, all well-known motifs from contemporary emblem

books (Cat. no. 203). The choice of these particular devices may represent a personal narrative now lost to us. SN

121. Pieces of dress fabric, 1600–1625

Silk embroidered and appliquéd with
cording and glass beads.
Victoria and Albert Museum,
London, 225-1893.

These pieces probably came from a man's cloak or woman's petticoat. Like much surviving costume, they have been re-used in several incarnations over the past 400 years. During the late nineteenth century, real seventeenth-century clothing was adapted and altered for wear as fancy dress. It was at this time that the fabric was cut up for sleeves, a process which unfortunately obliterated most of the evidence of their original seventeenth-century incarnation.

The unique texture of these sleeves has been created by couching cords covered in green silk to the ribbed ground, and applying tufts of floss silk and green glass beads. The sinuous pattern relates to strapwork, a popular design found on a variety of media during this period. It can also be compared to the curvilinear patterns of stems in contemporary embroidery, with the bugles and floss silk creating an abstract rendition of a flower.

Glass beads or bugles, as they were known, were one of the more unusual materials used to decorate clothing in the sixteenth century; there are only three references to bugles in the inventories of Elizabeth's wardrobe. The Murano glassworks outside Venice, the centre of glass manufacture during the Renaissance, had developed by the sixteenth century the 'drawn-glass' technique which allowed the production of large quantities of glass beads with a central hole. These 'bugles' were made primarily for trade with North America and Africa, but were also sold in Europe for use in embroidery. SN

LITERATURE: Arnold, *Wardrobe Unlock'd*, pp. 290 and 263; Hart and North, *Historical Fashion*, p. 28.

122. Looking Glass, c. 1590

Venetian.
Glass, painted walnut with gilt embellishments, inlaid with
mother-of-pearl plaques, decorated with gilt and lacquer
arabesques.
Victoria and Albert Museum, London, 506–1897.

During the sixteenth century the production of glass mirrors backed with an alloy of tin and lead was perfected in Venice. Highly reflective mirrors were therefore a relative novelty in Elizabethan England and became expensive luxury items. Elizabeth certainly owned several mirrors as part of her toilette, along with combs and a gold bodkin for braiding her hair. Hand-held mirrors became increasingly popular among the elite, but as large mirrors were prohibitively expensive few would have gained a reflection of their entire bodies. It was not until the mid-seventeenth century that the production of mirrors expanded and spread to other cities, including London. The sliding panel, the frame at the back and the base of the pedestal of this mirror are later replacements. TC

123. a-e. Courtier's Pocket Counters

(a) Counter box, c. 1580–90

Silver.
Victoria and Albert Museum, London, 791-1891.

(b) Counter of Sir Thomas Heneage, 1588

Silver.
Inscribed: rev.: *fast thoe untied 1588*.
British Museum, London, CM 1876-8-5-3.

(c) Counter of Robert Dudley, Earl of Leicester, 1588

Silver.
Inscribed: rev.: DROIET ET LOYALL (Just and loyal).
British Museum, London, CM M6901.

(d) Counter of Sir Edward Coke, 1603

Silver.
Inscribed: obv.: EDW COKE ATTORNAT GENERALIS;
rev.: PRVDENS QVI PATIENS (He who is patient is prudent).
British Museum, London, CM M7005.

(e) Counter of Lord Buckhurst, 1603

Silver.
Inscribed: rev.: SEMPER FIDELIS (Always faithful).
British Museum, London, CM GIII.1023.

The counter box, which is a crudely decorated and inexpensive object, could be carried easily and brought out when business called for it. Men and women of substance needed a set of counters — in this instance silver sixpences ranging in date from the 1540s to 1571 — for keeping accounts, playing cards and gambling. Sets of counters were normally stored with writing equipment.

Counters, or jettons, were in universal use in sixteenth-century England, mostly as manual reckoning aids, used rather like an abacus — the pocket calculator of the day. Ordinary people used mass-produced counters, mostly imported from Nuremberg, but great men — courtiers and officers of state — had special sets made in precious metal for use in their households and departments. PG & BC

LITERATURE: Hawkins, *Medallic Illustrations* I, pp. 151–2, 188–90.

124. Velvet Pouch, sixteenth century

Silk.
Museum of London, A25555.

This pouch, found in Finsbury in 1923, was originally shield-shaped and probably closed with a drawstring. It is made of silk which was a luxury import. The outside is constructed of velvet, which was cut on the cross, and it is lined with silk twill. The fabric has been stained brown by acids and iron salts present in the soil in which it was buried.
EE

125. Pair of Gloves, 1600–1625 (detail shown)

Leather and satin embroidered with silk, silver and silver-gilt thread, edged with silver gilt bobbin lace and spangles.
Provenance: bequeathed by Sir Frederick Richmond, Bart.
Victoria and Albert Museum, London, T.42&A-1954.

This magnificent pair of early seventeenth-century gloves has been densely embroidered to create a richly textured surface. The spangles worked into the lace would have trembled and sparkled in the light as the wearer moved. The motifs of roses, birds and wheat sheaves cannot be identified with any specific association. Although a Tudor symbol, the rose was such a favourite flower in Elizabethan and Jacobean textile

and decorative design that very little can be read into its appearance. While the objects embroidered were not heraldic, they may have acted as personal devices. The tradition of symbolic images chosen for tournaments, also known as *impresa*, during the Elizabethan era carried over to the decoration of articles of adornment such as sleeves, gloves, earrings and pendants. Scenting articles of dress was standard practice. Gloves, along with other items of clothing including stockings, shifts and shoes, were perfumed with fragrances derived from animal sources such as ambergris, civet and musk, floral oils extracted from orange, jasmine, lily and other blossoms, as well as spices like cinnamon, nutmeg and cloves.

SN

LITERATURE: Hart and North, *Historical Fashion*, p. 210.

on a natural linen ground, the effect occasionally heightened with the use of metal thread.

These uncut sleeve panels have matching pieces that would have formed the front of a jacket. Although the embroidery was completed the panels were never cut out and assembled for wear. The black silk embroidery has extensively decayed leaving the design drawn on the linen and needle holes marking the lost stitches, so that the pattern which here appears delicate would originally have been clear and well defined. The pattern is repeated between the four sleeve pieces, and incorporates favourite motifs from English embroidery of the period, including insects, birds, flowers and fruit.

CB

LITERATURE: Arnold, *Wardrobe Unlock'd*.

126. Uncut Panels for a Pair of Sleeves, early seventeenth century

Linen embroidered with silk in straight stitch to create a speckling effect.
Victoria and Albert Museum, London, 252-1902.

These sleeve panels have been decorated in a technique known as blackwork, a type of embroidery popular in England from about 1560 to 1630. In paintings such as the 'Pelican Portrait' (Cat. no. 193) Elizabeth is shown wearing similar blackwork sleeves which stand out distinctly beneath fine gauzy oversleeves of cypress, an almost transparent fabric of silk or linen. This type of embroidery, which utilised Elizabeth's favourite colours of black and white, was usually worked as a monochrome design in black silk

127. Pestle and Mortar with a Tudor Rose, c. 1600

Bronze.
Victoria and Albert Museum, London, M991-1926.

Pounding and grinding ingredients for cosmetics, face washes, tooth powders and remedies was a daily task, and personal servants, as much as cooks and apothecaries, needed access to a clean mortar. The purity of the alloy mattered too, since some metals could deposit trace elements and contaminate the contents, so mortars were carefully analysed and given an official stamp before being sold. Fear of poison, which could be absorbed through the mouth in food or drink or through the skin in cosmetics, was widespread.

PG

128. Ivory Comb, second half of sixteenth century

French or Flemish.
Carved ivory.
Victoria and Albert Museum, London, 7441-1860.

Dressing was an elaborate ritual for a gentlewoman in the late sixteenth and early seventeenth centuries. In *Lingua, or the Combat of the Tongues* (1607), Thomas Tomkins noted '. . . a ship is sooner rigged by far, than a gentlewoman made ready'. Maids, or in Elizabeth's case, ladies in waiting, were responsible for lacing and pinning a woman into her clothes. Fashionable men, like courtiers, also wore elaborate dress and would have required assistance as well. After a woman was dressed, a combing cloth would be arranged over her clothes and her hair would be cleaned by rubbing it with a warm cloth and then combing it with an ivory comb like this one. The hair would than be dressed, which might include the addition of false hair or an elaborate wired headdress of fabric and lace. During the second half of the sixteenth century, men wore their hair cut short and cropped close to the head. However, at the end of the century longer styles that required more attention were beginning to appear. APM

129. Shoehorn, c. 1590

Cattle horn.
Museum of London.

A 'shooinge horne', like this one, would be used to ease the feet into shoes made of coloured leather or, for the very wealthy, velvet or satin. In this period, both men and women wore the same style of shoes, so this shoehorn, with its image of a male figure in court dress may have belonged to one of Elizabeth's courtiers. APM

130. Riding Boots or Buskins

Leather, cork.
Ashmolean Museum, Oxford, AN 1836.

Mention of these buckskin boots with cork heels and leather soles is first made in 1836, when they are confidently attributed to Elizabeth: although this is entirely possible, supporting evidence is lacking. AM

ELIZABETH'S ADVENTURERS

IMPERIAL AMBITION AND ELIZABETH'S ADVENTURERS

Sian Flynn and David Spence

On 22 November 1577, Dr John Dee (Cat. no. 165), one of the great intellectuals of the age and the queen's celestial mathematician, noted in his diary that he 'rod[e] to Windsor to the Q[ueen's] Majesty', to discuss a matter of great magnitude.[1] When Dee finally spoke with Elizabeth, he laid before her his bold plan that challenged the existing division of the globe between the two major European powers, Spain and Portugal, which had been negotiated by Pope Alexander VI in the Treaty of Tordesillas of 1494. This treaty had resulted in Spain asserting its rights to much of Central and South America while Portugal claimed territories in the eastern parts of the American continent – Brazil, Newfoundland, Labrador and Greenland – as well as the East Indies. Refusing to accept this state of affairs, Dee proposed that Elizabeth should assume the title of emperor and England should seek to repossess lands it had already colonised, becoming the hub of an empire that would dominate the globe.

Dee's grand imperial vision was grounded in historical precedents, an antiquarian practice that was common among Tudor scholars. He claimed that England had already colonised lands through the northern voyages around the North Pole made by King Arthur in the mid-sixth century and through settlements in North America made by a Welsh Prince, Madoc, in the twelfth century. Dee's resourceful acquaintances included men such as the influential European cartographers, Gemma Frisius, Gerard Mercator and Abraham Ortelius and advocates of English settlement in North America, Humphrey Gilbert, the two Richard Hakluyts (who were cousins) and Walter Ralegh.

Such an empire-building ideology was audacious considering that England was a small and isolated nation on the fringes of northern Europe, ruled by an unmarried and childless queen, with limited military and financial resources. In contrast, the mighty Spanish Empire under Philip II controlled lands that encompassed much of the Americas and its fabulous riches. When Spain forcibly annexed Portugal and its empire in 1580, Philip became the master of a huge empire that also incorporated the East Indies, Africa and Brazil. Spain's immense vision of Catholic aggrandisement seemed limitless.

Dee, however, produced several manuscripts and printed works that challenged Spain's idea of global dominance. In doing so, he established himself as a leading maritime adviser and exponent of the British Empire. In 1570, against a backdrop of Elizabeth's excommunication, key courtiers Christopher Hatton and the earl of Leicester commissioned Dee to survey the current political, economic and social state

of affairs of England. In *Brytannicae Republicae Synopsis* (Cat. no. 169) Dee used the device of a large flow chart to identify the problems facing the nation and his suggested solutions. Among the many sections, his one on the navy notes that England should be maintaining at least twenty-five extraordinary ships (those in commission) and twenty-five ordinary ships (those laid up in port) in addition to merchant vessels. This was considerably more than was the current practice. This important manuscript was intended for private circulation among the political elite and was designed to influence the queen in crafting an active expansionist policy.

DEE'S MAGNUM OPUS, *General & Rare Memorials Pertaining to the Perfect Arte of Navigation*, of 1577 (Cat. no. 141) was dedicated to Hatton (Cat. no. 133), who exercised considerable influence as the queen's favourite and a newly appointed privy councillor. Here, Dee predicted the rise of the 'Brytish Impire' and saw that maritime supremacy, the colonising of new lands and the concomitant exploitation of local resources, were the ways that England could challenge Spain. *Brytanici Imperii Limites* (*The Limits of the British Empire*), written in the late 1570s, outlined Dee's belief in Elizabeth's rights over most of the seas and a large amount of land in the northern hemisphere. He used explorers' first-hand accounts, ambassadors' letters and family histories to support his conclusion. This work, along with an accompanying map (now lost), summarised his claims and was presented to the queen and her ministers.[2]

IN ADDITION TO his writings on imperialism, Dee was also a great advocate of improving navigation in England. At the outset of Elizabeth's reign, English sailors had little experience of ocean sailing and had to be taught unfamiliar methods of celestial and solar navigation. The state of English seamanship in the mid-sixteenth century was limited compared to the achievements of Portuguese and Spanish sailors. However, key Portuguese and Spanish maritime texts were beginning to be translated in the 1550s. Increasingly, maritime texts were being written and published by Englishmen themselves, such as the physician Robert Record's *The Castle of Knowledge* in 1555, a key treatise on the sphere (Cat. no. 142), which was probably written for the use of the Muscovy Company's navigators. Later in Elizabeth's reign, associates of Dee published widely

disseminated and influential works, such as trained gunner William Bourne's technical manual on the sea, *A Regiment for the Sea* (Cat. no. 139), which was first published around 1576. These works were carefully dedicated to key patrons who were courtiers and thus useful political agents in promoting maritime interests.

FROM THE 1570s, imperial ambitions were manifested in attempts to search for the North-West Passage to establish English sea routes to the lucrative eastern markets and the colonisation of America. Enterprising individuals of means, with tacit state approval but no state finance, were effectively the organs of imperial ambition. Elizabeth's adventurers, however, were primarily motivated by self-interest. This often meant short-term exploitation of local resources — something that Elizabeth herself appeared to support, as she occasionally invested in ventures with the hope of making money quickly. Nevertheless, the great propagandist of colonisation, Richard Hakluyt the Younger, argued that such ventures had to be a state enterprise; his ideas were nationalist, Protestant and, of course, anti-Spanish to the core.

THE MOST SUCCESSFUL seafaring nations, Spain and Portugal, had claimed the seaways around Africa and through the Strait of Magellan which were the only navigable routes to the rich markets of China and the East Indies. This blocked other seafaring nations like the English, and later on the Dutch, from trading directly with the eastern markets. Contemporary geographical knowledge suggested that there were two possible alternative routes: the North-East Passage which led to China, or 'Cathay', above Asia, and the North-West Passage above America. Although both these routes through a harsh icy landscape that freezes over for much of the year are possible, they came to be discarded as viable commercial seaways because of the immense difficulty in traversing them.

IN RESPONSE TO the existing economic and religious Iberian monopoly, a growing number of English men such as Dee, Humphrey Gilbert and Anthony Jenkinson of the Muscovy Company began to debate the existence of navigable northern

Atlas Sive Cosmographicæ . . ., 1595 (see Cat. no. 170). Mercator's map of the Arctic,
showing navigable North-West and North-East passages. National Maritime Museum, London.

passages to the East. This would give England an exclusive out-
let for its woollen goods and with this increase in trade would
come wealth and domestic security. Although approaches by
way of the North-West Passage and straight across the North
Pole were considered, the North-East Passage was attempted
first. This Arctic sea route was thought to lead into the Pacific
Ocean, via a relatively short route to the north of Europe and
Asia through what is now called the Bering Strait. A new

trading passage to the East could then be established, without
transgressing Spanish or Portuguese territory.

WITH THE CRUCIAL support of London merchants,
Englishmen opened up Russia for trade by sea in the 1550s.
Richard Chancellor and Sir Hugh Willoughby set off in 1553,
under the patronage of Elizabeth's brother Edward VI, on a
pioneering journey to China via the North-East Passage. As

123

they passed Greenwich '. . . courtiers came running out . . . the Privy Council they looked out at the windows of the Court and the rest ran to the tops of the towers'.[3] Great ambitions soon turned to desperation for Willoughby, as he and the crews of two ships were forced to overwinter on the ice. Despite frantic attempts to reach safety, they all perished of hunger and cold. Chancellor, in the third ship, managed to reach the Russian coast and encountered representatives of the Russian tsar Ivan the Terrible. Rather than exploring new lands, Chancellor accepted their offer to meet the tsar in Moscow and journeyed there by sledge on an epic 1,500-mile overland trip. The riches of Moscow impressed him and formal relations were set up with the English crown to develop trade with Russia and Persia by way of a northern route. In Elizabeth's reign, the port of Archangel in the White Sea was founded to handle this new trade and the Muscovy Company facilitated Elizabethan relations with Russia. Anthony Jenkinson was the most successful of the Company's merchants and duly became the queen's ambassador to the Russian court. Elizabeth was an investor in the Muscovy Company along with many others and intervened whenever the English monopoly was under threat. But, unlike Elizabeth, Ivan had ambitions for a political alliance and considered England as a potential place of future exile and the queen as a prospective wife. Elizabeth deftly avoided overcommitting England.

NOT UNTIL AFTER attempts to find the North-West Passage had failed did the Muscovy Company fund another attempt to seek a north-eastern route to China. John Dee advised the voyage of Arthur Pet and Charles Jackman in 1580. The instructions this time were to find the most direct route and the ships were also laden with goods designed to appeal to the Chinese market. Once again, English attempts to penetrate the icy sea route failed, yet it attested to the increase in English maritime confidence that such a focused expedition was attempted.

IT WAS DURING the first two decades of Elizabeth's reign that the search for a North-West Passage was vigorously advocated. In the mid-1560s Humphrey Gilbert wrote a lengthy pamphlet, *A Discourse of a Discoverie for a New Passage to Cataia*, in which he argued 'from reason' that the passage existed and then listed the benefits to England, such as creating a new market for English cloth and establishing new settlements along the passage.

THE TWO CHAMPIONS of the English claim to northern North America were the sometime privateer, Yorkshireman Martin Frobisher (Cat. no. 174) and Michael Lok, the London agent of the Muscovy Company. In 1574, this uneasy partnership sought backing for a pioneering voyage to discover a North-West passage and establish a trade route to the East. Dee was brought in to teach Frobisher and some of his crew the use of mathematics in navigation, and he recommended works on cosmography and navigation to be acquired for the voyages, such as his Mercator's 1569 atlas showing a mountain at the North Pole, surrounded by a circumpolar continent (Cat. no. 170), and Ortelius's widely distributed first commercial atlas of 1570 showing a navigable passage. Such geographical misconceptions were common at this time.

IN JUNE 1576 FROBISHER and his men departed in three small ships from Greenwich, where the queen was in residence at the palace. The ship's navigator, Christopher Hall, describes the departure: 'we shot off our ordnance and made the best show we could. Her majesty . . . bade us farewell, with shaking her hand at us out of the window.'[4] Between 1576 and 1578, three voyages under Frobisher sailed across the Atlantic Ocean to south-east Baffin Island. The land was claimed for Elizabeth, who later named it 'Meta Incognita' (unknown boundary).

FROBISHER'S ENTERPRISE, which was originally intended as a voyage of discovery, soon descended into rash speculation and the abandonment of searching for a passage to the East. When the first expedition returned to London, a 'token of possession' – a piece of black stone collected from the first Arctic landfall – was analysed and claimed to contain gold and silver (Cat. no. 175).[5] Despite meagre evidence, the court and the City of London were soon keen to back Frobisher's next Arctic venture, evidently spurred on by Spanish experience that America was replete with precious stones and minerals. Frobisher's confident talk of finding the passage soon gave way to the more lucrative goal of exploitation in 1577. Elizabeth

herself was hoping for huge returns having invested £1,000 in the venture, partly met by donating one of her naval vessels — the *Aid* — to the expedition.

THE SECOND VOYAGE in 1577 set sail to bring back further ore deposits, abandoning the search for a new trade route. The last voyage in 1578 comprised fifteen ships and more than 350 sailors, soldiers and miners; this was the largest expedition to the area prior to the twentieth century. Irrespective of the barren landscape, men mined and transported a total of almost 1,400 tons of black ore back to England. The unfortunate irony was that the ore proved to be worthless. The investors lost out as the expedition became saddled with huge debts. This was the first North American gold rush and the expedition's failure brought about angry condemnation.

DESPITE THE FAILURE of Frobisher's expeditions, they were well documented and made the first and most explicit English claims to northern North America. This documentation includes drawings of a captured Inuit man, woman and child (Cat. no. 176) who were transported to England in 1577 after relations with the indigenous people became hostile. They caused a sensation. Although we do not know exactly when or where they were drawn, we do know that the artist was John White, who later documented the indigenous peoples encountered on one of the Roanoke voyages.

AFTER FROBISHER, John Dee became involved in a later attempt to reopen the search for trade routes via the North-West Passage during the 1585–7 voyages of John Davis. Davis is attributed with the invention of the backstaff (Cat. no. 144) and was the author of *Seaman's Secrets* (Cat. no. 140), the first English book on navigation by an English professional sailor. Towards the end of the reign there was a renewed interest in the fabled North-west Passage but ultimately neither navigable northern trade routes nor Arctic settlements were to be Elizabethan achievements.

THE FIRST ENGLISH CIRCUMNAVIGATION

AT ABOUT NOON ON Sunday 1 March 1579, Francis Drake sighted the Spanish merchant ship, *Nuestra Señora de la Concepción* some four miles off the Peruvian coast at Cabo de San Francisco. The Spanish ship was sailing from Callao de Lima to Panama, transporting silver from the Peruvian mines destined for the treasury of Philip II of Spain. Drake, captaining a captured Spanish ship, deliberately slowed his vessel by trailing ropes and mattresses astern so as not to alert his prey. He eventually came alongside the *Nuestra Señora* as darkness fell. After a brief exchange of words, initially in Spanish as Drake maintained the friendly pretence, Drake opened fire at close range, crippling the ship. The wealth of silver, gold and other valuables on board the Spanish ship surpassed even Drake's expectations. The treasure included 360,000 pesos in silver bars, coins and gold. In addition, the ship carried a vast quantity of uncoined silver as ballast. The total value of the haul was immense, and if Drake could return safely home with his prize, he would be a very rich man.

IT WAS SIXTEEN MONTHS since Drake had left Plymouth, commanding a fleet of five ships and about 170 men. His voyage appears to have been primarily piratical and anti-Spanish in design, Spain being a country with whom England had fast-deteriorating relations. Since leaving Plymouth on 15 November 1577 the fleet had made its way south along the west coast of Africa to the Cape Verde Islands, crossing the Atlantic and sighting the coast of Brazil on 5 April 1578. The fleet then made its way south into the Pacific by way of the Strait of Magellan. This was new territory for English sailors, for they were now able to use charts conflating numerous Spanish and Portuguese sources that were beginning to be circulated more widely through European cartographers such as Ortelius and Mercator. It is thought that Drake carried with him Ortelius's world map of 1570 and accounts of Magellan's famous circumnavigation of 1519–22. One of Drake's crew, Francis Fletcher, made notes of the voyage, now lost. However, a later copy made by John Conyer included a map of the Strait of Magellan (Cat. no. 154), which demonstrates the crude understanding of the geography of this area. Fletcher was a chaplain who appears to have been sent by Francis Walsingham,

Elizabeth's vociferously anti-Catholic principal secretary and one of the financial backers of the enterprise. One of Elizabeth's most influential advisers, Walsingham was well aware of the tremendous value of such information in an age when charts were secret and highly prized, potentially the key to unlock the riches of hitherto unexplored continents. In addition John Dee thought that *terra australis* might be home to the mythical Land of Ophir and King Solomon's riches.

DRAKE CONTINUED HIS voyage northwards hugging the coasts of Chile and Peru, plundering Spanish shipping virtually at will and sacking settlements that formed the lightly guarded extremity of Philip's Spanish empire. Drake obtained information about the movement of Spanish ships carrying treasure from the Peruvian ports to Panama, where it was destined to be carried overland by 'mule train' to the Caribbean port of Nombre de Dios, ready for shipping to Spain. This information was gathered from the luckless crew of the captured Spanish ships, sometimes by the use of extreme force as in the case of Francisco Jacome, who was hanged by the neck and then dropped into the sea but survived to tell the tale. It was by these means that Drake finally learned of the *Nuestra Señora de la Concepción*, just one of countless ships carrying unimaginable wealth that swelled the treasury of Spain.

ALTHOUGH DRAKE WAS the commander of the piratical fleet he was not acting alone. Such an operation required considerable planning, financial backing and ultimately the tacit approval of the crown to maintain the fine line between privateering and illegal piratical activity. It is likely that Drake's founding partner in the enterprise, Thomas Doughty, who was Christopher Hatton's private secretary, used his master's influence to present their case to the privy council and the queen. We know the initial strategy for the enterprise, and the names of some of the most influential backers who helped fund the voyage from the remains of a document known as the 'Draft Plan'. Investors included at least three members of Elizabeth's council: the earl of Lincoln, who was lord admiral, the earl of Leicester, and Christopher Hatton. Drake's personal investment is listed as £1,000. The 'Draft Plan' outlines the

purpose and general route to be taken by the fleet and that 'he is to returne the same way home wards as he went out'.[6]

THIS WAS PROBABLY a briefing note prepared for Walsingham, or directly for Elizabeth. The men of rank and influence who backed Drake were part of the inner circle of Elizabeth's court. They would have known that not only was the venture potentially lucrative for investors but that the return would be at the expense of the Spanish crown rather than from the trading efforts of Drake's fleet. The fact that the venture would therefore injure Spanish interests suited many of the privy councillors' interests, particularly Walsingham, although it is clear that Lord Burghley steered clear of involvement and refused a share in the eventual proceeds. The extent of Elizabeth's knowledge of the venture is difficult to ascertain. Drake's version, retold by his associate John Cooke who sailed with the fleet aboard the *Elizabeth*, states that Drake was brought before the queen by Walsingham:

> There was I very shortly after and in an evening
> sent for unto her majesty by secretary Wallsingham,
> but came not to her majesty that night, for it was
> late, but the next day coming to her presence, these
> or the like words 'Drake so it is that I would gladly
> be revenged on the King of Spain for diverse
> Injuries that I have received'.[7]

IT IS UNLIKELY THAT Elizabeth would have risked direct involvement in the venture, as it was evidently a voyage of piracy against a kingdom against which no official hostilities had been declared. In fact, deliberate misinformation was fed to the court giving the impression that Drake was sailing to the Mediterranean. This fooled nobody, least of all the Spanish, whose spies reported back to Philip's envoy, Antonio de Guaras, that 'Francis Drake is going to the Antilles . . . It is important to know the location in order to send them to the bottom of the sea.'[8] However, this pretence put about the court went some way towards protecting Elizabeth from Spanish accusations of complicity.

ALTHOUGH THE 'Draft Plan' stated that Drake was to retrace his route homewards, indicating that there was no plan of

circumnavigation, it was difficult for him to do this. Word of Drake's piratical activities both on shore and at sea had spread and such forces that were at Spain's command at the fringes of its empire were hot on his trail. In April 1579 Licentiate Valverde, representing Spanish colonial authority in Guatamala, wrote to Philip informing him that a Spanish Armada sailed in search of Drake. He speculated that Drake would follow one of four possible routes home. The most likely was that Drake would retrace his outward route. He also suggested that Drake might try to find the Straits of Anian, the North-West Passage to the north of America thought navigable at that time, or complete a circumnavigation by crossing the Pacific.[9] Clearly the Spanish thought that a circumnavigation by way of 'China' was impossible for the Englishman. However, the Spanish changed their minds when they realised that Drake had on board a captured Portuguese pilot, Nuño de Silva, and had interrogated several captured Spanish pilots and stolen their charts of the Moluccas (Philippines).

DRAKE'S ROUTE TOOK him northwards along what is now the Californian coast. It is unlikely that he was searching for a passage home across the north of the American continent, rather that he was provisioning before making the six-week journey across the Pacific. Later depositions by Nuño da Silva showed that Drake deliberately set out to confuse the Spanish; 'While in the port of Guatulco he produced a map and pointed out a strait situated 66 degrees north saying that he had to go there, and that if he did not find an opening he would have to go back by way of China'.[10] The northernmost extent of Drake's voyage has been widely disputed, and evidence such as 'china' porcelain reputedly in Elizabeth's possession that matches shards found at Drake's Bay (38° N) supports one theory about the latitude achieved by the fleet (Cat. no. 155). After equipping his ships for the voyage, Drake set out on what must have been the most daunting leg of the journey, crossing the Pacific armed with only Spanish charts and knowledge prised from Spanish pilots.

NEWS OF DRAKE'S activities first reached Philip in August 1579. Letters from the Spanish authorities in Panama advised that 'the general opinion is that this Corsair [Drake] is going to the Moluccas, so as to proceed by the route which the

Portuguese follow'.[11] Philip's advisers exhorted him to press Elizabeth for the return of the treasure. Philip's note in the margins of the letter states 'Before the Corsair reaches England it is not expedient to speak to the Queen. When he arrives, yes. Investigate whether it would be wise to erect a fortification in the Port [strait] of Magellan.'[12] There was evidently still some doubt in Spanish minds as to whether Drake really could return by circumnavigating the globe, as after all only the ships of Ferdinand Magellan had been known to have accomplished this feat.

ULTIMATELY THE ACTIVITIES of 'the Corsair' were little more than an irritation to Philip whose interests spanned half the globe, and within the year would extend still further to include the Portuguese empire in the East. Nonetheless, they were an attack on Philip's reputation and he had to act. When Drake returned triumphantly to England on 26 September 1580 by way of the Moluccas (Cat. no. 156), thereby encircling the world, Elizabeth was met with Spanish demands for restitution. Elizabeth repaid some individual Spanish merchants who proved that Drake had robbed them, but much to Philip's dismay Drake's activities were not condemned. Drake was allowed to keep £10,000 of the looted Spanish treasure, while the majority went to the crown's coffers after the investors had been repaid at least fortyfold. Drake was lionised and, on 4 April 1581 after a huge banquet at Deptford on board the *Pelican*, which had been renamed the *Golden Hind* in honour of his patron Sir Christopher Hatton, he was knighted. It is possible, however, that Philip's displeasure still troubled Elizabeth, because it is said that she handed the sword to an agent of the duke of Anjou, her French suitor, to bestow the knighthood. The public knighting of Drake was, nonetheless, a major provocative gesture which helped convince Philip that Elizabeth was his enemy well before she actually sent troops to fight against him in the Netherlands.

ELIZABETH'S REACTION to English 'imperial' achievements, such as Drake's circumnavigation, can be perceived when she received a pair of impressive globes that were specifically dedicated to her in 1592. These £1,000 globes were the first terrestrial and celestial globes to be made in England by an Englishman, Emery Molyneux. He had sailed with Drake to

the West Indies and used the experience to correct earlier erroneous distances across the Atlantic. The terrestrial globe (Cat. no. 131), features the routes of Englishmen like Drake, Frobisher and Thomas Cavendish, who in 1588 matched Drake's achievement in circumnavigating the world. The globes, with the royal arms emblazoned across North America on the terrestrial globe, were first presented to Elizabeth at Greenwich.

THERE WAS SOME reluctance to recognise Drake's achievements officially, partly owing to the circumstances under which he had brought such wealth to England and where that wealth finally rested, but more importantly because knowledge of routes of sea navigation was power not to be given away lightly. Consequently no official publication of Drake's circumnavigation was made for many years, occasioning him to complain to the queen that reports of his voyage had been silenced, and leading Mercator to accuse the English authorities of a cover-up. The most complete account of what has today become one of the most enduring stories of English seafaring was published in 1628, based on the original accounts of Fletcher.

COLONISING AMERICA

THE FIRST SERIOUS colonising projects, or 'plantings', were planned in the 1580s. The agents behind these voyages were a small number of Elizabethan gentlemen for the most part connected by family or professional acquaintance, notably Walter Ralegh and his older half-brother Humphrey Gilbert. The colonisation of new lands would bring wealth and advancement in the form of revenues, taxes and rents and it was initially pursued, as in Ireland, in a martial rather than mercantile manner. Spanish dominion over large parts of the Americas meant a scramble for lands 'not actually possessed of any Christian prince or people', as they were described.[13] Although it was not beyond the imagination of English adventurers to seize territory held by the Spanish, this approach would have required permission from the crown and Elizabeth was too astute to be led into direct conflict with Philip in this way.

THERE WAS LITTLE difference between the 'planting' of Ireland and of America in the minds of those who initiated plans for American colonisation, with both offering cheap land and labour. However, the circumstances were very different. Ireland was already part of Elizabeth's kingdom but not effectively under her control, and it was state policy to replenish it with people of English birth in order to 'contain all parts in a perpetual subjection and civility'.[14] The principal protagonists of American colonisation, Philip Sidney, Humphrey Gilbert and Walter Ralegh were all involved in the planting of Ireland. The map of the province of Munster (Cat. no. 183) drawn up in 1587 demonstrates how confiscated lands were dispersed amongst leading figures of the English court such as Ralegh and Hatton in a virtually feudal manner. Elizabeth's letter of 11 June 1567 to Sir Henry Sidney, father of Philip Sidney, refers to 'our full resolution for planting of people in Ulster' and goes on to charge Henry Sidney with responsibility as 'the principal minister for the execution of the same'.[15] Gilbert's service in the planting of Ireland between 1566 and 1570, ruthlessly implementing the policy to establish English rule, equipped him with the confidence to apply for a patent to establish a colony in America.

IN JUNE 1578 ELIZABETH granted Gilbert royal permission to 'discover, search, find out and view such remote heathen and barbarous lands countries and territories not actually possessed of any Christian prince or people . . . '.[16] Prior to this petition Gilbert had met and consulted with John Dee and it is likely that he was working up the proposal to the queen with Dee's assistance. Gilbert's enterprise had considerable support. He had commissioned Richard Hakluyt to collect documentary evidence on America which was published in 1582 under the title *Divers voyages towchinge the discovey of America* (Cat. no. 184), dedicated to Philip Sidney. This was a work of propaganda designed to attract the interest of potential financiers and adventurers. Both Sir Henry and Philip Sidney were listed as adventurers on Gilbert's last voyage with Sidney paying for the rights to three million acres of land under Gilbert's patent. Gilbert's first voyage, however, ended in disaster when the fleet of seven ships was dispersed by a combination of bad weather, independent-minded captains with a privateering eye for Spanish prizes, and inadequate

Map of the Province of Munster (detail) (Cat. no. 183). The English estates are clearly marked.
National Maritime Museum, London [E9078].

organisation and leadership. Gilbert's subsequent attempts to establish a colony on the eastern coast of North America were doomed to failure. Gilbert drowned on his last attempt in 1583 when all but one of a fleet of five ships were lost. A verse from Thomas Churchyard's poem in celebration of Gilbert's 1578 voyage summarises the desperation of Gilbert's maritime exploits:

And still a fulsome smell
Of pitch and tarre they feele,
And when Seasicke (God wot) they are,
About the shippe they reele,
And stomake belcheth up,
A dish that Hadocks seeke,
A bitter messe of sundry meates,
A Sirrope green as leake.[17]

Ralegh had sailed with him on the 1578 venture in command of the *Falcon*. Subsequently Ralegh had caught the attention of the queen and by the time of Gilbert's death he was a figure of some prominence at court. In 1584 Ralegh was granted a patent transferring Gilbert's rights that gave him control of territory up to 600 miles north and south of his prospective settlement in America.

AN INITIAL RECONNAISSANCE voyage in 1584 convinced Ralegh that a colony should be planted at Roanoke, but that this would be expensive and ideally should be funded by the state. Ralegh gathered around him the pro-colonisation intellectuals of the day, including figures such as Thomas Harriot who participated in the voyage, and Richard Hakluyt the Younger. Harriot also set about learning the Algonquin language from two Indians, Manteo and Wanchese, who had been captured and brought back to England on the voyage of reconnaissance. Hakluyt composed the *Discourse of Western Planting* for Ralegh to present to Elizabeth as the basis for funding for his next voyage. Supported by Walsingham, Hakluyt composed a cogent argument for the colonisation of America that summarised the political, economic, military and religious advantages of such an enterprise. It sets out twenty key arguments, the first referring to 'th'enlargement of the gospel of Christ whereunto the Princes of the reformed religion are chiefly bound'.[18] The *Discourse* goes on to explain how the project will solve the unemployment problem, curtail Spanish activity and assist discovery of the North-west passage, and it makes the case for England's prior legitimate claim on America as argued vigorously by John Dee. Elizabeth, however, offered verbal encouragement but not the royal purse, and Ralegh's comment that 'Private purses are cold comfort to adventurers' is testament to his frustration.[19] Elizabeth's empire in America was to be initiated by the enterprise of private adventurers, not the state.

THE FIRST TRIAL COLONY landed at Roanoke in July 1585 (Cat. no. 185). It was clear from the outset that the colony, numbering 107 people under the command of Ralegh's appointed leader, Colonel Ralph Lane, was dependent on trading with local Indians, and within a year it was abandoned.

Lane commented that 'only with the discovery of precious metals or a route to East can this country in request be inhabited by our nation'.[20] Clearly Lane's expectations of easy wealth based on Indian treasure were unfulfilled, but a unique record of America returned with Thomas Harriot and John White, scientific adviser and artist respectively with the trial colony. White's drawings (Cat. nos. 185–90) have been described as the 'first naturalistic landscapes to be executed by an English artist'.[21] Both text and drawings attempt to catalogue and quantify the flora, fauna and topography taxonomically, unmediated by a narrative or chronology more commonly employed. Harriot's text, *A briefe and true report of the new found land of Virginia*, was published in 1588. It classifies products from the new world into three broad groups, the first being 'merchantable commodities' such as hemp. The second group is those things necessary for 'sustenance of man's life', such as maize and turkeys, and the final group 'which specially concern building, as also some other necessary uses', for example pine trees suitable for ships' masts. Clearly the purpose of the report was to encourage investors and settlers in future planting ventures. Of the indigenous population Harriot says they 'are not to be feared, but that they shall have cause both to fear and love us'.[22] Here then is a fertile country ready for appropriation, but unlike Ireland, sparsely populated with a people that will be in thrall to the colonisers.

BY 1590, WHEN Theodor de Bry's *America* was published, with the inclusion of Harriot's text and White's drawings, the Roanoke enterprise was over. The attempt of founding a second colony led by John White in 1587 failed, although his grand-daughter, Virginia Dare, was the first newborn of English blood in Virginia. Ignoring Ralegh's instructions to sail further north to Chesapeake and safe waters, the colonisers returned to Roanoke. Ralegh's relief voyage of 1590, delayed by hostilities with the Spanish, found the colony missing with no trace of its inhabitants. To this day their fate is unknown, the subject of as much speculation now as it was four hundred years ago.

THE NOTION OF conquest of new lands and quick and easy wealth as imagined by the early protagonists of colonisation

Drawing of loggerhead turtle by John White (Cat. no. 189 (b)). British Museum, London.

was gradually to be replaced by the commercial realism resulting from the 1607 Virginia Company planting at Jamestown, the first permanent English settlement that eventually prospered from that 'merchantable commodity', tobacco. Similar realism led to the abandonment of the search for navigable sea routes to the north, and the first successful East India Company voyage to the East in 1601 following established southern routes. This was piloted by John Davis, veteran of the earlier North-West Passage attempt in 1585–7. The conspicuous increase in maritime confidence during Elizabeth's reign, together with the increasing business acumen of companies such as the Muscovy Company, Virginia Company, East India Company and others, eventually established England as a keen competitor on a global scale. Elizabeth witnessed the genesis of the British Empire, but it was the spirit and greed of her adventurers that laid its foundation.

Johannes Dee.
Anglus.
Londinensis
Æts suæ
67.

EXHIBITION
CATALOGUE
ENTRIES
131-191

131. a-b. Pair of Celestial and Terrestrial Globes, 1592 and 1592/1603

Emery Molyneux (d.1598/9).
Mixed media (papier mâché, plaster and printed paper).
The Honourable Society of the Middle Temple.

The first English printed globes were made by Emery Molyneux of Lambeth in 1592, possibly in collaboration with his friend, Jodocus Hondius (1563–1612), who lived in London from 1583 to 1593, before returning to Amsterdam to become one of the leading map and globe makers in the Netherlands.

Molyneux had made his name in July 1591, when he presented a manuscript terrestrial globe to the queen at Greenwich. According to an eyewitness account, provided by the Italian ambassador, Petruccio Ubaldini, the purpose of the globe was quite specific: '. . . the Dedication to the Queen has to be printed with the Royal Arms and its wording suggests that he gave her the globe to let her see at a glance how much of the world she could control by means of her naval forces'. He then added, rather enigmatically: 'This is a fact well worth knowing.'

The original 1592 commission for the printed globes was funded by Sir William Sanderson (whose name appears in a number of the cartouches on the globes), a successful merchant-adventurer, who had already funded a number of expeditions around America, including John Davis's search for the Northwest Passage and Sir Walter Ralegh's 'adventures into Virginia' in 1584 and 1590.

The terrestrial globe, dated 1592, shows the paths of several important voyages, including those of Drake (Cat. no. 132) and Cavendish and Frobisher (Cat. no. 174). Molyneux himself had sailed with Drake to the West Indies and used his experience to provide a correct assessment of the distance across the Atlantic Ocean.

The cartography for the celestial globe is based largely on the 52.5 centimetre celestial globe made by the Dutch globe maker, Jacob Floris van Langren. It shows the canonical forty-eight Ptolemaic constellations, as well as some of the newer constellations of the southern hemisphere, created by the Dutch cartographer Petrus Plancius. The decoration seems to represent a slightly amended version of the original 1592 plates, to which a number of alterations have been added in manuscript (including a date of 1603).

The early provenance of the globes is not clear but they are documented in the Middle Temple as early as 1717. One attractive hypothesis is that they came to the Middle Temple via one of Elizabeth's 'adventurers', as a bequest of one of the members of Elizabeth's inner circle, as a number of her closest associates, such as Ralegh, were Middle Templars.

EW & KL

LITERATURE: Clifton, 'Globe Making', pp. 46–7; Crinò and Wallis, 'Molyneux Globes', pp. 11–18; Lippincott , 'Power and Politics', p. 138.

Opposite: The royal arms emblazoned across America.

himself. For this he received a knighthood. In 1585–6 he was sent by Elizabeth on a major expedition to the West Indies followed by a daring raid on Cadiz in 1587, capturing the silver ship the *San Felipe* on the way back. During the Armada campaign Drake was a vice-admiral with a force of thirty-nine ships. In 1589 he was joint leader of a disastrous expedition to Portugal and he only returned to favour in 1594.

Drake is portrayed here during this period but with the accessories denoting his fame and achievements. The globe refers to his circumnavigation. The jewel given to him by Elizabeth, containing her miniature by Nicholas Hilliard, hangs at his waist (Cat. no. 158). The coat of arms, granted to Drake by Elizabeth in 1581, is shown in an incomplete form; the upper part depicting a ship under sail drawn by a hand appearing from clouds is either omitted or painted out. It has been suggested that Drake did not approve of this part of the design, possibly objecting to his skill in seamanship being secondary to divine aid. He did not use this version of the crest on his official seal, nor does it appear on the National Maritime Museum portrait. Beneath is his motto which alludes to his humble origins: in translation 'Thus great things arise from small'. There is no reason to doubt that the portrait is by Gheeraerts and that it is an earlier version of the one formerly at Buckland Abbey dated 1594 (in which the arms and crest are complete).

Gheeraerts had been brought to England by his father, Marcus the Elder. Early portraits suggest that he had travelled in the Low Countries. From c. 1590 he became the most fashionable portrait painter of the day under the patronage of Sir Henry Lee (Cat. no. 76). RQ & DSp

LITERATURE: Kelsey, *Sir Francis Drake*; Hampden, *Francis Drake, Privateer.*

132. Portrait of Sir Francis Drake, 1591

Marcus Gheeraerts the Younger (1561–1635).
Oil on canvas.
116.9 x 91.4cm.
Inscribed: 'SIC PARVIS MAGNA' with arms of Drake, dated 1591.
National Maritime Museum, Greenwich, Caird Collection
 BHC2662.

From humble beginnings in Devon, Francis Drake (c. 1540–96) had early experience at sea with John Lovell and his cousin John Hawkins (Cat. no. 135). He began his outstandingly successful career as a privateer in 1570. His voyage round the world, 1577–80, was under-written by Elizabeth, and he raised £160,000 for the treasury by carrying out raids on Spanish ships and ports, keeping a percentage for

133. Double-Sided Painting with a Portrait of Sir Christopher Hatton, c. 1581

Ascribed to the workshop of William Segar (fl.1585–1633)
Oil on panel (double sided).
96 x 72.3cm.
Inscriptions Recto: top centre: 'TANDEM SI' (if at length); bottom centre: 'Si Spesmea' – (if my hope); top left corner: 'NATUS EXARATUS INHAMATUS' (born, created, buried); top right near coat of arms: 'Miles Creat 9 / 15' ; top left near edge: 'DIC Mensr Anno' (This table speaks the year ?); bottom left upon scroll from artist: '[AE]ternitati pinxit' (eternity painted it); bottom right upon scroll from figure: '[AE]ternitati Finit' (eternity made it). Verso: top panel left: 'TEM'; top panel right: 'PVS' (Time); centre panel left: 'ACHESIS TRAHIT' (Lachesis draws out the thread); bottom panel: 'DIALOGUS DE TEMPORE / cuius opus; quondam

Back (verso) of the panel connected to Sir Christopher Hatton including an emblem of Father Time, c. 1581.

lysippi dic mihi guis tu; tempus quidnam operae / est tibi; cuncta domo, cur tam summa tenes; propero super omnia / pernix, cur celeres plantae; me leuis aura vehit cur tenuem tua dextra / tenettonsoria falcem; omnia nostra fecans redit acuta manus, cur tibi / tam longi pendent a fronte capilli, fronte guidem facilis sum bene fosse / capi cur tibi posterior pars est a vertice calva; posterior nemo / prendere me poterit, talem me finxit quondam sytoinius hospes, et / monitorem hoc me vestibulo posuit, pulchrum opus artificem laudat / pro juppiter o guam, debuit hoc pigros sollicitae viros.' (Dialogue of Time Whose work? Once of Lysippus. Tell me who you are? Time. What is your work? I overcome all things. Why are you poised on tiptoe? I am swift, I hasten upon all. Why hast thou wings on your feet? The swift wind carries me. Why does your barber's right hand hold a slender knife? The sharp cutting hand shaves every thing of ours. Why does your hair hang so long from your forehead? Indeed, for him who meets me to take me by the forelock. Why in heaven's name is the back part of your head bald? Because no one can seize me from behind. The visitor sycion once fashioned me such, for your sake stranger and placed me in this entrance court as a lesson. A work of beauty praises the creator. O Jupiter O that this was destined to stir up lazy men.'

Provenance: sold at Christie's 1929. Purchased the same year from Algernon Tudor Craig.

Northampton Museums and Art Gallery.

This unusual painted panel has at the centre of one side a portrait of one of Elizabeth's favourites, Sir Christopher Hatton (1540–91). Why this painting was commissioned is unknown, but it was probably set up where visitors could see both sides, at one of Hatton's main residences, either Ely House in London or at Holdenby House in Northamptonshire.

Hatton's meteoric rise to power from being a member of the Northamptonshire gentry to a gentleman of the privy chamber, privy councillor and eventually lord chancellor of England was mainly due to his close relationship with the queen. Elizabeth rewarded his loyalty with grants of substantial estates as well as large annual gifts of gilt. As well as succeeding as a courtier, Hatton played an active part in political life: for example, he was a leading spokesman in the council against the Anjou marriage during 1579 (Cat. no. 74) and helped bring Mary Stewart to trial in 1586 (Cat. no. 233). In religion, he was conservative and opposed puritan attempts to change the Elizabethan Prayer Book.

Hatton was a great patron of the arts, and works by William Byrd, John Dee and Edmund Spenser were all dedicated to him. He was also an enthusiastic supporter of maritime adventurers and, like Dee (Cat. no. 165), saw the exploration of new lands as a means to uphold Elizabeth's imperial claims. He provided support for Martin Frobisher's ill-fated attempt to discover the North-west Passage and heavily invested in Drake's voyage of 1577. Drake honoured his patron by choosing Hatton's emblem, the golden hind (seen painted at the top of his coat of arms) as the new name for his ship, the *Pelican*.

This painting demonstrates some of the interests of courtiers educated within the humanist tradition and includes a complex mix of astrology, pagan mythology and a passion for emblems. The portrait side acts as a kind of register of Hatton's worldly achievements, while the reverse warns of the need to consider passing time and thus man's mortality. Encircling the portrait are representations of an astrological chart which have been taken to represent a date in time in December 1581 (Beer). The reverse side depicts a series of painted emblems including Father Time who speaks in the dialogue recorded in the text at the base. The central section might be read as emblems of different phases of Hatton's life. They show: a dancing couple (Hatton was renowned for his skill in dancing, attracting the queen's attention at a masque), a woman representing Lachesis, the second of the three Fates (shown

spinning out the span of a man's life), and finally a golden chalice surrounded by a burst of light which may represent the human soul. This image with its set of puzzle-like emblems and Latin text, interpretable only to the learned elite, would have offered an amusing diversion with a serious message for Hatton's visitors.　　TC

LITERATURE: Cooper, 'Memento Mori', ii, pp. 322–7; Cooper, 'Portraiture'; Beer, 'Astronomical Dating'; Vines, *Hatton*. We are grateful for access to unpublished notes at the Northampton Museum and Art Gallery and invaluable advice from Lucy Gent.

1550. Although he was deprived of the post in 1553 on Mary I's accession, she reappointed him in 1558 after other services. He remained admiral under Elizabeth, actively into the 1560s and thereafter as a member of the council. She created him earl of Lincoln in 1572 and he was also an investor in voyages of privateering and colonisation. He had a stake in Drake's round-the-world voyage of 1577–80 and probably in Humphrey Gilbert's expedition to America in 1578. When the latter failed, he was one of those charged with inquiring into the causes. This portrait of about 1575 shows him wearing the chain of the Order of the Garter (appointed 1551).　　PvdM

134.　Portrait of Edward Fiennes de Clinton, 1st Earl of Lincoln, c. 1575

British School.
Oil on panel.
61 x 51cm;
Provenance: Lincoln collection.
National Maritime Museum, Greenwich, BHC2841.

135.　Portrait of Sir John Hawkins, dated 1581

British School, sixteenth century.
Oil on panel.
Inscribed: 'AETATIS SVAE 44 ANNº. DNI. 1581 Sr. JOHN HAWKINS'.
62 x 52cm.
National Maritime Museum, Greenwich, BHC2755.

Clinton (1512–87) held high positions through four reigns. He began as a courtier of Henry VIII and became lord admiral to Edward VI in

John Hawkins (1532–95) was an adventurer, admiral, administrator and the architect of the Elizabethan navy. He began his career following his

family into the trade with Africa. On a voyage to Hispaniola in 1562, Hawkins captured and transported around 300 Africans, becoming one of the first Englishmen to be involved in the slave trade. Despite complaints from Spain and Portugal about the infringement of their trading monopolies, Hawkins led a second slaving voyage in 1564–5. He received backing from prominent merchants and Elizabeth I, who lent Hawkins a royal ship. The voyage yielded a great profit through the sale of Africans to the Spanish colonists. A third voyage in 1567–8, which included Frances Drake, was far less successful, with the royal ship, the *Jesus of Lubeck*, captured by the Spanish off the Mexican coast.

Hawkins now embarked on a career in naval administration. In 1577 he succeeded his father-in-law, Benjamin Gonson, as treasurer to the navy and in 1589 also became comptroller, with responsibility for the manning, design and maintenance of royal ships. These key Navy Board posts gave Hawkins huge scope to rebuild and reorganise the Elizabethan fleet through the replacement of Henry VIII's ageing vessels with faster, better-armed ships. At the same time he sought to improve the pay and conditions of English seamen. The sash around Hawkins's neck supports a signet of office.

Hawkins commanded the *Victory* in action against the Spanish Armada in 1588 and was knighted during the battle. In 1595, the sixty-three-year-old Hawkins took joint command with Drake of another expedition to the West Indies, which was marred by disputes between the commanders. Hawkins contracted dysentery and died in November 1595 off the coast of Puerto Rico. He was buried at sea. RB

LITERATURE: Andrews (ed.), *Last Voyage*; Loades, *Tudor Navy*.

136. Models of English Ships

(a) Warship, c. 1580

Unknown.
Reconstruction model built at a scale of 1:120.
Provenance: recorded as being made for the Great Exhibition of 1851.
National Maritime Museum, Greenwich, SLR0236.

(b) English merchantman, c. 1580

F.C.P. Naish, 1950.
Model reconstruction built at a scale of 1:60.
National Maritime Museum, Greenwich, SLR0326.

By the middle of the sixteenth century, the true fighting ship was beginning to emerge in which the ordnance was mounted on gun-decks within the ship. This greatly improved the ship's stability as the heavier cannons were nearer the waterline on the lower gun-deck, with the lighter demi-cannons, culverins and sakers on the decks above. In order for the guns to be fired, gun-ports were cut through the ship's side.

(a)

(b)

Model (a) represents a warship of about 140 feet in length by 36 feet in the beam and 1,000 tons in weight. Normally manned by a crew of about 250 men, the sailing qualities of these ships greatly impressed the officers of the Spanish Armada during their first encounter off the Lizard in 1588.

During the late sixteenth century, smaller merchant ships were being built incorporating the improvements by John Hawkins. He lowered the height of the superstructure at the bow and stern, which reduced the effect of the wind against the hull. This improved the ship's stability as well as its sailing qualities. Model (b) is based largely on the manuscript, *Fragments of Ancient English Shipwrightry*, thought to have been the work of Mathew Baker and produced in about 1586. It comprises a series of workings and drawings showing the shape of the hull, sail plan and decoration of an Elizabethan warship. The model illustrates a ship measuring approximately 68 feet in length by 19 feet in the beam and a weight of 100 tons. It was in a ship of this size that Drake made his famous circumnavigation of the world from 1577 to 1580. SS

137. *De Magnete (About the magnet)*, 1600

William Gilbert/Gilberd (1544–1603).
Printed book published by Petrus Short London.
National Maritime Museum, Greenwich, PBN8138.

William Gilbert, or Gilberd, was physician to Elizabeth I and present at her death. In 1588, he had been one of four physicians appointed to look after the health of the men of the Royal Navy. But his interests extended far beyond medicine, into magnetism, electricity and cosmology. The results of his research into magnetism were published in *De Magnete*, often described as the first great scientific book published in England. Gilbert put forward a new idea to explain the magnetic phenomena he observed – that the earth itself is a huge magnet. He also described the experiments which had led to his conclusions, in such a way that the reader could repeat them. The use of the magnetic compass in voyages of exploration had prompted growing interest in magnetism and Gilbert's work was the starting point for many subsequent studies. Gilbert wrote in Latin, as was usual among scholars at that time.

GC

138. Terrella, c. 1600

Maker unknown.
Silver case containing magnetite.
National Maritime Museum, Greenwich, AC01368.

William Gilbert was the first person to publish a complete theory to explain all the magnetic movements which were then known. He was also the first to use a series of carefully devised magnetic experiments to explore the problem. The terrella was an instrument which he described and illustrated in his book *De Magnete* (Cat. no. 137). He also coined the name 'terrella', meaning 'little Earth'. It was designed to show that the Earth acted as a large magnet and to assist in Gilbert's research. A sphere of magnetic ore is hidden inside a small silver globe, marked with twelve meridians of longitude and sixteen parallels of latitude, eight on each side of the equator. After the publication of Gilbert's work, similar terrellae were used by other scholars interested in studying magnetism.

GC

139. *A Regiment for the Sea . . .* , 1595

William Bourne (fl.1565–88), with amendments by Thomas Hood (fl. 1577–98).
Published by T. Este for Thomas Wight.
Printed book.
National Maritime Museum, Greenwich, D1161. Open at frontispiece.

William Bourne, a trained gunner, first published this practical manual in 1574. It was the first textbook on navigation written in English and represented a move away from relying upon Spanish and Portuguese texts, some of which only appeared in English translation in the 1550s. Although Bourne does incorporate existing knowledge, there is also original information, such as how to use the English invention of the log and line for measuring speed. The book proved to be such a success that it was republished with amendments by Thomas Hood in 1595.

Hood was a mathematician and geographer who gave public lectures on navigation in London and was the first lecturer on mathematics in England.

SF

140. *The Seaman's Secrets . . . , 1657*

John Davis (?1550–1605).
Printed book, eighth edition, published by Gartrude Dawson,
 London.
National Maritime Museum, Greenwich, PBE5163.

In 1595 John Davis was the first professional English sailor to write a maritime book. Captain John Davis was taught navigation by John Dee (Cat. no. 165) and probably spent some time in his household as a child. Davis wrote 'navigation is the means whereby countries are discovered and community drawn between Nation and Nation . . .' This book is a testament to increasing maritime confidence by the end of Elizabeth's reign.

Davis is also credited with the invention of the back-staff after experiencing difficulties in using the cross-staff at high latitudes, during his voyages to the North-West Passage in the 1580s. His 'Traverse Book' from his final voyage has since become the model for ships' logbooks.

SF

141. *General and Rare Memorials pertayning to the Perfect Arte of Navigation . . . , 1577*

John Dee (1527–1608).
Printed book published by John Day, London.
Inscribed on this copy: 'Captan Hichcok. Book. the gift of
 Docter Dee [15]77'.
British Library, London, C.21.e.12. Open at frontispiece.

Dee was one of the most ardent imperialists of the age and has been attributed with coining the phrase 'British Empire'. One of England's leading intellectuals, he was well connected and moved in political, academic and mercantile circles in England and Europe. This is contrary to a later view of him as an isolated magus.

General and Rare Memorials was written as the first volume of an ambitious work on the 'British Empire', in which he foresaw the rise of the empire through maritime supremacy. This was in fact to be the only

volume printed from his proposed four-part publication, which was to encompass a broad range of imperial themes and prove that a British Empire could be historically justified.

In this volume Dee puts forward his argument for the development of maritime resources, for 'No kingdom these Days hath more need of a PETY-NAVY-ROYALL'. He asserted that once a navy had been established it must 'be continually at sea maintained', consolidating his role as England's leading maritime adviser. From this time, he was increasingly able to participate in Elizabeth's government.

This important work is dedicated to Christopher Hatton, who was also Drake's patron and was knighted in the year this was published. The frontispiece depicts Elizabeth at the helm of the Christian ship of Europe, suggesting that England would dominate the seas. SF

influential treatise on the sphere that also contained astronomical information. It is thought to have been written for the use of the navigators of the Muscovy Company, which was founded in 1555, after the voyage of Richard Chancellor opened up the significant Russian market (Cat. no. 173).

Record never wrote the original English language book on navigation that he intended but his work was significant for making mathematics more accessible. A copy of this book was taken by Martin Frobisher (Cat. no. 174) on his quest for the North-West Passage. SF

142. *The Castle of Knowledge*, 1556
Robert Record (fl.1550s).
Printed book published by R. Wolfe, London.
British Library, London, c.124.f.4. Open at frontispiece.

Record, a physician, produced two seminal works in the 1550s. *The Pathway to Knowledge*, 1551, was the first English book on geometry and was fundamental to celestial navigation, followed by this book, an

143. *The Mariners Mirrour*, 1588
Lucas Jansz Waghenaer (1533–1606). Frontispiece by Theodor de Bry.
Printed book, published Anthony Ashley, London.
National Maritime Museum, Greenwich, PBD8264.

Waghenaer was a Dutch master-pilot, whose published work, *Spieghel der Zeevaerdt*, 1584 (*The Mariner's Mirror*), made a major impact on sailors of

all nationalities. For the first time it brought together in one volume, charts, views of coastlines, navigational tables and sailing directions. This comprehensive work was published widely and translated into several languages; later in England, all sea atlases became known as 'waggoners'.

In 1585, the privy council was persuaded by Lord Howard of Effingham, the Lord Admiral, to have Waghenaer's charts engraved again and published in English for the first time. Sir Anthony Ashley was the clerk to the council who oversaw the publication of this seminal work in English and added a section about Drake's recent exploits. SF

144. a-b Presentation Set of Navigational Instruments

(a) Back-staff
See above.

(b) Cross-staff

Thomas Tuttell, active 1695–1702.
Ivory.
National Maritime Museum, Greenwich, NAV0040, NAV0505.

This set was made in the seventeenth century, but provides a fine example of the types of navigational instruments being developed by the end of Elizabeth's reign. Both the back-staff and the cross-staff were used for finding latitude at sea, by measuring the height above the horizon of the sun or a star. The cross-staff had been adapted for navigation from a similar astronomical instrument by the Portuguese in the fifteenth century. The back-staff was developed by an Englishman, Captain John Davis, as a result of his voyage to find the North-West Passage, when he had difficulty using a cross-staff in high latitudes. He published a description in 1595. The set also includes two Gunter scales, invented by the mathematician Edmund Gunter (1581–1626). GC

145. Nocturnal and Tide Calculator

Humphrey Cole (?1525–91).
Gilt brass.
Signed 'H. Cole'.
British Museum, London, MLA1857, 11-16.2.

This instrument serves a double function; one side allows the user to tell the time by the stars, while the other can be used to predict high tide at a particular port. To tell the time using this instrument, as with all nocturnals, you need first to set the scale to the correct date. You then hold the instrument out and look through the hole in the centre to the Pole Star (Polaris), line the arm up with the two stars (Dubhe and Merak) that make up part of the constellation Ursa Major, and read off the time from where the arm crosses the hour circle. Nocturnals reached the height of their popularity in the late sixteenth and early seventeenth centuries. English examples tended to be made of boxwood, while French and Italian versions were made of gilt brass, suggesting that the maker of this example, Humphrey Cole, may have been influenced by his continental counterparts. EW

LITERATURE: Ackermann (ed.), *Humphrey Cole*, p. 47.

146. Astrolabe with Royal Arms, c. 1551

Thomas Gemini (working 1532–62).
Bronze.
National Maritime Museum, Greenwich, AST0567.

This astrolabe is signed by Thomas Gemini, who worked in England between 1532 and 1562. It was once believed to have been made for the Queen on account of the inscribed royal arms flanked by 'ER' on the back of the instrument, recent research confirms that it was actually constructed for her half-brother, Edward VI. Indeed, the style of engraving on the instrument, is remarkably similar to Gemini's signed and dated astrolabe made for Edward VI, currently in the Observatoire Royale de Belgique in Brussels.

The back of the Greenwich astrolabe is decorated with a series of concentric rings, detailing specific astrological information about the planets, zodiac signs, lunar mansions, decans and terms. Most of this information has been copied directly from an astrological disc, published by Gerard Mercator in 1551, which was intended as a companion piece for the celestial globe he published in the same year (the only known autograph example of Mercator's disc is in the Historisches Museum in Basel). The most likely conduit for this information is John Dee, Elizabeth's 'philosopher' (Cat. no. 165), who had spent a good deal of time with Mercator discussing the physical and epistemological underpinnings of astrological belief, when the two were both living in Paris between mid-summer 1548 and July 1550

(Turner and Van Cleempoel). In his *Propaedeumata aphoristica* of 1558, Dee describes Mercator as '. . . by far my dearest friend'. The inside of the empty mater was engraved with a circular slide rule in 1555 by Henry Sutton (working 1649–65). EW & KL

LITERATURE: Gunther, 'The Great Astrolabe'; Gabb, 'The Astrological Astrolabe'; Turner, *Elizabethan Instrument Makers*, pp. 95–7; Vande Broecke, 'Dee, Mercator'; Turner and Van Cleempoel, 'A Tudor Astrolabe'.

147. Sundial

> Humphrey Cole (?1525–91).
> Bronze.
> Inscribed: 'Humphrae. Colle. 1582' in the hour circle.
> National Maritime Museum, Greenwich, AST0390.

Humphrey Cole can easily be considered as the English originator of the London scientific instrument trade and its primary practitioner during the sixteenth century. Originally from the north of England, probably Yorkshire, he earned a steady income in the office of Sinker at the Royal Mint. It was here where he mastered the skills of metal working that served him so well in the production of maps, scientific illustrations and instruments. Twenty-six signed instruments by Cole have survived, revealing a wide variety in the spelling of his name: Humfray or Humfrey Cole, Humfridus Côle and Humfræ Colle. The earliest dated instrument was made in 1568, but he was certainly well established by the 1570s, when he was asked to supply instruments for the 1576 Frobisher expedition to find the North-West Passage to the Far East.

This sundial has been calculated for use at a latitude of 52-53° N, the approximate latitude for London. EW & KL

LITERATURE: Ackermann (ed.), *Humphrey Cole*, pp. 8–9, 39–40; Turner, *Elizabethan Instrument Makers*, pp. 20–23, 165–6; Higton, *Sundial Catalogue* pp. 57–8.

148. Ring Dial, c. 1575

Humphrey Cole (?1525–91).
Gilt brass.
Inscribed: 'H. Cole'.
British Museum, London,
MME 1905, 6-8.1.

This is the only ring dial made by Cole known to have survived. A ring dial allows you to tell the time from the sun's rays passing through a hole at the top of the dial, on to an hour scale on the inside of the dial. The hole is on a movable band, so that it is positioned differently depending on the date. This dial by Cole is large and uncommonly complex for a ring dial. As well as the hour scale and movable band for setting the date, this dial also includes a perpetual calendar for working out the day of the week for any date, a table of saints' days and Christian feasts, various astronomical tables and a list of latitudes for different cities.　　　EW

LITERATURE: Ackermann (ed.), *Humphrey Cole*, pp. 45–6.

149. Compendium, 1569

Humphrey Cole (?1525–91).

Gilt brass.
Inscribed: *Humfray Colle made this diall anno 1569* and *HC 1569*.
National Maritime Museum, Greenwich, Greenwich Hospital
　　Collection, AST0172.

A compendium is a complex portable device containing a number of instruments. Generally manufactured for wealthy gentlemen, compendia were usually made of gilt brass and were heavily engraved. This compendium is often referred to as 'Drake's Dial' as it was claimed in the nineteenth century that the instrument was made for Drake before his voyage to the Indies. There is nothing to support this attribution, however. It is the most complex of Cole's surviving compendia, containing a lunar volvelle, a perpetual calendar, a list of latitudes, a universal equatorial dial, a compass, a simple theodolite and a tide table labelled 'an instrumen to know the ebbes and flvddes'. The outside case is decorated with figures of Juno and Jupiter taken from designs by Etienne Delaune (1518–83 or 1595).　　　EW & KL

LITERATURE: Gunther, 'The Great Astrolabe', pp. 281–5; Waters, *The Art of Navigation*, pp. 517–18; *Armada*, p. 212; Ackermann (ed.), *Humphrey Cole*, pp. 15–22, 39–40; Higton, *Sundial Catalogue*, pp. 301–5.

150. Mariner's Quadrant c. 1600

Brass.
National Maritime
　　Museum,
　　Greenwich,
　　NAVI053.

A mariner's quadrant was used to find latitude, that is, the position north or south of the equator. To do this the navigator measured the angle of either the Pole Star or the sun above the horizon. The star or Sun was viewed through the small holes in the two sights on the top edge of the quadrant. The angle was then read off where the string of the plumb line cut the degree scale on the curved edge. This angle could then be used, with suitable tables, to calculate latitude. It was impossible to keep the quadrant steady on a moving ship, so normally the navigator had to make a landing to use it.　　　GC

151. Hourglass, sixteenth century

Unknown English maker.
Wood, glass, yellow sand.
National Maritime Museum, Greenwich, AST0074.

This hourglass is in fact a fifteen-minute glass filled with yellow sand. Early glasses such as this one were made of two bulbs of glass bound together rather than a single piece blown all the way through.

Hourglasses were used mainly on board ships and in churches in the sixteenth century. Those aboard ship normally measured thirty minutes to establish the time of day and the length of the watches. As they were fragile, spares were carried on important voyages. Frobisher (Cat. no. 174) took eighteen hourglasses on his voyage of 1576. In churches they were used to time sermons, sometimes with one to give the overall length (generally an hour) and with subsidiary glasses to give subdivisions of the hour.

EW

152. Armillary Sphere, 1568

Gualterus Arsenius (Flanders, fl. 1556–79).
Brass.

Inscribed: *Gaulterus Arsensius Nepos Gemmæ Frisÿ fecit Louanÿ 1568*
(on base plate).
National Maritime Museum, Greenwich, Caird Collection,
AST0618.

The Arsenius workshop in Louvain made some of the finest scientific instruments during the middle years of the sixteenth century. Whether Arsenius was really the nephew of Gemma Frisius (as he claims in the inscription) cannot be proved, but the great mathematician was certainly the driving force behind the scientific developments of the Louvain School. This Flemish city was a centre for printing, engraving, map making and the manufacture of scientific instruments. We know, for example, that John Dee (Cat. no. 165) visited Louvain between 1547 and 1550. Instruments of this type were very influential on the developing taste for scientific instruments in Elizabethan England – aided by the fact that several of the earliest scientific instrument makers in London were Flemish refugees. This armillary sphere depicts a model of the Ptolemaic or geocentric universe.

Armillary spheres can also be seen in portraits of the period, such as that of Sir Henry Lee (Cat. no. 76), although their precise meaning remains obscure.

KL

LITERATURE: Dekker, *Globes at Greenwich*, pp. 96–9, 147–9; Van Cleempoel, *Catalogue*, pp. 34–51 and 167.

153. Royal or Rose Noble of Elizabeth I, c. 1584

Gold.
Ashmolean Museum, Oxford, HCR (Browne Willis, Vaux147).

Elizabeth is shown on this coin standing in a sixteenth-century vessel, which is depicted with some care, showing a stern castle, rigging and furled sails with waves below. Ryals were first struck in the reign of Edward IV (1461–83). However, the designs of the Elizabethan coin have been carefully updated. The medieval king and ship of the original are replaced by an instantly recognisable three-quarter-length portrait of Elizabeth with crown, ruff and gown, holding an orb and sceptre. Much of the gold and silver supplying the Royal Mint in London at this time was brought through trade, or the privateering activities of English seamen like Drake. Around 1600 a ryal was worth 15 shillings, about a fortnight's wages for a skilled carpenter.

NMa

154. Map of the Strait of Magellan, 1677

John Conyers after the original by the Reverend Francis
 Fletcher, 1578.
Manuscript.
British Library, London, Sloane MS 61 fo 35v.

Francis Fletcher accompanied Francis Drake on his voyage of circum-navigation between 1577 and 1580. This map, with south at the top, shows a cluster of imaginary islands to the south of the Strait of Magellan through which Drake sailed in August 1578. Drake claimed to have doubled back to the southernmost tip of South America, record-ing that there was open sea beyond; however, it was not until 1616 that

Willem Schouten van Hoorn navigated south of the tip, or rounded the Horn, of America.

DSp

155. The Walsingham Bowl, late sixteenth century

Wan-li, Ming Dynasty, 1573–1619.
Porcelain and silver gilt.
The Burghley House Collection.

This bowl is reputed to be a gift from Elizabeth I to Sir Thomas Walsingham, cousin of her principal secretary, Sir Francis Walsingham. It is typical of the china carried by the Manila galleons bringing luxury Oriental goods to Spanish America and Europe from the 1570s. Drake took four chests of Chinese porcelain from a Spanish ship captured off the west coast of South America during his circumnavigation and more from his capture of the Spanish East Indiaman, the *San Felipe*, in 1587. It is possible that this bowl subsequently found its way to Elizabeth's court as a gift to Elizabeth or to Sir Francis. The silver-gilt mount is decorated in late Elizabethan style.

Only a very few items of porcelain are known to have reached England at this time and they were highly valued. The design on the bowl matches that on shards found at Drake's Bay in California, although this is not necessarily evidence that Drake visited this location and unloaded porcelain there in 1579, as a Manila galleon carrying similar china was wrecked nearby in 1595.

DSp

LITERATURE: Glanville, *Silver*, p. 334.

Initially the details of Drake's exploits were diplomatically sensitive but they became public knowledge during the 1580s. Silver is an appropriate material for the medals given that Drake looted large quantities of bullion on his voyage.

Michael Mercator was a cousin of the celebrated Flemish geographer and map maker, Gerard Mercator. The route taken by Drake is marked on both sides of the medallion by a dotted line, alongside which, in the Atlantic Ocean, are the dates of his departure and return. Also included are Frobisher's 1576 discoveries near the entrance to Hudson Bay. He repeats some of the mistakes in the map published by Richard Hakluyt in 1587 in his edition of *De Orbe Novo Petri Martyris*; for example, the date of Drake's landing on the Californian coast is given incorrectly as 1580 instead of 1579.

PA & BT

LITERATURE: Samuel Purchas, *'Purchas his pilgrims, in five books'*, III (London, 1625), pp. 461–2. Hawkins, Franks and Grueber, *Medallic Illustrations*, i, p. 131, no. 83; Wallis, 'Silver medal for the *Golden Hind'*.

156. Francis Drake in Ternate in the Moluccas

Published by Gottfried, 1655.

Etching on card sheet.

15.3 x 17.5cm.

National Maritime Museum, Greenwich, PAG7333.

Drake arrived in the Moluccas in about November 1579, having made the ten-week voyage across the Pacific following the route of the Manila galleons. He immediately commenced trading, where he acquired several tons of cloves, a spice that commanded a high price in Europe. Various colourful accounts of Drake's meeting with the local king, shown here, have been published, each building on the theme of Drake winning a trade monopoly for England in the Portuguese controlled Spice Islands, which did not materialise.

DSp

157. Medallions Commemorating Francis Drake's Circumnavigation

(a) **Medallion, 1589**

Michael Mercator.

Silver.

British Museum, London, 1882-5-7-1.

(b) **Medallion, 1589**

Michael Mercator.

Silver.

National Maritime Museum, Greenwich, MEC0004.

158. **The Drake Locket Jewel, second half of the sixteenth century**

Gold, enamel, pearl, diamond, ruby, sardonyx cameo and
miniature.
Inscribed: ANO DM 1575 (formerly 1586) REGNI 20.
Victoria and Albert Museum, London, anonymous loan.

This jewel is said to have been presented by Elizabeth to Frances Drake
on 4 April 1581 on board the *Golden Hind* at Deptford when he was made
a knight. He wears it in his portrait of 1591 (Cat. no. 132) and as an
heirloom it was worn hanging from a pearl necklace by his descendant,
Lady Seaton, in her portrait by Edward Long, 1884. The oval locket
frames a sardonyx cameo of a black man and a white woman,
crowned with a tiara, who are perhaps an emperor and
empress. The back, which is enamelled blue, opens to
reveal a fine miniature of Elizabeth painted by Hilliard
within a border of table-cut rubies. The parchment
lining of the cover is painted with a phoenix (now
damaged). Whereas the miniature and the device
of the phoenix are personal to Elizabeth, the
significance of the sardonyx cameo is more
elusive. The theme of the black man was
adopted by the gem cutters of the
Renaissance as a means of utilising the
contrasting dark and light layers of
the sardonyx, and was perhaps
inspired by depictions of the black
king, Balthasar, in paintings of the
Adoration of the Magi. These cameo
busts of black emperors, kings or
princes wear jewellery, draped necklines
and Roman armour. DS

LITERATURE: Dalton, 'Art for the Sake of
Dynasty'.

159. The Drake Sun Jewel, second half of the sixteenth century

Gold, enamel, ruby, diamond, opal, intaglio and miniature.
Provenance: traditionally associated with Sir Francis Drake.
Private Collection.

Behind this engraved hat jewel is a miniature of Elizabeth I. The orb, which is emblematical of sovereignty, may allude to Elizabeth, or to the historic circumnavigation of the globe. There are four loops for attachment to the hat. DS

LITERATURE: Somers Cocks (ed.), *Princely Magnificence*, no. 105.

160. English Sword, late sixteenth century

Iron, silver, steel and wood.
Private Collection.

This sword is traditionally held to have belonged to Sir Francis Drake. The guard and pommel are decorated with oak leaves and acorns inlaid in silver, and the blade, which may not have been made for the hilt, is etched. The etching, which was probably gilded, features Elizabeth I's coat of arms and the royal cipher 'ER', the Tudor rose, a vizored helmet denoting the rank of knight, and an armillary sphere on a hand-held support. The latter's similarity to the representation of the globe encompassed in Drake's crest may account for the sword's attribution to

Drake. The armillary sphere, an astronomical device used to locate the position of the planets, is a symbol widely used by Elizabeth, reflecting her use of cosmology (Cat. no. 208). DSp

LITERATURE: A.V.B. Norman, *The Rapier and the Small Sword 1468–1820* (London, 1980).

161. The Drake Cup, c. 1580s

Engraved coconut in a silver gilt mount.
Provenance: given by Elizabeth I to Sir Francis Drake.
Private Collection.

According to the Drake family history this coconut was a gift by Drake to Elizabeth following his circumnavigation in 1580, whereupon Elizabeth had the coconut engraved, mounted and re-presented to Drake. Another example of a mounted coconut may be seen here (Cat. no. 162).

The base of this particularly fine silver-gilt mount is in the form of a dragon. This refers to Drake's soubriquet 'the dragon', derived from the Latin form of Drake's name, *draco*, which translates as dragon. The design of the cup cover shows the sea, complete with monsters, surmounted by Drake's ship, the *Golden Hind*, on top of a globe. Drake's coat of arms, engraved on the coconut, includes the date that Drake

completed his circumnavigation, 1580. The shield comprises the Pole Stars separated by a 'fess wavy' – the sea – the crest is *Golden Hind* surmounted on a globe encircled by a bridle held by a hand appearing from a cloud, bearing the inscription AUXILIO DIVINO. As seen in his portrait (Cat. no. 132), Drake avoided using the allusion to divine assistance.

The second face of the coconut bears Elizabeth's arms, and the third a scene depicting Drake's ship being towed in the Molucca islands. This is a well-documented incident from his circumnavigation, and versions of the image appear as insets on the world maps published by Nicola van Sype in the 1580s and by Jodocus Hondius just a few years later. However, all versions are thought to have been copied from a map of the world presented by Drake to Elizabeth on his return, together with an illustrated account of the voyage, both now lost. It is possible therefore that the coconut engraving was made from the original manuscript, as the depiction of the ship is remarkably accurate and key differences separate it from the van Sype and Hondius representations of Drake's ship with their apparent errors on the flag (corrected by Drake on the second version) and unreefed sails respectively.　　　　　　　　　　　　　　　　　　　　DSp

162.　Coconut Cup, c. 1597

Engraved coconut in a silver mount.
Private Collection.

It is traditionally thought that this cup belonged to Sir Francis Drake, and that the silver mount was added after his death in 1596. Coconuts were highly prized examples of overseas exotica and many examples of mounted coconuts dating from this period have been found.

It is likely that Drake brought coconuts back from his voyages and the decorative engraving on the coconut indicates that this particular one was in the Drake household. The ornamental moresque band that runs around the rim of the silver mount is seen on coconut cups as well as communion cups in the late sixteenth century. The band on this mount mirrors that found on the communion cup at St Andrew's church, Plymouth, made by Exeter silversmith Christopher Easton in 1590 (Plymouth City Museum and Art Gallery).

This coconut bears three coats of arms, that of Elizabeth I, Sir Francis Drake and what appears to be a version of the Courtenay family arms including the lion rampant with torteaux. Drake's widow, Elizabeth, married Sir William Courtenay in 1597 and it is possible that the coconut was engraved and mounted at that time, before her death in 1598. The Courtenays were related to many distinguished West Country families such as those of Ralegh and Champernowne, forming a powerful network actively engaged in executing Elizabeth's policy of colonisation in Ireland and America.　　　　　　　DSp

163. Chart of Santo Domingo, 1588

Baptista Boazio (fl.1583–1606), Leiden.
Hand-coloured engraving.
42 x 54.5cm
National Maritime Museum, Greenwich, c4053.

Boazio's chart is one of five illustrating Drake's raid on the Spanish settlements in the West Indies in 1585–6. This was an act of open hostility towards Spain ordered by the queen, although Elizabeth stopped short of declaring war. Baptista Boazio was an officer serving under the military leader of the expedition, Christopher Carleill, and Boazio's chart is a detailed first-hand account of the attack on Santo Domingo (Dominican Republic) on 1 January 1586 made after a drawing of the incident. Drake's men looted and systematically burned the Spanish town until it was completely destroyed. The chart shows an alligator and tortoise, and the accompanying key to the chart describes the former as 'A strange beast drawn after the life, & is called by our English mariners Aligarta . . . which liueth both at sea and land.' In fact Boazio met John White (Cat. no. 185) when Drake picked up the surviving Roanoke colonists before returning to England and the sea creatures on Boazio's chart are taken from drawings made by White that were probably copied for this purpose.

DSp

153

164. *The World Encompassed by Sir Francis Drake, 1628*

Francis Drake.
Published by Nicholas Bourne, London.
Printed book.
National Maritime Museum, Greenwich, PBB1876.

This account of Drake's circumnavigation, attributed to Drake's nephew, also named Francis Drake, is a compilation of contemporary accounts published forty-eight years after the event. It is chiefly made up from the notes of the Reverend Francis Fletcher, a chaplain who went on the voyage at Sir Francis Walsingham's behest, although the original notes are now lost. It is the first comprehensive account of the voyage to be published and is favourable to Drake, as would be expected. DSp

LITERATURE: Hampden, *Francis Drake Privateer*, pp. 123–206; Quinn, *New American World*, I, pp. 467–76.

Searching for Trade Routes to the East

165. Portrait of John Dee, c. 1594

British School.
Oil on canvas.
74 x 62cm.
Inscribed: Johannes Dee / Anglus / Londinensis / Æt suae / 67.
Provenance: bequeathed by Elias Ashmole, 1692.
Ashmolean Museum, Oxford, WA 1692.0; F746.

John Dee (1527–1608/9), known to Elizabeth as 'my philosopher', was one of the most influential and enigmatic intellectuals of the English Renaissance. His fields of knowledge were boundless and included mathematics, astrology, medicine, navigation, cryptography, alchemy, theology and cartography. In his relentless pursuit for knowledge, he even sought to divine the secrets of the universe from angels – an aspect of Dee's polymathy that has been sensationalised. However, one recent scholar, William Sherman, has described Dee as 'perhaps the first English think tank . . . and "intelligencer" in the broadest sense'. Contrary to a later view of him as an isolated magus, he was in fact well connected and moved freely in political, academic and mercantile circles in England and Europe.

Dee was educated at Cambridge with contemporaries such as William Cecil (Cat. no. 33), and then studied abroad, numbering cartographers Gerard Mercator and Abraham Ortelius as his friends. In the 1550s he served in the households of the earl of Pembroke (Cat. no. 1) and Robert Dudley's father, the duke of Northumberland, establishing relationships with key courtiers, patrons and the royal household. In Mary's reign, he managed to survive accusations of magic, no doubt a result of his equivocal theology, being neither firmly Protestant nor Catholic.

Under Elizabeth, he acted as 'court philosopher', although patronage was inconsistent. He was commissioned to write seminal

documents including '*Brytannicae Republicae Synopsis*' (Cat. no. 169). Although he later felt rejected by the court, he did maintain contact with the queen throughout most of her reign and she even visited his magnificent library at his home in Mortlake. He advised Elizabeth on the most auspicious day for her coronation and she sought his views on the prospect of marriage to Anjou.

Dee was also one of the most ardent imperialists of the age and has been attributed with coining the phrase 'British Empire'. Being at the forefront of maritime affairs, he was closely involved in all English exploration, including quests to seek out new routes to the eastern markets via the North-West and North-East Passages, advocating the art of navigation and lobbying Elizabeth on imperial expansionism. SF

LITERATURE: Sherman, *John Dee*.

166. Nutmeg Grater and Case, mid-seventeenth century

English.
Silver and wood.
Victoria and Albert Museum,
 London, M896-1927.

Competition in the Far East between the Portuguese and the Dutch was driven by the demand for spices, a fight into which London merchants entered late but with energy. Spices from the Far East were the essential luxury of Elizabethan England, seasoning both savoury and sweet food, and spicing wine, mulled ale and possets, as well as featuring in medicines. Nutmeg was the key ingredient in hypocrass, the warm spiced wine served at celebrations in the City and at court. Although nutmeg gradually dropped in price, it remained a luxury. Substitutes or stale ground powder were always a risk, so wealthy and discerning people carried their nutmegs with them to grate freshly as required. This little holder, stamped with the long-fashionable motif of Tudor roses, was not an expensive object. It was both compact and practical, but embodied the dual attributes of silver, its perceived status and its purity. Made by a provincial silversmith to a standard and widely available design, it demonstrates how widely available nutmeg became once the East India Company was able to engage with this long-distance trade. PG

167. Spice or Comfit Box

Silver.
England (London), no marks
 c. 1560.
The Croft Lyons Bequest,
 Victoria and Albert Museum,
 London, M694-1926.

The spices imported by London merchants from the East were sometimes stored in small metal boxes like this one. The tiny compartment of this box has a sliding lid, cast with the royal arms, and each is numbered, to help identify the various contents. A personal accessory to be carried about like a pomander, this little box was for small pastilles or comfits of aniseed, carraway or dried fruit, eaten as a small treat between meals and to sweeten the breath. Supplied by the apothecaries and grocers, these could be made in fancy shapes. The Goldsmiths' Company ordered special ones in the form of leopard's heads, their badge, for Company dinners. PG

168. Coinage for the East Indies

(a) **Eight testerns of Elizabeth I, 1601**

London Mint.
Silver.
British Museum, London, CM E3838.

(b) **Four testerns of Elizabeth I, 1601**

London Mint.
Silver.
British Museum, London, CM E3840.

(c) **Eight reales of Philip II of Spain, 1591**

Segovia Mint.
Silver.
British Museum, London, CM 1935-4-1-10305
 (T.B. Clarke-Thornhill Bequest).

The charter of the new East India Company, granted by Elizabeth in 1599, allowed for the export of £30,000 in foreign coin and silver for the purposes of trade, provided that £6,000 of this was recoined by the queen's mint. This recoined money was to be in the form of a completely new set of silver coins, designed to challenge the ubiquitous Spanish piece of eight (eight-reales). They were thus given a design which reflected this purpose by replacing the usual portrait of the queen with a coat of arms in the Spanish style. A commission of 11

January 1601 set the mint to work on the new coinage, 2, 4 and 8 shillings (testerns), matching the range of denominations in reales of Spain. However, once the inaugural voyage eastwards of Sir James Lancaster reached the East Indies, they found that the new coin could not compete with Spanish money, long established in use and widely familiar and trusted. Later voyages had to dispense with this provision of the charter, and rely on Spanish coin in their trade. BC

LITERATURE: Challis, *The Tudor Coinage*, pp. 145–6.

169. *Brytannicæ Republicæ Synopsis* 1570

Manuscript.
British Library, London, Cotton Charter XIII art.39.

This manuscript is written in Dee's hand and comprises five sheets pasted together. There are few revisions and it was probably a presentation copy intended for privy councillors. This analysis of the 'commonwealth' (the 'state') was one of a group that was circulated amongst the political élite. Dee had been commissioned by Leicester and Hatton, via his patron

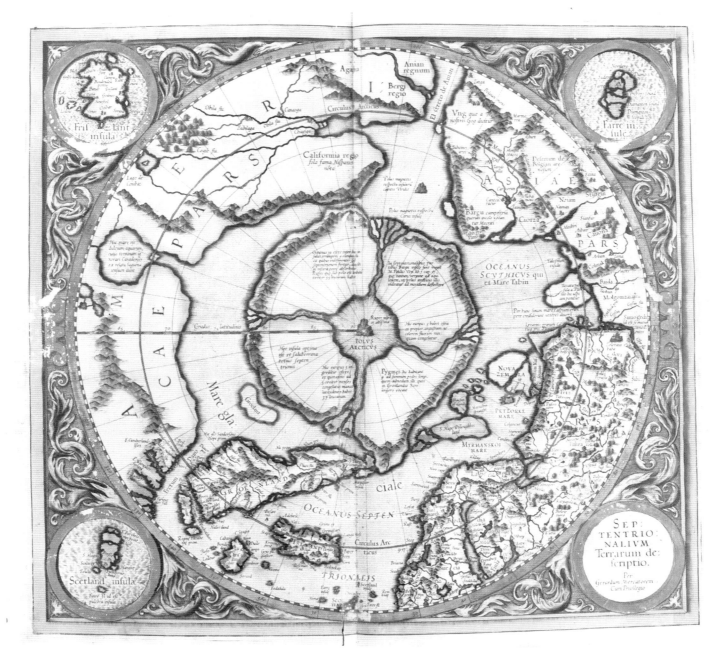

Edward Dyer, to survey the current political, economic and social state of affairs of England, and he used the device of a large flow chart to find solutions to problems facing the nation. Among the many sections, his one on the navy notes that England should be maintaining at least twenty-five ships in commission and twenty-five ships laid up in port in addition to merchant vessels. This figure, considerably more than was the current practice, shows Dee to be a key exponent of maritime expansionism. SF

LITERATURE: Sherman, *John Dee.*

170. *Atlas Sive Cosmographicæ . . .* , 1595

Gerard Mercator (1512–94).
Printed book, published Duisburg.
National Maritime Museum, Greenwich, D7623.

The Flemish cartographer Gerard Mercator was one of the most out-standing cartographers of the age. He was an associate of Dee and a pupil of the influential cartographer Gemma Frisius. In 1569, Mercator published his epoch-making world map, which included a prototype of

157

the Arctic area. It shows navigable North-West and North-East passages from Europe to the East and was an important source for English attempts on the North-West Passage by Frobisher during the 1570s.

Mercator's geography of the Arctic reveals the poor state of contemporary knowledge about the icy region. He relied on classical sources, such as the voyage of the Greek Pytheas to northern lands seeking trade. He also referred to the map published in Venice in 1558, showing the supposed voyages made by the Zeno brothers in the late fourteenth century. That map was actually a fanciful compilation of other sixteenth-century sources published for profit, but the fact that Mercator incorporated it reveals the general lack of knowledge.

The map shows a mountain at the North Pole itself, surrounded by a swirling open sea and a circumpolar landmass, with four northward flowing channels pouring into the polar sea before being drained away into the planet. On the opposite side of Europe, a large mountain of iron protrudes from the sea, indicating that this was the focal point for all magnetic needles.

Mercator copied his depiction of the northern polar region in his later printed maps and his concept of the Arctic was highly influential throughout the sixteenth century. This atlas was published in 1595, after his death, by his son Rumold. In 1604, the cartographer Jodocus Hondius acquired the copper plates and continued to print Mercator's maps, which enhanced his position in a highly competitive business.

SF

171. Sea Chart of the Passage from England to the Baltic, c. 1570

William Borough (1536–99).
Manuscript.
National Maritime Museum, Greenwich, G215:1/5.

William Borough had taken part in Richard Chancellor's 1553 voyage to find a North-East Passage to China. Chancellor reached Moscow and was welcomed by Tsar Ivan the Terrible, and then turned back. As a result of this voyage the Muscovy Company was founded in London in 1555 to import furs, tar, iron and copper direct from Russia, circumventing the Hanseatic merchants. Borough became the Company's chief pilot. He was also a navigational theoretician, investigating the problems of using the compass near the North Pole. In 1576 he made a chart of the North Atlantic for Frobisher's voyage, and in 1580 he drew one for Charles Jackman and Arthur Pet's search for the North-East Passage.

This chart is a working tool, showing only those coastlines which

would be needed for reference on a trading voyage and the names of the key ports. The bar-scales are aligned to the courses making up the passage.

GH

LITERATURE: Howse and Sanderson, *The Sea Chart*, pp. 38–9.

172. Map of the North-East Passage, 1580

John Dee.
Manuscript.
The Burghley House Collection.

During his 1548–51 stay in the Low Countries, Dee (Cat. no. 165) became firm friends with the cartographers Gerard Mercator and Abraham Ortelius. Dee strongly believed it had to be possible to reach China by sailing an Arctic route north-east or north-west. He drew charts for the inconclusive voyage in search of a navigable route along Russia's northern coast undertaken by Richard Chancellor in 1553. Dee also taught Martin Frobisher (Cat. no. 174) and Christopher Hall navigation, in preparation for their 1576 quest for the North-West Passage.

For William Cecil, Lord Burghley, knowledge of geography offered access to wealth. He was among the first to obtain a copy of Ortelius's atlas, *Theatrum Orbis Terrarum* (Cat. no. 34), and backed Frobisher's 1578 voyage. Dee directed his attention eastward again with this map, folded into Burghley's copy of Ortelius, showing a deceptively clear sea route to the riches of Cathay.

GH

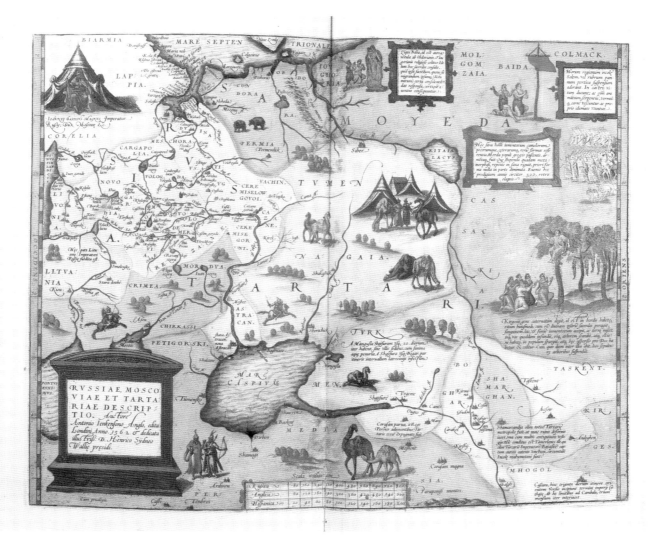

173. Map of Russia from *Theatrum Orbis Terrarum*, 1570

Abraham Ortelius (1527–98).
Printed book, published by Aegidius Coppens Diesth, Antwerp.
Gordon S. Barrass.

This map of Russia was removed from Ortelius's ground-breaking work of 1570 which was the first widely published atlas and the result of ten years of research and gathering information from some eighty-seven sources. Although expensive, the atlas was an essential commodity for the political elites, such as William Cecil who annotated his personal copy with the latest information (Cat. no. 34). This influential map of Russia was produced by Ortelius from a map made in 1562 (now lost) by Anthony Jenkinson (1525–1611), the English merchant who travelled to Moscow to establish Anglo-Russian trade links in 1557. Ortelius was the first to publish it. SF

174. Engraving of Martin Frobisher

Artist unknown.
Line engraving.
19.1 x 13.2cm.
National Maritime Museum, Greenwich, PAD4572.

Martin Frobisher (c. 1537–94), who ventured to present-day Arctic Canada on three voyages from 1576 to 1578, took with him a copy of Gerard Mercator's 1569 map. Sailing off to an unknown region in search of the North-West Passage was typical of the impetuous Yorkshireman. However, what was originally intended as a pioneering voyage to eastern markets via northern America descended into rash speculation when some black ore brought back was thought to contain gold and silver. After the third voyage in 1578, it proved to be worthless; the expedition's backer, Michael Lok, was bankrupted and penned an angry document accusing Frobisher of corruption and being 'so

full of lying talk as no man may credit any thing that he doth speak'.

Frobisher later took a prominent part in Drake's 1585 expedition to the West Indies, and commanded a squadron during the Armada campaign, for which he was knighted and promoted to admiral. He died from a bullet wound in 1594, incurred when serving the queen in a campaign at Brest. SF

LITERATURE: McDermott, *Frobisher*; Quinn, *New American World*, p. 227.

175. 'Black Ore': brought back from Frobisher's 1578 expedition to the Arctic

Calc-silicate gneiss with flecks of biotite mica.
Private Collection.

This igneous rock was part of the 1,400 tons perilously transported across the Atlantic. About 1,000 tons was taken to the main smelting furnaces at Dartford, downstream from London. Despite great hopes that it contained gold and silver, each smelting trial gave negative results. The venture collapsed and the worthless ore was dumped — some of it was later used in a wall surrounding the Queen's Manor House in Dartford. About 100 tons of ore is still in Ireland, as one of

the ships, *Emmanuel*, ran aground in Smerwick Harbour on the Dingle Peninsula. This ore was later used to construct a stone fort at Dún-an-Oir ('fort of gold'). SF

176. Drawings relating to Frobisher's 2nd Voyage

(a) Inuit woman 'Egnock' and child 'Nutiok'

John White (fl.1580–90s).
Watercolour.
22.2 x 16.6cm.
British Museum, London, PD 1906-5-9-1 (30).

(b) Skirmish at Bloody Point

After John White.
Pen and dark grey ink and watercolour.
31.5 x 26.6cm.
British Museum, London, Sloane MS 5270, 1999.9.3.

These drawings relate to Frobisher's exploration of present-day Arctic Canada and provide some of the earliest European evidence of the Inuit. The drawing of the woman and child brought back from Frobisher's second voyage of 1577 is only one of two extant drawings of Inuit by John White, whose recording of detail such as clothing, tattoos and tools increased European understanding of their culture. One of Frobisher's men, Dionyse Settle, wrote 'Two women, not being apt to escape as the men were, the one for her age, and the other being encumbered with a young child, we took. The old wretch, whom diverse of our sailors supposed to be either a devil, or a witch, plucked off her buskins [boots], to see, if she were cloven footed, and for her ugly hewe

[appearance] and deformity, we let her go: the young woman and the child, we brought away.' The woman (named Egnock), her son (Nutiok) and an unrelated man (Collichang) were all brought back to England as curiosities. Tragically, Collichang and Egnock died at Bristol within a month of their arrival, while Nutiok was taken to London to be presented to Elizabeth. However, the child died before the meeting took place and was buried at St Olave's church, which also contained the remains of an Inuit man brought back in 1576 by Frobisher. The study of the woman and child comes from the same album as nos 185–90, which also document the voyage White made to Virginia in 1585. Although it is not clear where this drawing was made, it is probable it was undertaken once the Inuit were back in England.

The drawing of the skirmish is a seventeenth-century copy of a lost drawing by White and relates to an event that happened in 1577. English sailors encountered the indigenous peoples of Baffin Bay on all three voyages, but relations became strained after five English sailors went missing on the first voyage in 1576. There is no evidence of their fate but the English suspected foul play. On the second voyage, believing that the missing men were still captive, the English attempted to take hostages from a camp but the Inuit began to escape by sea. The English fired their guns and the Inuit were forced ashore at a place the Elizabethans named 'Bloudie Point'. Five or six Inuits were killed and one Englishman seriously injured. SF

LITERATURE: Hulton and Quinn, *Drawings of John White*, p. 143, no. 116.

177. Narwhal Tusk

Parham House and Gardens, West Sussex.

The narwhal is one of the rarest whales and is found in Arctic waters, including the area around Baffin Bay, which was explored by Frobisher. The spirally grooved tusk was thought to be the horn of the legendary unicorn and was a collectable curiosity – as was the case with this tusk.

When Frobisher's crew discovered a dead narwhal on a beach at Baffin Island during his second expedition to the Arctic in 1577, they tested its magical properties as a poison antidote. A gentleman on the voyage, Dionyse

Settle, wrote '. . . we found a dead fish floating, which had in his nose a horn straight and torquet, of length two yards lacking two inches, being broken in the top, where we might perceive it hollow, into which some of our Sailors putting Spiders, they presently died . . . we supposed it to be a sea Unicorn'.

SF

178. Leopard Flagon

London.
Silver gilt.
Provenance: probably commissioned for the earl of Dorset's buffet. His family crest was a leopard. Listed for sale in 1626 from the Jewel House of Charles I.
Moscow Kremlin Museums.

This tall and striking beast, ostensibly made as a container for serving wine, is far too heavy to manipulate (more than 160 kilos) and stood on the buffet to impress. The flagon, one of a pair, went to Russia, with fancy Nuremberg and Portuguese cups, in the first of two sales of showy second-hand plate negotiated between Charles I and Tsar Mikhail. The only large-scale animals known in English silver, in Moscow they joined a positive zoo of German-made 'Beasts, fishes and fowls', presented by European envoys.

PG

179. Cup for Wine, 1557/8

London.
Silver gilt.
Moscow Kremlin Museums.

This rare 'flat cup' was made in the year of Anthony Jenkinson's first journey to Moscow. However, it was presumably purchased to present on a later Russian visit, since the London hallmarking year started a week after their departure in May 1557. Indeed, Jenkinson was sent three more times to Russia. In 1571, he went again and presented Elizabeth's gift of buffet plate as a 'Remembrance of friendship' together with personal gifts: a ewer and basin, looking glass and ostrich feathers. Although these visits were trade delegations, the tsar would only receive the English if they appeared to be an official embassy, so rich gifts, particularly of plate, had to be presented. These were carried in a public procession through Moscow, as tribute to the tsar; the Muscovy Company brought the largest and showiest pieces available in London, preferably with a royal association, often buying second-hand from the Jewel House.

The drinker could enjoy the busts stamped around the foot, the chased flange and the moresques engraved around the bowl. Within the bowl, more bands of decoration centred on a helmeted head, gradually exposed as the wine went down. Its sturdy stem and broad foot are typical of many London cups from around 1500 to be replaced by a more elegant curving bowl and lighter stem in the 1560s.

The English silver preserved in Moscow is exceptional, a peculiarity of the long-standing Russian protection of gifts to the tsars. Gifts of silver sweetened every diplomatic exchange across Europe but the heavier the object, the sooner it would be called to the melting pot. All courts had to balance the demand for magnificence against a chronic shortage of metal for the mint and silver was unceremoniously discarded as emergencies arose. PG

LITERATURE: Oman, *The English Silver in the Kremlin.*

180. Flagon, 1580/81

> London.
> Silver gilt.
> Inscribed: TF monogram, perhaps Thomas Flynt. Engraved
> with arms of James I.
> Moscow Kremlin Museums.

This flagon is one of a pair of tall and stately 'great flagons', which were used for serving wine and were designed to stand in pairs on the buffet or in ice in a wine cooler. They were part of the splendid presents of plate and cloth taken by Sir Thomas Smith to the tsar, Boris Godunov, in 1604, and are preserved in the Kremlin, with the red velvet coach, or 'chariot', sent from London. Their decoration, engraved foliage and high-relief sea monsters playing in the waves, is typical of London goldsmiths' work, taken from engravings printed in Antwerp and Paris.

Elizabeth owned thirty-four pairs of gilded flagons in 1574, weighing up to 500 ounces each, many of them inherited, plus plainer white silver sets. The distinguishing feature of a flagon is the tall neck, bulging body and heavy chains, and this shape was popular also for the tiny perfume, or 'casting', bottles of crystal, jet, agate or gold, given as New Year's gifts at the Tudor court. PG

181. Portrait of Sir Walter Ralegh dated 1588

British School. Attributed to the monogrammist H (fl.1588).
Oil on panel.
91.5 x 74.5cm.
Inscribed: top left 'AMOR ET VIRTUTE', top right 'AETATIS
SVAE 34 AN 1588'.
Provenance: presumably belonged to Sir Carew Ralegh of
Downton House, Wiltshire. Sold from Downton House in
1858.
National Portrait Gallery, London, NPG 7.

Ralegh (1554–1618) became one of Elizabeth's favourites during the early 1580s. Before then he had fought as a volunteer for the Protestant cause in France, participated in a voyage of exploration to North America in 1578 alongside his half-brother Humphrey Gilbert (Cat. no. 182), and served as a captain in Ireland during 1580. A consistent theme throughout these adventures was his hatred of Spain and support for Protestantism.

At court Ralegh soon made an excellent impression on the queen who was attracted to his wit, good looks and courtly manners. In 1586 Elizabeth made him her captain of the guard, and later she granted him

estates and lucrative monopolies. Once Ralegh had influence at court, he promoted a colonial policy which would challenge Spain's pre-eminent power. In 1584, 1585 and 1587 he sponsored voyages that led to the establishment of an English settlement on Roanoke Island, an area which he dubbed 'Virginna' after the Virgin Queen.

In this portrait painted in 1588, Ralegh presented himself as the queen's devoted servant, wearing her colours of black and white, and her emblem (the pearl) in his left ear. The pattern on his cloak displays a stylised design depicting rays of the moon or sun embroidered in pearls, another probable allusion to the queen. Over the motto *Amor et Virtute*, in the top left-hand corner, is painted a crescent moon, the device of Elizabeth as the moon goddess Cynthia. Punning on Elizabeth's nickname for him, 'water', Ralegh referred to the queen in his poetry as the moon goddess who controlled the tide or waters.

When this portrait was painted, Ralegh was the bitter rival of Robert Devereux, 2nd earl of Essex (Cat. no. 253). Ralegh retained the queen's favour until 1592, when she discovered his secret marriage to Elizabeth Throckmorton, a gentlewoman of the privy chamber. Because he had previously denied the marriage, the queen imprisoned him in the Tower. After a few months he was released but banished from court for five years. He then finished the famous 'Cynthia' poems, which expressed despair at losing royal favour. He also continued his colonial ventures, exploring Guiana on the northern coast of South America and writing *The Discoverie of the Large, Rich, and Bewtiful Empyre of Guiana* (1595) to promote its colonisation. Ralegh also participated in the war against Spain, distinguishing himself in the 1596 Cadiz Expedition, where he was wounded. After 1597, he took a more active role in court life but he never secured the influence he craved or a seat on the council.

TC & SD

LITERATURE: May, *Ralegh*; Hammer, 'Absolute Mistress', pp. 38–53.

182. Engraving of Sir Humphrey Gilbert, 1802

Edward Harding, publisher.
Engraving.
18.9 x 13.3cm.
National Maritime Museum, Greenwich, PAD4416.

This engraving shows a highly stylised drawing of Sir Humphrey Gilbert (?1537–83), holding an armillary sphere, a symbol associated with Elizabeth (Cat. no. 208). It was during his time as a soldier in Ireland that Gilbert discussed the planting of an English colony there with Elizabeth's lord deputy, Sir Henry Sidney, and his Devonshire relatives such as his uncle, Sir Arthur Champernowne. Gilbert turned his attention to planting in America, receiving royal permission in June 1578 to make an expedition to the North American coast, specifically Norumbega (New England), variously an island, city or land rumoured

to contain untold riches. The expedition was a fiasco but Gilbert redoubled his efforts and organised a second expedition in 1583 that managed to reach America but was forced by lack of supplies to return to England. Gilbert drowned when his ship, the *Squirrel*, was lost in a storm on the return journey. He was last seen by the crew of the accompanying ship the *Golden Hind*, shouting 'we are as near to heaven by sea as land'. His royal patent for America passed to his half-brother, Sir Walter Ralegh, who continued his work.

DSp

LITERATURE: Quinn, *Voyages . . . Gilbert*.

183. The Province of Munster, c. 1587

Manuscript.
National Maritime Museum, Greenwich, P49 f27.

Ireland was a perpetual drain on Elizabeth's resources. Like all her Tudor predecessors, she had to deal with the risings and disorders there, which arose in part from the government's attempts to extend English

rule over the island. Additionally, Ireland was a potentially hostile base for Catholic forces and Elizabeth was determined to enforce the Protestant settlement to neutralise this threat.

Sir Humphrey Gilbert, appointed colonel of Munster in 1569, ruthlessly 'pacified' the province to suppress the rebellion of 1569–70, applying himself with brutal vigour to slaughtering men, women and children alike. However, it was not until after the crushing of the earl of Desmond's rebellion in Munster, culminating in 1583 with the beheaded body of Desmond being publicly displayed in Cork while his head was sent to Elizabeth, that wholesale colonisation was planned.

Lord Burghley and Sir Francis Walsingham were behind the proposal for the Munster plantation that was made public in London in June 1586. The land was to be divided into 'seignories' of between 12,000 and 4,000 acres that would be granted to an undertaker. Each undertaker had to bring ninety-one English families to settle on the estate, and rents would be waived for seven years. There were thirty-five recorded undertakers in Munster who would be responsible for repopulating a land decimated by warfare and starvation with Protestant English stock. By these means Elizabeth hoped to stem the flow of costly military resources to Ireland but at the same time prevent insurrection or the threat of attack.

This map illustrates the grants of the lands to the undertakers. The names of Elizabeth's favourites, Sir Christopher Hatton (Cat. no. 133) and Sir Walter Ralegh (Cat. no. 181) are shown alongside Ralegh's Devon kinsmen such as Sir William Courtenay and Sir Warham St Leger.

At the same time that the plans for the plantation of Ireland were

made public, Ralegh's first English planting in America was fighting for survival. Ralegh's nominated leader of the 1585 voyage to settle a colony at Roanoke was Sir Richard Grenville, yet another of Ralegh's relations. Grenville left the fledgling American colony in August 1585, returning to Plymouth in October. He then turned his attention to planting his estate in Munster. As with the early American plantings, the English settlement in Munster did not succeed; however, one of Ralegh's American imports to his Irish estate, the potato, did take root. DSp

LITERATURE: Lennon, *Sixteenth-century Ireland*, pp. 208–29.

184. *Divers voyages touching the discoverie of America, and the Ilands adiacent unto the same, made first of all by our Englishmen and afterwards by the Frenchmen and Britons, 1582*

Richard Hakluyt the younger (1552–1616).
Printed Book, published by Thomas Woodcocke, London.
British Library, London, c.21.b.35.

The purpose of *Divers voyages* was to promote interest in Gilbert's second voyage of exploration and colonisation to America. In order to attract investors Gilbert needed literature to convince speculators that America was a fertile and temperate land ready for appropriation, and he commissioned Hakluyt, with the assistance of his older cousin, also named Richard Hakluyt, both Middle Templars, to make a compilation of favourable reports from earlier voyages to America. Many of these were translated from the Venetian publication *Delle Navigationi et Viaggi* (Giovanni Ramusio, 1559); however, Hakluyt emphasised English achievements, as the title suggests. Hakluyt went on to list the advantages of establishing a colony in America and the resources to be found there. The scheme attracted considerable interest and Gilbert sold to investors over eight million acres of land not even seen, including three million acres to Sir Philip Sidney, which probably accounts for the dedication to him in *Divers voyages*. DSp

LITERATURE: Quinn, *Hakluyt*; Quinn, *Voyages . . . Gilbert*.

185. Drawing of the Village of Secotan, West Virginia, 1585

John White (active 1585–1593).
Pen and black ink with coloured wash on paper.
32.3 x 19.9cm.
Inscribed: 'SECOTON' / 'The hovse wherin the tomb of their herounds standeth' / 'a ceromony in their prayers wth strange resturns and songs dansing about post carved on the tops like mens faces' / 'The sitting at meat' / 'corne newly sprung' / 'Their green corne' / 'Their rype corne'.
British Museum, London, PD 1906-5-9-1 (7).

White was employed as a draftsman to record the findings of Ralegh's voyage to Virginia in 1585–6. The mission was the first attempt to settle an English colony in America, and White and his scientifically minded companion, Thomas Harriot, carried instructions to note and draw everything of interest and importance. Their survey of the land, flora, fauna and people of North America, manifest in White's drawings and Harriot's publication, *A Briefe and True Report* (1590), provides a unique record of Indian life before the effects of European settlement. They have been compared to early ecologists demonstrating the complex relationship between the human and natural world. White's careful drawings, which were made as a form of reportage rather than art works, have immediacy unlike any English artists working at that time.

His drawing of the Indian village of Secotan, south of the English settlement at Roanoke, was made during White's visit in July 1585. The village is laid out in partial perspective showing the various activities therein, as if working life was another unusual specimen to be recorded. It is the first directly observed record of a North American Indian culture that had thrived for more than a thousand years. The drawings were probably finished at Roanoke, on the voyage home or on his return to England. They deeply impressed European viewers well into the eighteenth century, and White's studies were referred to by Linnaeus in his species classification, *Systema Naturae* (1758), albeit without realising their origins. Several sets of contemporary copies of White's drawings were made shortly after his return, probably for Harriot, Ralegh and for the engraver Theodore de Bry. Consequently,

186. Drawing of a Male Indian of Virginia Carrying a Bow, 1585

John White.
Pen and brown ink with grey, brown and black wash on paper.
16 x 14.5cm.
Inscribed: 'The manner of their attire and painting them selves
 when they goe to their generall huntings or at theire
 Solemne feasts'.
British Museum, London, PD 1906-5-9-1 (12).

This drawing probably depicts Wingina, chief of the Roanoke Indians and a number of villages surrounding the island. The chief's home was on the northern end of Roanoke Island and consequently he had frequent dealings with the English colonists. Allegiances between Indian tribes and the colonists were uneasy and Wingina sought the latter's friendship as a way to help him extend his power, yet he subsequently fell out with the English. After a skirmish with fatalities on both sides Wingina was killed by Edward Nugent, who brought his head to Ralph Lane, governor of the colony, as proof of his death. DSp

what survives today is a combination of some originals and some copies, themselves probably made by White's family. DSp

LITERATURE: Quinn, *Roanoke Voyages*; Hulton and Quinn, *Drawings of John White.*

A cheife Herowans wyfe of Pomeoc. and her daughter of the age of .8. or. .10. yeares .

This drawing shows the wife of one of the *weroances* (advisers to the chief) of the Pomeioc tribe with her daughter. The woman holds a gourd, used to carry water, while the little girl is holding a doll dressed in Elizabethan costume, clearly a gift from the English settlers. DSp

188. Drawing of a Pineapple, c. 1585

The Pyne frute .

John White.
Black lead and water-
 colour on paper.
25.9 x 14.2cm.
Inscribed: 'The Pyne
 Fruit'.
British Museum, London,
 PD 1906-5-9-1 (41).

Ralegh's expedition, under the command of Sir Richard Grenville, stopped in the West Indies en route to Roanoke, Virginia, a location selected for the colony after the reconnaissance voyage of 1584. It was here that White drew detailed studies of plants and sea creatures, including this picture of a pineapple. The colonists uprooted pineapple plants and sugar cane in an attempt to transplant them to Virginia; however, they died during the voyage. DSp

187. Drawing of the wife of one of the weroances of Pomeioc and her daughter, 1585

John White.
Pen and brown ink and watercolour on paper.
26.3 x 14.9cm.
Inscribed: 'A chief Herowans wife of Pomeoc. / and her
 daughter of the age of 8 or / 10 yeares'.
British Museum, London, PD 1906-5-9-1 (13).

189. John White's Drawings of Wildlife, 1585

(a) **Flying fish**

John White.
Black lead and water-
 colour on paper.
27.4 x 23.4cm.
British Museum, London,
 PD 1906-5-9-1-(46).

(b) **Loggerhead turtle**

John White.
Black lead and water-
 colour on paper.
18.7 x 26cm.
British Museum, London,
 PD 1906-5-9-1 (70).

BOLADORA•

These are two of White's most accomplished drawings of wildlife undertaken during the voyage. The flying fish may have landed on the deck of the *Tiger* as the colonists sailed north from the Caribbean to Virginia. Sea turtles were to be found in abundance along the outer banks protecting Roanoke Island from the Atlantic, and were a source of food for the colonists.

DSp

190. Map of Ralegh's Virginia, East Coast of North America from Cape Lookout to Chesapeake Bay, 1586

John White and Thomas Harriot (1560–1621).
Pen and brown ink with watercolour on paper.
British Museum, London, PD 1906-5-9-1 (3).

One of the main tasks of White and Harriot was to survey and map the new land. They were part of the exploration parties that ventured beyond Roanoke into the surrounding country, from Pamlico Sound to Chesapeake Bay. This map was constructed from field sheets drawn from a survey employing astronomical observations and a uniform scale, charting the land with unprecedented accuracy. By these means the colonists who returned with Sir Frances Drake in 1586 were able to demonstrate to their patron, Sir Walter Ralegh, the extent of his newly claimed land of Virginia, named in Queen Elizabeth's honour. DSp

191. Broadside Published by the Council of Virginia, 1610

Printed broadside published by Thomas Haueland, London.
Society of Antiquaries of London. Lemon Ballads no.112.

This broadside was circulated in London to counter stories that the Jamestown colony, established in 1607 by the Virginia Company, was in dire straits. The truth was that the colony was struggling badly, with many of the colonists dead from disease and starvation and the survivors suffering extreme privation. The rumours that this broadside aimed to scotch were probably started by seafarers and some colonists who managed to return to England in 1609 when a relief fleet carrying supplies suffered storm damage and had to return after hasty repairs. Accusing those responsible for the stories as malicious idlers who would rather 'starve for hunger than lay their hands to labour', the broadside, which was probably nailed up in public places, goes on to encourage 'good honest artificers' to sign up for the fleet preparing to resupply the colony. DSp

LITERATURE: Lemon, *Collection of Broadsides.*

REPRESENTING
THE QUEEN

THE QUEEN'S VISUAL PRESENCE

TARNYA COOPER

THE EARLY YEARS OF ELIZABETH'S REIGN WERE MARKED BY THE removal of religious images in parish churches across England and Wales. What frequently came to be set up in their place were the queen's royal arms painted in full colours and hung prominently upon the chancel arch facing out to the congregation.[1] The example from a parish in Suffolk (Cat. no. 52) gives us a vivid sense of the visual impression Elizabeth's accession might have made upon her subjects, whether they were learned or illiterate, in parishes from Sussex to Lincoln. This brightly coloured wooden board painted with a version of the royal arms served as a symbol of the ruler as governor of the Church of England. The visual message was clear: Elizabeth would reign as a Protestant monarch and the regime that supported her had every intention of making her God-given rule a lasting legacy.

IN THIS PROTESTANT CLIMATE, where religious imagery was no longer acceptable, it was heraldic devices and also portraiture that became the most important forms of painted imagery. Most of Elizabeth's subjects would have known her visual likeness not through personal experience, but via the profile images found upon coins, and in printed images within books and upon painted panel portraits made after patterns and probably sold on the open market. A few cheaply produced painted portraits of Elizabeth from this period remain in existence and are very probably evidence of far greater numbers which have since perished.

THROUGHOUT HER REIGN images had an essential role to play in presenting Elizabeth to her subjects at home, to her immediate court circle, and the wider world in Europe. Whether they were the symbolic colours and shapes of royal arms upon banners, badges, tapestry or embroidery seen in the cities and towns of the realm or in generalised portraits on painted panels at court, Elizabeth's right to rule was visually asserted. Portraits

of the queen were almost always made for particular purposes and there was a considerable difference between the types of portraits seen at court and engravings found in the front of some newly printed editions of the Protestant Bible (Cat. no. 56, illustrated page 29). The question of who controlled this imagery and who devised her often complex iconography is an important one, which is explored below. Such questions can help us to understand how the images might have been viewed at the time they were made, as well as help us to appreciate the problems of interpreting their meanings from the distance of over four hundred years. The problem of interpretation is often complicated by the condition of surviving paintings. Most of the paintings from this period have been painted upon wooden panels joined together to produce a flat board; over time these have been liable to warp or split and when compounded by poor conditions this has frequently caused significant paint loss, occasionally up to as much as 50–60 per cent of the original surface. Therefore some caution is needed in reading these images as most sixteenth-century paintings have been repainted

at a later date, sometimes obscuring original paint or changing important details.

BOTH HENRY VIII and Mary I had employed royal painters to have charge of producing powerful images of themselves that could serve to fulfil the many demands for their likeness. The policy proved extremely successful and Holbein's frontal portrait of Henry painted as a sure-footed, solid block of masculinity, for a now lost mural at Whitehall, serves to this day in the many copies and adaptations that survive as the most memorable image of this king (Cat. no. 2). In contrast, Elizabeth never appointed a royal painter. No single artist was ever given official responsibility for the queen's portrayal and the reason was probably connected to a desire to economise in the early years of her reign, while later she found she could rely upon key courtiers and officials, such as William Cecil (Lord Burghley), Robert Dudley (earl of Leicester) and Sir Christopher Hatton, to commission portraits on her behalf. Much like photographs today produced in a studio setting for a paying customer, portraits were always the tool of those who commissioned them, and Elizabeth's lack of interest in supporting a court painter perhaps ultimately meant that she had less control over the way she was represented. Certainly, some historians have argued that Elizabeth's imagery was constructed by individual courtiers and powerful groups such as civic elites, all of whom had their own varying agendas to serve, thus creating a competition for the representation of the queen's person.[2]

Miniature of Elizabeth I by Nicholas Hilliard, 1572. National Portrait Gallery, London. (No. 108).

THE PRACTICE OF PAINTING in this period owes much to foreign artists who had trained principally in the Netherlands and who came to work in England, usually for limited periods. Thus the court could make use of talented individuals from abroad such as Federico Zuccaro (1540/41–1609) who took Elizabeth's likeness about 1575 probably at the request of Robert Dudley (Cat. no. 60). Certainly, few native English painters could equal the sophistication or offer the polished skills of highly trained foreign artists. Elizabeth herself never left English shores, but courtiers and merchants resident in the Netherlands frequently took the opportunity of commissioning portraits from artists overseas: the supremely accomplished portrait of the courtier Henry Lee (Cat. no. 76) by the artist Antonis Mor (c. 1516/21–c. 1576) was painted, for example, while Lee was resident in the bustling mercantile city of Antwerp in June 1568.

THE TWO MOST IMPORTANT English-born painters working in Elizabeth's reign were Nicholas Hilliard (1547–1619) and George Gower (c. 1540–96). Hilliard was the next best thing to an official royal painter and he was probably the most talented English artist to serve the queen, although his abilities were poorly rewarded in his lifetime. He had trained as a goldsmith in Exeter and later in London with the queen's jeweller, Robert Brandon. Hilliard worked principally as a miniaturist producing finely worked small-scale portraits known as 'limnings' which were contained in decorative cases of precious metal designed to enhance their commercial value as jewels. George Gower specialised in commissions for portraits, but he also held an official role at court

as the queen's serjeant painter. This was a post which required him to manage a large body of temporarily employed artists working upon all manner of decorative projects for the crown, including palace interiors, the production of banners and flags, theatre sets and other decorative painting for temporary entertainments known as the 'Revels'. In 1584 Gower attempted to procure a patent for the monopoly of portraits of the queen 'in oil colours upon boards or canvas' (large-scale oil paintings on panel), as well as in printed designs, with the exception only of Hilliard. The petition was unsuccessful and it is probable that the queen wished to defer the ongoing expense of keeping a royal painter.[3] Gower appears to have been a prolific artist, undertaking portraits of the nobility and gentry, yet there are only a few known surviving images of Elizabeth associated with his name (Cat. no. 59).

VERY FEW OTHER ARTISTS working at court can be securely linked with existing imagery and, unlike artists working elsewhere in Europe, few English artists signed their work. Early in Elizabeth's reign a gentlewoman and amateur artist, Levina Teerlinc (c. 1510/20–76), was resident at court, and she may well have given instruction to the youthful Hilliard in the early 1550s (Cat. no. 202). Teerlinc certainly undertook numerous portraits and narrative miniatures, showing Elizabeth and occasionally events at court (Cat. no. 113), up until her death. As for other artists who worked at court, at least intermittently, we know that Cornelis Ketel (1548–1616), a painter from Gouda resident in England between 1573 and 1581, painted Elizabeth around 1580, and the English painter and herald William Segar (fl.1585–1633) undertook her portrait around 1597.

BEFORE LOOKING AT Elizabeth's imagery in detail, it is worth mentioning the distinctive appearance of Elizabethan painting in comparison with other European models. Elizabeth herself apparently shared the concerns of many other English Protestants on the uncertain value of painted images that appeared too realistic and thus pretended to mimic God's own handiwork upon earth. Such paintings were seen by Protestants as deceptive and the cause of idolatry in relation to religious images under Roman Catholicism. The general characteristics of work by many English artists might be seen as a response

to these concerns as they make use of linear outlines, boldly conceived blocks of colour and rarely apply the illusionary technique of perspective. Contemporary terms for the appreciation of paintings, such as 'eye ravishing' or 'eye pleasing delights', usefully describe the effects that bright colour, elaborate surface detail and sometimes painted text made upon sixteenth-century viewers.[4] Certainly, the art of English painting in this period was more about colour and narrative than the recreation of fantastic illusions.[5] The queen herself, as Hilliard informs us, disliked the use of artful shadowing, choosing to sit for the artist 'in an open alley of a goodly garden, where no tree was near nor any shadow at all' because, says Hilliard, 'beauty and good favour is like clear truth, which is not shamed with the light, nor needs to be obscured'.[6] The resulting portraits by English artists were frequently more diagrammatic than lifelike and show the queen's body as a fixed symbol of stable monarchy.

MANY HUNDREDS OF painted portraits of Elizabeth were produced in her lifetime, but few were made directly from life. Many of the existing portraits are copies which can be traced to patterns based upon some of the key images produced throughout her reign. Portraits of royalty, since their earliest conception, had acted not so much as a likeness of the monarch, but as a symbol of embodied statehood, and of a just God-given order. However, no artist in England had yet needed to develop a programme of imagery to glorify a single female monarch. Few commentators would disagree that Elizabeth's representation developed in relation to her status as an unmarried virgin queen. The problem for artists and, more importantly their courtly patrons, who frequently took the greater hand in devising suitable ways to depict Elizabeth, was the lack of useful precedents. It is difficult to overstate the precarious position of an unsupported female ruler in sixteenth-century Europe, and it is interesting that representations of the queen become more elaborate and less lifelike as she aged. After 1580 she was not only losing the power of her beauty, but, following the failure of the Anjou match, it was apparent there would be no marriage and thus no heir directly from her body. If portraiture was to remain a successful tool of propaganda, Elizabeth had to be presented outside her sex, not as a spinster queen, but as a magnificent emblem of

virtuous statehood. The large numbers of portraits claiming to represent Elizabeth have been the subject of significant lively debate over the last century; partly in response to her wide-ranging iconography which expresses the various ways she was championed, from virgin queen, just Protestant ruler, peace-maker and mother of the nation through to chaste heroine and defender of the realm.

ALTHOUGH FEW EXPECTED Elizabeth to remain unmarried, it is clear from very early in the queen's reign that there were concerns over how an unsupported female monarch might be best presented through portraiture. A draft proclamation written in the hand of William Cecil in 1563 records an attempt to regulate the production of the queen's por-trait by requesting that painters refrain 'from painting, [en]graving, printing, or making of any portrait of her Majesty, until some special person that shall be . . . allowed . . . to have first finished a portrait thereof'. The proclamation was not issued, and it is not known if any action was taken to ensure that painters who made 'deformed' or ill-considered portraits of the queen were provided with autho-rised patterns to copy from. Clearly the demand for Elizabeth's portrait had dramatically increased and the text accepts the 'natural desires' of 'all sorts of subjects and people, both noble and mean', who may 'hope to procure the portrait and picture of the Queen . . . '.[7] Evidence from the inventories of noble, gentry and merchant houses tells us that portraits of monarchs far outnumber those of private individuals in the sixteenth century.[8] Therefore if the demand for Elizabeth's image was high, not surprisingly the problem of unofficial imagery did not go away and throughout her reign artists must have continued to make their own images or copy a pattern so

Portrait of Elizabeth I with verses, c. 1590.
British Library, London.
(Huth Collection no. 11).

inaccurately that the resulting portraits were still considered unsuitable. By as late as 1596, the privy council needed to issue an order that a number of portraits – presumably on public sale – should be defaced while new images should be approved by George Gower, in his office of the serjeant painter. Some of these public images were cheaply printed woodcuts or engravings that were probably sold alongside illustrated 'broadsheets' displaying ballads and items of news. A very rare popular woodcut (illustrated here), probably dating from after the Spanish Armada, has been enlivened by a speedy application of watercolour perhaps by its printer or vendor and shows the queen holding an orb and sceptre as emblems of her rule. The handling is relatively crude, but the image offers a wonderful insight into how citizens from relatively modest backgrounds might have viewed their queen, and it was probably purchased to be pasted in to a book or even to be displayed upon the wall.[9]

PAINTED PORTRAITS OF Elizabeth produced at court present quite a different category of representation and were frequently designed for particular purposes or events. Prior to her succession, portraits of Elizabeth as a princess were not produced for public consumption but as records of her likeness for use within the immediate court circle. In her childhood and adolescence few had considered Elizabeth as a serious contender to the English throne and only after the death of her brother Edward, and then in the reign of Mary I, was her accession contemplated. Consequently, only a very few images survive from this early period when public demand for her likeness must have been minimal to non-existent. The portrait of Elizabeth in a crimson gown (Cat. no. 13) painted at the age of around thirteen shows her as a pale and cautious young woman, pious and diligent in

her studies, keenly aware of her duty as a royal princess and decked in the exquisitely crafted finery of her rank. It was not until the mid- to late 1570s that the queen's image as an orchestrated form of propaganda or token of adoration had began to emerge. Surviving images of Elizabeth in the 1560s are found mostly as engravings in printed text and show her not yet as a virgin queen, but in the more sober role as champion of the Protestant faith. The title page of the quarto edition of the Bishops' Bible of 1569 (Cat. no. 60, illustrated page 29) depicts Elizabeth as a providential heroine being crowned as queen by Mercy and Justice, reflecting her role as 'supreme governor' of the Church of England.

PROBABLY IN THE EARLY 1570s, when the queen was approaching her forties, Hilliard had begun to make limnings of her likeness. However, it was not so much an accurate portrayal of her changing features that was required and Hilliard was shrewd enough to recognise and interpret the royal requirements. His portrait miniature of 1572 (illustrated page 176) shows Elizabeth at the age of thirty-eight illuminated as if in the bright sunlight described by Hilliard above. The image represents an ideal prototype as her delicately drawn features are fair and even, while much care is placed upon the accurate depiction of elaborate jewels and surface decoration of her dress. As Hilliard developed his style, painting the queen over a thirty-year period, what emerged were brilliantly executed and exquisitely polished jewel-like images which displayed the queen as an object of beauty and evident virtue (Cat. no. 201). The small size of these images, which could be worn on the body or kept hidden, and the resulting difficulty in looking without cradling them in the hand near to the face, amounted to a new and private experience.

HILLIARD IS ALSO THE probable artist of two large-scale panel portraits of Elizabeth produced with similar compositions around 1575. The 'Pelican Portrait' (Cat. no. 193) and the 'Phoenix Portrait' were named after jewels hanging at the queen's breast in each image. These two portraits mark the beginning of a period to last up to her death where the queen's body becomes an emblem for female virtue. The pelican and the phoenix were adopted as motifs for their association with charity, piety, celibacy, eternal youth and to an extent

Protestantism.[10] The pelican, for example, was an ideal symbol of self-denial and personal sacrifice for the greater good, as it was understood to peck its own breast to draw blood as food for its young. The mythical phoenix, meanwhile, was a popular symbol of rebirth because its unique presence was reincarnated by fire every few hundred years (Cat. no. 203). For a monarch without an immediate heir, this emblem was a suitable metaphor as it was understood to arise from the ashes to renew its dynasty.

FROM AROUND 1579 until the 1590s numerous portraits of the queen were devised – principally by Elizabeth's courtiers – with complex allegorical and emblematic themes. These themes tended purposefully to construct particular identities by championing her virtues, such as virginity, or placing her as a personification of peace. Once established, these themes were reworked into numerous painted versions. For example, in the case of the various 'Sieve Portraits' attributed to George Gower, Quentin Metsys the Younger (?1543–89) and many other unknown artists, Elizabeth is placed in the role of a Roman vestal virgin named Tuccia, who was renowned for her ability to carry water in a sieve without losing a drop. The version by Gower (Cat. no. 59) dating from 1579 appears to be one of the earliest while the version attributed to Metsys dating from c. 1583 is one of the most complex and develops the allusions connected to Elizabeth's imperial claims. This version was probably commissioned by her ardent admirer, Sir Christopher Hatton, who had opposed the queen's ailing marriage negotiations of the same period.

ALTHOUGH PORTRAITS of the queen were rarely accurate records of facial likeness, one of their key functions was to make evident the majesty of the monarch, thus the detailed rendering of actual items of dress, jewellery and accessories were carefully depicted, possibly on some occasions from the original objects. Thus these portraits can be seen to document Elizabeth's liking for elaborate forms of dress; the use of sumptuous fabrics with highly detailed embroidery, expensive, carefully crafted jewels, headdresses and other accessories. Her preference for particular colours is also well recorded in portraiture and we rarely see Elizabeth without specific reason dressed in anything other than a combination of white,

black, gold, silver and touches of crimson. The early Hilliard miniature (illustrated page 176), the well-known 'Darnley Portrait' (National Portrait Gallery London), the 'Armada Portrait' (Cat. no. 238 for a later version), the National Maritime Museum's own portrait of the queen (Cat. no. 252) and many others, all show Elizabeth in a combination of these colours. She certainly had an extremely large wardrobe of newly made separate bodices, sleeves, kirtles (skirts), gowns, cloaks, and an endless array of accessories, which are documented in two existing volumes listing the contents of her wardrobe and jewels (Cat. nos. 117 and 118).

IN THE 1590S PORTRAITS showing the queen with a youthful appearance – sometimes called the 'Mask of Youth' – may in fact have aped a version of reality. Contemporary descriptions of the late Elizabethan court evoke a startling stage show with a dazzlingly dressed maiden monarch at the centre who was engaged in a game of agelessness, in which courtiers were expected to submit. An impression recorded by a German visitor in the 1590s describes the queen in her sixty-fifth year of age as:

The 'Ditchley' Portrait by Marcus Gheeraerts the Younger, c. 1592. National Portrait Gallery, London. [No. 2561].

very majestic: her face oblong, fair but wrinkled; her eyes small, yet black and pleasant; her nose a little hooked, her lips narrow, and her teeth black, (a defect the English seem subject to, from their too great use of sugar); she had in her ears two pearls with very rich drops; her hair was of auburn colour, but false . . . upon her head she had a small crown . . . her bosom was uncovered, as all the English ladies have it till they marry; and she had on a necklace of exceeding fine jewels; her hands were slender, her fingers rather long . . . [11]

She certainly appears to have worn very elaborate jewellery, open-cut collars, false hair and flattering make-up, and for everyone at court in the 1590s the gap between reality and image must have been wearing thin. This was the period in which such fantastical images as the famous 'Ditchley Portrait' of Elizabeth (National Portrait Gallery London), commissioned by Henry Lee in 1592, was produced showing the radiant queen standing on England depicted upon the top of a globe. An exceptional drawing by Isaac Oliver (Cat. no. 259) made in the same year is one of the few images in existence showing the queen as a much older woman. Oliver had been granted a sitting and must have taken this preliminary sketch from the life, which gives this drawing a particular poignancy as a record of a moment in time. Because the work is unfinished and was probably meant to serve as a pattern for future miniatures, Oliver has focused principally upon her facial features which clearly describe her slightly hooked nose and thin lips as noted by the German visitor. The portrait was used as a model for later engravings (Cat. no. 260), but Oliver's drawing was unlikely to have been readily sanctioned by the queen for such purposes.

PAINTED PORTRAITS of courtiers could also serve to offer visible deference to the monarch either by wearing her miniature or in more subtle ways making use of established emblematic devices such as the wearing of pearls, which might be seen to reflect upon Elizabeth's purity (Cat. no. 181). The Elizabethan court was inevitably a more feminised environment where young men could serve the purpose of ornament, delighting the female eye by being elegantly clad in tightly fitting leggings (known as hose), silk stockings and jauntily worn feathered caps. As Elizabeth was metaphorically cast as the sun or moon of her empire, and thus a giver of light in numerous literary texts, the wearing of white or silver attire could indicate that those around her were effectively illuminated by her presence.[12] This type of astrological reference was also one of the most popular literary devices for glorifying the monarch in verse. John Davies, for example, in a text on dancing, wrote in 1596 that, 'around her the court shown like a thousand sparkling stars' and even the popular woodcut (illustrated page 178) styles Elizabeth in the verse below her portrait 'as the one only star of light'.[13] Light colours and particularly white or silver costume were routinely worn by many courtiers from the 1570s, as can be seen from numerous existing portraits.

THE BROAD SCOPE of this subject and the vast literature compiled on Elizabeth's representation has meant that this essay can only be a brief overview of some of the key issues concerning Elizabeth's likeness during her reign and, far more generally, of aspects of the extraordinary nature of Elizabethan painting. Certainly, even though many foreign painters were employed at court, painting in England was in no sense a poor imitation of European artistic models, but a wholly English mode of portrayal. Artists in England not only adopted literary devices but the linear, non-illusionistic style in which they painted might itself have been shaped by a Protestant, particularly Calvinist, understanding of the nature of visual representation. The representation of the queen in visual imagery differed dramatically according to the function of imagery and the context in which a portrait or emblem might appear. It is true to say that much of Elizabeth's representation was constructed for her by those at court and that, at least to some extent, the use of emblems meant that she was depicted outside her own sexuality and mortal transience, rarely as an aging woman but as a stable figurehead with God-given right to rule. It is certainly clear that it was Elizabeth's royal presence that was visually asserted, not only in the houses of wealthy courtiers but far more widely into the cities and towns of England. The survival of many of these images is not only good fortune but evidence of how they were valued as important historical documents by the descendants of families who commissioned and acquired them.

ELIZABETH'S JEWELLERY

DIANA SCARISBRICK

'SHE MUCH AFFECTED RICH AND COSTLY APPAREL AND IF EVER JEWELS had just cause to be proud it was with her wearing them', wrote Thomas Fuller in *The Holy State* (1642). National pride in Queen Elizabeth's jewels was such that it was considered a tragedy when her successor, James I, began the series of sales and gifts which was to be completed by his son, Charles I. By 27 March 1626 so much had gone that Sir John Eliot demanded a parliamentary investigation with nostalgic regret: 'O! Those jewels! The pride and glory of this realm, which hath made it so far shining beyond others! Would they were here within the compass of these walls to be viewed and seen and examined in this place. Their very name and memory have transported me.'

IF SO MUCH HAD already disappeared by 1626, virtually nothing remains today. Nonetheless, with those few that have survived and through the evidence of paintings and miniatures we can still get glimpses into her great collection. Documents help complete the picture, especially the inventory of 628 jewels listed in 1587 by Mrs Blanche Parry on her retirement as lady of the bedchamber, for her successor, Mrs Mary Radcliffe.[1] As all Elizabeth's jewels, together with her wardrobe of over two thousand dresses, were claimed by James I, the inventory of the jewels of his wife, Queen Anne, compiled in 1607, is also of the greatest interest.[2] It contains many pieces which belonged to Elizabeth and which she herself had inherited from her Tudor predecessors.

THERE IS NO DOUBT that the nucleus of Elizabeth's collection came from her father, Henry VIII, who made vast additions to the jewels left him by his rich and frugal father, Henry VII. His passion for display was inflamed by rivalry with the French king, Francis I, when they met at the Field of the Cloth of Gold in 1520, and each tried to outdo the opulence of the other. It was also typical of Henry VIII that, having quarrelled with the pope and dissolved the monasteries

in 1536, he should have appropriated for his own use all gold, silver and gemstones remaining in the church treasuries. Besides this windfall he regarded the jewels of each of his six wives as his own property. He insisted that the first, Katherine of Aragon, return to him every single piece in her possession at the time of their divorce in 1533: some were still in Elizabeth's collection in 1587, identifiable because they were decorated with the pomegranate of Granada which was Queen Katherine's emblem. His last wife, Katherine Parr, was equally unfortunate for when Henry died in 1547 her ten-year-old stepson, Edward VI, ordered her to return all her jewellery to the crown just as her predecessors had done.

ALTHOUGH SO YOUNG, Edward VI loved finery and before his death in 1553 at the age of sixteen he had added to the ancestral collection. His most spectacular purchase was the jewel called the 'Brethren or Three Brothers' which consisted of three large rose-coloured spinels — hence the name 'Brothers' — set around a large point-cut diamond with three pearls called the Brethren between. In the fifteenth century it had been part of the treasure of the rich and elegant

dukes of Burgundy, and Elizabeth, who wears it as a pendant in the 'Ermine Portrait' at Hatfield, did not alter the setting.

Mary I, the daughter of Katherine of Aragon, was sixteen years older than Elizabeth. If her reign, plagued by religious conflict, had not been so difficult, she would have bought jewels, as her father and brother had done, for she shared their enthusiasm for the rich and the precious. Since money was in short supply most of her best pieces were gifts. Philip II, her husband, gave her wonderful jewels at the time of their wedding, including a diamond and pearl collar composed of their joint initials P and M. As this collar is listed in Queen Anne's inventory of 1607 – and she is known to have worn it – it must have previously been in the possession of Elizabeth. When Mary died in 1558, she willed that all presents from Philip II should return to Spain, but with the exception of a great pearl and diamond jewel, he offered the new queen anything she wanted 'as a good brother should'. This explains why she owned so many jewels with Philip's portrait, his initials and the Habsburg emblem of the eagle, twin columns and motto *Plus Oltre*.

Knowing Elizabeth's love of jewels, other monarchs, princes, ambassadors and courtiers followed Philip II's example. As it was customary to offer gifts to the queen each New Year's Day, many decided to present jewels rather than plate, purses of money or clothes, which are recorded in the gift rolls for each year (Cat. no. 98). On 1 January 1587 she received no fewer than eighty different pieces of jewellery. The most splendid came from her two favourites, Sir Christopher Hatton (Cat. no. 133) and Robert Dudley, earl of Leicester (Cat. no. 60). As a reminder of his devotion Leicester's jewels often bore his badge of the bear and ragged staff: he presented a white feather fan in 1574 set in a gold handle with a white bear on each side, and in 1580 a set of gold buttons for her hat and dress were decorated with a ragged staff with true love knots. He also started the ritual of welcoming the queen on her arrival at his country home with the gift of a jewel and giving another as a keepsake on her departure. These summer visits, or progresses, therefore proved an important source of new jewels. Others came by bequest, such as the legacy from Sir Thomas Heneage, vice-chamberlain to Elizabeth's household, who died in 1595.

In accordance with the rules of courtship Elizabeth's many suitors offered her jewellery. The most persistent, the duke of Anjou (Cat. no. 74), youngest son of the formidable dowager queen of France, Catherine de Medici (Cat. no. 225 (e)), was twenty years her junior, undersized, with a large nose and skin pitted by smallpox. Her nickname for him, 'very dear frog', must have inspired the two frog jewels he gave her, one containing his miniature, the other studded with emeralds. He gave her a diamond engagement ring, a bracelet composed of the letters of his name, another inscribed *Serviet Eternum Dulcis Quem Torquet Eliza* (He who sweet Eliza tortures will be her servant for ever) with a gold padlock and a pendant set with a sardonyx cameo of Diana.[3]

Elizabeth made important purchases of her own. In 1568 Mary Queen of Scots took refuge in England, leaving in Edinburgh the celebrated rope of pearls which was her wedding present from her mother-in-law, Catherine de Medici. The regent of Scotland who now governed in her place, offered the twenty-five single pearls, each as big as a nutmeg, and six long strings threaded together like a rosary, to Elizabeth. Knowing how desperate he was for money she succeeded in obtaining them at a bargain price.[4]

Equally hard-headed in her dealings with other monarchs, she refused to return the diamonds which Henry of Navarre had left as security for a loan, in spite of his protests that he had repaid it. Similarly, the 'Mirror of Portugal', a 30-carat table diamond valued at £5,000 on which she lent £3,000 to the pretender to the throne of Portugal, became hers at far less than its real value when he failed to repay the loan.[5] She was, of course, a customer of London jewellers, such as Hugh Kayle and Sir John Spillman, and directed Sir Nicholas Throckmorton, her ambassador in Paris, to buy watches and jewels on her behalf and to encourage French goldsmiths to 'come hither with furniture of aglets, chains, bracelets & etc. to be bought both for herself and by the Ladies to be gay in this court towards the Progress'.[6]

Another source of jewellery was loot from Spanish ships returning home laden with treasures from South America. The queen's investment in Francis Drake, the most successful of

the English seamen involved in these ventures, proved most lucrative. She obtained her share of the booty and they exchanged presents of jewellery. On New Year's Day 1580, she wore a diamond crown with five splendid plundered emeralds, and there is a tradition that Sir Francis also gave her the Hunsdon ship pendant (Cat. no. 105) and a diamond frog, which was presented at the banquet on the *Golden Hind* at Deptford in 1581. According to family tradition she gave him an opal and ruby sun (Cat. no. 159) and the cameo pendant (Cat. no. 158) which are still owned by the Drake family.

PORTRAITS SHOW A VARIETY of ornaments for the head. As a young princess, Elizabeth wore a French hood trimmed with two rows of jewels, called bilaments. The lower bilament consisted of a narrow row of pearls alternating with gold beads, and the upper bilament – which was wider – was composed of clusters of five pearls between enamelled gold quatrefoils set with table-cut gems on scrolled bases (Cat. nos. 28 and 29). In her coronation portraits, the official crown is shown made of a circlet of single rubies and sapphires set alternately between pairs of pearls and supporting a row of fleurs-de-lis and crosses also set with rubies, sapphires and pearls with arches meeting at a cross at the top. Below the cross was the large cabochon spinel about 5 centimetres long named after the Black Prince, eldest son of Edward III. In the 'Ditchley Portrait' Elizabeth wears the Black Prince's spinel at the top of a ruby and diamond obelisk crowning a mass of high padded artificial hair. The French hood disappeared in

Detail from the 'Ditchley' Portrait showing Queen Elizabeth's head crowned with a diamond and ruby obelisk surmounted by a large red cabochon stone, which may be the Black Prince's spinel.

the second half of the century but the queen continued to wear bilaments, but now only in a single row. One of the most magnificent is depicted in the 'Pelican Portrait' (Cat. no. 193). It is like a garland composed of clusters of five pearls piled high alternating with gems in settings enamelled with white daisies to each side of a large pointed diamond framed in rubies. In the 'Ermine Portrait' she wears a new style of head jewel, an attire composed of pearls standing up in points and arranged in sprigs mounted on a wire frame and encircling the back of the head like a halo. The attire of large pear-shaped pearls depicted in the portrait celebrating the victory over the Armada in 1588 was worn with a large bodkin headed by a fleur-de-lis and backed by an aigrette of feathers (illustrated pages 230–31). This introduces the largest category of her hair ornaments: the bodkin. Most were decorative clusters of gemstones, or pear-shaped pearls, but others represented insects and flowers, military and sporting motifs and even homely genre objects such as a pair of bellows, a cradle and gardening tools. The most spectacular of all her bodkins was the crescent pinned to the headdress depicted in the 'Rainbow Portrait'. Here she personifies the sun who brings the rainbow, a symbol of peace after storms, and the crescent – the attribute of Diana or Cynthia, goddess of the moon and Empress of the Oceans – which also symbolises her authority over seas and rivers, a clear allusion to the Armada victory. The crescent is set with a ruby and diamonds and is tipped with pearls: below is a red cabochon stone which could be the Black Prince's spinel. It forms the

pinnacle of an elaborate headdress copied from a contemporary Italian engraving of the picturesque costume of a Greek bride from what is modern Salonika.

FROM ELIZABETH'S EARS in the 'Rainbow Portrait' hangs a chandelier style earring with a cross bar of three diamonds supporting a large lozenge-shaped diamond between two hanging pearls, then three ruby drops and finally a pear pearl. In those days earrings were not always worn in pairs and we know that Sir Thomas Heneage gave her one single pendant for her ear, accompanied by a fulsome declaration of devotion. She sent him her thanks in a very amusing letter promising that whenever she wore his gift she would never listen to a word said against him. Although the majority of her earrings were pear pearls, her inventories also list chains of diamonds, pearls, cabochon emeralds, rubies and figurative motifs such as snakes and doves.

ELIZABETH'S NECKLACES were equally impressive. In the 'Pelican Portrait' (Cat. no. 193) the one she is wearing matches her bilament, consisting of pearl clusters with ruby links framed in white daisies centred on a point-cut diamond in a red strapwork mount, each section being a jewel in its own right. The majority of necklaces were pearls threaded into single or double rows as a choker high on the throat or in a fringe hanging from strings of diamonds. She continued to wear very low cut dresses even at an advanced age and with them bib-style necklaces with gemstones and pearls in multiple rows. No less than sixty-seven chains were listed in the 1587 inventory: designs varied from plain gold links to elaborate figurative compositions of black men climbing trees. Grandest of all were the collars she inherited from Henry

Detail from the 'Ditchley' Portrait showing a ruby and diamond celestial sphere or orrery hanging from the ear, declaring a concern for things spiritual as well as temporal.

VIII. In the 'Phoenix Portrait' she wears one of strongly dynastic character, composed of large Tudor roses set with precious gems linked by alternate clusters of pearls and of diamonds or coloured stones in cartouches. In the 'Ermine Portrait' her collar consists of pearls in groups of eight, enclosed in filigree, with rubies to each side of the large point-cut diamond in the centre.

HANGING BELOW THIS collar is the 'Three Brothers' jewel bought by Edward VI, described by Mrs Blanche Parry, in her inventory of 1587, as a jewel with three large spinels and a big point-cut diamond in the centre with three pearls between, called the 'Brethren', with a large pear-shaped pearl hanging below. It is these flowers or pendant jewels which illustrate the widest range of motifs in her jewellery collection. Whereas the 'Three Brothers' was designed to show off fine gemstones in the medieval tradition, other flowers incorporated motifs derived from classical art. The huge stone in the portrait of the queen in the character of the virgin Tuccia was flanked by figures of a nymph and a satyr, while a jewel in the 'Darnley Portrait' has a frame surmounted by Minerva, Jupiter at the base, with female breasted hybrids, Venus, Cupid and Mars — each with his attribute — at the sides (illustrated page 187). A pendant hanging on the skirt of a portrait at Hardwick Hall represents a diamond obelisk on a platform with two golden figures of Fame to each side sounding the queen's praises on trumpets. These classicising jewels, like cameos which are also a revival of the art of antiquity, must have had a special significance for Elizabeth, who was a true product of the Renaissance, being highly educated and quite capable of making an impromptu speech in elegant and witty Latin.

EVEN MORE SIGNIFICANT were the jewels proclaiming her rank as queen. She wore the Lesser George or badge of the Order of the Garter (Cat. no. 62) which showed the nation's patron saint in the act of killing the dragon, from a blue ribbon or jewelled chain. It linked her with her Plantagenet ancestors and in the historic atmosphere of Windsor Castle, Greenwich or Whitehall each St George's Day she re-enacted the picturesque Garter ceremonies, when the knights of the Garter would affirm their loyalty to her. She also adopted emblems symbolic of her role as sovereign, notably the pelican, which fed its young with its own blood. Geffrey Whitney explained

The Pelican, for to revive her
 younge
Doth pierce her brest, and geve
 them of her blood.
Then searche your breste, and
 as you have with fonge
With penne procede to do your
 countrie good:
Your zeale is great, your
 learning is profound
Then help our wantes, with
 what you doe abounde[7]

Detail from the 'Darnley Portrait', in which the figures of Jupiter, Minerva, Mars, Venus and Cupid surrounding the centre gem in the pendant on the Queen's skirt indicate her classical learning.

Another emblem she adopted was the phoenix which, rising from the ashes, was a wondrous and unique creature (Cat. no. 203). In 1586 the lord admiral, Lord Howard, gave her a bracelet inscribed with her motto, *Semper Eadem*, clasped with an opal and ruby phoenix. Both phoenix and pelican are represented in portraits attributed to Nicholas Hilliard.

OTHER EMBLEMATIC JEWELS made into pendants included ships (Cat. no. 105) which, to the educated sixteenth-century mind, signified happiness, deriving from a Roman coin struck during the reign of the Emperor Hadrian which in turn represented a ship with the inscription *Felicitas*.[8] A diamond crossbow in her collection symbolised, according to Whitney, the triumph of human brain power over brute strength.[9] Some, such as the jewel from Leicester, in which she is represented seated on the throne with the Queen of Scots in chains at her feet, the kingdoms of France and Spain submerged under water and 'Neptune and the rest of them bowing to this Queen' were highly political.[10] The number of jewels of military character — helmets, guns, gauntlets and trophies of arms — recorded in the gift rolls of the 1580s echo the confidence in her leadership during the years when the country was threatened by a Spanish invasion. This is the significance of the gold, diamond and opal jewel representing two hands, one holding a sword, the other a trowel. According to Whitney it conveys the message: 'That to defend our country dear from harm / For war or work we either hand should arm.'[11]

As A YOUNG PRINCESS Elizabeth hung a prayer book at her girdle and on her neck wore a diamond cross with arms and upright linked by filigree knotwork (Cat. no. 13). Many more jewelled crosses were acquired in the course of her reign as well as a diamond monogram of Christ I H S. She also showed her concern for things eternal by adopting the emblem of the celestial sphere (Cat. no. 208), which is depicted in several portraits. In the 'Ditchley Portrait' it is over her ear; in the 'Rainbow Portrait' it hangs on her sleeve.

ALTHOUGH ELIZABETH is usually shown wearing strings of pearls at her wrists, she also owned bracelets of goldsmiths' work — for instance, the pair of rock crystal bangles recorded in the 1587 inventory, one of which survives in the Hunsdon

heirlooms (Cat. no. 104). In the 'Pelican Portrait' she has a magnificent armlet above her elbow: a mosaic of great cabochon rubies, pointed diamonds and a sapphire, some set as stars in richly wrought enamelled gold (Cat. no. 195).

ELIZABETH'S GOLDSMITHS also turned objects necessary for comfortable living into fine jewels. Whether grand fan handles and sable heads, or the more humble toothpicks, like everything else in her wonderful collection they served to set her apart from the rest of the world and created the aura of majesty inseparable from her image. Even her rings, the smallest of her jewels, played their part. As was customary at that time she wore them in her hair and hanging around her neck. It is said that one of her favourite gestures was to pull off her gloves and extend long slender fingers sparkling with rings to those presenting letters and gifts. She seems to have been particularly attached to her coronation ring which became so embedded in her finger that it had to be filed off forty-three years after her accession. Then, at Elizabeth's deathbed, Lady Scrope is said to have removed a sapphire ring from the Queen's finger, and, as all the doors were closed, threw it out of the window for her brother Robert Carey, son of Lord Hunsdon, to take to the heir, James VI of Scotland, waiting in Edinburgh for proof that his moment had come.

192. Elizabeth I and the Three Goddesses, 1569

Attributed to Hans Eworth (fl.1540–70).

Oil on panel.

70.8 x 84.5cm.

Inscribed: lower right: '1569 / HE [ligature]'; on frame: 'IVNO POTENS SCEPTRIS ET MENTIS ACVMINE PALLAS / ET ROSEO VENERIS FVLGET IN ORE DECVS / ADFVIT ELIZABETH IVNO PERCVLSA REFVGIT OBSVPVIT PALLAS ERVBVITQ VENVS'.

Translated as: 'Pallas was keen of brain, Juno was queen of might, / The rosy face of Venus was in beauty shining bright, / Elizabeth then came, And, overwhelmed, Queen Juno took to flight; / Pallas was silenced; Venus blushed for shame'.

Provenance: Elizabeth I by 1600; by descent to Charles I, after whose execution sold to Hunt and Bass on 1 March 1653; recovered for the royal collection by the reign of James II (1685-8).

Her Majesty The Queen.

We know that this remarkable painting belonged to Elizabeth herself because it was seen by a visitor, Baron Waldstein, at Whitehall Palace in 1600. The queen stands on the steps to the left and is about to emerge through a classical arch from a royally decorated interior, wearing a crown and holding her orb. Her dress is richly jewelled and embroidered with Tudor roses. Elizabeth gazes down past the figures of three classical goddesses: Juno, with her symbolic peacock behind her and her garments flying, who turns to beckon to the queen; the helmeted Pallas, who holds a tall banner and raises her right hand in

Opposite: Portrait of Elizabeth I with a Pelican Emblem, c. 1574, see p. 192.

apparent surprise; and Venus, an elegant nude, who sits with one arm round her son Cupid, her swan-drawn chariot on the path behind. On the hill in the centre distance is Windsor Castle. The goddesses' identities are confirmed by the Latin inscription on the frame.

It is clear that Elizabeth has here subverted the role of the shepherd Paris who, according to classical legend, had to judge which of the three goddesses was the most beautiful; Paris selected Venus, to whom he awarded a golden apple. Here Elizabeth is the decision maker, her orb perhaps paralleling the golden fruit – but rather than choosing between the three goddesses and the qualities that they represent, she may be seen as representing elements of all three. The question of whom the queen should marry was a major contemporary concern: Juno, the central figure here, was goddess of marriage, a state to be entered into, ideally, with both love (Venus) and wisdom (Pallas).

The monogram 'HE', bottom right, is associated with the Antwerp-born and trained artist Hans Eworth, who came to England as a religious exile during the 1540s, and became one of the most significant portraitists to work for the court elite there.　　KH

LITERATURE: Millar, *Collection*, p. 69; Hearn (ed.), *Dynasties*, cat. no. 29, pp. 73–4.

193. Portrait of Elizabeth I with a Pelican Emblem, c. 1574

See previous page.
Attributed to Nicholas Hilliard (1547–1619).
Oil on panel.
79 x 61cm.
Provenance: the earl of Suffolk, Charlton Park, by 1801; by descent to countess of Suffolk, from whom it was bought by Spink for E. Peter Jones, 1930. Presented to the Walker Art Gallery 1945.
Board of Trustees of the National Museums and Galleries on Merseyside (Walker Art Gallery, Liverpool).

The 'Pelican Portrait' shows Elizabeth at the age of around forty, dressed in a jewelled gown of red velvet with a pelican pendant pinned at her chest. The pelican was one of the queen's favourite emblems and symbolised the virtues of charity and self-sacrifice, as it was frequently shown feeding its young from the blood of its own breast (Cat. no. 194). As the 'mother' to her Protestant nation Elizabeth likewise nurtured her subjects and she is described by the author Anthony Munday 'as a loving mother and nurse of all her subjects' (Wilson, p. 218).

A little noticed feature of this portrait is that she is shown standing under the edge of a fringed canopy which appears at the top of the panel. Both her throne and litter included canopies fringed with gold and therefore Elizabeth appears in this painting as if holding court or on public display. Her elaborate dress might well have been painted

from life and the 1570s mark the beginning of a period when her appearance becomes increasingly magnificent. Her attire uses the four colours of white, black, red and gold that made up much of her wardrobe. Her undershirt (or partlet) and matching sleeves are embroidered with Tudor roses in black silk and are similar to an existing pair of sleeves at the Victoria and Albert Museum (Cat. no. 126).

The untouched cherries she wears tucked into her right ear have been interpreted as a eucharistic symbol, although it is more likely that they relate to her virginity as the cherry appeared later in Shakespearian drama as slang for a woman's maidenhood. Conservation treatment has revealed the unusual cast of the queen's dark shadow in the background to the left side of the panel that provides a sense of interior space and situates Elizabeth as looking out in the direction of bright sunlight, which was probably intended as symbolic. Another image of the queen known as the 'Phoenix Portrait' was painted around 1575–6 by the same hand and is a reversed version of this composition, in different attire (National Portrait Gallery, NPG 190). Despite suffering from some losses, it is evident that the composition of this painting has been extremely carefully devised. The painting's linear exactitude and impressive level of detail down to the design of lace stitching and fall of each lock of hair suggests that it may have been made by, or under the direction of the miniaturist, Nicholas Hilliard.　　TC

LITERATURE: Hearn (ed.), *Dynasties*, pp. 235–7; Strong, *Portraits of Elizabeth*, 1963, p. 60, pl. P.23; Wilson, *England's Eliza*, pp. 217–18. We are grateful for the use of unpublished papers at the Walker City Art Gallery.

194. Pelican Cup, 1579/80

London mark a bird, probably the royal goldsmith Affabel Partridge.
Silver gilt.
Victoria and Albert Museum, London, anonymous loan.

This cup, modelled as a pelican in her piety, was originally even more striking than it appears today. Its body was a fragile nautilus shell, brought from the Pacific Ocean. Not made as a drinking vessel, it was devised to stand on a buffet to express the goldsmith's skill and the patron's taste. The goldsmith, one of the most inventive supplying the court, has incorporated a complex cast knop and added a band of hunting dogs around the foot. His mark, a fat little bird, was identified within the past twenty years. Three or four London goldsmiths supplied the court with plate and gold collars on annual contracts.

The self-sacrificing pelican was an emblem associated with Elizabeth. Some bird cups, like the five cocks made for the Skinners Company in memory of William Cockayne (d.1598), referred to the donor's name, a typical Elizabethan delight in wordplay. PG

195. Pelican Pendant, second half of the sixteenth century

Spanish.
Gold, vari-coloured enamel, foiled red glass and pearl.
Provenance: the Treasury of the Virgin of the Pillar at Saragossa, Spain.
Victoria and Albert Museum, London, 335-1870.

This pendant, worn hanging from chains, comprises a cast and chased white bird on a green perch, wings displayed, and fledglings on a dish below decorated, as is the back of the bird, with black and white arabesques. Of Spanish origin, it represents a pelican in its piety pecking its breast and therefore symbolising both charity and Christ. In England it was adopted by Elizabeth as an allegory for her loving care for her subjects, and is the theme of the 'Pelican Portrait' by Nicholas Hilliard (Cat. no. 193). In popular prints, it is often paired with the phoenix symbol (Cat. no. 203). Elizabeth's identification with the pelican is referred to in many literary works. DS

LITERATURE: Somers Cocks (ed.), *Princely Magnificence*, no. 105; Strong, *Gloriana*, p. 83.

196. Portrait of Elizabeth I, c. 1585

See overleaf.
Marcus Gheeraerts the Elder (c. 1525–before 1591).
Oil on panel.
45.7 x 38.1cm
Signed: 'MGF' on the chair support.
Provenance: Matthew Prior, who bequeathed it in his will of 9 August 1721 to Henrietta Cavendish-Holles, wife of the 2nd earl of Oxford, thence by descent.
Private Collection.

In this unusual portrait Elizabeth stands before the viewer as an allegorical personification of 'Peace' holding an olive branch in her right hand, while almost beneath her feet is a sheathed sword decorated with a Tudor rose and the royal arms. Elizabeth is elaborately dressed in what has been described as Polish fashion and wears jewels similar to those seen in the 'Ermine Portrait' of around the same period. In the background to the right there is a view out to an open doorway into a formal courtyard, where a male courtier is in conversation with two ladies. It is possible that he may be connected with the commission. Although the figure would be difficult to identify positively, he appears to have reddish fair hair and wears a medallion jewel in his hat and is accompanied by a dog, at the far edge of the picture. There is a long tradition that the house is Wanstead Place, the home of the earl of Leicester, where the queen was frequently entertained in the 1580s.

The exact date of this painting is unknown, but the costumes are unlikely to date from before 1580. This is also one of the few paintings of the queen that can be securely linked with an artist. Marcus Gheeraerts the Elder had left his native city of Bruges in 1567/8 as a religious refugee, and appears to have practised in London both as a painter and a printmaker (for which he is better known). This image is one of the few paintings by Gheeraerts in existence relating to an English subject. He was certainly working in Flanders from 1577 until 1586 and it is possible that he may have undertaken the commission for this portrait while back in his native country. If Dudley was connected to the commissioning of this image, he might well have met the artist in the Netherlands where he led a campaign assisting the Dutch against Spain from August 1585 to December 1587 (Cat. no. 228). TC

LITERATURE: Hearn (ed.), *Dynasties*, pp. 86–7; Hodnett, *Gheeraerts*; Strong, *Gloriana*, pp. 113–15.

197. Late Elizabethan Coins

(a) Two pound sovereigns of Elizabeth I, 1591/2–4
London Mint.
Gold.
British Museum, London, CM E0306; E0307.

(b) Crown (5 shillings) and half-crown of Elizabeth I, 1601–2
London Mint.
Silver.
British Museum, London, CM Grueber 506; E0352.

When the mint issued its first pound sovereigns in 1593, the queen's coin portrait retained its iconic agelessness but the detail of the new portrait was much richer and more majestic than before, with exaggeratedly ornate clothing, and profuse, flowing hair, emphasising her virginity. The dies for the new coins were the work of Charles Anthony, who was assuming the workload of his father Derek, and would formally succeed him as mint engraver on his death in 1596.

In 1601 the crown and half-crown became large silver coins instead of small gold ones for the first time since their brief change under Edward VI, requiring another new set of large-scale images from Charles Anthony. For these, the presence of an orb and sceptre make the queen's appearance even more emphatically authoritative. BC

LITERATURE: Brown and Comber, 'Portrait punches used on the hammered coinage of Queen Elizabeth I', pp. 91–101.

198. Cameo Portraits of Queen Elizabeth

(a) Cameo ring, last quarter of the sixteenth century
Gold, onyx cameo.
Provenance: Bram Herz, Lord Braybrooke, Sir Augustus Wollaston Franks.
British Museum, London, AF.1432 (Dalton 380).

(b) Cameo pendant, last quarter of the sixteenth century
Gold, enamel, rubies and sardonyx cameo.
British Museum, London, AF.2654 (Dalton 379).

(c) Sieve portrait cameo pendant, last quarter of the sixteenth century
Gold, sardonyx cameo.
Victoria and Albert Museum, London, 1603-1855.

(d) Cameo, first half of the seventeenth century
Sardonyx cameo.
Provenance: the Cheapside Hoard.
Museum of London, A14603.

These belong to a group of thirty surviving cameo portraits of the queen, all cut from about 1575 until 1603 according to established patterns, size and style, presumably by a specialist workshop, which supplied the court jewellers with cameos for setting into rings, brooches and pendants. Following the example of the emperors and empresses of ancient Rome, the monarchs of the Renaissance also commissioned cameo portraits of themselves to give as marks of royal favour and to reward those loyal to them, and which were treasured by the recipients.

In the sieve cameo (c), the queen is wearing a veil on her jewelled headdress, a high ruff fringed with pearls, padded sleeve rolls and a

dress embroidered with a trailing vine, symbolic of wealth and prosperity. Her gloved left hand holds the cuff of her other glove, and in her bare right hand she holds a sieve. The sieve, symbol of virginity, is the attribute of the vestal virgin Tuccia, who proved her virtue by carrying a sieve full of water from the Tiber to her temple without spilling a drop. The sieve emblem, which appears in several painted portraits of 1579 to 1580, can be traced back to the lyrical poetry of the court.

The fine sardonyx portrait from the British Museum (b) is still in a late sixteenth-century wheel-shaped frame, mounted with eight table-cut rubies. Another small sardonyx cameo portrait from the Museum of London ((d) not illustrated), presumably ready for setting in a ring or other jewel, shows that the demand for them continued for at least half a century after her death. This is confirmed by John Evelyn, who in 1654 recorded in his diary that Jerome Lanier was wearing a ring set with a cameo portrait of Queen Elizabeth. DS

LITERATURE: Kagan, 'Portrait Cameos'; Scarisbrick, *Jewellery 1540–1940*; Somers Cocks (ed.), *Princely Magnificence*, no. 43.

199 Bust of Elizabeth I

British School.
Marble.
49.5 x 59 x 25cm.
Provenance: by descent.
Earl of Scarbrough, on loan to the Leeds Castle Foundation.

This bust of Elizabeth is one of four marble sculptures depicting Henry VIII and his three children. It is designed to show the queen during the early years of her reign, since she is wearing a costume from the 1560s, but the marble is probably far later. The design is rather stiffly composed and has been linked with a medal of Elizabeth produced by the Netherlandish artist Steven van Herwijk in 1565.

The four busts have been associated with those once belonging to a prominent Catholic nobleman John, Lord Lumley (?1534–1609). A list of paintings and sculptures found within the inventory of his estate at Lumley Castle, made in 1590, includes a reference to 'four lively statues all wrought in white marble in memory of K Henry the 8, King Edward 6, Queen Marie and Q. Elizabeth in whose reigns his lord lived' (Hearn ed., p. 83). The inventory includes numerous pen and ink sketches of Lumley's possessions which have proved helpful in identifying existing art works. A sheet depicting various sculptures mounted upon a wall includes drawings of the four busts which differ in significant details from the existing marbles (Hearn ed., p. 159). The drawings of the Lumley busts depict Mary and Elizabeth wearing distinctively different attire from the existing sculptures: Elizabeth's costume, for example, comes from c. 1590 and includes a deep open ruff with circular pleats. It therefore appears probable that the bust sculpture exhibited here is not that described in the Lumley inventory but a slightly later version. Few artists in England specialised in marble sculpture and those who did were mainly employed in making tomb monuments. Only very few sculpture portraits of Elizabeth were produced in her lifetime and the Lumley sculpture described in the inventory (which must have been commissioned before 1590) was probably one of the few three-dimensional images of Elizabeth in existence in her reign. TC

LITERATURE: Cust, 'Lumley Inventories', Hearn (ed.), *Dynasties*; Strong, *Portraits of Elizabeth*, p. 145, pl. S1.

200 Portrait of Elizabeth I with the Cardinal and Theological Virtues, c. 1598

British School.
Oil on panel.
113 x 88cm.
Provenance: purchased by the Corporation of Dover in 1598.
Dover Museum.

Most of Elizabeth's subjects knew her likeness via official portraits, as found upon coins or some printed images. However, it appears that some towns commissioned their own painted portraits of the queen to be set up in the town hall as evidence of their loyalty to the crown. This is one of the few paintings of Elizabeth that is documented as specifically made for a civic environment, and it was commissioned in the fortieth year of the queen's reign to be displayed as an emblem of

monarchy in the town hall at Dover in Kent. On a progress in Kent the queen had visited Dover for at least five days in August 1573, yet the painting was probably not connected to this visit as it was paid for only in 1598. It cost 25 shillings, with a special wooden frame carved with the Tudor heraldic supporters of a dragon and lion costing 6 shillings and 9 pence under the city mayor 'Jeromy Garrett'. In line with the civic function of this portrait, the queen is shown as head of state wearing her parliament robes. As Janet Arnold has observed, the painter was probably not able to work directly from the actual robes and had some difficulty in painting the mantle.

The queen's face looks extremely youthful, and the portrait includes an interesting series of emblems, designed to reflect upon Elizabeth's virtues. Both these aspects project a stable image of monarchy that was not compromised by the queen's gender or the passing of time. A pillar in the background is inset with medallions showing at the top the three theological virtues: Faith, Hope and Charity, and below the four cardinal virtues: Justice, Prudence, Temperance and Fortitude, all personified by women with various attributes. These were common symbols in Renaissance art and would have been readily understood by the educated townspeople and merchants of the city. TC

LITERATURE: Arnold, *Wardrobe Unlock'd*, p. 62; Wollaston-Knocker, *Dover Corporation*, p. 46; Strong, *Portraits of Elizabeth*, p. 84, pl. P.99.

201. Elizabeth I as Cynthia, 1586–7

Nicholas Hilliard (1547–1619).
Vellum, relaid on to modern card.
8.6 x 6.6cm.
Victoria and Albert Museum, London, P23-1875.

In contemporary literature as well as painting, Elizabeth was often personified as one of a number of mythological or literary figures, such as the nymph Astraea, the vestal virgin Tuccia or Petrarch's chaste heroine Laura. Another figure with whom she was often compared was Diana, or Cynthia, goddess of the moon. Elizabeth's particular association with Cynthia, rather than the better-known Diana, seems to have been influenced by Sir Walter Ralegh's long narrative poem 'The Ocean's Love to Cynthia', thought to have been written in the late 1580s, though completed during the early 1590s, where the queen is compared to the moon.

In this miniature, painted during the decade of Hilliard's greatest success at court, Elizabeth's disguise as Cynthia is alluded to by the crescent moon – one of the goddess's attributes – in a jewel adorning her hair. Other jewels decorate her elaborate costume and ruff: Hilliard's early training with the royal jeweller Robert Brandon gave him the necessary skill to achieve the lustre and sparkle of precious stones, even though these painted jewels, like Elizabeth's face, have faded. Most miniatures, or limnings as contemporaries called these little pictures

on vellum, were painted directly from life, a direct engagement between sitter and artist, but this example, like others by Hilliard of the queen from this decade, is an idealised portrait of a young woman, not the *ad vivum* image of the middle-aged queen. This youthful facial type, which is also found in large-scale portraits of the queen, has been described as the 'Mask of Youth'; as the prospect of an aging Elizabeth marrying and securing an heir became unlikely, her portraits represent her as forever young. Uniquely there is a direct relationship between this miniature and a later engraving by Francis Delaram produced between 1617 and 1619. Delaram's image, in reverse, adds a fan in Elizabeth's right hand, and surrounds the queen with heavenly rays and a crown of stars. DD

LITERATURE: Berry, *Chastity and Power*; Strong, *The Cult of Elizabeth*.

202. Self-Portrait by Nicholas Hilliard, 1560

Nicholas Hilliard (1547–1619).
Vellum laid down on to card.
2.6cm diameter.
Inscription around edge: 'NICHOLAIS HELIAD IN ÆTATIS SVEA 13 + OPERA QVEDAM IPSIVS'; to left: 'NH 1550' (repainted should read 1560).
Provenance: Edward, Lord Harley, then by descent.
Private Collection.

An important characteristic of the visual arts under Elizabeth was the development of miniature portrait painting, and it was Nicholas Hilliard who was central in creating a demand for this medium. The

queen is known to have kept a cabinet of miniatures within her private bedchamber which included a portrait of Robert Dudley, and a considerable number of these were probably painted by Hilliard.

This small self-portrait is one of the earliest in existence by an English artist, and Hilliard is stated as being in the thirteenth year of his life at the time it was painted. If we can assume the portrait was painted in 1560 (rather than the repainted date 1550), it was made two years before Hilliard became apprenticed to the queen's jeweller, Robert Brandon. The miniature was probably painted in London, following several years spent in Geneva, and provides us with interesting evidence of Hilliard's precocious talent for miniature painting or the art of limning. Hilliard's early training is obscure but he may have received some instruction in painting miniatures from Levina Teerlinc (Cat. no. 113). The artist's features are carefully drawn with a great attention to detail that would later become highly characteristic, but at this young age he has not yet gained the incredible delicacy of touch he was later to employ in portraits of Elizabeth and other members of the court (Cat. no. 201). In the last few years of Elizabeth's reign Hilliard wrote a comprehensive work entitled *The Treatise Concerning the Arte of Limning*, which serves as one of the single most valuable documents on artistic practice in this period.

TC

LITERATURE: Auerbach, *Hilliard*, pp. 70–7; Hilliard, *Treatise*; Goulding, 'Miniatures', no. 12.

203. *A Choice of Emblemes and other Devises*, 1586
Geffrey Whitney.
Printed book, published by Christopher Plantin, Leyden.
British Library, London, C.57.1.2 pp.176–7.

This translation and anthology of continental emblems explains the symbolic meaning of emblems, which were widely used by Elizabethans in paintings, textiles and jewellery. Whitney, however, had not intended his work to be a reference book of esoteric symbolism. He wrote it to publicise and win support for Leicester's campaign in the Netherlands (Cat. nos. 226–228). The book therefore praised the earl and included dedications to the notable scholars, soldiers and preachers who accompanied him on his expedition against Spain.

The emblems in this collection combine an enigmatic motto, a picture, and a verse commentary. Some of the emblems – such as the sieve, pelican and phoenix – were closely associated with the queen (Cat. nos. 59, 193–5 and 203), and Whitney also comments on her motto *Video et Taceo* – I see and hold my peace. On this page is shown the phoenix with the motto 'a bird always unique', which explains why people who were thought to be extraordinary – like Elizabeth and Philip Sidney – were so often called 'a phoenix'. But, because the mythical bird was said to be reborn from its own ashes, survivors of destructive experiences

were also likened to the phoenix, and here Whitney dedicates his verse to his fellow countrymen from Namptwich in Cheshire, whose town had been rebuilt after a devastating fire. In this context, too, the phoenix was an appropriate symbol for Elizabeth and her Protestant Church, since both had survived the dangers and persecutions of Mary I's reign. SD

LITERATURE: Freeman, *English Emblem Books*; Manning, 'Whitney's "Choice of Emblems"'; Bath, Manning and Young (eds), *Art of the Emblem*. A facsimile version of Whitney was printed in 1990 by Ashgate Press.

204. Medal of Elizabeth, 1574

Unidentified artist.
Silver.
British Museum, London, CM M6883.

Elizabeth is compared here with the phoenix, which, according to ancient legend, arose from its own ashes and lived again. In Christian iconography the phoenix came to be equated with the Resurrection of Christ, and it was also linked with chastity, an association that would have lent an additional appropriateness to its use on this medal. The inscription surrounding the portrait laments that Elizabeth's virtue and beauty would not enjoy perpetual life. This theme is repeated on the reverse, where a crowned monogram of the queen appears above the phoenix, shown among flames, while the legend pities the 'wretched English', whose phoenix will not revive after death. PA

LITERATURE: Hawkins, Franks and Grueber, *Medallic Illustrations*, i, p. 124, no. 70; Dixon (ed.), *Women Who Ruled*, p. 143, no. 66.

205. Medal of Elizabeth, c. 1582

Unidentified artist.
Silver.
British Museum, London,
 CM M6891.

Elizabeth is thought to have presented examples of this medal to those invested as knights of the Order of the Garter during the latter part of her reign. She is shown sumptuously dressed in a jewelled gown, with a large ruff and a hood, and pearls in her hair. Encircling the portrait is a Garter bearing the motto of the Order, and the motto recurs on the reverse, where it surrounds the royal coat of arms. PA

LITERATURE: Hawkins, Franks and Grueber, *Medallic Illustrations*, i, p. 132, no. 85.

206. Medal of Elizabeth, c. 1580s

Unidentified artist.
Gold.
British Museum, London, CM 1865-7-20-7.

This exquisitely executed medallet bears one of the smallest portraits of Elizabeth to have been produced in any medium. Cast from a carved model, the portrait has then been chased in order to define further the features, particularly the eyes and the hair, and to increase the ornamentation of the ruff and jewelled dress. Its plain convex reverse would seem to indicate that it was intended to be set into some decorative object, perhaps a jewel, that would serve as both a personal adornment and an expression of allegiance to the queen. Difficult to date on account of its size, the medal appears to belong to the 1580s. PA

LITERATURE: Hawkins, Franks and Grueber, *Medallic Illustrations*, i, p. 182, no. 185.

207. 'Regina Fortunata' by Lord Henry Howard, c. 1576

Manuscript book.
British Library, London, Egerton MS. 944 fos 1v-2.

This manuscript book was a Latin eulogy presented to Elizabeth by Lord Henry Howard, younger brother to the 4th duke of Norfolk (Cat. no. 216). Its frontispiece is unusual in that it compares Elizabeth

directly with the Virgin Mary. The Marian allusion is unmistakable; in the open book on the queen's lap is inscribed '*Pax tibi ancilla mea*' (Peace be with you my handmaid), words which recall Mary's salutation to Gabriel at the Annunciation (Luke 1: 38). At the same time, Elizabeth's own divinity was implied by the sun's rays beaming down upon the royal canopy under which she was enthroned. Her virginity was again exalted by the words in the banderole by her feet, though here the allusion was classical rather than scriptural. The phrase – '[*O Quam te*] memore[*m*] *virgo. O Dea digna Deo*' – is a variation of Aeneas' words in Virgil's epic poem *The Aeneid*, uttered when the Trojan hero came upon his mother Venus disguised as one of the nymphs of Diana. As John King has pointed out, Elizabeth (possibly for the first time) was being represented as Virgo-Venus, the celestial goddess who for Renaissance Platonists symbolised the union of opposites (in this case chastity and love) and the highest order of beauty and harmony. At Elizabeth's feet are sleeping lions. They make a reference to the arms of Mowbray, and hence to Howard's status as the second son of the earl of Surrey, but they also probably allude to Elizabeth as a messianic figure bringing peace and harmony (Isaiah 11: 6).

Although complimentary, even sycophantic, this single book illustration is hardly evidence of a widespread cult of the virgin queen; not only was Howard a Catholic with his own political agenda but also the manuscript was a personal gift to the queen and did not have a general readership. Howard, moreover, failed in his attempt to ingratiate himself with Elizabeth and had to wait until the reign of her successor before he received the political advancement he desired.　　SD

LITERATURE: King, *Tudor Royal Iconography*, pp. 259–60

208. Drawing within a French Psalter

Pen and ink.
12.4 x 8.2cm.
Her Majesty the Queen.

This drawing of an armillary sphere and a poem, which is thought to be in Elizabeth's hand, appears on the final leaf of a psalter. The sphere was a sign of heavenly wisdom and used in later portraits of Elizabeth. In the psalter, it takes on Protestant connotations because it stands on a Bible (the '*verbum domine*', or the word of the Lord).

The connection between the poem and the drawing, if any, is unknown. Because of its references to the 'crooked leg' and 'part deformed', it could be that Elizabeth wrote the poem as a reproof to Robert Cecil who was a hunchback (Cat. no. 261). However, the style of handwriting is more characteristic of the younger Elizabeth and it has been suggested that the poem was a reproof to the earl of Leicester, with whom she was 'much offended' in August 1565.　　NM

LITERATURE: Marcus, Mueller and Rose, *Elizabeth I*, p. 132.

209. Woodcut of 'Elizabetha Regina', c. 1590

Woodcut on paper.
50.5 x 68cm approx.
Ashmolean Museum, Oxford, Sutherland Collection BI. 17.

This large woodcut is a rare survival of a once-popular print and presents a traditional representation of the monarch: Elizabeth is shown with crown, orb and sceptre, the instruments of monarchical power. Woodcuts were cheap to produce and were printed in reasonably large numbers; they frequently accompanied text as they could be printed on the same press as letterpress text. However, this example was probably a 'single leaf' print sold separately along with popular printed ballads and designed for wide dissemination. It would have been bought on the streets in London and other major cities either to be pasted into scrapbooks and albums or even hung for display and provides valuable insight into how ordinary Elizabethan citizens kept mementoes of their monarch. TC & SD

LITERATURE: Anglo, *Images of Kingship.*

210. English Cutwork Band Sampler, c. 1590–1603

Susan Negadri (or Negabri).
Linen, embroidered with linen,
silk and metal threads.
Museum of London, A7448.

This sampler incorporates the arms of Elizabeth I and the initials 'E.R.'. It was made by Susan Negadri (or Negabri), who recorded her name on the sampler. The identity of Susan Negad[b]ri is unknown but it is possible that her family had some link with the royal household.

During the Elizabethan period samplers were made by women and teenage girls to record stitch techniques and patterns. This sampler includes designs originally published in Italian lace and embroidery pattern books from the 1540s as well as patterns not published until the late 1580s. Cutwork was used to decorate male and female clothing such as shirt collars, coifs and handkerchiefs, ruffs and cuffs. All but the top two bands of the sampler are worked in linen thread. The top band is worked in red silk and silver-gilt thread and the second band in silver thread. Metal threads were expensive and their use suggests that Susan's family was wealthy. The letter S worked in red silk and silver-gilt thread probably stands for 'sovereign'. It is a very early example of a sampler incorporating a name, and it may have been made as a gift or to commemorate a particular occasion. EE

Opposite: Portrait of Elizabeth I in her Robes of Office. See page 204

211. Commemorative Charger, 1600

Delftware decorated in blue, ochre, yellow, green and
manganese pigments.
Inscribed: 'THE ROSE IS RED THE LEAVES ARE GRENE GOD
SAVE ELIZABETH OUR QUEENE', with the date '1600'.
Museum of London, C84.

This charger has three claims to fame. It is the earliest dated and com-
memorative piece of English delftware, and it is the first known with an
English inscription. The central scene depicting a fanciful cityscape of
towers and turrets, crenellated walls and a jumble of gabled buildings is
generally considered to be a visualisation of the City of London or the
Tower of London with the moat or river in the foreground. The 1600
date and arabesque Italianate border suggest that the charger was made
in Aldgate, which was the only delftware pottery operating in London
at this time. The pottery was established in 1571 by Antwerp potters
Jasper Andries and Jacob Jansen, following their unsuccessful petition
to Queen Elizabeth for sole rights of manufacture and a twenty-year
patent to 'sell and transport' their 'handiwork', with 'houseroom in
or without the liberties of London by the waterside'. Although
Jansen's and Andries's petition was not granted, both men stated that
they would 'pray to the Living Lord for [their] Ma[jes]tiy's godly and
prosperous success' and perhaps the production of this commemorative
charger was undertaken in a similar spirit by men who had fled to
England to escape religious persecution. When the charger was made
there were thirteen potters of Flemish/Italian descent working at
Aldgate in premises converted from the former precincts of the
dissolved Holy Trinity Priory. The pots were sold from Jansen's house,
'the Rose', in nearby Duke's Place, and it is possible that the verse
inscribed upon the charger was partly inspired by the name of the shop
from which it was sold. It is unknown whether the charger was made to
commission or was part of a range of commemorative wares produced
to celebrate a long and prosperous reign. HF

LITERATURE: M. Archer, *English Delftware: Engels Delfts Aardewerk*
(Amsterdam, 1974); F. Britten, *London Delftware* (London, 1987).

212. Portrait of Queen Elizabeth in her Robes of Office, late 1580s-1590

See page 203.
English School.
Oil on panel.
110 x 103cm.
Provenance: recorded at Helmingham in the mid-seventeenth
century.
The Lord Tollemache.

This imposing and little known portrait shows the queen in her
parliament robes seated upon a throne covered in gold velvet and
holding a sceptre in her right hand as an insignia of royal power. She is
thus depicted here as a majestically attired queen and powerful ruler,
characteristics that were constructed to be clearly evident to those at
court. Elizabeth wore these sumptuous robes on the state opening of
parliament, and she is depicted in this attire in a number of portraits
on official documents. The robes were made of crimson velvet lined
with ermine and are listed in the Stowe inventory of the Wardrobe of
Robes made in 1600 as a 'mantle of crimson velvet furred throughout'
(Cat. no. 118). As Janet Arnold has noted, the skirt (or kirtle) was
altered several times to keep up with the latest fashions and the bodice
was remodelled in 1585 with a lower cut square neckline by Elizabeth's
tailor William Jones, although this is obscured here by her closed lace
cutwork ruff.

It is not clear why this portrait was produced but, like most of the
existing portraits of Elizabeth, it is unlikely to have been undertaken
from the life. It has been suggested that the portrait was commissioned
in connection with Elizabeth's state progress in Suffolk and Norfolk in
the summer of 1578, but the style of costume indicates that the portrait
dates from around ten years after this visit. In her hair Elizabeth wears
a distinctive jewelled anchor, considered as an emblem of Christian
hope, which was probably given to her as a gift. As late as the summer
of 1602 in her last progress of England Elizabeth was given a 'jewel in
the form of an anchor' on leaving her host, lord keeper Sir Thomas
Egerton, at Harefield. The gift was part of a series of elaborate enter-
tainments and was given to signify the hope that 'where ever you shall
arrive, you may anchor safely, as you do and ever shall do in the hearts
of my owners' (Wilson, p. 325). The picture is probably slightly earlier
than this event, but its impressive scale suggests that it may have been
produced to hang in the house of a member of the nobility or gentry
perhaps in preparation or anticipation of a royal visit. TC

LITERATURE: Arnold, *Wardrobe Unlock'd*, p. 60; Strong, *Portraits of
Elizabeth*, p. 83, pl.P.93; Wilson, 'Harefield Entertainment', pp. 315–28. I
am grateful for additional information kindly provided by Lord
Tollemache and Diana Scarisbrick.

A	B	C	D	E	F	G	H	I	K	L	M	N	O	P	Q	R	S	T	V	X	Y	Z	W	EA

Nulles . x . x . ♯ . F . G . ♃ . X . L . z . ff . α . A . ♡ . St . ♯ . W . E . M

January . Februarie . Marche . Aprile . Maye . June . Julye . August . Septeber . O

X: ♯: α: ♯: W:

This note. I shall always double the Caracters preceding the same . This □ for the punctuing. This for periods & Sentences

							
X.	The Pope .	+.	the Earle of Arundel	-o.	the E: of Angous	-o.	Madam
X.	The king of france	e.	the Earle of Oxforde	œ.	the E: of Atholl	♃.	Maiest
♃.	the k. of Spane	=.	the Earle of Sussex	ト.	the E: of Ergyle	♂.	your M
G.	the Emperour	X.	the Earle of Northuberl	♃.	the E: of Arran	m.	My goo
8.	the k. of Demark	v.	the E: of Leycester	♃.	the E: of Gowry	♃.	My Lo
♃.	the Q. of England.	π.	the lo: H: Haward	♃.	the E: of Huntly	n♃.	Maiste
X.	the Q. of Scotland	S.	the E: of Shrewesbury	w.	the b: of Glasgo	Q.	I pray
⊥.	the Q. of france	L.	the E: of Huntington	n.	the Sp: Ambassador	SS.	most
♯.	the Q. mother in france	♭.	the lo: gret Treasurer	♯.	the lord Seton	♯.	erneste

THE CATHOLIC THREAT TO ELIZABETH

Thomas McCoog sj

Pedro de Ribadeneira, a Spanish Jesuit in the entourage of the count of Feria, arrived in London in early November 1558 and over the next few months observed the religious changes introduced by the new queen. Initially, he argued against active papal intervention in support of the Roman Catholic cause, but by April 1559 he was convinced that external assistance was necessary to preserve Catholicism against an increasingly Protestant government. Would such assistance ever land on the beaches of England? If so, would the invading armies be welcomed by resident Catholics? These questions, albeit real after 1570, were rarely raised during the first decade of Elizabeth's reign.

Elizabeth's first parliament of 1559 introduced a new religious settlement and legislated that all the queen's subjects must attend Protestant church services. Although the majority of English people were probably Catholic at that time, their response to the new legislation was cautious. Very few of them chose to go into exile; over 95 per cent of the parochial clergy stayed in their posts and used the new Protestant prayer book (Cat. no. 54); and only a small number of lay people refused to go to church. Instead, many attended passively, although some heckled the ministers and the services. Unlike the Calvinists in France and Lutherans in the Empire, English Catholics did not rebel when their bishops were imprisoned, their nonconforming priests were evicted and their traditional forms of worship came under attack. After so many religious changes during the reigns of Henry VIII, Edward VI and Mary I, few English Catholics could believe that the Elizabethan alterations were permanent and they fully expected an eventual reversal. Thanks to their seeming passivity, the government was convinced that obligatory church attendance, lengthy harangues on the virtue of obedience to rightful authorities and the gradual passing away of the older generation would eventually secure their religious policies. Consequently, the crown proceeded judiciously, believing that vestigial Catholicism would eventually die out.

During the first years of Elizabeth's reign, the main Catholic threat came from France. As soon as the French king, Henry II, heard of the death of Mary I of England, he advised his Catholic daughter-in-law, Mary Queen of Scots, to proclaim her right to the English throne by adding the arms of England to her coat of arms. Through her mother, Mary was related to the Guises, one of the most powerful, ambitious and fervent Catholic families in France. Through her father, Mary was descended from Margaret Tudor, sister of Henry VIII. The French king, as a dutiful son of the Roman Catholic Church, judged Elizabeth illegitimate because of the bigamous marriage of Henry VIII to her mother, Anne Boleyn and considered Mary to be the rightful queen of England.

The danger that France would take diplomatic and military action in support of Mary intensified in late 1559 after the accidental death of Henry II in July promoted Mary's husband, Francis II, to the throne. But during this period of

danger, Elizabeth had an unexpected ally: the Habsburg king, Philip II of Spain, protected her against Catholic wrath because of his dynasty's traditional hostility to France and need for friendship with England. Thus, when French diplomats and supporters agitated for a papal decision in Mary Stewart's favour against Elizabeth, the Habsburgs countered each move. Mary's accession would have upset the traditional Anglo-Spanish alliance against France. Instead of an English ally, Spain would be confronted by a dynastic union of the thrones of Scotland, England and France. Philip preferred a heretical ally to an orthodox enemy. Concern for the preservation of an alliance against France and fear that the establishment of French hegemony in north-western Europe would threaten Spanish control of the Netherlands prompted Philip II to offer his hand, or that of an Austrian Habsburg cousin, to Elizabeth. This traditional marital alliance would conserve the coalition against France, protect Elizabeth against any French aggression in aid of Mary, and, perhaps, restore Catholicism. Catholic exiles, meanwhile, reminded Pope Pius IV of Elizabeth's crimes against Catholicism and urged him to excommunicate her, deprive her of her kingdom and recognise Mary as the rightful ruler. The Habsburgs, however, persuaded the pope to take no action.

THE DEATH OF FRANCIS II in December 1560 and Mary's departure from France the following spring reduced significantly the possibility of French intervention in Mary's cause. The new regent, Catherine de Medici (Cat. no. 225(e)), cultivated a Protestant faction to balance the influence of the increasingly marginalised Guises, who sought to regain their power by pledging themselves to the defence of Roman Catholicism within France. In Scotland, Mary encountered a militant Protestantism supported by England. As John Knox ridiculed her faith and insolent nobles curtailed her authority, Mary had to proceed cautiously. Guise involvement in the religious wars in France prevented their supplying military aid, and, without it, she was unable to act freely in Scotland let alone press her claims to the English throne.

SPANISH PROTECTION OF Elizabeth waned as the likelihood of Mary's mounting a serious challenge receded. Indeed, the recently widowed and extremely eligible Mary offered Spain an opportunity to scuttle the 'Auld Alliance' of Scotland and France in favour of a new Spanish–Scottish coalition directed towards the acquisition of the English throne for Mary and the encirclement of France. Elizabeth anxiously monitored all Habsburg overtures to Mary, and proposed more acceptable English suitors, the principal of whom was her favourite Robert Dudley (Cat. no. 60), elevated to the peerage in 1564 as earl of Leicester. Fearing international isolation, Elizabeth breathed new life into proposals for marriage with the Habsburg, Archduke Charles of Austria. The Habsburgs may have been famous for their successful dynastic marriages, but for the second time they lost a marital campaign: to their – and to Elizabeth's – dismay, Mary married her cousin Henry, Lord Darnley in July 1565 (Cat. no. 218).

THE FINAL YEARS of the 1560s witnessed numerous events that ultimately shaped Elizabeth's relations with Catholics. First, the arrival of a large Spanish army under the direction of the duke of Alva in the Netherlands in the spring of 1567 greatly alarmed Protestant Europe. Only a narrow channel protected England from the most feared army in the world. Would it be sent to assist Mary in her struggle against the Protestant nobles? Or, indeed, to support a Catholic uprising in England? Second, Mary had been losing her grip on Scotland. The murder of Darnley on 10 February 1567 (Cat. no. 223) and her marriage to James Hepburn, earl of Bothwell (Cat. no. 221), three months later led to revolt. Mary was captured in July and deposed. In May 1568 she escaped and rallied her supporters for another battle. Defeated, she fled to England. Within a year she was reconciled with the Roman Catholic Church. Pope Pius V (Cat. no. 214), more aggressive in his promotion of Catholicism than his predecessor, consoled Mary in her imprisonment, and urged Alva to employ his troops for her liberation and for English Catholic relief.

RELATIONS BETWEEN SPAIN and England deteriorated further in December 1568 when Elizabeth and Cecil put into action plans to 'borrow' Genoese gold from Spanish ships which were seeking sanctuary from Dutch pirates and bad weather in ports of southern England. When informed of this scheme, Alva immediately retaliated with an embargo on

English property in the Netherlands and the arrest of English merchants. Elizabeth responded in kind, and official trade between England and Spanish territories (including the Netherlands) ceased from January 1569 until it was restored in 1573. This incident of the Genoese gold transformed Philip from Elizabeth's protector into her foe.

MEANWHILE, WITHIN ENGLAND, Catholicism continued to survive, despite the establishment of the 1559 Protestant settlement. During the 1560s traditionalist priests tried to 'counterfeit the mass' in parish churches, while Catholic sacraments were celebrated in many private chapels. Furthermore, to train priests for ministry to English Catholics, William Allen founded a college in Douai in 1568 and the first 'seminary priest' ordained there returned to his homeland in 1575. More forcibly than their predecessors, the seminary priests exhorted their co-believers to avoid the services of the Established Church. Such attendance, they claimed, was not a demonstration of loyalty to their monarch but a sign of their acceptance of a heretical faith. Through their efforts recusancy (from the Latin *recusare*, to refuse) was born.

SUBSEQUENT ANTI-CATHOLIC propaganda linked the establishment of the college at Douai with the first serious domestic threat to the Elizabethan regime, the Northern Rising of November 1569, but this is more coincidental than causal. Infuriated by religious changes and angered by the marginalisation of the traditional Catholic nobility and the rise of 'new men' such as William Cecil (Cat. no. 33), the earls of Northumberland and Westmorland raised their retainers in a brief and unsuccessful revolt. Alva ignored pleas from Pius V and Philip II to provide some assistance because he considered the rebellion a major mistake. Pius, meanwhile, provided his own assistance with the promulgation of *Regnans in Excelsis* on 25 February 1570. This infamous bull excommunicated Elizabeth, declared her deposed and absolved all her subjects from any oath of allegiance or fealty which they may have sworn. Pius forbade any subject to obey the queen and threatened with excommunication anyone who remained faithful to her. If only the timing had been better, some Catholic exiles opined, more would have rallied to the Catholic cause and Elizabeth would have been overthrown.

THE BULL PLACED CATHOLICS firmly on the horns of an uncomfortable dilemma: if they recognised the queen, they risked excommunication; if they obeyed the bull, they risked charges of treason. Worried that Catholics would serve as a fifth column, parliament passed further legislation. One law made it treason to call Elizabeth heretical or schismatic, or to question her claim to the throne. Another forbade reconciliation with Rome because a rejection of her religious authority was synonymous with disloyalty. To ascertain their loyalty, the government asked suspected Catholics specific questions regarding their acceptance of papal claims that Rome had the authority to depose rulers and their reaction to a possible invasion sponsored by Rome to restore Catholicism.

THE POLITICAL CRISIS in England did not end with the defeat of the Northern Rising. In 1571 a conspiracy was uncovered which involved England's premier peer, Thomas Howard, duke of Norfolk (Cat. no. 216), some other disgruntled English noblemen, the Spanish ambassador, agents of the incarcerated Mary Stewart, and a Florentine banker, Roberto Ridolfi, who may possibly have been a double agent working for Cecil. Norfolk was already in trouble with Elizabeth and Cecil for discussing with the Scots a proposal to marry Mary Stewart and he had been sent to the Tower in October 1569. Once released the following August, he was contacted by Ridolfi and persuaded to enter a conspiracy to obtain Spanish and papal assistance for the deposition of Elizabeth and the accession of Mary, safely married to Norfolk. The duke was found guilty of treason in January 1572 and executed the following June (Cat. no. 217), but Elizabeth ignored demands that Mary be put on trial.

GREGORY XIII, elected pope in May 1572, pursued a still more aggressively anti-Protestant policy than his predecessors. In August, he celebrated the St Bartholomew's Day massacre of Huguenots in France with a *Te Deum* and other thanksgiving services for the victory of faith over infidelity. English Catholic exiles such as William Allen, Thomas Stapleton and Thomas Harding exhorted Gregory to initiate action against Elizabeth and recommended various solutions: military support for rebellion in Ireland; a direct invasion of England; kidnapping the infant King James VI of Scotland (Cat. no.

67). The schemes varied but the goal was always the same: the deposition of Elizabeth, the accession of Mary, and the re-establishment of Roman Catholicism. None of them, however, could secure the wholehearted backing of Philip II, whose full involvement was necessary for success.

NEARLY CONTINUOUS CONFLICT with the Muslims in the Mediterranean and Protestant rebels in the Netherlands so stretched Spain's resources that Philip was unable to punish Elizabeth as he intended. Philip entertained all proposals, promised much, but delivered little. The papal nuncio in Spain actively encouraged schemes for an invasion. He arranged that Thomas Stukeley, armed with papal gold and assisted by hired mercenaries, work with Irish rebels led by James FitzMaurice for an invasion of Ireland. But Stukeley's involvement in the misguided crusade of the Portuguese King Sebastian against the Muslims in North Africa, left Sebastian dead, his army defeated and the Irish expedition fatally weakened and almost bankrupt. Philip was now more interested in his claim to the Portuguese throne than revenge against Elizabeth. FitzMaurice landed in Ireland in July 1579 with 700 men, Nicholas Sander as a papal nuncio and Spanish promises of future aid. Few Irish lords joined in the rebellion against the heretical, pretended queen of England. Spanish aid did not arrive. By the summer of 1581, the Elizabethan government had crushed the rebels.

WHAT IF A SPANISH FLEET had transported the promised aid to the rebels? England had no allies to assist in her defence. In order to end her diplomatic isolation Elizabeth resurrected proposals for a marital alliance with Francis, duke of Anjou (Cat. no. 74), brother of the king of France. Amidst expectations of a more tolerant environment for Catholics as a result of this projected Catholic marriage, William Allen petitioned Everard Mercurian, the superior general of the Society of Jesus, for Jesuit participation in the English mission. Mercurian had denied earlier requests but now, perhaps because of the Anjou matrimonial negotiations, he granted the petition. The first Jesuits, Edmund Campion, Robert Parsons and Ralph Emerson, consequently left Rome in April 1580. Before their departure, Campion and Parsons questioned Pope Gregory XIII on the validity of Pius's bull against Elizabeth. Although Gregory refused to revoke the

Edmund Campion – Catholic authorities constructed a martyrology around his death.

excommunication, he did mitigate it and announced that given the current situation (perhaps meaning by this the matrimonial negotiations), English Catholics were not bound under pain of sin to obey the bull at the 'present time'. When would the 'present time' end? Presumably the pope could make that decision whenever he wished. Consequently a sentence of excommunication and deposition remained a powerful weapon in the papal arsenal, repromulgated at the pope's discretion.

BY THE TIME of the arrival of the Jesuits in England in June, public opinion had successfully sabotaged the Anjou marriage. At the same time, the papal sponsorship of FitzMaurice's landing in Ireland had confirmed Protestant warnings of Catholic aggression and perfidy. Were the Jesuits the vanguard,

P·ROBERTUS PERSONIUS ANGLUS
Soc·Iesu Socius et Superior P·Campian in
pria Missione Anglicana obiit 15·Ap·1610 Ætat suæ 64·
Ascendit ex adverso et opposuit murum pro domo Israel Ezech·13·

Robert Parsons — he promoted direct measures to
bring down the Protestant regime.

a papal SAS, to open a second front in the assault on England? The Jesuits protested their innocence and claimed to have known nothing about the invasion of Ireland. They were in England to strengthen the faith of Catholics. Parsons showered profuse praise on Elizabeth in the dedication of a treatise, published clandestinely in England, but insisted that Catholics, albeit loyal, could not attend Church services.

NOT SURPRISINGLY the government used their agents to hunt down Campion and Parsons. Under pressure, the two Jesuits drafted statements of the purpose and goals of their mission for release after their capture. Campion's explanation, better known as his 'Brag', circulated widely while he was still at large. Overnight this quiet, former Oxford don became

a celebrity. His challenge for a public debate made him a 'champion' for the Catholics and public enemy number one to the government. As agents searched for him everywhere, Campion travelled among Catholic households in the north of England, writing *Rationes decem*, an explanation of the grounds for his confidence in victory. This small volume, distributed secretly in Oxford in June 1581, demonstrated a Catholicism unwilling to remain quietly out of sight. The high-profile Jesuit campaign challenged the religious settlement. Campion was captured at Lyford Grange in July 1581 and imprisoned in the Tower of London. He was then granted his debate but under conditions so prejudicial to him that public interest quickly waned. Popular broadsheets sought to discredit the Jesuit (Cat. no. 224).

AS A RESULT of the Jesuit mission, instead of winning religious toleration Catholics endured more severe legislation. Fines for convicted Catholic recusants were increased. Anyone convicted of having persuaded English subjects to abandon the Established Church for the Church of Rome would be guilty of high treason. Anyone reconciled with Rome could suffer the same fate. Campion's capture, and his execution, in December 1581 demonstrated the government's new approach.

SEEKING POSSIBLE SANCTUARIES for English Catholics, Robert Parsons sent a priest to Scotland in the early summer of 1581. This apparently innocent overture had fateful consequences for English Catholics. King James VI's favourite, the duke of Lennox, promised the priest that he would work for the king's conversion but argued that only the presence of loyal foreign troops could guarantee the survival of Catholicism against strong Protestant opposition — and foreign mercenaries cost money. Subsequent discussions resulted in plans for an enterprise against England. Throughout the 1580s, English religious exiles, including Allen and Parsons, collaborated with Philip II, Gregory XIII, the duke of Guise and other rulers who, for various reasons, temporarily joined the coalition for the invasion of England. Plans and participants varied but the goals remained the same: the release of Mary Stewart and her immediate succession to the English throne. Elizabeth would be deposed and imprisoned. Catholicism would be restored. Occasionally there were hints

of a still more drastic solution. For example, in May 1583 rumours circulated of a Guise conspiracy to assassinate Elizabeth as a prelude to invasion. Apparently Parsons reported these rumours to Claudio Acquaviva, superior general of the Society, who advised him that Jesuits should not involve themselves in such matters. Assassinations were common: William (the Silent) of Orange (Cat. no. 225(c)) was assassinated in 1584, Duke Henry of Guise in 1588 and King Henry III of France in 1589. Apprehension that a madman or a zealot would murder Elizabeth justified English fears even if many of the plots remain unconvincing.

FOR SUCCESS, the coalition needed to establish secure lines of communication with Mary and to obtain assistance from Catholics within England. In the summer of 1583, Charles Paget crossed to England to present the most recent invasion proposals to Mary, and to discuss possible internal support from sympathetic nobles. Paget returned with news that Mary opposed the proposals and that the nobles wanted nothing to do with the scheme. Catholic gentry such as Sir Thomas Tresham and Richard Shelley disassociated themselves from all treasonous activities and professed their allegiance to the queen.

THROUGH A COMPREHENSIVE system of spies, *agents provocateurs*, apostate Catholics and Catholics eager to demonstrate their loyalty to Elizabeth, Sir Francis Walsingham (Cat. no. 213) and Lord Burghley (Cat. no. 33) kept track of the shifting series of alliances as they monitored Mary's household and the activities of suspected domestic associates. Moles within the French embassy in London provided crucial information as it passed between Mary and France. The Scottish queen, whether she actively cooperated or not, was the epicentre of so many schemes that many regarded her continual existence as the greatest challenge to Elizabeth's regime and to the Protestant settlement. But Elizabeth was reluctant to execute a legitimate monarch regardless of the cause.

WALSINGHAM AND BURGHLEY discovered a series of Catholic plots and conspiracies between 1583 and 1584: the Sommerville plot, the Throckmorton plot and the Parry plot. Questioning the authenticity of these plots, some historians argue that Elizabethan ministers planted evidence and forged confessions in their zeal to eliminate all possible support within the realm. No one, however, can doubt how effectively these plots proved official identification of Catholicism with treason. In November of 1584, parliament acted to protect Elizabeth by legislating that anyone involved in a successful plot or conspiracy against Elizabeth was, *ipso facto*, excluded from the English throne.

SPANISH VICTORIES in the Netherlands under the leadership of the prince of Parma (Cat. no. 225(d)), Guise victories over the Calvinists in France and persistent rumours of assassination attempts within England intensified fears of an imminent invasion. Yet, despite their victories, Spain, the Papacy and the Guises could not agree on tactics. Elizabeth, however, altered hers: she publicly allied herself with the Dutch rebels against Spain in the Treaty of Nonsuch in August 1585 and placed Leicester in command of English troops to be sent to the Netherlands (Cat. nos. 226–28).

THE BABINGTON PLOT succeeded in eliminating the threat of Mary Stewart. In the autumn of 1586, a commission at Fotheringhay judged that Mary was actively involved in this plot to assassinate Elizabeth (Cat. no. 231). In parliament, Sir Job Throckmorton described her as 'the daughter of sedition, the mother of rebellion, the nurse of impiety, the handmaid of iniquity, the sister of umshamefastness'. Despite a universal parliamentary outcry against continual leniency, Elizabeth still hesitated to order the execution of a legitimate monarch, but Burghley guided Elizabeth through the shoals of scruples into signing Mary's death warrant. Her execution on 8 February 1587 outraged Catholic Europe, as well as Mary's son (Cat. no. 232), and removed the only commonly acceptable candidate for the throne. Henceforth Catholic exiles would be divided into factions supporting either Spanish or Scottish claimants.

PREPARATION FOR AN INVASION accelerated after Mary's execution. Pope Sixtus V exhorted Philip II to act. As a prelude, the pope created William Allen a cardinal in August 1587. Any possibility that Henry III of France would aid English resistance ended when Spain's allies, the Guises, gained control of Paris and the king in May 1588. The prince of

Parma's army awaited transport from Flanders. Fearful of alienating the Scots, Spain decided to defer discussion of the English succession until after victory. For distribution after a successful invasion, Allen penned *An admonition to the nobility and people of England and Ireland* and its broadside summary *A declaration of the sentence and deposition of Elizabeth, the usurper and pretensed queen of Englande*. Allen enumerated Elizabeth's crimes, but salvation for Catholics was at hand as the Spanish army approached. By 12 June 1588, Burghley had seen Allen's work and commented on Allen's self-deception if he believed that any noble or gentleman would aid the invasion. Whether any Catholic would have rallied to Spain's side we shall never know: on 29 July the Spanish fleet was dispersed off Gravelines. England watched anxiously as the remaining ships headed north, circled Scotland and limped home (Cat. nos. 240 and 241).

A PROTESTANT WIND may have providentially aided Elizabeth's defeat of the pope, but the threat of another attack remained so strong that the Elizabethan government took the offensive in the 1590s. English vessels harassed Spanish shipping and invaded Spanish ports; English soldiers fought alongside the Dutch and the French. More armadas failed. In England, the old guard of Walsingham and Burghley, with competitive assistance from the rising stars Robert Devereux, earl of Essex (Cat. no. 253), and Sir Robert Cecil (Cat. no. 261),

exploited more bizarre plots involving poisoned pommels, court doctors and retired military to eliminate rivals, destroy any perceived domestic threat, and reinforce anti-Catholic anxiety. Both Walsingham and Burghley had consistently demonstrated they were the queen's 'good servants' but would the next generation be as effective?

WITH THE HINDSIGHT of 400 years, how can we evaluate the seriousness of the Catholic threat? Was England as beleaguered as Elizabethans commonly believed? An external threat was serious indeed. Only ill winds, disagreement over tactics and overstretched military involvement prevented military expeditions under the auspices of the papacy. Internally, even if we accept the authenticity of all the so-called Catholic plots and conspiracies, there seems to have been little enthusiasm for military enterprises. More and more Catholic nobility and gentry protested their loyalty and resented restrictions on their services in their kingdom's need. Even Philip II realised that Spain could not count on support from Catholics within England, and some generals allegedly said that Spanish swords would not distinguish Catholic from Protestant after the invasion. The external threat remained until Elizabeth's death in 1603 but the internal threat diminished significantly as English Catholics, wishing 'to render to Caesar the things that are Caesar's', sought to demonstrate that they could be faithful Catholics and good subjects.

developing a network of secret service agents, who provided critical intelligence to the crown, at great cost to his own purse. He had helped Cecil uncover the details of the Ridolfi plot of 1570–71, and was to be instrumental in implicating Mary, Queen of Scots, in the Babington plot of 1586 to murder Elizabeth. In foreign policy, Walsingham usually favoured the cause of militant Protestants and urged Elizabeth to give aid to William of Orange (Cat. no. 225(c)). In 1587 Walsingham advised Elizabeth to begin preparations against a Spanish invasion, which only began in earnest the following year. He was also interested in furthering English progress in maritime exploration, being a close friend of John Dee and supporting the voyages of Drake, Frobisher and the Gilbert brothers.

Elizabeth was not personally sympathetic to Walsingham, perhaps because of his gloomy cast of mind, although she clearly recognised his valuable intelligence, diplomatic expertise, insight into foreign affairs and his skill in silently engineering political events. She knighted him in 1577, and appointed him Chancellor of the Order of the Garter (Cat. no. 62). For his part, Walsingham became frustrated at the queen's inability to take action. In 1586 when the fate of Mary, Queen of Scots, was in the balance he wrote: 'I would to God her Majesty would be content to refer these things to them that can best judge of them as other princes do' (Neale, p. 274).

This portrait shows Walsingham as a man of sober intellect and his penetrating eye-contact with the viewer allows us a sense of guarded immediacy. The exact date of the portrait is not known; it was not undertaken from life but derives from a type probably first conceived around 1585 by the Netherlandish artist John de Critz the Elder. The panel has been restored, having suffered from paint loss particularly in the lower part of the ruff.

TC

LITERATURE: Read, *Walsingham*, i, pp. x–xi; Strong, *Portraits*, pp. 320–22; Neale, *Elizabeth*.

213. Portrait of Sir Francis Walsingham, c. 1590

Anglo-Netherlandish School, after John de Critz the Elder
 (c. 1551/2–1642)?
Oil on panel.
37.5 x 29.8cm
Provenance: Blair-Drummond Collection, Perthshire;
 purchased 1913.
National Portrait Gallery, London, NPG 1704.

Walsingham (c. 1532–90) came to prominence in the late 1560s under the influence of William Cecil. He acted as ambassador to France between 1570 and 1573, where he negotiated the defensive Treaty of Blois. Soon after his return, he was appointed principal secretary and over the coming decades he took a central role in ensuring the security of England by

214. Medal of Pope Pius V, 1571

Gianfederico Bonzagna.
Gilt bronze.
British Museum, London, CM G.III PM AE VI 88.

Pope Pius V issued a papal bull on 25 February 1570 entitled *Regnans in Excelsis*, ordering the excommunication of Elizabeth I. The order sent shock waves around Europe and left English Catholics with divided loyalties. Pius was driven by a religious conviction that was often unconcerned with political considerations and he devoted much of his six-year papacy (1566–71) to encouraging other Roman Catholic princes to engage in hostilities with non-Catholic states. Zealous in the conflict with Protestantism, his excommunication and, more important, his proposed deposition of Elizabeth were based on an exalted late-medieval concept of papal power.

Timed to coincide with the Northern Rising, the bull not only

made life more difficult for Catholics within England but also infuriated Catholic rulers with its lofty claims of papal power. Never again did the papacy pass a similar judgement against a reigning monarch. John Felton posted a copy of the bull on the gate of the residence of the bishops of London on 15 May 1570. For this offence he was executed as a traitor in the following August. In 1571 parliament enacted new legislation whereby anyone asserting Elizabeth was a schismatic or not the rightful queen could be charged with high treason. PA & TM

LITERATURE: Attwood, *Italian Medals*, p. 389; Clancy, 'English Catholics'; Kelly, *Dictionary of Popes*.

215. Queen Elizabeth as Diana with Time and Truth disclosing the Pregnancy of the Pope as Callisto, c. 1585

Peter van der Heydin (*fl.*1551–85).
Engraving.
60 x 80cm.
British Museum, London, PD 1870, 6-7.

This print is a parody of Titian's painting of Diana and Callisto, which was owned by Philip II. The original painting had depicted the story told in Ovid's *Metamorphoses* of the chaste and militant goddess, Diana, judging and punishing the nymph Callisto, whom Jupiter had raped and made pregnant. In this anti-papal print Diana is shown as Elizabeth, her extended right hand grasping a shield bearing the Tudor arms. Elizabeth is judging the pope in the guise of Callisto, who sprawls in an undignified manner at her feet. The allegorical figures of Time and Truth lift up his cope to reveal that he is hatching a brood of monsters, including the Inquisition, the St Bartholomew's Day Massacre in Paris and the assassin (Balthasar Gérard) who murdered William the Silent (Cat. no. 225(c)). Time looks to Elizabeth to interpret what he has uncovered, for in this print she is the superior judge.

Attending on Elizabeth are her true companions, four nymphs who represent the provinces of Holland, Zeeland, Friesland and Gelderland in the Netherlands. In August 1585 Elizabeth had signed the Treaty of Nonsuch with the representatives of the Dutch provinces, a military alliance which committed her to sending an army to the Netherlands to fight against their Catholic ruler, Philip II. The verses in Dutch at the bottom of the print are addressed to Elizabeth, both praising her and warning her against the pope. This print therefore exploits Elizabeth's virginity to praise her as a militant and wise Protestant ruler but she would almost certainly have disapproved of her depiction as the nude Diana. SD

LITERATURE: Montrose, 'Idols of the Queen', pp. 108–148; Howarth, *Images of Rule*, pp. 111–14.

216. Portrait of Thomas Howard, Duke of Norfolk, dated 1565

See overleaf.
Anglo-Netherlandish School.
Oil on panel.
103 x 80cm.
Inscribed: top left: 'Thomas D: of Norfolk, top right beheaded
 1573' (not contemporary).
Provenance: by descent.
Private owner.

Thomas Howard, 4th duke of Norfolk (1536–72) was the highest ranking nobleman and Earl Marshal of England. None the less, it was not until October 1562 that he entered the privy council, where he became a leading spokesman in favour of the proposed match between Elizabeth and the Catholic Archduke Charles of Austria. When the matrimonial negotiations failed, he blamed the earl of Leicester for sabotaging them. In May 1568 Norfolk became a commissioner to investigate the complicity of Mary Stewart in the death of her husband Henry, Lord Darnley (Cat. no. 218), and from then on he began to consider marrying the deposed Scottish queen himself. It is likely that his idea was not to depose Elizabeth but to settle the English succession question in Mary's favour and negotiate her restoration to the Scottish throne. Norfolk was conservative in religion although almost certainly not a Roman Catholic. His fatal mistake was in attempting to advance his plans in secret from Elizabeth, a stratagem which laid him open to a charge of treason. Norfolk was forgiven by Elizabeth for his offences but he again became implicated in a conspiracy with Mary. This time a papal agent, Roberto Ridolfi, and the Spanish ambassador were also involved, and when the details were uncovered Norfolk was tried and found guilty of treason. After some prevarication by Elizabeth, he was executed in June 1572 (Cat. no. 217).

This half-length portrait shows Norfolk before his fall from grace, posed in an architectural setting as a knight of the Garter, wearing the Order's distinctive badge hanging from a velvet cord at his chest. In the year this portrait was painted Norfolk was involved in a public quarrel with Robert Dudley, after the favourite seized the queen's handkerchief to wipe his own brow following a tennis match. It is curious that both Dudley (Cat. no. 60) and Norfolk, as shown here, are painted in this year wearing purses at their belt which hold a handkerchief. A second much damaged and over-painted original inscription is just visible at the very top right of the panel, stating the date and probably the age of the sitter. TC & SD

LITERATURE: Alford, *Cecil*, pp. 199–205; MacCaffrey, *Elizabethan Regime*; Williams, *Norfolk*.

Thomas D.e of Norfolk, beheaded 1573.

(7) 13

My lord me thinkes that I am more beholdinge to the hinder part of my hed than wel dare trust the forwards side of the same. and therfor sent to the Leueftenant and the S: as you know best the order to defar this execution till they hire furdar and that this may be done I doubt nothing without enrocatie of my furdar warrant for that they rasche determination upon a very unfit day was countermaunded by your considerat admonition the cause that moue me to this ar not now to be expressed lest an irreuocable dede be in meane while omitted. If they wyl midd a warrant let this suffice all writen with my none hand. Your most louinge souuerain

Elizabeth R

217. Letter from Elizabeth to Lord Burghley, 11 April 1572

Manuscript.
Bodleian Library, University of Oxford, MS Ashmole 1729 fo. 13.

Elizabeth sent this note in her own hand to defer the execution of the duke of Norfolk who had been convicted of treason in January 1572. Norfolk admitted that he had made errors of judgement and concealed evidence about his plans to marry Mary Stewart, but he denied plotting treason with the papal agent, Roberto Ridolfi.

Elizabeth was reluctant to enforce the death sentence, mainly because Norfolk was her kinsman and the premier English nobleman. She may also have had doubts about his guilt. This letter marks the third time that she withdrew her warrant for his execution. On this occasion she had signed the warrant on 9 April and then had second thoughts in the middle of the night. The hind part of her head (the seat of the affections), she explained, would not trust the forward part. Elizabeth's critics cite her reluctance to execute Norfolk as an example of her vacillating nature and unwillingness to take irrevocable decisions. Her supporters prefer to see her erratic behaviour as evidence of a merciful nature.
 SD

LITERATURE: Marcus, Mueller and Rose, *Elizabeth I*, p. 131; Neale, *Elizabeth*.

218. Portrait of Mary, Queen of Scots, and Henry Stuart, Lord Darnley, after 1565

British School.
Oil on panel.
108 x 142cm.
Hardwick Hall, The Devonshire Collection, The National Trust, accepted in lieu of tax by HM Government and allocated in 1959.

Mary Stewart (1542–87) took the nobleman Lord Darnley (1545–67) as her second husband on 29 July 1565. Elizabeth had strictly forbidden the match as Darnley himself had a claim to the English throne but, apparently struck by love, Mary disregarded the views of both Elizabeth and the Scottish nobles.

Mary's passion for Darnley proved extremely short-lived; he had little understanding of political life and spent his time not only in the pursuit of pleasure but in trumpeting his own claims to the crown of Scotland on equal terms with Mary. By December 1565 Mary was three months pregnant with the future James VI (Cat. no. 67) but she was now virtually estranged from her new husband. Instead she gave her trust to her secretary David Rizzio, who was murdered on 9 March 1566 in the queen's presence, stabbed to death with Darnley's dagger by a band of nobles. The following February, Darnley was also murdered (Cat. no. 223) and shortly afterwards Mary married the earl of Bothwell (Cat. no. 221(a)) who was apparently implicated in Darnley's death.

It is not known when this double portrait was produced but it was clearly designed to record the couple's union. It is probable that the slightly awkward figures have been copied from two other separate contemporary portraits, and although the costumes and other details have been over-painted the painting appears to date from the 1560s. Despite Mary's position as queen of Scotland and Darnley's as that of her consort, the portrait shows the couple following the usual conventions for marriage portraits where the woman appears to the right of her husband.
 TC

LITERATURE: Wormald, *Mary Queen of Scots*; Lindsay Boynton and Peter Thornton, 'The Hardwick Hall Inventory of 1601', *Journal of the Furniture History Society*, 7 (1971), p. 27; M.K. Martin, 'A Lost Picture of Mary Queen of Scots and Lord Darnley', *Burlington Magazine*, 10 (1906), pp. 43–7.

[cipher table manuscript image]

Cecil and Walsingham employed intelligence workers to break these codes. The best known were Thomas Phelippes and John Sommers.

Here symbols are substituted for letters for particular words and the names frequently mentioned. It is interesting to note some of these names: the pope, various European rulers and leaders, the countess of Shrewsbury (Bess of Hardwick, who was for many years the wife of Elizabeth's custodian and Mary's close companion), the earl of Hertford and his two sons (Mary's rivals for the succession). SD

LITERATURE: Haynes, *Invisible Power.*

220. Page of Ciphers used in Correspondence between Mary, Queen of Scots, and the Duke of Alva

Manuscript.
Public Record Office, Kew, SP 53/23 fo 13.

This page represents the ciphers used in Mary's correspondence with Alva when he was acting as Philip II's governor-general in the Netherlands from 1567 to 1573. Alva had arrived in Brussels at the head of a 10,000-strong army, with instructions to extirpate heresy and restore royal authority after the risings and riots of the previous year. He executed his orders ruthlessly and was consequently viewed in England as a brutal enemy of European Protestantism and a potential threat to the Elizabethan regime. In fact, he was often a restraining hand on Philip II and advised him against aiding Catholic rebellion in England and supporting the Ridolfi plot. SD

LITERATURE: Parker, *Strategy.*

219. Page of Ciphers used by Mary Queen of Scots

Manuscript.
Public Record Office, Kew, SP53/22 fo. 1.

After the discovery of the Babington plot in 1586, Mary's apartments at Chartley Castle in Staffordshire were searched and her papers seized. Amongst them were more than one hundred ciphers used in Mary's correspondence.

Several different codes were employed in secret correspondence. Often, letters of the alphabet were shuffled in a certain sequence and, once the key was worked out, the message could be read. Alternatively, individual letters could be substituted with numbers, characters, symbols or signs of the zodiac. Some codes could only be understood by placing a sheet of paper punched with holes over the top so that only the relevant letters making up the message could be seen. Success therefore depended on calculating the exact sequence of thousands of holes.

221. Portraits of the Earl of Bothwell and his First Wife, 1566

(a) James Hepburn, 4th Earl of Bothwell

Netherlandish School.
Oil on copper.
3.7cm diameter.
Provenance: purchased
 from Isabella, Lady
 Arbuthnot by the
 Scottish National
 Portrait Gallery in 1917.
Scottish National Portrait
 Gallery, Edinburgh, PG 870.

(b) Lady Jean Gordon, Countess of Bothwell

Netherlandish School.
Oil on copper.
3.5cm diameter.
Scottish National
 Portrait Gallery,
 Edinburgh, PG 869.

Bothwell (c. 1535–78), the third husband of Mary, Queen of Scots, was a man of inordinate ambition and violent character. Although never proved guilty, he was deeply implicated in the murder of Lord Darnley at Kirk o' Field (Cat. no. 223). Bothwell then abducted Mary, perhaps with her consent, and married her in a Protestant ceremony after the annulment of his first marriage to Lady Jean Gordon (1544–1629), daughter of the Earl of Huntly. Soon afterwards, the Scottish Protestant lords rebelled against Mary and Bothwell. Her army was defeated on 15 June 1567 at Carberry Hill, near Musselburgh, and Bothwell fled to Norway, spending the rest of his life as a prisoner in Denmark.

Bothwell corresponded with Mary from his initial captivity in Malmö, but after 1573 he was imprisoned by Frederick II of Denmark, and held incommunicado within the fortress of Dragsholm. It was reported that he became demented, having been shackled by a short chain to a post only half his height, so that he was never able to stand upright. He died at Dragsholm on 14 April 1578 and for over four centuries his mummified body was displayed in the nearby parish church of Faarevejle. He was finally buried there a few years ago, on the instructions of the present queen, Margarethe of Denmark. Lady Jean, meanwhile, married again: first in 1572 to the 12th Earl of Sutherland and later in 1599 to Alexander Ogilvie of Boyne, with whom she had fallen in love nearly thirty-five years earlier.

These portraits, which are of exceptional quality, were painted in the year of the Bothwells' marriage. The one of the earl is the only surviving authentic likeness and shows him in a fashionable high-necked yellow doublet. The authenticity of his wife's likeness is strongly supported by the close similarity of Lady Jean's portrait to an oil portrait of her in old age (c. 1625), now at Dunrobin Castle, Sutherland. This tiny portrait shows her in fashionable black with a high-necked white ruff, and wearing gold chains and a French hood.

The artist of these portraits is highly likely to be Netherlandish, perhaps one of the Pourbus family of artists, although it is difficult to understand the circumstances in which they were painted. Bothwell travelled frequently in northern Europe but apparently not in 1566. There are no records of his first wife, Lady Jane, ever having visited the Low Countries. There is the possibility that a Netherlandish artist may have travelled to Scotland to paint these portraits. SL

LITERATURE: Holloway (ed.), *Scottish National Portrait Gallery*, p. 19; Derek Severn, 'Bothwell: The Last Exile', *History Today* (Oct. 1975), pp. 671–9; Barbara I.W. Lothian, 'A Strange Wooing: Lady Jean Gordon: A Sixteenth-Century Portrait', *Aberdeen University Review*, 34, 3, no. 106, (1952), pp. 225–32.

222. Map of Scotland, c. 1564

Laurence Nowell.
Manuscript.
British Library, London, Cotton MS Domitian A.xviii, fos.98v-99.

This map of the kingdom of Scotland was drawn soon after Mary, Queen of Scots, returned from France. The cartographer was an English antiquarian, Laurence Nowell, dean of Lichfield. His map is far more detailed and accurate than the best work produced up to that time – George Lily's map of the British Isles engraved in Rome in 1546 – and shows that it must have been based on new surveys. In 1563 Nowell had compiled a manuscript atlas of England and Wales and in the same year wrote to Lord Burghley of his plans to make maps of the English counties. GH

223. Contemporary Drawing of Lord Darnley's Murder at Kirk o' Field

Pen and ink.

44 x 52.3cm.

Public Record Office, Kew, MPF 366 ex 52/13 no. 1.

This drawing depicting the murder of the husband of Mary, Queen of Scots, was sent to William Cecil soon after the event. Darnley's house at Kirk o' Field, just outside the walls of Edinburgh, was blown up with gunpowder in the early hours of 10 February 1567. He and his servant, however, were discovered strangled or smothered in the garden outside. As seen in the top right, Darnley was dressed only in a nightgown; nearby were placed a doublet, dagger, chair and rope. It seems that the chair and rope had been used by the two men to effect their escape from the house when they realised it was surrounded by armed men. In the top left of the drawing, Darnley's son James, or possibly Darnley himself, is shown in bed with the legend 'Judge and revenge my cause O Lord'.

On 24 February 1567, Elizabeth strongly advised Mary to bring the culprits to justice but instead Mary married the earl of Bothwell (Cat. no. 221(a)), the chief suspect in the murder. As a result, many were convinced that Mary herself was an accomplice and the Scottish Protestant lords rebelled against her. After Mary's defeat at the Battle of Langside, she fled to England and was installed in Carlisle Castle by 18 May 1568. Elizabeth initially wanted to help Mary regain the Scottish throne but her councillors persuaded her to keep the unexpected guest in custody. On several occasions Elizabeth attempted to negotiate Mary's

restoration but the Scottish regency government opposed her return. Consequently, Mary remained a virtual prisoner in England. SD

LITERATURE: Jones, *Elizabethan Age*, pp. 137–55; Wormald, *Mary Queen of Scots*.

224. *A triumph for true subiects, and a terrour vnto al traitours: by the example of the late death of E. Campion*, 1581

Anonymous, attributed to William Elderton.
Broadsheet printed in London by R. Jones.
Society of Antiquaries of London; Lemon ballads no. 76, vol. 3.

This printed broadsheet was produced for a popular market and commemorates the execution of the well-known Jesuit priest, Edmund Campion (1540–81). Campion arrived in England in June 1580 on a mission to strengthen the faith of Catholics, as Elizabethan ministers discussed a marital alliance with France. Fearful that the government would circulate false information upon his capture, Campion wrote his so-called 'Brag' for circulation after his death. In the 'Brag' and later in his *Rationes decem*, Campion challenged ecclesiastical and secular leaders to debate the religious settlement. As Catholics cheered their champion for his audacious plea, the government increased surveillance, eventually capturing him in July 1581. An attempt to convince Campion to return to the established Church failed. The government consequently sought to discredit him by staging semi-public disputations in the Tower of London. Alone against a team of professors of divinity, Campion so held his own that the government cancelled further debates as counterproductive. In November, the government tried Campion for treason at Westminster Hall. Found guilty, he was hanged, drawn and quartered at Tyburn on 1 December 1581.

From popular ballads, broadsides and pamphlets, to more sophisticated theological treatises, Catholics and Protestants contested Campion's virtues and his status as a martyr. Dismissing the official verdict of treason, Catholic authors asserted that religion was his only offence. The author of this particular broadside reminded his readers of Pope Pius's excommunication of Elizabeth and recent papal aggression in Ireland. TM

LITERATURE: Lemon, *Catalogue*, p. 76; Pollard and Redgrave, *Short-Title Catalogue*, i, p. 341, num. 7564; McCoog , '"The Flower of Oxford"'.

225. Medals of European leaders

(a) Medal of Philip II of Spain, 1557

Gianpaolo Poggini.
Silver.
British Museum, London, CM G.III FI&D M311.

(b) Medal of Emperor Maximilian II as King of Bohemia, 1551

Leone Leoni.
Lead.
British Museum, London, CM 1881-5-1-7.

(c) Medal of William the Silent, 1577

Coenraad Bloc.
Silver.
British Museum, London, CM G.III. FI&D M332.

(d) ## Medal of Alessandro Farnese, Duke of Parma, c. 1586

Attributed to Giuliano Giannini.
Silver.
British Museum, London, CM M0223.

(e) ## Medal of Catherine de Medici, 1589

Unidentified French artist.
Gilt silver.
British Museum, London, CM M2205.

(f) ## Medal of Henri IV of France, 1591

Unidentified French artist.
Silver.
British Museum, London, M2219.

(g) ## Medal of Cosimo de Medici, Duke of Florence, 1549/50

Domenico Poggini.
Bronze.
British Museum, London, CM 1921-6-11-11.

Most of these European leaders never met Elizabeth but they corresponded with her and influenced her policy. Initially Philip II of Spain (1527–98) and his cousin, the Emperor Maximilian II (1537–76), were cordial towards the queen but religious differences and commercial rivalries soon turned them against her. William the Silent (1533–84), the leader of the revolt in the Netherlands against Spain, repeatedly asked Elizabeth for military assistance but it was only after his assassination that she sent an army under Leicester to help the Dutch (Cat. nos. 226–228). Philip's brilliant commander, the duke of Parma (1545–92), was poised in 1585 to win back Antwerp from the rebels and the revolt seemed on the point of collapse. Meanwhile, Catherine de Medici (1519–89), the influential queen-mother in France tried several times to negotiate a marriage between Elizabeth and one of her three sons. She died just at the point when France slipped into a long war of succession between Henri IV (1553–1610), the leader of the French Protestants, and a Catholic claimant supported by Spain. In 1589, Elizabeth sent troops to France to help Henri, and she continued to assist him even after he converted to Catholicism in 1593.

These medals were used as vehicles for conveying political messages that would enhance the prestige of these European leaders, and some were worn as badges of loyalty. Male rulers were often shown dressed in ornate parade armour, a symbol of military prowess, and their female counterparts appear in equally rich attire. The reverses contain allegories and inscriptions affirming their power through allusions to virtues or references to specific achievements. Philip II is equated on the reverse of his medal with Hercules, a personification

of supreme strength and courage. The medal of Catherine de Medici carries a more personal message, focusing on the French queen's devotion to her husband, who had died thirty years earlier, but it also defines her as a symbol of continuity and constancy in a time of political strife for France. The reverse of the medal of Henri IV bears an expression of loyalty to the king from the north-eastern French town of Chalons-sur-Marne. The medal of the duke of Parma commemorates his capture of Antwerp after a siege of fourteen months, one of a series of victories of 1585 that secured the southern Netherlands for Spain. By contrast, the reverse of the medal of Farnese's adversary, William the Silent, is a rock in a stormy sea, a symbol of steadfastness. PA & SD

LITERATURE: Doran, *Foreign Relations*; Scher, *Currency of Fame*, p. 372, no. 100; Mark Jones, *A Catalogue of the French Medals in the British Museum*, i, AD 1402–1610 (London, 1982), pp. 182, 256; Attwood, *Italian Medals*, pp. 105, 338, 433, 442.

226. ## Coinage of the United Provinces

(a) ## Leicester reaal of Holland, United Provinces of the Netherlands, 1586

Amsterdam.
Silver.
Inscribed: obv.: 'CONCORDIA RES PARVAE CRESCUNT HOL'
(Through concord, small things increase. Holland);
rev.: 'MO NO ORDIN PROVIN FOEDER BELGIAE 1586' (New
coin by order of the United Provinces of the Netherlands).
British Museum, London, CM G.III. Fl&D, AR1.6.

(b) ## Double Leicester rijksdaalder of Utrecht, United Provinces of the Netherlands, 1587

Utrecht.
Silver.
British Museum, London, CM G.III. Fl&D, AR1.8.

In 1585 Elizabeth reluctantly agreed to Dutch pleas and the urgings of figures at her own court to send a military expedition under Leicester to aid the Netherlands in its revolt against Philip II of Spain. In 1586 the Dutch, worried by Elizabeth's lack of enthusiasm for the expedition, offered him the post of governor-general of their lands. Though aware that the queen would certainly be furious, he accepted, and a coinage for the Dutch provinces carrying his portrait was put into circulation. The queen's fury was indeed immense and Leicester only just managed to avoid a humiliating public resignation of his position. He eventually resigned his command in December 1587, having achieved

(a)

(b)

the blame for his enforced resignation squarely on the Dutch. The identity of the commissioner of the medal is unknown. The title given to Leicester and the sentiments expressed would argue against it having been made in England, and its style suggests a Netherlandish artist.

PA

LITERATURE: Hawkins, Franks and Grueber, *Medallic Illustrations*, i, p. 140, no. 100; Michael Vickers, 'The Medal of Robert Dudley, Earl of Leicester in the Bibliothèque Nationale', *Numismatic Chronicle*, 141 (1981), pp. 117–19.

little through lack of support from England, his own incompetence and poor relations with the Dutch.

BC

LITERATURE: Delmonte, *Le Benelux d'Argent*, nos. 891 and 904a.

227. Medal of the Earl of Leicester, 1587

> Unidentified artist.
> Silver.
> British Museum, London, CM M6893.

This medal was produced in commemoration of Leicester's departure from the Netherlands and as a protest against the treatment he had received while he was there. Described on the obverse as governor of the Low Countries, on the reverse he is represented as a sheepdog forced to abandon his sheep. The accompanying Latin inscriptions, which translate as 'I leave unwillingly' and 'Not a flock but ungrateful', place

228. The Earl of Leicester as Governor of the Low Countries, c. 1585–7

> Cornelis van Sichem (c. 1546–1624).
> Line engraving.
> 18.8 x 14.4cm.
> National Maritime Museum, Greenwich, PAD2357.

This engraving of Leicester celebrates his rise to power in the Low Countries and probably does not date beyond his disgruntled departure in 1587.

SF

225

229. A Ryall and Counter, depicting Mary, Queen of Scots

(a) Ryall (30 shillings Scots), 1565

Edinburgh Mint.
Silver.
Inscribed: rev.: 'QVOS DEVS COIVNXIT HOMO NON SEPARET'
(Whom God has joined together, let no man put asunder
[Matthew 19: 6]).
British Museum, London, CM MI 130-82.

(b) Counter, 1579

France?
Silver.
Inscribed: Obv. and rev.: 'ADRASTIA ADERIT' (Justice will
come).
British Museum, London, CM M6890.

These objects reflect very different periods of Mary's life. This coin is from a time of relative success, the start of her personal rule in Scotland and her marriage to her cousin Henry, Lord Darnley, in July 1565, in defiance of Elizabeth. By this time large silver coins were being introduced into most European coinages and in December 1565 her privy council ordered one, to be called the 'Marie ryall'. This rare early portrait version, with its joint portraits and distinctive text, clearly celebrates the recent marriage.

The counter was made when Mary was in custody in England. It is a rare type, probably made in France in support of the queen, with a reverse design offering hope of improvement in her fortunes. The type appears to correspond to those in a set of 'jetons with the arms of her Majesty' mentioned in an inventory of Mary's possessions made at Chartley in 1586, in the run up to her trial and execution. BC

LITERATURE: Ryal: Bateson, *Coinage in Scotland*, p. 109; Burns, *The Coinage of Scotland*, ii, p. 338; Counter: Hawkins, Franks and Grueber, *Medallic Illustrations*, i, pp. 130–31, no. 82.

230. Embroidery made by Mary, Queen of Scots

Linen canvas embroidered in silks in cross stitch, bordered with
fragments of gold tissue and mounted on a silk velvet
ground.
Monogram: MR for Maria Regina.
Victoria and Albert Museum, London, T.33J-1955, given by the
National Art Collections Fund.

Mary embroidered this panel with a number of others during her time of imprisonment in England. Needlework provided her with a practical occupation and it was also an outlet for her to express the frustration of her situation, her choice of subject matter including many mottoes and emblems representing courage in adversity. She also depicted various subjects from natural history and in this case has copied an illustration from the 1560 edition of Conrad Gesner's *Icones Animalium*. The dark silk with which the ape was embroidered has partially decayed, exposing the drawing out of the design on the canvas ground. CB

LITERATURE: Swain, *Needlework of Mary*.

231. Proclamation concerning the Sentence against Mary, Queen of Scots, 4 December 1586

Three sheets of printed paper pasted together.
British Library, London, Add. MS 48027 (Yelverton MS 31)
fo. 448.

The Babington Plot, implicating Mary in a conspiracy to assassinate Elizabeth I, was broken by Walsingham's network of spies and *agents provocateurs* in August 1586. Babington and his fellow conspirators were hanged, drawn and quartered in September, and on 11 October Mary was brought to trial before a commission of thirty-six peers, privy councillors and judges at Fotheringhay Castle in Northamptonshire. Mary spoke in her own defence although she refused to recognise the court's jurisdiction over her. Not surprisingly she was found guilty and the queen immediately came under intense pressure from both her privy councillors and parliament to put Mary to death. Elizabeth, however, was slow to commit herself: her reluctance to execute Mary was probably not feigned, for she had similarly hesitated in the case of Norfolk (Cat. no. 217). At last on 2 December Elizabeth promised her parliament that she would publish the sentence against Mary. This proclamation was published two days afterwards and was greeted in London with bells, bonfires and prayer. It took Elizabeth another two months before she would sign the death warrant. SD

LITERATURE: Hughes and Larkin, *Tudor Royal Proclamations*, ii, pp. 528–32; Neale, *Elizabeth*; Neale, *Parliaments*, ii.

232. Letter from James VI of Scotland to Elizabeth, 26 January 1587

Manuscript.
British Library, London, Cotton MS Caligula c.IX art. 72 fos 192r–93r.

James VI wrote this personal letter to Elizabeth in a last attempt to save the life of his mother, Mary, Queen of Scots. He had previously sent William Keith, his close household servant, to the English court, written an earlier brief to the queen on 28 November 1586, and sent a formal Scottish embassy to London in December, all for the same purpose of securing a pardon for Mary. But, as he admits in this letter, Elizabeth had not taken his 'plainness' well. Indeed, she had been enraged by the November letter which had included the rather tactless argument that Henry VIII had stained his reputation by executing Elizabeth's mother.

James wrote this letter as a final petition to 'his dearest sister'. It

would, he said, touch his honour if his ally, the queen of England, were to put to death his mother and a 'sovereign prince' of Scotland. And it would, he continued, dishonour Elizabeth were she to execute a kinswoman and fellow monarch. Here he proved to be right, for Elizabeth's reputation suffered badly from Mary's execution. James presented his request to Elizabeth as a personal favour and he was consequently distressed and angry when the execution went ahead on 8 February 1587, even though Elizabeth tried to slip out of direct responsibility for issuing the death warrant. For some time afterwards his relations with Elizabeth were strained, but despite cries for revenge in Scotland he would give no help to Spain during its invasion attempt on England.
 SD

LITERATURE: Doran, 'Revenge'; Marcus, Mueller and Rose, *Elizabeth I*, pp. 291–3.

233. Drawings of the Execution of Mary, Queen of Scots

See overleaf.
English.
Pen and ink.
British Library, London, Add. MS 48028 (Yelverton MS 31)
fo. 650.

These sketches of the trial and execution of Mary, Queen of Scots, are in the papers of Robert Beale, clerk of the council. He carried the death warrant for Mary to Fotheringhay and read it aloud to her on Tuesday 7 February, the evening before the execution. The sketch here depicts three different stages of the execution: first Mary entering the great hall of the castle; then Mary disrobed by her women, Jane Kennedy and Elizabeth Curle, on the scaffold; and finally Mary with her head on the block and the executioner ready to strike. The two seated men (number 3 and 4) were the earls of Shrewsbury and Kent. One estimate suggested that some 300 people attended the event. SD

234. Gold Cross of Mary, Queen of Scots

Gold and enamel.
Provenance:
 bought in
 Paris in 1696
 by Mary
 Howard of
 Worksop (mother of 8th
 and 9th Dukes of Norfolk)
 and then by descent.
The Duke of Norfolk, Arundel Castle.

This small gold cross is a fine example of Renaissance gold and enamel work, and was thought to contain a relic of the True Cross. Mary Howard wrote a note about the provenance of the cross, which is preserved in the Norfolk Archives. She relates that she bought it from a Father Lowick, an English Benedictine monk, who told her that it had been given by Mary to Abbot Feckenham of Westminster, the last Benedictine abbot of Westminster. The rosary worn by Mary as she went to the executioner's scaffold at Fotheringhay Castle also survives. Walsingham ordered that her body should be placed in a leaden coffin so that Catholics could not seek relics, but the preservation of Mary's religious possessions is a testament to her iconic power. SF

LITERATURE: Robinson, *Arundel Castle*, pp. 84–5.

235. Jewels of Mary, Queen of Scots

(a) Cameo locket, second half of the sixteenth century

Gold, enamel, diamond, ruby, and chalcedony cameo.
Trustees of the National Museums of Scotland, Edinburgh,
 KL1999.181.

(b) Cameo locket, second half of the sixteenth century

Gold, enamel diamond, ruby, and
 chalcedony cameo.
Trustees of the National Museums of Scotland, Edinburgh,
 HNF 33.

Mary reputedly gave the first cameo locket to the lord lieutenant of Northampton just before her execution. Many of her possessions were later dispersed (Cat. no. 237). The jewel would probably have hung from a jewelled collar or gold chain around the neck, or possibly from a ribbon pinned to the sleeve or bodice. Originally, it would have presented a quite colourful and rich appearance, but much of the enamel is now gone as are the three pendant jewels or pearls that would have hung from the gold loops at the bottom of the locket.

 The second cameo was reputedly one of several brought to Scotland by Mary on her return from France in 1561, and mounted into the locket by an Edinburgh goldsmith. The heart-shaped golis is set with table-cut diamonds and at the base a cabochon ruby, framing an oval cameo chalcedony portrait bust of Mary, Queen of Scots in profile. The backplate of the cameo is finely enamelled with a vase amidst leafy scrolls.

 AM & DS

LITERATURE: Dalgleish, *Art of Jewellery*, p. 14.

236. A Petition of Mary's Household remaining at Fotheringhay, 12 June 1587

Manuscript.
Public Record Office, Kew, SP 53/21 fo. 74.

After Mary's execution her household attendants, numbering some thirty-three people, were kept as virtual prisoners in the castle of Fotheringhay under the custody of Sir Amyas Paulet, their mistress's last jailer. In despair they petitioned Elizabeth for their release but although they asked to be 'straightly permitted to depart' it was several months before they left. They stayed at the castle until 30 July 1587 when they accompanied Mary's embalmed body on its journey to Peterborough Cathedral. The next day they attended the funeral, but absented themselves from the Protestant religious service, and then they returned to the castle. When they were eventually permitted to leave, some returned to Scotland while others went to Antwerp. SD

237. An Inventory of Mary, Queen of Scots', Possessions, 20 February 1587

Manuscript.
Public Record Office, Kew, SP 53/21 fos 41-47v, article no. 20 i.

After Mary's execution, an inventory was drawn up of the jewels, plate, money and other goods found in the custody of her servants. These items included a bed, a piece of unicorn's horn, various portraits, bracelets with a history of the Passion of Christ, a number of rings, an image of the Virgin in red coral and 'necessaries belonging to a massing priest'. Mary's apparel was also listed and showed that she usually wore black.

Some of the items were to be delivered to Mary's son James, including the bed wrought with needlework of silk, silver and gold, the unicorn's horn, a cloth of estate and various pictures of Mary and James's ancestors. Mary asked for the remainder to be sold and the money used to contribute towards the cost of sending her household homewards. SD

238. The 'Armada Portrait' of Elizabeth I, c. 1588

British School; with later additions.
Oil on oak panel.
110.5 x 127cm.
William Tyrwhitt-Drake.

This painting proclaims Elizabeth as 'great Empresse of the world' – splendid, virtuous and triumphant over her enemies. Her fashionable bejewelled dress, and the predominance and arrangement of her pearls,

underline her regal status, chastity and the wealth of her realm. To her left, the arm of her chair of estate is carved as a mermaid – a symbol of lasciviousness said to lure seamen to their destruction, as seen in the view above of Armada ships wrecked by night on Britain's western coasts. From darkness and divine retribution ('He blew with his winds and they were scattered') the queen turns to favour the sunlit view of the fireship attack on her right, key to the Armada victory. This is distantly seen beyond part of the English fleet. Below, on a globe, her right hand overshadows the Americas, where her seamen have long defied Spain's monopoly and where Virginia, the first English colony, is already established. The 'closed' crown, placed centrally between Elizabeth's New World ambitions and the fireship scene, alludes to longstanding Tudor claims of imperial status, now vindicated by the defeat of the Armada.

The painting may have been commissioned by Sir Francis Drake, whose descendants have held it since before 1775, when it was first recorded. There are two other versions by different sixteenth-century hands. One, cut down at the sides, is in the National Portrait Gallery: the other, at Woburn Abbey, has been attributed to George Gower. The one exhibited here differs in costume details, while the style and the flags of its Armada scenes show that these were repainted shortly after 1707 by a Dutch-trained artist working in England. X-rays reveal traces underneath of the same original sixteenth-century versions as in the other variants, partial in the NPG case. PvdM

LITERATURE: Strong, *Gloriana*, pp. 131–3: Belsey, 'Icons of Divinity', pp. 11–14: Hearn (ed.), *Dynasties*, no. 43.

239. *Thamesis Descriptio:* map of the Thames Estuary, 1588

Robert Adams (1540–95).
Ink and colour on vellum.
British Library, London, Add. MS 44839.

This shows the existing and proposed Thames defences between Westminster and Tilbury in 1588. Lines radiating over the river indicate potential fields of fire for cannon on the banks and a defensive boom is shown between Gravesend and Tilbury. The 'pricked line' shows Elizabeth's route to review Leicester's troops at West Tilbury camp on 20–30 July. Here she made her famous rallying speech against the Armada (Cat. no. 244). PvdM

240. The Armada Charts from *Expeditionis Hispanorum in Angliam vera descriptio*, 1590.

Drawn by Robert Adams (1540–95) in 1588 and engraved by Augustine Ryther (fl.1576–95).
Hand-coloured engravings.
National Maritime Museum, Greenwich, E4735.

Lord Admiral Howard's account of the stages in the Armada campaign formed the basis for Petruccio Ubaldini's book, *The Spanish expedition to England truly described*. The book was illustrated by a series of eleven plates, drawn by Robert Adams, a draughtsman, surveyor and architect who held the appointment of Surveyor of the Queen's Buildings. Augustine Ryther had engraved three charts for the recently published English edition of Waghenaer's *Mariner's Mirror*.

(a) The track of the Armada around Britain and Ireland

The first map in the *Expeditionis* series shows the entire route taken by the Armada, skirmishing with the English fleet along the Channel. After the failed rendezvous with the invasion forces from the Low Countries, the wind direction indicated on the map forced the Armada to continue its voyage north. The ships rounded Scotland and sailed out into the Atlantic towards Spain.

(b) The fleets between Portland Bill and the Isle of Wight

Ten plates depict the positions of the opposing fleets on each day from 19 to 29 July 1588. To the left in this image, the Armada is seen regrouping into its crescent formation after the action near Portland Bill on 23 July. During 24 July the wind veers south-westerly, allowing the Armada to reach away from the English coast towards its rendezvous with the prince of Parma's forces. The English ships are depicted sailing in pursuit, drawn up into four tightly formed squadrons. GH

(a)

(b)

241. Englísh Ships and the Spanish Armada,
sixteenth century

British School.
Oil on panel.
114 x 145cm.
National Maritime Museum, Greenwich, BHC0262.

The highly schematised rendering of the ships, sea and gun smoke has an extremely high horizon, a feature of Netherlandish marine paintings of the period. It has been suggested that the picture may be a design for a tapestry but there is no evidence that such a tapestry existed. It is also possible that the picture, depicting a phase in the Armada campaign, may have been painted as part of a decorative scheme by a serjeant painter employed by the English court. Yet the painting seems to have been intended as a symbol of the Armada campaign as a whole rather than a specific event, although it is closest to the Battle of Gravelines. Its message is satirical and anti-Catholic. While battle rages in the background, the emblematic foreground holds the key to the meaning. It consists of a Spanish galleass flying the papal banner with two English warships on either side, that on the right being Lord Howard's flagship *Ark Royal*. There is a skeleton in a jester's costume on board the galleass with a number of figures led by a preaching monk, suggesting that she is a 'ship of fools'. In a boat near the stern of the galleass is a figure representing a distraught Spaniard, perhaps intended as Philip II or the Spanish commander Medina Sidonia, and monks disappear into the sea. RQ

242. Miniature of Charles Howard, 2nd Baron Howard of Effingham, 1st Earl of Nottingham

Attributed to Rowland Lockey (c. 1565–1616).
Watercolour on vellum.
4.7 x 3.9cm oval.
Inscribed: *Ano Dm. 1605*.
Provenance: Buccleuch collection.
National Maritime Museum, Greenwich, MNT0136.

Charles Howard (1536–1624) was the eldest son of Lord Howard of Effingham and the first cousin of Anne Boleyn. In 1585 he was appointed lord admiral, a position he held for thirty-four years, and in December 1587 was designated 'lieutenant general and commander-in-chief of the navy prepared to the seas against Spain'. He therefore held chief command against the Armada in the *Ark Royal*. In 1596, he was joint commander with the earl of Essex in the raid on Cadiz but the two men quarrelled over strategy. Thereafter they were bitter enemies. In 1601 Howard was one of those who tried Essex for treason.

Howard also had a successful career as a courtier and diplomat. He held the position of lord chamberlain from 1573 to 1585 and served on several diplomatic missions. This miniature, formerly attributed to Hilliard, shows Howard at the time that he was involved in peace negotiations with Spain in 1604–5. RQ

243. Mariner's Astrolabe, c. 1588

Spanish or Portuguese.
Brass.
National Maritime Museum, Greenwich, NAV0022.

This famous instrument was found in 1845, in the remains of a leather case, under a hillside rock on Valentia Island, Co. Kerry. It probably comes from one of three homeward-bound Armada ships lost in the nearby Blasket Sound. The engraving is incomplete and it may have been among items hurried aboard at Lisbon. These astrolabes were used by seamen to find their latitude, c. 1500–1700 (Cat. no. 146). PvdM

LITERATURE: Stimson, *Mariner's Astrolabe*, pp. 64–5.

244. Elizabeth's Speech delivered at Tilbury: undated, probably early seventeenth-century copy

Manuscript.
British Library, London, Harleian MS 6798 fo. 87.

This is Elizabeth's most famous speech, delivered to her troops at the camp at Tilbury in Essex on 30 July 1588, just after the main body of the Spanish Armada had been dispersed but before anyone could be certain that it would not regroup and attempt an invasion. Elizabeth's rhetoric in the Tilbury speech has been much admired, in particular the masterly use of contrasts, that can best be seen in her celebrated line: 'I know I have the body but of a weak and feeble woman, but I have the heart and stomach of a king and of a King of England too.' Also rhetorically effective is the contrast Elizabeth draws between the tyranny of Spain and her kingship which depends on the 'loyal hearts and goodwill of my subjects'.

In her attempt to rally the troops, Elizabeth tried to play the part of male ruler who would fight from the front and lay down his life for his subjects, but the reality was that she could not lead her troops into battle, as she acknowledges in the words: 'My lieutenant general [the earl of Leicester] shall be in my stead.' Her inability to act as a military commander was probably the greatest problem she faced as a woman.

But did Elizabeth actually write and deliver this speech? Susan Frye has questioned its authenticity on the grounds that no contemporary manuscript version exists. Furthermore, unlike other of the queen's important speeches, the Tilbury speech was not published at the time,

first appearing in print only in 1654. Despite these doubts, most historians believe that Elizabeth did give this speech or something very like it.

SD

LITERATURE: Marcus, Mueller and Rose, *Elizabeth I*, pp. 325–6; Teague, 'Elizabeth in Her Speeches'; Frye, 'Myth of Elizabeth'.

245. Treasures from the *Girona*

Ulster Museum, Belfast, (Antiquities Collection).

(a) Salamander pendant

Gold, set with rubies.

(b) Ring

Gold, originally with an inset stone.
Inscribed: MADAME DE CHAMPAGNEY, MDXXIIII [1524].

(c) Chain

Gold.

(d) Cameo

Lapis lazuli in a gold, pearl and (fragmentary) enamel setting.

(e) Gold ring

Inscribed: NO TENGO MAS QUE DAR TE.

(f) Ear- and toothpick shaped as a dolphin

Gold.

(g) Three eight-*real* silver pieces

Lima, Peru.

(h) Four-*real* silver piece

Seville.

(i) Ten *escudos*: an Armada seaman's wages

Seville, Seville, Granada, Seville, Naples.
Four gold, one silver.

The *Girona*, captained by Fabricio Spinola, was one of four fifty-gun Neapolitan galleasses in the Spanish Armada. Although unsuited to northern waters, two of them reached safety at Santander and Le Havre

but the third ran aground off Calais and the *Girona* was wrecked on Lacada Point, Co. Antrim, on 16 October 1588. Of 1,300 men aboard, including survivors from two other ships, all but nine drowned. The *Girona*'s remains were found in 1967 and it is the only Armada site to have yielded substantial 'treasure' in coins and jewellery, probably owing to the abnormal number of officers and gentlemen being carried.

The pendant (see a.) must have belonged to someone of high social rank. The salamander was a charm against fire but, since Spain colonised the Philippines in 1565, it may also represent an East Indies flying lizard long before these were scientifically recorded. The rubies are probably Burmese. The ring (see b.) belonged to a twenty-two-year-old French-born gentleman, 'Don Tomas Perrenoto' (Jean-Thomas Perrenot). He had survived the wreck of two Armada ships before drowning in the *Girona*. The ring was a family heirloom, probably marking the birth in 1524 of his uncle Jérome to his grandmother, Nicole Bonvalot of Champagney (Franche-Comté) and her husband, Nicholas Perrenot, a minister of the Emperor Charles V.

The chain (see c.) is one of two recovered from the *Girona* site, with portions or links from others. They were often worn as symbols of wealth and status but links were also readily detached, to make money payments if needed. The cameo (see d.) is one of eleven, probably originally twelve, from the *Girona*. The grotesque frames show they were a matching set. This is the only one with all its eight original pearls and one of only six retaining their carved lapis lazuli portraits. Of these, three have been identified as Byzantine emperors but not this example.

'I have nothing more to give thee' is the poignant motto on the ring (see e.), possibly a Spanish lady's farewell gift to her lover. It may originally have been a completely closed belt design (possibly for chastity), with the buckle end joined to the hand firmly grasping a heart. Such a gift would always be worn and the wearer must have drowned in the *Girona*.

Combination pocket-items (see f.) were common in the sixteenth century. The 'tail' of this luxury hygiene aid is the ear-pick; the narrow projection from the head is the toothpick.

The three 'pieces of eight' (see g.) bear the arms of Spain on the obverse, those of Castile on the reverse. They represent an infinitesimal fragment of the wealth Spain extracted from its New World empire. The ten escudos (see i.) represent the top monthly wage of a Spanish seaman or soldier in the Armada campaign. All bear the arms of Spain on one side and a cross with fleurs-de-lis on the other. Several of the gold pieces have been illegally clipped. PvdM

LITERATURE: *Armada*, pp. 185–99.

246. Shipboard items from *La Trinidad Valencera*

Ulster Museum, Belfast, (Antiquities Collection).

(a) Goblet, large bowl and dish

Pewter.

(b) Braid

Gold braid with four embroidered buttonholes.

(c) Apothecary's mortar

Bronze.

(d) Fire grenade

Semi-glazed earthenware.

The *Trinidad* was an 1,100-ton Venetian armed merchantman, requisitioned in Spanish-ruled Sicily for the Armada and commanded by Don Alonzo de Luzon. Although she distinguished herself in the fighting, she also carried massive bronze guns for the Armada's siege-train. Several of these were recovered from her wreck, found in 1971 in Kinnagoe Bay, Co. Donegal, where she went ashore in sinking condition on 2–4 September 1588. Many of her survivors were subsequently massacred by English forces.

The fire grenade (see d.), called an *alcancía*, was filled with a sticky compound of gunpowder, spirits and resin. When thrown on to an enemy deck with a burning fuse around it, it would burst with effects similar to ancient 'Greek fire', or modern napalm. PvdM

247. Letter from John Dee to Elizabeth, 10 November 1588

Manuscript.
British Library, London, Harleian MS 6986 fo. 45.

This beautifully written letter by John Dee (Cat. no. 165) was sent from Trebona in southern Bohemia. Dee had secretly left England in 1583 for the Continent with his wife and the medium Edward Kelly (mentioned in the letter). He had been expelled from Bohemia in 1586 after the papal nuncio accused him of heresy and was forced to take refuge in the castle at Trebona, which belonged to his patron, the count of Rosenburg. Dee sent messages to his English friends and the queen, begging for help to return home.

Dee received news of the defeat of the Armada several months after the event. Like most Protestants, he ascribed the English victory to 'the God of heaven and earth'. Taking advantage of 'Lady

Most gratious Soueraine Lady, The God of heauen and earth,
Who hath mightilie, and euidently, giuen vnto your most excellent
Royall Maiestie, this wunderfull Triumphant victorie, against
your mortall enemies) be allwaies, thanked, praysed, and glorified:
And the same God Almightie, euermore direct and defend your
most Royall Highnes from all euill and encumbrance: and finish
and confirme in your most excellent Maiestie Royall, the blessings,
long since, both decreed and offred: yea, euen into your most
gratious Royall bosom, and Lap. Happy are they, that can
perceyue, and so obey the pleasant call, of the mightie Ladie,
OPPORTVNITIE. And, Therfore, finding our duetie concurrent
with a most Secret beck, of the said Gratious Princess, Ladie
OPPORTVNITIE, NOW to embrace, and enioye your
most excellent Royall Maiesties high fauor, and gratious great
Clemencie, of CALLING me, Mr Kelley, and our families,
hoame, into your Brytish Earthly Paradise, and Monarchie
incomparable: (and, that, abowt an yere since: by Master
Customer Yong, his letters,) I, and myne, (by God his fauor
and help, and after the most conuenient manner, we can,)
Will, from hencefurth, endeuour our selues, faithfully, loyally,
carefully, warily, and diligently, to ryd and vntangle our
selues from hence: And, so, very deuowtely, and Sowndlie,
at your Sacred Maiesties feet, to offer our selues, and all,
Wherein, we are, or may be, hable, to serue God, and your most
Excellent Royall Maiestie. The Lord of Hoasts, be our
help, and Gwyde, therein: and graunt vnto your most excellent
Royall Maiestie, the Incomparablest Triumphant Raigne, and Monarchie,
that euer was, since Mans creation. Amen

Trebon, in the kingdome of Boemia,
the 10th of Nouebre: A. Dñi: 1588: Stylo vet.

Your Sacred and most excellent
Royall Maiesties
most humble and dutifull
Subiect, and Seruant:
John D.

Opportunity', Dee also asked Elizabeth to call him home 'unto your British Earthly Paradise'. Apparently without obtaining a reply, he set out for England on 1 March 1589. SD

LITERATURE: French, *John Dee*; Fenton, *The Diaries of John Dee*.

248. Medal commemorating the Defeat of the Spanish Armada

Unknown maker.

Bronze.

Inscribed: on the front; DITIOR . IN TOTO . NON . ALTER . CIRCVLVS . ORBE (No other circle in the whole world more rich). On the reverse; NON . IPSA . PERICVLA . TANGVNT (Not even dangers affect it).

National Maritime Museum, Greenwich, MEC1378.

Silver versions of this medal (some provided with a loop and chain) may have been awarded to those who played a leading role in the defeat of the Armada. The queen is shown richly dressed on the front of the medal within the inscription. The reverse shows a bay tree, believed to

249. 'A songe made by her ma[jest]ie and songe before her at her cominge from White Hall to Powles through Fleete streete in Anno domini 1588'

Ink on paper.
National Maritime Museum, Greenwich, SNG 4.

This is a contemporary copy of a song, reputedly written by Elizabeth herself, and sung before her in procession to old St Paul's Cathedral for the thanksgiving service after the defeat of the Armada, in November 1588. Two lines demonstrate that it shares the widespread Protestant attribution of the victory to God's intervention on the English side:

> he made the wynds and waters rise
> To scatter all mine enemyes.

PvdM

LITERATURE: Waters, *Elizabethan Navy*, pp. 100–102.

250. The Armada Jewel, second half of the sixteenth century

Gold, vari-coloured enamel, ruby, diamond, miniature.
Inscribed: on back cover; SAEVAS TRANQUILLA PER UNDAS (Peaceful through the storm waves). Inside; HEI MIHI QUOD TANTO VIRTUS PERFUSA DECORE NON HABET ETERNOS INVIOLATA DIES (Alas that so much virtue suffused with beauty should not last for ever inviolate).
Provenance: Queen Elizabeth to Sir Thomas Heneage (d.1595), Privy Councillor and Vice-Chamberlain to mark the defeat of the Armada and thence by descent. Sold Christie's, 18 July 1902, lot 99, bought by J. Pierpont Morgan, sold Christie's 24 June 1935, lot 99. Then presented to the nation by Lord Wakefield through the National Arts Collection Fund.
Purchased with the assistance of the National Art Collections Fund, Victoria and Albert Museum, London, M8-1935.

be immune from lightning strikes. The tree, representing Elizabeth, protects the island on which it stands and lightning destroys a ship in the distance instead.

Although the dangers from Mary, Queen of Scots, and the Armada were over by 1589, when medals of this design were struck, the threat to England from Spain had not fully abated. Philip began work almost immediately on repairing and renewing his fleet, and he also opened up a new land front in France. New armadas were launched in 1596 and 1597, though they were not on the same scale as that of 1588. They too were thwarted by storms.

BT

The openwork enamelled frame embellished with table-cut diamonds alternating with rubies encloses a portrait bust of Elizabeth, shown in profile on a blue ground. Inside, under glass, is a miniature of the queen, looking slightly towards the left, dated 1580. The back cover is enamelled with an ark on storm-tossed seas with the Latin words 'peaceful through the storm waves' and inside there is a double red rose within a leafy garland inscribed with a verse from the Walter Haddon,

Poemata (1567), 'Alas that so much virtue suffused with beauty should not last for ever inviolate'. The miniature is by Nicholas Hilliard, and the motif of the ark refers to the queen's safeguarding of the Church of England. The jewel, recording a great victory, is, like the Armada portrait (Cat. no. 238), a visual expression of the poem by George Peele, celebrating the queen's Accession Day of 1590:

> Elizabeth, great Empress of the world,
> Britannia's Atlas, Star of England's globe
> That sways the massy sceptre of her land
> And holds the royal reins of Albion.

<div align="right">DS</div>

LITERATURE: Somers Cocks (ed.), *Princely Magnificence*, no. 38, p. 60; Strong, *Gloriana*, pp. 131–3.

251. The Armada in the Strait of Dover

> Flemish school, c. 1600–10.
> Gouache on vellum.
> 13.3 x 38.8cm.
> Inscribed: ARMÉE NAVALE D'ESPAIGNE / SURNOMÉE INVINCIBLE VAINCUE / PAR LES ANGLOIS LE 22 JUILLET 1588, with the royal arms and initials (IR) of James I of England.
> Provenance: Rosebery Collection, Mentmore.
> National Maritime Museum, Greenwich, PAJ 3949.

This miniature combines various Armada events. The inscribed (OS) date refers to the battle off Portland. Beacons burn on the English coast (to the right) where defending soldiers bear Elizabeth's personal standard. In the middle distance, Lord Howard's *Ark Royal* flies the royal standard, with the fireship attack to the left. In the left foreground a small Dutch vessel attacks Spanish ships. This is the more elaborate of two such miniatures known and may have been a Dutch diplomatic gift to James I.

<div align="right">PvdM</div>

LITERATURE: *Armada*, p. 254.

ELIZABETH'S LAST YEARS AND DEATH

EXHIBITION CATALOGUE ENTRIES 252-270

252. Portrait of Elizabeth I, c. 1590s

British School, formerly attributed to John Bettes the Younger
(fl.1570–d.1616).
Oil on panel.
114.4 x 85.5cm.
National Maritime Museum, Greenwich, Caird Collection,
BHC2680.

One of a series of six closely related portraits which form a distinct group, whether or not they were painted by Bettes, a minor painter. They were painted between 1585 and the early 1590s, and are evidence of the rising demand for portraits of Elizabeth. None of them, however, would have derived from a sitting by the queen. Instead, as with many other portraits of Elizabeth painted during the latter part of her reign, the artist used tracings of the queen's head and other elements such as fabrics, jewels and ornaments. The face derives from a portrait now known as the 'Darnley portrait' which was possibly painted by the Italian artist Federico Zuccaro, who visited England in 1575, and which became the source of the official face mask for many subsequent portraits. The portrait presents a stiff and formalised image of the queen whose figure is turned fully to the front. Typically for English painting of this period, the formality is reinforced rather than alleviated by the focus upon surface decoration which covers the clothing as well as the background of tooled leather. RQ

The Earl of Essex

253. Portrait of Robert Devereux, 2nd Earl of Essex

Marcus Gheeraerts the Younger (1561/2–1636).
Oil on canvas.
211.2 x 127cm.
National Maritime Museum, Greenwich, BHC2681.

Robert Devereux (1566–1601), the elder son of Walter Devereux and Lettice Knollys, was brought up as a royal ward in Burghley's household after his father's death in 1576. First brought to court in 1585 as the protégé of his stepfather, the earl of Leicester, he left soon afterwards to join the English military campaign in the Netherlands. On his return he quickly became a young favourite of the queen, and the main rival of Sir Walter Ralegh (Cat. no. 181), and in May 1587 he succeeded Leicester as master of the horse when the latter was promoted to lord steward. Essex's secret marriage to Sir Philip Sidney's widow, Frances, only revealed by her pregnancy in October 1590, greatly angered the queen but she soon forgave him and by 1591 he was fully restored to royal favour.

By 1596, the probable date of Gheeraerts's portrait, Essex was acclaimed for his expedition to Cadiz. Essex's beard, which he grew on the Cadiz voyage, helps provide a *terminus post quem* for this portrait. Earlier images of Essex were by the herald painter, William Segar, but later representations of a more mature Essex were produced by this fashionable Anglo-Flemish artist. The face pattern and pose are based on Gheeraerts's full-length portrait now at Woburn Abbey. Essex's status is signified by the chain and pendant of the Lesser George, part of the insignia of the Order of the Garter to which he had been appointed in 1588. The carefully rendered details of the jewellery stand out against the white of Essex's costume, a colour closely associated with the virgin queen; in his right hand he holds a marshal's baton. This work was painted at the height of Essex's popularity; just five years later he was charged with treason (Cat. no. 257). DD

LITERATURE: Hammer, *Polarisation*; Hearn (ed.), *Dynasties*, pp. 133, 178.

254. Score-cheque for the Accession Day Jousts at Whitehall, 1596

Manuscript.
The College of Arms, London, TC 21.

This is a remarkable proof of Essex's prowess at martial sports. It shows him challenging all comers, running the usual six courses against all eighteen – 108 courses in all – and breaking ninety-eight lances (not ninety-seven, as mistotalled). His opponents together seem to have broken 120 lances, some apparently amongst each other. The note at the top shows the judges awarded the best prize to the earl of Southampton (Cat. no. 116) who broke twenty-two, and second prize to Henry Carey, who broke fourteen. PvdM

LITERATURE: Anglo, *Score Cheques.*

255. Rapier, c. 1600

Daniel or Emanuel
 Sadeler of Munich.
Steel hilt chiselled,
 blued and gilt.
Victoria and Albert
 Museum, London,
 M52-1947.

In the portrait of Essex (see page 000), he is shown wearing a swept-hilt rapier with a companion dagger, both suspended from an embroidered sword belt. By the sixteenth century, the rapier was defined as a duelling sword worn by gentlemen of the courts of Europe, not only for defence but also to denote status and wealth. Described as moody, petulant and jealous of rivals, Essex challenged Sir Charles Blount and Sir Walter Ralegh, both favourites of Queen Elizabeth, to duels. LV

LITERATURE: North, *European Swords.*

256. Astronomical Compendium made for the Earl of Essex

James Kynvyn.
Gilt brass.
British Museum, London, 1866, 0221.

This compendium appears to have been made for Essex and his arms are on the inside of the cover. Compendia – a collection of smaller instruments, all either hinged together or fitted into the same box – were popular amongst the very wealthy throughout Europe around the end of the sixteenth and beginning of the seventeenth centuries. They required a huge amount of technical skill on the part of the maker who needed the necessary mathematics and craftsmanship requisite in each instrument contained. They were, however, used more to display the

a private meeting with the Irish chieftain, where he offered him a truce in the queen's name. Again in total contravention of the queen's orders, Essex had returned home on 28 September 1599 to explain his conduct to Elizabeth in person; he had burst into Elizabeth's bedchamber while she was still dressing, to her evident discomfiture. Elizabeth had ordered that he be held in custody but it took eight months before the full inquiry into his erratic behaviour was heard.

Although Essex was accused in this document of treason, the commissioners only found him guilty of disobedience and a dereliction of duty. As punishment, he was stripped of all his offices except his position as master of the horse. Although he was released in August, he remained banished from the queen's presence and his days as a favourite and councillor were over. SD

LITERATURE: Lacey, *Essex*; MacCaffrey, *War and Politics*.

owner's wealth and appreciation of science and maritime endeavours than to make any actual observations or calculations. This particular example consists of a nocturnal, a latitude list, a magnetic compass, a list of ports and harbours, a perpetual calendar and a lunar indicator. The compendium could be used for timekeeping as well as for establishing high tide at particular ports and for calendrical calculations.

EW

257. Abstract of the Evidence in Support of the Charge of Treason against Essex, 22 July 1600

Manuscript.
Public Record Office, Kew, SP 12/275 fo. 56.

In June 1600 a special commission assembled at York House under the chairmanship of Lord Keeper Egerton to inquire into the conduct of Essex while acting as lord lieutenant of Ireland. In April 1599 Essex had landed in Ireland with instructions to use his army of 17,000 men to suppress the rebellion of Hugh O'Neill, the earl of Tyrone. As explained in this document, Essex had ignored the queen's orders to fight against Tyrone who was based in Ulster, and had instead wasted time in fruitless journeys in the south. Then, in August, Essex had held

258. Letter from the Earl of Essex to Elizabeth, September 1600

Manuscript.
Public Record Office, Kew, 275 fo. 102.

This is one of several pleading letters that Essex sent to Elizabeth after his disgrace and banishment from her presence. The earl was desperate to return to court and win back the queen's favour, for there were only a few weeks to go before the lucrative lease on the farm of sweet wines (which had been granted to him for ten years on Michaelmas Day 1590) was due to be renewed. If he could not secure this royal gift, his creditors would call in their debts, he would be totally insolvent and his political career would be over. Beneath Essex's loving and courtly language, therefore, lay serious material concerns.

In November 1600, Elizabeth announced that the revenue from the farm would revert to the crown. In despair and close to bankruptcy Essex listened to some of the wilder schemes of the disaffected soldiers, courtiers and noblemen who had gathered about him at Essex House. On Saturday 7 February 1601, some of this following arranged for Shakespeare's *Richard II* to be played at the Globe as a preliminary to a coup against the queen and her ministers. But when on the next day Essex and some two hundred of his men marched through the City in the hope that the Londoners would flock to him and rise against the court he was disappointed. His armed demonstration won no supporters and he quickly surrendered. On 25 February 1601 Essex and five other conspirators were executed secretly but other leading participants, including the earl of Southampton (Cat. no. 116), were reprieved. Essex's betrayal dismayed the queen and she suffered from melancholy for some time afterwards. SD

LITERATURE: Lacey, *Essex*; MacCaffrey, *War and Politics*.

259. Miniature of Elizabeth I, c. 1590–92

Isaac Oliver (c. 1565–1617).
Brush and black ink, white, yellow and blue gouache, on vellum
 stuck to playing card.
8.2 x 5.2cm.
Victoria and Albert Museum, London, PD. 8-1940.

This haunting unfinished image is one of the few images in which Elizabeth is obviously depicted as a significantly older woman. It was designed as a pattern for a miniature and from the evidence of the close focus of the queen's bone structure, and tiny details such as the slight crease in her forehead, it was undertaken from life. Her features are clearly portrayed with only a minimal touch of artistic refinement and show her heavily hooded dark eyes, slightly hooked nose and small mouth. Although the vivid blue background has been laid in, the miniature is clearly unfinished as the vellum support has not yet been trimmed to an oval shape in order to fit a case. The face pattern depicted here was used for other engravings principally produced by Netherlandish artists and appears to have been used as the basis for the engraving by Crispin van der Passe of around this period (Cat. no. 260, not illustrated). Isaac Oliver came to England in 1568 as a child and trained with Nicholas Hilliard, but his work was far more directly influenced by European traditions. Into the reign of James I he became widely recognised for his abilities to produce highly realistic portraits through the use of carefully applied shadows. TC

LITERATURE: Auerbach, *Hilliard*, p. 239, no. 24; Strong, *Portraits of Elizabeth*, pp. 92–4, pl. M.2; Strong, *Artists of the Tudor Court*, pp. 124–5.

260. Queen Elizabeth I, 1596

Netherlandish, attributed to Crispin van der Passe
 (c. 1565–1637).
Engraving (published by John Wootneel).
60 x 80cm.
British Museum, London, PD 1886-8-22-853.

This print celebrates the victorious Anglo-Dutch expedition against Cadiz, which was commanded by Lord Admiral Charles Howard (Cat. no. 242) and the earl of Essex (Cat. no. 253). The Spanish town was captured and looted, while the Spanish fleet laden with treasure from the Indies was burnt and sunk by its captains to prevent its capture by the English. Cadiz, on the estuary of the river, can be seen in the background of the print.

The figure of Elizabeth dominates the image: she holds the orb in her outstretched hand and points with her sceptre to her motto *Posui Deum Adiutorum* (I have made God my help), taken from Psalm 88, inscribed on the open Bible. She stands between matching Corinthian columns, from which hang the dynastic escutcheons of the house of Tudor and upon which sit her emblems, the pelican in piety (on the left) and phoenix (on the right). These columns represent the imperial and religious aspirations of the Spanish king over which Elizabeth and English Protestantism had prevailed. The engraving therefore portrays the queen as an instrument of divine will, the scourge of Catholic Spain, and a monarch who with God's help and English sea power would build up an empire of her own and oversee the triumph of European Protestantism. SD

LITERATURE: Doran, 'Virginity'.

261. Robert Cecil, 1st Earl of Salisbury
(1563–1612)

Robert Elstrack (1570–after 1625).
Engraving.
British Museum, London, PD P1-90.

The inscription in the cartouche at the upper left of this print identifies the sitter as Robert Cecil, 1st Earl of Salisbury and Viscount

or listen to the viewer, the epitome of the powerful and dedicated royal servant. As with his political reputation, Cecil was highly regarded as a collector of paintings, including portraits of foreign statesmen and monarchs and, less conventionally, mythological and religious works. He was also a considerable patron of architecture, demonstrated by the work at Hatfield House, the former royal palace he received from James I in exchange for the Cecil estate at Theobalds, and at his new London town house in the Strand, where he himself claimed to be the architect.

DD

LITERATURE: Croft, 'Robert Cecil'; Hearn (ed.), *Dynasties*; Susan Bracken, 'The Patronage of Robert Cecil, 1st Earl of Salisbury 1591–1612', unpublished MA report, Courtauld Institute (1993); A.V.G. Griffiths, *The Print in Stuart Britain 1603–1689*, (BMP, 1998).

262. Peter Wentworth's 'A Pithie Exhortation to her Majestie for Establishing her Successor to the Crowne'

Manuscript book.
British Library, London, Royal MS 18A LXVIII.

Even after the execution of Mary Stewart, there was considerable anxiety about who would succeed to the throne on Elizabeth's death. To the consternation of many of her subjects, Elizabeth still prohibited any discussion of the succession issue. Her ban, however, did not stop the outspoken puritan MP Peter Wentworth (c. 1524–97) writing 'A Pithie Exhortation', a pamphlet which argued that the question should be resolved in parliament. Wentworth first drafted the work in 1587 but he did nothing with it until 1589, when he paid a Banbury schoolmaster to make a fair copy in readiness for it to be presented to Elizabeth. What happened to that copy is unknown. A few years later, though, Wentworth was interrogated by the council about the tract. Believing he had supporters amongst the councillors, Wentworth discussed with friends a plan to raise the question of the succession in the next parliament and to present a handwritten copy of the 'Pithie Exhortation' to the queen. His activities were soon discovered, however, and he was committed to the Tower in 1593, where he remained until his death in 1597. His long confinement shows the extreme sensitivity of the queen to any discussion of the succession.

Wentworth used puritan rhetoric to make his points in the 'Pithie Exhortation', as can be seen from the pages on display. In this section, which addressed ten questions to the queen, Wentworth asked whether it was not 'a grievous sin in you' to leave the succession uncertain, a sin which would have to be accounted for at the tribunal of the Lord. Similarly, he implied in his final question that Elizabeth's refusal to act on this important matter would 'provoke the Lord to be angry with you and so withdraw his hedge and strong wall of defence from about

Cranbourne (1563–1612). Cecil was the only surviving son of Elizabeth's treasurer, William, Lord Burghley (Cat. no. 33), and his second wife Mildred Cooke, and under his father's tutelage became one of the most powerful and influential courtiers and statesmen in late-sixteenth- and early seventeenth-century England. After a knighthood in 1591 he was appointed as Elizabeth's principal secretary in 1596 and was later responsible for ensuring the smooth transition to her successor, James VI of Scotland. His political influence continued under James, who referred to him as his 'little beagill'. In 1604 he was made Viscount Cranbourne and in the following year the earl of Salisbury. In 1606 he was made a Knight of the Garter, an honour alluded to here by the Lesser George he wears around his neck and the Order's motto within the Cecil coat of arms, which he used on his personal seal, in the upper right of the print. Underneath is Cecil's personal motto *SERO SED SERIO* (Late but in earnest). In 1608 he was appointed lord treasurer.

This engraving by the native-born Robert Elstrack, a prolific and well-regarded printmaker, is based on a face pattern and compositional type, with a figure seated or standing by a side table, established by the serjeant painter John de Critz, who painted Cecil on a number of occasions. In Elstrack's print Cecil turns from his desk, as if to address

you'. Such providential language would clearly not have endeared him to the queen.

In the Tower, Wentworth wrote another tract on the succession in which he named James VI as the claimant with the best title to the crown. Shortly after his death an anonymous friend had both tracts published in a single book. SD

LITERATURE: Neale, *Parliaments*, ii; Levin, *The Heart and Stomach of a King*, pp. 166–7. Facsimile version published by Theatrum Orbis Terrarum.

263. John Manningham's Diary

Manuscript.
British Library, London, Harleian MS 5353 fo. 3.

This personal diary records the queen's death on 24 March 1603. John Manningham's informant for this event was the royal chaplain, Dr Henry Parry. According to Parry, the queen had been 'oppressed' with 'melancholy' for a fortnight and refused to eat, 'receive any physic, or admit any rest in bed'. For the previous two days, said Parry on 23 March, she had been speechless.

Elizabeth died at about 3 am, 'mildly like a lamb, easily like a ripe apple from the tree'. Attended by the Archbishop of Canterbury, she had a 'good death', squeezing his hand when he prayed and spoke of the joys of heaven. The cause of her death might have been a stroke or a severe throat infection. To Manningham's immense relief the succession went smoothly. Cecil had made the necessary arrangements and James VI of Scotland was swiftly proclaimed King of England.

Manningham wrote this commonplace book while he was a law

student at the Middle Temple throughout the year 1602 and until April 1603. He noted down anecdotes, gossip, aphorisms, notes from sermons and extracts from books. From the diary, readers obtain a valuable record of the events at the very end of Elizabeth's reign, the men who frequented London (including William Shakespeare), and a sense of contemporary preoccupations. SD

LITERATURE: Robert Parker Sorlien (ed.), *The Diary of John Manningham of the Middle Temple. 1602–3* (Hanover, NH, 1976).

264. Elizabeth's Funeral Procession

Colour drawings in Indian ink.
6.15 x 193.5cm.
British Library, London. Add. MS 35324 fos 26-39.

These drawings, executed by an anonymous artist, are the first ever pictorial records of the funeral procession of an English monarch.

After Elizabeth's death on 24 March, her corpse was embalmed and placed in a coffin which was then transported in a black-draped barge from Richmond to Whitehall. Following traditional practice it lay in state on a black velvet bed in a chamber at the palace, where it was watched at night by several lords and ladies. The funeral took place on 28 April 1603. The focal point of the thousand-strong procession was the chariot carrying the coffin, covered with purple velvet, upon which lay a lifelike, painted effigy of the queen wearing her parliamentary robes and holding the sceptre and orb. On each side of the chariot were earls and barons in mourning dress carrying banners displaying the dragon of Wales, the lion of England, the fleur-de-lis of France and the greyhound of the Tudors. Close to them were gentleman pensioners

(the monarch's ceremonial bodyguard) whose pole-axes were pointing downwards. The marchioness of Northampton was chief mourner, although according to heraldic regulations Elizabeth's cousin Arbella Stuart should have taken on that role. The funeral arrangements were supervised by Robert Cecil and the estimated costs of the event have ranged from £11,305 to £25,000. As was customary, Elizabeth's successor did not attend. Tens of thousands of Londoners, however, turned out to see her final journey and expressed a ritualised grieving at her passing. Elizabeth was buried under the main altar of the Henry VII Chapel at Westminster Abbey. In 1606 her body and that of her sister Mary were relocated by James I to the north aisle, while his mother's tomb was removed from Peterborough Cathedral into the south aisle of the abbey. Only the torso and legs of Elizabeth's royal effigy (by John Colte) have survived; in 1760 the rest of the figure was entirely remade. SD

LITERATURE: Woodward, 'Dead Queen'; Woodward, *Theatre of Death.*

265. Elizabeth's Hearse in Westminster Abbey

Augustine Vincent (c. 1581–1626).
Ink and colour on paper.
21.6 x 13cm.
The College of Arms, London, Vincent Collection MS 151
 pp. 534–5.

This is another of the illustrations recording the pageantry of Elizabeth's state funeral. It appears in Vincent's monumental *Precedents*, a manuscript on the ordering of public ceremonies, and also gives the order of the funeral cortege, which included the queen's household down to the scullery and stable workers, 'besides the greatest part of the nobility, all the council, and representatives of all ranks of society, in strict precedence'. As was customary, the queen herself was represented by a lifelike wooden effigy, resting on top of her coffin. This appears to have been designed to perpetuate the myth of the aged Elizabeth as 'Gloriana', in scarlet satin robes lined with white and with a flaming red wig over a wooden face, carved and coloured 'so faithfully she seems alive' in the words of the Venetian ambassador. The 'hearse' at this time was the canopy under which the coffin rested during the funeral service. Vincent's drawing shows it decorated with heraldry including Elizabeth's personal arms and motto, *Semper Eadem*, in the centre, and those of England and the Garter, the Tudor rose and greyhound, the dragon of Wales and the harp of Ireland. Vincent was a scholar and antiquarian who became Rouge Croix Pursuivant at the College of Arms in 1616 and Windsor Herald in 1624. PvdM

LITERATURE: *Armada*, no. 16.29; Woodward, *Theatre of Death.*

266. Genealogy of James VI of Scotland and I of England

See overleaf.
British School.
Painted leather.
87 x 71cm.
Inscribed: around the arms top left; HONI SOIT QVI MAL Y
 PENSE 1604. Around the portraits from bottom to top:
 HENRY THE 7 OF THE HOWSE OF LANCASTER, ELIZABETH
 DAVGHTER TO . . . OF YORKE; / FIRST JAMES THE K. OF
 SCOTLAND, MARGARET DAVGHTER TO KING HENRY 7
 MARRIED, SECONDLY TO ARCHIBALD DOVGHLAS EARL OF
 ANOWISH / JAMES THE FIFT KIING OF SCOTLAND, MARY
 SISTER TO THE D. OF GVISE DUCHES OF LONGVIL,
 MARGARET MARIED MATHEW STEWARD EARL OF LENOX,
 MATHEW STEWARD EARL OF LEN . . . / FRANCES THE
 SECOND KING OF FRANCE, MARY QVEENE OF SCOTLAND
 MARRIED FIRST, SECONDLY HENRY E. DARLEY D . . .
 ALBANY KING OF SCOTLAND, / JAMES KINGE OF
 ENGLAND. SCOTLAND FRANCE AND IRELAND, ANNE
 DAVGHTER TO FREDERICK KING OF DENMARK.
Parham House and Gardens, West Sussex.

James succeeded to the throne on 24 March 1603 and was crowned on 25 July. In the first year of his reign he visited more than forty houses of the English nobility and gentry and many of these individuals would

have been keen to show their allegiance to the new king. This painted portrait genealogy may have been one of a number designed to record his accession and relates very closely in all details to an engraved version of the same year by William Kip (1588–1618), a Dutch goldsmith resident in London. The engraving was part of a printed text published under the title *Description of the Kingdoms of England, Scotland and Ireland*. The fourteen portraits illustrate the king's lineage from Margaret Tudor (elder sister to Henry VIII) and thus his claim to the crown of England. It begins at the base with Henry VII and Elizabeth of York and following left to right: James IV, Margaret Tudor, Archibald Douglas / James V, Mary of Guise, Lady Margaret Douglas, Matthew Stuart earl of Lennox / Francis II of France, Mary Queen of Scotland, Henry Lord Darnley / James, Anne daughter to Frederick King of Denmark. As with the engraving by Kip, the portraits are quite crudely, if charmingly, undertaken, perhaps by a herald, and derive from the patterns established in existing portraits.

TC

LITERATURE: Hind, *Engraving*, ii, pp. 31–31, pl. 4, P45; Antony Griffiths, *The Print in Stuart Britain 1603–1689*, British Museum Exhibition catalogue, London: British Museum (1998), pp. 41, 45; Watkins, *Public and Private*. p. 151.

267. James I's Answer to Letters of the English Peers and Council, 31 March 1603

Manuscript.
Bodleian Library, University of Oxford, Ashmole MS 1729
no. 24 fo. 43r.

On 24 March 1603, the English peers and council had sent James VI a copy of the proclamation declaring him King of England. James designed his reply to reassure all the leading men of England that they would have nothing to fear from the accession of a foreign king. He promised that he would work for the 'continuance and increase of the peacable and flourishing estate' of both England and Scotland and that he would not alter the laws or constitution of England in any way.

In a marked contrast with Elizabeth's Hatfield speech of November 1558 (Cat. no. 27) James also stated his intention to retain all the queen's late councillors and 'magistrates', referring to this both in the main body of the letter and in the postscript. He also held out the hope of rewards for gentlemen who would 'repair unto us'. Within a few months, James had made good his promise: he knighted many Englishmen on his way down to London and brought men like Lord Henry Howard into his council.

SD

268. James I Stirrup Cup, seventeenth century

'The Pitfirrane Glass'.
Venice or northern Europe.
Trustees of the National Museums of Scotland, Edinburgh.

This fragile glass, treasured in a Scottish family, was by tradition handed to James VI for a final toast before he rode south to take the English throne. He left Scotland for the celebrations which warmed his long journey to London. His welcome was genuine; the royal family had sons to secure the succession and 'Peace and Prosperity' were promised after the bad harvests and risk of invasion during the 1590s. His entry into London (deferred because of plague) celebrated the new era with triumphal arches. One designed for the City of London was draped in silk painted with a dark cloud, which was drawn aside as the king approached, summing up the official attitude to the new regime.

PG

269. Elizabeth's tomb effigy, c. 1605–07

After Maximilian Colte (fl.1596–1641).
Electrotype copy by Elkington & Co., c. 1872.
National Portrait Gallery, London, NPG 357.

In April 1605 Colte received £150 for work on Elizabeth's white marble tomb in Westminster Abbey, subsequently coloured and gilded by Nicholas Hilliard and John de Critz the Elder. An orb is in the queen's right hand and part of a long-missing sceptre in her left. The likeness is presumed to be based on the wooden head of her funeral effigy, carved by Colte's brother, John. This lasted until 1760 but was then in a poor state and was discarded after the abbey's present wax copy was made.

PvdM

LITERATURE: Strong, *Portraits*, I, p. 107.

270. Triptych with the text of the Ten Commandments, c. 1550–1600

Anonymous, British School.
Oil on three joined panels.
127 (at highest point) x 203 (open) cm.
Inscribed: On the outer wings: 'Math. Chapt 6 verse 19:20. / Lay not up for your selves treasures upon / earth, where moth and rust doth corrupt and / where thieves break through and steal; But / lay up for your selves treasures in heaven, where / naither moth nor rust doth corrupt, and where / thieves do not break through or steal. / 2 Corin. Chapt. 9. verse. 6. 7. / He which soweth sparingly shall reap also / sparingly, and he which soweth bountifully shall / reap bountifully. Every man according as / he purposeth in his heart so let him give ; not / grudginghly, or of necessity; for God loveth a / cheerful giver / Eccles, xi : vers. 1. / Cast thy bread upon the waters, for thou / shalt find it after many days. /Hebrews, Chapt. xiii : vers. 16. / But to do good, and to communicate forget / not, for which such sacrifices God is well pleased. / I John, 3, Chap: verse. xvii. / But whoso hath this worlds goods, and seeth / his brother have need, and shutteth up his bowels / of compassion from him, how dwelleth the love / of God in him. / Proverbs: Chapt. 14: vers. 21 : 31 / He that despiseth his neighbour sineth : but / he that hath mercy on the poor happy is he. He / that oppresseth the poor reproacheth his Maker ; / be her that honoureth him hath mercy on the/ poor./ Prov. Chapt. 28 ; vers. 27. / He that giveth to the poor, shall not lack ; / but he that hideth his eyes shall have many / curses. / Tobit. Chapt. 4 : vers. 8. 9. / Give almes according to thy substance ; if / thou have but a little be not afraide to give a / little almes. For thou laiest up a good store for / thy selfe against the day of necessitie. / Prov. Chapt. 19 : vers. xvii. / He that hath pity upon the poor lendeth unto / the Lord, and that which he hath given will he / pay him again. / Psalms, 41, vers. 1. / Blessed is he that considereth the poor, the / Lord will diliver him in time of trouble. / Prov. xvii chapt., 5 vers. / Whoso mocketh the poor reprocheth his / maker : and he that is glad at calamities shall not / be unpunished. / Prov. Chapt. xxii, vers. xxii, 23. / Rob not the poor, because he is poor, neither / oppress the afflicted in the gate. For the Lord / will plead their cause and spoil the soul of those / that spoiled them./ Prov. Chapt. xxi, vers. 7. / The robbery of the wicked shall destroy them, because they refuse to do judgement. /
Inside of open triptych central panel: '1. I am the Lord thy God which have brought / the[e] out of the land of Egypt out of the house of bondage. Thou shall have none other Gods but me. / 2. Thou shalt not make to thyselfe any graven /

image nor the likeness of any thing that is in / heaven above or in the earth beneath nor in the / water under the earth; thou shalt not bowe / downe to them nor worship them for I the Lord / thy God am a jelous God and visite the sinnes of / the fathers upon the children unto the third and / fourth generation of them, that hate mee, and / shewe mercy unto thousands in them that love / me and keep my commaundements.' / 3. Thou shalt not take the name of ye

Lord thy / God in vaine : for the Lord will not holde him / giltlesse yt taketh his name in vaine. / THE FOURTH COMMANUNDEMENT. / Remember that though keepe holy the sabboth / day. Six dayes shalt thou labour and doe all that / thou hast to doe but the seventh day is the sabboth / of the Lord thy God. In it thou shalt doe no / maner of worke thou and thy sonne, and thy / daughter, thy manservant and thy maydservant / thy cattell and the

straunger yt is within thy / gates : for in six dayes the Lord made heaven / and earth the sea and all that in them is and rested / the seventh day where fore the Lord blessed the / seventh day and hallowed it. / 5. Honor thy father and thy mother that thy / dayes maye be prolonged upon the land which / the Lord thy God giveth thee. / 6. Thou shalt do no murther. / 7. Thou shalt not commit adulterie / 8. Thou shalt not steale. / 9. Thou shalt not beare false witness against thy neighbour. / 10. Thou shalt not covet thy neighbours house, / thou shalt not covet thy neighbours wife, nor / his servant, nor his mayde, nor his oxe, nor is asse, nor anything yt is his.'

On the inside of the open triptych left wing: Blessed is the man that keepth the Sabbath / and polluteth it not, and keepeth hys hande / from doing any evyl. / Leviticus 19 : 30. / Yee shall keep my sabbathes and reverence my / sanctuarye. I am the Lorde. / Isaiah 58, 13, 14. / Yf thou turne away thy foote from the sabbathe, / from doing thy wyll on my holy daye, and call / the sabbathe a delighte, to consecrate it as / glorious to the Lorde, and shalt honor hym, / not doinge thine owne wayes, nor seekynge / thyne own pleasure, not speakynge a vayne / worde. Then shalt thou delight thy selfe in the / Lorde ; and I wyll cause thee to ryde upon the / hyghe places of he earthe, and feede thee with the / heritage of Jacob thy father : for the mouthe of / the Lorde hathe spoken it.

On the inside of the Open Triptych, right wing: 'Leviti. 26. 3. 12. 14, 24, Yf yee walke in Gods ordinances, and keepe / his commandimentes God will be amonge you: / he wyl be yor God and yee shal be his people: / But yf you wyll not obaye hys lawes, but despise / them breake them, and do walke stubburnelye / agaynste hym the Lorde wyll smyte you and

/ destroye you. / Revel. 22, 14. / Blessed ar thay that doe his commandimentes / that thay may have righte to the tree of lyfe and / may enter in throughe the gates into the cyttye of newe Jerusalem. / Deute. 6, vers. 6, 7, 8, 9. / And these wordes which I commaund the[e] this / day shall be in thine hart. And thou shalt / rehearse them continually unto thy children and / shalt talke of them when thou taryest in thine / house, and as thou walkest by the way, and / when thou lyest downe, and when thou risest up. / And thou shalt bind them for a signe upon thine / hand and they shal be as frontlets between / thine eyes. Also thou shalt write them upon / the postes of thine house and upon thy gates.'

Provenance: not recorded by Robert Reyce in 1616 (Cat. no. 52) but probably at the church in the late 16th century.
Parochial Church Council of the Parish Church of St. Mary's, Preston St. Mary, Suffolk.

As religious images had largely been removed from places of worship, many Elizabethan and Jacobean churches set up 'tables' with the texts of the Ten Command-ments or lines from the scriptures in their place. An order of 1560 decreed that these 'tables' were to be set up in churches to 'give some comely ornament and demonstration that the same was a place of religion and prayer' (Cautley, p. 109). As the reformed faith put renewed emphasis on the word of the gospel, the painted texts, which are also found in other parts of northern Europe, were a useful way of reiterating the word of God to the widest possible literate audience. The practice continued under James I and in 1614 the order to adorn church walls with instructive scriptural texts was confirmed and continued as a Tudor legacy for several centuries to come. TC

LITERATURE: Cautley, *Royal Arms*, pp. 110–16; Aston, *England's Iconoclasts.*

ELIZABETH'S LEGACY

MICHAEL DOBSON AND NICOLA WATSON

A COURT OF DASHING CHIVALRIC ADVENTURERS, MOST CONSPICUOUSLY the young Robert Devereux, 2nd earl of Essex, heroic leader of the naval raid on Cadiz in 1596 (Cat. no. 253); a bustling London full of aspiring love-sonneteers and brilliant playwrights, among them Christopher Marlowe and William Shakespeare; and at the centre of it all their inspiration and patroness, Elizabeth, hailed as Gloriana, Cynthia, Astraea, the Empress of Virginia, the Faerie Queene. Many of posterity's most rosy and most enduring images of Elizabeth and the Elizabethans — memorably condensed (albeit with some irony) by the film *Shakespeare in Love* (1998) — derive from the very last phase of the queen's reign, which witnessed the meteoric career of her most famous and charismatic favourite, Essex, and the composition of most of the Elizabethan literature which is still widely read. But to contemporaries the years between the defeat of the Armada in 1588 and the death of Elizabeth in March 1603 were anything but a golden age. As war with Spain dragged on and harvests failed, many feared that a second, better organised Armada might be launched at any time and, although any open discussion of the succession would have constituted treason, uncertainty as to who would succeed to the throne when the childless queen died was palpable. If these were the years in which the mythologising of Elizabeth as the divine Virgin Queen reached its apogee, it was in part because the ageing queen herself no longer quite fitted the image promulgated by the imaginative propaganda which has now outlasted her for four centuries.

THE ASSERTION THAT Elizabeth ruled as a goddess amongst men, eternally virginal and perpetually youthful, was made ever more stridently during the 1590s. An official proclamation of July 1596 ordered that any 'unseemly' portraits of the queen — those which admitted to her real age — were to be destroyed. All further likenesses had to be vetted by the Serjeant Painter, George Gower, who superintended the mass-production of paintings based on officially approved patterns for the depiction of her face (principally by Hilliard), which were completed without the painters ever seeing the queen in person. Isaac Oliver had drawn the queen from life in around 1592, when she was approaching sixty, but his realistic image (Cat. no. 259) was largely suppressed, and it became well known only after Elizabeth's death, when it was used as the basis for Crispin van der Passe's engraving.

POETRY ALSO AVOIDED looking too closely at the royal person, although in this medium the anxieties and discontents that lay behind the assertion of the queen's immortality were sometimes more audible. Edmund Spenser's epic *The Faerie Queene* (1590–96) provides a case in point. Supporting the Tudors' pretensions to be the successors to King Arthur, Spenser's poem – set in part in a mythologised Britain, in part in Fairy Land – depicts a young Prince Arthur forever questing on behalf of the Fairy Queen, Gloriana. Gloriana, we are told, represents Elizabeth in all her splendour: but she never appears in person in the poem, remaining a strictly offstage inspiration for the knights who occupy its foreground. While the whole poem is officially dedicated to the queen – 'the most High, Mighty and Magnificent Empress renowned for piety, virtue and all gracious government Elizabeth by the Grace of God Queen of England France and Ireland and of Virginia, Defender of the Faith, &c' – it also bears dedicatory sonnets to her principal courtiers, among them Sir Walter Ralegh (Cat. no. 181) and the earl of Essex. Both were by now growing frustrated with the Queen's government, particularly her policies in Ireland, of which Book V of *The Faerie Queene* is in some measure a critique. Furthermore, as well as the eulogised but largely ignored Gloriana, this poem's potential versions of Elizabeth include not only the holy Protestant maiden Una, the implacably chaste Belphoebe and the female knight-errant Britomart, but the tyrannous and finally humbled Amazon Radigund. It is striking that the Shakespeare play from Elizabeth's lifetime in which the queen is most important – *A Midsummer Night's Dream* (1595), in which she is invoked in passing as 'a fair vestal thronèd by the west' (2.1.158) – also features a tamed Amazon queen (Hippolyta, newly conquered by Theseus), along with a Fairy Queen who is given one of Elizabeth's own poetic nicknames (Titania, one title of the goddess Diana). This Fairy Queen, however, so far from being left discreetly offstage, is magically humiliated into a liaison with the ass-headed Bottom. In the 1590s, the cult of Elizabeth, though reaching its climax, was also beginning to wear thin. Indeed this play opens with Theseus's expression of impatience with the rule of the chaste moon:

> . . . but O, methinks how slow
> This old moon wanes! She lingers my desires

> Like to a stepdame or a dowager
> Long withering out a young man's revenue.
>
> (1.1.3–6)

Just such sentiments informed Essex's eventual rebellion in 1601. In 1599 Elizabeth had sent him to Ireland to cope with continuing discontent and insurgency, but he had achieved only an ignominious truce with the rebellious earl of Tyrone. He had then returned in haste without permission, bursting into the queen's private chamber at Nonsuch Palace (Cat. no. 96) in an attempt to explain himself, and had been banished from court and stripped of his offices and revenues. While writing alternately pleading and indignant letters to the queen (Cat. no. 258), Essex was already in secret and treasonous correspondence with James VI of Scotland, who had the best claim to the succession. On 8 February 1601 Essex launched his attempted coup, marching through London to gather popular support prior to seizing the queen. Whether he intended to install himself as some sort of regent for the remainder of her lifetime, or planned to send for James at once and serve as the new king's chief minister while his former mistress languished in custody, never became clear: in the event, the support on which he had counted failed to materialise. Essex was arrested, tried for high treason on 19 February (with his former ally Francis Bacon as chief prosecutor), and was executed at the Tower on 25 February.

THE EARL'S SURVIVING sympathisers now had nothing left to hope for but the queen's own death, and, tellingly, the last of her great rhetorical triumphs, achieved later in this same year, would itself exploit the pathos of her impending demise. On 30 November 1601, Elizabeth finally backed down in response to parliamentary complaints about her grants of monopolies to courtiers. However, she turned this apparently damaging concession into one of the most successful appeals for loyalty and commitment she had ever made, appending a brilliantly stage-managed, tear-jerking farewell:

> For it is not my desire to be or reign longer than
> my life and reign shall be for your good. And
> though you have had and may have many mightier
> and wiser princes sitting in this seat, yet you never

had nor shall have any that will love you better . . .
And I pray you, Mr Comptroller, that before these
gentlemen depart into their countries [i.e. con-
stituencies], you bring them all to kiss my hand.[1]

As ELIZABETH no doubt intended, these words were remem-
bered long after the occasion for this speech was forgotten:
nicknamed her 'Golden Speech', it was endlessly printed and
reprinted throughout the seventeenth century and well into the
eighteenth. The news of her death on 24 March 1603 was
greeted by some with bonfires and cries of 'We have a king!' –
since the succession of James VI of Scotland was carefully
stage managed by Robert Cecil and the privy council.
However, this relief over the peaceful passage of the throne to
a fertile Protestant male soon gave place to disappointment
and nostalgia. The new king did what he could to manage his
glorified predecessor's memory – spending something in the
region of £20,000 on Elizabeth's state funeral to assert his
status as her rightful heir, for example, while at the same time
forbidding the historian William Camden from completing his
projected hagiographic biography of her in case it should
make James I look too much like an anticlimax. But the more
reservations were felt about James's pacific policies towards
Catholic Europe, his undisguised contempt for public opinion
and his entourage of opportunistic Scottish courtiers, the
more the English began to look wistfully back towards a
legendary Elizabeth whose latter-day shortcomings were all
forgotten. 'The people were very generally weary of an old
woman's government', remembered Godfrey Goodman in the
1650s, 'but after a few years, when we had experience of the
Scottish government . . . the Queen did seem to revive; then
was her memory much magnified . . .'[2] This magnification of
her memory has continued ever since, with successive periods
investing it with different significances.

FOR MANY JACOBEANS, Elizabeth came to represent every-
thing which James, disappointingly, was not: a charismatic
exponent of public relations, and the unambiguously
Protestant survivor of Catholic oppression. In the theatres of
London, plays soon began to re-enact Elizabeth's persecution
under Bloody Mary and her subsequent triumphant accession

(most notably Thomas Heywood's much revived and reprinted
If You Know Not Me, You Know Nobody, 1605), along with her
cordial relations with the City, her providential deliverance
from Catholic assassins, and her finest hour at Tilbury
(Heywood's *If You Know Not Me, You Know Nobody, The Second
Part*, 1606, and Thomas Dekker's *The Whore of Babylon*, 1607). In
political controversy no less than in popular entertainment,
Elizabeth's reign would long be remembered and idealised as a
time when the relations between crown, Church, parliament
and commons had been in perfect constitutional balance. Both
sides in the Civil Wars, for instance, felt that they were fight-
ing to restore this balance (the Cavaliers glorifying Elizabeth
as a defender of the royal prerogative against puritanism; the
Roundheads celebrating her as a militant Protestant who
redressed parliamentary grievances). The celebration of
Accession Day on 17 November, known as 'Queen Bess's Day',
had been revived as a popular anti-Catholic festival within a
few years of James's accession ('in effect, more solemnity and
joy in memory of her coronation than was for the coming in
of King James', according to Goodman),[3] and it remained a
major national holiday into the eighteenth century, providing
the occasion for demonstrations, bonfires and street theatre
against most of James's Stuart descendants (all of them
suspected, with some justice, of having at very least Catholic
sympathies) at one time or another.

ABOVE AND BEYOND this posthumous idealisation of
Elizabeth as a Protestant leader, her successful identification of
herself with her island realm – most memorably in her speech
at Tilbury in 1588 (Cat. no. 244) – made her a potent symbol
of national integrity and unity for generations. With the body
of a weak and feeble woman but the heart and stomach of a
king, as she put it, Elizabeth could embody both the nation
(traditionally gendered female) and the crown (whose authorit
was conventionally likened to that of a husband over a wif
it is not therefore surprising that her successor as qu
regnant, Queen Anne, deliberately imitated some
Elizabeth's robes for her own coronation and adopte
personal motto (*Semper Eadem*), or that Anne's most loy
Sir Richard Blackmore, should have dedicated an epic
Anne called *Eliza* (1705), in which Elizabeth's victor
Armada prefigures Anne's recent victories in th

Spanish Succession. It is in the defiantly insular posture of 1588 that Elizabeth was appropriately enshrined in the Temple of British Worthies in the 1730s, part of Viscount Cobham's elaborately allegorical landscape gardens at Stowe: her bust wears the ruff of a weak and feeble woman but the breastplate of a king, and a king of England too.

SUCH REPRESENTATIONS of Elizabeth at Tilbury have been mobilised during most real and perceived national crises ever since, whether the invasion scares of the Napoleonic wars or those of the twentieth century. Flora Robson gave a rousing rendition of the speech in the film version of A.E.W. Mason's *Fire Over England* in 1937, for example, a film which was subsequently released in the United States in 1941 in a bid to drum up support for invasion-threatened Britain's war effort against Nazi Germany. A nostalgic re-enactment of the speech, performed by Elizabeth among her chief naval officers as they reminisce about the Armada a few years later, supplies one of the climaxes of Caryl Brahms and S.J. Simon's novel *No Bed For Bacon* (1941), written during the Blitz itself. The deep and enduring cultural memory of 1588 has kept Elizabeth a major national heroine for four centuries, even if by the mid-twentieth century she was already liable to be burlesqued as such. Even *No Bed for Bacon* is in part parodic (a precursor of *Blackadder II* no less than of *Shakespeare in Love*); as such it was a worthy successor both to Sellar and Yeatman's *1066 And All That* (1930) and to E.F. Benson's novel *Mapp and Lucia* (1931). In Benson's classic comedy of manners the Tilbury speech, performed by the provincial arch-snob Lucia, forms the climax to a dire village pageant in which Lucia also performs the knighting of Drake – here played by her outrageously camp admirer, Georgie.[4]

THE SCENE OF ELIZABETH knighting Drake, affectionately parodied by Benson, was in essence a distinctively Victorian contribution to the mythos of Elizabeth. It crystallised in miniature a number of important Victorian notions of the relations between men and women, and between nation and men. On the one hand, it served as a chivalric fantasy: the queen, like all proper women, stayed behind to mind the hearth, home and nation, while her men forayed out in search of adventure and brought back the spoils to her. She, in turn, as embodiment of nation and incarnation of the English

spirit, gave meaning and purpose to this exercise of manliness. Moreover, Drake's career as a Devon man made good spoke immediately to Victorian ideas of meritocracy and self-making, which were particularly bound up with the business of sending young men out into the wide world to make their fortunes and paint the map of the world red. Drake and his fellow sea dogs were seen as exemplary empire builders, pushers back of the frontiers, and were variously celebrated by the Victorians in the foundation of the Hakluyt Society in 1846, and in J.A. Froude's enormous twelve-volume *History of England from the Fall of Wolsey to the Death of Elizabeth* (1856–70) which itself served as the source for Charles Kingsley's wildly successful romance, *Westward Ho!* (1855). Kingsley's novel founded a long line of Elizabethan adventure stories for boys, designed to promote healthy masculinity and muscular patriotism, still earnestly being recommended as reading for the school half-holiday held on Empire Day in the first third of the twentieth century. Such swashbuckling historical fictions served, too, as part of the source-material for the pageants of which the early twentieth century was so fond, which usually managed to contrive, as Benson's *Mapp and Lucia* suggests, the appearance of Drake and Elizabeth one way or the other. A spectacular and officially sanctioned example was even mounted on the site of Elizabeth's birth, at the Royal Naval College, Greenwich, in 1933.[5] Although, as Virginia Woolf's darkly comic rendition of just such a pageant of English history in *Between the Acts* (1941) suggests, this optimistic vision of the empire on the up and up would look threadbare during the wars, it did enjoy a very brief last flowering on the accession of Elizabeth II, in the vision of New Elizabethanism. England, resurgent victor from the ashes of world conflict, would be a world leader once again, as she had been in the time of the first Elizabeth. This brief nostalgic optimism was summed up by the ever-sceptical and disaffected Nigel Molesworth in his remarks on 'How to be a Young Elizabethan' (1956): '. . . we are young elizabethans and it can't be altered – i expect drake felt the same way . . . Fie fie – the grown-ups canot kno what a privilege it is to be YOUTH in this splendid age of Queen Bess – when all are brave proud fearless etc and looking with clear eyes at the future . . .'.[6] Since then, the whole celebration of sea-dog heroism has been unmercifully sent up in Richard Curtis and Ben Elton's scripts for *Blackadder II* (BBC2, 1985).

John Hassall's final illustration to Brenda Girvin's *Good Queen Bess, 1533–1603* (1907). Bodleian Library.

IF THE SCENE OF ELIZABETH knighting Drake none the less remains one part of 'all the history you can remember' (to borrow the immortal subtitle to *1066 And All That*), that of Ralegh flinging off his cloak to lay it over a puddle for the queen to step over dry-shod is just such another. For the Victorians, it summed up their idea of the Elizabethan period as one of chivalry. That vignette, of course, is flanked by the other of Ralegh casually presenting the queen with a

potato, fruit of his successful exploration of the Americas and foundation of Virginia. Here again, Elizabeth appears as sponsor of Ralegh's empire-building manliness, and the notion informs a number of important civic representations of Ralegh as empire builder, such as the vast inspirational mural that adorns the corridors of Westminster Palace, A. K. Lawrence's *Queen Elizabeth the Faerie Queene of her Knights and Merchant Venturers commissions Sir Walter Raleigh to sail for America and discover new*

countries (1927). It is this version of Elizabeth and Elizabethanism that animated twentieth-century American collective self-identifications as the last true Elizabethans, prompting, for example, the setting up of the Yale Elizabethan Club in 1911: this idea still drives the longest running show in American stage history, *The Lost Colony*, performed every summer since the 1920s at Roanoke in North Carolina.

FLANKED BY DRAKE and Ralegh in this way, Elizabeth appeared throughout the nineteenth and well into the twentieth century as an appropriately feminine sponsor of national and imperial manliness. But the queen had long before been provided with an interesting and eventful private life, which since the eighteenth century has been an even more prominent mainstay of popular representations of her. In 1680 a little book appeared entitled *The Secret History of Q. Elizabeth and the E. of Essex*, translated from the French, and it inaugurated an enduring tradition of writing about the queen's love life. Restoration and eighteenth-century culture found it hard to imagine a virgin queen as adequately womanly: by contrast Elizabeth's great political rival, Mary, Queen of Scots, seemed perfectly feminine. Eternally young and attractive, fatally susceptible sexually, suitably victimised by official history, the Queen of Scots cast Elizabeth into a poor light whenever they enjoyed a (fictitious) confrontation, as they do most influentially in Friedrich Schiller's important play *Mary Stuart* (1800), the source text for Donizetti's opera *Maria Stuarda* (1833). English writers accordingly evolved ways of retrospectively making Elizabeth more womanly and they did this by playing up her loves, most especially by dramatising her well-documented, if ambiguous, relations with the earls of Essex and Leicester. They evolved a fiction which tended to depict Elizabeth as torn between private passion and the needs of the state – forced by political considerations to renounce or even execute the secret love of her life – which has informed many of the most important depictions of the private woman ever since: these include, for example, Sir Walter Scott's historical novel *Kenilworth* (1821), the film *The Private Lives of Elizabeth and Essex* (1939) starring Bette Davis, the relevant episodes of BBC2's *Elizabeth R* (1971) starring Glenda Jackson, and, most recently, Shekhar Kapur's blockbuster *Elizabeth* (1998), starring Cate Blanchett.

IF THE POLITICS of the marriage negotiations, and the problems of balancing court factions by judiciously rationed favouritism, were thus converted into feminine susceptibility reined in by the stern demands of duty, the iconography of dress and portraiture also underwent a sea-change. By the nineteenth century, the clothes depicted in Elizabeth's official portraits no longer appeared as elaborate allegorical representations of herself as the embodiment of the state but spoke merely of gross personal vanity. Nineteenth-century culture became obsessed with a desire to see below the clothes, to strip off the wigs, the face paint, the jewels, the ruff and the farthingale, and expose the 'real' woman below. One of the most striking traditions that emerges as a result is the importance of scenes of dressing and undressing of the queen in her private rooms, which can be sympathetic or hostile. Very broadly, the queen undressed before her mirror may turn out to be hideously old, suggesting that her glamorous power is a willed fraud: the most powerful scene in Benjamin Britten's opera *Gloriana* (1953), for example, latest of a line of dramatisations of Essex's irruption into Elizabeth's chamber on his return from Ireland, pulls off this theatrical effect. Alternatively, the queen undressed may turn out to be attractively nubile, as in Kapur's *Elizabeth*; that is, until she renounces womanhood, shears her hair and at the climax of the film sheaths herself in the impregnable iconography of historical power. In such descendants from sentimental fiction, at least, full womanhood and successful queenship are usually incompatible.

IT IS THE CONFLUENCE of these different ways of representing Elizabeth that has ensured her continued liveliness in the popular imagination on both sides of the Atlantic. This is because, evolved as they were at different periods since her death to meet very diverse cultural and political needs, they are very often mutually contradictory. The triumphant armed heroine of the Armada sits uneasily with Bloody Mary's helpless prisoner of conscience; and she does not sit too easily, either, with the young woman in love with Leicester or the doting old one heartbroken over Essex. The inspiration for manly chivalry who was still visible in recent memory on the covers of children's books such as *Sir Walter Raleigh, An Adventure from History* (1957) is not, surely, the same woman who,

depending on which historians one trusts, oscillates between being politically 'savvy' and hopelessly indecisive. The 'New Elizabethan' version of Elizabeth as lovelorn teenaged sweetheart of Admiral Seymour, played by Jean Simmons in the 1953 film *Young Bess*, is just as hard to reconcile with the old and unfeminine Elizabeth played by Quentin Crisp in Sally Potter's 1992 film version of Virginia Woolf's *Orlando*. The combination produces Elizabeth as a fascinating celebrity, more than the sum of all the stories told about her, enigmatic because composed of and yet exceeding gossip and epic, drama and opera, history and historical novel, Westminster mural and television parody. Just as in the 1590s, the myth of Elizabeth, the once and future Faerie Queene, divine personification of her realm, remains fascinatingly and beguilingly larger than the historical figure.

FOOTNOTES AND FURTHER READING

THE CITY OF LONDON: COURT AND TRADE

Pages 33–40

1. *Holinshed's Chronicles of England, Scotland, and Ireland* (6 vols, 1807–9), IV, pp. 171–2.
2. Burgon, J.W., *The Life and Times of Sir Thomas Gresham* (2 vols, 1839), II, p. 217.
3. Ibid, I, p. 221.
4. *Holinshed's Chronicles*, IV, p. 900.
5. Burgon, II, pp. 12, 148, 243.
6. Tawney, R.H., and Power, E., (eds), *Tudor Economic Documents* (3 vols, 1924), II, p. 45.
7. Helgerson, R., *Forms of Nationhood: The Elizabethan Writing of England* (1992), p. 179.

Adams, S., *Household Accounts and Disbursement Books of Robert Dudley, Earl of Leicester, 1558–1561, 1584–1586* (Camden Society, fifth series, VI, Cambridge, 1995)

Andrews, K.R., *Trade, Plunder and Settlement: Maritime Enterprise and the Genesis of the British Empire, 1480–1630* (Cambridge, 1984)

Archer, I.W., *The Pursuit of Stability: Social Relations in Elizabethan London* (Cambridge, 1991)

Beier, A.L., and Finlay, R. (eds), *London, 1500–1700: The Making of the Metropolis* (London, 1986)

Brenner, R., *Merchants and Revolution: Commercial Change, Political Conflict, and London's Overseas Traders, 1550–1653* (Cambridge, 1993)

Brigden, S., *London and the Reformation* (Oxford, 1989)

Burgon, J.W., *The Life and Times of Sir Thomas Gresham* (2 vols, London, 1839)

Challis, C., *The Tudor Coinage* (Manchester, 1978)

Clark, P., *The Cambridge Urban History of Great Britain*. Vol. II, *1540–1840* (Cambridge, 2000)

Clay, C., *Economic Expansion and Social Change: England, 1500–1700* (2 vols, Cambridge, 1984)

Fisher, F.J., *London and the English Economy 1500–1700* (London, 1990)

Griffiths, P., and Jenner, M. (eds), *Londinopolis: Essays in the Social and Cultural History of Early Modern London* (Manchester, 2000)

McDermott, J., *Martin Frobisher, Elizabethan Privateer* (London, 2001)

Orlin, L.C. (ed.), *Material London* (Philadelphia, 2000)

Palliser, D.M., *The Age of Elizabeth: England Under the Later Tudors, 1547–1603* (London, 1983)

Ramsay, G.D., *The City of London in International Politics at the Accession of Elizabeth Tudor* (Manchester, 1975)

Ramsay, G.D., *The Queen's Merchants and the Revolt of the Netherlands* (Manchester, 1986)

Rappaport, S., *Worlds Within Worlds: The Structures of Life in Sixteenth-Century London* (Cambridge, 1989)

Saunders, A. (ed.), *The Royal Exchange* (London Topographical Society, 1997)

Smith, D., Strier, R., and Bevington, D. (eds), *The Theatrical City: Culture, Theatre and Politics, 1576–1649* (Cambridge, 1995)

Stow, J., *A Survey of London*, ed. Kingsford, C.L. (2 vols, Oxford, 1908)

Van der Stock, J., *Antwerp: Story of a Metropolis 16th–17th Century* (Antwerp, 1993)

Willan, T.S., *Studies in Elizabethan Foreign Trade* (Manchester, 1959)

THE QUEEN'S SUITORS AND THE PROBLEM OF THE SUCCESSION

Pages 65–71

1. Levine, M., *Dynastic Problems*, p. 177.
2. Ibid., pp. 177–8.
3. Bassnett, S., *Elizabeth*, pp. 40–41; Haigh, *Elizabeth* (1988), pp. 13–16.
4. Plowden, A., *Marriage* (1977), p. 160.
5. Doran, S., *Monarchy and Matrimony*, pp. 43–4; George Bernard, in G.W. Bernard (ed.), *Power and Politics in Tudor England* (Aldershot, 2000).
6. Doran, S., *Monarchy and Matrimony*, p. 164.
7. Clapham, *Observations*, pp. 98–9.
8. National Library of Scotland 2970.

Adams, S., 'Queen Elizabeth's Eyes at Court: The Earl of Leicester', in *Leicester and the Court: Essays on Elizabethan Politics* (Manchester, 2002)

Alford, S., *The Early Elizabethan Polity: William Cecil and the British Succession Crisis, 1558–1569* (Cambridge, 1998)

Axton, M., *The Queen's Two Bodies* (London, 1977)

Clapham, J., *Elizabeth of England: Certain Observations Concerning the Life and Reign of Queen Elizabeth*, eds. Evelyn Plummer Read and Conyers Read, (Philadelphia, 1951)

Doran, S., *Monarchy and Matrimony: The Courtships of Elizabeth I* (London, 1996)

Levine, M., *The Early Elizabethan Succession Question, 1558–1568* (Stamford, Calif., 1966)

—, *Tudor Dynastic Problems, 1460–1571* (London, 1973)

ENTERTAINMENTS AT COURT

Pages 73–80

1. Levin, C., *The Heart and Stomach of a King*, pp. 22–6.
2. 'The Queen at Greenwich, 1559', in Nichols, J. (ed.), *Progresses and Processions*, i, pp. 1559–73.
3. 'The Four Foster Children of Desire', in Wilson, J. (ed.), *Entertainments for Elizabeth* (Totowa, NJ: Rowman and Littlefield, 1980), pp. 61–85.
4. Strong, R., *The Cult of Elizabeth*, pp. 129–63.
5. Segar, W., *Honor, Military, and Civill* (London: Robert Barker, 1602), pp. 197–200.
6. Cole, M. Hill, *The Portable Queen* (1999).
7. Queen Elizabeth, from Pierpont Moran Library, PML 7768, first flyleaf, recto. Reproduced in May, S.W., *The Elizabethan Courtier Poets: The Poems and Their Contexts* (Columbia, Mo.: University of Missouri Press), p. 342.
8. Anne Bradstreet, 'In honour of that High and Mighty Princess, Queen Elizabeth', in *The Tenth Muse* (London: Stephen Bowtell, 1650), p. 200.

IMPERIAL AMBITION AND ELIZABETH'S ADVENTURERS

Pages 121–131

1. Fenton, E. (ed.), *The Diaries of John Dee*, p. 3.
2. Sherman, W.H., *John Dee*, pp. 182–3.
3. Hakluyt, *Principal Navigations, Voiages and Discoveries of the English Nation* (1589).
4. Ibid., pp. 615–22.
5. Kenyon, *Tokens of Possession*, p. 121.
6. Hampden, J. (ed.), *Francis Drake, Privateer*, pp. 110–18, for a reconstructed transcript of the damaged manuscript (BL Cotton MS, Otho E. VIII, fols 8–9).
7. Ibid., p. 237.
8. Kelsey, *Sir Francis Drake*, p. 82.
9. Nuttall, *New Light on Drake*, pp. 100–103.
10. Ibid., pp. 317–18.
11. Ibid., pp. 403–4.
12. Ibid., p. 404.
13. Quinn, D.B. (ed.), *Roanoke Voyages*, II, pp. 266–7.
14. See the inscription on *Map of Ulster and the North Channel showing Sir John Courcie's expedition to capture Ulster*, c. 1580s; National Maritime Museum P49/25.
15. Quinn, D.B. (ed.), *Roanoke Voyages*, I, pp. 118–19.
16. Ibid., I, pp. 118–89.
17. See Fuller, M.C., *Voyages in Print* (Churchyard, Thomas, *A discourse of the Queenes Maiesties entertainment in Suffolk and Norfolk; Whereunto is adioyned a commendation of Sir Humfrey Gilberts ventrous iourney*, London, 1578).
18. Richard Hakluyt the Younger, *Discourse of Western Planting* (reprinted in Quinn, D.B., *New American World*, III, pp. 70–123).
19. Coote, *A Play of Passion: The Life of Sir Walter Ralegh* (1993), p. 173.
20. Ralph Lane's narrative of the Roanoke Island Colony printed in Hakluyt, *Principal navigations* (1589); (Quinn, D.B., *New American World*, III, pp. 295–306).
21. See Fuller, M.C., *Voyages, Raleigh and Roanoke: The First English Colony in America*, March 8–June 6 1985; catalogue of the British Library Exhibition hosted by the North Carolina Museum of History: text Helen Wallis, 65.
22. Harriot, *A briefe and true report of the new found land of Virginia*, 1588 (reprinted in Quinn, D.B., *New American World*, III, pp. 139–55).

THE QUEEN'S VISUAL PRESENCE

Pages 175–181

1. Royal arms had first been set under Henry VIII and Edward VI. They were removed under Mary I and re-established by Elizabeth as part of her revival of English Protestant practice in the early years of her reign.
2. See Frye, S., *Elizabeth I*, and Doran, S., 'Virginity'.
3. Auerbach, E., *Tudor Artists*, p. 107.
4. Giovanni Paolo Lomazzo, *A Tracte containing the Artes of curious Paintinge, Caruinge & Buildinge* (an. Trattato dell' arte della pittura, scoltura ed architettura), incomplete translation by Richard Haydocke (Oxford: Joseph Barnes, 1598), sig. iiiiv.
5. For further discussion see Gent, L., *Picture and Poetry*.
6. Hilliard, N., *The Arte of Limning*, ed R.K.R. Thornton and T.G.S. Cain (Manchester: Carcanet Press, 1992), p. 67.
7. Hughes, P.L., and Larkin, J.F. (eds), *Tudor Royal Proclamations*, Vol. 1 and Vol. II: *The Early Tudors*, pp. 240–41.
8. Foister, S., 'Paintings and Other Works of Art in Sixteenth-Century English Inventories', *Burlington Magazine*, 123 (1981), 273–82, especially p. 277.
9. The sixteen-line text accompanying the portrait praises her virtues and God-given protection of England. For a discussion of popular prints see Watt, T., *Cheap Print*.
10. Doran, S., 'Virginity'.
11. Rye, *England as seen by Foreigners in the days of Elizabeth and James the first comprising translation of the journals of the two Dukes of Wirtemberg in 1592 and 1610* (London: John Russell Smith, 1865), pp. 104–5.
12. See discussion on Giordan Bruno's *La Cena de Le Ceneri*, 1584, and Walter Ralegh's *The Book of the Ocean to Cynthia* in Strong, *Gloriana*, pp. 125–6.
13. McCracken, G., 'Dress', pp. 515–33, especially p. 277.

Coombs, K., *The Portrait Miniature in England* (London, 1998)
Doran, S., 'Virginity, Divinity and Power: The Portraits of Elizabeth I', in Susan Doran and Thomas S. Freeman (eds), *The Myth of Elizabeth I* (Basingstoke, 2003)
Frye, S., *Elizabeth I: The Competition for Representation* (Oxford, 1993)
Strong, R., *The Cult of Elizabeth: Elizabethan Portraiture and Pageantry* (London, 1977)
—, *Gloriana: The Portraits of Queen Elizabeth I* (London, 1987)

ELIZABETH'S JEWELLERY

Pages 183–188

1. BL Royal MSS Appx 68.
2. National Library of Scotland, Add. MS 31, I, IV; Scarisbrick, D. (ed.), 'Anne of Denmark's Inventory', *Archaeologia*, 109 (1991), pp. 193–237.
3. Payne Knight, R., *Catalogue of Gems* (1824), no. 30, Department of Greek and Roman Antiquities, British Museum; Dalton, O.M., *Catalogue of the Engraved Gems of the Post Classical Period in the British Museum* (1915), no. 73.
4. Labanoff, A., (ed.), *Lettres, Instructions et Memoires de Marie Stuart, Reine d'Ecosse* (1844), vii, pp. 132–3.
5. *CSP Span. Elizabeth 1580–1586*, no. 279 .
6. Somers Cocks, A., (ed.), *Princely Magnificence* (London, 1980), p. 40.
7. Whitney, G., *A Choice of Emblemes* (1586), p. 87.
8. Valerio Bolzano, G.P., *Hieroglyphicam Sive de Sacris Aegyptiorum aliarumque gentium literis commentarium libri LVIII* (1614), p. 569.
9. Whitney, G., *A Choice of Emblemes*, p. 168.
10. Jenkins, E., *Elizabeth and Leicester* (1972), p. 200.
11. Whitney, G., *A Choice of Emblemes*, p. 66.

Arnold, J., *Queen Elizabeth's Wardrobe Unlock'd* (Leeds, 1988)
Scarisbrick, D., *Jewels in Britain 1066–1837* (London, 1994)

THE CATHOLIC THREAT TO ELIZABETH

Pages 207–213

Bossy, J., *Under the Molehill: An Elizabethan Spy Story* (New Haven, 2001)

Edwards, F., s j, *Robert Parsons: The Biography of an Elizabethan Jesuit 1546–1610* (St Louis, 1995)

—, *Plots and Plotters in the Reign of Elizabeth I* (Dublin, 2002)

McCoog, T.M., s j, *The Society of Jesus in Ireland, Scotland, and England 1541–1588: 'Our Way of Proceeding'?* (Leiden, 1996)

— (ed.), *The Reckoned Expense: Edmund Campion and the Early English Jesuits* (Woodbridge, 1996)

Morey, A., *The Catholic Subjects of Elizabeth I* (London, 1978)

Pritchard, A., *Catholic Loyalism in Elizabethan England* (London, 1979)

Walsham, A., *Church Papists: Catholicism, Conformity, and Confessional Polemic in Early Modern England* (London, 1993)

ELIZABETH'S LEGACY

Pages 255–261

1. Marcus, Mueller and Rose (eds), *Elizabeth I*, p. 342.

2. Goodman, G., *The Court of King James the First*, ed. John S. Brewer (2 vols, London, 1839), I, pp. 97–8.

3. Ibid., p. 98.

4. The most important precedent for burlesque renderings of 1588 was, of course, Mr Puff's ludicrous patriotic 'play-within-the-play' of 'The Spanish Armada', in Sheridan's *The Critic; or A Tragedy Rehearsed* (1779).

5. This – 'as close as England came to fascist theatre at this age' – was scripted by Sir Arthur Bryant. Its progenitor, the College President Admiral Barry Domvile, was later interned as a wartime fascist sympathiser. Kevin Littlewood and Beverley Butler, *Of Ships and Stars: Maritime Heritage and the founding of the National Maritime Museum, Greenwich* (London, 1998) p. 61.

6. Willans, G., and Searle, R., *Whizz for Attomms* (1956) in *Molesworth* (Harmondsworth, 1999), p. 214.

Dobson, M., and Watson, N., *England's Elizabeth: An Afterlife in Fame and Fantasy* (Oxford, 2002)

Doran, S., and Freeman, T.S., (eds), *The Myth of Elizabeth I* (Basingstoke, 2003)

Haigh, C., *Elizabeth I* (London, 1988)

Hodgdon, B., 'Romancing the Queen', in *The Shakespeare Trade: Performances and Appropriations* (Philadelphia, 1998)

Perry, M., *The Word of a Prince* (Woodbridge, 1990)

SELECT BIBLIOGRAPHY

Ackermann, Silke (ed.), *Humphrey Cole: Mint, Measurement and Maps in Elizabethan England*, British Museum Occasional Paper, no. 126 (London, 1998)

Adams, Simon, *Household Accounts and Disbursement Books of Robert Dudley, Earl of Leicester, 1558–1561, 1584–1586*, Camden Society, fifth series, VI (Cambridge, 1995)

—, *Leicester and the Court* (Manchester, 2002)

Alford, Stephen, *The Early Elizabethan Polity: William Cecil and the British Succession Crisis, 1558–1569* (Cambridge, 1998)

Alsion, M., and Susan Hillier, *New American World: A Documentary History of North America to 1612* (Basingstoke, 1979)

Andrews, K. R. (ed.), *The Last Voyage of Drake and Hawkins* (Cambridge, 1972)

—, *Trade, Plunder and Settlement: Maritime Enterprise and the Genesis of the British Empire, 1480–1630* (Cambridge, 1984)

—, N. K. Canny and P.E.H. Hair (eds), *The Westward Enterprise: English Activities in Ireland, the Atlantic, and America 1480–1650* (Liverpool, 1978)

Anglo, Sydney. 'Archives of the English Tournament: Score Cheques and Lists', *Journal of the Society of Archivists*, 2 (1962), pp. 153–62

—, *Images of Tudor Kingship* (London, 1992)

Archer, Ian W, *The Pursuit of Stability: Social Relations in Elizabethan London* (Cambridge, 1991)

Armada, 1588–1988, ed. M.J. Rodriguez-Salgado and staff of the National Maritime Museum (London, 1988)

Arnold, Janet, 'The "Coronation" Portrait of Queen Elizabeth I', *Burlington Magazine*, 120 (1978), pp. 727–41

—, *Queen Elizabeth's Wardrobe Unlock'd* (Leeds, 1988)

Aston, Margaret, 'The *Bishops' Bible* Illustrations' in Diana Wood (ed.), *The Church and the Arts*, Studies in Church History, 28 (Oxford, 1992), pp. 267–85

—, *England Iconoclasts*, vol 1, *Laws Against Images* (Oxford, 1988)

Attwood, Philip, *Italian Medals, c. 1530–1600, in British Public Collections* (London 2002)

Auerbach, Erna, *Tudor Artists: A Study of Painters in the Royal Service and Portraiture on Illuminated Documents from the Accession of Henry VIII to the Death of Elizabeth I* (London, 1954)

—, *Nicholas Hilliard* (London, 1961)

Baart, J. M. et al., *Opgranvingen in Amsterdam* (Amsterdam, 1977)

Barclay, C., and G. L. Syson, 'A Medal Die Rediscovered: A New Work by Nicholas Hilliard', *The Medal*, 22 (1993) pp. 3–11.

Bassnett, Susan, *Elizabeth I: A Feminist Perspective* (London, 1988)

Bateson, J.D., *Coinage in Scotland* (London, 1997)

Bath, Michael, John Manning and Alan R. Young (eds), *The Art of the Emblem: Essays in Honour of Karl Josef Hoeltgen* (New York, 1993)

Beer, Arthur, 'Astronomical Dating of Works of Art', *Vistas in Astronomy*, 9 (1967), pp. 177–224

Beier, A.L., and R. Finlay (eds), *London, 1500–1700: The Making of the Metropolis* (London, 1986)

Belsey, Andrew, and Catherine Belsey, 'Icons of Divinity: Portraits of Elizabeth I', in Lucy Gent and Nigel Llewellyn (eds), *Renaissance Bodies: The Human Figure in English Culture, c. 1540–1660* (London, 1990)

Berry, Philippa, *Of Chastity and Power: Elizabethan Literature and the Unmarried Queen* (London, 1989)

Biddle, Martin, 'The Stuccoes of Nonsuch', *Burlington Magazine* (July, 1984), pp. 411–16

Bindoff, S. T., *The Fame of Sir Thomas Gresham* (London, 1973)

Birch, W. de G., *Catalogue of Seals in the Department of Manuscripts in the British Museum*, I (London, 1887)

Blair, C, 'Greenwich Armour', *Transactions of the Greenwich and Lewisham Antiquarian Society*, 10.1 (1985), pp. 6–11

—, 'The Inventory of Henry Keene, Armourer of London, 1665', *Journal of the Arms and Armour Society*, 15.4 (1996), pp. 238–51

Blakeley, E., 'Tournament Garniture of Robert Dudley, Earl of Leicester', *Royal Armouries Yearbook*, 2 (1997), pp. 55–63

Blakiston, N., 'Nicholas Hilliard and Queen Elizabeth's Third Great Seal', *Burlington Magazine*, 90 (1948), pp. 101–7.

Boucher, François. *A History of Costume in the West* (London, 1967)

Brenner, R., *Merchants and Revolution: Commercial Change, Political Conflict, and London's Overseas Traders, 1550–1653* (Cambridge, 1993)

Brigden, Susan, *London and the Reformation* (Oxford, 1989)

Brooks, Eric St. John, *Sir Christopher Hatton* (London, 1946)

Brown, I.D. and C.H. Comber, 'Portrait Punches used on the Hammered Coinage of Queen Elizabeth I', *British Numismatic Journal*, 58 (1988), pp. 91–101.

Burgon, J. W. *The Life and Times of Sir Thomas Gresham*, 2 vols (London, 1839)

Burns, E., *The Coinage of Scotland*, 2 vols (Edinburgh, 1887)

Cautley, Munro, *Royal Arms and Commandments* (Ipswich 1934)

Challis, C.E., 'Mint Officials and Moneyers of the Tudor Period', *British Numismatic Journal*, 45 (1975), pp. 51–76.

—, *The Tudor Coinage* (Manchester, 1978)

Chambers, E.K., *Sir Henry Lee* (Oxford, 1936)

Charleston, R.J., *English Glass* (London, 1984)

Clancy, s.j., Thomas H., 'English Catholics and the Papal Deposing Power, 1570–1640', *Recusant History*, 6 (1961–2), pp. 114–40, 205–27; 7 (1963–4), pp. 2–10

Clark, Peter, *The Cambridge Urban History of Great Britain*, vol. II (Cambridge, 2000)

Clay, C., *Economic Expansion and Social Change: England, 1500–1700*, 2 vols (Cambridge, 1984)

Clifton, Gloria, 'Globe Making in the British Isles', in Elly Dekker (ed.), *Globes at Greenwich* (Oxford, 1999), pp. 46–7

Cole, Mary Hill, *The Portable Queen: Elizabeth I and the Politics of Ceremony* (Amherst, Mass., 1999)

Collinson, Patrick, *Archbishop Grindal, 1519–1583: The Struggle for a Reformed Church* (Berkeley, Ca., 1979)

—, 'Sir Nicholas Bacon and the "Via Media"', in *Godly Rule: Essays on English Protestantism and Puritanism* (London, 1983)

—, *Elizabethan Essays* (London, 1994)

Colvin, H., *The History of the King's Works*, vol. 4, *1485–1660* (London, 1982)

Connor, R.D., *The Weights and Measures of England* (London, 1987)

Cook, B.J., 'Showpieces: The Medallic Coin in Early Modern Europe', *The Medal*, 26, 1995, pp. 3–25

Coombs, Katherine, *The Portrait Miniature in England* (London, 1998)

Cooper, Tarnya, 'Portraiture and the Rhetoric of Hope in Sixteenth Century England', On-line journal *Sharp*, vol. 1 (www.sussex/ac.uk/Units/arthist/sharp/contents.shtml)

—, 'Memento Mori Portraiture, Painting, Protestant Culture and the Patronage of Middle Elites in England and Wales 1540–1630', Ph.D. thesis, University of Sussex (2001)

Crankshaw, David J., 'Preparations for the Canterbury Provincial Convocation of 1562–63: A Question of Attribution', in Susan Wabuda and Caroline Litzenberger (eds), *Belief and Practice in Reformation England: A Tribute to Patrick Collinson from his Students* (Aldershot, 1998), pp. 60–93

Crinò, Anna Maria, and Helen Wallis, 'New Researches on the Molyneux Globes', *Der Globusfruend* (1987), 35, pp. 1–18

Croft, Pauline, 'Robert Cecil and the Early Jacobean Court', in L. Peck (ed.), *The Mental World of the Jacobean Court* (Cambridge, 1991)

Cust, Lionel, 'The Lumley Inventories', *Walpole Society*, 6 (1917–18) pp. 15–35

Dalgleish, G., *The Art of Jewellery in Scotland* (Edinburgh, 1991)

Dalton, Karen C.C., 'Art for the Sake of Dynasty', in Peter Erickson and Clark Hulse (eds), *Early Modern Visual Culture: Representation, Race and Empire in Renaissance England* (Pa., 2000), pp. 180–214

Dekker, E., in *Globes at Greenwich. A Catalogue of the Globes and Armillary Spheres in the National Maritime Museum, Greenwich*, ed. K. Lippincott, P. van der Merwe and M. Blyzinsky (Oxford, 1999)

Delmonte, A., *Le Benelux d'Argent* (Amsterdam, 1967)

Dixon, Annette (ed.), *Women Who Ruled: Queens, Goddesses, Amazons in Renaissance and Baroque Art* (London and Ann Arbor, Mich. 2002)

Dixon, P. 'Greenwich Palace Excavations 1970', *London Archaeologist*, 1, no. 10 (1971), pp. 219–22

—, *Excavations at Greenwich Palace 1970–1971. An Interim Report*, Greenwich and Lewisham Antiquarian Society (London, 1972)

Dobson, Michael, and Nicola Watson, *England's Elizabeth: An Afterlife in Fame and Fantasy* (Oxford, 2002)

Donaldson, Gordon (ed.), *The Memoirs of Sir James Melville of Halhill* (London, 1969)

Doran, Susan, *Monarchy and Matrimony: The Courtships of Elizabeth I* (London, 1996)

—, *Elizabeth I and Foreign Policy 1558–1603* (London, 2000)

—, 'Elizabeth I and Religion: The Evidence of her Letters', *Journal of Ecclesiastical History*, 51 (2000), pp. 699–720

—, 'Revenge her Foul and Most Unnatural Murder? The Impact of Mary Stewart's Execution on Anglo-Scottish Relations', *History*, 85 (2000), pp. 591–612

—, 'Virginity, Divinity and Power: The Portraits of Elizabeth I', in Susan Doran and Thomas S. Freeman (eds), *The Myth of Elizabeth I* (Basingstoke, 2003)

Edmond, Mary, 'Limners and Picture-makers', *Walpole Society*, 47 (1978–80), pp. 134–150

—, *Hilliard and Oliver: The Lives and Works of Two Great Miniaturists* (London 1983)

Farquhar, H., 'Portraiture of our Tudor Monarchs on their Coins and Medals', *British Numismatic Journal*, 4 (1907), pp. 79–145.

—, 'Nicholas Hilliard, "Embosser of Medals in Gold"', *Numismatic Chronicle*, 4th series, 8 (1908), pp. 324–56

Fenton, Edward (ed.), *The Diaries of John Dee* (Charlbury, 1998)

ffoulkes, C., *The Armourer and his Craft from the XIth to the XVIth Century*, (London, 1912)

—, *Inventory and Survey of the Armouries of the Tower of London*, vol. I, (London, 1916)

Fisher, F. J., *London and the English Economy 1500–1700* (London, 1990)

Fletcher, John, 'The Date of the Portrait of Elizabeth I in her Coronation Robes', *Burlington Magazine*, 120 (1978), p. 753

Ford, Boris (ed.), *The Cambridge Guide to the Visual Arts in Britain*, vol. 3, *Renaissance and Reformation* (London, 1988)

Forsyth, H.R., *Toys, Trifles and Trinkets: Base Metal Miniatures from London c.1150–c.1800* (forthcoming, 2003)

Forsyth, Hazel, 'The Cheapside Hoard', *Goldsmiths' Review* (2001/2), pp. 14–17

Freeman, Rosemary, *English Emblem Books* (London, 1948)

Freeman, Thomas S., '"As true a subiect being prysoner": John Foxe's Notes on the Imprisonment of Princess Elizabeth, 1554–5', *English Historical Review*, 117 (2002), pp. 104–16

French, Peter J., *John Dee: The World of an Elizabethan Magus* (Dorset, 1972)

Frye, Susan, 'The Myth of Elizabeth at Tilbury', *Sixteenth Century Journal*, 23 (1992), pp. 95–114

—, *Elizabeth I: The Competition for Representation* (Oxford, 1993)

Fuller, Mary C., *Voyages in Print: English Travel to America 1576–1624* (Cambridge, 1995)

Gabb, G.H., 'The Astrological Astrolabe of Queen Elizabeth', *Archaeologia*, 86, (1937), pp. 101–3

Gaimster, David, 'London's Tudor Palaces Revisited', *London Archaeologist*, 8, no. 5 (1997), pp. 122–6

Gaimster, David, and Paul Stamper (eds), *The Age of Transition: The Archaeology of English Culture 1400–1600* (Oxford, 1997)

Gamber, O., 'Armour Made in the Royal Workshops at Greenwich: Style and Construction', *Scottish Art Review*, 12.2 (1969), pp. 1–13, 30

Gent, Lucy, *Picture and Poetry 1560–1620: Relations between English Literature and the Visual Arts* (Leamington Spa, 1981)

Gere, John A., and Philip Pouncey with Rosalind Wood, *Italian Drawings in the Department of Prints and Drawings in the British Museum, Artists Working in Rome, c.1550–c.1660*, vol. 1 (1983)

Glanville, Philippa, *Silver in Tudor and Early Stuart England* (London, 1990)

Goulding, Richard W., 'The Welbeck Abbey Miniatures', *Walpole Society*, vol. 4 (1914–16), pp. 1–224

Graves, Michael A.R., *William Cecil, Lord Burghley* (Harlow, 1998)

Griffiths, P., and P. Jenner (eds), *Londinopolis: Essays in the Social and Cultural History of Early Modern London* (Manchester, 2000)

Grueber, H.A. and others, *Exhibition of the Royal House of Tudor* (London, 1890)

Gunther, R. T., 'The Great Astrolabe and other Scientific Instruments of Humfrey Cole', *Archaeologia*, 76 (1927), pp. 273–317

Guy, John (ed.), *The Reign of Elizabeth I: Court and Culture in the Last Decade* (Cambridge, 1995)

Hackett, Helen, *Virgin Mother, Maiden Queen: Elizabeth I and the Cult of the Virgin Mary* (Basingstoke, 1994)

Haigh, Christopher (ed.), *The Reign of Elizabeth I* (Basingstoke, 1984)

——, *Elizabeth I* (London, 1988; 2nd ed. 1998)

Hammer, Paul J., 'Absolute and Sovereign Mistress of her Grace? Queen Elizabeth and her Favourites 1581–92', in J. H. Elliott and L.W.B. Brockliss (eds), *The World of the Favourite* (New Haven, Conn., and London, 1999), pp. 38–53

——, *The Polarisation of Elizabethan Politics: The Political Career of Robert Devereux, 2nd Earl of Essex, 1585–97* (Cambridge, 1999)

Hampden, John (ed). *Francis Drake Privateer: Contemporary Narratives and Documents* (London, 1972)

Hart, Avril, and Susan North, *Historical Fashion in Detail: The 17th and 18th Centuries* (London, 1998)

Hartley, T.E. (ed.), *Proceedings in the Parliaments of Elizabeth I*, 3 vols (Leicester, 1981–95)

Harvey, Anthony, and Richard Mortimer, *The Funeral Effigies of Westminster Abbey* (Woodbridge, 1994)

Haugaard, William P., *Elizabeth and the English Reformation: The Struggle for a Stable Settlement of Religion* (Cambridge, 1968)

Hawkins, Edward, Augustus W. Franks, and Herbert A. Grueber, *Medallic Illustrations of the History of Great Britain and Ireland*, 2 vols (1885; reprinted 1978), vol. 1

Haynes, Alan, *Invisible Power: The Elizabethan Secret Services 1570–1603* (Stroud, 1992)

Hearn, Karen (ed.), *Dynasties, Painting in Tudor and Jacobean England, 1530–1630* (London, 1995)

Hilliard, Nicholas, *The Treatise Concerning the Arte of Limning…*, ed. R.K.R. Thornton and T.G.S. Cain (Manchester, 1992)

Hind, Arthur M., *Engraving in England*, vols 1 and 2 (Cambridge, 1955)

Hodgdon, Barbara, 'Romancing the Queen', in *The Shakespeare Trade: Performances and Appropriations* (Philadelphia, Pa., 1998)

Hodnett, Edward, *Marcus Gheeraerts the Elder* (Utrecht, 1971)

Holloway, James (ed.), *A Companion Guide to the Scottish National Portrait Gallery* (Edinburgh, 1999)

Holmes, Peter, 'Mary Stewart in England', in Michael Lynch (ed.), *Mary Stewart, Queen in Three Kingdoms* (Oxford, 1988), pp. 195–215

Horie, Hirofumi, 'The Lutheran Influence on the Elizabethan Settlement 1558–63', *Historical Journal*, 34 (1991), pp. 519–37

Howard, Maurice, *The Tudor Image* (London, 1995)

Howarth, David, *Images of Rule* (Basingstoke, 1997)

Howse, D., and M. Sanderson, *The Sea Chart* (Newton Abbot, 1973)

Hughes Paul L., and James F. Larkin (eds), *Tudor Royal Proclamations*, 3 vols (New Haven, Conn., and London, 1964–9)

Hulton, Paul, and D.B. Quinn, *The American Drawings of John White 1577–1590 with Drawings of European and Oriental Subjects*, vols 1 and 2 (London, 1964)

Ingamells, John, *The English Episcopal Portrait* (London, 1981)

Ives, Eric, *Anne Boleyn* (Oxford, 1986)

James, Susan, *Kateryn Parr: The Making of a Queen* (London, 1999)

James, Susan E, and Jamie S. Franco, 'Susanna Horenbout, Levina Teerlinc and the Mask of Royalty', *Jaarboek koninklijk museum voor Schone kunsten Antwerp, Antwerp Royal Museum Annual* (Antwerp, 2000), pp. 91–126

Jones, Norman, *Faith by Statute: Parliament and the Settlement of Religion 1559* (London, 1982)

——, *The Birth of the Elizabethan Age England in the 1560s* (Oxford, 1993)

Judson, A. C., *Sidney's Appearance* (Bloomington, Ind., 1958)

Kagan, J., 'Portrait Cameos in the Age of the Tudors, Problems of Interpretation, Dating and Attribution', *Muzeum* 1 (1980), pp. 29–36

Kelly, J.N.D., *The Oxford Dictionary of the Popes* (Oxford, 1986)

Kelsey, Harry, *Sir Francis Drake: The Queen's Pirate* (New Haven, Conn., and London, 1998)

King, John, *Tudor Royal Iconography: Literature and Art in an Age of Religious Crisis* (Princeton, NJ, 1989)

Klein, Lisa M., 'Your Humble Handmaid: Elizabethan Gifts of Needlework', *Renaissance Quarterly*, 50 (1997), pp. 459–93

Koenraad van Cleempoel, *A Catalogue Raisonné of Scientific Instruments from the Louvain School, 1530–1600*, Turnhout 2002

Lacey, Robert, *Robert, Earl of Essex: An Elizabethan Icarus* (London, 1970)

Lemon, Robert, *Catalogue of a Collection of Printed Broadsides in the Possession of the Society of Antiquaries* (London, 1866)

Lennon, Colm, *Sixteenth-century Ireland: The Incomplete Conquest* (Dublin, 1994)

Levin, Carole, *The Heart and Stomach of a King: Elizabeth I and the Politics of Sex and Power* (Philadelphia, Pa., 1994)

——, *The Reign of Elizabeth I* (Basingstoke, 2002)

Levine, Mortimer, *Tudor Dynastic Problems 1460–1571* (London, 1973)

Liefkes, Reino (ed.), *Glass* (London, 1997)

Lippincott, Kristen, 'Power and Politics: The Use of the Globe in Renaissance Portraiture', *Globusfreund* 49/50, 2002, pp. 129–47

Loades, David, *Mary Tudor: A Life* (Oxford, 1989)

—, *The Tudor Navy: An Administrative, Political and Military History* (Aldershot, 1992)

MacCaffrey, Wallace B., *The Shaping of the Elizabethan Regime* (London, 1969)

—, *Queen Elizabeth and the Making of Policy, 1572–1588* (Princeton, NJ, 1981)

—, *Elizabeth I: War and Politics, 1588–1603* (Princeton, NJ, 1992)

MacCulloch, Diarmaid, *The Later Reformation in England 1547–1603* (Basingstoke, 1990)

MacLeod, Catherine, *Tudor and Jacobean Portraits in the National Portrait Gallery at Montacute House* (London, 1999)

Mann, J.G., *Exhibition of Armour Made in the Royal Workshops at Greenwich*, (London, 1951)

Manning, John, 'Whitney's "Choice of Emblems": A Reassessment', *Renaissance Studies*, 4 (1990), pp. 155–200

Marcus, Leah S., Jane Mueller and Mary Beth Rose (eds), *Elizabeth I: Collected Works* (Chicago, Ill., 2000)

Marshall, Rosalind K., *Queen of Scots* (Edinburgh, 1986)

—, (ed.), *Dynasty: The Royal House of Stewart* (Edinburgh, 1990)

—, George Dalgleish and others, *The Art of Jewellery in Scotland*, (Edinburgh, 1991)

May, Steven W., *Sir Walter Ralegh* (Boston, 1989)

McCoog, sj, Thomas M., '"The Flower of Oxford": The Role of Edmund Campion in Early Recusant Polemics', *Sixteenth Century Journal*, 24 (1993), pp. 899–913

McCracken, Grant, 'Dress at the Court of Elizabeth I: An Essay in Historical Anthropology', *Canadian Review of Sociology and Anthropology*, 22 (1985), pp. 515–33

McCullough, Peter E., *Sermons at Court: Politics and Religion in Elizabethan and Jacobean Preaching* (Cambridge, 1998)

McDermott, J., *Martin Frobisher, Elizabethan Privateer* (London and New Haven, Conn., 2001)

Mears, Natalie, 'Love-making and Diplomacy: Elizabeth I and the Anjou Marriage Negotiations, c. 1578–1582', *History* 86 (2001)

Merton, Charlotte, 'The Women who Served Queen Mary and Queen Elizabeth: Ladies, Gentlewomen and Maids of the Privy Chamber', University of Cambridge Ph.D. thesis 1992

Millar, Oliver (ed.), 'Abraham van der Doort's Catalogue of the Collections of Charles I', *Walpole Society*, 37 (1960)

—, *The Tudor, Stuart and Early Georgian Pictures in the Collection of Her Majesty The Queen* (London, 1963)

Montrose, Louis A., 'Idols of the Queen: Policy, Gender and the Picturing of Elizabeth I', *Representations*, 68 (1999), pp. 108–48

Murray, Croft, and P. Hulton, *Catalogue of British Drawings* (London, 1960), vol. 1

Neale, John E., *Elizabeth I and her Parliaments*, 2 vols (London, 1953, 1957; reprinted 1971)

Neale, John, *Queen Elizabeth* (London, 1934)

Nichols, John, *The Progresses and Public Processions of Queen Elizabeth*, 3 vols (London, 1823)

Nicolas, Sir Nicholas Harris, *Life and Times of Sir Christopher Hatton* (London, 1847)

Oman, Charles, *The English Silver in the Kremlin, 1557–1663* (London, 1961)

Orlin, L.C. (ed.), *Material London* (Philadelphia, Pa., 2000)

Orwell, George, and Reginald Reynolds, *The British Pamphleteers*, vol. 1 (London, 1948)

Palliser, D.M., *The Age of Elizabeth: England Under the Later Tudors, 1547–1603* (London, 1983)

Parker, Geoffrey, *The Grand Strategy of Philip II* (New Haven, Conn., and London, 1998)

Parker, K.T., *The Drawings of Hans Holbein in the Collection of His Majesty the King at Windsor Castle* (Oxford and London, 1945)

Perry, Maria, *The Word of a Prince: A Life of Elizabeth I from Contemporary Documents* (Woodbridge, 1999)

Plowden, Alison, *Marriage with My Kingdom: The Courtships of Elizabeth I* (London, 1977)

Pollard, A.W., and G.R. Redgrave (eds), *A Short-Title Catalogue of Books Printed in England, Scotland & Ireland*, 2nd ed. (London, 1986)

Price, B., *Techniques of Medieval Armour Reproduction: The 14th Century* (Boulder, Colo., 2000)

Pridmore, F., 'Documentary Evidence relating to Countermarking Elizabeth 1560', Spink's *Numismatic Circular*, 70 (1962), no. 1, pp. 1–3.

Quinn, David B. (ed), *The Roanoke Voyages 1584–1590*, 2 vols (London, 1955)

—, *The Voyages and Colonising Enterprises of Sir Humphrey Gilbert* (London, Hakluyt Society, 1940)

—, *New American World: A Documentary History of North America to 1612*, edited with a commentary by David Beers Quinn with the assistance of Alison M. Quinn and Susan Hillier (London, 1979)

—, *Set Fair For Roanoke: Voyages and Colonies, 1584–1606* (Chapel Hill, NC, 1985)

Rabb, Theodore K., *Enterprise and Empire: Merchant and Gentry Investment in the Expansion of England, 1575–1630* (Cambridge, Mass., 1967)

Ramsay, G.D., *The City of London in International Politics at the Accession of Elizabeth Tudor* (Manchester, 1975)

—, *The Queen's Merchants and the Revolt of the Netherlands* (Manchester, 1986)

Rappaport, S., *Worlds Within Worlds: The Structures of Life in Sixteenth-Century London* (Cambridge, 1989)

Read, Conyers, *Mr Secretary Walsingham and the Policy of Queen Elizabeth*, 2 vols (Oxford, 1925)

—, *Mr Secretary Cecil and Queen Elizabeth* (London, 1955)

—, *Lord Burghley and Queen Elizabeth* (London, 1960)

Roberts, Jane, *Drawings by Holbein from the Court of Henry VIII* (Houston, Texas, 1987)

Robinson, John Martin, *Arundel Castle* (Chichester, 1994)

Rowlands, J., and D. Starkey, 'An Old Tradition Reasserted...', *Burlington Magazine*, (February 1983)

Saunders, Ann (ed.), *The Royal Exchange*, Publications of the London Topographical Society, no. 152 (London, 1997)

Scarisbrick, Diana, 'Treasured in Adversity: The Jewels of Mary Stuart', *Country Life*, 171 (1982), pp. 1740–42,

—, in *Treasure Houses of Britain* (Washington, DC., 1985)

—, *Ancestral Jewels: Treasures of Britain's Aristocracy* (London, 1989)

—, *Jewellery in Britain 1066–1837* (London, 1994)

—, *Tudor and Jacobean Jewellery* (London, 1995)

—, *From the Renaissance to Art Deco: Jewellery 1540–1940* (Tokyo, 2003)

Scarisbrick, J.J., *Henry VIII* (New Haven, Conn., and London, 2nd ed. 1997)

Scher, Stephen K., *The Currency of Fame: Portrait Medals of the Renaissance* (New York, 1994)

Sherman, William H., *John Dee: The Politics of Reading and Writing in the English Renaissance* (Amherst, Mass., 1995)

Singh, Duleep, *Portraits in Norfolk Houses*, n.d. (c. 1900), vol. II, p. 4

Smith, D., R. Strier and David Bevington (eds), *The Theatrical City: Culture, Theatre and Politics, 1576–1649* (Cambridge, 1995)

Somers Cocks, A., 'Intaglios and Cameos in the Jewellery Collection of the Victoria and Albert Museum', *Burlington Magazine* (June, 1976)

— (ed.), *Princely Magnificence* (London, 1980)

Spence, Richard T., *The Privateering Earl: George Clifford, 3rd Earl of Cumberland 1558–1605* (Stroud, 1995)

Starkey, David (ed.), *Henry VIII: A European Court in England* (London, 1991)

— (ed.), *The Inventory of King Henry VIII, 1: The Transcript* (London, 1998)

—, *Elizabeth I: Apprenticeship* (London, 2000)

Stewart, Alan, *Philip Sidney: A Double Life* (London, 2000)

Stimson, Alan, *The Mariner's Astrolabe: A Survey of Known Surviving Sea Astrolabes* (Utrecht, 1988)

Stops, Gervase Jackson (ed.), *The Treasure Houses of Britain: Five Hundred Years of Private Patronage and Art Collecting*, (Washington, DC, 1985)

Stow, J., *A Survey of London*, ed. C.L. Kingsford, 2 vols (Oxford, 1908)

Strong, Roy, *Portraits of Queen Elizabeth I* (Oxford, 1963)

—, *English Icon: Elizabethan and Jacobean Portraiture* (London, 1969)

—, *Tudor and Jacobean Portraits* (London, 1969)

—, *The Cult of Elizabeth: Elizabethan Portraiture and Pageantry* (London, 1977)

—, *Gloriana: Portraits of Queen Elizabeth I* (London, 1987)

Strong, Roy and Julia Trevelyan Oman, *Elizabeth R* (London, 1971)

Strong, Roy, with contributions from V.J. Murrell, *Artists of the Tudor Court, The Portrait Miniature Rediscovered 1520–1620* (London, 1983)

Swain, Margaret, *The Needlework of Mary Queen of Scots* (London, 1973)

Taylor, E.G.R., *Late Tudor and Early Stuart Geography* (London, 1934)

Teague, Frances, 'Queen Elizabeth in Her Speeches', in S.P. Cerasano and Marion Wynne-Davies (eds), *Gloriana's Face: Women, Public and Private, in the English Renaissance* (New York, 1992), pp. 63–78

Thomson, Duncan, *Painting in Scotland* (Edinburgh, 1975)

Thorpe, W.A., 'An Historic Verzelini Glass', *Burlington Magazine*, 67 (1935)

Thurley, Simon, 'Greenwich Palace', in David Starkey (ed.), *Henry VIII. A European Court in England*, National Maritime Museum (London, 1991), pp. 20–25

—, *The Royal Palaces of Tudor England. Architecture and Court Life 1460–1547* (New Haven, 1993)

—, *Whitehall Palace. An Architectural History of the Royal Apartments, 1240–1690* (New Haven, Conn., 1999)

Tittler, Robert, *Nicholas Bacon: The Making of a Tudor Statesman* (London, 1976)

Turner, G.L.E., and K. Van Cleempoel, 'A Tudor Astrolabe by Thomas Gemini and its Relationship to an Astrological Disc by Gerard Mercator of 1551', *Antiquaries Journal*, 81 (2001), pp. 400–409

Turner, G.L'E., *Elizabethan Instrument Makers. The Origins of the English Trade in Precision Instrument Making* (Oxford, 2000)

Van Cleempoel, K., *A Catalogue Raisonné of Scientific Instruments from the Louvain School, 1530–1600 [De diversis artibus, no. 65 (n.s. 28)]* (Turnhout, 2002)

Van de Broecke, S., 'Dee, Mercator and Louvain Instrument Making: An Uninscribed Astrological Disc by Gerard Mercator (1551)', *Annals of Science*, 58 (2001), pp. 219–40

Van der Stock, J., *Antwerp: Story of a Metropolis 16th–17th Century* (Antwerp, 1993)

Vines, Alice, G. *Neither Fire Nor Steel: Sir Christopher Hatton* (1978)

Voorthuis, Jacob, 'Portraits of Leicester', *The Dutch in Crisis 1583–88: People and Politics in Leicester's Time* (Leiden, 1988), pp. 58–9

Waddington, Raymond, 'Elizabeth I and the Order of the Garter', *Sixteenth Century Journal* 24 (1993) pp. 97–113

Walker, Julia M. (ed.), *Dissing Elizabeth: Negative Representations of Gloriana* (Durham, 1998)

Wallis, Helen, 'Silver Medal for the *Golden Hind*', *The Geographical Magazine* (1977), pp. 112–17

Waters, D.W., *The Art of Navigation in England in Elizabethan and Early Stuart Times* (London, 1958)

—, *The Elizabethan Navy and the Armada of Spain*, NMM Maritime Monograph, no. 17 (London, 1975)

Watkins, Susan, *In Public and Private Elizabeth I and her World* (London, 1998)

Watt, Tessa, *Cheap Print and Popular Piety* (Cambridge, 1991)

Wells-Cole, Anthony, *Art and Decoration in Elizabethan and Jacobean England, The Influence of Continental Prints, 1558–1625* (New Haven and London, 1997)

Whitton, C.A., 'The Coinage of Henry VIII and Edward VI in Henry's Name. Part 2', *British Numismatic Journal*, 26 (1949–51), pp. 171–212

Willan, T. S., *Studies in Elizabethan Foreign Trade* (Manchester, 1959)

Williams, A., and A. de Reuck, *The Royal Armoury at Greenwich, 1515–1649: A History of its Technology* (London, 1995)

Williams, Neville, *A Tudor Tragedy, Thomas Howard Fourth Duke of Norfolk* (London, 1964)

Wilson, Derek, *Sweet Robin: Robert Dudley Earl of Leicester 1533–1588* (London, 1997)

Wilson, Elkin Calhoun, *England's Eliza* (Cambridge, Mass., 1939)

Wilson, J., 'The Harefield Entertainment and the Cult of Queen Elizabeth', *Antiquaries Journal*, 66, ii (1986), pp. 315–28

Wollaston-Knocker, E., *Dover Corporation, Insignia, Seals, Plate, Mayors, Officers, Honorary Freemen, Town Hall Portraits, Pictures, Windows and Charities, Ezra* (Dover, 1898)

Woodfill, W.L., *Musicians in English Society from Elizabeth to Charles I* (Princeton, New Jersey, 1953)

Woods, H., 'Excavations at Eltham Palace, 1975–9', *Trans. London & Middlesex Archaeological Society*, 3 (1982), pp. 215–65

Woodward, J., *Tudor and Stuart Drawings* (London, 1951)

Woodward, Jennifer, 'Images of a Dead Queen', *History Today* (November 1997), pp. 18–23

—,*The Theatre of Death: The Ritual Management of Royal Funerals in Renaissance England* (Woodbridge, 1997)

Wormald, Jenny, *Mary Queen of Scots: A Study in Failure* (London, 1991)

Wright, Pam, 'A Change in Direction: The Ramifications of a Female Household, 1558–1603', in D.A.L. Morgan, John Murphey, Pam Wright, Neil Cuddy and Kevin Sharpe (eds), *The English Court from the Wars of the Roses to the Civil War* (Harlow, 1987), pp. 147–73

Youings, Joyce, *Raleigh in Exeter 1985, Privateering and Colonisation in the Reign of Elizabeth I* (Exeter, 1985)

Yung, K.K., *National Portrait Gallery, Complete Illustrated Catalogue* (London, 1981)

CHRONOLOGY

1527 Henry VIII tries to obtain the annulment of his marriage to Katherine of Aragon.

1533 Henry's secret marriage to Anne Boleyn (Jan.); annulment of Aragon marriage (May); birth of Elizabeth at Greenwich Palace (7 Sept).

1534 Elizabeth's christening (10 Feb); Act of Supremacy whereby Henry is declared Supreme Head of the Church of England.

1536 Death of Katherine of Aragon (Jan.); Boleyn marriage is declared invalid and Elizabeth thereby made illegitimate (17 May); execution of Anne (19 May); Henry marries Jane Seymour (30 May).

1537 Birth of Prince Edward (12 Oct).

1543 Elizabeth attends wedding of Henry to Katherine Parr (12 July).

1544 Elizabeth is restored to the line of succession; William Grindal becomes Elizabeth's tutor.

1545 Elizabeth gives Henry VIIII a translation of Katherine's devotional writings as a New Years' gift (31 Dec).

1547 Death of Henry VIII (28 Jan.) and accession of Edward VI; Katherine Parr marries Lord Thomas Seymour.

1548 After Grindal's death, Roger Ascham is appointed Elizabeth's tutor; Elizabeth leaves Seymour establishment (May); death of Katherine after childbirth (Sept).

1549 Arrest of Thomas Seymour (Jan.); interrogation of Elizabeth at Hatfield (Feb).

1550 William Cecil is appointed surveyor of Elizabeth's estates.

1553 Edward disinherits his sisters (June) and dies (6 July); brief reign of Lady Jane Grey; accession of Mary (19 July).

1554 Sir Thomas Wyatt's rebellion (Jan.); imprisonment of Elizabeth in the Tower (17 March); Elizabeth leaves Tower for house-arrest at Woodstock (May); Mary I's marriage to Philip of Spain is celebrated (July).

1555 Elizabeth leaves Woodstock for Hampton Court (April) and is allowed to go to her home at Hatfield (Oct.); foundation of Muscovy Company.

1556 Arrest of Kat Ashley and others in Elizabeth's household (May).

1558 Mary Stewart marries the dauphin (April); death of Queen Mary I and accession of Elizabeth (17 Nov.); Hatfield speech.

1559 Elizabeth I's coronation (15 Jan); new Elizabethan Prayer Book endorsed by parliament (April); Mary Stewart (married to Francis II) becomes queen of France.

1560 Death of wife of Robert Dudley (Sept.); Katherine Grey gives birth to a son (Sept); death of Francis II of France (Dec.); re-coinage of debased coinage (Dec.).

1562 Elizabeth falls ill with smallpox (Oct.).

1563 Convocation draws up 39 Articles of Faith (Jan.); parliament calls for Elizabeth to marry and name a successor.

1564 Negotiations begin for a marriage between Elizabeth and the Archduke Charles of Austria; Robert Dudley is created earl of Leicester.

1565 Marriage of Mary Queen of Scots to Henry Lord Darnley.

1567 Murder of Darnley at Kirk O'Field (Feb.), deposition of Mary.

1568 Death of Katherine Grey (Jan.); publication of folio edition of Bishops' Bible; Mary's flight to England (May).

1569 Northern Rising (Nov).

1570 Papal bull of excommunication (Feb.); rebellion in Ireland suppressed by Sir Humphrey Gilbert.

1571 Elizabeth visits 'Royal Exchange' (Jan.); Ridolfi Plot; William Cecil is created Lord Burghley.

1572 Execution of Norfolk (June); St Bartholomew's Day massacre of Protestants in France (Aug).

1573 Sir Francis Walsingham is appointed principal secretary.

1575 Death of Matthew Parker (May) and Edmund Grindal becomes archbishop of Canterbury; Kenilworth entertainment (July).

1576 Martin Frobisher begins first of three voyages to find Northwest Passage; Grindal refuses to obey queen's command to suppress prophesyings (Dec).

1577 Frobisher's 2nd voyage; Sir Francis Drake sets out on a voyage that was to be his circumnavigation of the globe (Nov).

1578 Sir Humphrey Gilbert's voyage to America; Frobisher's 3rd voyage; opening of the Anjou match (Aug).

1579 Anjou courts Elizabeth in England (Aug.); opposition to marriage including John Stubb's *Gaping Gulf*; outbreak of rebellion in Ireland.

1580 Drake returns to England (Sept).

1581 Elizabeth knights Drake (Apr); Anjou's second visit to England (Nov); execution of the Jesuit, Edmund Campion (Dec.).

1583 Sir Humphrey Gilbert drowns on voyage back from America.

1584 Ralegh's 1st Roanoke expedition; death of Anjou (June).

1585 2nd Roanoke expedition; in treaty of Nonsuch Elizabeth promises military help to the Dutch (Aug); Drake sets out to raid the West Indies; Leicester leaves for the Netherlands (Dec).

1586 Ralegh made captain of the guard; Babington plot (July) to assassinate Elizabeth; trial and conviction of Mary Queen of Scots (Oct).

1587 Elizabeth signs Mary's death warrant (1 Feb); Mary's execution (8 Feb.); Drake's attack on Spanish fleet at Cadiz (Apr.); Leicester resigns command in Netherlands (Oct). 3rd Roanoke expedition.

1588 Defeat of the Spanish Armada (July); death of Leicester (Sept).

1589 Francis Drake and Sir John Norris lead a campaign to Portugal.

1590 Death of Sir Francis Walsingham (Apr.); Roanoke colony is found abandoned by a relief expedition.

1591 Death of Sir Christopher Hatton (Nov).

1593 Peter Wentworth raises question of succession in parliament and is sent to Tower.

1594 Beginning of a series of bad harvests; Frobisher dies.

1595 Ralegh's voyage to Guiana; Spanish land in Cornwall (July); death of Hawkins on Panama expedition (Nov.); publication of John Davis's *The Seaman's Secrets*.

1596 Death of Drake on Panama expedition (Jan.); Essex's success at Cadiz (June-Aug); Robert Cecil is appointed principal secretary.

1598 Death of Burghley (Aug).

1599 Essex's unsuccessful campaign in Ireland; his arrest after returning without Elizabeth's consent; Elizabeth grants charter of new East India Company.

1600 Trial of Essex (June).

1601 Essex's revolt, and execution (25 Feb).

1603 Death of Elizabeth I (24 Mar.) and funeral (28 Apr.); accession of James I.

GENEALOGY

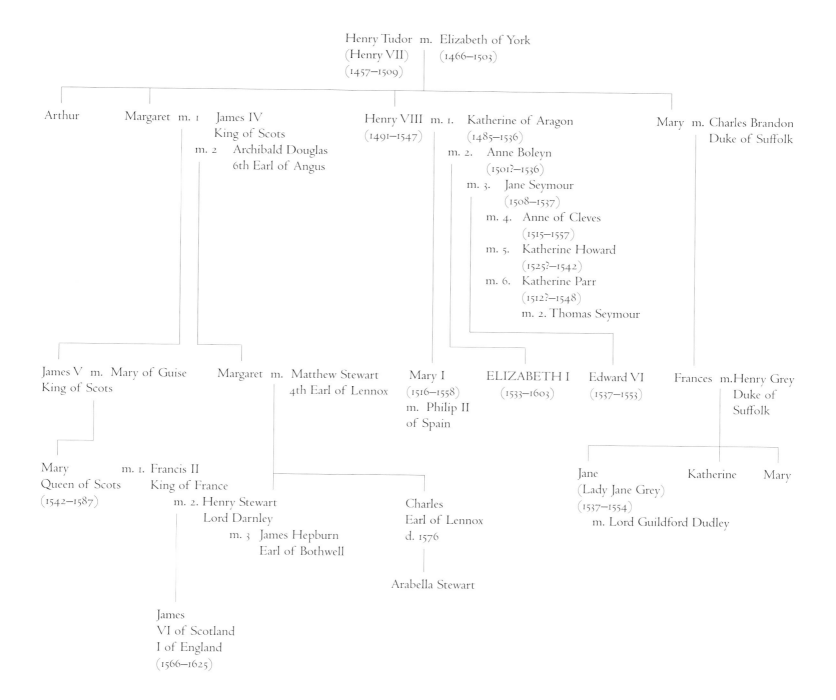

Henry Tudor m. Elizabeth of York
(Henry VII) (1466–1503)
(1457–1509)

Arthur Margaret m. 1 James IV Henry VIII m. 1. Katherine of Aragon Mary m. Charles Brandon
 King of Scots (1491–1547) (1485–1536) Duke of Suffolk
 m. 2 Archibald Douglas m. 2. Anne Boleyn
 6th Earl of Angus (1501?–1536)
 m. 3. Jane Seymour
 (1508–1537)
 m. 4. Anne of Cleves
 (1515–1557)
 m. 5. Katherine Howard
 (1525?–1542)
 m. 6. Katherine Parr
 (1512?–1548)
 m. 2. Thomas Seymour

James V m. Mary of Guise Margaret m. Matthew Stewart Mary I ELIZABETH I Edward VI Frances m. Henry Grey
King of Scots 4th Earl of Lennox (1516–1558) (1533–1603) (1537–1553) Duke of
 m. Philip II Suffolk
 of Spain

Mary m. 1. Francis II Jane Katherine Mary
Queen of Scots King of France (Lady Jane Grey)
(1542–1587) m. 2. Henry Stewart Charles (1537–1554)
 Lord Darnley Earl of Lennox m. Lord Guildford Dudley
 m. 3 James Hepburn d. 1576
 Earl of Bothwell

 Arabella Stewart

James
VI of Scotland
I of England
(1566–1625)

Note: dates given are those of birth and death

PICTURE CREDITS

The publishers would like to thank the following sources for their kind permission to reproduce the pictures in this catalogue:

The Royal Collection © 2002, Her Majesty Queen Elizabeth II: pp. 11, 190, 201 (right)

The Royal Collection © 2002, Her Majesty Queen Elizabeth II – Photographer: John Freeman: pp. 9, 16

Reproduced with the permission of the Chequers Trust: p. 12 (top)

By kind permission of The Lord Mayor of the City of London, © Corporation of London – image courtesy of the Guildhall Art Gallery: p. 55 (right)

Dover Museum/Dover District Council: pp. 189, 197

The Earl of Scarbrough: p. 196

De Danske Konges Kronologiske Samling paa Rosenborg: p. 84 (bottom)

Board of Trustees of the National Museum and Galleries on Merseyside (Walker Art Gallery, Liverpool): p. 191

Property of the Trustees of Lady Beauchamps Will Trust: p. 74

The College of Arms, London: pp. 32, 44, 86 (left), 244 (left), 249

© The Board of Trustees of the Armouries: pp. 94, 95

William Tyrwhitt-Drake: pp. 230, 231

By courtesy of the National Portrait Gallery, London: pp. 21, 43, 76, 91, 165, 176, 180, 185, 186, 187, 216, 252

© The British Museum: pp. 12 (bottom), 23, 25, 36, 48 (bottom), 49 (top), 6650, 51, 54 (top left), 56 (top left), 77, 78 (top left and right), 85, 86 (left), 100 (right), 131, 145 (top), 146 (top), 161 (right), 162 (left), 169 (both), 170 (all), 171, 172, 195 (left and top right), 200 (all), 225 (left top and bottom), 245, 247

The Marquess of Salisbury – Photographer J. Bethell 22/7/02: p. 90 (bottom)

Northampton Museums & Art Gallery: pp. 137, 138

The Vintners' Company: pp. 38, 56 (right)

© National Trust Photographic Library – Derrick E. Witty: p. 111

© The Trustees of the National Museums of Scotland: pp. 229 (top right and bottom), 251

Trustees of the Berkeley Will Trust: p. 62

The Lord Tollemache: p. 203

Loseley Park: p. 101 (left)

By kind permission of the Duke of Norfolk, Arundel Castle: pp. 215, 229 (top left)

Trustees of the Titsey Foundation: p. 53

Society of Antiquaries of London: p. 223

Bodleian Library, University of Oxford; Douce Bib. Eng. 1583 B.1, front cover: pp. 108 (bottom right)

Bodleian Library, University of Oxford; MS. Ashmole 1729, art. 7 (fol. 13): p. 219

Bodleian Library, University of Oxford; MS. Eng. Hist. e. 198, fol. 85r: p. 112 (left)

Bodleian Library, University of Oxford; 17078 d.225: p. 259

By kind permission of the Honourable Society of the Middle Temple: pp. 134, 135

Ashmolean Museum, Oxford: pp. 4, 99 (left), 106 (left), 117 (right), 133, 154, 202 (left)

Glasgow Museums: Art Gallery & Museum, Kelvingrove; Greenwich armour for man and horse c. 1550, E.1939.65a-d: p. 1

Reproduced by permission of the Public Record Office, the National Archives, England; EXT11/25: p. 24
SP11/4/2 fos 3r-v: p. 24
SP 53/22 f.1: pp. 205, 220
MPF 1/366 (1): p. 222
SP12/215 no. 65: p. 88 (bottom right)
SP15/20 no. 9: p. 88 (top left)
SP12/142 no. 8: p. 89

V&A Picture Library: pp. 39, 56 (bottom left), 60, 61, 80, 81, 92, 93, 98 (top and bottom), 99 (bottom), 106 (right), 107 (top), 108 (top right), 113, 114 (top and bottom), 116, 150, 155 (left and right), 192, 193, 195 (right bottom), 198, 240, 244 (right), 246

Courtesy of the Trustees of the V&A – Photographer: Mr D. P. P. Naish: p. 12 (top)

V&A Picture Library – Photographer Richard Davis: p. 115

The Marquess of Salisbury: p. 20

The Burghley House Collection: pp. 46, 47, 148 (right), 159 (left)

© The Friends of Preston St. Mary Church – Photography by David Emeney; Boards displayed by kind permission of the Parochial Church Council of the Parish Church of St. Mary, Preston St. Mary: p. 57, 253

The Earl and Countess of Bothwell, artist unknown, The Scottish National Portrait Gallery: pp. 220 (bottom), 221 (top)

© By kind permission of the British Library:
(Add. 8159): p 75
(Huth Coll. No. 11): p. 178
(Harl. 6986, ff. 45–6): p. 22 (top left)
(C124 f 4): p. 143 (left)
(C21 b 35): p. 168
(Royal MS. 7 D X): p. 15
(Add. 48028, f. 650): p. 228
(Add. 35324, f. 37 v.): p. 241, 248
(Harl. 283, fo. 75): p. 14 (top)
(Add. 44839): p. 232
(Egerton MS. 944, fo. IV–2): p 201 (left)
(Harley 6986 fo. 23): p. 238 (left)

© By kind permission of the British Library (*continued*):
 (Cotton MS. Domitian A, xviii ff. 98v–99): p. 221 (bottom)
 (Seals xxxvi 10): p. 49 (bottom)
 (Sloane MS. 61): p. 148 (left)
 (Kings MS. 396): p. 105 (bottom)
 (Cotton Charter XIII art. 39): p. 156
 (G12047/845.c.21): p. 31
 (1105.f.1 Title page): p. 29
 (c.21.e.12): p. 142 (right)
 (c.57.1.2): p. 199 (right)
By kind permission of HMS Drake: pp. 119 (detail), 152
Collection of the Duke of Northumberland: p. 64
© Museum of London: pp. 15 (top left), 44 (bottom), 100 (left), 109 (left and right), 115, 117 (left), 202 (right), 204
The Society of Jesus: pp. 210, 211
Courtesy of the Trustees of the V&A – Photographer: Sara Hodges: p. 226
James VI & I by Arnold Bronckorst, The Scottish National Portrait Gallery: p. 86 (left)
Photograph © Ulster Museum; Photograph reproduced with the kind permission of the Trustees of the National Museums & Galleries of Northern Ireland: p. 236 (all)
The collection at Parham House & Gardens, West Sussex, England: pp. 6, 45, 162 (right), 250
Staatliche Museen Kassel, Graphische Sammlung: p. 103
Waddesdon Manor, The Rothschild Collection (Rothschild Family Trusts) – Photographer: Mike Fear/Stephen Van der Meulen; Robert Dudley, 1st Earl of Leicester; c. 1564: p. 84
His Grace the Archbishop of Canterbury: p. 58
Campion Hall Oxford University: p. 210
Moscow Kremlin Museums – Photographer: Jeremy Richards: p. 163, 164
Reproduction by permission of the Syndics of the Fitzwilliam Museum, Cambridge: p. 112 (left)
Private Collection: pp. 13 (bottom), 35, 42, 45, 48 (top), 55 (left), 67, 82, 84 (top), 101 (right), 102, 104, 105 (top left), 108 (left), 110, 151 (both), 194, 199 (left), 218
Hatfield Old Hall © Mark Fiennes: p. 6

Every effort has been made to acknowledge correctly and contact the source and/copyright holder of each picture. We apologise for any unintentional errors or omissions which will be corrected in any future editions of this book.

The following are NMM photographic references. Pictures may be ordered from the Picture Library, National Maritime Museum, Greenwich, London, SE10 9NF (tel. 020 8312 6600). All © National Maritime Museum, London.

E2317-1: p 149 (bottom)	BHC2763: p. 10
BHC2952: p. 22 (top right)	PU4572: p. 161 (left)
BHC2755: p. 139 (right)	BHC2680: p. 242
E3598-1: p. 238 (right)	E3598-2: p. 238 (right)
E9046: p. 142 (left)	E9047: p. 143 (right)
E0433: p. 140 (bottom)	E9098: p. 141 (top)
E9132: p. 144 (left)	E9078: p. 129
E9076: p. 54 (right)	E9077: p. 239
E9137: p. 141 (bottom left)	BHC2678: p. 18
B7285: p. 146 (right)	PU2367: p. 69, 90 (top right)
E9048: p. 140 (top)	BHC2841: p. 139 (left)
PU2357: p. 225 (right)	PU4416: p. 166
B3771: p. 147 (top)	D3296: p. 233 (bottom)
D3301: p. 233 (top)	E0052-1: p. 152
E0052-2: p. 119	2673: p. 96 (right)
D2635: p. 19	B183: p. 149 (top)
D8908-1: p. 146 (bottom left)	D5747: p. 147 (bottom)
A87: p. 235 (left)	C5386: p. 235 (right)
BHC2662: p. 136	BHC2681: p. 243
BHC0262: p. 234	E0646: p. 145 (top left)
E0649: p. 145 (bottom left)	E0650: p. 145 (bottom left)

INDEX

Page numbers in *italic* indicate illustrations

A.

Abergavenny, Lord 79
Accession Day tournaments 76-7, 91, 95-6,
 257
 score-cheques 95-6, *96*, 244, *244*
Acquaviva, Claudio 212
Adamas, Robert (attrib.): Mayor of
 London's chain of office 55, *55*
Adams, Robert
 Armada charts 232, *233*
 map of Thames Estuary 232, *232*
Admiral's Men, the 80
'Admonition Controversy' 30
Alexander VI, Pope 121
Allen, Cardinal William 209, 210, 211, 212
 An admonition . . . 213
 *A declaration of the sentence and deposition of
 Elizabeth* 213
Alleyn, Sir John 55
Alva, Duke of 37, 38, 208-9
 Mary Queen of Scots' correspondence
 with 220
Andries, Jasper 204
Anjou, Francis, Duke of 69-70, 75, 83, 90,
 127, 138, 155, 177, 184
 portrait 69, 90, *90*
Anne, Queen 257
 inventory of jewels 183, *184*
Anthony, Charles 195
Anthony, Derek 195
 (with Hilliard) Elizabeth I's Second
 Great Seal 49, *49*
Armada *see* Spanish Armada
Armada Jewel 239-40, *240*
'Armada Portrait' of Elizabeth 180, 230,
 230-1, 232
armillary spheres
 Arsenius 147, *147*
 drawing of 201, *201*
armour 10, 92, 93, *93-4, 94*, 95, *95*
Arms, Royal 57, *57-8*
Arnold, Janet 198, 204

Arsenius, Gualterus: armillary sphere 147, *147*
Arundel, Earl of 75-6, 79
Ascham, Roger 17, 18, 80
Ashley, Sir Anthony 144
Ashley, Katherine (*née* Champernowne) 17,
 19, 20
 portrait *17*
Astley, John 17
Astley, Katherine *see* Ashley, Katherine
astrolabes
 Gemini 144-5, *145*
 Spanish or Portuguese 235, *235*
Atlas Sive Cosmographicae (Mercator) 123, 124,
 157, 157-8, 160
Attley (composer) 102

B.

Babington plot 37, 112, 212, 216, 227
Bacon, Francis 80, 256
Bacon, Nathaniel 36
Bacon, Sir Nicholas 11-12, 28, 36, 48
 portrait 48, *48*
 staff of office 48, *48*
bags
 sweet bag 110, *110*
 velvet pouch 115
Baker, Mathew: *Fragments of Ancient English
 Shipwrightry* 140
Baret, John: *Dictionary* 109
Barker, Christopher 109
Barley, William: *New Booke of Tabliture for the
 Orpharion* 102
Basse, Henry: (attrib.) medal of Edward VI 21
Bassnett, Susan 67
Bayning, Paul 39
Beauchamp, Edward, Lord 70
Beaufort, Lady Margaret 55
beer pot 98-9
Berkeley, Lord 79
Bettes, John, the Younger 21
 (attrib.) portrait of Elizabeth 243

bibles (exhibited)
 Bishops' Bible, The 29, 59, 61, 179
 Geneva Bible 108, *109*
Blackmore, Sir Richard: *Eliza* 257
Bloc, Coenraad: medal 223, *224*
Blount, Sir Charles 244
Boazio, Baptista: chart of Santo Domingo
 153, 153
bodkins 109-10, 185
Boleyn, Anne 10, 14, 28, 58, 207
 coin 12, *12*
 Latymer's treatise of 14
 letter to Lord Cobham 14, *14*
 medal 12
 pendant 11-12, *12*
 portrait (Holbein) 11, *11*
 portrait on Elizabeth's locket ring 12-13,
 13
Boleyn, Mary 108
Bonzagna, Gianfederico: medal of Pius V
 216
Book of Common Prayer (1571) 59
books (exhibited)
 The Castle of Knowledge (Record) 122, 143,
 143
 A Choice of Emblemes and other Devises
 (Whitney) 187, 199, *199*-200
 De Magnete (W. Gilbert) 141, *141*
 Divers voyages touchinge the discovey of America
 (Hakluyt) 128, 168, *168*
 *General and Rare Memorials Pertaining to the
 Perfect Arte of Navigation* (Dee) 83, 122,
 142, *142*-3
 The Mariners Mirrour (Waghenaer) 143,
 143-4
 A Regiment for the Sea (Bourne) 122, 141,
 141
 'Regina Fortunata' (Howard) 200-1, *201*
 The Seaman's Secrets (Davis) 125, 142, *142*
 The World Encompassed by Sir Francis Drake
 (Drake's nephew) 154
Boonen, William 103
boots, riding 117, *117*

Borough, William 158
 sea chart of passage from England to
 the Baltic 158, 158-9
Bothwell, James Hepburn, 4th Earl of 208,
 219, 221, 222
 portrait 220, 220-1
Bothwell, Lady Jean Gordon, Countess of
 221
 portrait 221, 221
Bourne, William: *A Regiment for the Sea* 122,
 141, 141
boxes
 counter box 115
 spice or comfit box 155, 155
Bradstreet, Anne 80
Brandon, Robert 43, 176, 198, 199
'Brethren' (jewel) 183-4, 186
broadsheet 223, 223
broadside (pub. by Council of Virginia) 172
Bronckhorst, Arnold: portrait of James VI
 with a hawk 86, 86-7
Brown, Robert/'Brownists' 30
Bry, Theodor de 168
 America 130
Buckhurst, Lord: counter 115
Burghley, William Cecil, Lord 28, 34, 35, 36,
 37, 39, 42, 46, 48, 65, 66, 68, 69, 91, 113,
 159, 160, 167, 176, 178, 208, 209, 212,
 213, 220, 221, 222, 247
 answers to objections to Elizabeth's
 marriage 90
 memorandum on Elizabeth's marriage
 85-6
 portrait 45, 46
buskins 117, 117
Byrd, William 101, 138
Byrde, William 37

C.

Camden, William 35, 257
cameos 80, 108, 108, 150, 150, 186, 195, 195-6,
 229, 229, 236, 237
Campion, Edmund 31, 210, 210, 211, 223
Candelar, Richard 35
candle-sconces 100, 100
Canterbury, Archbishops of *see* Grindal,
 Edmund; Parker, Matthew; Whitgift,
 John

caps, knitted 44, 44
Carey, George: portrait (Hilliard) 108, 108
Carey, Robert 188
Carleill, Christopher 153
Carlisle, bishop of 44
Cartwright, Thomas 30
Catherine de' Medici 68, 69, 90, 184, 208,
 224
 medal 224
Cavendish, Thomas 128, 134
Cecil, Sir Robert *see* Salisbury, Earl of
Cecil, Sir William *see* Burghley, Lord
ceramics
 delftware charger 204, 204
 Walsingham Bowl 148, 148
chairs with embroidered cushions 101, 101
Champernowne, Sir Arthur 166
Chancellor, Richard 123-4, 143, 159
charger, delftware 204, 204
Charles I, 163, 183
Charles V, Emperor 23, 91
Charles, Archduke of Austria 65, 68, 85, 86,
 208, 217
charts *see* maps and charts
Cheke, Sir John 11, 18
Cheke, Lady Mary 80
church plate 59, 60, 61, 61
Churchyard, Thomas: poem 129
ciphers, Mary Queen of Scots' 220, 220
clothes
 children's 44, 44, 46
 inventory of 113
 petticoat panel 113, 113-14
 sleeves 114, 114, 116, 116
 woman's girdle 113
 see also boots; caps; gloves
Clough, Richard 37
Cobham, Viscount 258
coconut cup 152
coins
 East Indies 155-6
 Edward VI 50
 Elizabeth I 35, 50, 50, 51, 51-2, 147, 195
 Henry VIII and his queens 12, 12
 Leicester 224
 Mary Queen of Scots 226
 Philip II 23, 155
 Spanish 236, 237
 trial plates 50
Coke, Sir Edward: counter 115

Cole, Humphrey 145
 compendium 146, 146
 nocturnal and tide calculator 144, 145
 ring dial 146, 146
 sundial 145, 145
Cole, Mary Hill 77
Colte, John: funeral effigy of Elizabeth 249,
 252
Colte, Maximilian (after): Elizabeth's tomb
 effigy 252, 252
comb, ivory 117
compendiums
 Cole 146, 146
 Kynvyn 244-5, 245
Conyer, John: map of Strait of Magellan
 125, 148, 148
Cooke, John 126
Cooke, Robert 105
Coronation Procession, Elizabeth's 33, 43, 44
 drawings 32, 43-4
Cosimo de' Medici: medal (D. Poggini) 224
counter box and counters 115, 226
Courtenay, Lady Elizabeth 152
Courtenay, Sir William 152, 167
Cranmer, Archbishop Thomas 10
 1552 Prayer Book 27, 29, 59
Critz, John de, the Elder 247, 252
 (after) portrait of Sir Francis
 Walsingham 216, 216
Cumberland, George Clifford, 3rd Earl of
 76-7, 96
 miniature (Hilliard) 77, 96, 96-7
cups
 coconut cup 152
 Drake Cup 151-2, 152
 James I stirrup cup 251, 251
 Pelican Cup 192, 192-3
 Stoke Prior Cup 98
 wine 98, 163, 164
Curle, Elizabeth 227
cutlery, Elizabethan 99, 99-100

D.

dagger (of Henry VIII) 13, 13
Dare, Virginia 130
Darnley, Henry Stuart, Lord 68, 86, 208,
 217, 219, 221
 drawing of murder 222, 222

portrait with Mary Queen of Scots 219
'Darnley Portrait' of Elizabeth 180, 186, *187*
Davies, John 181
Davis, John 125, 131, 134, 144
 The Seaman's Secrets 125, 142, *142*
Dee, Dr John 43, 121-2, 124, 126, 128, 130, 138,
 144-5, 147, 154-5, 216, 237
 Brytanici Imperii Limites 122
 Brytannicae Republicae Synopsis 122, 155, *156*,
 156-7
 *General and Rare Memorials Pertaining to the
 Perfect Arte of Navigation* 83, 122, *142*,
 142-3
 letter to Elizabeth 237-8, *238*
 map of the North-East Passage 159, *159*
 portrait *154*, 154-5
 Propaedeumata aphoristica 145
Dekker, Thomas 80
 The Whore of Babylon 257
Delaram, Francis 198
Delaune, Etienne 146
delftware charger 204, *204*
Denny, Sir Anthony 19
Denny, Edward 107
Derby, Earl of 79
Desmond, Earl of 167
dish, pewter 99
'Ditchley Portrait' of Elizabeth (Gheeraerts
 the Younger) 91, 180, *180*, 185, *185*, 186,
 187
Donne, John 80
Dorset, Henry Grey, Marquis of 22
Doughty, Thomas 126
Dowland, John 102
Drake, Sir Francis 108, 125, 126-8, 134, 136,
 138, 139, 140, 148, 153, 161, 172, 184-5,
 232, 258, 259, 260
 Drake in Ternate in the Moluccas 149, *149*
 portrait (Gheeraerts the Younger) 136,
 136
 sword 151
Drake, Francis (nephew): *The World
 Encompassed by Sir Francis Drake* 154
Drake Cup 151-2, *152*
Drake Locket Jewel 150, *150*
Drake Sun Jewel 151, *151*
'Drake's Dial' 146, *146*
drinking vessels 98-9; *see also* cups; flagons
Dudley, Ambrose 44
Dudley, Amy Robsart, Lady 68, 83, 86

Dudley, John 104; *see also* Northumberland,
 Duke of
Dudley, Lord Robert *see* Leicester, Earl of
Dyer, Edward 80, 157

E.

East India Company 39, 131, 155
Edgecumbe, Margaret 106, 107
Edward VI 10, 11, 17, 27, 28, 58, 62, 67, 123,
 183, 186
 Elizabeth's letter to 22, *22*
 medal (attrib. Basse) 21
 portrait as prince (after Holbein) 18, *18*
 shillings 50
Egerton, Sir Thomas 204 245
Elderton, William (attrib.): broadsheet 223,
 223
Eliot, Sir John 183
Elizabeth I
 answer to Commons' petition that she
 marry 85
 funeral effigy (J. Colte) 249, *252*
 funeral procession 248, *248-9*
 letters:
 to Lord Burghley 219, *219*
 to Edward VI 22, *22*
 to Mary I 23-4, *24*
 to Katherine Parr 19
 to Edward Seymour, Lord Protector
 Somerset 20, *20*
 marble bust 196, *196*
 portraits 16, 17, 175-81
 'Armada Portrait' 180, 230, *230-1*, 232
 attrib. Bettes 243
 with cardinal and theological virtues
 196, *197*, 198
 in Coronation robes 42, *42-3*, *43*
 'Darnley Portrait' 180, 186, *187*
 'Ditchley Portrait' (Gheeraerts the
 Younger) 91, 180, *180*, 185, *185*, 186,
 187
 'Ermine Portrait' 185, 186, *193*
 by Gheeraerts the Elder 193, *194*
 by Gower 82, 83, 179
 by van Heydin (as Diana) 21
 by Hilliard 101, *101*, 180, 198, *198*; *see
 also* 'Pelican Portrait', 'Phoenix
 Portrait' (*below*)

 on locket ring 12-13, *13*
 by Metsys 83, 179
 by Oliver (in old age) 180, 246, *246*, 255
 by van der Passe (engraving) 246
 'Pelican Portrait' (attrib. Hilliard) 116,
 179, 185, 186, 187, 188, *191*, 192
 'Phoenix Portrait' (attrib. Hilliard)
 179, 186, 187, 192
 'Rainbow Portrait' 185, 186, 187
 in robes of office *203*, 204
 'sieve portraits' 80, 82, 83, 179, *195*,
 195-6
 by Teerlinc (miniature) 74
 with verses *178*
 woodcut 178, 202, *202*
 by Zuccaro (drawing) 78, 79, 87, 176
 song 239, *239*
 speech before coronation 42
 Tilbury speech 235-6, 257
 tomb effigy (after M. Colte) 252, *252*
 written answers to interrogations 20
Elizabeth I and the Three Goddesses (Eworth) 190,
 190, 192
Elizabeth receiving Dutch emissaries 103, 103-4
Elstrack, Robert: portrait of Robert Cecil,
 Earl of Salisbury 246-7, *247*
Emerson, Ralph 210
'Ermine Portrait' of Elizabeth 185, 186, *193*
Essex, Lettice, Countess of 68
Essex, Robert Devereux, 2nd Earl of 96, 112,
 166, 213, 243, 244, 245, 255, 256, 260
 abstract of evidence in support of
 charge of treason 245
 compendium (Kynvyn) 244-5, *245*
 letter to Elizabeth 245
 portrait (Gheeraerts the Younger) 243,
 243, 244
Eworth, Hans: *Elizabeth I and the Three
 Goddesses* 190, *190*, 192

F.

Feckenham, Abbot 229
Felton, John 217
Field, John, and Wilcox, Thomas: *Admonition
 to the Parliament* 30
films 255, 258, 260
FitzMaurice, James 210
flagons, silver gilt 163, *163*, 164, *164*

Fletcher, Reverend Francis 125, 128, 148, 154
Francis I, of France 65, 109, 183
Francis II, of France 207, 208
Frederick II, of Denmark 221
Frisius, Gemma 121, 147, 157
Frobisher, Martin 38, 46, 124-5, 128, 134, 138, 143, 145, 147, 149, 158, 159, 160-1
 drawings relating to 2nd voyage 125, *161*, *161-2*, *162*
 ore from Arctic expedition 161
 portrait (engraving) 160, *161*
Froude, J.A.: *History of England . . .* 258
Fuller, Thomas: *The Holy State* 183

G.

Gardiner, Bishop 33
Gemini, Thomas: astrolabe 144-5, *145*
genealogical trees
 Elizabeth *105*, 105-6
 James I *249*, *250*, 251
Geneva Bible *108*, 109
Gérard, Balthasar 217
Gheeraerts, Marcus, the Elder: portrait of Elizabeth I *193*, *194*
Gheeraerts, Marcus, the Younger
 'Ditchley Portrait' of Elizabeth 91, 180, *180*, 185, *185*, 187
 portrait of Sir Francis Drake 136, *136*
 portrait of Earl of Essex *243*, *243*, 244
Giannini, Giuliano: medal 224
Gilbert, Sir Humphrey 121, 122, 128-30, 139, 165, 167, 168
 A Discourse of a Discoverie for a New Passage to Cataia 124
 portrait (engraving) 166, *166*
Gilbert, William 141
 De Magnete (About the magnet) *141*, 141
girdle, woman's 113
Girona, treasures from *236*, 236-7
glass beads 114, *114*
globes, terrestrial (Molyneux) 127, 128, 134, *134*
gloves and mittens 106-7, *107*, 115, 115-16
goblet (Verzelini) 98, *98*
Godunov, Tsar Boris 164
Goldsmiths' Company, London 56, 155
Goltzius, Hendrick 96
Gonson, Benjamin 140
Goodman, Godfrey 257

Gower, George 176-7, 178, 232, 255
 portrait of Elizabeth I with a Sieve 82, 83, 179
 portrait of Elizabeth Knollys 111, *111*
Grafton, Richard 34
Granvelle, Antoine Perrenot de 23
Greenwich Armoury 10, 93, 94
Greenwich Palace 74, 97
 excavated artefacts 97, *97*
Gregory XIII, Pope 209, 210, 211
Grenville, Sir Richard 168, *170*
Gresham, Sir Thomas 35, 36, 37, 53, 54, 55
 Grasshopper signet ring 55, *55*
 portrait *35*, 52-3, *53*
Greville, Sir Fulke 75, 80
Grey, Lady Jane 22, 67
Grey, Katherine 65, 66, 70
Grindal, Edmund, Archbishop of Canterbury 28, 29-30
Grindal, William 15, 17
Guaras, Antonio de 126
Guise, Duke Henry of 211, 212
Gunter, Edmund: scales 144

H.

Haddon, Walter: *Poemata* 239-40
Hakluyt, Richard, the Elder 121, 168
Hakluyt, Richard, the Younger 121, 122, 130
 Discourse of Western Planting 130
 Divers voyages towchinge the discovey of America 128, 168, *168*
 map in *De Orbe Novo Petri Martyris* 149
 Principall Navigations 40
Halder, Jacob: *Almain Armourer's Album* 92, 93, 93-4, *94*, 95
Hall, Christopher 124, 159
Hall, Rowland 61
handkerchiefs 84, 106, *106*
Hanseatic League 34, 38
Harborne, William 39
Harding, Thomas 209
Harington, John 80
Harriot, Thomas 130, 168
 A briefe and true report of the new found land of Virginia 130, 168
 map of Ralegh's Virginia *172*, 172
Harrison, William 99
 Description of England 100, 104

Hassall, John: illustration 259
hat jewel, salamander 109, *109*
Hatton, Sir Christopher 69, 74, 75, 83, 104, 121, 126, 127, 128, 138, 143, 156, 167, 176, 179, 184
 armour 92, 93-4, *94*
 letters to Elizabeth 89, *89*
 portrait (workshop of Segar) 136, *137*, 138, 138-9
Hawkins, Sir John 136, 139-40
 portrait *139*, 139-40
hearse, Elizabeth's (Vincent) 249, *249*
Heere, Lucas de 23
Helgerson, Richard 40
Heneage, Sir Thomas 80, 184, 186
 counter 115
Henri II, of France 207
Henri III, of France 69, 70, 212
Henri IV, of France 224
 medal 224
Henry VII 10, 11, 55, 56, 183
Henry VIII 10, 14, 15, 21, 27, 28, 33, 58, 61, 103, 183, 186, 227
 dagger 13, *13*
 medals 12, *12*
 portrait (after Holbein) *10*, 10-11, 176
 will 65, 66, 70
Henry of Navarre 184
Herbert, George 27
Hertford, Earl of 66, 70, 79; *see also* Somerset, Duke of
Herwijk, Steven van: portrait medal 52, 196
Heydin, Peter van der: portrait of Elizabeth as Diana 217
Heywood, Thomas: *If You Know Not Me, You Know Nobody* 257
Hilliard, Nicholas 42, 43, 176, 177, 179, 246, 252, 255
 Armada Jewel miniature of Elizabeth 239-40, *240*
 Great Seals 49, *49*
 miniature of Earl of Cumberland 77, 96, 96-7
 miniature of Elizabeth (1572) 176, 179
 miniature of Elizabeth (in Drake Locket Jewel) 136, 150
 miniature of Elizabeth as Cynthia 198, *198*
 miniature of Elizabeth playing a lute 101, *101*

miniature of Henry Wriothesley, 3rd
 Earl of Southampton 112, *112*
(attrib.) 'Pelican Portrait' of Elizabeth
 179, 185, 186, 187, 188, *191*, 192
(attrib.) 'Phoenix Portrait' of Elizabeth
 179, 186, 187, 192
portrait of George Carey 108, *108*
self-portrait 198-9, *199*
The Treatise Concerning the Arte of Limning
 199
Hoby, Edward 80
Hoefnagel, Joris 103
Hogenberg, Frans
 Bishops' Bible title page 29, 61
 interior view of Royal Exchange 36, 53-4,
 54
 Nonsuch Palace, with the Queen in her
 Coach 103
Hogenberg, Remigius 59
Holbein, Hans
 (after) portrait of Edward VI as prince
 18, *18*
 (after) portrait of Henry VIII *10*, 10-11,
 176
 portrait of a Woman (?Anne Boleyn) 11,
 11
Hondius, Jodocus 134, 152, 158
Hood, Thomas 141
Hooker, Richard: *Laws of ecclesiastical polity* 30
Horenbout, Lucas 19, 21
hourglass 146-7, *147*
Howard of Effingham, Charles Howard,
 2nd Baron (1st Earl of Nottingham)
 75, 80, 144, 187, 232, 234, 246
 portrait (attrib. Lockey) 235, *235*
Howard, Lord Henry: 'Regina Fortunata'
 200-1, *201*
Howard of Effingham, William Howard,
 Lord 73, 235
Hunsdon, Henry Carey, 1st Lord 80, 101,
 107, 108
Hunsdon jewels 107, *107*, 107-8, 185, 187-8

I.

Inuit, drawings of (White) 125, *161*, 161-2
inventories 113
Ireland, Great Seal of (Hilliard) 49, *49*
Isabella of Castile 23, 70

Ivan the Terrible 124, 158

J.

Jackman, Charles 124, 158
Jacopo da Trezzo: medal of Philip and
 Mary 23, *23*
James I (James VI of Scotland) 31, 32, 70, 71,
 80, 106, 113, 183, 188, 209, 211, 219, 230,
 247, 248, 249, 256, 257
 answer to letters of English peers and
 council 251
 genealogy 249, *250*, 251
 letter to Elizabeth 227
 portrait with a hawk (Bronckorst) 86,
 86-7
 stirrup cup 251, *251*
Jansen, Jacob 204
Jenkinson, Anthony 38, 122, 124, 160, 164
Jesuits (Society of Jesus) 31, 32, 112, 207,
 210-12
Jewel, Bishop 30
jewellery 183-8
 'Brethren or Three Brothers' 183-4
 Drake Locket Jewel 136, 150, *150*
 Drake Sun Jewel 151, *151*
 inventories of 113
 salamander hat jewel 109, *109*
 see also cameos; Hunsdon jewels;
 pendants; rings
Jones, William 204
Jonson, Ben 79, 80
 Cynthia's Revels 79
Jugge, Richard 61

K.

Katherine of Aragon 10, 21, 183, 184
 coin 12, *12*
Kayle, Hugh 184
Keith, William 227
Kelly, Edward 237
Kennedy, Jane 227
Kent, Earl of 227
Ketel, Cornelis 177
King, John 201
Kingsley, Charles: *Westward Ho!* 258
Kip, William 251

Knollys, Catherine (Carey) 111
Knollys, Elizabeth 111
 portrait (Gower) 111, *111*
Knollys, Sir Francis 111
Knox, John 208
Kyd, Thomas 79
Kynvyn, James: astronomical compendium
 244-5, *245*

L.

Lancaster, Sir James 156
Lane, Colonel Ralph 130, 169
Langren, Jacob Floris van: globe 134
Latymer, William: treatise of Anne Boleyn
 14
Lawrence, A.K.: *Queen Elizabeth . . .* 259-60
Lee, Sir Henry 75, 76, 77, 91, 95, 136, 180
 armour 93, *93*
 portrait (Mor) 76, 91, *91*, 147, 176
Leicester, Robert Dudley, Earl of 30, 35, 37,
 39, 44, 66, 67-8, 69, 73, 74, 78, 79,
 83-4, 86, 88-9, 91, 104, 121, 126, 156, 176,
 184, 187, 193, 199, 201, 208, 212, 217,
 224-5, 243
 armour 92, 95, *95*
 coins 224
 counter 115
 drawing of (Zuccaro) 78, 79, 87, 176
 as Governor of the Low Countries (van
 Sichem engraving) 225, *225*
 letters to Elizabeth 88, 88-9
 medal 225, *225*
 portrait 67, 83-4, *84*
Leighton, Sir Thomas 111
Lennox, Duke of 211
Leoni, Leone: medal 223, 224
letters
 Anne Boleyn to Lord Cobham 14, *14*
 Dee to Elizabeth 237-8, *238*
 Essex to Elizabeth 245
 Hatton to Elizabeth 89, *89*
 James VI of Scotland to Elizabeth 227
 Leicester to Elizabeth 88, 88-9
 Mary Queen of Scots' correspondence
 with Alva 220
 Simier to Elizabeth 90, *90*
 see also under Elizabeth I
Levant Company 39

Levin, Carole 74
Lincoln, Edward Viennes de Clinton, 1st
 Earl of 126, 139
 portrait 139, *139*
Lockey, Rowland (attrib.): miniature of
 Lord Howard of Effingham 235, *235*
Lok, Michael 38, 124, 160-1
looking glass 114, *114*
Lord Chamberlain's Men, the 80
Lovell, John 136
Lumley, John, Lord 103, 196
Lyly, John 80
 Euphues 62
Lysle, Anthony de 98

M.

Magellan, Ferdinand 125, 127
Makin, Bathsua 80
Manningham, John 71, 248
maps and charts (*see also* globes)
 Armada charts (Adams) 232, *233*
 Atlas Sive Cosmographicae (Mercator) *123*,
 124, *157*, 157-8, 160
 on medallions (M. Mercator) 149, *149*
 North-East Passage (Dee) 159, *159*
 Province of Munster 128, *129*, 166-8, *167*
 Russia (Ortelius) 160, *160*
 Santo Domingo (Boazio) 153, *153*
 Scotland (Nowell) 221, *221*
 sea chart of passage from England to
 the Baltic (Borough) 158, *158-9*
 Strait of Magellan (Conyer) 125, 148,
 148
 Thames Estuary (Adams) 232, *232*
 Theatrum Orbis Terrarum (Ortelius) 46, *47*,
 124, 125, 159, 160, *160*
 Virginia (White and Harriot) 172, *172*
Margaret of Parma 37
Marlowe, Christopher 79, 80, 255
Marprelate Tracts 32
Mary I 10, 17, 21, 22-3, 27, 28, 33, 34, 42, 58,
 73, 139, 184, 249
 coins 23
 Elizabeth's letter to 23-4, *24*
 medal (Jacopo da Trezzo) 23, *23*
 portrait 22, *23*
Mary of Guise 65
Mary Queen of Scots 28, 37, 48, 65-7, 68,

70, 104, 110, 138, 184, 207-8, 209, 210,
 211-12, 216, 217, 221, 222, 260
 ciphers used 220, *220*
 coin 226
 counter 226
 drawings of execution 227, *228*
 embroidery 226, *226*
 gold cross 229, *229*
 inventory of possessions 230
 jewels 229, *229*
 marriage medal 66, 86, *86*
 petition of her household 230
 portrait with Lord Darnley 219
 proclamation concerning sentence
 against 227
Maundy ceremonies 73-4, *74*, 110
Maximilian II, Emperor 68, 224
 medal (Leoni) 223, *224*
Mayor of London's chain of office (attrib.
 Adamas) 55, *55*
measurement standards, Elizabethan 39,
 55-6, *56*
medals/medallions
 Anne Boleyn 12
 Catherine de' Medici 224
 commemorating defeat of Spanish
 Armada 238, *238-9*
 commemorating Drake's circumnavigation
 (M. Mercator) 149, *149*
 Cosimo de' Medici (D. Poggini) 224
 Edward VI (attrib. Basse) 21
 Elizabeth 85, *85*, 200, *200*
 Henri IV, of France 224
 Leicester 225, *225*
 marriage medal of Mary Queen of
 Scots 66, 86, *86*
 Maximilian II (Leoni) 223, *224*
 Duke of Parma (Giannini) 224
 Philip II (G. Poggini) 223, *224*
 Philip and Mary (Jacopo da Trezzo) 23,
 23
 Pius V (Bonzagna) 216
 Thomas Stanley (van Herwijk) 52
 William the Silent (Bloc) 223, *224*
Melville, Sir James 101
Mercator, Gerard 121, 144-5, 154, 159
 Atlas Sive Cosmographicae 123, 124, *157*,
 157-8, 160
Mercator, Michael: medallions commemorat-
 ing Drake's circumnavigation 149, *149*

Mercator, Rumold 158
Merchant Adventurers 34, 35, *35*, 38, 39
Mercurian, Everard 210
Metsys, Quentin, the Younger: portrait of
 Elizabeth 83, *179*
Middleton, William 103
Mikhail, Tsar 163
Mildmay, Sir Walter 35, 113
'Mirror of Portugal' (diamond) 184
mirrors 114, *114*
mittens 106-7, *107*
Molyneux, Emery 127-8
 globes *127*, 128, 134, *134*
Monument of Matrones . . . , The 31
Mor van Dashorst, Antonis 46
 portrait of Sir Henry Lee 76, 91, *91*, 147,
 176
More, Elizabeth 101
More, Sir William 101
Morgan, Mr (apothecary) 104
Munday, Anthony 192
Munster, map of 128, *129*, 166-8, *167*
Murad III, Sultan 39
Muscovy Company 39, 122, 124, 131, 143, 158,
 164

N.

narwhal tusk *162*, 162-3
navigational aids
 instruments 144-7, *145*, *146*, *147*, 235,
 235, 244-5, *245*
 manuals and textbooks 141-4
 see also maps and charts
Negadri, Susan: cutwork band sampler 202,
 202
New Year's gift rolls 75, 101, 104, 106, 109,
 184
Nichols, John 105
Nonsuch Palace, Surrey 77, 103, 256
Nonsuch, Treaty of (1585) 212, 217
Norfolk, Thomas Howard, 4th Duke of 35,
 44, 68, 83-4, 200, 209, 217, 219
 portrait 217, *218*
Northampton, Marchioness of 249
Northern Rising, the 112, 209, 216
Northumberland, John Dudley, Duke of 67,
 154
Northumberland, Earl of 209

Nowell, Laurence, Dean of Lichfield: map of Scotland 221, *221*
Nugent, Edward 169
nutmeg grater and case 155, *155*

O.

Ogilvie, Alexander 221
Oliver, Isaac 246
portrait of Elizabeth in old age 180, 246, *246*, 255
Order of the Garter 83, 84, 139, 187, 200, 243, 247
badge 84, *84*-5, 95, 217
ore (from Frobisher's Arctic expedition) 161
orpharion, Elizabeth's (Rose) 102, *102*
Ortelius, Abraham 121, 154, 159
Theatrum Orbis Terrarum 46, 47, 124, 125, 159, 160, *160*
Osborne, Edward 39
Oxford, Edward de Vere, Earl of 75, 79, 80

P.

Paesschen, Hendryck van: Royal Exchange 53
Paget, Charles 212
Parker, Matthew, Archbishop of Canterbury 27, 58-9, 61
portrait 58, *58*, 59
Parma, Alessandro Farnese, Duke of 224, 232
medal (Giannini) 224
Parr, John 109
Parr, Katherine 15, 19-20, 21, 28, 183
Elizabeth's letter to 19
portrait 21, *21*
Parry, Blanche 107, 109-10, 183, 186
Parry, Dr Henry 248
Parry, Thomas 20
Parsons, Robert 31, 210, 211, *211*, 212
Passe, Crispin van der: engraving of Elizabeth 246, 255
Paulet, Sir Amyas 230
Peele, George 240
'Pelican Cup' 192, *192*-3
'Pelican Pendant' 193, *193*
'Pelican Portrait' of Elizabeth (attrib. Hilliard) 116, 179, 185, 186, 187, 188, *191*, 192

Pembroke, 2nd Earl of 79, 154
armour 92, *93*-4
Pembroke, Mary Sidney Herbert, Countess of 80
Pembroke, William Herbert, 1st Earl of: armour 10
pendants 186
gold and enamel 11-12, *12*
Hunsdon ship pendant *107*, 107-8, 185, 187
pelican pendant 193, *193*
salamander pendant (from *Girona*) 236, 237
sieve portrait cameo pendant 80, *195*, 195-6
Perlin, Etienne 98
pestle and mortar 116
Pet, Arthur 124, 158
petition of Mary Queen of Scots' household 230
petticoat panel 113, *113*-14
Phelippes, Thomas 220
Philip II, of Spain 22-3, 33, 34, 37, 38, 65, 70, 90, 91, 121, 125, 126, 127, 128, 184, 208, 209, 210, 211, 212, 213, 217, 220, 224, 239
medals 23, *23* (Jacopo da Trezzo), 223, 224 (G. Poggini)
portrait 22, *23*
coins 23, 155
'Phoenix Portrait' of Elizabeth (attrib. Hilliard) 179, 186, 187, 192
Pickering, William 94
pillow cover, embroidered 109, *109*
pint measures, Elizabethan 56, *56*
Pius IV, Pope 208
Pius V, Pope 27, 30, 208, 209
medal (Bonzagna) 216-17
Regnans in Excelsis 209, 216-17
Plancius, Petrus 134
Poggini, Domenico: medal 224
Poggini, Gianpaolo: medal 223, 224
pouch, velvet 115
prayer books
Cranmer's 1552 Prayer Book 27, 29, 59
Elizabethan Book of Common Prayer (1571) 59
embroidered prayer book translation 15, *15*
girdle prayer book 62, *62*

Q.

quadrant, mariner's 146, *146*
Queen's Men, the 79, 80

R.

Radcliffe, Mary 109, 183
'Rainbow Portrait' of Elizabeth 185, 186, 187
Ralegh, Sir Walter 74, 80, 121, 128, *129*, 130, 134, 165-6, 167, 168, 170, 172, 256, 259, 260
The Discoverie of . . . Guiana 166
'The Ocean's Love to Cynthia' 198
portrait 165, *165*, 166
rapier (Sadeler) 244, *244*
Record, Robert
The Castle of Knowledge 122, 143, *143*
The Pathway to Knowledge 143
Reyce, Robert 58
Ribadeneira, Pedro de 207
Rich, Lord 79
Rich, Penelope, Lady 95-6
Ridolfi, Roberto/Ridolfi plot 38, 112, 209, 216, 217, 219, 220
ring dial (Cole) 146, *146*
rings 188
cameo ring 195, *195*
Elizabeth's locket ring 12-13, *13*
from *Girona* 236, 237
Gresham's grasshopper signet ring 55, *55*
Rizzio, David 219
Rose, John: orpharion 102, *102*
Royal Exchange 35, 36, 53-4, *54*
Russell, Lady Elizabeth 80
Russia Company 39
ryal 147
Ryther, Augustine: charts 232

S.

Sackville, Sir Richard 36
Sackville, Thomas 80
saddle, Elizabeth's 103
Sadler, Sir Ralph 113
St Bartholomew's massacre 38, 69, 209, 217
St Leger, Sir Warham 167
salamander hat jewel 109, *109*

salamander pendant (from *Girona*) 236, 237
Salisbury, Robert Cecil, 1st Earl of 6, 70,
 112, 201, 213, 246-7, 257
 portrait (Elstrack) 246-7, 247
salt, Vintners' Company 38, 56, 56
sampler, cutwork band (Negadri) 202, 202
Sander, Nicholas 210
Sanderson, Sir William 134
scent bottles 104, 104-5, 105
score-cheques for Accession Day jousts 95-6,
 96, 244, 244
Scotland, map of (Nowell) 221, 221
Scrope, Lady 188
Scrots, Guillim 17
seals
 Elizabeth I's Second Great Seal 49, 49
 Great Seal of Ireland (Hilliard) 49, 49
Sebastian, King of Portugal 210
Segar, William 177, 243
 (workshop of) double-sided painting
 with portrait of Sir Christopher
 Hatton 136, 137, 138, 138-9
Settle, Dionyse 162-3
Seymour, Edward *see* Somerset, Duke of
Seymour, Jane 10-11, 18, 19
 coin 12, 12
Seymour, Thomas, Lord Seymour of
 Sudeley 19, 20, 21, 24, 67
 miniature (workshop of Holbein) 19, 19
Shakespeare, William 79, 80, 105, 112, 192,
 248, 255
 As You Like It 80
 Henry VIII 80
 Love's Labour's Lost 80
 Measure for Measure 80
 The Merry Wives of Windsor 80
 A Midsummer Night's Dream 79, 80, 256
 Richard II 245
 Twelfth Night 32, 80
Sheffield, Lady Douglas 68
Shelley, Richard 212
Sherman, William 154
ship pendants 107, 107-8, 187
ships, models of 140, 140
shoehorn 117, 117
Shrewsbury, Earl of 227
Shrewsbury, Elizabeth, Countess of 110
Sichem, Cornelis van: portrait of Earl of
 Leicester as Governor of the Low
 Countries 225, 225

Sidney, Sir Henry 128, 166
Sidney, Sir Philip 69, 75, 79, 80, 89, 90, 93,
 128, 168, 199, 243
 Arcadia 79
 Astrophel and Stella 80
 New Arcadia 95
'sieve portraits' of Elizabeth 80, 82, 83, 179,
 195, 195-6
Silva, Nuño de 127
Simier, Jean de 69, 90
 letter to Elizabeth in code 90, 90
Sixtus V, Pope 212
sleeves/sleeve panels 114, 114, 116, 116
Smith, David 103
Smith, Sir Thomas 164
Smyth, Sir Thomas 39
Smythe, Thomas 37
Somerset, Edward Seymour, Duke of
 (*formerly* Earl of Hertford) 13, 17, 19
Sommers, John 220
Southampton, Henry Wriothesley, 3rd Earl
 of 244, 245
 portrait (Hilliard) 112, 112
 Spanish Armada campaign 112, 140, 161,
 185, 213, 232, 233, 234, 234, 235
 medal 238, 238-9
 miniature of 240
 see also Girona; *Trinidad Valencera*
Spencer, Sir John 39
Spenser, Edmund 79, 138
 The Fairie Queene 79, 256
spice box, silver 155, 155
Spillman, Sir John 184
Stanley, Thomas: portrait medal (van
 Herwijk) 52
Staper, Richard 39, 40
Stapleton, Thomas 209
stirrup cup, James I 251, 251
Stoke Prior wine cup 98
stove tiles 97, 100, 100
Stow, John 53
Stuart, Arbella 70, 249
Stubbs, John: *The Discovery of a Gaping Gulf . . .*
 69
Stukeley, Thomas 210
sundial (Cole) 145, 145
Sussex, Earl of 27, 79
sweet bag, embroidered 110, 110
swords
 Drake's 151

see also dagger; rapier
Sype, Nicola van 152

T.

Tallis, Thomas 101
Taylboyes, Robert 61
Teerlinc, Levina 42, 43, 177, 199
 Elizabethan Maundy ceremony (attrib.)
 110
 miniature of Elizabeth 74
Ten Commandments triptych 252-4, 253
terrella 141, 141
Theatrum Orbis Terrarum (Ortelius) 46, 47,
 124, 125, 159, 160, 160
Thirty-Nine Articles of Religion 62
Thomysen, Mrs (courtier) 104
'Three Brothers' (jewel) 183-4, 186
Throckmorton, Elizabeth 166
Throckmorton, Sir Job 212
Throckmorton, Sir Nicholas 184
tiles, stove 97, 100, 100
Tomkins, Thomas: *Lingua, or the Combat of the
 Tongues* 117
Tordesillas, Treaty of (1494) 121
toys, Elizabethan 14-15, 15
Treasury Account Book 54, 54
trenchers 99, 99
Tresham, Sir Thomas 212
Trial of the Pyx 50
Trinidad Valencera, La: shipboard items 237
triptychs
 Royal Arms 57, 57-8
 Ten Commandments 252-4, 253
Turkey Company 39
Tuttell, Thomas: navigational instruments
 144, 144
Tyrone, Hugh O'Neill, Earl of 245, 256
Tyrwhit, Sir Robert 20

U.

Ubaldini, Petruccio: *The Spanish expedition to
 England . . .* 232, 233

V.

Valverde, Licentiate 127
Venice Company 39
Verzelini, Giacomo: goblet 98, *98*
Vincent, Augustine: Elizabeth's hearse 249, *249*
Vintners' Company: Standing Salt 38, 56, *56*
Virginia, map of (White and Harriot) 172, *172*
Virginia Company 131, 172

W.

Waghenaer, Lucas: *The Mariners Mirrour* 143, 143-4
Waldstein, Baron 100, 190
Walsingham, Sir Francis 35, 36, 39, 69, 89, 109, 125-6, 154, 167, 212, 213, 216, 220, 227, 229
 portrait (after de Critz the Elder) 216, *216*

Walsingham, Sir Thomas 148
Walsingham Bowl 148, *148*
Warwick, Earl of 39, 79
Watts, John 39
Wedel, Lupold von 76
Wentworth, Peter: *A Pithie Exhortation* 70, 247-8
Westmorland, Earl of 209
White, John 125, 130, 153, 168
 drawings:
 Indians 169, *169*, 170, *170*
 Inuit 125, *161*, 161-2
 pineapple 170, *170*
 (after) 'Skirmish at Bloody Point' 162, *162*
 village of Secotan 168, *169*
 wildlife *131*, 170, 170-1, *171*
 map of Ralegh's Virginia 172, *172*
Whitgift, John, Archbishop of Canterbury 30, 248
Whitney, Geffrey: *A Choice of Emblemes and other Devises* 187, 199, 199-200
Wilcox, Thomas *see* Field, John

William III, of Orange 79
William (the Silent) of Orange 212, 216, 217, 224
 medal (Bloc) 223, 224
Willoughby, Sir Hugh 123-4
Winchester, Marquess of 35, 36
Windsor, Lord 75
wine cups 98, *163*, 164
Wingina (White) 169, *169*
Wodwall, William: 'The Actes of Queene Elizabeth Allegorized' 111-12, *112*
wool weights, Elizabethan 39, 56, *56*
Wroth, Mary Sidney 80
Wyatt, Sir Thomas 23, 24, 34, 91

Z.

Zeno brothers 158
Zuccaro, Federico 79
 drawings of Elizabeth and Leicester 78, 79, 87, 176
 portrait of Elizabeth 243